SCOTTISH PAINTING

PAST AND PRESENT

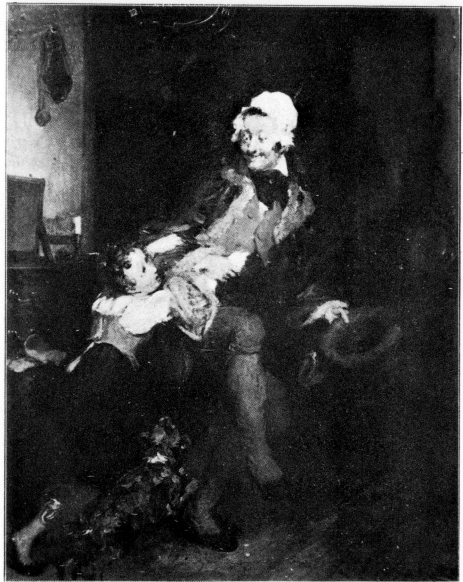

SIR DAVID WILKIE, R.A.

GRANDMAMMA'S CAP

SCOTTISH PAINTING
PAST AND PRESENT
1620-1908

BY JAMES L. CAW

NEMO ME IMPVNE LACESSIT

KINGSMEAD REPRINTS
BATH

FIRST PUBLISHED 1908
REPRINTED 1975

KINGSMEAD REPRINTS
KINGSMEAD SQUARE
BATH

SBN 901571 71 7

PRINTED IN GREAT BRITAIN BY
REDWOOD BURN LIMITED
TROWBRIDGE & ESHER

TO THE MEMORY OF
SCOTTISH PAINTERS OF THE PAST
AND TO
THOSE SCOTTISH ARTISTS OF THE PRESENT
WHOSE WORK IS AN HONOUR TO OUR COUNTRY, THIS
STUDY OF THE HISTORY AND CHARACTERISTICS
OF SCOTTISH PAINTING IS DEDICATED
BY A BROTHER SCOT

CONTENTS

LIST OF PLATES

The Author desires to express his gratitude to the owners, and to the committees of public galleries, who have permitted pictures in their possession to be reproduced. In all cases copyright is reserved on behalf of owner and artist. The reproductions have been made by the Swan Electric Engraving Co. from photographs taken directly from the originals by the photographers whose names appear in the left corner of the plates.

Mr. Caw would also take this opportunity of acknowledging his indebtedness to Mrs. Louey Chisholm for valuable assistance in revising the proofs of the letterpress.

INTRODUCTION

THE history of Scotland before the union of the Crowns is picturesque and varied. Old chronicles tell of the coming of Christianity, and of the slow spread of civilisation, of the welding of the ancient peoples into one nation, and of the long, and noble, and successful struggle for national existence; and in the songs and ballads of nameless makers the life of these old days pulsates for us with the intense vitality of realism become romance. They were stirring times for the most part and counted but few years of peace, for, when not combined against the 'auld enemy o' England,' the fierce and turbulent nobles were at feud amongst themselves or were contesting the authority of the King. Yet if society as a whole was in a state of unrest, life was not without its refinements, as the manuscripts and jewellery, the metal-work and furniture and tapestry, much of them of foreign origin perhaps, which have survived the ravages of time, testify; the Stewart kings were patrons of learning, music, and architecture; and here and there a Scot approved himself a fine poet or a sound scholar; but only within the Church was there the quietude and security necessary for the production of art-work of the higher order. Beyond her pale, or at least outside her service, it was scarcely safe to be an artist, as the row of James's favourites that hung over Lauder Bridge, one summer morning in 1482, gave unmistakable warning. Ancient records give hints of the splendour of some of the churches, and that much of the decoration was fine is almost implied in the beauty of the ruined abbeys and broken priories for which it was wrought; but the surge of passion against idolatry and ritual, which accompanied the Reformation, swept almost all trace of religious art other than architecture from the land. The earlier sculpture on palace, church, and tomb is broken and defaced, and in pictorial art little is left from times before the beginning of the seventeenth century. Even portraits are rare. Of the great nobles and churchmen there is hardly a representation, and the pictures of kings and queens before James III. are mythical and without authority. The Trinity College altar-piece, that masterpiece of Flemish painting, contains what are perhaps the earliest of reliable Scottish portraits,[1] and, like them, those of succeeding sovereigns are not specimens of native art. But, except Pierre Quesnel, the progenitor of a line of notable French

[1] King James III. and his Queen, Margaret of Denmark, with their son, and Sir Edward Boncle. See *Scottish Portraits*, by James L. Caw.

A

artists, who accompanied Mary of Guise to Scotland, where he lived some years, marrying a Scottish lady and having a son born to him in Holyrood, and Jean de Court, who figures in the list of Mary Stuart's household (1566-7), but is not known to have visited Scotland, no painter of importance appears to have been attached to the court of the Stuarts, and of their work nothing remains in Scotland, and little or nothing even in France. They seem, indeed, to have been the only artistic visitors of note, all the other artists' names, including that of Hadrian Vauson or Vaensoun, 'paynter to His Majesty' (*circa* 1594), who painted Knox and Buchanan, mentioned in the Treasurer's accounts or elsewhere, being meaningless to us through lack of work or reputation to give them significance. Holbein, Antonio Moro,[1] Lucas d'Heere, and Zuccaro, the painters who confer artistic distinction on the reigns of Henry VIII. and his children, never crossed Tweed, and, while it is possible that there were native painters, none emerges as clearly as the shadowy Streetes, who was probably of Dutch origin, and with whom English painting is sometimes said to begin. The state of painting in Scotland during the latter part of the sixteenth century is indicated significantly by the fact that there is not a single authentic portrait of Mary Stuart in existence which was painted in her own country. It was not until the Scots had ceased to exist as a separate nation, although not as a distinct people, that they produced a native painter of worth.

Into the vague conjectural places of romance and tradition it is not here intended to venture, nor is it purposed to detail the references in literature to art or even to mention the payments for artistic services which appear in the Lord High-Treasurer's accounts. From such sources one is, no doubt, able to prove that art existed in Scotland ; but without examples we can arrive at no estimate of its character and quality, or of its relationship to that of other countries. The remains of painted roof and wall, which have been discovered from time to time, are more promising material, but the professed archæologist has been unable to determine how much of the work is native, how much foreign ; and as it happens that neither the pre-Reformation ecclesiastical decorations, of which that in Foulis-Easter Kirk is almost the only example left, nor the heraldic or quaintly pictured ceilings of the seventeenth century in Collairnie Castle (1607), Pinkie House (1613), Earlshall (1620), and elsewhere seem to have had any effect upon the development of Scottish painting as we know it, the question of their origin need not be discussed in these pages. The object of this book is not so much to recount the history of Scottish painting by telling the lives of Scottish artists in detail, as to attempt to trace its development in their works, to contrast its different phases and analyse its characteristics, to point out in what it has

[1] He is said to have made a brief visit to Scotland and to have painted a portrait-group of Lord Seton and his family, but there is nothing but tradition and a copy of a picture to go by.

fallen short and indicate in what it has excelled. At the same time, events in the lives of artists, in so far as they have affected their work, and the influence of environment and tradition—the atmosphere of a particular time—upon the individual worker, have not been neglected; and the part that the general condition of society, the facilities for education, and the politics of art have played in the artistic evolution of Scotland has been considered. The venture is perhaps a bold one, and I am conscious of its inadequate accomplishment, but my hope is that the love which prompted the attempt and the care bestowed upon it may render it acceptable not only to my own countrymen, but to all interested in art. For art has a wider appeal than to the people of the district in which it is produced.

In the preparation of this history and criticism of Scottish painting I have of course been greatly indebted to previous workers in the same field or some part of it. To Sir George Chalmers (article in *The Weekly Magazine*, 1772), Patrick Gibson (View of the Arts in Great Britain: *Edinburgh Annual Register*, 1816), Allan Cunningham and John Burnet amongst the earlier writers; to Alexander Fraser, R.S.A., R. A. M. Stevenson, J. M. Gray, my predecessor at the Scottish National Portrait Gallery, and Robert Brydall, of those recently dead; and to Sir Walter Armstrong, Mr. E. Pinnington, and Mr. Bulloch,[1] I owe much; but while I have availed myself of their investigations, it has been my endeavour to verify the evidence, and in doing so I have been fortunate enough to obtain fresh facts of interest, and, by relating them to what was known already, to throw new light upon the art and career of several men.[2] During the ten or twelve years the book has been growing in my hands, I have made a point, also, of criticising nothing I have not seen, and of tracing, from the pictures themselves, the relationship of one man's work to another's, and the evolution of each painter's style.

As regards the illustrations, while a number have been taken from pictures in public galleries, the great majority are from pictures in private collections, many of them now reproduced for the first time. But the objects chiefly in view in this connection were to obtain examples characteristic of the more distinctive qualities in the art of the most interesting painters, and to make the series representative of Scottish painting as a whole. In attempting to do this I met with the greatest kindness from many private owners and the keepers of the public collections. And to Mr. William M'Taggart and Mr. Croal Thomson I owe gratitude for assistance and encouragement in many ways.

A few words should be added, perhaps, as to the reasons which induced

[1] Mr. W. D. Mackay's *Scottish School of Painting* (1906) was not published until after the narrative in this volume had been carried well past the point at which his book ends.

[2] The accounts given of Jamesone, Wright and the Scougalls, of Aikman, Allan Ramsay, the Alexanders and Gavin Hamilton, and of Raeburn and some of his contemporaries, and the discussions of the relationship of the earlier genre and landscape painters to one another, may be instanced.

me to bring this record down to the present, for, had I acted upon the advice of certain wise friends, or regarded my own comfort—and I value both highly—the work of none but dead men would have been mentioned in these pages. But as to have done so would have involved a ragged and unsatisfactory ending, with the beginning of new movements mentioned and the action of those older incompletely traced, and, let us say, the art of John Pettie and Arthur Melville discussed and that of Sir W. Q. Orchardson and Sir James Guthrie ignored, or else the drawing of an entirely arbitrary line across the course of a school as vital to-day as it has ever been, and in which development and change have been continuous and closely related, I deliberately chose the more perilous but, to me personally, the more satisfactory way. To estimate the work of one's contemporaries is of course a risky, perhaps a futile, and certainly a thankless undertaking ; but while one studies the past he lives in the present, and, although any contemporary estimate of men and movements will require readjustment by posterity in the light of the wider perspective and the juster sense of proportion which personal detachment brings, it may serve—should the writer have caught even in minor degree the underlying spirit of his own day—as helpful material in the formation of the future and final verdict. In this later period, also, one is faced by much greater difficulty in selection, for artists are far more numerous than they were, and minor men, whose work would have had significance at least at an earlier date as indicating tendencies, are now so many that to treat what they have done in detail is impossible.

PART I

THE PAST—1620-1860

SECTION I.—THE PRECURSORS—1620-1787

CHAPTER I

FROM JAMESONE TO MEDINA

TOWARDS the close of the sixteenth century the mists which obscure the history of the earlier art of Scotland begin to disappear. For some time considerable uncertainty continues as to the authorship of particular works and the identity of individual artists, but many examples can be authenticated clearly, and one begins to be able to form some idea of the personality of the different Scottish painters. During the next two centuries, however, the history is a story of struggle rather than of accomplishment. The Reformation had severed the ancient connection of art and religion, in 1603 the union of the Crowns withdrew such patronage and encouragement as courts can bestow, and for long the condition of the country, social, political, religious, was much against the growth of the arts.

Writers on art and historians of a certain bias have made so much of the destruction of art and architecture which marked the religious revolution that they make it appear as if Presbyterianism and Puritanism were but Philistinism writ large. And no doubt there was much wanton destruction, for mobs are ever eager to pull down, and the Scots mob in the old days was one of the fiercest in Europe. Amongst the people, however, the wrecking fury was directed principally against the monasteries of the begging friars, of whose buildings scarce a trace remains in Scotland, and the corrupt state into which these and other religious orders had degenerated was such as to justify Knox's most famous epigram. The kirks suffered less, for the clergy of the reformed faith were anxious to preserve them for their own services, and while the formal letters of instruction issued ordered the purging of the buildings of all images and 'monuments of idolatrye,' a footnote requested that the desks, windows and doors, and the glass and iron-work 'be not hurt or broken.' The Reformers had nothing to do with the ruinous condition of the Border abbeys, which is due to English incursions, and particularly to that under Lord Hertford in 1545. But the greed of the Scots nobles, who had seized the Church lands, and who, although constantly repeating their promises to provide more adequately for the Church and to carry out the great scheme of national education devised by Knox, never did so, is largely responsible for the decay of

many ancient churches, many of which became in one way or other private property at that time.

The Scots reformers were not so opposed to ritual in itself—they had a service-book—nor did they take so sombre a view of life as their successors of sixty or seventy years later, and their zeal for learning was evinced in the founding of Edinburgh University. It was not until the despotism of Charles I. and the persecutions of his sons had driven the iron of asceticism into their souls that the joy was taken out of life. But the events of the last half of the sixteenth century were so momentous that art might well seem of little moment to those who engaged in or witnessed them. 'The birth of modern society,' says Sainte-Beuve in his fine essay on Mary Stuart, 'of civil equality, of respect for the rights of all, was laboriously taking place amid barbarous scenes and even fanaticism'; and he goes on to describe the reformers as 'a religious party, logical and gloomy, moral and bold, discussing rationally, Bible in hand, the rights of kings and thrusting logic into prayer.'

While much of the destruction of architecture can thus be traced to causes other than the mob, the other arts, which had contributed to the pomp and beauty of the Catholic ritual, suffered severely at its hands. The shrines and altars, the pictures and images, the vestments and the altar furniture made one great holocaust from end to end of Scotland, and even the postscript already referred to did not always save the useful fittings from destruction. Little ecclesiastical wood or iron work, and not half a dozen pieces of stained glass, survive to-day. What was worse, many of the people mistook the appearance for the reality, the symbol for the thing itself, and art had been so closely, if not exclusively, identified with the old religion, that it became distrusted in any form. Still, the poverty of the country was perhaps a greater hindrance to art than religious convictions and scruples. In Holland, where, as in Scotland, the Reformation had swept ritual and æsthetics out of the churches, and so deprived art of the chief function it had performed, the rise of a great commercial class led to the production of those pictures of everyday life and landscape, and those great groups of syndics, city guards, and managers of charitable societies, which form so large a part of the Dutch galleries. But in Scotland there was nothing to correspond to such institutions : the burghers were poor and socially unimportant, and there were no town-halls or dollens, and few alms-houses or hospitals. Constant struggle with a powerful neighbour, although successfully maintained, had kept everything in an unsettled condition ; and the recent union of the Crowns, necessitating the removal of the court to London, led to many of the Scots nobility, in whose hands the wealth of the country was concentrated, becoming non-resident. Agriculture was rude and unskilled ; commerce was of no great account, and suffered from the existence of monopolies ; industries were few,—excepting a little lead and coal mining, the mineral wealth was untouched ; and for

more than a hundred years there was little increase in the wealth and material wellbeing of the people. To all appearance the condition of Scottish affairs at the opening of the seventeenth century was not such as is conducive to the origin or growth of an art. But until the policy of Charles I. led to the Solemn League and Covenant and the Civil Wars there was internal peace, and it was during that period that the first Scottish painter lived and worked.

While the authentic history of Scottish pictorial art begins with George Jamesone, we possess most meagre details of his career. Even the date of his birth, usually given as 8th February 1587, is unknown. But some time about the close of the sixteenth century he was born at Aberdeen, then a city of only some five or six thousand inhabitants, but the capital of the northern districts, the seat of a university, and a chief centre of the trade with the Low Countries. His father, a decent burgess, was a master mason and architect, and in May 1612 he was entered 'printeis' 'for aucht yeiris' to one John Andersone, 'paynter' in Edinburgh. Anderson, who, like the versatile 'Davie do a'thing,' was his uncle, seems to have had some reputation, a writer mentioning his 'fine painting yet remaining in Gordon Castle' in 1642. Yet this, the first clear fact in Jamesone's life, is followed by another blank, and when, in 1620, he again emerges, it is as the painter of a portrait of Sir Paul Menzies, Lord Provost of Aberdeen. From then until 1644, when he was laid in a nameless grave in Greyfriars churchyard, the incidents of his career, gleaned from old account-books, letters, diaries, deeds, and the signatures on pictures, have been pieced together by Mr. Bulloch, and, if the mosaic thus made shows blanks here and suppositions there, it is perhaps all we shall ever know of the earliest Scottish painter. The discovery, a few years ago, of his indenture in a 'List of Apprentices' (from 29th May 1583 to 28th December 1647), preserved in the archives of the city of Edinburgh, seemed to give the *coup de grâce* to the tradition that he had studied under Rubens and had had Van Dyck as a fellow-pupil, but, only the other day, Mr. J. A. Henderson unearthed another fact which once more makes the story credible. On 6th September 1616 Anderson, already a simple burgess of Aberdeen (1601), was promoted to the grade of guild burgess, a privilege involving residence in the city. It is possible, therefore, that removal from Edinburgh broke the agreement between him and his nephew, and that the latter seized the opportunity to go to Antwerp, whence he is said to have returned about 1619. Yet no definite trace of his having done so has been found. His name does not appear in the Register of the Antwerp Guild of Painters, upon which the name of every student as well as of every master had to be placed. But Rubens having been specially exempted from entering his pupils, absence is no proof.[1]

[1] I am indebted to M. Henri Hymans, the well-known Belgian expert, for investigating this point. He assures me that no name at all resembling Jamesone appears in the Antwerp registers.

Moreover, one is faced by the difficulty of accounting for his style on other grounds. Unmistakably related to the prevailing Flemish tradition, it does not seem that of an entirely self-taught man. If Jamesone evolved it for himself, he is in reality a finer artist than we have been in the habit of considering him, for at his best he achieved results so simple and dignified that they would imply an originality of peculiar refinement.

Although it has been asserted that he painted landscape and history, none of his work in these kinds has survived, and the pictures indicated in the well-known portrait of himself, which forms the frontispiece in Mr. Bulloch's book, are almost the only evidence that remains. And whatever Jamesone's ambitions may have been, portraiture was the only branch of art which could be profitably pursued in the Scotland of his day. Religious art was impossible, and genre and landscape were luxuries which the poor and practical Scot could do without. For portraits, however, there was a certain demand, and he was amply employed in painting, not only his neighbours in the north, but many of the most important people in Scotland. Notwithstanding the bitter religious and political differences of the time and the clear party cleavage, he kept himself wonderfully free from suspicion of bias,[1] and painted the leaders of each side impartially— Charles and Montrose, as well as Argyll, Johnston of Warriston, and old Leslie. He died in Edinburgh, where he often resided during the latter part of his career, just as the parties so long at variance came to blows.

His earliest portraits, such as 'Sir Paul Menzies' (1620) and 'Dr. Arthur Johnstone' (1621), both in Marischal College, Aberdeen, although stiff in pose, archaic in drawing, halting in technique, and hot and bricky in colour, are marked by much of the quick sense of character and simplicity of design which distinguish the work of his maturity, and before 1630 he had produced some of his finest things. The 'Lady Mary Erskine, Countess Marischal' (National Gallery, Edinburgh), probably the most charming and best preserved of his works, belongs to 1626 ; the imposing full-length 'Maister Robert Erskine' in Lord Buchan's collection, which in importance, richness of colour, fullness of tone, and dignity of design may be counted his *chef-d'œuvre*, to the year following ; and the engaging likeness of the young Montrose on the eve of his wedding, and the King's College (Aberdeen) picture of Dr. Arthur Johnston, which shows the great advance his art had made in eight years, are dated 1629. Van Dyck's visits to England in 1621 and 1630 were of short duration and were attended with little popular success, and, as he did not take up residence in London definitely until 1632, it is evident from the dates of these pictures that Jamesone had attained his own style before the accomplished Fleming's influence became directly operative in England in the work of William Dobson (1610-46), Robert Walker (? -1666), and others.

[1] The only trace of his political bias is the occurrence of his name in a list of 'malcontents' (Privy Council Register, 1641).

Having made so much of his talent in circumscribed conditions, one wonders why his visit to Italy in 1633 should have left practically no trace on his art, and why the pictures painted during his last decade are inferior, in not a few cases, to those painted previously. For this it is, of course, impossible to account completely, but probably the King's patronage when in Edinburgh in 1633, combined with the prestige which his travels would create, resulted in an increase of commissions, and led to a tendency to hurry. What is certain is, that many of his later works, such as several of those at Taymouth dated between 1636 and 1642, are less considered and more hurried in style; and his undertaking to paint sixteen portraits in less than three months for Sir Colin Campbell of Glenorchy, his most constant patron, is indicative of the speed at which a number of them were executed. At the same time some of his ablest portraiture belongs to quite late in his career. He never painted more powerfully than on the canvases representing three Carnegies—the first Earls of Southesk and Northesk, and Sir Alexander Carnegie of Balnamoon—which are dated 1637 and hang beside a picture of the fourth brother, painted eight years earlier, in the dining-room of Kinnaird Castle; and seldom more charmingly than in the portrait of the boy, 'Thomas, Lord Binning' (1636), at Langton. The 'Lady Hope' at Pinkie, a particularly pleasing, if somewhat repainted, example of his female portraiture, the 'Sir Archibald Johnston, Lord Warriston' (Sir J. H. Gibson Craig, Bart.)—a more than usually subtle and delicate rendering of a man —and the fine portrait of himself, illustrated in W. E. Henley's *Century of Artists*, probably belong to this period also.

A few miniatures have been ascribed to him, and he painted a number of full-lengths, including that already referred to, but hands seem to have presented considerable difficulty to him (they are poorly drawn and seldom introduced), and his characteristic pieces are short half-lengths— from the waist, as he phrased it—with the head slightly smaller than life, almost invariably turned to the right, and coming somewhat high on the canvas, usually about 28 by 24 inches in size. His drawing is sympathetic, if rather archaic, the foreshortening of the features and particularly the projection of the nose being defective frequently; his modelling inclines to flatness and is deficient in form; his poses are frequently stiff and awkward; his colour is lacking in variety and richness: but the general air of his finer pictures is distinguished, the tone refined, the handling delicate and charming in its clear fluency of touch, and the simplicity of his motive—the pale flesh of the face, pearly-grey in quality, with the red lips for the one touch of positive colour, coming quietly and harmoniously against the low-toned grey-brown of the background—reposeful and even dignified. Often happily inspired in characterisation, he treated the picturesque costume of the period cleverly, rendering laces and ruffles and suchlike frippery with daintiness and precision, and yet keeping them

subordinate to the interest of the face. He was peculiarly free from artistic affectation, and, being primarily interested in his sitters as persons, he, as a rule, represented them in everyday dress. Armour seldom figures in his pictures ; compared with most of his contemporaries, he was a domestic portrait-painter.

Jamesone left a considerable fortune, but part of it was probably inherited, for his prices were exceedingly modest, as is evident from a letter he wrote to Sir Colin Campbell in 1635. 'The pryce quhilk ewerie ane payes to me, abowe the west,' it runs, 'is twentie merkis (23s. 6d.), I furnishing claith and coulleris ; bot iff I furniss ane double-gilt muller, then it is twentie poundis (34s. 4d.). Thes I deall with all alyk ; bot I am moir bound to hawe ane gryte cair of your worship's serwice, becaus of very gouid payment for my laist employment.' And from his will it would appear that for full-lengths of Lord Haddington and Lady Seton, frames included, he was to have received 300 marks, and for Lord and Lady Maxwell 'to the knees' 100 marks. He seldom signed his pictures, but frequently inscribed them with the date and age and occasionally the name of his sitter. If Jamesone's work is unworthy of his reputation as the 'Scottish Van Dyck,' he yet remains the far-off harbinger of the many artists Scotland has since produced, and it is pleasant for patriotic Scots to think that, with fewer opportunities and under less advantageous circumstances, Scotland possessed a native painter of merit before the sister kingdom south of Tweed.[1] Of the historical value of his pictures at least there can be no doubt. The sombre tone, the limited colour, and the restraint of the whole effect express, even without the grave faces with which they are associated, the serious crisis in the national history of which they are a record and a commentary ; and in the faces can be read that devotion to civil and religious liberty which marks the period and illumines with a sober glory the actions and the lives of these stern and not quite lovable men.

The lull betwixt two storms in which Jamesone had spent his life and done his work was broken a few years before he died. He had taken few or no pupils and he left no immediate successors, and even if he had, the condition of the country made art almost impossible as a career. The triumph of the Parliamentary party in England, to which the Scots army had contributed, created a state of affairs that brought Cromwell to Scotland and led to her subjugation ; while the Restoration, although it gave her back the old line of kings, brought in its train persecution and injustice from which the great Protector's rule was entirely free, and deprived the poorer country of that freedom of trade so essential to her progress. From 1660 to the Legislative union is perhaps the bitterest chapter in Scottish history, and it is not surprising that most of the few

[1] Nicholas Hilliard (1547-1619) and Isaac Oliver (1556-1617) were much more accomplished than Jamesone, but they were miniaturists.

Scottish painters of talent then living spent their lives in London or abroad.

Born about 1625, John Michael Wright is said to have been a pupil of George Jamesone and to have gone to England at the age of seventeen, two years before his master's death. Soon afterwards he went to Italy, where he studied for several years and was elected (1648) a member of the Academy of St. Luke, and, either then or during a later visit, of the Academy of Rome. Returning to England during the Commonwealth, he found considerable employment as a portrait-painter, painting Mrs. Claypole, Cromwell's favourite daughter, Colonel John Russell (Ham House), and General Monck amongst others, and by 1659 he was so prominent as to be mentioned by Evelyn as 'the famous painter, Mr. Wright.' After the Restoration he shared fashionable patronage with Sir Peter Lely (1617-80), and according to the inscription 'Jo. Michael Wright, Lond. pictor Regius, pinxit 1672' on the back of the full-length of Prince Rupert in Magdalen College, Oxford, and other pictures, he was one of the court painters. Amongst other work executed by him for Charles II. were some decorative pieces for Whitehall, which have disappeared, and a portrait (1675) of Lacy, the low comedian, of whom the Merry Monarch was so fond, now at Hampton Court. He was a good deal employed by the aristocracy, and in 1668 received an important commission from the City of London under rather curious circumstances. The Corporation had been so pleased with the way in which the judges had adjusted the claims arising out of the Great Fire, that it decided to have their portraits painted for the Guildhall, and asked Lely to execute them. But Sir Peter, being 'a mighty proud man and full of state,' declined because their lordships were to be waited on in their chambers, and would not give sittings in his studio. The City fathers then asked several of the better known portrait-painters to tender for the work, and finally it was given to Wright at the price of £36 (Walpole says £60) for each portrait. There are two-and-twenty of them, each an 87 × 60 inch canvas, and although showing signs of having been done *en bloc*, several, such as the 'Earl of Nottingham' and 'Sir Timothy Littleton,' possess merits of simple and almost distinguished design, which even the villainous repainting they underwent at the hands of Spiridione Roma in 1779 has not obliterated completely. They excited much interest at the time, Evelyn mentioning that he went to see them at the Guildhall as if that had been quite the thing to do ; but probably they were never fine examples of his art, and in their present condition they tend to lower a reputation that should be higher than it is. As Steward of the Household he accompanied the Earl of Castlemaine on his unsuccessful embassy to Pope Innocent x. in 1686, and published a curious account of it in Italian, afterwards translated (1688) into English by Nathan Tate, a forgotten poet-laureate. On his return he found Sir

Godfrey Kneller (1648-1723) the idol of society, and in 1700 applied to William of Orange for the position of King's Painter in Scotland, but previous connection with the Jacobites led to him being passed over in favour of a shopkeeper. In the same year he is supposed to have died, and his fine collection of gems and coins was acquired by Sir Hans Sloane.

Amongst the few portraits by him in Scotland, that of Sir Charles Bruce, the architect of Holyrood as we know it, painted in 1665, and one of his most charming works, the 'Lady Cassillis,' at Yester, and two in Melville Castle may be mentioned. England is more fortunate, for, in addition to a considerable number in private collections, the National Portrait Gallery has three good examples, and the 'John Lacy,' of whom there is another portrait by Wright in the Garrick Club, is easily accessible. 'Mrs. Claypole' (1658) being a comparatively early work of cabinet size, is not very characteristic, but 'Thomas Chiffinch,' a connoisseur seated amongst his treasures, shows his style to advantage, and 'Thomas Hobbes,' which represents the author of *Leviathan* at the age of eighty-one (1669), is wholly admirable. But Lacy in his triple bill of 'a Gallant, a Presbyterian Minister, and a Scotch Highlander in his plaid' is more important than any of these. A piece of fine characterisation and design, with the figures admirably posed and grouped, and good in action; interesting in colour and in disposition of light and shade; and refined yet full in tone, and excellently drawn and painted, one would count it the best English portrait of its period, were it not that there is good reason to attribute the much discussed and curiously named 'Regent Moray' at Langton to the same painter. That picture has been assigned to Jamesone, but it bears no marks of his style, and the dress is conclusive proof that it belongs to the time of Charles II., while comparison with Wright's finest authentic work indicates his authorship. The drawing of face and figure and the pose have many of his characteristics, and the hands, as often with him, are both elegant and expressive; the handling with its creamy impasto and thinner passages, the quality of the colour and the pitch of the tone, resemble his, and the general design possesses that rather distinguished quietude which differentiates Wright from his contemporaries. Everything considered, it is almost certainly his work, and probability is greatly increased by Walpole's statement that 'two of his most admired works were a "Highland Laird" and an "Irish Tory," whole-lengths, in their proper dresses, of which several copies were made.' Full-sized copies are unknown, but Mr. Cunninghame of Balgownie possesses a smaller version, which is said to differ from the Langton picture only in the headdress.

While Pepys mentions Wright with some contempt as compared with Lely—'But, Lord! the difference that is between their two works!'— Evelyn, as has been indicated, thought more highly of him—'he liv'd long

at Rome and was esteemed a good painter,'—and his best work has certainly nothing to lose by comparison with that of any of his contemporaries. If at times his flesh inclines to be over dark in the shadows, he was a sound and pleasing colourist, and the general tone of his work is rich, low, and harmonious; his drawing was delicate and his characterisation sympathetic, and, at times, subtle; above all, his pictures possess unity and are free from that element of pose and puffed-out allegory so dear to the debased taste of his time. He had neither the facility of execution nor the fertility of invention of either of his successful rivals; but at its best his portraiture possesses a certain dignified restraint, and his technique and colour a simplicity and reticence, that connect it with the finer taste and purer style that prevailed in England before the Restoration. Some of this he probably owed to early connection with Jamesone, but, while his portraits lack that mingled naïveté and distinction which give Jamesone's finest things a charm all their own, he was a distinctly better draughtsman and possessed a much completer technical equipment.

Somewhat later than Wright, Thomas Murray (1663-1734), another portrait-painter of Scottish origin, worked in London, and was much thought of by society, for he had polished manners and a handsome face, which, to judge from the autograph portrait in the Uffizi, showed no trace of that parsimony which enabled him to leave a fortune, and found expression in his will, where he directed (and his nephews took him at his word) that, if it would not cost 'too much,' his monument was to be erected in Westminster Abbey. He had been a pupil of one of the De Critz, a family of Flemish painters, the first of whom had settled in England under Walsingham's patronage in Elizabeth's reign, and became sergeant-painter to that Queen's successor, but he was more influenced by John Riley (1646-91), and followed that artist's method of painting the faces himself and leaving the draperies and accessories to others. It is to that habit that the discrepancy between the parts which detracts from the modest merit of his pictures is due: while those painted by himself are frequently delicate and expressive, the others are too often heavy in handling and inferior in style. There is little variation even in his impasto, however; his drawing is careful rather than delicate or expressive; and if his colour is refined in tone, it is negative and monotonous and lacking in modulation. But, although his handling of oil-paint is rather dry and sapless, it is simple and refined, and he had a considerable sense of character, which redeems his portraiture from the taint of manufacture, which might otherwise have asserted itself. He is represented by busts of Sir John Pratt and Captain Dampier in the London Portrait Gallery, a full-length of Queen Anne hangs in the town-hall of Stratford-on-Avon, and several of the learned societies own portraits by him; but, while his portraits are fairly numerous in English family collections, they are rarely, if ever, met with in Scotland.

Little is known of the Scots working abroad at this time ; but James Hamilton is said to have excelled as a painter of still-life and fruit, and a number of pieces remain to testify to the skill with which William Gouw Ferguson (1633 ?-90?) handled similar subjects. Born at Murdieston, Fifeshire, Hamilton practised in Scotland until the advent of the Commonwealth, when, being a Royalist like most of his name, he retired to Brussels, where he resided until his death many years later. His three sons, born and educated abroad, became painters, two of them attaining considerable reputation. Ferdinand Phillip (1664-1750), a clever painter of animals, was appointed painter to the Emperor Charles VI. at Vienna, where specimens of his art may be seen in the Belvidere Palace ; and John George (1666-1733?), who followed much the same line, is represented in the same collection and at Berlin. In foreign catalogues their names are prefixed by Von, and their connection with Scotland is too remote to make more than mention necessary here.

Neither the time nor the place of Ferguson's birth has been ascertained, but he seems to have left Scotland while still young, and, after travelling in Italy and France, lived so much in Holland, where he married, and acquired such command of the Dutch convention that he is usually grouped with the Dutch school. While at the Hague he paid his rent partly in kind—one picture a year being the stipulation. Until the Glasgow Gallery acquired two still-lifes in 1900, the only picture by him in a public collection in this country was the 'Sculptured Ruins and Figures' in the National Gallery of Scotland, which in subject and treatment resembles two pictures (signed and dated 1679), 'composed in Italy and representing bas-reliefs, antique stones, etc., on which the light was thrown,' says Vertue, 'in a surprising manner,' which Walpole mentions as having been sold in Andrew Hay's collection. A work 'entirely in the style of Solemachers,' according to Dr. de Groote, it shows a group of statuary and a white column standing in bright light against a background of black-brown curtain and dark sky, with some brightly costumed peasants and a dog introduced towards the right. The chiaroscuro is exaggerated and melodramatic, the colour slaty and cold in the lights and black in the shadows, the handling hard and unsympathetic, the whole effect very different from that characteristic of his still-life pieces, of which no better examples exist than those in Glasgow. Representing several varieties of birds—partridge, thrush, and goldfinch in the signed picture, and pigeon, kingfisher, and two finches in the other—lying upon a white shelf, over which some drapery is thrown, beside a fowler's snare, a hawk's hood, and other accessories, they exhibit his ability as a craftsman and colourist ; the forms and plumage are admirably drawn, the textures finely realised in a fused creamy impasto, the tone is low but luminous, the colour rich and harmonious. Signed examples in the Berlin Gallery and the Ryks Museum, Amsterdam (dated 1662), catalogued amongst the

Dutch pictures, are also of dead birds; but in a larger canvas than any of these, in the Kunsthalle at Hamburg, one can see how well he could paint a hare and the contrast of fur with plumage, while the larder window opens on a landscape with a castle perched on a hill under a cloudy sky, in which it may not be fanciful to trace a reminiscence of his native land. Pictures by Ferguson are rare, and these seem all that bear his name in public collections. It is understood, however, that his work frequently passes as that of Weenix and other well-known masters of the school of his adoption, from which it may be differentiated, perhaps, by rather greater fullness of colour and impasto. In being thus deprived of some portion of his posthumous fame, the ill-fortune that he experienced in life attends his memory also. Walpole's meagre account of Ferguson in the anecdotes concludes with the suggestive phrase, 'He worked very cheap and died here.'

While these men were following their art with more or less success in England or abroad, a few Scotsmen were finding employment as portrait-painters at home. But their personal history is scarcely less obscure; and their portraits, although nothing great as art, present many problems in attribution and the identification of subject, for they seldom signed their work or recorded their sitters' names. Broadly regarded, however, the interest, such as it is, centres in the work of the Scougalls and their pupils, and the pupils might be left in obscurity without loss to any one. The tradition is that there were two painters of the name, usually distinguished as 'elder' and 'younger,' and although doubt has been thrown upon it, the few known facts are sufficient to justify the traditional view. It is but fair to add that an essential fact has emerged since Mr. Brydall pronounced so strongly in favour of the one-man theory. On the other hand, the signature 'Dd. Scougal' upon one of a pair of portraits, dated 1654, in Newbattle Abbey creates some difficulty, especially as the name 'David Scougall, painter,' also appears in a receipt (8th September 1666), for 'eight dollors' for a portrait of Viscount Oxford, probably one of the unidentified pictures in Lord Stair's possession. It is possible that this is the painter represented in the portrait called 'John Scougall,' in the National Gallery of Scotland. That portrait shows a dark-complexioned man in the costume of the Charles I. period, and as it came from a descendant of the Scougalls, he may have been John's father. There is a story to the effect that a painter of the name received a ring from James VI., in token of approval of a portrait of Prince Henry, who died in 1612, and the man in the picture holds a ring between finger and thumb. But as to the existence of John and his son George there can be no reasonable doubt. An article (said to be by Sir George Chalmers, the painter), which appeared in *The Weekly Magazine* or *Edinburgh Amusement* for 16th January 1772, some forty years after the elder Scougall's death, tells us that 'He [John Scougall] had a son, George, whom he bred as a

B

painter and is known by the name of the younger Scougall, but greatly inferior to the father. . . . For some time after the revolution painters were few. The younger Scougall was the only one, whose great run of business brought him into an incorrect stiff manner void of expression. His carelessness occasioned many complaints by his employers ; but he gave for answer that they might seek others, well knowing that there was none to be found at that time in Scotland.' This account is not quite reliable, for, as is well known, there were others—his father, Sir John Medina, and Medina's son, to name only these—at work after the Revolution, but it shows a belief in George Scougall's existence, which has been vindicated completely by researches made by Dr. David Murray. In 1715 the members of the Merchants' House, Glasgow, commissioned George Scougall to paint James Govane for £60 Scots ; two years later he was employed by the patrons of Hutcheson's Hospital to paint portraits of Mr. George and Mr. Thomas Hutcheson ; in 1723 he had £7 sterling for a picture of Robert Saunders of Auldhouse ; and in 1724 he received £3, 10s. for painting Dean of Guild Thomson, with 25s. extra for the frame. All this detail may seem superfluous in the light of the wretched quality of George Scougall's work, which quite bears out Sir George Chalmers's description ; but it elucidates a point that has created considerable difference of opinion, and helps one to adjust the relative positions of the Scottish portrait-painters of the period.

The information available concerning John Scougall (1645?-1730?) is even more explicit. A cousin of Patrick Scougall, Episcopal Bishop of Aberdeen from 1664, he had a large practice, and his house and studio in the Advocates' Close are said to have been a favourite resort of Edinburgh society. A portrait of the Countess of Marchmont (dated 1666) at Mellerstane is assigned to him, but the earliest examples known to me personally are the 'Lord Carrington' (1670) at Dalmeny, of which several versions exist, and two portraits at Penicuik, said to represent Sir John Clerk, 1st Bart., and his lady, which are verified by an entry 'To John Scougall for 2 pictures £36 [Scots],' dated November 1675, in an old 'Book of Accompts.' In 1693, and again in 1702, he was employed by Glasgow University to copy portraits of celebrated persons (these are probably the Wishart, Patrick Hamilton, Knox and other similar likenesses of doubtful authenticity preserved at Gilmore Hill) at a guinea sterling apiece, and in 1698 he made the excellent copy of Van Somer's 'George Heriot,' which represents that pious founder in the Hospital that bears his name. Some years later he is mentioned in the minutes (1708 and 1712) of Glasgow Town Council in connection with three full-lengths, now in the Corporation galleries. For those of King William and his consort he received twenty-seven, and for that of Queen Anne fifteen, pounds sterling. And as his son's name begins to figure in the Glasgow records, searched by Dr. Murray, in 1715, it is perhaps a fair inference to assume that he

retired from practice about that time. He was then some seventy years of age, and the declension which advancing years was bringing upon his style is revealed by comparing the 'Queen Mary' of 1708 with the 'Queen Anne' of four years later.

Although John Scougall produced some very indifferent work, particularly in the later part of his career, when he was influenced by the work of Lely and Kneller, his art is upon a distinctly higher plane than his son's, and, at its best, possesses considerable charm. To estimate his talent from the Glasgow full-lengths, even from the 'Queen Mary,' which is much the best, would be unfair, for they are late in date and were not painted from life. But the 'Lord Carrington' already mentioned, 'Lord Harcarse' in the Parliament Hall, and 'Lady Elphinstone' in the Lauderdale collection may be instanced as excellent examples of his appreciation of character and of his skill as a craftsman. The sitters are admirably individualised, and his drawing, although not without its own mannerisms, is free from that tendency to coarseness which mars much contemporary work in England ; his colour, if it is not rich, is pleasant, and the pigment has been used thinly and cleanly with a good deal of medium. But the high-water of his gift is marked by the Penicuik pair and a Countess of Lauderdale in Thirlestane Castle, for these possess a delicacy of handling and a pearly quality of cool colour, combined with a demure elegance of conception, which he nowhere else equals.

Marshall and Wait, two pupils of the Scougalls whose work can be identified, belong more properly perhaps to the following period, but David Paton may be given a place in the annals of the seventeenth century. He is supposed to have painted in oils, for the rare engraving[1] by Vanderbanck (1649-97) of General Thomas Dalzell, the 'Muscovite Beast' of the Covenanters, was taken from an original by him, which may or may not have been the picture shown in the 1884 exhibition of Scottish National Portraits, but his authenticated work consists of miniature portraits in plumbago. Dr. G. C. Williamson, in his elaborate work on miniatures, describes him as perhaps the best of the miniaturists working in pencil at the period, and states that 'his portraits are of great rarity and of remarkable beauty.' The Ham House collection contains many charming examples, marked with the initials D. P., and at Hamilton Palace there are several frames of little pencil-portraits, some of them drawn from well-known pictures by others, signed 'David Paton fecit 1693 Edinborough.'

Although native artists were given little inducement to remain at home, a few foreigners were brought to Scotland by aristocratic patrons towards the close of the seventeenth century. In this one seems to touch a Scottish characteristic, for throughout the history of Scottish art one, again and again, comes upon instances (and they are being repeated to-day

[1] It is to be noted, however, that the lettering on the print is 'D. Patton *del.*' and not 'pinxit.'

with little excuse) in which strangers were preferred or native talent was neglected and even flouted, until it obtained recognition in London or on the Continent. The result is that southward migration of Scottish talent which so grieves patriotic people, and which, from time to time, deprives the resident school of painters of some of its best men.

In 1684 a Fleming, Jacob de Wett, contracted with Government to execute the series of one hundred and ten portraits of Scottish sovereigns from the remotest times to Charles II.—James VII. must have been included at a later date—which is still to be seen and wondered at in the long gallery at Holyrood; but when it is remembered that the price stipulated for, and never completely paid, was £240, the artist supplying colours and canvas and his employers 'originals' from which to copy, the result need cause no surprise. His talent, however, was not given wholly to imaginary portraiture. He painted portraits from life, of which several are at Glamis, and also executed some decorative panels, not without merit, for chimney-pieces or ceilings in Holyrood, and designed the fine sculptured arms over the main entrance.

Nicolas Heude and Sir John Baptist Medina were importations of more importance. The former had been a director of the French Academy, but on the revocation of the Edict of Nantes (1685) he had to flee, and, like many of his countrymen, found asylum in England. There he met the 1st Duke of Queensberry, who invited him to Scotland, where he painted a number of portraits now at Drumlanrig, and decorated several ceilings in Caroline Park with figure subjects of considerable charm. Of his work in France little is known, but at Versailles there is an allegorical piece in which the Prince of Orange figures as Hercules. His portraiture has been described as 'out of the common style and set off by touches of historical composition,' but it does not seem to have given very general satisfaction, as he died in 'straightened circumstances'; and in 1688, at the instigation of the Earl of Leven, £500 was subscribed to induce Medina (1659-1710), a Brussels painter of Spanish extraction who had arrived in London two years previously, to settle in Edinburgh. Accepting the invitation, Medina soon had a great practice, and as an old writer puts it, 'must have wrought with great facility and expedition, for he filled the country with portraits' before he died in 1710. His style is trenchant and telling, but deficient in subtlety and beauty. As a colourist he inclined to be at once crude and black, and an unpleasant bluey-greyness pervades his flesh shadows, and the reds of the complexion do not fuse with the rest; his drawing was incisive and spirited, but unsympathetic, and he was apt to be perfunctory in characterisation; his idea of pose and arrangement was stiff and conventional, and almost all his smaller pictures are planned in the same way. But if Vertue's statement, that he brought with him a large number of canvases on which the shoulders, enveloped in classic drapery or armour, were already painted, and to complete which

he had only to add the head of his sitter, is borne out, apparently, by much of his work, the supply must have been exhausted soon after his arrival, and the best, as well as the most ambitious, of his works could not have been painted on this factory system. Occasionally also, as in his own portrait, which hangs with some other excellent examples of his skill in the College of Surgeons, Edinburgh, he did something that came near being fine, and was wonderfully free and spirited without coarseness. Like Heude, Medina had been trained as a historical painter, and a number of pictures with classical subjects were purchased by Scottish patrons, while he illustrated editions of *Paradise Lost* (1705) and Ovid's *Metamorphoses* ; but he had been invited to Scotland to paint portraits, and it was as a portrait-painter that he was chiefly employed. His social success was great, he was the last knight created in Scotland before the Parliamentary union, and he left a fortune of over thirteen thousand pounds Scots. His son (d. 1764) and grandson (d. 1796), both of whom bore his name, followed him in his art, and amongst them they are responsible for many of the great number of Queen Mary's portraits, principally after the discredited 'Carleton' type, treasured in Scottish families to-day. They were poor painters and no credit to their progenitor. But from Sir John, William Aikman (1682-1731), the most important Scottish artist in the first quarter of the following century, received his early training.

The invitation to Medina would seem to indicate a desire amongst the Scottish aristocracy to have an artist of some standing resident in the capital, but their real interest was not in art, but in portraiture. Even in the seventeenth century many of the nobles spent much of their time in London, where they were painted by the portrait-painters connected with the court, and so it was not unnatural that those who had not the same opportunities should arrange for the presence in Edinburgh of a painter who could supply what they required. During this and the following century many portraits were produced in Scotland, or painted in England for Scots, but practically no interest was taken in art for its own sake; and although the first half of the seventeenth century saw some fine houses built, and apartments in them decorated with elaborately painted ceilings, such as those referred to in the Introduction, no private collections were formed as in England, where the example of Charles I. (his own was one of the finest ever brought together) was followed by the Earl of Arundel and other courtiers. The condition of Scotland throughout the period surveyed in this chapter was not favourable to either progress or interest in art, and it was not until wellnigh a hundred years later that Scottish national sentiment commenced to reveal itself in pictorial art.

CHAPTER II

FROM WILLIAM AIKMAN TO DAVID ALLAN

AFTER the Revolution settlement of 1688 the Scottish nation, relieved from constant struggle and turmoil in Church and State, turned its attention more to commercial affairs. The immediate outcome was the Darien scheme (planned by the Scotsman who had founded the Bank of England), which, owing to the jealousy of English traders and the action of the English Parliament, as well as to weaknesses inherent in itself, ended in such dire disaster for all concerned. Scotland had sunk all its available capital in the great venture, and the circumstances attending its failure exasperated national feeling so intensely that complete separation from England was contemplated; but in the end wiser counsels prevailed, and in 1707 Legislative union was accomplished, and the two nations became one. Even during the first half of the century the beneficent effects of union made themselves felt, but it was not until nearer its close that the material condition of the country commenced to improve rapidly. The turmoil and bitter experiences of the preceding hundred years seem to have left the people in a state of lethargy from which even 'the fifteen' and 'the forty-five' hardly wakened them. But it was not death, but sleep from which men rise refreshed, that they lay under. Beneath the passivity that enveloped the country a ferment of ideas was at work, which eventually threw up a group of men whose writings on philosophy, economics, and history placed Scotland high amongst the nations. Edinburgh became less populous after the Union, which had deprived it of much of its social and political importance, for the Scottish members of the British Parliament and the representative peers were drawn from the best educated and influential classes; but before the eighteenth century closed it had regained a commanding position, and attained its zenith as a city of culture. The Union had brought perfect equality in the privileges of trade, an enormous boon, as foreign trade had previously been confined to English merchants and companies, and now with new opportunities the west of Scotland began to develop, and Glasgow commenced to assume great importance in Scottish affairs. Previous to 1707 it had been declining, both in population and trade, but with the removal of restrictions it developed a connection with America and the West Indies, for which situation on the western sea-board gave many facilities. From this arose the tobacco trade, in which many fortunes were made before

the American War of Independence (1775) brought it to an abrupt close ; but shipping had grown with it, and new industries were arising : sugar and cotton importing ; spinning, weaving, and calico-printing ; and the iron trades. But whether they make money or lose it, pioneers in industry and commerce are usually so absorbed in their own undertakings that they have no time for other interests, and until well on in the nineteenth century pictorial art in Scotland depended upon the aristocracy, and for the most part their patronage was confined to portraiture. At a Glasgow sale in 1702, out of seventy-seven pictures, fifty-four were portraits, and the thirty lots in one in Edinburgh a few years later included no pictures at all. Everything is comparative, of course, but, while it may seem as if it would have been as easy for a laird with £500 a year, and such was esteemed wealthy, to spend £30 on a picture, as it is for a man with £2000 or £3000 to give £200 or £300 for one to-day, rents were paid largely in kind, and although the gentry lived in rude plenty at home, there was little money available for luxuries. Under the influence of freedom and a more settled state, however, kindlier feelings grew up, and interest in many matters neglected in more critical times reappeared. In the earlier part of the century music became the rage, and musical parties and dancing assemblies, inaugurated in Edinburgh in 1710, were the fashionable amusements, while in 1726 Allan Ramsay (1686-1758) opened a circulating library, the first in the United Kingdom. The narrower section of the clergy did not stand idly by, for the old suspicion of the things of time and sense was not dead. Even Ramsay's library met with opposition, and when some ten years later the enterprising poet turned impresario, the theatre he had built in Carrubber's Close was closed by the magistrates. But opposition, although irritating, could not withstand the quickening sense of life for ever. It only postponed the inevitable. Art had its share, a small one to be sure, in this little renaissance of the joy of life. As early as 1729 it was possible to consider the advisability of forming a society for the encouragement of the fine arts in Scotland, principally by establishing classes for drawing from the antique and the life, but the 'School of St. Luke' had a very short career. Neither the time nor the men had come. The indenture, which is now in the possession of the Royal Scottish Academy, is signed by but eighteen artist and eleven honorary members, and of the former, Allan Ramsay the younger, then a youth of sixteen ; Richard Cooper (d. 1764), the engraver ; John Alexander, and the Nories, were the more conspicuous. Most of the rest are forgotten.

William Aikman (1682-1731), the most notable Scottish painter in the first quarter of the eighteenth century, had left Edinburgh for London six years before the 'School of St. Luke' was formed. He was a man of good family, being nephew of Sir John Clerk of Penicuik and

Sir David Forbes of Newhall ; and although his father, a Forfarshire laird and sheriff of his native country, who had desired him to become an advocate, died in 1699, it was not until he attained his majority that he was able to follow his own bent and place himself in pupilage to Sir John Medina. Three years later, having sold the family estate, he went to Rome, where he remained until 1710, when he visited Constantinople and the East. Returning to Scotland in 1712 he settled in Edinburgh as a portrait-painter, and soon, through his own connections and the patronage of John, Duke of Argyll and Greenwich, the most influential man in Scotland, had a large practice. But it was weary work painting poor clients at £10 a head, and after eleven years of it Argyll persuaded him to go to London, where Kneller's recent death had made an excellent opening. The district of Leicester Fields, so soon to become famous artistically through association with William Hogarth, was then the residence of many able men, and Aikman took a studio there and was welcomed by them. He counted Sir Robert Walpole and Lord Burlington amongst his friends, but seems to have been most at home in literary society, in which his charming personality and refined tastes made him a great favourite. Somerville eulogised his memory, Allan Ramsay and James Thomson, whom he had introduced to his circle in London, lamented his loss in verse, and Mallet wrote his epitaph. Walpole says that his health languished for a long time before he died, but the immediate cause seems to have been grief for the death of his only son, and they were buried in one grave in Greyfriars Churchyard, Edinburgh.

His style previous to going abroad, which can be studied in two portraits at Penicuik, noted by his cousin Sir John as 'Painted, 1706, by Mr. Aikman when he was learning to paint, but very like,' is angular, stiff, and wanting in delicacy, and clearly influenced by that of his master, from whose inferior pieces these and others of this period are scarcely distinguishable. It is not known with whom he studied in Italy, but as several copies, done by him at Rome, of classical subjects by Carlo Maratti (1625-1713) exist, he may have had some connection with that aged artist ; and, whatever the influences under which he came, the result was a method which, while deficient in vigour and incisiveness of drawing and expressive brush-work, is yet workmanlike and refined. Resemblance to Kneller, so frequently referred to, is not at all marked in his most characteristic works, and the little likeness there is cannot be traced, as some would have it, to direct personal intercourse. He was not a colourist, however ; too often his tints are poor and thin and grey, and even at its best, the most that can be said for his colour is that it is inoffensive and harmonious in a quiet and rather negative way. His average portraits of women, particularly those of bust-size within a painted oval, are always refined in feeling and sometimes lifelike and dignified in pose and expression ; but, as a rule, there is something thin and meagre about them,

due in some degree, perhaps, to the rather trying simplicity of their gowns, from which the shoulders emerge with little grace, but also to a want of animation in the conception and of richness and juiciness in the handling and colour. On the other hand, he painted men with considerable insight and power, and the best of his male portraits are designed with an unaffected and pleasing simplicity which comes near to being distinguished. No better example of his gifts, as a whole, could be found than the refined and dignified portrait of his cousin, Sir John Clerk, in his robes as Baron of Exchequer, or the bust, in armour, of the 6th Earl of Lauderdale at Thirlestane. In appreciation of character, however, these are probably surpassed by his 'Allan Ramsay,' the best and most satisfactory portrait of the author of *The Gentle Shepherd* ever painted. This souvenir of friendship was painted for Baron Clerk just before Aikman went to London, and the fortunate owner expressed his satisfaction with it by pinning the following 'Roundlet in Mr. Ramsay's own way' on the back of the canvas :—

> 'Here painted on this canvass clout,
> By Aikman's hand is Ramsay's snout,
> The picture's value none can doubt,
> For ten to one I'll venture
> The greatest criticks could not tell,
> Which of the two does most excell,
> Or in his way should bear the bell,
> The Poet or the Painter.
> J. C., Penicuik, 5 *May* 1723.'

Other literary friends whose portraits he painted were Thomson, Gay, and Somerville, but with these he was less happy than with Ramsay. The 'Gay' and a poor version of the 'Thomson' hang in the Scottish National Portrait Gallery, where he is also represented by 'Patrick, Earl of Marchmont' and a fine head of himself. Another autograph portrait, firmer in handling and fuller in colour, is owned by the Royal Scottish Academy, a third is in the Uffizi, and others belong to the present head of his family, Major Robertson Aikman of The Ross, where there are many pictures by him, and to the Clerks, the latter having been painted 'when dying and left as a legacy to me. J. C., Anno. 1733,' as recorded by his cousin. Edinburgh University has his 'Principal Carstares and the Parliament Hall,' his 'Lord President Sir Hew Dalrymple,' and a third three-quarter-length, more pleasing in effect but not quite so keenly characterised, 'John, Duke of Argyll and Greenwich,' may be seen in the London Portrait Gallery.[1] Many of his portraits are in country houses in Scotland and England, and the large group in three compartments of the royal family, which he left unfinished, is in the possession of the Duke of Devonshire.

[1] There is an excellent full-length of Argyll by Aikman in Holyrood.

Two years later than Aikman, John Smibert (1684-1751) was born in Edinburgh. After serving an apprenticeship as a house-painter, he made his way to London and thence to Italy, where he supported himself by copying for the dealers, and later practised with some success as a portrait-painter in London ; but, coming under the influence of Bishop Berkeley, whom he had met abroad, he joined the abortive mission to civilise the natives of the Bermudas. That project had taken him to America (*circa* 1728), where, on its failure, he settled, first at Newport and finally in Boston, and became one of the pioneers of art in the United States. Smibert's portraits are little known in Scotland, but at Monymusk there is a cabinet-sized oval of Lady Grant, dated 1717, and a large group of twelve life-size figures, 'Lord Cullen and his family,' painted three years later. These I have not seen, but J. M. Gray noted that the group was hard in execution and smooth in handling and had little colour in the shadows, but was carefully drawn, with much character in the faces. His friendship with Allan Ramsay, like Aikman's, is perpetuated in a portrait, and it must have taken a good deal of friendship on the poet's part to stand the strain of that record of his appearance. It hangs, amongst other interesting portraits by Aikman and the younger Ramsay, in 'Pennecuik's Parlour' in Newhall House, the district around which is so intimately connected with *The Gentle Shepherd*. But his best works are said to be in America. They include a large group of Bishop Berkeley and his family preserved in Yale College, and a portrait of an aged clergyman, Dr. Robinson of Salen, in the Essex Institute. The National Gallery of Ireland has a small and rather indifferent version of the Berkeley group, and there is a half-length of the Bishop (1728) in the London Portrait Gallery.

Of George Marshall and Richard Wait, both of whom were pupils of the younger Scougall, little is known and little need be said. Their work is of no particular merit, and has not even the interest of being associated with people of historical importance. Both supplemented study with Scougall by working under Kneller, and Marshall visited Italy, but with little improvement to his style. Yet in the dearth of talent in Scotland he was of sufficient importance to be elected Preses of the Edinburgh School of St. Luke. Wait's portraiture was of rather better quality, and although quite undistinguished, possesses considerable feeling for character simply and not ineffectively expressed, as may be seen in several portraits in the Seafield collection painted between 1706 and 1714, and in a few at the Doune, Rothiemurchus, dated 1725 and 1726. In later life he is said to have painted still-life subjects, but I have seen only one of these. An oblong (30 × 22 ins.) of several cauliflowers, a leg of mutton, a couple of plucked chickens, a loaf of bread, and some coins lying upon a shelf against a simple brownish background, it was excellent in colour, full in tone, well drawn, and painted in a firm yet flowing manner, with rich and

well-modelled impasto, which expressed the textures and contours of the forms admirably.

Even greater confusion than existed about the Scougalls clings round the identity of the Alexanders, Jamesone's descendants who painted in the eighteenth century, but here also careful sifting of the known facts leads to a fairly definite result. The father, John Alexander (1690?-1760?), who was either a grandson or great-grandson of Jamesone, through the marriage of his daughter Marjory with John Alexander, an Edinburgh advocate, studied in Italy, and while in Florence executed (1712) a series of etchings after Raphael which he dedicated to Cosimo de Medici, the reigning Duke of Tuscany. Soon after his return he decorated a staircase in Gordon Castle with scenes from the Rape of Proserpine, of which a description was published in 1721 ; and he is said to have commenced a picture of the escape of Queen Mary from Loch Leven in which the landscape was painted from nature. The Loch Leven picture has disappeared, which is greatly to be regretted, as it was probably the first Scottish landscape painted out-of-doors, and the only thing of his of this nature that remains seems to be the ' View of Santa Croce in Gerasalemme, Rome,' dated 1715, an India-ink and sepia-wash drawing with pen outlines, showing the church standing amongst vineyards with the Claudian Aqueduct and a glimpse of the Alban Hills in the distance, preserved in the Print Room of the British Museum. Portraits by him are fairly numerous, however. The earliest known is probably that of a man in the Royal College of Physicians, Edinburgh, which, being inscribed ' A.D. 1720 Altas sue 80,' is either a posthumous likeness or does not represent Sir Robert Sibbald, whose name it bears, for he died in 1712. Other dated examples are the ' Margaret Drummond, Daughter of the second titular Duke of Perth' (1727) at Keir ; the 'Lord Lewis Gordon,' hero of the song ' Oh send Lewie Gordon hame' (1738 and signed), in the collection of the Duke of Richmond and Gordon ; the engraved three-quarter-length of Lord Provost Drummond in his robes (1752 and signed) in Edinburgh Royal Infirmary ; and the 'George Murdoch' (1757 and signed), which, taken in conjunction with four portraits in Trinity Hall, Aberdeen, and others in country houses, are sufficient to enable one to form a fair estimate of his accomplishment. His drawing was hard and unsympathetic, but expresses a considerable grasp of character and form, his handling of paint fluent enough but without style or expressiveness, his colour harsh, the flesh being bricky in its reds, if transparent and fused as a whole. Although far inferior in grace of design, quality of colour, and actual craftsmanship, his art has something of the same character as that of Allan Ramsay. In 1728 he etched the picture, now in Fyvie Castle and completely repainted, in which Jamesone represented himself with his wife and child. As already noted, he was one of those who signed the indenture of the Edinburgh School of St. Luke in 1729.

The son, Cosmo John Alexander (1724-1773?), was named in all probability after his father and his father's Florentine patron, Cosimo III. The date of his birth is fixed by the inscription, 'A Prototypg Georg Jameson, Depict. Cosmus Ioan. Alexr Pinxit. A.D. 1742 Ætatis suæ 18,' upon his copy of Jamesone's portrait of the 5th Earl Marischal in Marischal College, for the age given cannot apply to the subject ; and his father and he, 'John Alexander and Cosmos Alexander, Picture Drawers,' figure in a contemporary list of those in the Aberdeen district who were 'out' in the '45, their whereabouts being unknown. It is probable that Cosmo went to Italy after the Rebellion, as portraits painted there about that date are signed by him ;[1] but it is likely that he had returned before 1754, when James Gibbs (1674-1754), the architect of the Radcliffe Library and St. Martins in the Fields, made him his heir.

In 1763 the little portrait of Jamesone in the Scottish Portrait Gallery, probably that referred to by Lord Buchan as a chamber-piece, 12 by 10 inches in size, in the possession of a descendant in Leith, was retouched by him ; and in 1765 he sent a portrait from Edinburgh to the exhibition of the Incorporated Society of Artists, London, becoming a member during the following year. Considerable dubiety exists as to whether certain portraits should be assigned to the elder or the younger Alexander, for their styles and signatures possess considerable resemblance, and occasionally probability of date is the only determining factor. Artistically, however, the chief interest in Cosmo Alexander's career is his connection with Gilbert Stuart (1754-1828), the most gifted American painter of his day and one of the best exponents of the Reynolds tradition. Stuart, to whom we owe the most famous likeness of George Washington and fine portraits of others who took part in founding the United States, was himself of Scottish extraction, his father having emigrated from Perthshire to Rhode Island, where he set up as a snuff-miller. He was eighteen and just beginning to paint when Cosmo Alexander, who had gone to America about 1770 and was painting portraits in Rhode Island, took a fancy to him and gave him his early lessons in art ; and when the Scottish artist returned home he brought his protégé with him, and Stuart's education was completed in England in the studio of Benjamin West, the President that America gave the Royal Academy. Alexander is supposed to have died at Edinburgh, shortly after returning to Scotland.

Of the artists who signed the indenture of the Edinburgh School of St. Luke in 1729, Allan Ramsay (1713-84) was the only one who attained any considerable position as a painter. Unlike Aikman, he had from the first the encouragement of his father. The author of *The Gentle Shepherd* early discerned his son's talent and gave him every opportunity to learn his craft. From the time he was twelve, as the proud

[1] There is a half-length of George, 5th, but attainted, Earl of Winton, signed 'C. Alexander Rome 1749,' at Touch, Stirlingshire.

father wrote to his friend Smibert, he had been pursuing his science, and when about twenty he went to London to study in the St. Martin's Lane Academy, then, or only a little later, for the most part, superintended by William Hogarth, who had dedicated his large 'Hudibras' to the Scottish poet. He seems also to have been for some time with Hans Huyssing, a Swedish portrait-painter then working in London. Returning to Edinburgh, he wrought there for two years, and in 1736 set out with two friends for what the elder Ramsay described as 'the seat of the beast beyond the Alps.' Their travels are vividly and humorously related in Alexander Cunyngham's (after Sir Alexander Dick) journal, a portion of which was published a few years ago. Having journeyed through France by canal and river, they took ship along the Riviera to Italy, but being wrecked near Pisa, made the rest of their way to Rome by land. And here the old Scottish religious prejudice reveals itself in a half-jesting phrase of Cunyngham : 'So soon as we came into the Pope's dominions the wine was not bad, but the air smelled sulpher.' In Rome Ramsay studied at the French Academy and with Solimena (1657-1747), a celebrated history and decorative painter, and Imperiale, and under these influences his style was finally formed. The portraits executed there gained him considerable fame, and when communicating this fact to his companion, who had returned home, he adds : 'I have over and above been writing sonnets and odes and epigrams with like success, so you may believe I am not lookt upon here as a useless member of Society.' In 1738 he was again in Edinburgh, where two years later he painted the rather distinguished full-length of the 2nd Duke of Argyll, which was so well mezzotinted by Faber. Many fine portraits followed, and much of his best work was done during the eighteen years he remained in Scotland.

Moving in the best society in Edinburgh, Allan Ramsay took a chief part in forming the 'Select Society' of which David Hume, Adam Smith, and William Robertson were leading members, but in 1756, after a second visit to Italy, he transferred his studio to London. He soon made a place for himself in the most cultured circles in the metropolis, living on terms of intimacy with statesmen and literary men and painting the leaders of society. His gifts as a linguist and particularly his knowledge of German contributed to his success at court, and George III., with whom he was a favourite, appointed him principal painter to His Majesty, in succession to Shackleton, in 1767. Thereafter, while still occasionally accepting commissions from private patrons, he was employed chiefly in producing portraits of the King and Queen Charlotte for presentation to foreign sovereigns or favourite servants of the Crown. In this work he had numerous assistants, amongst whom Philip Reinagle (1749-1812), who acquired special facility in imitating his master's style, and Ramsay's countrymen, David Martin and Alexander Nasmyth, may be mentioned

specially. He went to Italy again in 1775, and a few years later, having met with an accident that incapacitated his painting arm and weakened his general health, he retired to Rome, leaving Reinagle to complete his commissions and paint 'fifty pairs of kings and queens.' In 1784, however, a longing for home seized him, and travelling by easy stages, he reached Dover, but only to die.

Fashionable and successful though Allan Ramsay was, his claims as a painter were not taken very seriously by his artist contemporaries, and since his death they have been dismissed somewhat lightly by most critics. Reynolds, ten years his junior but incomparably a greater artist, thought him a very sensible man but not a good painter, and Northcote described his manner as 'dry and timid'; while, although the Royal Academy was founded sixteen years before he died and included most painters of standing at the time, he does not seem to have been asked to join, and certainly he was never a member.[1] In part this may have been due to jealousy of his great social success, but there is no doubt that Ramsay himself was also responsible. Whatever his enthusiasm for art may have been in reality, the attitude of his maturity was that of a man whose chief interests were scholarly and intellectual rather than artistic. His literary ambitions were considerable, and Mr. Austin Dobson thinks that his enthusiasm for letters was genuine, and that the essays, collected and published as *The Investigator* (1762), possess merit far above average. During his later visits to Rome he devoted much time to deciphering Greek and Latin inscriptions in the Vatican and to other archæological pursuits, and his chief associates there, to judge from the journal kept by his son when there with his father in 1782-3, were antiquaries and antiquarian artists like James Bruce and Gavin Hamilton rather than painters. Moreover, he was esteemed highly by Dr. Johnson, whose opinion, 'You will not find a man in whose conversation there is more instruction, more information, or more elegance than in Ramsay's,' goes far to entitle the Scottish painter to an honourable place in the brilliant intellectual society of his time. He was also a friend and correspondent of Voltaire and Rousseau, and when the latter sought asylum in England (1766) he painted him for their mutual friend David Hume, whose portrait he also painted at that time. Both pictures are now in the National Galleries of Scotland. But these and kindred interests and friendships, indicative though they are of Ramsay's accomplishment and personal charm, must have made him appear more a man of culture than an artist to painters more deeply absorbed in their craft, and in later years his method of conducting his studio (he had a decorative branch also, which brought him wealth if it did not add to his fame) with a crowd of assistants, who advanced his pictures and produced scores of replicas of royal portraits, and even carried on the work during their master's long

[1] Ramsay was Vice-President of the Incorporated Society of Artists in 1766, but that seems to have been his only active connection with his contemporaries.

absences in Rome, savoured of business rather than of art. To this factory system, also, there is no doubt that much of the dull and inferior work that issued from his studio, and bears his name and the superficial marks of his style, is due, and it is only by discounting it and concentrating attention upon his earlier things and upon those of a later date to which he gave his personal interest and skill that one can arrive at a just estimate of his talent. The mere fact of having to do so suggests that he was not an artist of first-rate and really individual gifts, but it need not blind one to the admirable quality of many of his portraits and drawings. Taken in relation to his environment and the schools in which he was trained, Ramsay's art is admirable and expressive, and in a wider survey it possesses distinct charm. Trained in Italy, he acquired a graceful style of drawing and a clear and definite method of painting, lacking in spontaneity and power of handling indeed, but refined, and with all his love and skill of elaboration not too mechanical or over hard in effect ; and to these he added appreciation of character, a pleasant and elegant if not very dignified feeling for design, and colour which, while deficient in richness, vibration, and quality, was agreeable enough and at its best harmonious and refined. Without the rich and powerful contrast of light and shade, and the fullness and resonance of glowing colours wrought into complete harmony, which give such abiding and profound beauty to Reynolds's masterpieces,[1] and with little of that clear silvery brilliance of lighting and high pitched scintillating colour which make a fine Gainsborough so fascinating, Ramsay's happiest things possess a serene charm of gently diffused light and a softness and tenderness of quiet colour of their own.

Ramsay's portraiture is highly characteristic of the somewhat artificial yet eminently elegant air of the beau-monde of his time, more particularly in France perhaps, but to a considerable extent in England also. Of the British painters of his period, he more than any other possessed French ' elegance,' and, although his finest work shows an intimacy of characterisation rare amongst contemporary Frenchmen, one could name a goodly number of his pictures which could be hung in the eighteenth-century French rooms in the Louvre and seem quite at home. And it is of some significance perhaps, and worth pointing out, that the charming Watteaus and Greuzes and other French pictures bequeathed to the National Gallery of Scotland by Lady Murray were collected by Allan Ramsay. It was probably this quality in his art that prompted Horace Walpole to write (1758) to Dalrymple, ' Mr. Reynolds seldom succeeds in women, Mr. Ramsay is formed to paint them,' and to which Northcote, the painter, paid tribute when, at a later date, he said : ' I have seen a picture of his of the queen soon after she was married ; a profile, and slightly done, but it was a paragon of elegance. She had a fan in her hand ;—Lord, how she held that fan ! It was weak in execution and ordinary in features,

[1] Ramsay was Reynolds's senior by ten and Gainsborough's by fourteen years.

but the farthest possible removed from anything like vulgarity. A pro-
fessor might despise it, but in the mental part I have never seen anything
of Vandyke's equal to it.' And at times, when happily inspired by his
sitter, as in the captivating picture of his young wife in the Edinburgh
Gallery, the less known but even more beautiful 'Mrs. Bruce' which
represents him here, the 'Countess of Kildare' at Carton, the fine full-
length of Lady Mary Coke (1762), standing in a shimmer of white
satin, a chitarrone in her hand, which hangs in Mount Stuart with the
famous 'Earl of Bute' (1760), with which Sir Joshua wished 'to show
legs,' or the sprightly and picturesque picture of a lady in pink in
Holland House, his portraiture of women is not only elegant but delight-
fully refined and even beautiful. His best portraits of men again, things
like the full-lengths of the Earl of Hopetoun (1748 : Royal Infirmary,
Edinburgh), the 3rd Duke of Argyll (1750 : Glasgow Gallery), and the
19th Macleod of Macleod, in tunic and plaid and trews of 'rob-roy'
tartan, at Dunvegan Castle, or the fine half-lengths of the 2nd Earl of
Stair (1745), and Lord Drummore (1754 : New Hailes)—all of them, it
may be remarked, belonging to his Edinburgh or early London days—are
marked by a virility of handling and drawing and a masculine grasp of
character one would scarcely expect after seeing many of the more-than-half
studio pieces of his most fashionable period. Occasionally, also, he broke
from the prevailing convention, and, as in an oblong seated three-quarter-
length of a lady in grey in Lord Ilchester's collection, painted in a
surprisingly modern spirit, and with a perfectly natural arrangement of
figure and accessories, very rare in the middle of the eighteenth century.
But the best elements in Ramsay's gift are displayed most fully in his
chalk sketches and studies. In spite of his many interests he was a keen
student. His life studies in sanguine or black upon thick buff or grey-
blue paper are gracefully rather than powerfully or searchingly drawn, but
show careful study of the figure ; and he made many elaborate studies of
hands, gracefully posed, elegant in form, and drawn with rare appreciation
of their plastic beauty. In addition, he studied the portraiture of his pre-
decessors in England, making drawings from pictures by Van Dyck, Lely,
and others. It is in his own portrait drawings and sketches, however, that
his gift for charm of pose and elegance of motive and the graceful and
suggestive ease of his draughtsmanship are best seen. Some of these were
done obviously as preliminary studies for portraits, and have pencilled
notes of the colouring on the margins, and, now and then, indications of
contemplated alterations in the pose or swing of the figure, while others
are probably no more than notes and suggestions. I know of nothing of
his in paint as charming as a design in red, black, and white chalk for
a group of two ladies in a landscape ; a head of an unknown lady in the
Laing collection is almost as fascinating in sentiment and expression as the
famous drawing of Madame de Pompadour by De la Tour, in the Museum

de St. Quentin ; and a sketch of a lady and gentleman promenading seems a premonition of the motive, which Gainsborough elaborated so deliciously in the ' Morning Walk.' The slighter and more suggestive impressions of single figures or attitudes have occasionally much of the allure and exquisiteness of the drawings of Watteau and his followers, a few reminding one even of the incomparable master of courtly elegance and feminine charm himself. His work in these directions is represented admirably in the large collection of his drawings presented by Lady Murray to the Board of Manufactures in 1860, and others are in the library of the Royal Scottish Academy, to which they were bequeathed, with many drawings by Old Masters, by Dr. David Laing. It is to be regretted that not a single drawing by him is in the Print Room of the British Museum. Quite a number of his portraits were engraved in mezzotint by M'Ardell and Faber, and only a misunderstanding about price (Ramsay was almost certainly wrong in assuming that politics had anything to do with it) prevented his portrait of the Prince of Wales being engraved by Sir Robert Strange (1721-92), the most celebrated line engraver of the day. Strange was a native of the Orkney Islands, and served an apprenticeship to Richard Cooper, the Edinburgh engraver, but he went out in '45, through love of Miss Lumisden (afterwards his wife), sister of Prince Charles's secretary, and for many years afterwards he was suspected. This led to his spending much time on the Continent, where he received many honours from the Academies of Italy and France ; but later he lived more in London, and when he engraved West's picture of the ' Apotheosis of the Children of George III.' (1787), the King was so much pleased that he made him a knight. He worked in pure line, and his plates are remarkable for delicate clearness and precision, united to admirable feeling for the structure and relationship of the component parts in the pictures he interpreted. They give him the foremost place amongst British line engravers, and the honours showered upon him show the high esteem in which his work was held abroad.

The ' Select Society,' inaugurated in Edinburgh in 1754, largely on Ramsay's initiative, had for its principal object the improvement of its members ' in reasoning and eloquence, and by the freedom of debate to discover the most effectual methods of promoting the good of the country ' ; but in the following year, without abandoning the original programme, it became also an association for the ' Encouragement of Arts, Sciences, Manufactures and Agriculture,' which things it resolved to foster by offering premiums for improved products and methods of production. This system had previously been adopted with success by the Hon. The Board of Manufactures for Scotland, which had been created in 1727 to administer the grant (something like £2000 a year) made to Scotland under the Act of Union (1707), as an equivalent for the additional taxation due to the English National Debt ; but the Select Society's scheme

was wider in scope and included such subjects as history and literature, while the close connection between art and manufactures was recognised by awarding premiums for drawings and designs. But the competition in these classes was not great, and any encouragement given to art was insignificant and indirect. A much completer scheme, however, had taken definite form in Glasgow in 1753. For this the country was indebted to Robert (1707-76) and Andrew Foulis (1712-75), the celebrated printers. It was no sudden birth. For years Robert Foulis, who had travelled much and observed intently, had seen that 'whatever nation has the lead in fashion, must previously have invention in drawing diffused, otherwise they can never rise above copying their neighbours,' and to attain this end he determined to inaugurate a fully equipped Academy of the Fine Arts. In this most laudable design he was cordially supported by his brother, who, after the Academy was founded, took over the management of the printing and bookselling business, leaving Robert free to devote himself to the schools. Their project met with little sympathy from the public, but the University gave them rooms in the College, and three gentlemen guaranteed £40 a year each towards the expenses. A collection of pictures, prints, and casts was formed. Payen, a painter, Aveline, an engraver, and a copperplate printer were brought from the Continent, and the work began. During the day the students, who not only paid no fees but received wages, as if they had been apprenticed to a trade, painted, engraved, and made designs for book illustration, and in the evening drew from the life and the antique, and modelled. In spite of many difficulties the Academy was carried on for twenty-two years ; but in the interval the printing business, if not neglected, had received less attention than it demanded, and when, in 1775, Andrew Foulis died, the affairs of both were so involved that they had to be wound up. This was a heavy blow to the surviving brother, who only lived until the June of the following year. The attempt was a noble one and deserved success. It was the first organised art school in Scotland, and was founded some fifteen years before the Royal Academy of London came into existence ; but Scotland was not ripe for an experiment on such a scale, and it met with little encouragement, even in places where that might have been expected. At the same time such good and devoted service could not be without effect on the future, and, no doubt, it prepared the way for others no more worthy but more fortunate. The immediate results of the Foulis Academy were most meagre ; it included no artist of real power except James Tassie (1735-99) among its pupils, although in David Allan (1744-96) it trained a pioneer in Scottish art, and had for a short time in Alexander Runciman (1736-85) a scholar of considerable but undisciplined gifts. Of those sent abroad to study none achieved anything worthy of remark.

In 1760, when the Foulis Academy had already been at work for

seven years, the Board of Manufactures instituted in Edinburgh a school of design, which ultimately developed into the 'Trustees' Academy,' and exerted great influence upon art in Scotland. Originally intended solely for artisans, and owing its origin to a desire to improve manufactures, it became the nursery of nearly all that is best in Scottish art until comparatively recent times. Unfortunately the books and registers which dealt with the early years of this school have disappeared, and all we possess of its earlier history is a mere outline, little more indeed than a list of the successive masters, and here and there the name of a pupil, or the subject for a competition. As had been the case in Glasgow, the University authorities assisted by providing a room for the class, which, at first confined to a morning meeting, was at a later date extended by one at night. Instruction was free, but attendance was limited to four years and the number of students to twenty, while the facilities for teaching were of the most meagre description, and the teaching itself hardly went beyond the most elementary stage. The first master was William Dela Cour, a Frenchman resident in Edinburgh. He had been a good deal employed as a portrait-painter, but his principal qualification for the mastership of a school of design was his experience as a decorator. Several panels at Caroline Park, in the ballroom at Yester, where several of the pictures are signed and dated 1761, and in Lord Glenlee's house in Chambers Street, Edinburgh (now the Dental Hospital) show that he had considerable talent in that direction; and some of his portraits, such as the cabinet full-lengths of ladies, one represented as 'Diana' seated bow in hand in a wood, two of her nymphs cheering on her dogs after a flying stag, and the other, also in a landscape, holding wreaths of flowers, once at Lennoxlove (dated 1758), were treated in rather a decorative spirit. His easel pictures, again, were of the Watteau type, gaily attired gallants and ladies dancing and flirting and sporting in forest glades, but, while not without some merits of invention and a touch of the grace of his school, they are wanting in sparkle and charm of colour, and in ease and elegance of handling. The landscape settings, which show some directness of observation and a sense of cool out-of-doors colour, are perhaps their most satisfactory feature. Everything considered, he was probably as capable a man for the position he was selected to fill as any then in Scotland, but, as has been indicated, the facilities for teaching were inadequate, and the results attained were insignificant. Under his successor, another Frenchman, Pavillon by name, about whom practically nothing is known, there was little or no advance in the character of the instruction given, but, the Runcimans, Brown, and Nasmyth having been amongst his pupils, the influence of the school upon native art may be said to begin with his appointment. Alexander Runciman was the next master (1771-85), and on his death he was followed by David Allan, who held office until 1796. John Wood, who succeeded the last, was dismissed for incompetence,

after about a year's service ; and then the trustees had the good fortune to appoint, from among some nine or ten candidates, John Graham, under whom the scope of the work was greatly extended, and a collection of casts from the antique was formed. Graham's influence was great, for among his pupils he counted Sir William Allan, Sir David Wilkie, Sir J. Watson Gordon, Andrew Wilson, and others in whose hands Scottish art first assumed a truly national character. The position the Trustees' Academy attained under Graham's direction was maintained and increased by a succession of able masters until 1858, when it ceased to exist in the form in which it had done such signal service to Scottish art.

Before the institution of the Foulis and Trustees' Academies there were no schools in Scotland where a youth could receive an artistic train-ing. He had either to pick up what he could by experiment and experience or from the hints of others, or go abroad to study. The glamour of Italy fell like a spell on one or two, and Scotland saw them no more. Gavin Hamilton (1723-98),[1] who claimed kindred with the ducal family, and was born at Murdieston House, Lanarkshire, went to Rome early in his career, and there, except for a few brief visits home, he remained until death. He seems to have had some little training before going abroad, but he studied with Agostino Masucci (1691-1758), and his art belongs to the country of his adoption, although in spirit it is perhaps more kindred to that which sprang up in France about the time of the Revolution. It was a product of the classic revival, which received such a stimulus from the excavations at Pompeii in 1755, and from those then in progress in Rome. Jacques Louis David (1748-1825), under whose commanding influence classicism became paramount throughout the greater part of Europe, did not arrive in Rome until 1775, and it was 1784 before he painted the 'Horatii,' which first gave complete expression to his ideals, while as early as 1770 Hamilton had exhibited 'Agrippina weeping over the Ashes of Germanicus' and 'The Heralds leading Briseis from the tent of Achilles,' pictures conceived and carried out in a similar spirit, at the Royal Academy. His work is not to be compared to David's for power of execution or intellectual grasp, and it exerted little obvious influence on the classic revival which gathered round the celebrated Frenchman ; but it is interesting to compare the dates of pictures in which movements reveal themselves for the first time, and as Hamilton was greatly admired by his foreign contemporaries and was a great man in Rome, it is probable that his example counted for something in David's development. Many of his works were engraved by Cunego, including the series of pictures from the *Iliad*, which were regarded as his chief achievement. And the story of Paris supplied motives for another cycle

[1] Mr. W. H. C. Hamilton, a relation of the artist, who supplied these dates (those hitherto given were incorrect), adds that Gavin was the second son of Alexander Inglis Hamilton of Murdieston, and succeeded his brother in the family estate in 1783.

with which he decorated an apartment in the Villa Borghese about 1794. Few of his pictures of this kind came to this country : but Alderman Boydell gave 'Apollo washing his locks at the Castalian Fountain,' which hangs in a committee-room at the Guildhall, to the Corporation of London in 1793 ; the very characteristic and David-like 'Hector and Andromache' is in the Hamilton collection (in Holyrood); and the 'Achilles dragging the body of Hector,' which was acquired by the Duke of Bedford, is now at Arniston. Like all work belonging to this movement, his was stronger in drawing and design than in colour or handling, while the underlying sentiment was largely impersonal. He painted in a solid and conscientious but rather dull and heavy manner. His drama was posed and theatrical, his attitudes well enough imagined but stiff and conventional, and his design, while admirable as regards linear disposition, lacked the emotional significance of chiaroscuro, which his monotonously grey or dullish brown colour, with its definite patches of cold blue, orange yellow, and bricky red, demanded as some compensation for its want of modulation and quality. Devoting himself thus ardently to the pursuit of high art and achieving contemporary fame by it, it is the irony of fate that his most pleasing things should be portraits. The full-length (*circa* 1755) in Hamilton Palace of the Gunning Duchess, standing in a woodland glade in robes of white and grey and crimson, an Italian greyhound fawning upon her, may be singled out for special praise, for, despite some artificiality and coldness in the conception, it makes her a charming woman, and he has expressed himself with considerable style. But in spontaneity and charm it is distinctly inferior to the bust-size sketch of the same lady, in the possession of Sir W. Gordon Cumming, which was stopped at the end of the first sitting because the Duke thought it such a happy likeness. Other notable portraits of about the same time are those of the Duke himself and the Countess of Coventry at Hamilton, and that in Eglinton Castle of the pretty and witty Countess of Eglinton, to whom Allan Ramsay dedicated *The Gentle Shepherd*. The three-quarter-length of Mrs. Siddons as 'Euphrasia' (1783), which attracted great attention when it was painted, crowds going to see it in Hamilton's studio, is of later date.

But Hamilton's merit as a painter, mediocre at the best, is quite over-shadowed by his success as a discoverer of antiquities, principally marbles. Some of these passed into the Townley collection, now in the British Museum, others are in the Louvre or such private collections as the Lansdowne, and many remained in Italy. He held high state in Rome, and was helpful to many young artists, encouraging Canova, who ever afterwards spoke of him with admiration and respect, and assisting Benjamin West when that adventurous American found his way to Italy. To Hamilton the country of his adoption became dearer than the country of his birth. Neither the climate nor the artistic atmosphere, or want of

it, of Scotland or of London pleased him. Writing to Sir John Dalrymple (London, 4th February 1790), he says : ' In short, I find no good air for my lungs and no proper aliment for the mind. I am afraid I cannot hold out long here, but must resolve to cross the Alps once more. Rome has always been propitious to me, and I hope still to be cherished by her even in times of adversity.' And later he goes on : ' What you say of the College of Edinburgh I believe is too true, and as to the College of Glasgow I have given them up. I am afraid they are true disciples of that cursed fellow John Knox, consequently nothing to be expected in the way of the sublime.'

It was the landscape of Italy rather than its associations, though these in that time of classic revival could scarcely be escaped and had some effect on his work, that fascinated Jacob More (1740?-93) when at the age of thirty-three or more he arrived in Rome. He was a native of Edinburgh, and served an apprenticeship to Norie, the painter and decorator, with whom Alexander Runciman, at that time an enthusiast for landscape, then was ; but as he read three papers on artistic subjects before a literary society in Glasgow between 1752 and 1755—they were printed by Foulis in 1759—he seems to have had some connection with the western city, and the dates of these essays would seem to indicate that he was older than has usually been supposed. It is very unlikely that a boy of twelve or even fifteen would write essays that Foulis would publish. Be that as it may, his pictures, and landscape-painting was a novelty in Scotland, seem to have won considerable appreciation amongst his compatriots, and through the interest of some admirers he was placed in a position to go to London, and eventually to Italy. In 1771, when he showed six landscapes, including a ' View of Corehouse Linn ' and a ' View of Dunbar Castle,' at the exhibition of the Incorporated Society of Artists, of which he became a member, he was in London, and Sir Joshua Reynolds was so much pleased with his work that he bought several pictures from him and introduced him to some of his influential friends. Going to Italy in 1773, he continued to send to the Society's exhibitions for some years, but after 1783 he seems to have preferred the Royal Academy. He had settled in Rome, in the environs of which, about Tivoli, Albano, and Nemi, and as far as Naples, he found many congenial subjects, and Scotland was never again painted by her earliest landscape artist. He became ' More of Rome ' and an artist of consideration in the Eternal City, where he was visited by travellers of importance, including Goethe, who expressed admiration for his landscape in *Winkelmann und sein Jahrhundert*. The Roman nobility also patronised him. Like Gavin Hamilton, he decorated a saloon for Prince Borghese, and he laid out an English garden, said to be the first of its kind in Italy, for the same princely patron.

Owing to want of richness in the handling and impasto and too little

concentration in design (the lighting is too equally diffused for his pleasant but limited range of colour), most of his pictures are rather.thin and flat in effect, but he painted with a fluent touch and distinct feeling for the material charm of his medium, generalised with some skill, and designed in the manner of Claude—best seen, perhaps, in his drawings in pen and wash—with a taste for line which, had it been supported by fuller tone and judiciously placed accents, would have been far more effective than it is. For these limitations in his art, early experience of decorative landscape while with the Nories may have been responsible in part. His feeling for nature, however, uncoloured as it is by passion, was genuine as far as it went, and it was more fully developed than any that had previously found expression in Scottish painting, if we except the landscape passages in Alexander Runciman's lost decorations and in some of the pictures of that artist's brother, John. The dramatic aspect of More's sentiment, as embodied in such things as 'The Deluge' (1788) and 'An Eruption of Mount Etna' (1788), exhibited in the Royal Academy, is unknown to me, except from the 'Eruption of Mount Vesuvius' (signed 'Jacob More, Rome, 1780') in the loan collection belonging to the Scottish National Gallery, which is sheer melodrama; but considering the general tendencies of his style, it is not likely to have been very impressive at any time. Yet I have seen one little picture of his of less melodramatic mood which reaches a high level. This 'Land Storm,' being one of the pictures acquired by Reynolds, probably belongs to More's pre-Italian days. A little upright, some eighteen inches by fourteen, of a wild and gloomy day in a woodland, it has a unity of design and a depth of tone, and is informed by a romanticism of spirit which seem a foretaste of Rousseau and Diaz. Had he often reached the quality displayed in it, he would have been a force to reckon with. His normal mood, however, was at once serener and less profound, and of it one may mention as typical 'The Great Fall of Clyde called Cora Linn' (1771), another Reynolds and Kinfauns Castle picture, and 'The Falls of Tivoli,' formerly in a collection in the north of Scotland, which, in mellowness of colour, tranquillity of lighting, and balance of design, recall some of Richard Wilson's (1714-82) less notable works. But the resemblance to Wilson is more superficial than real, for More lacked that fine artist's eye for colour and gradation, his unfailing instinct for noble design, and his masterly use of a virile technique; and it is curious that, while Wilson was glad enough to take fifteen guineas for a fairly important picture, More received thirty-five for a small, eighty for a medium size, and as much as one hundred and twenty for a large landscape.

Neither of these men, nor Charles Cunningham (1741-89), who, after studying with Raphael Mengs, made a great reputation as a historical and battle painter in Germany and Russia before his death at

the age of forty-eight, had any influence on Scottish art. Their work was done abroad, where most of it remained ; it was alien in spirit and in style, and, although rumour of their success may have stimulated some young Scot to devote himself to art, they cannot be considered of any importance in the evolution of a national style. The same is true of William Hamilton (1751-1801), who was born at Chelsea to Scottish parents and was educated in Italy and in the R. A. schools. Before his election as R.A. in 1789 he had painted portraits, but afterwards he devoted his attention to Biblical, historical, and poetical subjects. His art was popular and meretricious ; pretty rather than beautiful, and theatrical where it should have been dramatic. There was, indeed, little evidence of any particular qualities in the art which was being produced at home ; but those who, after a foreign training, returned to Scotland found their productions little in favour. Such demand as there was, was still confined to portraiture ; but in Sir James Clerk of Penicuik, son of him who had been friend of Allan Ramsay (*père*) and William Aikman, Alexander Runciman (1736-85) fortunately found a patron willing to give him an opportunity of expressing himself.

Runciman served an apprenticeship to John and Robert Norie, house-painters, and while with them had some experience in painting landscape panels, that form of decoration being in fashion. The Nories executed much work of this kind, most of which has now disappeared, and from their workshops proceeded several men who made a position in art. It was only natural, then, that Runciman's first essays should be in landscape, but they were not very successful, it is said, and he turned to historical composition, in which his energy and enthusiasm found a more congenial field. Through the kindness of two friends he was enabled to visit Italy, and there, in Rome, he met Henry Fuseli (1741-1825). At once they became friends. Allan Cunningham has pointed out the similarity of their characters and the close resemblance of their styles, and it is an interesting, if indeterminable, question which exerted the greater influence on the other. The Scot was the elder by five years and had had considerably more experience as a painter, but the other was, perhaps, the stronger personality and was much better educated. Placing ideas far above technique, they refused to discipline their hands, and never attained that power of expression and ease of manner which are in painting what clear articulation is in speech. While Fuseli was more fertile and imposing in invention and the more finished draughtsman, Runciman was, perhaps, the finer colourist and possessed a truer instinct for paint. Belonging to a time in which ' High Art' was a fetish, their work is not free from affectation ; but a certain romanticism of conception gives it an interest which that of most of their contemporaries does not possess, while Runciman's may be said to mark the emergence of the subject-picture in Scottish painting. When in 1771 he returned to Edinburgh, the

controversy about the Ossianic poems was at its height, and he declared for their authenticity with characteristic enthusiasm. Their grandiose imagery and shadowy suggestiveness fired his imagination, and when the laird of Penicuik commissioned him to decorate the ceiling of his drawing-room with scenes from the poems, Runciman had the opportunity of his life. He did not prove a rival to Michael Angelo, as he had sometimes dreamt; but his work, while faulty in many respects, revealed a certain rude, if undisciplined, power and was not without interest. The room was large and lofty, with a coved ceiling, and in the oval compartment in the centre Runciman painted Ossian harping to a crowd of rapt listeners upon the seashore, beneath a fantastic sunset sky. The four spandrels outside this panel were filled with figures symbolising the great Scottish rivers, Tay, Spey, Clyde, and Tweed, while the broad cove beneath was divided into some eleven compartments, in which passages in the poems were depicted. In some of these, and notably the 'Finding of Corban Cargloss,' the 'Hunting of Catholda,' and 'Cormac attacking the Spirit of the Waters,' the last eminently characteristic of his style, the artist was seen to greater advantage than in the central piece. Throughout, the attitudes were exaggerated, the actions forced, and the situations conceived in a grandiose and rhetorical rather than in a grand or poetical way. The compositions, also, were full of turmoil and unrest, and in a decorative sense the panels did not keep their places. Yet the ceiling, as a whole, revealed a power of execution and a certain imaginativeness of conception which made it interesting apart from its unique place in the history of Scottish art.

Just before undertaking the Ossian series Runciman had completed the decoration of a cupola over a staircase in the same house with scenes from the life of St. Margaret, Queen of Scotland. These were four in number. In the first King Malcolm welcomes the lady to Scotland; the second depicts the Royal Wedding; the third shows how the Queen lived among her people and earned a claim to saintship through unfailing charity; and in the last, her life ended, she ascends heavenward, where the Father awaits her above the parting clouds. A charming feature of these pictures was the landscape setting, that in the last representing with panoramic sweep Edinburgh and the Firth of Forth. He wrought with an oil medium on the plaster itself, and the pictures were still in very good preservation when, on 16th June 1899, fire destroyed the Ossian series and damaged the other seriously.[1]

A man of great enthusiasm and energy, and given to strong language, the name 'Sir Brimstone,' which he bore in a convivial club of the time, seems to indicate his character. In his case the style was the man, and the

[1] Runciman also executed a series of mural pictures in the Episcopal, now Roman Catholic, church in the Cowgate, Edinburgh, but the chief of these, an 'Ascension' painted over the altar, is now concealed by a new ceiling, and the others, two Prophets and two New Testament subjects, are of little interest.

Ossian Hall was the work of considerably less than two years. But the exertions then made seems to have undermined his constitution : he was never quite well afterwards, and when, one night in 1785, he dropped dead in Chapel Street, he was only forty-nine.

Of Runciman's pictures 'Agrippina landing with the Ashes of Germanicus' (1781), in the Kinfauns collection, was considered the most finished production, but probably the compliment was earned by appreciation of qualities which are not characteristically his. A composition of between twenty and thirty figures showing Agrippina, the urn which contains her husband's ashes in her hands, landing from a great galleon, accompanied by friends and watched by sympathetic bystanders, it is put together with considerable skill and in an orderly and balanced manner, and the figures are drawn with greater care than usual ; but, on the other hand, the fervour of conception and abandon of execution which give life to his more characteristic things are wanting, and the colour lacks the richness and emotional significance he attained in the Ossian decorations and some other pictures. At its best his colour, although low in tone, is full and rich and sometimes possesses a glowing quality of some charm. This, however, was the element in his work to which most exception was taken by the critics of his time, one writing of 'The Parting of Lord and Lady Russell' (1781) as 'a sturdy rawboned Caledonian picture coloured with brick dust, charcoal, and Scotch snuff.' Against this may be placed the estimate of a fellow-artist, John Brown, who wrote : 'With regard to the truth, the harmony, the richness and the gravity of colouring—in that style, in short, which is the peculiar characteristic of the ancient Venetian, and the direct contrast of the modern English school, he was unrivalled.' Amongst his other pictures special interest attaches to 'The Prodigal Son' (1774), for Robert Fergusson (1750-74), the ill-starred Edinburgh poet, served as model. Runciman also painted a number of portraits, deficient in form but good in character, and simple and dignified in effect. The group of John Brown, the draughtsman, and Runciman disputing about a passage in *The Tempest*, in the Scottish National Gallery, is an admirable example of what he could accomplish in portraiture, of how well he painted at times, and of his colour and tone at their best.[1] Raeburn is said to have taken his tone of colour from Runciman's portraits, and the fact that he seems to have owned the likeness of Fergusson, still in the possession of his family, would seem to indicate that he at least admired his work.

While in some senses Runciman's work may be considered history painting, and the subjects of pictures like 'Mary Queen of Scots signing her Abdication' and of the Queen Margaret decorations were taken

[1] This picture, which was bequeathed to the Scottish Society of Antiquaries by David Laing, is said to have been the joint work of the artists, but there is no trace of Brown's hand in it. It is signed by Runciman alone, and Brown's share was probably drawing Runciman's portrait, the painting being entirely by the latter.

from Scottish history, he was inaccurate in costume and detail, and more concerned in expressing his own idea of an incident than in realising its actuality. In these respects he resembled his English contemporaries, but he usually attained an imaginative quality which gives his art an interest of its own, while in Scotland, save for his brother, he stood quite alone. Compared with Gavin Hamilton, whom he probably met in Rome and with whose work his has subjectively much in common—they painted the same subject more than once—he was a romantic, with the tendencies to exaggeration, expressive chiaroscuro, and fine colour characteristic of the breed. His etchings, some of which were taken from the Ossian ceiling and are the only record of what it was, possess less merit than his pictures, for the bad drawing and exaggeration of gesture are repeated, and, without the glow of colour of the originals, are more in evidence. As etchings they are free and spirited in treatment and not wholly wanting in feeling for expressive line, but they are hard in effect, thin in colour, and lacking in just emphasis.

A younger brother, John Runciman (1744-68), who accompanied him to Italy in 1766, and died there, left a few pictures which reveal great promise and a finer and more sensitive talent. They are delicate and transparent in colour, mellow and golden in tone, and sensitive and refined in handling. Imaginative in conception, they are free from the exaggeration of sentiment and tendency to melodrama which disfigure most of his brother's pictures, while the drawing is at once more suggestive and more accurate. ' They indicate,' as has been well said, ' a strange and unexpected imaginative gift, a naïveté and intensity, which remind one of the early German masters, and are altogether unlike in tone to the work of the period in which he lived.' This is true specially of three little Biblical pictures, a ' Temptation,' a ' Flight into Egypt,' and a very original and charming ' Christ and His Disciples on the Road to Emmaus,' in the National Gallery of Scotland. A rather less restrained and more obviously dramatic mood is touched in ' King Lear ' in the same collection. At the sea's edge and beneath lofty cliffs, along the base of which the waves break white, five figures are grouped, the mad King in the centre, while towards the right the sea spreads darkly beneath an ominous sky to a dim horizon where a ship drives before the gale. Figures and landscape are attuned and make one harmony : the mood of the situation is admirably realised and rings true. Of his more important pictures—it is only 24 by 18 inches —this is the finest, for ' Belshazzar's Feast ' at Penicuik, its only possible rival, although as fine in colour, is less impressive in sentiment and style. John Runciman was only twenty-four when he died, and having destroyed a number of pictures with which he was dissatisfied, examples are very rare. His life was too short for the full development of his talent, but the work he did was of the highest promise, and gives him a distinctive place amongst Scottish painters of the eighteenth century.

One of the most charming personalities in Edinburgh about this time was John Brown (1752-89), the draughtsman. Of amiable nature, wide sympathies, and truly cultured, he seems to have been a most lovable man, and, within the restricted sphere of his practice, he was an admirable artist. After some training under Pavillon, and possibly Dela Cour, who drew his portrait as a boy,[1] he went to Italy, where he resided nearly eleven years, during which time he accompanied Mr. Townley and Sir William Young on their antiquarian expedition to Sicily, and made many careful drawings of classical remains. While in Rome, he began to execute portraits in pencil, and on his return home (*circa* 1781) devoted himself to that form of portraiture in which David Paton had been such an adept towards the close of the preceding century. A series of life-size drawings representing original members of the Scottish Society of Antiquaries, originated in 1780 by Lord Buchan, is in the Portrait Gallery in Edinburgh ; but, accomplished in execution and full of character as many of them are, it was in work on a much smaller scale that Brown showed to greatest advantage. Some of his pencil drawings, little larger than miniatures, delight one by their fine draughtsmanship, crisp delicacy of touch and modelling, and beauty of line. Several, such as those of Dr. Joseph Black, the celebrated chemist, Sir William Young, F.R.S., and Dr. James Beattie, were engraved, and two exquisite examples of his skill on this scale can be seen in the Queen Street Gallery and compared with the Antiquaries series. One of these is a drawing of his friend Alexander Runciman, the other represents George Paton, a well-known antiquary of the day. The Royal Scottish Academy has a number of his drawings, both large and small, and so has Mr. Maconochie Welwood, while examples are frequently met with, either singly or by twos and threes, in the possession of Scottish families. Passionately fond of poetry and music, his letters on ' Italian Opera,' addressed to Lord Monboddo, and published by him after Brown's death, are said to abound in wise criticism and novel insight, and he assisted Monboddo with the Italian section of his work on *The Origin and Progress of Language.*

Brown, good artist though he was, does not find a place in Dr. G. C. Williamson's important book on miniatures, but John Donaldson (1737-1801) and John Bogle (d. 1804), two of his contemporaries who found their way to London, are treated of at some length. The former was a native of Edinburgh, where his father was a poor glove-maker, and he is said to have been earning money by drawing portraits at an age when most boys are still at school. He was twice awarded premiums by the Society for the Encouragement of Arts, Sciences, etc. (the ' Select Society '), and, migrating to London in 1762, became a member of the Incorporated Society of Artists, and met with considerable success as a miniaturist. ' His miniatures are scarce, but of extraordinary force and vigour, although

[1] In the Scottish National Portrait Gallery.

often marked by most eccentric colouring. At times they are painted upon a black background, and they can be distinguished by the occasional presence of emblematic symbols upon them.' He also worked in enamel, and his 'Death of Dido' and 'Hero and Leander' were honoured by awards from the Society of Arts. And for a time he painted china at Worcester. He had inherited a morbid tendency of mind, however, which revealed itself to some degree in his art, and his erratic conduct to his clients, his passion for social reform, and his fondness for chemical and other experiments, spoiled his career as an artist, and in the end reduced him to subsist on charity. Bogle, according to Cunningham, was a little lame man, very proud, very poor, and very singular. A native of Glasgow, he worked there and in Edinburgh, but went to London in 1772, where, after exhibiting at the Royal Academy for twenty years, he died in great poverty. His miniatures, usually on a very small scale, are delicately drawn and subtly modelled, refined and quiet in colour, and, though somewhat lacking in breadth, very graceful in effect. I have seen one of an old lady, wearing a white mutch with pale blue ribbons, that is quite a triumph of delicate colour and refined but simple workmanship ; and it has been said that his rendering of the Lady Eglinton, to whom *The Gentle Shepherd* is inscribed, may be compared with any miniature of modern times. Another authority considers that ' his work rivalled that of Smart in delicacy of execution, careful modelling, and quiet scheme of colour.' A year after Bogle settled in London, another Scottish miniature-painter found his way there also. This was Charles Sheriff. He was deaf and dumb, but had a very successful career, becoming the leading practitioner of the art amongst the fashionables who frequented Bath in the closing years of the eighteenth century. His work is said to bear a very close resemblance to that of Cosway.

After this English incursion one may return to the men working at home, and as Archibald Skirving (1749-1819), who was a son of the author of ' Hey, Johnnie Cope ' and is described as ' an eccentric man who desired to be thought an epigrammist,' commenced as a miniature-painter and seldom painted in oils, we may resume with a brief considera-tion of what he did. His chosen medium, after returning from Italy, where he studied for some time, was what would now be called pastel, but was then described as crayon. In the hands of Rosalba Carriera, the Italian lady who took Paris by storm, and of Quentin de la Tour in France, and of Francis Cotes and John Russell in England, this kind of portraiture became exceedingly fashionable during the eighteenth century. Their work possessed none of the exquisite suggestiveness which marks the medium as used by Whistler, Sir James Guthrie, and a few other moderns, who sketch rather than ' paint ' in it, but was carried to a completeness of modelling which rivals that attainable in oil-paint. And Skirving used it, in the approved manner of his day, with a skill which

entitles him to an honourable place amongst his contemporaries. He drew admirably in an academic manner, had a pleasant sense of colour and design, and possessed considerable grasp of character ; but he was lazy and his works are comparatively few. Latterly he produced but one or two portraits a year, and as his talent was admired, received as much as a hundred guineas for a head, a very big price at that time and four or five times more than Raeburn was being paid. The beautiful red chalk drawing of Robert Burns is the most famous of his portraitures, and although it is probable that he was in Italy when the poet visited Edinburgh and it is not known that they ever met, Burns enthusiasts, because of its more poetical look, have placed it high in their affections and prefer it to those more authentic. Excellent examples of his crayon work in colour are in the two Edinburgh galleries, and the Portrait Gallery also possesses two oil portraits, a likeness of his father and an excellent rendering of the imposing head which earned the Rev. Alexander Carlyle of Inveresk the name of 'Jupiter' from his intimates. Of Skirving himself there are numerous portraits, including renderings by Raeburn, Geddes, George Watson, and himself.[1]

Among the portrait-painters who worked in oils, several who had been trained in Allan Ramsay's studio were prominent. Of these David Martin (1737-98), the 'Davie' of his master's letters, had the largest practice. Son of the parish schoolmaster at Anstruther, it is not known where or when he began to paint, but he seems to have gone to London early, and about 1765 he was working as one of Ramsay's assistants, and some years later his master summoned him to join him in Rome with a selection of drawings executed by Ramsay's pupils, to prove to the President of the Roman Academy that artistic ability and capacity to train painters were not confined to Italy. He spent about a month in Rome, and this short visit was his only experience of foreign travel : his technical training was obtained chiefly with Ramsay and at the school in St. Martin's Lane. After spending some years as an assistant, he set up on his own account with considerable success, but in 1775 he decided to remove to Edinburgh, and was appointed painter to the Prince of Wales for Scotland. He was a member of the Incorporated Society of Artists, exhibiting seventy-four pictures or engravings with them between 1765 and 1790, and he acted as Treasurer during the two years preceding his return home. Amongst the portraits painted in London, that of himself in the National Gallery of Scotland (*circa* 1760) ; 'Benjamin Franklin' (1766) ; the full-length of Lord Mansfield[2] (1770) in the library at Kenwood, admirably engraved in line by the painter ; and the excellent three-quarter-length—good in

[1] This is the crayon in the Portrait Gallery and represents him as a young man.
[2] A smaller version is in the Scottish National Portrait Gallery, and a three-quarter-length hangs in the Parliament House, Edinburgh.

characterisation, well drawn and posed and lively in expression, and possessing something of Ramsay's elegance—of the 1st Lord Melville when Solicitor-General (1773), at Melville Castle, may be named as specially interesting. In Edinburgh he occupied the leading position as a portrait-painter until, some twelve or fifteen years later, Henry Raeburn (1756-1823), who had received a few hints from him when beginning to paint, began to be appreciated adequately. Later Martin married a lady of fortune and again lived for some time in London, but when she died he came back to Edinburgh, dying there in 1798. Important examples of his later period are 'Dr. Cullen,' a picture showing a considerable sense of appropriate setting, in the rooms of the Royal Medical Society;[1] 'Lord Kames' in his old age; 'Dr. Joseph Black,' the celebrated chemist; and Sir James Pringle of Stitchell. Martin's style reveals his master's influence clearly, but is inferior in refinement, finish, and grace. His handling when compared with Ramsay's is heavier and less supple, his colour greyer and inferior in quality, his drawing less elegant and no more searching in character. While Ramsay possessed a technical equipment and a personal sense of elegance and character which make his finest things distinctive, if scarcely great, Martin, like the average practitioner of every period, had a more or less adequate but undistinguished command of the technique in fashion, and no special qualities of taste or style to differentiate his art markedly from that of his time and school. Yet superficially there is sufficient resemblance to create confusion between some of his better things and Ramsay's weaker efforts. At the same time he was appreciative of merit in work of a different order from that in which he had been trained. A little picture of Lady Sophia Hope shows distinct traces of Gainsborough's influence, and although he sneered at Raeburn as 'the lad in George Street,' and said that he painted better before he went to Rome, his full-length of Sir James Pringle is evidence of a desire to emulate the younger artist's bold and brilliant style, and perhaps even to challenge comparison with 'Dr. Spens,' which was hung in the Archer's Hall shortly before Martin presented his picture to the Royal Company (1795). It remains to add that he engraved in both line and mezzotint with considerable skill. In the former method the plate after his portrait of 'Lord Mansfield' is the best, and in the latter those from Allan Ramsay's 'David Hume' and 'Rousseau,' Carpentier's 'Roubiliac,' and his own 'Franklin.'

But of all Ramsay's pupils, Alexander Nasmyth (1758-1840), who has been called the father of Scottish landscape, was the most interesting and important. He was an apprentice coach-painter in Edinburgh, executing armorial bearings and other devices on the panels of carriages, when Ramsay met him, and, noticing his talent, induced his master to cancel

[1] It is probable that the picture of Dr. Joseph Black engaged in a chemical experiment, in the same possession, is also by him.

his indentures. Ramsay then took him to London and placed him in his own studio, where he acquired a good knowledge of technique and proved a valuable assistant. At the age of twenty he returned to Edinburgh to practise as a portrait-painter, and found a patron in Patrick Miller (1731-1815) of Dalswinton, who, however, utilised his knowledge of mechanism as much as his artistic skill, for he was engaged upon experiments, which ultimately led to the invention of steam propulsion for ships, and found in the young artist one who could place his ideas on paper in a concrete form. In 1782 Miller lent him money to continue his art education in Italy, where he remained two years, at the end of which he resumed his work in Edinburgh, with such success that he was soon able to repay his friend and to marry a sister of Sir James Foulis of Woodhall. Shortly after this he painted the portrait of Robert Burns (1759-96), the poet, by which he is best known as a portraitist. It is by no means, however, the finest example of his powers in this direction. Such a picture as the cabinet full-length of Miss Burnet, daughter of the judge, who was one of the Ayrshire poet's warmest admirers, is far more charming as art, and one would think much more satisfactory as likeness. In the winsome grace of the figure and the sweetness of the face one sees the 'fair Burnet' of the poet's 'Address to Edinburgh' and of the 'Elegy,' while in the proportion and arrangement of the design and the landscape setting there is a far-off echo of Gainsborough's charm. Many of his portraits were on the same small scale, and frequently his sitters were grouped in a room or on a garden terrace, a little in the same way as Zoffany (1733?-1810) treated his subjects. His portrait work, although wanting in both power and grace, was much in favour; but Nasmyth was an outspoken man, whose politics were at variance with those of most of his clients, and about 1793 he determined to devote himself to landscape, for which, indeed, he had more natural affinity. This step had an important bearing on the evolution of Scottish art, but its results can be better estimated in a later chapter, and in relation to the work of the earlier Scottish landscape-painters, many of whom were his pupils.[1]

Postponing for the present consideration of Nasmyth's landscape, we may now consider with becoming brevity a few minor portrait-painters of the eighteenth century, and then, at somewhat greater length, David Allan, who, toward its close, produced the first Scottish genre pictures.

Sir George Chalmers (? - d. 1791), Bart., of Cults, who was referred to in the introductory chapter as the probable author of an article of considerable value on the history of Scottish painting, was a descendant of Jamesone through the Alexanders, and studied with Allan Ramsay, and

[1] Mention should be made, perhaps, of the many etchings made by John Clerk of Eldin (1736-1812), 'that country gentleman, who, playing with pieces of cork on his own dining-table, invented modern naval warfare' (R. L. S.). Although amateur in handling, they show some sense of light and shade and considerable feeling for landscape.

in Italy. His work, although showing some power of characterisation, errs in excessive projection of the features, and while fair in tone, is rather hard in handling and negative in colour. The best known, and probably the finest example of his skill is a large full-length of William St. Clair of Roslin, who as captain of the Honourable Company of Golfers is represented in his red coat on the links and in the act of driving off. This admirable study of aged character—St. Clair was seventy-one at the time—is to be seen in the Archers' Hall, Edinburgh. The reputed portrait of the 'gentle' Lochiel is also by him, but if it represents that chief of Clan Cameron it must be a posthumous likeness, as it is dated 1762. A few words are due to George Willison (1741-97), for Cunningham's statement that he 'drew indifferently and coloured worse' is not borne out by the pictures I have seen, which are pleasant in colour and rather graceful in design, fair if not searching in character, and painted in an easy though somewhat thin manner. A nephew of George Dempster of Dunnicken, who did a great deal for Scottish agriculture, he, after some training in Italy, practised for some ten years in London before 1777, when he went to India, where he painted many portraits, including one of the Nabob of Arcob, now at Hampton Court. Returning home in comparatively affluent circumstances, through a fortune left him by one to whom he had been of service, he pursued his art in Edinburgh, painting amongst other things the very pleasing portrait of John Beugo (1759-1841), the engraver, in the Scottish Portrait Gallery.

Two lady-artists, the earliest to make any figure in Scottish painting, belong to about this time. Miss Catherine Read (1723-78) came of a good Forfarshire family, her father being laird of Torbeg, and going to London, she was for some years in great request with the aristocracy as a miniature and portrait painter. Working in a graceful and refined manner, she was specially successful in pictures of women and children, and in 1763 painted Queen Charlotte with the Prince of Wales, and two years later the Prince and his brother, while engravings by Finlayson of her portraits of the beautiful Gunnings, the Duchess of Hamilton and Argyll and the Countess of Coventry, were and have continued popular. Such pictures as 'Miss Harriott Powell' show the influence of Allan Ramsay, and pictures like the 'Miss Jones' that of Reynolds. Perhaps the most charming and personal of her portraits is 'Lady Georgiana Spencer' as a child, in Lord Spencer's collection. In 1770 Catherine Read went to India, but the usual accounts which say that her visit was brief are almost certainly incorrect, as she is known to have been there in 1775 and 1777, and in 1778 she died at sea off Madras when on her way home.[1] The second lady, Miss Anne Forbes (1745-1834), who was also well connected, followed the example of her grandfather, William Aikman of Cairney

[1] See articles by Mr. A. Francis Steuart in *Asiatic Quarterly Review*, January 1902, and *The Scottish Antiquary*, 1904.

(1682-1731), in studying at Rome, where about 1770 she made a number of copies of Old Masters. Her portraits of Signora Felice, painted in Rome, and Lord Polwarth were engraved in mezzotint by J. R. Smith. And in Scotland she seems to have had a considerable *clientèle*. One of the most pleasing and capable of her oil-pictures is a portrait of Lady Elizabeth Hamilton, in white and gold turban and a green and white gown, in Hamilton Palace, where and at The Ross, which contains so much of Aikman's work, there are other examples. But her most characteristic things are in crayons.

Mere mention must suffice for Andrew Allen and William Robinson, for Jeremiah Davison (1695-1745), William Cochran (1711-58), and Alexander Reid (1747-1823), minor portrait-painters of the period. Their work is of no particular interest in itself, and—except that Davison[1] painted the best authenticated portrait of Lord President Duncan Forbes of Culloden (Parliament House, Edinburgh), and Admiral Lord Torrington (National Portrait Gallery), and Reid, who was a miniature-painter, a likeness of Robert Burns—represents subjects for the most part too obscure to entitle it to further consideration here. Nor does James Wales (1747-95), who, after working in Aberdeen and London, found his way to India in 1791, painting portraits of native princes and others, and making drawings of the cave-temple and other carvings in connection with the Elurâ and Elephanta excavations there, call for more extended notice. Charles Cordiner, a pupil of the Foulis Academy, who is represented by a 'Bothwell Castle' in the Hunterian Museum, and Mrs. Blackwell, whose chief work was the drawings of flowers she made, engraved, and coloured for a herbal published in 1737-9, are in similar case.

With David Allan (1744-96) one touches far more interesting material, for his work was not only novel in its kind in Scotland but opened the way for much that is most characteristically Scottish in art. When only eleven years of age he was expelled from school for caricaturing his master, and a year later went to the academy of the Foulis brothers in Glasgow. Shortly after the completion of his apprenticeship there, of which he left a memento in a picture of the school with the pupils at work, he attracted the attention of some wealthy people in the neighbourhood of his native town, Alloa, and by them was sent to Italy, where he resided eleven years. As was to be expected, he commenced by painting incidents drawn from ancient history and mythology, and with considerable success, for he was awarded (1773) a gold medal for historical composition by the Academy of St. Luke in Rome, being the first Scottish painter after Gavin Hamilton to whom it was given.[2] The picture,

[1] Davison's work bears a certain resemblance to Allan Ramsay's, but is much inferior, being harder in drawing, harsher in colour, and more mechanical in handling. There is no doubt, however, that a number of his portraits are now attributed to Ramsay.

[2] Allan was subsequently a member.

which was engraved by Cunego, represents ' The Origin of Painting,' and is now in the National Gallery of Scotland, while the medal is in the possession of the Royal Scottish Academy. In Italy he also painted a number of portraits, including the rather dull full-length of Sir William Hamilton, now in the National Portrait Gallery, which he inscribed ' Painted by D. Allan, and by him humbly presented to the British Museum, Anno. Dom! 1775,' and between 1777 and 1780 he practised, principally as a portrait-painter, in London. Returning to Scotland in the latter year, he painted a number of portraits, such as the quaintly charming cabinet group at Hopetoun, the little .full-length of Craig, the architect, in the R.S.A. collection, and the large family group in a local landscape setting at Alloa House ; and, finding to his vast regret (expressed in dedicating his illustrations to *The Gentle Shepherd* to Gavin Hamilton) that ' heroic or historic subjects' were at a discount, applied himself to depicting the life around him. And yet, despite the fervour of his complaint against the impracticability of pursuing what, to Hamilton at least, was the supreme work for an artist, one cannot help thinking that it was only half sincere, and that Allan found in homelier scenes and incidents, and in the people he knew and to whom he belonged, the material best suited to the expression of his individual gifts. He did not abandon history wholly, but he came to see, to quote the dedication already referred to, that ' it seems essential towards the advancement of the art of painting in any country, that the country itself should furnish good models, in nature, for the imitation of the artist ! ' Even some of his Italian work had given hints of this spirit, which was to bring him such fame as he has. While his etchings of Roman and Neapolitan life —' Preaching in the Colosseum,' ' Pilgrims in St. Peter's,' and others— and the four sketches of the Roman Carnival, which were shown in the Royal Academy of 1779, and published as aquatints by Paul Sandby two years later, are not free from conventionality, they reveal a considerable interest in life and character as it is and for its own sake. And in Scotland the time was ripe for an art which would express the feelings of the common people. Ramsay had reawakened the nation's interest in its own poetry, Fergusson had given vivid expression to some phases of contemporary life, Burns had just added the crowning glory of his song, and David Allan, weak artist though he was, led the way towards similar themes in pictorial art. Runciman, indeed, had chosen subjects from a Scottish source, but he presented them in classic guise, and his work possesses little flavour of nationality except in fervour and colour. It was not until Allan produced his drawings of domestic scenes, either original or illustrative, that art became racy of Scottish life and character. Of these, the principal are the illustrations executed in aquatint, which he made for an edition of Ramsay's famous pastoral published by the Foulises in 1788. The figures were studied from Pentland shepherd

lads and lasses, the landscape backgrounds were drawn on the spot, and if in some of them he did not quite succeed in escaping the sentimentality of the pseudo-pastoral, others show a humorous, if somewhat strained, appreciation of character and situation, and all possess the interest of an adventure in a fresh field of art. He also made a number of illustrations to poems by Burns, which gained the enthusiastic approbation of the poet, who took 'Mr. Allan and Mr. Burns to be the only genuine and real painters of Scottish costume in the world.'

Allan was nearly forty before he gave his natural inclinations free play, and his genre pieces are usually water-colour drawings or engravings. For the most part his subjects were of a social or domestic nature, such as 'The Penny Wedding' (1795) in the National Gallery of Scotland, and 'A Domestic Scene' in the Glasgow collection, but in 'The Repentance Stool,' a 'Rantin' Robin' doing penance in church, and a few others he touched other phases of life with some satire, and his prints of 'The General Assembly of 1783,' 'The Commissioner's Walk,' and 'Laying the Foundation Stone of the New University' (1789) are valuable as records of contemporary events of more public interest. It is to be noted, however, that he usually preferred indoor incident, while in the few cases in which he chose an out-of-doors sitting he never, so far as I am aware, dealt with the labour of field or farmyard and man's relationship to the soil. But that, of course, is a more modern sentiment in art. Technically his work shows little real accomplishment. His draughtsmanship was not informed by any particular power, he had little feeling for beauty, his ideas of light and shade were very limited, his compositions conventional. And while it would be unfair to judge his drawings by the standard of the full range of coloration, which was not attained in water-colour until many years later, his use of the simple tints in vogue reveals little real colour sense, and is absolutely wanting in distinction of any kind. Amongst the few oil-pictures, not portraits, by him, two quaintly archaic landscapes, showing Alloa House and the river Forth, in Lord Mar's collection, may be named. Yet his designs are interesting as studies of character and as representations of the customs and costumes of a bygone age, while their effect on Scottish painting was great. Even before he died others, now forgotten, were beginning to look about them and were chronicling passing events. Thus in 1791-2, R. Rogers drew and engraved, in a combination of etching and aquatint, several scenes at Leith Races, which form a pictorial commentary on poor Fergusson's lines ; a few of Bogle's prints give glimpses of the life of the time ; and in Kay's *Edinburgh Portraits*, innocent of art as they are, we have a complete portrait gallery of 'Auld Reekie' at the close of the eighteenth century. As master of the Trustees' Academy, to which he was appointed (1786) in succession to Runciman, Allan exercised considerable influence on his pupils and immediate successors as regards subject ; and one of the most

interesting features of the following half-century and more is the import-
ance of the domestic genre-painting, which originates in his designs.

Throughout the period, a survey of the art of which we have now
completed, there was a slow but constant increase in the prosperity and
wealth of Scotland, which became more marked with the passing years.
During the latter part of the century agriculture was greatly improved by
the introduction of enclosures and an improved mode of cropping, while
Watt's invention of the steam-engine about the same time made the
mineral wealth available to a much greater extent, and prepared the way
for the enormous industrial development which marks the following
century. The early years had been sterile in great men. A few proved
themselves good soldiers, shrewd politicians, capable administrators or
sound lawyers, but until the fifties, Scotsmen, with the exception of James
Thomson (1700-48), did not shine intellectually and scarce practised the
arts at all. About that time, however, a remarkable intellectual move-
ment commenced to make itself felt in history and philosophy, in science
and in political economy. It was a product of the reaction which followed
the narrow and intense theological ideals which had dominated Scotland,
and was closely associated with the reign of the Moderates, who, with
their breadth of view, tolerance, and intellectual gifts, and their spiritual
indifference and coldness, had become the most influential, if not the most
numerous, party in the Church. Offering an outlet for the humane
instincts and secular activities, it had a special attraction for independent
minds, and induced boldness of speculation and first-hand investigation
of the phenomena of history and society. The leaders were David Hume
(1711-76), William Robertson (1721-93), and Adam Smith (1723-90);
but lesser lights, such as Lord Kames (1696-1782), Thomas Reid
(1710-96), and Lord Hailes (1726-92), James Hutton (1726-97) the
geologist and Joseph Black (1728-99) the chemist, Adam Ferguson
(1723-1816) and Dugald Stewart (1753-1828), contributed to the general
lustre. 'And yet,' says Carlyle in his essay on Burns, 'in this brilliant
resuscitation of our "fervid genius" there was nothing truly Scottish,
nothing indigenous, except, perhaps, the natural impetuosity of intellect,
which we sometimes claim and are sometimes upbraided with as a charac-
teristic of our nation. It is curious to remark that Scotland, so full of
writers, had no Scottish culture nor indeed any English ; our culture was
almost exclusively French.' But while this may be partially true of the
literature of the study, Scottish poetry in the eighteenth century, even
before its culmination in Burns, was not wanting in national flavour.
James Thomson's work, although in an English dress, has much of the
characteristic Scottish feeling for nature, and, if it cannot be said to have
inaugurated the remarkable outburst of joy in nature which marked the
close of the century, it was certainly the earliest modern poetry to
express that spirit. Allan Ramsay's famous pastoral and his collections

of Scots songs show that interest in national life and literature was not extinct; such songs as 'The Flowers of the Forest,' Hamilton of Bangour's 'Willie's drowned in Yarrow,' and Mrs. Wardlaw's 'Hardyknut' reveal a continuance of the emotional charm of the ballads; Fergusson's verse is racy of the convivial life of the old grey city it celebrates; and the poetry of Robert Burns is, perhaps, the supremest expression of nationality in the literature of the world. Nor should one forget the extraordinary interest aroused by the appearance (1762-3) of Macpherson's *Ossian*, with its suggestiveness and mystery and its touches of natural magic. In the closing years of the century, also, Walter Scott (1771-1832) was collecting the store of ballad poetry and historic lore and tradition which was to transfigure Scottish history in the colours of romance, and cultivating during many a holiday raid that passion for scenery which his genius was to make a wider possession.

These things were soon to find expression in pictorial art, in which, between Jamesone and the close of the eighteenth century, there had been little or nothing that indubitably bore the national stamp. In France the elegant depravity and irresponsible and artificial gaiety of the Regency and the periods of Louis xv. and Louis xvi. had been mirrored perfectly in the boudoir pieces of the painters of the *fêtes-galantes*; in the decorations of Boucher (1703-70) and Fragonard (1732-1806), and in the portraiture of Nattier (1685-1766), Van Loo (1705-65), and Drouais (1727-75); and the spirit of the Revolution had found appropriate expression in the classicism of Jacques Louis David (1748-1825) and his following, with its penchant for acts of ancient patriotism. In England national sentiment had issued in the typically English art of Hogarth (1697-1764), and the nobly artistic and racially characteristic portraits of Reynolds (1723-92), Gainsborough (1727-88), and Romney (1734-1802), while the landscape of Gainsborough and of Wilson (1714-82) had given promise and foretaste of the revolution British painters were to work in landscape art, and of the rich harvest that was to be gathered from communion with nature. But during this period, as we have seen, Scotland had practically no art of her own. To this two causes contributed: there was not a sufficiently patriotic and national sentiment among those who could have patronised art, and, there being little opportunity for artistic training at home, artists, even if fashion had not prescribed Italy, had to study abroad, with the result that they returned with the ideas of the school in which they were trained. Almost without exception the artists named in this chapter studied in Italy, a number of them for many years, and as there was no tradition in Scotland, and the artists were too few in numbers to create an atmosphere, they remained bound individually to what they had been taught. But with increase in numbers and with a quickened feeling of nationality abroad, first one and then another found his way to more personal expression, and the last ten

years of the century contained the germs of a distinctive art. Henry Raeburn had emerged into prominence and was producing some of the portraits on which his fame most securely rests, Alexander Nasmyth had abandoned portrait for landscape in 1793 and was instructing one or two of those who were to give it character and style ; and David Allan had commenced to paint scenes of Scottish rural life as early as 1783. Thomson of Duddingston was born in 1778, William Allan in 1782, Wilkie in 1785, and Watson Gordon in 1788; and the appointment of John Graham (1754-1817) to the mastership of the Trustees' Academy in 1798 resulted in increased and better opportunities for artistic training at home. Before the century closed, art in Scotland had commenced to assume some national characteristics, but what these were must be discussed in relation to the developments of which they were the germ.

SECTION II.—THE EARLIER SCHOOL—1787-1860

CHAPTER I

INTRODUCTORY

THE nineteenth century dawned auspiciously for Scottish art. There were still many things to contend against, the apathy of the great majority of the people, the tacit opposition of the narrow, the assumption of superiority by some would-be art patrons; but the general situation was more favourable to development than ever before, and Scottish painting had reached the stage when it was going to dispense with leading-strings and take a path of its own. After the commercial and industrial lethargy of the preceding hundred years, the people awoke to manifold activities. New industries were created, and those introduced towards the close of the previous century were greatly extended, while shipping and commercial enterprise made rapid strides. Before Watt retired from business in 1800 the steam-engine was in use everywhere, and the success of the *Comet* (1812) led to the great industries of steam shipbuilding and marine engineering, which, with all the iron-trades, were further stimulated by Neilson's discovery of the hot blast in 1828. All this meant greater wealth, which went on increasing with the passing years. It was a considerable time, however, before its effects became apparent in direct encouragement of the arts. In Lord Cockburn's day 'nothing was so rare in Scotland as a merchant uniting wealth with liberal taste and the patronage of art or science with the prosecution of private concerns,' and he summed up by declaring that Scotland was 'neither rich enough, nor old enough, for the rise of merchants princely in their tastes.' As in the preceding period, tangible recognition remained largely with the gentry, who for the most part confined it to portraiture[1] of people and places and cattle in which they had a personal interest, or to the patronage of talent with local claims upon them. Yet there were a number of genuine enthusiasts amongst the upper classes, and, in various ways, they stimulated an interest in art in their own set, and did what they could to advance the interests and education of the artists, and to foster a taste for pictures amongst the masses. But neither material prosperity nor liberal patronage, necessary as both are if art is to flourish, would have resulted in anything worth

[1] The landscapes of Thomson of Duddingston and 'Grecian' Williams were the chief exceptions.

while, if the social condition and feelings of the people as a whole had not been such as made art possible. Towards the close of the eighteenth century, however, a more humane and generous view of life came into existence ; the austerity, if not the seriousness, of the national character was gradually modified, and more gentle and refined, if less formal, manners came into vogue. Moreover, the rise of the middle classes in consideration and power, which was acknowledged politically in 1832, had a direct bearing on art, for it is from the lower rather than from the upper orders that artists usually spring.

Under the impulse, direct and indirect, of all these things, combined with the influence of the French Revolution in opening up new horizons or throwing people back upon the past, the emotional, spiritual, and political apathy of the eighteenth century, during most of which speculative, intellectual, and coldly moral sentiments had held sway amongst the educated classes, was superseded by a more kindly, impulsive, and imaginative spirit, which found some of its chief outlets in the arts. In literature profoundly reasoned treatises upon philosophy and economics, and learned dissertations upon the history and societies of the past, were succeeded by poetry and prose dealing intimately or imaginatively with life both present and past, and marked by keen sensibility to nature. In painting there now appeared, instead of mere mechanic likeness-making or 'High Art' learned in Rome, national sentiment, human sympathy, and natural emotion.

For a considerable time fear of social upheaval and unreasoning repugnance to popular government, created by the aftermath of the Revolution in France, continued to haunt the older generation and to obsess the ruling and official caste; but after 1802 the 'generous young,' who had drawn inspiration from its great ideals and cared more for liberty than for personal advantage, found expression for their views in the *Edinburgh Review*. Founded by Jeffrey, Horner, Brougham, and other intellectual independents, the 'blue and yellow' united literature with journalism and exercised great influence upon contemporary taste and opinion. Associated for a time with these writers, but belonging to no party, Thomas Carlyle, with his profound moral earnestness and dynamic energy, was soon to become a more potent and stimulating and a far more lasting literary force. In the Church, also, the cold reasonableness and the tolerance of everything but enthusiasm, which had marked the reign of the Moderates, who had served their purpose in steadying the national temperament after the exaltation of the Covenant and had now become purely worldly and of little intellectual account, were being displaced by greater warmth of feeling, which eventually issued in the social experiments of Dr. Chalmers, and, later, in the Disruption. On the other hand, the passion for the past and the dread of change, which were vital elements in the Tory creed, were advocated with much brilliance in *Blackwood's*

Magazine (founded 1817) and took imaginative and touching form in the poems and novels of Sir Walter Scott.

Clearly marked as party cleavage may be, the strands of life in a community are usually closely woven, and art, literature, and music afford common ground for all. It was so to some extent with the poetry of Thomas Campbell and the work of the 'Edinburgh Reviewers.' And from its national and imaginative character, it was emphatically so with the achievement of Walter Scott. Tory of the Tories as he was, his hatred of democratic ideals sprang more from love of old associations and traditions than from party spirit, and his sympathies were too human and his sentiments too generous to permit his imaginative writings, biased though they occasionally were, becoming a vehicle for political propaganda. Hence it came that the mingling of romanticism and human sympathy embodied in his work permeated much of the Scottish literature and art of his time, and influenced the romantic movement abroad profoundly.

As regards painting, Sir Walter's influence revealed itself most obviously in historical genre and in landscape. In the one there was a succession of pictures drawn from the Waverley Novels and the national history : in the other a rush to the Highlands. In the work of Scott, as R. L. Stevenson has said, we become suddenly conscious of the background, and in the pictures of his contemporaries we have, for the first time in Scottish painting, the expression of delight in wild nature. The effect of his example, if active to some extent, was much less noticeable in domestic genre, for here the painters entered into the heritage of the vernacular school of poetry with its realism, humour, and pathos, and its long descent from ' Robin and Makyne' to the 'Gentle Shepherd,' and from ' Christ's Kirk on the Green' and 'Peblis to the Play' to 'The Holy Fair,' ' Willie Brew'd a Peck o' Maut,' and 'A Man's a Man for a' That.' The beginning of the local, or, as it has been called, the 'Kailyard' novel was taking place simultaneously in the stories of John Galt and 'Delta.'

Meanwhile portraiture, which had hitherto been almost all we possessed in painting, had passed from the elegant formality of Allan Ramsay into the noble and mature art of Raeburn and his immediate successors. Sculpture also, which had had practically no existence in Scotland since the Reformation, commenced to show signs of life in the productions of a few self-taught men, and the work of Robert (1728-92) and James Adam (d. 1794) had led to increased regard for architecture, which the rise of the New Town at Edinburgh gave opportunity to display.

Edinburgh was then, and continued for long, indisputably the intellectual centre of the country : it was the seat of romance and poetry, of philosophy and criticism, of *Maga* and the *Edinburgh,* and gained a reputation for judicious appreciation which it still retains. A hundred years ago its society was at its brightest and best, two generations of gifted men met and overlapped, strangers of distinction, Sydney Smith

and De Quincey, to name no more, were not wanting, and London had only commenced to exercise her potent spell on Scots literary men and artists. It was in this atmosphere, in this New Town so significant of change and progress, that Scottish art matured and assumed significance.

<center>II</center>

When one turns from the work of the early Scottish painters to that produced by the artists who arrived between 1787 and 1860, what first strikes one is its comparative variety. During the preceding two hundred years there had been little but portraiture ; now, and almost at a bound, genre and landscape became equally important, and portraiture itself assumed new characteristics. The last two decades of the eighteenth century had seen signs of the coming spring. Raeburn (1756-1823) had shown the measure of his powers in a series of amazingly vital portraits ; David Allan (1744-96) had painted the first pictures of contemporary Scottish life and made the first illustrations to Scottish poetry ; and Alexander Nasmyth (1758-1840) had abandoned portraiture for landscape before it closed. But it was during the first twenty-five years of the new century that the seed sown by these pioneers of a more modern and a more inclusive and expressive art came to full blossom.

Until his death in 1823, Raeburn remained the most conspicuous of the portrait-painters. Indeed, in technical mastery and power and that rare gift of combining vivid portraiture with distinguished and simple pictorial design he is without a rival in the Scottish school, and has few superiors anywhere. But in Watson Gordon (1788-1864) and Geddes (1783-1844), and somewhat later in Graham Gilbert (1794-1866) and Macnee (1806-82), he had capable successors whose work at its best is marked by simplicity and sincerity of style, acute characterisation and able craftsmanship.

The fate of the pioneers in genre and landscape was less happy. David Allan, the initiator of domestic incident in Scottish painting, was eclipsed completely by Sir David Wilkie (1785-1841), who, in virtue of his technical accomplishment and gifts as a story-teller, soon took such a commanding position that Fraser, Burnet, Carse, and the other genre-painters became little more than his entourage ; and Sir William Allan (1782-1850), who was the first to paint incidents from Scottish history in a modern spirit, interesting as was his work in that field, was surpassed in historical perception, artistic talent, and emotional appeal by Scott Lauder (1803-69), and by Harvey (1806-76) and Duncan (1807-45), who had been his pupils. Although rendered less obvious by the want of atmosphere and by the warm brown tone which prevailed in their pictures, the aim of both domestic and history painters was realistic. The former painted certain phases of everyday life with all the truth possible to the

convention of their time ; the latter, while not escaping a tendency to theatricalism, steered clear of heroics and gave considerable attention to truth of detail and circumstance. On the whole, however, interest of story predominated over the pictorial possibilities of subject, and amongst the history painters at least there were few who could do without an author and invent incident for themselves.

A more personal and poetic quality appeared in the pictures of David Scott (1806-49) and William Dyce (1806-64). Those of the former are pregnant with an imaginative lift, a high romantic note, which makes them unique in Scottish painting ; and the work of each in its own way anticipated that of the pre-Raphaelites.

While many of the earlier Scottish landscape-painters were trained or helped by Alexander Nasmyth and show traces of his influence in their art, in that of the Rev. John Thomson of Duddingston (1778-1840) landscape assumed a form more consonant with the bold and beautiful character of Scottish scenery and more expressive of the romantic spirit in which, under the sway of newly awakened sensitiveness to its appeal, it was regarded. And it was in this direction, rather than in the other, that Horatio M'Culloch (1805-67), who was the determining factor, led this aspect of Scottish art. Yet if the landscapes of these men and their followers gave expression to that fervid love of country which distinguishes the Scot, contemporary with them, in the work of H. W. Williams, David Roberts, and Andrew Wilson, one can trace his roving disposition too.

During the late forties a group of men emerged who carried many of the traditions of the earlier school well into the second half of the century. The spirit which underlay the domestic scenes of Erskine Nicol, the Faeds, and R. T. Ross was very similar to that which had inspired those of Wilkie and his contemporaries, and, while local colour was more keenly noted and insisted upon, the general tone of their work remained mellow and brown, and their handling was neat and deft rather than powerful and expressive. Sir Noël Paton, James Archer and W. Bell Scott, and in some measure Sir W. Fettes Douglas and Robert Herdman, although influenced in certain ways by the pre-Raphaelite movement, with its microscopic detail, love of vivid local colour, and interest in the past, were intimately related to these painters. Instead of the homely incidents in which the genre men took such a naïve delight, they sought out learned or literary subjects, or gave their pictures an 'improving' tendency ; but their attitude to life was no deeper and less touching, and the purely æsthetic qualities of their art were on much the same plane. Only a little later than these figure-painters, several landscape-painters of distinct talent appeared. The landscape of Harvey and Wintour, Milne Donald, Bough and Fraser, while retaining traces of the older conventions, is informed by closer study of nature and of the moods of the weather and by greater delight in colour, and is marked by a freshness of impression

and a breeziness of effect which make it almost modern in sentiment. More than the subject painters, their contemporaries, they belong to the modern school, but all of them are dead, and the fact that their art was formed under the earlier influences and is transitional in character makes their inclusion with the earlier men both convenient and appropriate.

Towards the close of this period, also, John Phillip (1817-67), after working for years as a disciple of Wilkie, visited Spain, and thereafter, under the influence of Murillo and Velasquez, produced a series of pictures of contemporary Spanish life painted with a breadth and power and a richness of colour which made them not only remarkable in themselves, but a potent influence upon much succeeding Scottish painting. More important still as regards the future, Robert Scott Lauder (1803-69), with his enthusiasm for beauty, his gift of colour, and his knowledge of the mature art of Italy, was training in the Trustees' Academy a group of men whose achievement was to be the most notable feature of the succeeding fifty years.

<center>III</center>

Increase in numbers, improved social conditions, and awakening interest in art led to attempts at combination among the artists. Towards the close of the eighteenth century several unsuccessful efforts (in 1786 or 1787, in 1791, and again in 1797) were made in Edinburgh to institute an Academy of the Fine Arts, and at length, in 1808, a Society of Artists was formed, and held an exhibition, the first of the kind ever seen in Scotland. Writing of this, Lord Cockburn says it did incalculable good. ' It drew such artists as we had out of their obscurity ; it showed them their strength and their weakness ; it excited public attention ; it gave them importance.' Previously 'There was no public taste for art, and, except for Raeburn's portraits, no market for its productions. Art was scarcely ever talked of.' The society had lasted but five years, however, when the needs of the majority of the members induced them to divide the profits accumulated from the exhibitions (amounting to over eighteen hundred pounds), and dissolve the society. This was a great disappointment to the others, who had contributed most to the success gained, for it had been their intention to apply for a charter, and form themselves into a corporate body, and they carried on the exhibitions for three years more before abandoning them. Three years later, in 1819, a number of the more public-spirited of the nobility and gentry established the ' Institution' for the purpose of promoting art in Scotland by providing means for a more general diffusion of taste, and by raising the status of the artist. This end it was hoped to attain by annual exhibitions of ' Paintings of Ancient Masters,' by the formation of an art library and a collection of prints, and by affording relief to deserving artists in necessitous circumstances. But the ' Old Masters ' did not pay their way, and in 1821,

with the co-operation of the artists, the modern exhibitions abandoned in 1816 were restarted by the Institution, on the understanding that any surplus arising should be set aside for the benefit of the artists and their families. During its active existence four exhibitions of old and nine of modern art were held with considerable popular success and undoubted advantage to art. From 1826, in which year both an old (the third) and a new show took place, the exhibitions were located in the Royal Institution, which had just been built, at a cost of £47,000, upon the Mound by the Board of Manufactures, several members of which were also active in the affairs of the Institution. Previously Sir Henry Raeburn's gallery in York Place, and 'Mr. Bruce's gallery, Waterloo Place,' had been used. In the fore-note to the catalogue of the 'Old Masters' of 1826, we are told that the receipts at the preceding modern exhibition had amounted to £962 (nearly double those of any former occasion), and the number of visitors to between sixteen and eighteen thousand ; and it proceeds : ' Within these very few years a most surprising increase has taken place in the number of valuable works of the great masters which have been brought to Scotland. . . . With a few exceptions the whole of the fine works at present exhibited have been brought to this country since the establishment of the present Institution.' Amongst the few exceptions referred to was Lord Elgin's equestrian portrait of Olivares by Velasquez, which had been exhibited in the first exhibition, 1819. It and three others, which had been shown previously, were included ' to gratify the earnest desire of some gentlemen of the profession to have another opportunity of benefiting by their inspection.' The influence of the Institution tended rather to encourage the collection of Old Masters than to foster native art, and, although many spurious works were forthcoming to supply the demand, a number of private collections of considerable value and interest were formed. Of these the most notable was that brought together in Hamilton Palace, which contained many famous works before the great sale in 1882 denuded it of all save family portraits ; but Lord Hopetoun, Lord Grey of Kinfauns, whose collection included a sprinkling of Scottish pictures, Lord Breadalbane, whose treasures are now at Langton House, Lord Fife, who had a taste for historical portraiture, Sir Archibald Campbell of Garscube, Lord Eldin, James Gibson Craig, and others were enthusiastic connoisseurs. Of greater importance from a public point of view, Sir James Erskine of Torrie formed the small but fine collection of Dutch and Flemish pictures which he bequeathed to Edinburgh University, and which that body deposited in the National Gallery of Scotland, and Archibald M'Lellan, a Glasgow coach-builder, the remarkably interesting one which he left to form the nucleus of a permanent collection in his native city.

But while the Institution and the interest it aroused were of distinct service to art in Scotland in certain ways, its management did not make

for permanent success. It was run by the amateur for the benefit of the artist, who, although the modern exhibitions were a great source of revenue, was allowed no voice in the shaping of its policy or the administration of its affairs. 'A rooted jealousy of our living artists as a body (not individually) by the persons who led the Institution was its vice,' and, conducted in such a spirit, it was destined to die sooner or later. The situation as between artists and Institution, three years after the formation of the latter, is summarised in a letter which Sir Henry Raeburn, who was a member of the Institution and not a mere professional associate, as all the other artists connected with it were, wrote to Mr. James Skene, the Secretary, and as it is obviously an impartial statement and has never been published, it is given in full here.

'YORK PLACE, 24*th December* 1822.

'DEAR SIR,—I formerly mentioned to you that I had received several visits from some of the oldest and best established artists of this place, and also stated to you what had been the object of their visits.

'It will probably be in your recollection that a few years ago the artists here had several Exhibitions, which were made by way of experiment, and which succeeded far beyond their expectations.

'By these Exhibitions they had realised a fund amounting to between £5 and 600, and at that time it was the intention of those whose labours had perhaps contributed most to the success of the Exhibitions, to apply for a Charter and have themselves formed into a Corporate Body.

'But unfortunately for their purpose, they had at the first outset been guilty of a great oversight. That they might not seem to act upon a system of exclusion, they had admitted too many into the Society whose works were of little importance to its success, but whose voice when a matter came to the vote was just as efficient as that of those by whom alone it may be said to have been sustained.

'Before those members had matured their plan, the poorer and less efficient members threw their eyes upon the fund, a motion was made to divide it, and carried by a majority against the sense of the older and more efficient members ; and thus what would otherwise have been a bond of union was dissolved.

'This was to many a great disappointment, but there was no quarrel as the public supposed, for it was impossible to be displeased with them who voted for the division, as it was known that the fund, small as it was, had become an object to several, and that others to whom it was a matter of indifference had, from a knowledge of this circumstance, voted with them.

'It had been found at the same time from experience, that an annual Exhibition was too great an undertaking for this place, and more than

they were able to sustain. The idea of continuing it was therefore laid aside for the present, and it was just beginning to be taken up again when the Institution for the encouragement of the fine Arts was established.

'The purpose of instituting a Society having again been resumed by those who first projected it, they now propose to admit only a limited number, and to make it a *sine qua non* of admission, that the funds shall never be divided, but shall be applied to the purposes after mentioned.

'When these gentlemen came to inform me of their intention, I begged to know if they were influenced by any motives or views that were hostile to the Institution. They replied that it was quite the reverse. They had the highest esteem and respect for the gentlemen of the Institution, and both their motives and their conduct met with their most unqualified approbation. But as it was their own fixed purpose that their funds, as they came in, should be laid out in the purchase of Books, Prints, and such other articles connected with Art, as would be useful both to the student and advanced artist, they considered themselves co-operating in the views of the Institution, and therefore had no doubt but that they would meet with their countenance and approbation.

'Upon my stating, that in all probability the Institution, in as far as the application of the funds was concerned, had the same things in contemplation, they replied that it might be so, but even in that case that a separate Society and distinct funds would be necessary for the following reasons :—

'1st. Because they could in no instance derive benefit from the good intentions of the Institution without previous or perhaps frequent applications to that Society, that every such application would of course be delayed till there should be a meeting of the Com[tee], and probably a reference made by the Com[tee] to the gen[l] meeting, and that delays even with the kindest intentions on the part of the Institution might thus take place, till the very purpose for which the application was made had gone by.

'2nd. That every application necessarily implied a power of control on the one side and a state of dependence on the other, to which, in so far at least as concerns the use of their own property arising from the fruit of their own labours, there was no necessity for subjecting themselves.

'3rd. That in the management of their own affairs, it was easy to foresee a variety of little circumstances which would require to be attended to, and arrangements that would require to be made, in order to afford conveniences and facilities to themselves in the use of their property, which it could not be expected that the Institution would condescend to be troubled with.

'4th. And besides all this, there was something degrading in the idea which had gone abroad that they were unfit to conduct their own affairs, and therefore it had become necessary to take the management into their own hands.

'Now, my dear Sir, I confess to you that there were several of these arguments which I thought unanswerable, but I shall be glad to have your opinion upon the subject, before you communicate these views of the artists to any members of the Institution.

'As for myself, I have nothing to gain by the measure. I have in my own possession as many of the means of improvement as I have time to attend to, and my business, though it may fall off, cannot admit of enlargement. In so far, therefore, as I am personally con-, I am quite indifferent about it, but I wish well to the Arts of this place, which I think this measure would rather tend to improve, and I wish well to the Artists because I believe them to be as worthy a set of men as can be found in any profession, and I have uniformly received so much kindness and regard from them, that I cannot refuse to go along with them in any matter that appears reasonable.

'The present proposal I consider to be of this kind, at least according to the view that I have of it, but as I am anxious to be concerned in nothing but what shall be considered just and reasonable, I shall be glad to receive your opinion upon the subject.—I am, with great esteem and regard, my dear Sir, your most obed[t] and faithful ser[t],

'HENRY RAEBURN.

'To James Skene, Esq.'

Raeburn's death during the following year seems to have put an end to that particular attempt to form a Society of Artists upon a permanent basis ; but, discontent with the Institution continuing to increase, steps for the formation of a Scottish Academy of Painting, Sculpture, and Architecture were again taken and carried to a successful issue in 1826. In this movement William Nicholson, portrait-painter, and Thomas Hamilton, architect, were the leading spirits. Of the twelve artist associates of the Institution only three joined the new Society, which in the beginning met with great opposition from that body and the Board of Manufactures. Application was made to Government for a Royal Charter, but, although warmly commended by Sir Thomas Lawrence, the President of the London Academy, and favourably entertained by the Home Secretary (Sir Robert Peel), it was refused and one granted to the more influential Institution. The Academy's first exhibition was opened in the rooms in Waterloo Place in February 1827, almost simultaneously with that of the Royal Institution, to which it proved inferior. But the sympathy of the public was with the new Society : in a couple of years the positions were reversed, and the directors of the Royal Institution, deserted by their artist associates, who had joined the Academy in a body, yielded the field to the Scottish Academy in as graceful a way as possible, and turned their attention to acquiring 'ancient pictures as a nucleus of a national collection.' A sum of £614, 3s. 10d.

was paid over to the Academy as the entire profits of the modern exhibitions held by the Institution while associated with the artists, but afterwards it transpired that the collection of ancient pictures above referred to had been purchased with money mainly derived from the same source. After the amalgamation, thus happily consummated by Lord Cockburn and Lord Justice-Clerk Hope in 1829, the number of Members of the Academy was forty-two, and half of the twenty-four then added were associates of the Institution. Subsequently the number of Academicians was fixed at thirty and of Associates at twenty. But the difficulties of the Academy were not yet over; it did not receive its charter until 1838, the arrangement of renting rooms for exhibition purposes in the Royal Institution, which originated in 1835, was vexatious and unsatisfactory, and the life school was conducted in inconvenient apartments in Register Street. The whole expenses were met from the proceeds of the annual exhibitions, and as the formation of a collection of pictures, principally modern, had also been commenced, the tax upon the resources of the Academy was great. At last the relations between the Board of Manufactures and the Academy became so strained that a movement was inaugurated by the artists to secure galleries for themselves. This led to a Government inquiry into the whole question at issue, and in the long-run resulted in the formation of the National Gallery of Scotland, and the erection of the galleries on the Mound which accommodate that collection and the Royal Scottish Academy. The building, which was commenced in 1850, and used for the first time by the Academy five years later, cost £50,000, the Board supplying £20,000 from its accumulated funds, and Parliament voting £30,000, while the city showed its interest in the Academy by giving a very valuable site for a nominal sum.[1] With the opening of its own galleries, the first chapter of the Academy's history, its time of stress and storm, comes to an end. Throughout the whole period its affairs were conducted with conspicuous success, to which the enthusiasm and capacity of the successive presidents, George Watson, Sir William Allan, and Sir J. Watson Gordon, and secretaries, William Nicholson and D. O. Hill, contributed in no small measure.

Seven years after the Academy originated, in 1833 the Association for the Promotion of the Fine Arts in Scotland was formed. It was the first society of the kind established in Britain, and for many years rendered considerable service to Scottish art by buying the work of promising young artists, and by distributing engravings and reproductions of good pictures to its subscribers. But, like the Royal Institution and with equally good intention, it was based on a system which lent itself to patronage, the prizes being selected by the committee and not the winners. This ultimately led to a loss of public confidence, and finally, after a career of sixty-four years, the society, whose annual revenue, at

[1] £3500, paid by the Board

one time nearly £7000, had dropped to a few hundreds, was dissolved, bequeathing to the National Gallery of Scotland the collection of modern works it had acquired with a portion of its funds.[1]

Although Edinburgh was the scene of these the most important events in the politics of Scottish art during this half-century, efforts to practise painting and sculpture, and stimulate appreciation of them, were not confined to the capital. In Glasgow the Dilettanti Society inaugurated a series of exhibitions, which, beginning in 1838, continued for eleven years.[2] They were followed after a short interval by those of the newly founded West of Scotland Academy, but, that society also coming to an untimely end, it was not until the Institute of the Fine Arts was founded in 1861 that the advantages of well-organised and representative annual exhibitions were secured for 'the second city.' While these tentative experiments and others of even less duration had afforded certain opportunities to the local painters, artists continued few in number, the encouragement to remain in the west was not great, and, excepting Graham Gilbert and Milne Donald, no painters of real merit lived their lives out in Glasgow : McCulloch and Macnee settled in Edinburgh ; Leitch and others found their way to London.

IV

During all these years the Royal Scottish Academy exercised, through its exhibitions and prestige, a great influence upon art in Scotland, but the training of artists continued principally in the hands of the Board of Manufactures. The Trustees' Academy, established in a room in the old College buildings in 1760, was thirty years afterwards removed to Mint Court, whence it was transferred to an upper room in the High Street, rented at five guineas the year. In 1800, two years after John Graham became master, it again changed its quarters, and for the next six was carried on in the studio once occupied by David Martin, the portrait-painter, in St. James' Square. The next removal (1806) was to a gallery specially built in Picardy Place at a cost of £1000, and there it remained until 1826, when it was finally accommodated in the Royal Institution. Very little change or improvement in the instruction given took place until after John Graham's appointment. Originally founded with the intention of fostering design for manufactures, it was in fact a school of applied art. At first its work was directed to making designs for linen fabrics, and later its scope was widened to include other industries ; but under Graham it definitely assumed the position of a school for artists as well. The 'examples of fruit, flowers, and grotesque ornament,' which were previously the only models set before the students, were supplemented or

[1] Although the society had many subscribers in the colonies, as well as at home, the decrease in public support dates from the failure of the City of Glasgow Bank in 1879.
[2] An Art Union was formed in Glasgow in 1841.

superseded by a good collection of casts from the antique, pictorial com-
position was taught, and painting introduced as a definite study. To the
premiums already given for drawing, others for painting were added, and
the subjects for these competitions being chosen from poetry and history,
Wilkie, like David Allan, started his career by winning a prize for a
classical composition. Graham was a capable and enthusiastic man, his
own work is not unworthy of respect, and his influence upon his pupils,
of whom Wilkie, William Allan, and Watson Gordon are the more
important, and through them on Scottish art, was great and salutary. He
was followed in the mastership by Andrew Wilson, a landscape-painter of
merit, and a cultured and travelled man, under whom the good work
inaugurated by Graham was continued. Robert Scott Lauder, William
Simson, and D. O. Hill were among those trained by him. With Sir
William Allan, who was appointed Wilson's successor in 1826, new
influences came into play. His work, and that of his pupils, Duncan and
Harvey, mark the beginning of the national historical picture, and his
consideration for accuracy of costume and accessory was of the greatest
moment in giving it a basis in reality. The number of students having
considerably increased, Duncan was made teacher of the class for colour,
and on Allan's resignation in 1844, six years after he had been elected
P.R.S.A., Duncan succeeded him, but died the following year. A life class
had been introduced by Allan, and the general management of the school was
now given to Alexander Christie, the antique, life and colour classes being
under John Ballantyne, another member of the Scottish Academy, while
the headmaster and an assistant taught ornament and design. The number
of pupils had meanwhile risen to a hundred and thirty, all of whom received
instruction free, the collection of casts from antique sculpture had become
thoroughly representative of the art, or at least of those phases of it most
appreciated at that time, and the small but fine collection of Old Masters
belonging to the Royal Institution, supplemented by the Academy's
pictures and the Torrie collection, was available for study. The good
fortune which had followed the Trustees in their appointments culminated
in 1852, when Robert Scott Lauder was elected headmaster, for under him
was trained a group of painters of great distinction.

CHAPTER II

RAEBURN

WELLNIGH two hundred years lie between the birth of Jamesone, the earliest, and the advent, toward the close of the eighteenth century, of Raeburn, the greatest of Scottish portrait-painters. In the interval a considerable number of Scotsmen had painted portraits ; indeed, there was scarcely a time during these two centuries in which a few men were not making some sort of pictorial record of their contemporaries. In the seventeenth century we had Jamesone himself, whose portraits, besides forming an invaluable commentary on the history of his day, possess artistic interest, Wright, Murray, and the Scougalls, and a few adventurous foreigners of no great merit who found their way north of Tweed ; while Aikman in the beginning of the eighteenth led on through Alexander, Smibert, and a few more to Allan Ramsay, who trained Martin and others, with whose work, and that of Skirving and Brown, and of the miniaturists Donaldson and Bogle, the early period of Scottish portrait-painting may be said to close. The earlier portraiture, although showing considerable grasp of individual character, had for the most part been conventional in type, and showed very clearly the influence of contemporary foreign methods and pictorial ideals, Flemish and Dutch in the seventeenth century, and Italian and French in the eighteenth. That which followed was connected to some extent with the fine tradition that had grown up in England during the latter half of the eighteenth century, and revealed, both in technical and compositional qualities and in the stress laid upon differences in character, qualities that had not been very evident in the work which preceded it. Technically there came a desire for directness and expressiveness rather than for polished elegance of achievement, and design was used more to enforce characterisation than as an end in itself. And these qualities combined with completer and more intimate realisation of individual character to give the portraiture of the earlier half of last century a character of its own, and that distinctively Scottish. In this access of naturalism, with its greater dependence upon immediate impression of reality, and in the simplification of pictorial motive that involved, Raeburn played the most important part, and neither he nor Watson Gordon, his most conspicuous successor, owed much to foreign schools.

Left an orphan at the age of six, Henry Raeburn (1756-1823), the son of Robert Raeburn, an Edinburgh yarn-boiler, descended from a

family of Border ' bonnet-lairds,' was educated at Heriot's Hospital, and was apprenticed at the age of fifteen or sixteen to James Gilliland, a jeweller and goldsmith in his native city. He showed considerable aptitude for his craft, but had not been at it long when David Deuchar [1] (1743-1808), the seal-engraver and etcher, calling to see his master, surprised young Raeburn at work upon a portrait of himself. Struck by the ability it revealed, he inquired of Raeburn if he had had lessons, and, being answered in the negative (with the added remark that he wished he could, but could not afford them), offered to give him an hour's teaching, after business hours, once or twice a week. This kind offer was accepted eagerly, and, closer acquaintance having convinced Deuchar that the youth ought to become a portrait-painter, he spoke to his friend Gilliland about it, and between them they had him introduced to David Martin (1737-98), the leading portrait-painter in Scotland. As Martin did not settle in Edinburgh until 1775, Raeburn must have been at least nineteen when he made his acquaintance. He had been a pupil and assistant of Allan Ramsay (1713-84), and painted in his manner, though with less elegance and style ; but, beyond lending Raeburn some pictures to copy, he does not seem to have given him any assistance, and before long even this slight connection was broken by Martin upon a trumped-up excuse. Gossip has it that the real reason was jealousy of the younger artist's rapidly maturing powers. So far as is now known, Raeburn received no more training than is indicated in these relationships,[2] but, such as they were, they appear to have given him confidence in his own gifts, for he came to an arrangement with his considerate master which enabled him to devote his whole time to painting. Through the interest of friends he now received numerous commissions for miniatures, and after a little for portraits in oil, which, being far more suitable for the exercise of his special talent, soon became his chosen medium. In 1778, at the age of twenty-two, marriage with one of his sitters brought him both domestic happiness and a considerable fortune. It was not until 1785, however, that, feeling the necessity for greater knowledge than could be obtained from studying the pictures available in the neighbourhood of Edinburgh, he decided to widen his horizon by a visit to Italy. In passing through London he called upon Sir Joshua Reynolds, who not only gave him letters of introduction, but, unaware of his easy circumstances, generously volunteered financial aid. His wife had accompanied him, and the next two years were spent chiefly in Rome. But the rising tide of the classical revival, in which his countryman, Gavin Hamilton (1723-98), was prominent, seems to have touched him not at all. He perfected his technique in the Eternal City, becoming a more accomplished draughtsman, acquiring a more assured touch, and

[1] I am indebted to Miss Deuchar for this account of the relationship between Raeburn and her great-grandfather.

[2] It is said that he took his tone of colour from Runciman's portraits, but Runciman's colour was much warmer than Raeburn's in his earlier time.

attaining a bolder use of colour than before; but he remained true to his own perceptions of reality and his own shrewd and direct interpretation of character. Returning to Edinburgh in 1787, he took a studio in George Street, and, almost at a bound, attained the foremost place in Scottish art. Thereafter, save for great financial difficulties about 1809,[1] his career was one of unbroken success. He was looked up to as the head of his profession, he painted everybody of importance, and was one of the most notable men in the distinguished society of the Scottish capital. In 1810, however, moved probably by monetary considerations, he proposed trying his fortune in London, and consulted Lawrence (1769-1830), who dissuaded him. It is as unnecessary, as it would be unfair, to suggest that the future President of the Royal Academy had ulterior and personal motives in urging the Scottish painter to rest content with his supremacy in the north, for Raeburn was fifty-four at the time, and, after his undisputed reign at home, even his generous nature might have taken ill the competition inseparable from such a venture. Lawrence's advice was wise in many ways, and Raeburn, secure in the admiration and constant patronage of his compatriots, lived his life to the end unvexed by the petty jealousy of inferior rivals. Nor was recognition confined to Scotland: he was elected A.R.A. in 1812,[2] and Academician three years later. It was in relation to the latter honour that he wrote to a friend in London: 'I observe what you say respecting the election of an R.A., but what am I to do here? They know I am on the list; if they choose to elect me without solicitation, it will be the more honourable to me, and I will think the more of it; but if it can only be obtained by means of solicitation and canvassing, I must give up all hopes of it, for I would think it unfair to employ those means.' At a later date the Academy of Florence made him a member, and two American academies conferred honorary membership upon him. In 1822 he was knighted by George IV. at Hopetoun, and two months before his unexpected death on 8th July 1823, news reached Edinburgh that he had been appointed His Majesty's Limner for Scotland.

Raeburn had many interests, mechanical science and archæology, building speculations and 'gangin pleas,' angling and archery, gardening and golf, but he found portrait-painting the most charming occupation of all, and most days were spent in the painting-room in York Place. Sometimes he had as many as three, or even four, sitters in one day, and he usually required about half a dozen sittings of from one and a half to two hours

[1] After this date he was only tenant of the fine studio and gallery he had built in York Place in 1795. 'The house in York Place did not belong to Raeburn; it was purchased by a lady at the time of his failure, and he has since paid for it the interest on £2000 yearly.'—Andrew Wilson to Andrew Geddes, 8 July 1823. It may be pointed out, perhaps, that Cunningham's statement (followed by most other writers) that the upper flat formed a gallery lit from the roof, is not borne out by examination of the premises. The top flat consists of a number of rather low-roofed rooms, the painting-room is quite obviously that on the first floor, and it is almost certain that the exhibitions of the Society of Artists were held in the fine rooms on the ground floor.

[2] The date, 1814, usually given, is an error.

each for a bust portrait. His habit was to start at once with the brush,
indicating forehead, chin, nose, and mouth with the first touches, and
Cunningham makes special mention of the fact that he did not use a
maulstick. Working with his canvas placed beside his sitter, he would
often go to the other end of the studio to look at both, and, if one can
reason from a particular case [1] to his general practice, such was his regard
for ensemble that he did not care to proceed with the painting of a group
unless all the sitters were present. 'His palette was a simple one ; his
colours were vermilion, raw sienna (but sometimes yellow ochre instead),
Prussian blue, burnt sienna, ivory black, crimson lake, white of course,
and the medium he used was "gumption," a composition of sugar of lead,
mastic varnish, and linseed-oil. The colours were ground by a servant in
his own house and put into small pots ready for use.' [2] When one
adds that his studio had a very high sidelight and that he painted on
half-primed canvas with a definitely marked twill, which frequently
runs diagonally across the picture from left to right, all that is known of
his practice has been noted. Unlike most of his successful contemporaries,
he employed little assistance. He thought that nothing ought to divert
attention from the face, that accessories should be strictly subordinate,
and so preferred to do the whole himself. It is said that it was not until
his difficulties had made it desirable to produce more rapidly that he had
a regular assistant, but his later work bears little or no trace of extraneous
help, except perhaps in replicas. John Syme, R.S.A. (1795-1861),
worked occasionally for him, however, and Samuel Mackenzie, R.S.A.,
was in some degree a pupil ; and Raeburn was ever ready to give advice
and encouragement to young artists. The long letter, quoted in the
preceding chapter, proves that his relations with his fellow-painters were
of the most cordial kind.

Miniature-painting in England was in its most graceful, if not its
greatest, period when Raeburn was practising the art. During the decade
in which most of his work of this kind was probably done, the Cosways and
the Plimers, Smart, Shelley, and Engleheart were producing those dainty
little portraits for which present-day millionaires are giving fancy prices,
but Raeburn's miniatures possess none of the charm of colour, elegance of
design, and grace of sentiment that were distinctive marks of the prevail-
ing mode. His, to judge from the few authentic examples one can see,
are rather simple and direct portraits than elegant abstractions, and their
sole interest lies in their having been the prelude to the masculine and
virile style he achieved in oil-paint. Yet, beyond that they are drawn
carefully and that the heads are placed and lighted in a way not unlike

[1] One of the boys in the Binning group (about 1811) told Sir George Reid that Raeburn
insisted upon both of them going to the studio and posing whenever he was to be working at the
picture.
[2] Alexander Fraser, R.S.A., in *The Portfolio.*

what one finds in his oil-pictures, the relationship is not very evident ; and, as the full-length of George Chalmers (Dunfermline Town Hall) was painted in 1776, when he was no more than twenty, he must have passed almost at once from miniature to life-size and found his true *métier* with little difficulty.

Portraits that can be assigned with some degree of certainty to a date prior to 1785 are not numerous, but 'Dr. Hutton' and 'Professor Black' (Sir George Warrender, Bart.), and the group 'Mrs. Ferguson and Children' at Raith may be taken as representative, and, while immature in many ways, they are remarkable for breadth and simplicity of style and direct characterisation. And these are qualities highly characteristic of his maturity. His style, indeed, in many of its essentials was formed before he visited Italy, and the pictures painted immediately after his return, such as the '2nd Lord President Dundas' at Arniston, the 'Neil Gow' in the Scottish Portrait Gallery, or the Penicuik portrait of John Clerk, Lord Eldin, are differentiated not only from his earlier ones, but from those that soon followed, by the greater precision with which they are drawn, the more definite elaboration of their detail, the more formal and laboured quality of their handling, and the greater richness of their colour. In those most typical of the next few years one finds that while his colour has lost the inclination to greenish-greyness of tint, which had marked most of his early oil-pictures, it remains cold and wanting in quality, the more vivid tints now and then introduced being over-gaudy and un-modulated, and that the handling is swift and flowing rather than powerful and expressive. But a few, amongst which 'William Ferguson of Kilrie' and 'Sir John and Lady Clerk' are notable, reveal a new interest in subtle-ties of light and shade and arrangement, and the famous full-length of the archer 'Dr. Spens' (1791-2) more than foreshadows the finer colour and the superb accomplishment of his later years. The following decade saw the production of many fine pieces, including the splendidly audacious yet highly dignified 'Sir John Sinclair, Bart.,' and 'Mrs. Campbell of Ballimore,' both painted about 1795, the picturesque 'Captain David Burrel' and the charming 'Lady Steuart of Coltness,' 'Admiral Lord Duncan' (1798), 'Professor Robison' (*circa* 1798), and the vivacious group of 'The Macdonalds of Clanranald' (*circa* 1800), which show extraordinary brilliance and directness of handling, great certainty of modelling by simplified planes, and a ripened feeling for colour and fine tone.

Broadly considered, Raeburn's art shows no marked periods. It developed slowly and surely, never changing its essential character, and always giving fuller expression to that acute sense of actuality which is its most outstanding quality. But the pictures painted before 1800 or thereabouts are handled in a more summary and blocked-out manner and with more of the square touch, which reaches its apotheosis in the wonderful three-

quarter-length of Professor Robison in night-cap and striped red dressing-gown, than those which belong to the following twenty years, when he attained rounder and more subtle modelling, richer and more marked light and shade, and fuller, if lower-toned, colour. And, although scenic settings still hold in many of his full-lengths, one notes such an increase in the use of plain backgrounds, particularly in portraits of women —in those of men he had always inclined to simplicity—as to make that rather characteristic of his later pictures. His powers continued to mature to the very end, and the work of the last twenty years is therefore not only the fullest expression of his personal preferences and tastes, but includes what are, everything considered, his finest achievements. The portraits of men belonging to that time include the 'Hon. Henry Erskine' and 'Lord Newton,' 'John Wauchope, W.S.,' and 'James Wardrop of Torbanehill,' while amongst those of ladies are 'Mrs. Scott Moncrieff,' 'Mrs. Irvine Boswell,' and that astonishing masterpiece 'Mrs. James Campbell.'

His is the very uncommon case of a man showing enormous technical power without having received a thorough technical training in youth. What Raeburn learned before he went to Rome at the age of twenty-nine was literally picked up ; but he had taken the trouble to found himself upon the best models available, and, more important still, he had looked at nature for himself. Moreover, he made the most of his two years in Italy, and James Byres's[1] advice never to paint an object without having it before him must have fallen on soil already prepared. It is worthy of remark, also, that the influence of Van Dyck, whose art has been an enduring power in English portraiture, is far less noticeable in his work than in that of any of his great contemporaries. Lawrence, Hoppner, Romney, Gainsborough, Sir Joshua himself, are nearer the Fleming than Raeburn, whose vigorous, decisive, and direct handling and keen observation of reality are more kindred to Hals and Velasquez. The dash and brilliance of his brush-work in things like 'Sir John Sinclair' and 'Professor Robison' almost equals that of Hals, and the comparison with Velasquez, first made by Wilkie, is more justifiable than such comparisons usually are. If his expression lacks the elusive quality of modelling, the beauty and richness of impasto and handling, and the wonderful charm of atmospheric colouration of the Spanish master's, its later phases possess similar though less exquisite qualities of simplicity and directness, and convey even a fuller sensation of life. And, if John Burnet may be relied on, this resemblance was not wholly the result of inspiration, as Wilkie supposed, but was due in some measure to his having studied 'a single picture of Velasquez in the possession of the Earl of Lauderdale.'[2]

[1] James Byres (1734-1818 ?) of Tonley, Aberdeenshire, an architect and connoisseur resident in Rome, and Raeburn's most intimate acquaintance.

[2] No picture by Velasquez is now in the Lauderdale collection.

Fortunate in appearing when a splendid pictorial convention prevailed in English art, he used it, not slavishly, but in his own way, and in a manner that expressed the sane and manly view of the world which was his. He did not glory in beauty of design and splendour of colour as Reynolds did, nor did he possess the spontaneity of sentiment and the spirituelle quality which make Gainsborough's finest creations so fascinating. The range of pictorial effect and sentiment in his work is more restricted than that of either of these masters, and seems the product of a nature less rich on the emotional and imaginative side, while a certain austerity and a preference for the essentials rather than for the graces of style mark Raeburn as the Scot in this distinguished trio. But in sheer technical dexterity, in soundness of method, and in veracity of characterisation he surpasses both. His handling is broad and masterly, full of grip and character ; his drawing marked by a splendid sense of construction, which is adequately, if simply, expressed in the modelling of his earlier style, and very fully and subtly in that of his later ; and his colour, although not particularly fine and wanting in quality, is harmonious and belongs to a distinguished convention. Of course, he suffers from the defects of his qualities. When he is much below his best, which is not so rare as one would imagine from his great technical gift, his method is too apparent, and his paint and colour have that thin and rather poor look which often accompanies the *première coup* method, and gives the result an appearance of empty facility from which Raeburn's work, however, is usually saved by unerring grasp of character.

His style was eminently suited for rendering character in which grit and power, shrewdness and humour were present, and his pictures of men are amongst the most veracious and satisfying portraits in the world. Yet, trenchant and masculine though his method was, he was almost as successful in expressing the soft and alluring beauty of women as he was unfailing in catching the look of men. When compared with his male portraits, differences of character are less keenly discriminated, but here also he was less given to reproducing a conventional type than his English compeers, and, if his women rarely possess the dignity of Sir Joshua's, the graceful and pensive fascination of Gainsborough's, or the allure of Romney's, they have a truer and more individual existence. Nothing could well be more feminine and charming than ' Mrs. Vere of Stonebyres,' ' Miss Emily de Vismes,' ' Mrs. Scott Moncrieff,' or ' Mrs. M'Call ' ; and many of his portraits of older ladies, ' Mrs. Cruikshank of Langley Park,' ' Lady Abercromby,' ' Mrs. James Campbell,' and others are veritable triumphs of sympathetic characterisation. In portraits of children, however, he approached more nearly perhaps than elsewhere, a pictorial motive of the decorative or incidental kind, but at the same time he never failed to give character its due, or strayed far from actuality. While his art is marked to some extent by the fashion of his day and

he reduced the pictorial problems of portraiture to their simplest terms, he is one of the least conventional of the great British portrait-painters. He heired the sense of repose and dignity, the easy breadth of conception and design and treatment, which had marked English art during the latter part of the eighteenth century, to which the earlier part of his own career belonged, but he added a keener feeling for the play of light, a simpler and more direct method of expression, and a wonderful zest for individuality and type. And possession of these qualities connects his art with the modern developments of which it may be counted a precursor. To describe him, as Mr. Ricketts has done, as a parodist of Lawrence is to fail to grasp the essential quality of his gifts, and to show ignorance of the complete isolation from London and its exhibitions in which the Scottish master lived. How little communication even he had with the metropolis, which he visited only three times, may be gathered from a letter,[1] dated September 1819, four years after he was elected R.A. In it he beseeches, rather than asks, Wilkie to write to him at least once a year, because, for all he hears of what is going on, he might as well be at the Cape of Good Hope. Farther, he is anxious to know what is thought of the one or two pictures he sends annually to London as an advertisement that he is still in the land of the living, and not for any good they do him. No notice is ever taken of them in the London papers, the Scottish ones ignore such matters, and he would like to know what is said about them by his fellow-artists.

While the average portrait offends as much by vulgarity of handling as by commonness of seeing, and in the merely clever one cannot get at the person painted for the ostentatious dexterity of the painter, in those of a master point of view and handling rise together until, united and inseparable, they impress with redoubled force. It is to this fine kind of portraiture that Raeburn's belongs. To recall the Raeburns you have seen is to recall not so much a gallery of pictures as a number of people you have met personally, and this is due, of course, to the consummate art with which the painter expressed his own impressions of actuality. And the effect is heightened by the unconscious air of his sitters, who seem unaware that they are being looked at. His portraits are splendidly convincing—they capture at the first glance : you feel that that must be the man. At once authentic documents and valuable commentary, they are, to quote R. L. Stevenson, 'racier than many anecdotes and more complete than many a volume of sententious memoirs.' Moreover, they are great art. Few painters anywhere have balanced the claims of pictorial interest, technique, and characterisation so justly as he. His portraiture takes high rank, not only in the work of the British school, but amongst the finest achievements in a difficult and fascinating art.

[1] In the possession of Mr. Fairfax Murray.

Raeburn had lived and painted solely in Scotland, and for long his reputation remained little more than local. Forty years after his death his art was so little known south of Tweed that the Redgraves, in their *Century of Painters of the English School*, relegated him to a chapter headed 'The Contemporaries of Lawrence.' But time brings its revenge, and of late years Raeburn has taken a place in the very front rank of British painters, before all the contemporaries of Lawrence, before Lawrence himself. And the better his work has become known, the more it has been appreciated. Dealers are now alert, collectors at home and abroad are anxious to secure examples, and prices are rising steadily. His own prices were modest, and Lawrence thought them much too small. No definite record of what he charged is available, for his account-books and other business papers seem to have been lost or were destroyed shortly after his death, but I have been able to ascertain the sums paid for several, and the letters written in connection with some of these show that he was the very reverse of grasping. Taking these instances in chronological order, he had £18 in 1787 for the three-quarter-length (50 × 40) of the 2nd Lord President Dundas, while he received sixty guineas for the group of Sir John and Lady Clerk, painted some three years later. During the next few years he seems to have received considerably more, for in 1797, when suggesting thirty guineas for a portrait of Mr. David Anderson, he says, 'he has had no consideration of his present prices.' Then in 1804: as we learn from a letter written about the portrait of Burns painted 'from the original by Mr. Nasmyth' for Messrs. Cadel and Davies, his price for a head size (30 × 25) was twenty guineas, and that, as is evident from the following letter, had been increased to twenty-five by 1810: 'I return you my best thanks for the very handsome manner in which you have paid me for Mr. Bell's picture. You have enclosed 25 gs. I return you five of them, which I have no right to accept, my price having been raised since I painted that picture.' Portraits of Mr. and Mrs. Gordon of Aitkenhead, 50 × 40 canvases, give some indication of what he was receiving in 1818, but these particular pictures seem to have been paid for more handsomely than usual, for he wrote: 'To say that the Gentn of Glasgow pay like princes would be doing them the highest injustice, for they pay infinitely better than any of your very great folks that ever I had anything to do with. I have just had the pleasure of your letter covering a Bill on Messrs. Kinnear & Sons for £147, for which I beg you will accept my best thanks. With much esteem and many good wishes for yourself and family.'

In the following year, however, we find him in communication with Wilkie, whom he asks to ascertain what Lawrence—who he understands has recently raised his charges—Beechey, and others receive, not that he has any intention of levelling his prices with those of these distinguished London

artists, but so that he may have something to go by.[1] And perhaps we may trace the effect of these queries in the hundred guineas paid by the W.S. Society in 1822, for the 50 × 40 of Baron Hume, and the same sum paid to his trustees in November 1823 for two portraits, probably the busts of Mr. and Mrs. James Smith, by Mr. Smith of Jordanhill.

Although many of Raeburn's finest portraits remain in the possession of the families for whom they were painted, his art is seen to great advantage in his native city. The National Gallery of Scotland possesses a magnificent series, and the National Portrait Gallery, the Parliament Hall, the University, the Archers' Hall and Trinity House, Leith, contain fine examples. Those in the Glasgow, Dublin, and Dresden galleries are also good, but he is inadequately represented in the London public collections, and the three examples in the Louvre are of doubtful authenticity.

[1] In a letter written in 1820 he says : 'Your picture of Lord Polkemmet was done in March 1815, price 30 guineas. The same size done now would cost you 50, my price having been raised two or three times since then.'

CHAPTER III

RAEBURN'S CONTEMPORARIES AND SUCCESSORS

PREVIOUS to Raeburn's advent, Scottish portrait-painting had for the most part been conventional in manner and restricted in outlook. Here and there a man between Jamesone and Allan Ramsay had possessed artistic characteristics, which raised him above his fellows, and which give his work enduring interest ; but Raeburn's art, with its grasp of reality, vitality of expression, and pictorial distinction, was a source of inspiration, and the soberly handsome, if sometimes rather heavy, appearance of much succeeding Scottish portraiture is due in large measure to his example. At the same time, while owing him much, the best of his contemporaries and successors were less disciples than independent workers in a similar spirit. None of them equalled him as a painter or approached him in certain pictorial qualities, and none generalised the national type while preserving individual character as he had done ; but in their several manners they were good craftsmen, and their rendering of character and type, if less brilliant, was in some ways more intimate and analytical. Their work, simple in statement and design, and sincere in characterisation, may be said to mark progression in the movement from the conventional to the individual in portraiture inaugurated by Raeburn. Yet, admirable as much of it is, the impression left by the bulk of the portraiture of this period is that its authors were too often craftsmen exercising their considerable skill in likeness-making rather than artists interested in the pictorial possibilities of portrait-painting.

Of Raeburn's immediate contemporaries, George Watson (1767-1837), the first President of the Scottish Academy, bulked most in the public eye. The son of a landed proprietor in Berwickshire, he received some instruction from Alexander Nasmyth, and, at the age of eighteen, entered the studio of Sir Joshua Reynolds, where he remained two years. Settling in Edinburgh, he soon made a good position as a portrait-painter, and in his later years, it is said, even maintained an honourable rivalry with Raeburn. He had caught something of richness and breadth from his experience with Reynolds, and signs of his pupilship are forthcoming in such pictures as the pleasing canvas of four children's heads emerging from clouds, until recently in the possession of his family ; but, on the whole, his designs are wanting in inventiveness and style, and his handling, while solid, able, and

workmanlike, has little refinement or subtlety. Possessed of considerable appreciation of character, his statement often erred in over-emphasising peculiarities and sometimes verged, if it did not actually trespass, upon caricature. At his best, however, as in the sober and expressive head of himself, or the 'Benjamin West, *P.R.A.*' (1821), in the National Gallery of Scotland, or the half-length of 'Lang Sandy Wood,' which was etched by Kay, he not only escaped this tendency, but attained a degree of dignity in character and placing which, in combination with the reticence which belonged to the current convention, would make his better things look distinguished and sincere if hung beside much modern work. Belonging to the same period, and representing people of the same country and often of the same class, there is so much superficial resemblance, in build, lighting, tone, and even handling, between his work and Raeburn's, that the unscrupulous will some day pass off the best of his portraits upon the unwary as examples of the greater painter. In reality, however, there is little real resemblance. Watson's handling is heavier, the brush-strokes have not the cleanness and sureness and swiftness, the tone is duller and less transparent, and the colour is commoner and browner, while the grasp of character is less searching and masterly. Still, judged on its own merits, George Watson's portraiture is workmanlike and worthy of respect, and, quite apart from his labours on behalf of the infant Academy, entitles him to remembrance. Watson, who had been associated with the Society of Artists which organised exhibitions in Edinburgh between 1808 and 1813, took a prominent part in the steps which led to the formation of the Scottish Academy in 1826, and, being elected its first President, held office until his death, which took place in Edinburgh in 1837, a few months before the Academy received a Royal Charter.

The work of Sir John Watson Gordon[1] (1788-1864) was of greater excellence, and in some respects his finest portraits approach Raeburn's in merit. A son of Captain Watson, R.N., he was educated for the Royal Engineers, but while studying drawing at the Trustees' Academy, where he met Wilkie, determined to become an artist. This training under John Graham was supplemented by hints from his uncle, George Watson, and from Raeburn, who was a friend of the family, and Watson Gordon never studied abroad. At the commencement of his career he painted a number of historical and fancy subjects ; but, of little interest in themselves, they are quite overshadowed by his success in portraiture. Amusingly pretentious and of large size, they suggest a young actor who imagines he can play a leading part without experience. Yet, if juvenile in some respects, the 'Lay of the Last Minstrel,' painted when he was twenty, and other pictures of that period contain passages of fine and sound technique, which foreshadow in character that which he subsequently

[1] He was one of the Watsons of Overmains, Berwickshire, but as there were four portrait-painters of the name in Edinburgh, he added that of Gordon in 1826.

attained, and it was not long before he discovered his gift as a portrait-painter.

Edinburgh still maintained its character as a capital city, its literary glory was not yet past, its society still possessed distinctive qualities and was the centre of Scottish social life; and on Raeburn's death Watson Gordon stepped into the place he had filled and carried on the series of famous Scots begun by him. Although less brilliantly handled and scientifically constructed, many of his earlier portraits show clear trace of Raeburn's influence in arrangement, pitch, and even in colour, which was sometimes cool and silvery, as in 'Lady Nairne' (*circa* 1815: ·Scottish National Portrait Gallery), and sometimes warm and glowing, as in 'Dr. Andrew Duncan' (1825 : Royal Medical Society, Edinburgh).[1] In others the technique and style are reminiscent of his uncle's, and occasionally one comes upon an essay which shows that he had been looking at Romney or Reynolds. Gradually, however, he evolved a highly personal and distinctive manner, and some of the pictures painted in the thirties, the admirable full-length of 'John Taylor' golfing, the 'James Hogg,' which hangs in the 'Old Saloon' in George Street, with portraits of others who helped to make *Maga* famous, the 'General Sir Alexander Hope' in Linlithgow County Hall, and the finely statuesque 'Lord President Hope' in the W.S. Library, to name no more, are fine achievements and thoroughly characteristic of his gifts. In the best efforts of later years, his colour, which until well on in his career had been rich and varied, though low in tone, became a pleasing, if austere, harmony of pearly greys and blacks (when he missed it was apt to be leaden), with sometimes, but rarely, a warm background; his brush-work, in his earlier days over slippery and thin, became more expressive, at once vigorous and delicate, caressing and descriptive in the way the details were handled and the features modelled, powerful and broad as regards the greater masses; and everything in his arrangements was subordinated to the head, on which the principal light was concentrated. At a time when Velasquez was much less admired and understood than now, Watson Gordon considered him the greatest of portrait-painters, and, when he himself had done something more than usually good, he would ask his friends if they thought Velasquez could have done very much better. And in their subtle silvery tone and restrained and atmospheric colour the best pictures of his latest period have a likeness to the Spaniard's that those of Raeburn do not possess. Compared with that of Raeburn, his actual handling, however, lacks that absolute mastery which gives the elder artist's work such brilliance and spontaneity. At the same time the intimacy of his modelling is apt to mislead one as to the amount of labour by which it was attained. In reality he was a very direct worker. The sketch (1830) of Sir Walter

[1] This full-length, which was painted specially for the Royal Medical Society in 1825, was exhibited in the 1884 Exhibition of Scottish National Portraits as by Raeburn.

Scott in the Scottish Portrait Gallery, from which he painted several other portraits, is an example of what he could do in one painting, and for one of his finest pictures—the three-quarter-length for which David Cox[1] came to Edinburgh to sit—he had but five sittings.

In Watson Gordon's portraitures the personality of the painter is present in very pleasant degree, neither unduly prominent nor too much suppressed. And his was a nature which usually saw the best side of character and looked upon the foibles and failings of men in a genial spirit. Keenly appreciative of intellect and shrewdness, it was with heads in which these qualities predominated that he succeeded most fully. A born painter of men, the allure and charm of women almost invariably eluded him, and the animation and abandon of childhood became lifeless and petrified under his brush. It was seldom that he approached the three-quarter-length of the lady in white satin, which represents this phase of his art in the National collection, in grace of design and charm of sentiment. Nor did he ever attain the distinction of style of his great predecessor. His full-lengths specially are seldom satisfactory. They are frequently empty and purpose-less. The spacing lacks style, the forms are often a trifle mean, and the relation between figure and background is not infrequently wrong in scale.[2] But while beauty and distinction were rather beyond him, his rendering of masculine character was marked by great insight, subtly and strongly expressed. Some of his portraits of men can scarcely be surpassed in this respect, and when wedded to a happy design, as in many of his busts and three-quarter-lengths, the result is admirable. In these the background is usually exceedingly simple, often little more than a warm grey umber tinting. Few more exquisite pieces of craftsmanship and colour than the 'James Smith of Jordanhill, F.R.S.' have been produced by Scottish painters; and more intimately expressive portraits than the 'Henry Houldsworth of Coltness,' the 'Roderick Gray, Provost of Peterhead' (1854: first-class medal in Paris, 1855), and the 'David Cox' (1855) would be difficult to find anywhere. Notwithstanding his limitations, which are clearly enough marked, he was the most gifted of all the immediate successors of the great period of British portraiture, and within his range he did much excellent work. In the hands of Lawrence accessories and millinery, as if to compensate for weightier qualities, had commenced to assume undue prominence, but Watson Gordon handed on the simple and noble tradition as he had received it. His portraiture, whatever it lacks in brilliance, is simple, sincere, and, at its best, gravely beautiful. Nor was his example without effect in England. On returning from a visit to London, he was heard to complain that 'the fellows up there were copying his backgrounds.'

He was elected an associate of the Royal Academy in 1841 and a

[1] In the Birmingham Gallery.
[2] Several portraits in the Queen Street Gallery illustrate this.

full member ten years later, while in 1850 he was selected to fill the presidential chair of the Royal Scottish Academy and appointed Her Majesty's Limner for Scotland.

Unlike Watson Gordon, Andrew Geddes (1783-1844) paid several visits to the Continent, and the effect of this is evident in his art. A devoted student of the Old Masters, he made many fine copies of their pictures and 'pasticcio compositions'[1] in their styles. It was somewhat late in life, however, before he was able to devote himself to painting. Systematic study did not begin until he entered the schools of the Royal Academy at the age of twenty-three. Student days over, he returned to Edinburgh, his native city, where he practised intermittently for some years; but by 1823, when Andrew Wilson wrote urging him to come north to fill the place left vacant by Raeburn, he had settled definitely in London, and in 1832, a few years after a prolonged stay in Italy, he was elected A.R.A.

His earliest exhibited picture was a 'St John in the Wilderness' (R.A. 1806), and it was followed by a few genre pieces such as the 'Draught Players' (1810: Mr. A. N. G. Aitken, Edinburgh), of a Wilkie-like character, though fuller in local colour; while after his visit to Paris with John Burnet, the engraver, in 1814, when the Louvre was filled with the art treasures of which Napoleon had spoiled Europe, he painted an altar-piece for a London church (St. James's, Garlick Hill) in which Venetian influence is said to be evident. From the indifferent light in which it hangs, one cannot express a decided opinion as to the details of this picture, but the general effect is certainly distinguished. If the design is influenced obviously by the great 'Assumption of the Virgin,' now in the Academia at Venice—it has, however, more coherence and unity of design than that famous work—the tone and scale of colour are more reminiscent of Van Dyck than Titian. Later in life Geddes painted another religious picture of some importance, 'Christ and the Woman of Samaria' (1841), which I have not seen, and about 1820 a large picture of the 'Discovery of the Scottish Regalia,' which was ruined by neglect and now exists no more. His chief successes, however, were in portraiture. For some years after 1814 the cabinet full-length was a favourite with him, and he treated that somewhat trying type of portrait very charmingly indeed. Those of 'Andrew Plimer' (1815: National Gallery of Scotland), 'Sir David Wilkie, R.A.' (1815: Earl of Camperdown), and 'Sicily Brydone' (Earl of Minto), and of Edward Terry and his wife in the picture called 'Dull Readings' in the Scottish Gallery, are delightful pieces of their kind; and the genre spirit in which they are conceived, the sitter being

[1] Seven sketches 'painted in the National Museum at Paris in 1814' (after Titian, Correggio, Rubens, and Jordaens) 'were selected as useful studies in exemplifying the principles of the different great masters of the schools celebrated for effect and colour,' and shown in Geddes's exhibition in Edinburgh in 1821. The same exhibition included pasticcios in the styles of Giorgione, Rembrandt, Metzu, Terburg, and Watteau.

placed amid his everyday surroundings, gives them an intimacy in which more ambitious and monumental portraiture is often deficient. His work in this vein has been compared with that of Terburg and Metzu, and almost merits the compliment. It unites charming precision of touch with beautiful paint quality, and elaborate detail with fine feeling for ensemble.

Yet admirable as his cabinet portraits are, they are inferior to the best of his work on a larger scale. As early as 1813 he proved his capacity to handle a life-size portrait in the beautiful bust of his mother, so well known from his etching of nine years later ; but charming as that picture is in conception and colour, its actual handling is tentative and hesitating, and it is in the powerful and expressive head of Sir Walter Scott (about 1818 : Scottish National Portrait Gallery), the delicately felt and handled bust of Skirving the artist in his old age (Mr. A. S. Skirving, C.M.G., Edinburgh), and the gay and brilliant 'Summer' (1828)—a portrait of Miss Charlotte Nasmyth—in the National Gallery on the Mound that he is seen at his very best. Suggested as 'Summer' obviously is by Rubens's 'Chapeau de Paille'[1] (now in the National Gallery, London, but then only recently acquired by Sir Robert Peel), it differs from that not only in type of feminine beauty, but in colour and the way in which the problem has been solved. Combining suavity with sparkle and intimacy with distinction, Geddes has justified the reminiscence by the different and personal use made of it. Less brilliant and masterly in execution and drawing than the Rubens, and less vivacious in conception, the Geddes is lovelier in colour and is fragrant with a rarer kind of beauty. The portrait of Scott, on the other hand, is altogether his own. Handled broadly and with power, rich in colour and simple and dignified in design, it is at once admirable as a picture and convincing as a character study. In the higher qualities of art it is one of the finest things of the period to which it belongs. Still finer in accomplishment and more intimate in character is the three-quarter-length of William Anderson (Mr. W. Davidson), which was one of the surprises of the Scottish National Exhibition. The combined virility and subtlety of the expressive brush-work in that picture, the broad yet selected modelling and restrained and beautiful colour, and the manner of its conception, so entirely free from formula, proclaim an indubitable masterpiece. Compared with this wonderful evocation of life, won by such subtle art, even the finest achievements of Raeburn seem mannered and perfunctory. Probably Geddes never again touched the level he here attained, but in virtue of the 'William Anderson' alone he challenges the supremacy of his older and more famous contemporary.

In these and other pictures Andrew Geddes shows real feeling for his medium, and handles paint with a true sense of its material charm. Specially happy in transitions, his colour possesses richness, range, volume, and

[1] The writer has in his possession two small pastel studies by Geddes connected with this picture: one is of the Rubens, the other a sketch for Geddes's own picture.

quality, and, whether grave or gay, he saw his colour motive simply and in its fused and broad relationships. His drawing also, if not above reproach, has a refinement and an air of distinction, which much more correct draughtsmanship frequently lacks. Moreover, he designed simply and well, and his characterisation is at once searching and tender. If a less assured craftsman and biographer than Raeburn, less brilliant and elegant in design and drawing than Lawrence and Watson Gordon's inferior in grasp of character and simplicity of tone, Geddes had yet finer taste and a keener and purer sense of beauty than any of his contemporaries. The formula which tends to become an obsession with most portrait-painters, and is indeed all but inevitable when a man has a large practice, he escaped through constant study of the problems of light and shade and colour, and through an enduring and cultivated interest in the pictorial effects of the masters. Each of his finer portraits, whether cabinet or life-size, is carefully thought out and designed as a picture, and this, united to his instinct for colour and refinement of feeling, gives almost everything Geddes did definite charm.

His enthusiasm for art had been awakened early by a collection of prints his father had made, and some of the best and most individual work he did himself was with the etching needle. His etched portraiture in particular is remarkably spirited and incisive. As a rule the figure makes a charming pattern upon the plate, and the whole is designed with a spirit and refinement and a sense of style which recall Van Dyck. But at other times, as in the etching of his mother's portrait, he used the needle to produce effects which in richness and fullness resemble Rembrandt's. Usually small in size, his plates were often executed in dry-point ; and sometimes he used a simple tint to tone and enrich important passages, from which the high lights stand out with delightful crispness. In addition to portraits he etched some fancy pieces (the little girl with a pear is charming) and a few fine landscapes. That showing 'The Field of Bannockburn,' a moorland with a range of hills in the distance, is beautiful in composition and in the expressiveness of its lines, while another of a cottage beneath trees is fuller in tone and in other ways almost as good. Wilkie and Geddes may be said to have been the precursors of the modern revival of the 'painter-etcher' which has come with Seymour Haden and Whistler.

While Watson and Watson Gordon and several others of less import-ance were busy in Edinburgh, John Graham Gilbert (1794-1866) was engaged in painting the magnates of the western capital. His father, David Graham, a rich Glasgow merchant, was strongly opposed to his being an artist, and for a number of years young Graham was engaged in business. At length, at the age of twenty-four, he secured his liberty, and, entering the schools of the Royal Academy, at once took a good place, and at the end of three years won the gold medal for historical composition.

From 1820 to 1823 he practised in London, exhibiting portraits and fancy subjects at the Academy, and then, after a stay of two years in Italy, which left an enduring impression on his art, he returned to Scotland. Settling in Edinburgh in 1827, he became an artist-associate of the Royal Institution, but, seceding with the others, joined the Academy with the rank of Academician in 1829. Meanwhile his family connections had brought him numerous commissions from the west, and in 1834, having, like Raeburn, married one of his sitters, he removed to Glasgow, where the rest of his career was spent. Miss Gilbert of Yorkhill was an heiress, and, when she succeeded to the estates in 1838, he added her name to his own. For some time thereafter his name does not figure in the catalogues, and he seems to have been a good deal abroad. Nor, except now and then, did he paint quite so well after this access of fortune. Yet his devotion to art remained unabated. He formed a collection of Old Masters,[1] including two noble Rembrandts once in Reynolds's possession ; he used his influence to promote the cause of art in Glasgow, acting as President of the West of Scotland Academy (1840-53), and helping to form the Art Institute in 1861 ; and, despite other interests, he painted many portraits and fancy figure subjects. Latterly his prominence socially and in art circles was such that, although resident in Glasgow, he only missed election (1864) as President of the Royal Scottish Academy by the casting vote of the chairman.

Graham Gilbert's most notable work was done in portraiture, but his personal inclination seems to have been for subject, and throughout his career there were few years that did not see him produce several subject pictures. Influenced by what he had seen in Italy and by the opportunity such themes give for rich colour schemes, some of these were sacred in kind; but, apart from subject, ' St. Sebastian,' ' Christ and the Woman of Samaria,' ' Christ appearing to Mary Magdalen' (all in the Glasgow Gallery) and the rest have little that is religious about them ; and the quality of his talent, which was sensuous and decorative rather than imaginative and significant, found far happier expression in simple studies of womanly loveliness. Occasionally, as in ' The Love Letter' (1829 : Lord Kingsborough), a picture which, though less exquisite in colour and handling, challenges comparison with Geddes's ' Summer' in delicate management of luminous shadow and in refinement of feeling, he combined interest of incident and of pictorial motive with charm of subjective material ; but, for the most part, his pictures of Roman ladies and Scottish peasant-girls and gipsies are rather motiveless, and possess little emotional appeal. Still, deficient in significance as they often are, these studies of fair women are obviously enough the work of a man of fine taste and artistic culture. Working as he did, surrounded by casts of ' the most

[1] Mrs. Graham Gilbert bequeathed this collection and many of her husband's works to the Glasgow Gallery in 1877.

beautiful heads of antiquity,' and, like Wilkie, often with an Old Master beside him, his faces, if inclined to be somewhat expressionless, are frequently marked by a certain serene beauty, and the simplicity of his designs and the richness of his colour schemes often remind one of his favourite Venetians.[1] In portraiture, on the other hand, while influenced æsthetically by similar ideals, he revealed considerable grasp of character. This combination of qualities is seen at its best, perhaps, in some of his portraits of men, notably in the vivacious and vitally characterised and admirably designed and painted 'James Hamilton' (1826) and the intimately conceived and subtly characterised 'John Gibson, R.A.' (1847), in the Glasgow and Edinburgh galleries respectively ; but if these mark the high-water of his achievement as a portrait-painter, it is rather to his female portraiture that he owes his reputation. While his average portraits of men lack the intimacy and shrewd insight of Watson Gordon's, and his pictures of both men and women the mastery and convincing quality of Raeburn's, his portrayal of ladies is marked by a more active sense of feminine charm and by greater grace of pose and design. None of his immediate contemporaries, at least, ever equalled the full-length of a lady in white in the Glasgow collection in these respects, and such things as 'Miss Oswald of Scotstoun' (Mr. Oswald) or 'The Countess of Southampton' (Colonel Gordon Gilmour) combine charm and dignity in a manner quite his own. As a rule, however, his art is pleasing rather than satisfying. The admirably ordered and balanced ensemble, touched with beauty as it occasionally is, of his finer things even, is insufficiently supported by the more virile qualities of craftsmanship. His drawing, while facile and good enough to be pleasing, was neither stylish nor learned ; his modelling, if suave and tender, was lacking in a sense of construction ; and his actual handling of paint was deficient in gusto and expressiveness. But he had good taste, an instinct for beauty, whether subjective or pictorial, and the grace and refinement of his best pictures ensure him a definite place amongst the Scottish painters of his time, who were none too well endowed with these commendable qualities.

Daniel Macnee (b. 1806) had divided the suffrages of the west with Graham Gilbert, but from the death of the latter until the removal of the former to Edinburgh, on being elected President of the Royal Scottish Academy, he reigned alone. But as Sir Daniel lived until 1882, his art, with that of his contemporary, Sir Francis Grant (1803-78), the President of the Royal Academy, finds more appropriate place in a later chapter. Nor need the occasional portraits of Duncan and Dyce, Scott Lauder and Sir George Harvey be analysed here. Portraiture was but a part of their artistic activities, and their achievement in that sphere will be considered with their art as a whole.

[1] In addition to the cabinet of Old Masters which he had formed, he had made many copies of famous pictures.

It is otherwise with Colvin Smith, John Syme, and some others. Not only do they belong to the period, but, being wholly or chiefly portrait-painters, their work bears more obviously than that of their betters the impress of the aims then dominating portraiture. They had neither the skill nor the taste necessary to give pleasing or convincing expression to the instinctive interest in character which underlay all Scottish portrait-painting during the first half of last century, and their portraiture was little better than more or less competent likeness-making. Therefore no purpose would be served by describing or criticising it at length. Here and there we owe them gratitude for a likeness of some man or woman of note of whose appearance we had otherwise had no record, but the art of most of them possesses no fine or even very personal qualities of colour, technique, draughtsmanship, or design. The pictorial convention in which they wrought is of more interest, for it gave what they did something of a school-like character. Broadly considered, it was dominated by Raeburn's example, modified by the more realistic spirit introduced by Watson Gordon. But the simplicity of this convention, and still more the close relationship to nature which it involved, demanded more talent than they possessed ; and, uninformed by novel insight or fastidious taste, their treatment was bald, literal, and without emotional appeal.

Colvin Smith (1795-1875) was probably the most accomplished of these minor men, and in his day he was looked upon as of considerable importance. Belonging to a good family he had every opportunity of learning his craft, and study in the schools of the Royal Academy was followed by a sojourn in Italy. Nor had he to wait long for a practice. His faculty of likeness-making and his personal connections soon brought many sitters to Raeburn's old studio, in which he had set up his easel in 1827. But his talent was neither original nor assimilative, and his portraiture seldom rises above competent commonplace. While he drew correctly, had a certain appreciation of character, and arranged his pictures simply, his handling was heavy and dull, his impasto often patchy and without charm, and his colour, usually subordinated to the black and white design, either leaden and uninteresting or, when warmer in tone, hot and brown. At times, however, he did admirable work in the Raeburn manner, and not infrequently he designed a full-length with considerable dignity and excellent feeling for the relationship, in character and scale, of figure and background. An artist-associate of the Royal Institution, he became a Scottish Academician at the union of 1829, and was for many years a constant and prolific exhibitor at the Academy.

Samuel Mackenzie and John Syme were more directly connected with Raeburn. Born at Cromarty, Mackenzie (1785-1847), who, like his famous townsman, Hugh Miller, had been a stonemason in his youth, came to Edinburgh to work at his trade, but eventually, greatly encouraged by Raeburn, who gave him the run of his studio and the benefit of his

advice, became a portrait-painter of some skill. His work bears clear traces of this pupilship, and no doubt some of it now passes under the greater artist's name.[1] It is designed on similar lines, has the light and shade arranged in a similar simple and effective way, and, although browner in colour, is modelled on his as regards relief and tone relationship. But the handling is deficient in certainty and spontaneity, the designs are lacking in real significance, and the expression of character is usually superficial and without force. He seems to have been well employed, specially in the northern and the Border districts, which he visited periodically and where the influence of the Dukes of Gordon and Roxburghe brought him many sitters; and in 1829 he was elected to the Scottish Academy. Syme's (1791-1861) portraiture possessed greater grit. Somewhat hard and grim, and what Louis Stevenson, writing of his grandfather's portrait (now in the Scottish National Portrait Gallery), describes as 'constipated,' it has at times, as in the half-length of Professor Barclay, the clerical anatomist, in the National Gallery, considerable decision of character. In that and other portraits of a similar kind, the observation, if deficient in subtlety, is sincere, and the drawing and modelling, while lacking grace and fullness, express the salient characteristics of the sitter with commendable simplicity and directness. But most of Syme's portraits, and more notably perhaps his more ambitious efforts, such as an equestrian full-length at Pinkie, are more obviously founded on Raeburn in tone and handling. It is, however, rather through his connection with Raeburn than on its own account that his work possesses a certain degree of interest. To some extent a pupil of that artist, and later his assistant—the only one he is known to have had— Syme's share in any Raeburn worthy of the name must have been infinitesimal, and it was probably only in sideways or on replicas, some of which are obviously merely studio pieces, that he was employed. Yet some of his own work is very Raeburnesque in style,—he completed the portraits left unfinished by his master,—and for some years after Raeburn's death he had a considerable practice, and painted a number of people of importance. He was a foundation member of the Scottish Academy, of which he claimed to have been the originator.

The oil-portraits of William Nicholson (1784-1844), another original member of the Academy, and one to whom that body owed much during its early years when he acted as Secretary, may be bracketed with those of these men. A native of Newcastle, he spent the last twenty-five years of his professional life in Edinburgh, and came under the influence of the prevailing Scottish convention, which, however, he used without distinction or any special power. But while his work in oil possesses little merit,

[1] On one occasion he made such a good copy of one of Raeburn's portraits that Raeburn said, 'Well, Mackenzie, you can take yours aside now —I don't know which is mine and which is the other.'

being hard and surfacy in quality, his portrait-drawings are often charming. They are not elaborate pictures in water-colour, but delicate drawings daintily tinted with colour. It was a *métier* which he understood, and fortunately for him it was appreciated by the public. His miniatures were also in great favour, and he etched a series of portraits of Scottish notabilities which, although of no great merit, had a very cordial reception.

To describe the work of Thomas Fraser, who flourished about 1830 and died in 1851; James Tannock (1784-1863), a Kilmarnock shoemaker who developed into a metropolitan artist and a frequent exhibitor at the Royal Academy; W. Smellie Watson, R.S.A. (1796-1874), a son of the President; the north-country portrait-painter, John Moir (1775 ?-1857); or of half a dozen others would be to repeat, with variations and rather less commendation, what has been said of Mackenzie or Syme or Nicholson. They wrought in the manner of their time, but, for the most part, were tradesmen rather than artists. William Crabb (1811-76) is a possible exception, for he is said to have 'ranked high in the opinion of his contemporaries, and to have painted numerous portraits very similar in style, and sometimes almost equal in quality, to those of Raeburn,'[1] but, having no first-hand acquaintance with his art, I can offer no opinion as to its merits. And in his own modest way William Yellowlees (1796-1856 ?) occupied a place apart. His small portraits were so spirited and decided in touch, so broad in treatment, and so full of character as to earn him the not inappropriate name of 'Raeburn in little.' Little larger than minia-tures, they are distinguished by a fullness and richness of impasto and a beauty of colour one does not usually associate with oil-painting on such a small scale.

In pure miniature Andrew Robertson (1777 ?-1845), a native of Aberdeen, occupied a very prominent place in the beginning of the century. After studying with Alexander Nasmyth, he worked for a time at home and then found his way to London (it is said he walked), where he was fortunate in arousing the interest of Benjamin West (1738-1820), P.R.A., who gave him sittings for a portrait which attracted great atten-tion. Thus began a highly successful career, for as Cosway and his con-temporaries aged, Robertson moved to the front, and in time became the fashion with society. His style differed from that of Smart (1741 ?-1811), Cosway (1740-1821), and Edridge (1768-1821), possessing greater veracity and directness, but missing the grace and charm which give their miniatures a value quite apart from the interest or beauty of their subjects. Still he drew correctly, finished with elaboration, and secured a good likeness, and, save for the occasional introduction of ungraded masses of pure colour, his work, always that of a craftsman, has an interest of its own. Of his many pupils Sir William Charles Ross (1794-1860), born in London of Scottish

[1] Brydall's *History of Art in Scotland.*

parents, was the most distinguished. It was not until after a highly successful career as an Academy student, during which he gained five medals, that he became connected with Robertson in the capacity more perhaps of assistant than pupil. He had a hankering after historical composition, but his real talent was for miniature, in which he soon made a great reputation. Among his sitters were Queen Victoria and many members of the Royal Family, and in the same year (1839) as he was elected an R.A. he was knighted. His design and handling show refinement, taste, and skill, and he was not deficient in a sense of character. In some respects his style was modelled on Reynolds, and almost invariably he painted on ivory.

Contemporary with Robertson was George Sanders (1774-1846), a Fifer by birth, who, although he did not go to London until over thirty years of age, soon made a highly fashionable connection. He received large prices—from eighty to one hundred guineas—for his miniatures, and later, when he turned to full-size portraiture in oils, he charged proportionately. But while his miniatures possess considerable delicacy both of colour and execution, his oil-portraits are coloury, crude, and pretentious.

In his own special line Anthony Stewart (1773-1846) was for some time almost as much in vogue. He excelled as a painter of children, and, having been brought to the notice of the court, was commissioned to paint a miniature of the Princess Victoria when she was only a year old. This was the forerunner of other royal commands—he painted the same little lady several years in succession—and during the latter part of his career his practice was almost confined to painting the children of the nobility. A native of Crieff, he owed his artistic training to the daughters of General Campbell of Monzie, who paid the expenses of his apprenticeship with Alexander Nasmyth, and it was as a painter of landscape, more in the style of Richard Wilson than of his master, that he was best known before going to London. Like Sanders, he was the subject of one of Geddes's portraits.

Robert Thorburn (1818-85), another Scot, who worked somewhat later in London with much success, lived to see the miniaturist's art a thing of the past. For many years he divided aristocratic patronage with Sir William Ross, and the full-lengths, on a larger scale than was usual in miniature, which were his speciality, are marked by considerable grace and even dignity. His colour was fresh, his compositions agreeable, his handling delicate and very detailed. On the introduction of photography he turned to portraiture in oils, but failed to retain in it the qualities which had made his miniatures pleasing. His work, however, is not of the character which stands the test of time.

In Scotland the chief practitioner of the art was W. J. Thomson, R.S.A. (1771-1845). Characterised by strong and brilliant colour, full tone and careful finish, his miniatures, like those by Thorburn, had little of the

grace which belongs to the more selective and conventional manner of the English masters, and were indeed ordinary portraits on a small scale.

The tinted drawings in water-colour which were also in fashion yielded happier results, and the portraits of William Nicholson, William Douglas, and Kenneth M'Leay in that style possess distinct merit and considerable charm. Of Nicholson's I have already written, and those of the others deserve notice also. Douglas (1780-1832) was considerably the older, and his drawings must have been in request, for they are to be found in many Scottish houses. The small cabinet full-lengths, which are his most characteristic works, are easily, if rather emptily, drawn and modelled, and are not infrequently pleasing in design and delicate in colour. When painting a group it was his usual practice to relate the figures by the introduction of some simple incident, such as petting a dog or admiring a horse, and most of his drawings have sketchily treated landscape back-grounds. M'Leay (1802-78), combining accomplishment and style with taste and fine feeling, was an artist of a higher order. Unfortunately for his reputation, however, the drawings of Highlanders, by which he is best known—they were very indifferently reproduced in lithography—give little indication of what he was capable, and his fame has been further obscured by a popular inclination to credit, or discredit, him with the cast-iron Highland landscapes painted by his brother, M'Neil M'Leay. But his portrait-drawings and fancy studies are always capable and often beautiful. He was a good draughtsman and an excellent colourist, and, handling his medium with delicate certainty, his work possesses that subtle bloom and play of tint which belong to water-colour only, and only to water-colour when used with understanding of its limitations and possibilities. Moreover, his sense of construction was real, and gave distinction and clarity to the abstract convention in which most of his portraiture is wrought. For imitation was no part of this limited, but charming, 'little' master's creed. His drawings, in which the head and bust are usually treated in broad washes enriched with stipple to accentuate the more delicate passages of modelling, and the figure and accessories are indicated by refined pencilling faintly tinted, are essentially selective in character, and epitomise rather than elaborate the qualities in his sitters which interested him. In its own way nothing could well be more delightful than the best of his work, and that portraiture of this type has not remained fashionable, or has not been revived, is a distinct loss to those who cannot afford to employ the best portrait-artists, or in whose houses life-size oil-portraits, however good, cannot be placed or seen to advantage.

The development of photography some fifty years ago brought minia-ture-painting to an end. Its later practitioners having been too apt to treat it as mere likeness-making on a small scale, it had lost the charm and grace it had possessed when treated as an independent convention,

when, without attempting to rival the completeness of work on a larger scale and in a more powerful medium, the artist had been content, while aiming at likeness, to make a graceful approximation to the actual colour of nature, and had employed the beauty of parchment or ivory to influence the result. But photography could do almost as much as the later miniaturists and at much less cost, and so miniature fell at the first assault. It, however, was not the only branch of art affected, for, while the camera did not extinguish the ordinary portrait as it had the miniature, the results obtained by its use influenced portrait-painters and indeed all artists profoundly. In Scotland, it is true, the advent of photography was marked by the appearance of many remarkable and highly artistic calotypes by D. O. Hill, R.S.A. (1802-70), the landscape-painter, but popular favour soon produced a crowd of tasteless trade-photographers, and scientific advance—improvement in lenses, plates, and printing processes—issued in the attainment of an excessively detailed and attractively superficial kind of realism which for years exercised a deadening influence upon certain phases of painting.

CHAPTER IV

DOMESTIC GENRE : WILKIE AND HIS FOLLOWING

THE religious, political, and social condition of a country has a direct bearing upon its art. It was the commanding influence and general tendencies of the Roman Church, varied by local considerations as in Venice and Siena, and, in lesser degree, the fondness for display of the splendour-loving princes and grand seigneurs of the Renaissance, which determined the character and influenced the development of the Italian schools ; the patronage of Francis I. and his successors gave the art of France characteristics which, modified and democratised by political changes, still retain some elements of aristocratic birth; and the social and religious circumstances of the Dutch burghers, freed from foreign oppression and at liberty to pursue their own ideals, produced the simple and realistic painting of Holland. And in Scotland, as I have attempted to show, the conditions of life from after the Reformation until little more than a hundred years ago were such that all pictorial art except portraiture was wellnigh impossible. But towards the close of the eighteenth century a more favourable state of affairs commenced to obtain, and with the advent of the nineteenth painting blossomed. Unconnected with and unpatronised by either Church or State, as had been the case in Holland, the art which then grew up in Scotland was, like that of the seventeenth-century Dutchmen, a spontaneous expression of national sentiment. The influences at work and the atmosphere of the time having been described and analysed in a preceding chapter, here one need only repeat that they were national and democratic, and that it was in the life around them, and in the passions and feelings of ordinary men, that Scottish painters found material for their art when they first turned their attention to the subject picture. It was not long, however, before the romantic impulse which accompanied the appearance of the Waverley Novels made itself felt, and soon pictures from Scottish history and legend became as popular as those of domestic and social incident.

In the drawings and illustrations of David Allan's later years we have the beginning of the Scottish domestic picture, but it was not until David Wilkie appeared that the new material took the form of art ; and while Alexander Runciman had ventured upon historical subject, his work is touched with the blight of 'High Art,' and it was left. to William Allan to give it basis in reality. They came at a fortunate moment. The

quickened national and social sentiment, which had already found expression in Burns and Scott, and had in turn been stimulated by them, was ripe for pictorial outlet also ; and the appointment of John Graham as master of the Trustees' Academy and the reforms introduced by him, affording better and completer means of technical training than had existed in Scotland before, made it possible for an artist to learn his craft at home, and so enabled him to develop free from the irresistible pressure exerted by alien ideals upon a young painter studying alone in foreign schools.

Although he only lives in the reflected glory of his pupils, Sir David Wilkie, Sir John Watson Gordon, and Sir William Allan, John Graham (1754-1817) was an artist of considerable ability, and had his attention not been divided between his pupils and his pictures, he might have done much more than he did. As it is, his work possesses merit ; his handling is broad and not wanting in grip and power, and his colour, although sombre, is usually harmonious. He was a native of Edinburgh, and after serving an apprenticeship as a coach-painter there, went to London, where he became a student at the Academy, and finally abandoned trade for art. While in London, where he resided, except for a visit to Italy, until he became master of the Edinburgh school in 1798, he was intimate with many of the most prominent artists, and painted a number of historical pictures, two of which were engraved for Boydell's Shakespeare, and a few Biblical subjects, for one of which Mulready, then a boy of ten or eleven, sat for the youthful Solomon. He also made a number of studies of the lions at the Tower, and his ability as an animal painter was evident in the ' Disobedient Prophet,' withdrawn from the National Gallery of Scotland some years ago. This was the picture which Graham would unroll when he wished to descant to his pupils upon the advantages of painting direct from nature, and he would instance how Gainsborough had praised the donkey which he had painted from life, although he had had to have it carried up three stairs to his studio. It was notable also for a certain largeness of design and handling, which was peculiarly interesting when one thought of David Wilkie's early style as that of one of his pupils. But Graham's fame as a teacher quite overshadows his performances as a painter, for Wilkie is one of the most widely known, and perhaps the most popular, of all Scottish artists.

Born at Cults and a son of the manse, David Wilkie (1785-1841), after receiving an ordinary education at the village school, was sent by his father, who curiously enough appreciated and encouraged his son's talent, to Edinburgh to study art. He was only fourteen when he joined the Trustees' Academy, and was for a while discouraged by the poor appearance he made beside his more experienced fellows, but soon he began to progress, and in 1803 he gained a ten-guinea prize for a picture of Calisto in the bath of Diana. But even in his student days the subjects he chose for himself were not taken from the classics, but from Scottish

song or story, and his library consisted of the Bible and *The Gentle Shepherd*, possibly the edition illustrated by David Allan, whose work and that of Alexander Carse he admired greatly. In 1804 he left John Graham, and, in his Fifeshire home, commenced a picture of the annual fair at Pitlessie, a neighbouring village, to which all the folk of the countryside gathered. Many of the one hundred and forty figures in it were elaborated from sketches made surreptitiously in his father's church on Sundays, and Wilkie himself thought that, although very badly painted, it had more subject and more entertainment in it than any three pictures he had painted up to 1812. The colour, which has been mellowed a good deal by time, must have been hot and crude when fresh, the design lacks concentration and the interest is too diffuse, neither lighting nor linear arrangement coming to a focus, but 'Pitlessie Fair' (Mrs. Kinnear) is a wonderful picture for a boy to paint, full of incident vividly rendered, of character admirably studied, and in technique far abler than Wilkie's modest words imply. And in addition to its interest on its own merits and as the work of so inexperienced a painter, it contains the germs of several of his later pictures, such as the 'Jew's Harp' and the 'Blind Fiddler.'

With twenty-five pounds, received from Mr. Kinnear of Kinloch for the 'Fair,' and the proceeds of a number of portraits (some £70 in all) Wilkie went to London in 1805, and at once entered himself as a student in the Academy schools. In the following year he sent the 'Village Politicians' (Earl of Mansfield), painted after his arrival, to the Academy, and with the opening of the exhibition he was famous. The appearance of this simple little picture of village life may indeed be said to mark the beginning of an epoch in the British school. At the time it was exhibited the subject-painters, forgetful of the example of Hogarth and Morland, were given over to the mock heroics and affectations of 'high art and history' founded upon the eclecticism of the Bolognese school. They were the victims of false ideals and simulated imagination, to which the simplicity and sincerity, the unaffected observation and direct expression of Wilkie must have offered the greatest contrast imaginable. The success of the 'Politicians' was great; and as Wilkie followed it up by other pictures in the same vein, but more masterly in execution, which proved even more popular, he had soon many imitators in choice and type of subject. Even such individual artists as Mulready (1786-1863) and Collins (1788-1847), who, with Haydon and Jackson, had been fellow-students of his in the Academy schools, may be classed with those influenced by him, while Leslie's (1794-1859) choice of simpler themes from literature than had previously been the case was a less direct outcome of the same movement. And Turner himself arrested his career for a moment to paint a 'Blacksmith's Shop' (1807) in the Wilkie manner. It was, of course, with Hogarth (1697-1764) that English realism originated, but the success of Wilkie's homely incidents made it

widely possible ; and 'The Village Politicians' of this Scottish youth of less than one-and-twenty was the immediate inspiration of the many pictures of domestic genre, which have been so characteristic of modern British painting.

The merit of Wilkie's work and the reputation it brought resulted (1809) in his election as an associate of the Royal Academy, followed, after an interval of less than three years, by full membership. Until he went to Paris in 1814 with Haydon—surely as ill-assorted a pair as ever travelled together—he had never been abroad, but neither this visit nor one to Holland two years later had any obvious effect on his art. That to Holland could only confirm him in the path he had chosen. But in 1825, after a severe illness, he was ordered south, and when he returned his ideals not only of technique but of subject had undergone complete transformation. He deserted simple subjects for those of more 'import-ance,' and adopted a bolder and more rapid method of execution. When, on the death of Lawrence, Shee was elected President of the Academy, George IV. appointed Wilkie his painter in ordinary, and in 1836 he was knighted by William IV. Then in 1840 he, all at once and in the midst of many commissions, resolved to visit the Holy Land, whence he was returning full of projects for Biblical pictures, when he died suddenly off Gibraltar on 1st June 1841, and at sundown was buried at sea.

Wilkie came with Scott and a little later than Burns, as the old Scots world with its strongly marked character and traditional customs was beginning to give place to a more modern and cosmopolitan civilisa-tion, and merely local interests were becoming swallowed up in the wider heritage of the British people, and his best work, like theirs, was devoted unconsciously to seizing and depicting the character and customs which were imperceptibly, but none the less surely, passing away. As already indicated in the introduction to this section, the domestic painters, of whom he was the greatest, entered into the heritage of the vernacular school of poetry, into its realism, and particularly into that phase of it which dealt with the humorous, but always avoiding the grosser elements, which make *The Merry Muses* treasure-trove to the connoisseur in the nasty. The elements which went to make the life which they depicted might seem insignificant to those who live with a finger laid upon the pulse of the world, but to people cut off from outside communication they assumed the greatest importance. And the primary instincts being the same irrespective of the outward form, a game at 'Blindman's Buff' and a 'Penny Wedding' were justly as much to them as a Countess's ball and a wedding in St. George's, Hanover Square, are to Society. But although Wilkie drew his subjects from the life of the Scots peasantry, he only touched it at certain points. The shrewdness and greed of gain, the boisterous good-humour and the pawky dry wit, the tendency to argument and the inclination to drink, these and suchlike characteristics are admirably expressed in his pictures ; but one looks

G

almost in vain for that austere sense of responsibility and duty, and for that stern and dour Covenanting spirit, which are at once the glory and the reproach of the Scottish people. It was not until after the advent of Harvey (1806-76) with his episodes from Covenanting times, and of Thomas Faed (1826-1900) with his scenes of domestic piety and pathos, that these appeared in the national art. Nor did he touch the hard toil and struggle for existence with a poor soil and a not too genial climate, which have made us what we are. He looked at life with an eye intent on fun and frolic ; the comedy and not the tragedy of existence was his field, and he saw even dolorous incidents in a humorous light. But while he showed a disposition to dwell on the lighter aspects of life, his work reveals touches of pathos and is not wanting in tenderness, and his reading of character, if not very profound, was sure and strong. He was no moralist, but he was a keen observer, and within his range an admirable artist. In the invention of principal situations and auxiliary incident he showed great ingenuity and resource ; but interest in incident and character did not blind him to the claims of pictorial effect, and his technique was excellently well fitted to express the results of his insight and observation.

There is nothing to prove that Wilkie had seen a Dutch picture before he painted 'Pitlessie Fair,' but whether he had or not, it remains a remarkable performance for one so young and inexperienced, and for all practical purposes it was an innovation with the potentials of a discovery. Arrived in London, however, he studied the foreign pictures available, and, later, frequently worked with a Dutch picture beside him. At first Teniers [1] influenced him, then Ostade ; but he was ever himself, and only adapted their art to suit the requirements of what he had to say. 'The Blind Fiddler' (1806 : National Gallery) and most of his early pictures are grey in colour, precise in handling, and somewhat heavy and monotonous in impasto, and, as a rule, the interest centres on a few figures and the light is diffused. But in 'The Village Festival' (National Gallery) of 1811 the groupings and incidents are more complex, the handling daintier and easier, the quality of pigment more delightful, and a warmer glow as of tarnished silver and a tendency to richer and fuller light and shade commence to appear. These are more marked in 'Blindman's Buff' (H.M. King Edward) of two years later, and his colour assumed something like the golden quality of Ostade. Later still, in the best pictures painted before he visited Spain, the influence of Rembrandt made itself felt and he inclined to deeper tones, running from golden to rich dark brown, in which local colour was of little account. And although he was not a colourist in a positive

[1] Cunningham says that the greyness of Wilkie's earlier colour is due to his having taken his tone from Carse's pictures, and there is certainly much resemblance in the pitch and thread of their tone and colour.

sense—colour was not a passion with him and an end in itself—this pre-
ference for unity of tone, grey or silvery in the beginning, golden deepen-
ing to rich brown later, gives his work a harmony, which makes the want
of more splendid colour of minor importance. As is the case in much
Dutch art, colour with him was subordinated to light and shade, as were
values and atmospheric effect ; and, as he cultivated a direct manner of
painting and scraped off the passages with which he was dissatisfied and
repainted them on the ground, his handling combined with his colour and
chiaroscuro to produce unity of effect. But while Wilkie's pictures have
the ensemble which comes from the legitimate use of such devices, they do
not possess atmosphere as we understand it—the atmosphere of Millet,
Israels, M'Taggart. This is more obvious in his open-air pictures,
where the concentrated effects of light which he affected could not be
contrived and accounted for as in interiors. 'The Village Festival,' 'The
Parish Beadle,' and others are too low in tone and wanting in that
simplicity of effect which belongs to the broad play of light in open
spaces. Still, it was not often that he set his figures in the open air,
and indoors there are many ways of justifying his treatment of light.
Pictorially, indeed, none is needed, for the results achieved whether
indoor or out are at once significant and beautiful. By sympathetic
and scholarly use of chiaroscuro, he concentrated attention upon
the points of dramatic interest in his stories, subordinated the dainty
elaboration of auxiliary incident and accessories to the main event, and
evoked pictorial richness from the subtle interplay of local colour through
the carefully designed distribution of his light and shade. The incidents
in his pictures, again, are often exceedingly clever in invention, full of
character, and graceful in themselves, but each also plays a part in the
composition as a whole, serving to introduce passages of light or dark, or
to repeat notes of colour essential to harmony of result. That such was
his intention is borne out by what is known of his practice, of how having
found certain spots of colour or light pleasant in the general sketch or
blot of his masses, he was careful to introduce figures or invent incidents
to retain them in his picture.

Wilkie's work prior to 1825 suggests and almost invites comparison
with that of the Dutch and Flemish realists with which it has so much
in common as regards style and subject. As we have seen, he enriched
his art by study of Teniers, Ostade, Rembrandt and others, but what was
acquired in that way he mastered and modified to serve his own ends.
His debt to them was chiefly technical and concerned handling, tone, the
management of light and shade, and, in less degree, design. Subjectively
and in spirit and sentiment his pictures are his own and essentially national.
Revealing a greater range and variety of life and circumstances than
most Dutch genre—for although perhaps more at home amongst the
people, in farm kitchen or village public, he was almost equally happy in

scenes in the laird's parlour—they are as Scottish, or English, as those of Teniers are Flemish, or of Ostade or Jan Steen, Dutch. Moreover, his invention was remarkably interesting and apt. He was excelled by none in the art of arranging figures to tell a story in a dramatic way, and his humorous and racy narrative is never disfigured by those lapses from good taste, or what seems good taste to us, which mar many admirable pictures by the 'little' masters. Nor even technically need he fear comparison. While he falls short of the best of his exemplars in draughtsmanship, and he does not rival Terburg or Metzu in subtlety of characterisation, or even approach Vermeer of Delft in delicacy of feeling, his drawing is exceedingly dainty and vivacious and instinct with the spirit of movement, his pawkiest expression of character free from caricature, his homespun sentiment social, sympathetic, and refined. If his rendering of tone does not equal that of Vermeer or De Hooch, whose inferior he was in sensitiveness to the beauty of real light, he managed chiaroscuro with great skill and combined it with a rhythmic sense of grouping and action to form most admirable pictorial designs. Finally his colour is harmonious, and at its best possesses a pearly or golden quality of distinct charm, his paint texture is often delightful, and his touch wonderfully dexterous and very expressive in its union of precision and lightness.

Wilkie's first visit to the Continent took place when he was nearly thirty, and although he spent much time studying in the Louvre, where hung the art treasures of which Napoleon had stripped the galleries of Europe, it left little or no impress on his ideas of technique or subject. 'The Penny Wedding' was painted in 1819 ; 'The Reading of the Will' in 1820 ; 'The Chelsea Pensioners' in 1822 ; 'The Parish Beadle,' in which his first style culminated and virtually closed, in 1823. The turning-point in his career was a sojourn in Spain in 1827-8 at the close of a three years' stay on the Continent. The superb simplicity and noble realism of Velasquez, but even more the 'nature itself,' as he phrased it, of Murillo, carried him away, and never afterwards was his work what it had been. He believed that the seven months and ten days spent in Spain were the best employed of his professional life, but his contemporaries thought otherwise, and time has confirmed their verdict. 'He seemed to me,' wrote Delacroix, who saw him in Paris after his sojourn in Spain, 'entirely unsettled by the paintings he had seen. I wondered that a man with so true a genius, and almost arrived at old age, could be thus influenced by works so different from his own.' Yet if it is strange that a man of his gifts and of his years should have completely altered his ideals, it is not wholly to his discredit, for it proves that, *arrivé* though he was, he was yet receptive and capable of appreciating, if not of grasping, the fuller possibilities of his medium revealed in the work of the Spanish masters. In this Wilkie differs from many successful men, who are content to go on reaping the certain rewards of a style intimately associated with their names, although

fully conscious of its inferiority to their more matured ideas. But his attempt to secure breadth of handling and simplicity of statement resulted in carelessness of detail and in a manner rather loose and flimsy than suggestive and powerful, while desire to attain rich and juicy tone led to an excessive use of asphaltum, a practice which has ruined some of his later works, and which exercised for years a hurtful influence on the methods of British, and particularly Scottish, painters. Increase in size also told against him, and revealed a weakness in his drawing and a lack of distinction, which had scarcely been evident on a smaller scale. The 'Council of War,' the 'Guerilla's Departure,' 'The Maid of Saragossa' (all in the Royal collection), painted in Spain or immediately after his return, are all larger than anything he had attempted previously ; and such pictures as 'Napoleon and the Pope' (1836 : National Gallery of Ireland), 'The Peep o' Day Boy' (1836 : National Gallery of Ireland), and 'Sir David Baird discovering the body of Tippoo Saib' (1838 : Sir David Baird, Bart.) are very large canvases with life-size figures. In addition, his court connection led to his painting a number of portraits of great size, only a few of which can be considered successful.[1] His sense of style in design and draughtsmanship was not sufficient to dignify a great canvas ; his brushwork was too flimsy to grapple with the large simple surfaces, and his method lacked the solidity necessary in work on the scale of life. Some of his smaller portraits are more satisfactory and now and then possess considerable charm.

Beyond all this there was a radical alteration in his relation to subject, which, even more than change in technique or scale, destined his later pictures to a lower place. For this the art of Spain cannot be held responsible. Its greatest master, at least, always held by reality, and the path into which Wilkie now strayed was history. His attitude to subject had been an inversion of the usual one. Most painters, who grow in ideas, begin by borrowing subjects from literature or history, and gradually come to the point where they cease to be illustrators and invent pictorial motives for themselves : Wilkie started by being his own librettist and ended by illustrating other people's stories. And in doing this he forfeited his greatest qualities. He was not a strongly intellectual or an imaginative man ; his power lay more in observation (he was a wonderful mimic) than in mental grasp, and so, when he attempted subjects of heroic interest, he failed. His 'John Knox preaching' (1832 : Tate Gallery), usually considered his best essay in this style, possesses many fine qualities, but reveals a want of creative and imaginative power just where, in the work of a greater man, that would have asserted itself. His Knox is an excited shouting fanatic, and not he above whose dead body the Regent Morton said, ' Here lyeth a man who in his life never feared the face of man.' Wilkie was bound to the scene and the incident. During the earlier part of his

[1] The 'Lord Mar and Kellie ' in the County Hall, Cupar, is one of these.

career he must study the thing on the spot, and even in later life he made elaborate arrangements to secure truth of light and shade ; if he could he visited the scene where his incident was laid, and the relationship of one group to another was fixed by making a complete model. The subjects of his later pictures are of ' a higher class ' than his earlier ; but in art it is better to succeed in a little thing than to fail in a great, and the former rank below the latter because they are much less satisfactory within the limits he himself has indicated. ' The Village Politicians ' and ' The Letter of Introduction,' ' Reading the Will,' ' Blindman's Buff,' and ' The Penny Wedding ' are achievements accomplished and complete ; ' John Knox preaching,' ' Columbus,' and ' Napoleon and the Pope ' are gropings after some good he felt but could not fully realise. Without the interest awakened and retained by his earlier work the later would never have attracted the attention it did in his lifetime, and by itself would not entitle him to the distinguished position he holds, not only in the art history, but, in the art of this country. Still justice should be done—and it rarely is —to the merits which Wilkie's historical pictures undoubtedly possess. In their own way creditable, if not great, performances, they would have made a reputation for a lesser man. They exhibit all his old capacity for arranging figures to tell a story ; they are cleverly composed and possess richness of colour and fullness of tone ; above all, they reveal a creditable striving after a higher technical ideal. And in the rare cases where, as in ' The Bride's Toilet ' (1838), he employed the new methods upon material with which he was familiar and in phases of life in which he was at ease, he achieved results which are comparable in their own way, and even technically, with his earlier successes. At times, also, he succeeded admirably in ceremonial subjects which depended for pictorial result upon observation and reality rather than imaginative grasp. Such a picture as ' Queen Victoria's First Council ' is not only one of the most satisfactory ceremonial pictures in the Royal collection, but a very pleasing and artistic treatment of a prescribed subject.

It has been suggested that Wilkie's indifferent health influenced his later work ; but, when everything is said in its favour that can be, the fact remains that his reputation suffers more than it gains by consideration of his historical pictures, that his fame rests almost solely upon his work in that domestic genre of which he proved himself a master, a little master, if you will, but still a master accomplished and complete within his range.

With Geddes he shares the honour of having executed the first fine original etchings produced in this country. Their work was an isolated phenomenon, and did not lead to greatly increased practice of the art, but their best plates possess qualities which will always entitle them to a high place amongst the achievements of the painter-etcher, and, now that a revival has come, they have attracted the recognition and admiration which

they always deserved. The 'Pope and the Jeweller' is Wilkie's master-piece as regards conception and design ; the quantities of light and dark are admirably balanced, the play of line is subtle and satisfying, the atti-tudes and characterisation wonderfully fine. In technical mastery, however, and in richness and fullness of tone, the dry-point known as 'The Lost Receipt' more than equals it. The tone and treatment of these and a few more are of the Rembrandtesque order, but others are more kindred to Ostade in method. Some of the latter are only an inch or two square, but they are usually marked by fine line-work and much spirit, and seem to have been simply and directly executed, as if he had known definitely what he wished to express. Thus in the trial print of the woman with a child standing on a table beside her, the design is only blocked in, and in parts no more than suggested, but even as it stands the scheme of light and shade, although requiring development, is fully indicated. At the same time he appears to have dallied with his plates—the first state of the 'Cottage Door' is dated 1805, the finished print 1820—as if etching had been a ploy with him : and that perhaps is the reason that he succeeded so fully.

The popularity of Wilkie's pictures at the Academy led to many of them being engraved, and this in turn spread his fame far and wide, abroad as well as at home. Yet admirably as the engravings were executed, from a technical point of view, by Abraham Raimback (1776-1843), John Burnet (1784-1868) and others, one is more than doubtful if line engrav-ing was adapted to bring out the qualities of Wilkie's technique, the rich-ness of his light and shade, or the glow of his colour. It is indeed a question if his reputation as a craftsman in paint has not suffered from the false impression these prints give of the more painter-like elements in his work. But they were enormously popular, and there was a time, and that not far past, when engravings of 'The Blind Fiddler,' 'Blindman's Buff,' and 'The Reading of the Will' were to be found in most middle-class homes in Scotland.

Success so great indicated clearly that Wilkie's work had touched responsive chords in the heart of the great public, and, although painters are prone to consider themselves a class apart, with a taste superior to the merely popular, such a demonstration is never without result even amongst them. We have seen how it affected his English contemporaries, and in Scotland its results were still more definitely marked. For there the social circumstances which had produced Wilkie were common to the great mass of the people, and the sentiment expressed was native to the soil. More-over his example was so potent, not only as regards choice and treatment of subject, but technically, that there were comparatively few Scottish genre-painters of his or the immediately succeeding generation who did not work in a more or less Wilkie-like manner. And if as a story-teller and dramatist in paint, no less than in craftsmanship, he remained *facile princeps*,

those he influenced, if treating them with less taste, and, for the most part, in a too farcical spirit, added variety to the subjective material and motives which he had introduced.

The effect in Scotland of his second period was chiefly technical. Sir William Allan had embarked upon the illustration of history before Wilkie turned his attention in that direction, and, as master of the Trustees' Academy, Allan's influence upon the rising generation was more direct. At the same time, one notices that the painting of historical incident increased greatly after Wilkie took to it, and that the methods of the younger painters were founded very largely upon his. His later manner was richer and more powerful than Allan's, but, unfortunately, it was marred by grave technical defects, and the use of asphaltum encouraged by his example has worked havoc with some of the finest achievements of Harvey, Duncan, and others.

Of many domestic painters amongst his countrymen perhaps none was so directly influenced or possessed so much painting talent as Alexander Fraser (1786-1865). A year younger than Wilkie, he studied with him at the Edinburgh Academy, and, having gone to London in 1813, was engaged as assistant by his old companion. For wellnigh twenty years he is said to have painted still-life and accessories in Wilkie's pictures ; but that did not prevent him doing much work on his own account. This, as one might expect, bears considerable resemblance to his friend's in both subject and style. He painted a few historical subjects, but to him, as to his confrere, humour appealed more than tragedy or pathos, and most of his pictures deal with social or convivial situations conceived in the spirit of comedy. Usually, however, he contented himself with simpler designs and restricted them to a few figures. He seems also to have been fonder of the open air, and quite a number of his incidents are set out-of-door. Yet no more than Wilkie did he escape the fashionable brown tone which was so antagonistic to atmospheric quality and envelope, and it is as the ablest of Wilkie's followers, rather than as a fine artist in a vein of his own, that he is to be remembered. More than once the design and ensemble of pictures by him have resulted in their being attributed to the more famous painter. He had not the same command of composition as Wilkie, and his inventive power was much less, but some of his pictures are admirably put together, and his work, especially about 1840, when he was elected A.R.S.A., is marked by rich and mellow colour, inclining to a golden glow, by good and racy, if somewhat exaggerated, characterisation, and, occasionally, by handling in which precision is combined deftly with an appearance of brilliant ease.

At least two more of Wilkie's fellow-students became disciples, but in each case they are now known as engravers rather than as painters. W. H. Lizars (1788-1859), indeed, showed much promise, but the untimely death of his father, an engraver, throwing the support of his mother and

the family upon him, he was compelled to carry on the parental business. That was in 1812, the same year as his 'Scotch Wedding' and 'Reading the Will' appeared at the Academy, where they attracted much attention and praise, which were not undeserved. Both are now in the National Gallery of Scotland, and show Lizars to have been a careful observer, a fair colourist, and a conscientious craftsman with more individuality than most of his fellows. The handling in the 'Will' is somewhat tight and unsympathetic, but the arrangement is good, and obviously he had looked at the incident for himself : the other possesses similar merits, and technically and in colour is considerably superior. And for Lizars's credit it should be added that they were painted several years before Wilkie chose the same subjects and treated them in a more masterly way. John Burnet (1784-1868) was much more intimately associated with the master, round whom all the earlier Scottish domestic painters revolve like satellites about a planet. It is to him we owe many of the best reproductions of Wilkie's pictures, and his engraving, strong, clear, and vigorous, is perhaps more interesting in its kind than his work in paint. The eldest son of the surveyor-general of excise for Scotland, he was born at Musselburgh, studied under Graham, and served an apprenticeship to Robert Scott (father of David and William Bell Scott), the Edinburgh engraver, who as early as 1803, when Burnet was about twenty, engraved, in a combination of etching and aquatint, a series of clever drawings of 'Edinburgh Cries' by his apprentice. But going to London in 1806, his own first important plate was after Wilkie's 'Jew's Harp,' the first of that artist's pictures to be engraved. It is in the style of Le Bas, but he afterwards adopted a bolder and more expressive method founded, he tells us somewhere, on that of Cornelius Vischer. Amongst other Wilkies engraved by him were 'The Reading of the Will,' 'The Rabbit on the Wall,' 'The Letter of Introduction,' and 'The Chelsea Pensioners,' and he also executed some excellent plates after the Old Masters. His painting, however, suffered from his training and practice as an engraver, and his pictures show little personality. Quite a number are Wilkie-like in character and subject, and his most important canvas, 'Greenwich Pensioners,' was painted as a naval version and a companion to Wilkie's army veterans at Chelsea. If lacking the finesse and accomplishment in design and handling of the latter, it is a spirited enough performance and not wholly unworthy of the company for which it was destined. But as a rule his genre motives were as simple as those in 'Playing at Draughts' (1808) or 'The Valentine' (1820), both familiar from his engravings of them. A painter of comedy, like Fraser, his incidents are at once pawkier in conception and more tender in feeling. Yet it is in landscape that one sees him at his best. There he showed a certain personality of sentiment, which, despite reminiscences of the tranquil afternoons of Cuyp, has a pastoral quality of its own. His work in that vein is somewhat similar to his

younger brother's, but more accomplished, very carefully and tenderly painted, and often happy in design.

Burnet, who had seen much and had studied the Masters intently, was also a writer upon art, and his treatise on painting, in which composition, light and shade, and colour are illustrated and analysed, is a work of such interest that it has frequently been reprinted. Dealing with the problems of picture-making in a thoroughly practical, as well as in a cultured and scholarly, way, his are amongst the few books on art of real and lasting value to the student.

Chronologically Alexander Carse (d. 1838 ?) came between David Allan and Wilkie, but, as he exercised little obvious influence in the development of the school of genre-painters, and was inferior as an artist to those already discussed, consideration of his work has been deferred until now. He had something of a reputation, when exhibitions were instituted in Edinburgh in 1808, and Allan Cunningham says that the tone of Wilkie's earlier pictures was taken from those of Car'se. If this be so, it is to be traced in 'The Blind Fiddler' rather than in 'Pitlessie Fair.' In 1812 he went to London, but, some eight years later, returned to Edinburgh, where in 1831 he was elected an artist-associate of the Royal Institution. The date of his death is uncertain, but his artistic activity seems to have extended from before 1808 to about 1835.

Principally a painter of Scottish genre subjects, Carse often invented incident for himself—'A Brawl in an Ale-house' (1809), 'Country Relations' (1812), 'The New Web' (1813), once in the National Gallery of Scotland, and 'On Tent Preaching' (Hon. Stuart Gray), may be instanced as typical of his success as his own librettist;—but occasionally he found motives in the pages of Ramsay and Burns, and on one occasion, 'The Witches' Late Wake' (1815), in an unpublished poem of his own. The spirit of his comedy is broadly humorous. Where Wilkie would have chosen the more subtle humour of a situation, he seized it at its broadest grin, and forced expression until it became caricature. His pictures raise immediate laughter, but leave no ripple of merriment behind : you never recur to them in memory. Yet honestly observed and full of character, they are racy and realistic and completely free from the pseudo-pastoral flavour which detracts from David Allan's more original work. And while he was not much of a craftsman, he handled paint with some vigour and gusto. Artistically the best quality in his pictures is their tone, which is wonderfully free from the prevalent brown, and now and then he attained considerable unity in virtue of the rather atmospheric, if too cold, greenish-grey of his choice. Of William Carse, supposed to be his son, who painted a similar class of subjects in an inferior manner, there is nothing to be said.

William Kidd (1796-1863), another domestic painter of the period, is understood to have had a great admiration for the elder Carse and for

Wilkie, whose influence is quite marked in his art. Little is known of his life, but from first to last he was unsuccessful, and towards the end he lived on the charity of friends and a pension from the Royal Academy. Fecklessness seems to have been his weakness, for his work possesses distinct merit, and, having exhibited nearly two hundred pictures in London between 1817 and 1853,[1] he cannot be accused of want of industry. He was certainly precocious. In 1809, when only thirteen years old, he exhibited 'A Cobbler's Shop,' and this was followed in successive years by 'The Travelling Showman' and 'The Fish Caddie.' The catalogue entry (Edinburgh Exhibition Society), which informs us of his age, adds, in almost the exact words adopted by Whistler in a similar case, 'Apprentice to J. Howe.' This disposes of the tradition that Kidd was trained as a house-painter, for James Howe (1780-1836) was a well-known animal-painter and a member of the society. To some extent, also, it helps to account for the skill with which he painted animals, whether as portraits or in pictures. But his predilection was for genre, sometimes pathetic, but more often in a lightly humorous vein ; frequently Scottish, as in 'The Highland Reel' (1842), 'The Cottar's Saturday Night' (1845), or 'The Jolly Beggars' (1846), one of his most important works ; occasionally generalised, as in 'The Refractory Model' (1835) and 'The Elopement Discovered' (1837); and now and then merely whimsical, as in the monkey looking at a picture, in the example recently presented to the Glasgow gallery by Mr. Arthur Kay. His drawing was vivacious and expressive ; his handling, fluent and easy, had animation and sparkle ; his colour variety and some charm ; and his sense of design, if lacking distinction, was apposite to what he had to say. He was not a great or even a fine artist, but his pictures possess such definite, if modest, merit, that one wonders why they have attracted so little notice.

[1] He was elected an Honorary Member of the Royal Scottish Academy in 1849, and thereafter sent most of his work north.

CHAPTER V

HISTORICAL GENRE

FROM the painting of national character and everyday incident to the
depicting of national history is but a step, and in Scottish art it was first
taken by one who had sat in Graham's classes beside David Wilkie.
While attending the Trustees' Academy William Allan (1782-1850)
worked as an apprentice coach-painter; apprenticeship over, he went to
London and studied for some time in the R.A. schools. But he had to
make a living, and, getting little encouragement at home, determined to
try his fortune in Russia, where he painted many portraits, and, travelling
in Tartary, Circassia, and the South, filled his sketch-books with studies of
life and landscape, which later developed into pictures. Nine years passed
in this way, and as he set out on his adventurous journey when Decamps
(1803-60), who is usually credited with having discovered the artists'
East, was only two years old, Allan may be regarded as a precursor of his
more gifted and famous successor, and of the many painters who derive
from him. Returning to Edinburgh in 1814 he was made much of, but
his Oriental pictures,[1] like most new things in art, did not sell. A certain
number of people, evidently not purchasers, admired them hugely, and
Lockhart, who has left a vivid description of Allan and a very high
estimate of his gifts in *Peter's Letters* (1819), felt the charm of their
strangeness. 'For many years I have received no such feast as was now
afforded me, it was a feast of pure delight—above all it was a feast
of perfect novelty, for the scenes in which Mr. Allan has lived have
rendered the subjects of his paintings totally different for the most
part from those of any other artist, dead or alive, and the manner in
which he treats his subjects is scarcely less original and peculiar.' But
disheartened by lack of practical appreciation, Allan was talking of re-
turning to Circassia and settling there, when Sir Walter Scott exerted
himself on his behalf and succeeded in finding purchasers for some of
his work.

Contact with Scott involved other and more important and far-reaching
results. It fanned, if it did not awaken, Allan's interest in medievalism
and history, and from then onward his principal work lay in the field of
historical romance. The titles of his later pictures show his absorption in

[1] It should also be noted that H. W. Williams (1773-1829) achieved his reputation by pictures of
Greece.

the romantic movement of which Sir Walter's novels are the supreme expression. 'Heroism and Humanity : an incident in the career of King Robert Bruce' (1840), 'John Knox admonishing Mary Queen of Scots' (1823), 'The Regent Murray shot by Hamilton of Bothwellhaugh' (1825), 'The Murder of Archbishop Sharp on Magus Muir' (1821), and 'The Battle of Prestonpans' (1842), are some of the incidents he illustrated, and he died in his studio before a great canvas of 'The Battle of Bannockburn.' But the glamour of the East was not quite extinguished, and the passion for travel would sometimes reassert itself. On several occasions they took him far afield, and subjects suggested by his journeyings in Spain, Morocco, Turkey and Greece, such as the 'Slave Market, Constantinople' (1834), which is perhaps the most interesting and certainly the best painted of his Eastern pictures and secured him his R.A., alternated with those from Scottish history. During one of his later trips he revisited St. Petersburg, where he painted 'Peter the Great instructing his subjects in the Art of Shipbuilding' for the Czar, who already owned several of his works. A few battle-pieces, two 'Waterloos,' one of which was purchased by the Duke of Wellington, and 'Nelson boarding the San Nicolas at the Battle of St. Vincent,' a work of much animation and now in the gallery of sea-fights at Greenwich; two or three Biblical subjects; several genre pieces not unlike Wilkie's in type; and a number of portrait pictures, of which that of Scott seated in his study reading is the best known, are further evidence of his versatility as an artist and his width of interest as a man. He also modelled a little and executed a few etchings of no particular merit.

Allan's work is perhaps more interesting as inaugurating a new development in Scottish painting than on its own account; but it also possesses some intrinsic merit, considerably more than is indicated by the pictures which represent him in public collections. His colour possessed no particular quality or charm, as a draughtsman he was rather mincing and neat, as a designer his merit, although considerable, was more anecdotal than decorative, and weakness of drawing and smallness of parts contradicted the vigour and spirit with which he occasionally arranged his subject; but, when compared with the standard of his day, his technique was respectable, and his conception of incident intelligent and straightforward. He was among the first, in Scotland certainly the first, to study correctness of historical costume, and in this respect his work was always abreast of the best contemporary knowledge. When contrasted with the plates in Boydell's Shakespeare, which were being published in his youth, his accuracy is remarkable. And his choice of subject was often good. Such a picture as the 'Slave Market at Constantinople' is original in the true sense. It is the result of personal observation, deals with fresh material, and in its contrast of races, Turks and Greeks, Circassians and Negroes, presents a vivid picture of the

complexity of life where East and West meet and mingle. His Oriental subjects opened up wider horizons to the artist, and gave stay-at-home folk—travelling was more difficult and rarer then than now—glimpses of strange lands and unfamiliar peoples ; and while his work in Scottish history owed much to Scott, and was, in a way, a product of the romantic movement, it broke new ground for Scottish painters. Yet it must be confessed that the romanticism of his art was more in subject than treatment, and that his personal friendship with Sir Walter resulted in less of the true spirit of romance than reading the Waverley Novels did among the young Frenchmen of 1830.

In 1838 Allan was elected to succeed George Watson as President of the Royal Scottish Academy, and four years later he was appointed Her Majesty's Limner for Scotland and knighted. He was also a Member (A.R.A. 1825 : R.A. 1835) of the Royal Academy. Although making no claims to scholarship, he was a cultured man, who had travelled far and observed intelligently, and his house in Great King Street was frequented by the people best worth knowing in the northern capital. As master of the Trustees' school from 1826 and President of the Academy, he exerted a direct, and, on the whole, a beneficial influence on art in Scotland.

It was the fate of Sir William Allan, as it had been of John Graham, as it was to be of Robert Scott Lauder, to be eclipsed in reputation and popularity by some of those who had studied under him. The interest awakened by Allan's pictures was as nothing to the appreciation and applause which greeted those of Duncan and Harvey.

Thomas Duncan (1807-45), who died when only eight-and-thirty, was perhaps the most talented painter of historical genre in his generation. For some years after leaving school he sat unwilling on a long-legged stool in a W.S. office in Perth, but, after he had his way and was allowed to study art, he made rapid progress at the Trustees' Academy, where he was soon appointed teacher of the colour class and ultimately succeeded Sir William Allan in the head-mastership, a position from which death took him within a year. But short as his life was, he is to be reckoned, both as a teacher and through his pictures, a formative influence on the art of his immediate successors. The charm of colour and the interest in pictorial problems displayed in his art combined with the personal impulse derived from Scott Lauder to form the band of brilliant young men who studied in the Edinburgh school during the fifties.

Like his master, Duncan found a number of subjects in Scottish history, but, save in the last picture he exhibited, dealt with its romance rather than with its tragedy. Two of his finest works were inspired by the glamour that had gathered round the '45, and when he gave a charming rendering of the devoted friendship of the fair Skye girl for the hunted prince who failed in that last effort of his exiled house, he attained

his greatest popular success, and his associateship.[1] This was in 1843, only
three years after he commenced to send to the Royal Academy, where
his ' Martyrdom of John Brown of Priesthill' (Glasgow Gallery) was seen
the following season. When the exhibition opened in 1845 Duncan was
dead, and a year later fifty Scottish artists purchased the portrait of him-
self which then appeared, and presented it to the Royal Scottish Academy,
with whose pictures it now hangs in the National Gallery of Scotland. In
addition to subjects from history, he painted a few from Scottish poetry,
and a number from the Waverley Novels, which in conception and senti-
ment come nearer the spirit of romance which informs Sir Walter's stories
than almost any of the many pictures so inspired.

If, following the prevailing fashion, Duncan took his subjects from
literature and history, and always told his story well, his aims were more
artistic and less literary than usual. His pictures are pleasant to look at
irrespective of what they express. Composition, drawing, and colour are
pleasing in themselves, and in their combination produce admirably ordered
pictorial beauty. Of all the genre-painters in Scotland before Scott
Lauder and Phillip, he was the most gifted colourist. He had studied
Titian and Veronese in Paris, and, whether grave or gay, his colour is
clear and limpid in quality, and attuned to a dominant harmony, rich yet
sparkling, as in ' Anne Page and Slender' (1836 : National Gallery of
Scotland), or full and glowing, as in ' Prince Charles asleep in a Cave'
(1843 : Sir Robert Jardine, Bart.). That this feeling for colour was
instinctive is apparent from his work, and the high place he gave it
amongst artistic qualities is indicated in the story which tells how he
interrupted a young painter, who was expatiating upon a subject he
intended painting, by remarking, ' But, have you got a colour motive for
your picture ?' There are few of his own pictures which do not show
personal taste in colour, and while his designs are based, for the most
part, on a chiaroscuro foundation, and he inclined to the warmer tones and
used but little blue, green, or cool grey, local colour plays a considerable
part in his harmonies, and accentuates his admirable management of
pictorial light and shade. Modulated to express the nuances of light and
colour upon figures, draperies, and background, his touch was delicate or
vivacious as suited the theme, and his handling of the traditional method
of impastoed lights with glazes and scumblings and transparent and semi-
transparent shadows, if more refined than powerful, was both dexterous
and expressive. Something of the same limitation marked the way in
which he drew. It was neither distinguished nor constructive. Grace
and refinement are precious qualities, however, and when united, as in
his case, to designs happy in line and in disposition of mass, they produce
charming results. It is because these distinctive qualities of his art were
completely suited to the sentiment that the scene from *The Merry*

[1] A.R.A.—He had been elected Academician by the Royal Scottish Academy in 1830.

Wives is his most satisfactory picture, and one of the very best of its class and period.

If now better remembered for his historical and genre pieces, Duncan attained considerable celebrity as a portrait-painter, and some of his work of that kind is equal to anything he did. Perhaps his finest portrait is that of himself. In subtlety of conception and largeness of grasp, it may be described not inaptly as noble, and the same word might be applied to his portrait of Dr. Chalmers (1843 : Miss Wood). Simply designed, but arranged upon dignified lines, they escape all trace of that ready-made tradesmanlike look which vitiates much contemporary portraiture, and, although delicately handled, the searched character of the drawing and modelling give them an appearance of power which would suffer little even in presence of a fine Raeburn. Yet, on the whole, he was more sensitive to feminine charm than appreciative of masculine character, and if none of his portraits of ladies equals those mentioned in impressiveness, some of them possess qualities that are more seductive.

The defects of Duncan's art in conception and execution were those of his day, but they are less obvious than with most of his fellows, and they are redeemed by refinement of feeling, fine colour, and a sense of beauty. If without the fertility of invention and the breadth of intellect which make the historical pieces of Daniel Maclise—by far the most conspicuous English history-painter of the time—interesting in spite of obvious and great faults, Duncan's ideas were less rhetorical in themselves, and were controlled by finer taste and a more pictorial conception of treatment. Compared with Wilkie or Allan or Harvey, again, he had an acute perception of the beautiful and a developed colour sense. His women are charming of face and elegant in person ; the poses of his figures are often graceful ; his drawing, if lacking the vivacity of Wilkie's, is dainty and refined; his design satisfying within its range and intention ; his colour nearly always delightful in quality, and in the subtle way in which its dominant chords are repeated so as to form with the brownish *fond* of the period, from which he did not wholly escape, a clearly conceived colour scheme.

While Duncan, like Allan, dealt with the obviously picturesque periods and incidents of Scottish history, Sir George Harvey found motives

> 'In records left
> Of persecution and the Covenant—times
> Whose echo rings through Scotland to this hour !'

His pictures, which represent many an episode of the dismal 'killing times,' the stealthy meeting of resolute and honest men in the glens to worship God in the way their conscience approved, the christening of a Covenanter's child beside a mountain stream by a proscribed minister, or the blows struck for right and liberty at Drumclog, are imbued with something of the austere and grave spirit of the age by which they were

inspired. And 'Quitting the Manse' (1847) summed up in one pregnant situation all the intense feeling aroused by the Disruption. In that picture and in others, such as 'The Curlers' (1834-5: Sir E. Tennant), 'The Bowlers' (1853: National Gallery of Scotland), and 'The Penny Bank' (1864: Mr. Ford), dealing with the everyday life of the people, or in those incidents of school-life and child-play which he loved to paint, he has left work of true historical value. They embody the feelings of a contemporary with the veracity of an eye-witness.

Excepting 'Dawn revealing the New World to Columbus' (1852), which was beautiful in atmospheric effect and had something epical in its feeling, his more ambitious historical works—'Shakespeare before Sir Thomas Lucy' (1836-7), 'Reading the Bible in St. Paul's' (1839-42), 'An Incident in the Life of Napoleon' (1843), and the rest, are neither so spontaneous in conception nor so personal in character. In these that element of homeliness, which marked his thought and style, and made his Covenanting and social pictures so fully and sympathetically expressive of Scottish life and piety, was out of place ; and good criticism agrees with the popular idea in considering them of less account. Taking the Covenanting scenes then as the most characteristic and personal products of Harvey's art on the historical side, one sees at once that his method of picture-making differed from the prevailing one in this, that, although primarily interested in incident for its own sake, he was not dependent on literary descriptions and particular incidents for subject, but evolved it from a generalised conception of a period. And it is much the same with those suggested by poetry : they have a meaning and beauty of their own quite apart from the lines they illustrate. Further, his pictures of childhood represent the appearance of a fresh feeling for children at once deeper and more tender than the old. It was somewhat clumsily expressed perhaps ; it was wanting in the lyric strain which has marked the works of one or two of his successors ; it was a little deficient in appreciation of the plastic beauty of youth ; but it was spontaneous, sympathetic, naïve, and may be said to have prepared the way for M'Taggart and Cameron.

Subject and sentiment were not the only things which differentiated Harvey from his fellows. His technique was related to theirs, but his treatment was personal, and the preference for landscape backgrounds, which was early evident in his work, and the manner in which incident and accessories were combined, were quite his own. Although considerably earlier than Millet (1814-75), the way in which he weds figure and landscape frequently recalls that incomparably greater master.[1] To both, and they were pioneers in a difficult venture, Man and Nature constituted a harmony and formed a pictorial whole ; and, while neither quite succeeded in transfusing incident and setting alike in that magical unity of atmospheric

[1] 'The Covenanter's Preaching' appeared in 1830 ; 'The Winnower,' the first of Millet's great rustic pictures, in 1848.

envelope and colour which has been attained by a very few artists of later date, and in the pictures of each the blues and greys of costume are apt to be over assertive and detached amid the brownish transition tone which characterises their work, both succeeded wonderfully in expressing their emotional impressions through sheer force and sincerity of imaginative perception.

In no sense a stylist, the homeliness and earnestness of Harvey's sentiment is echoed in his technique. His drawing was occasionally defective and never distinguished ; his brush-work, if fine in surface and carefully wrought, lacked flexibility of handling and suggestiveness of touch ; his colour was sedate and even a little monotonous and deficient in quality. But, on the other hand, gravity of colour suited a sentiment with which more brilliant craftsmanship might have been out of place, and his drawing, such as it is, expressed with considerable felicity the type of people and the range of character with which he dealt. His earlier work showed considerable attention to form, but latterly in pursuit of tone, to which he was perhaps the first in Scotland to become really sensitive, he rather neglected it. But he was always fastidious, and painted and repainted on his pictures until he attained something like the effect he was striving for. His influence has been held responsible for much slovenly work in Scottish painting, but the truth is that the pictures, almost exclusively landscapes and the work of his later years, in which tone and its results predominate, were little appreciated, and did not sell. They were the fullest, truest, and most beautiful expression of his nature however, and are, with the discriminating minority, at least, the most highly prized of his works. Even when quite subsidiary and attuned to the mood which dominates the human action in his figure-pictures, his landscape is full of suggestion and beauty, and where he made it the sole motive it does not fail in poetry and power. Its full significance cannot be appreciated except in relation to the work of the landscape-painters of his time, and it will be discussed at length later.

While his conception and range of subject make him a somewhat isolated man in a period when either picturesque historical incident or true domestic genre was the rage, the combination of these elements in his art makes him in another sense peculiarly representative of its main currents. And in treatment, and especially in striving after truer tone, he may be considered as marking the beginning of a transition to a more modern manner in landscape.

For years a victim of the bitumen craze, many of his pictures, and among them 'Quitting the Manse,' and 'Columbus,' are now in a deplorable state ; but, learning by sad experience, he latterly adopted a sounder method, and his landscapes, for the most part, are in good preservation.

Harvey was a native of St. Ninians, and after serving an apprentice-

ship to a bookseller in Stirling, went to Edinburgh, where for two years he studied with Sir William Allan, whose influence, however, is not at all obvious in his work. From the beginning an active and devoted supporter of the Scottish Academy, he was in 1864 elected its fourth president, and in 1867 he was knighted.

A third pupil of Sir William Allan's to attain distinction, less personal perhaps but no less honourable than Duncan's and Harvey's, was Robert Scott Lauder (1803-69). It was his good fortune to train a group of men whose work forms one of the most brilliant passages in the history of Scottish art. Born at Silvermills, Edinburgh, three years before Harvey and four before Duncan, his first master was Andrew Wilson (1780-1848), and it was not until after he had been in London, where he drew in the British Museum and attended a life-class, that he came into contact with Allan at the Trustees' Academy. Of greater importance, however, than his masters as an influence on his art were friendship with the artist-minister of Duddingston, whose daughter he married, and a five years' residence in Italy, during which he painted portraits and studied the works of the great masters. On his return in 1838 he settled in London and produced pictures which attracted much notice. But he had had a misunderstanding with the Royal Academy, and when in 1852 he was offered the Mastership of the Trustees' Academy he accepted and removed to Edinburgh. John Phillip always held that Lauder had made a mistake, and should have remained in London, where he was beginning to make a mark, and where it was almost certain he would ultimately have achieved great success. 'That is as it may be,' as D'Artagnan would have said; but if he missed immediate recognition through his own work, his going to Edinburgh has made him famous through that of the pupils he inspired by his contagious enthusiasm. His Italian sojourn had quickened his sense of style and given his colour richness and depth, and it is in his influence in these directions, and particularly in the latter, the vital element of his personality being disregarded, that his importance as a teacher consists. But consideration of his methods and success as a master is better postponed until the work of his pupils comes under review.

Lauder's well-deserved reputation as a teacher has overshadowed his merits as a painter. These, if not remarkable, are considerable. As far as subject goes his pictures were of their time. The Bible and Scott supplied the themes. At the same time, they possess qualities of design, colour, and handling, which meant more than mere illustration. Although many of his subjects, particularly in later life, were taken from Holy Writ, his was not the temper of the religious artist. He was more interested in the drama, and in the play of colour it involved, than in the spiritual significance of the Gospel story, and hence his pictures from the Bible miss one of the most important essentials of sacred art. While some among them are dramatically effective, almost all are wanting in that spirit

of religious reverie, or that savour of simple yet sublime imagination, which marks the work of the artists who find, as did Angelico, or Perugino, or Rembrandt, a true vocation in such themes. In other subjects, where the intellectual demands were different, his turn for colour and expressive light and shade served him well, and such a motive as 'The Trial of Effie Deans' (R.S.A., 1842), with its clearly marked human interest, enabled him to achieve a remarkable success. The play of varied emotion awakened in prisoner, bench, bar, and audience by the sudden fainting of old Davie Deans is admirably conceived and subtly expressed, and the dull yellow light of a dying sunset, which fills the court-room, touches everything with its pathos. Undoubtedly his masterpiece and dramatically one of the finest pictures of its school, it has found a semi-public resting place at Hospitalfield—the Monkbarns of *The Antiquary*—near Arbroath, where one of his pupils, Patrick Allan Fraser, founded and endowed a somewhat fanciful and Utopian 'nursery' for budding artists. The memorable scene from *The Bride of Lammermoor* (1831: Earl of Ellesmere), in which the Master of Ravenswood interrupts the signing of the marriage contract, if scarcely so complete artistically, or dramatically so convincing, is also a fine conception admirably carried out. And while these are the finest results of the inspiration he drew from Sir Walter, illustration of dramatic incidents in the Waverley Novels frequently brought him good luck. It is unfortunate, therefore, that the only important picture by him in the National Gallery should be the large, and, for all its fine colour, rather empty 'Christ teacheth Humility' (1848). Representing his ambitions rather than his achievement, the only part of the huge canvas that shows him to advantage is the landscape vista towards the right, which is conceived in a highly romantic mood recalling Delacroix, to whom he has sometimes been compared, and to whose work his, though far less impassioned and inspired, sometimes bears a far-off resemblance.

In Rome Lauder had lived by portraiture, and on his return he did not wholly abandon it. No doubt, to one with his aspirations and ideals, it must have seemed but trivial work. Yet his success in such portraits as the full-length of 'Christopher North' (Edinburgh University), or the very striking head and shoulders of 'J. G. Lockhart' (Mr. William Blackwood), is marked. They unite excellent characterisation with fine colour and quiet dignity of design, and in them, perhaps because of their closeness to reality, one can trace even more clearly than in his pictures a resemblance to the work of his pupils.

Lauder was not a very original or a powerful painter, but his instincts lay in the right direction, while his fine taste and his appreciation of the great masters tended to give his work the flavour of art. His colour, if it never passes beyond the conventional, has glow, luminosity, and sometimes sparkle ; his compositions, if wanting in concentration, are graceful

and harmonious and possess a certain dignified reticence ; he used light and shade with the exaggeration of a romantic, and handled his medium somewhat weakly, it is true, but with understanding of its character, and with a variety and expressiveness of touch and impasto which differentiate his work from that of the great majority of his immediate contemporaries.

The tendency to approach subject in its literary rather than in its pictorial aspect, and a certain inability to conceive an incident or a scene without chapter and verse, noticed in connection with the best and most individual Scottish painters of historical genre in this period, are of course more pronounced among the minor men, who, as a body, seemed incapable of seizing the pictorial significance of subject, or of appreciating beauty of composition, chiaroscuro, and colour. Their ideal of picture-making seemed to be to combine the descriptive power of the writer with the effect of the theatrical tableau : a task for which, even if they had been much greater painters than they were, their medium was unsuited. A sentence or two of fine prose, or a few lines of poetry can reveal the intense passion of a crowd, the swaying to and fro, the hard breathing, the momentous wailing, far more vividly than any picture ; they can make our blood gallop or cause us to hold our breath in a way beyond the powers, and therefore outside the province, of painting. And contest with the theatre is no more successful, because there the scale is far more imposing and the appearance of reality, for which painters of history strive, more easily and perfectly attained. Complete and perfect in its own domain—the significant and beautiful pictorial expression of the emotions pertaining to vision—painting cannot rival literature and the drama when it attempts effects more suitable for them.

The greatest offender in this respect was one who cannot be described as 'minor,' for he brought conspicuous, if over-rhetorical and theatrical, talents to bear upon his painted illustrations of English and Irish history and literature. But Daniel Maclise (1806-70) was born at Cork, lived his professional life in London, and, save that he was the son of an old Scots soldier (his mother was Irish—of the name of Buchanan), had no connection with Scotland. Neither in choice nor treatment of subject does his work bear traces of his descent, and as he seemingly exercised no direct influence on Scottish painting, it were superfluous to analyse his art here. C. R. Leslie (1794-1859) also—as is pointed out in the history of the early years of the Royal Academy, in the preparation of which his son, Mr. G. D. Leslie, R.A., collaborated with Mr. Eaton, the secretary—was of Scottish descent, his grandfather having emigrated from Scotland to Maryland in 1750 ; but for similar reasons the humorous genre, which he painted with such intimacy and so well in his own way, need not be considered.

With others the case is different, for although far less interesting than Maclise and Leslie as men and artists, their work is relevant to our subject.

Of these James Eckford Lauder (1811-69) was one of the more talented. His elder brother, Robert Scott Lauder, had encouraged his youthful efforts, and, after studying the antique for three years with Allan, James joined him in Italy (1834), where he remained four years. Having thus come under the same influences as his brother, as well as being directly influenced by him, it was but natural that their work should possess a certain likeness, but while the younger man was perhaps the better draughtsman—he was certainly the more incisive—he was inferior as a colourist, he had less feeling for beauty, and his conception of subject was tamer and more commonplace. A picture like his brother's ' Effie Deans ' was quite beyond him ; but in less complex compositions and less emotional situations he was frequently successful. It was a stroke of great good fortune for his reputation, therefore, when his completest and most accomplished work was bequeathed to the National Gallery of Scotland. ' Bailie McWheeble at Breakfast' (1854), however, is too isolated an achievement to be a fair sample of his powers. Taken by itself, a fine picture and a most admirable piece of painting, its tradition is more Dutch than Italian, and neither in colour and chiaroscuro nor in handling and draw-ing is it nearly so characteristic as the much weaker ' Hagar ' (1857) in the diploma collection.[1] He did many finer things than the latter, but its faults as well as its good qualities are typical of his average performance. Receiv-ing less encouragement than his merits deserved, he was somewhat soured latterly ; but, through causes that need not be entered upon, he hardly fulfilled the promise of his earlier work.

More interesting than Eckford Lauder, but for reasons unconnected, or at most only remotely connected, with art, was James Drummond (1816-77), another of Sir William Allan's students. Born in the old house in Canongate which popular legend has made the home of John Knox, of a father absorbed in the lore of Old Edinburgh, his preoccupa-tion in Scottish history and archæology was almost predestined. But if the accurate knowledge of Scottish costumes, arms, and customs revealed in his pictures gives them considerable interest to the student of the past, zeal for accuracy of fact being uppermost and apparent, militates against their appeal as works of art and converts them in¬o documents. He failed to appreciate, or at least to express, the dramatic and emotional elements in the stirring scenes of Scottish history he chose to illustrate, and seemed to think it sufficient to dress models in historically correct costumes and pose them in appropriate positions and groups to represent the selected incident. If capacity for taking pains would have made a history-painter, Drummond should have been one ; but despite the pre-sence of several pictures of his in the National Gallery of Scotland no one now thinks of him as an artist. He was unable to grasp a scene in its masses and relationship ; his colour is poor and thin ; his handling

[1] He was elected A.R.S.A. in 1839, and R.S.A. in 1846.

mechanical and unsympathetic; his types of people a little mean. A certain skill in linear composition, a knack of telling a story in an intelligent but common way, and of producing an effective if somewhat theatrical *mise-en-scène*, seen to great advantage in 'The Porteous Mob' (1855 : National Gallery of Scotland), are almost all the merits his work possesses. His truest claims for remembrance are as an authority on ancient weapons, as the author of an excellent book on the sculptured stones of the West Highlands, and as the maker of a highly interesting series of drawings of many of those historic spots and buildings (exhibited in the Scottish National Portrait Gallery), which recent alterations in Edinburgh have made mere names. W. B. Johnstone's (1804-68) interest in art, like Drummond's, was not that of a painter. As pictures his are uninteresting, and possess none of that æsthetic charm without which art does not exist. But his knowledge of the history of art and his antiquarian tastes made him, in some respects, an admirable curator of the Scottish National Gallery, to which he was appointed at its formation, and of which he compiled an excellent catalogue. All his life he had been collecting material for a history of Scottish art, and at the time of his death it was almost ready for publication, but by some mischance the MS. was destroyed and the result of his labours lost for ever. Of Alexander Christie (1807-60), another subject-painter of the time, there is nothing to record except that he conducted the Trustees' Academy between Duncan's death and Scott Lauder's appointment, and had Thomas Faed amongst his pupils.

While the past also supplied John Adam Houston (1813-84) with material, his treatment of subject was more pictorial, and he was more interested in the picturesque and romantic than in the antiquarian element in history. A Scotsman born in Wales, he was trained in the Edinburgh School and then went to Paris and Germany to continue his studies. Returning to Edinburgh he was elected A.R.S.A. in 1841, and full member three years later, but in 1858, for reasons of health, he removed to London, where the rest of his life was spent. He took subjects from many periods of history, but perhaps his favourite was that of the great struggle between the Cavaliers and the Parliament with its picturesquely contrasting types and costumes. Within his range, and on the comparatively modest scale he usually employed, his work was accomplished and refined, and as he aimed at combining brilliance of tint with harmony, his designs are frequently effective, particularly when carried out in water-colour. A number of his incidents have pleasant landscape settings, and, although his drawings of Italian cities are over-pretty and conventional, he painted some landscapes which show considerable feeling for the sparkle and play of light.

Contemporary with these men, who were principally, although not exclusively, painters of historical genre, were others who, while frequently

painting subjects from history, are seen at their best in simpler and more domestic themes. William Bonnar (1800-53) is typical of this class. He executed a number of ambitious pictures in which ' John Knox preaching in St. Andrews Castle,' ' Bruce and the Spider,' and suchlike memorable incidents figured, while his real strength lay in pastoral pieces and the representation of childhood. Some of his smaller pictures, of which ' Kilmeny's Return' (Misses Carfrae) and 'The False Face' (1836) are admirable examples, possess considerable charm and grace, and are so pleasant in colour and arrangement that one is almost surprised at his failure whenever he tackled subject on a larger scale. Occasionally, how-ever, he painted life-size studies of single heads, fancy or portrait, with considerable force and distinction. With Bonnar one may bracket Charles Lees (1800-80), who found his true function in depicting not tragedies like the ' Murder of Rizzio' or the ' Death of Cardinal Beaton,' but the field sports he loved and understood, and, in his later years, in landscape. Some of the former, such as the ' Hockey-players on Linlithgow Loch,' are full of character and action, while many of the latter reveal delicate feeling for Nature expressed with refinement if not with power. It is more difficult to place Andrew Somerville (1808-34), for he died before his art was fully developed. The glorious ballads of the Border had a peculiar fascination for him, and he painted one or two moderately good pictures suggested by them ; but those I have seen do not appeal to me so much as the ' Cottage Children' in the Mound Gallery. They are wanting in the spontaneity and grace both of handling and spirit which mark that charming little sketch, and give it something of the charm of Gainsborough. Mere mention must suffice for Robert M'Innes (1801-86), a painter of picturesque Italian genre, by whom there is a characteristically polished and neatly finished ' Italian Hostelry' in the Glasgow Gallery ; Robert Ronald MacIan, A.R.S.A. (d. 1856), and his wife Mrs. Fanny MacIan, H.R.S.A., both of whom derived their motives chiefly from Highland legends and stories ; and George Simson, R.S.A. (1791-1862), who varied portraiture by subjects much in the vein and manner of his more gifted brother, William.

Although more accomplished than any of these minor subject-painters, William Denholm Kennedy (1813-65), and Alexander Johnston (1815-91), owing to their having settled early in London, and having exhibited little in Scotland, have dropped from the roll of Scottish painters to which they belong by birth. Kennedy, who studied in the R.A. schools, was influenced by William Etty to some extent, and his pictures, many of which were Italian in subject, were usually moderate in size, good in colour, and carefully arranged and painted. A native of Dumfries and receiving considerable tangible encouragement in that district, his example may have had some influence upon Thomas Faed, whose early pictures show some affinity to his in manner and colour. On the other hand, Johnston

was a pupil of the Trustees' Academy before entering the schools of the London Academy, and his pictures, sometimes 'of the affections,' and occasionally historical, are conceived in a somewhat similar spirit to those of Sir George Harvey. Austere and grave in feeling, and dwelling upon the pathos of life, his pictures, amongst which one may name 'The Mother's Grave,' 'The Covenanter's Marriage,' and 'The Last Sacrament of Lord William Russell,' are marked by sound drawing and expressive composition, which, in combination with reticent colour, give a certain severe stateliness to his work.

CHAPTER VI

DAVID SCOTT AND WILLIAM DYCE

IN the whole history of art it would be difficult to find two artists belonging to one country, living in the same period, and treating a somewhat similar class of subject, who present a greater contrast, both as men and painters, than those whose names form the heading of this chapter. When one has stated that they were born in the same year, and were members of the same Academy (R.S.A.), and that the work of neither can be classed with that of any other of his countrymen, one has almost exhausted the points of similarity. The life and art of each was essentially dissimilar. David Scott (1806-49) was as unrecognised officially as William Dyce (1806-64) was distinguished ; and while the art of the one was the issue of somewhat undisciplined genius, that of the other was largely the product of culture and educated taste.

Consideration of David Scott's art is best prefaced by some indication of the environment in which he was reared, for, while that does not explain how he came to possess the vital spark of genius, it helps to account for its bent. He was the son of Robert Scott (1777-1841), an Edinburgh engraver of some skill who, although caring little for his own art, filled his house with prints and illustrated books, which his children found a never-ending source of delight and education. A younger brother, William Bell Scott (1811-90), has drawn so minute a picture of the home life in the old house near St. Leonard's, that here no more than a suggestion is required. He might have touched it with a kindlier hand, but even so the atmosphere must have been depressing enough. Family bereavement and feeble health [1] had accentuated the father's naturally grave and sombre temperament, and he was gloomily religious ; the mother was prematurely old with grief ; the house seemed to lie in perpetual shadow. From this the workshop in Parliament Square and the aforesaid engravings provided a variation, while the latter, and especially Blake's designs to Blair's *Grave*, influenced the older brother profoundly. The father opposed their desire to be painters, and both spent some years engraving and etching for the publishers. Meanwhile David attended the Trustees' Academy, read the classics, and studied anatomy ; and, in 1827, he joined some other young artists in starting a life-class. Gradually he emanci-

[1] 'He was a monomaniac about disease,' writes his dutiful son.

pated himself from commercial engraving, and in 1828 exhibited his first important picture. Its subject—'The Hopes of Early Genius dispelled by Death'—was almost prophetic of his own career. 'Nimrod,' 'Cain' (Diploma Collection, R.S.A.), 'Wallace defending Scotland' (Misses Carfrae), 'Sarpedon carried by Death and Sleep' (Miss Brown), were among its immediate successors, so that from the very first he found his way to the regions of the abstract and the heroic, which remained his themes to the end. But the most remarkable products of these earlier years were the weird designs known as 'The Monograms of Man,' and a marvellous series of etchings illustrative of Coleridge's *Ancient Mariner*. Different though his work was in spirit and style from the pictures amongst which it appeared in the Scottish Academy, it compelled attention, and in 1830 he was elected an Associate, and five years later a full member. In 1832 he went to Italy, where, after visiting the northern cities, he spent fifteen months in Rome. There he painted 'The Agony of Discord,' 'Sappho and Anacreon,' 'The Vintager,' and four pictures illustrative of the periods of the day. Back again in Edinburgh, perhaps more influenced than he thought by what he had seen (he wrote several papers on Italian art for *Maga*), Scott settled down to live his own life and dream his own dreams; to puzzle the unimaginative public by the boldness and unfamiliarity of his conceptions, and to irritate the critics and the conventional among his fellow-painters by his expressive but extravagant draughtsmanship and fine colour. A few choice spirits gathered round him, an audience fit but few; but the wider appreciation for which he longed, isolated soul though he was, was denied, and unsold canvases crowded the big studio he had built at Easter Dalry. This, added to enfeebled health and a hopeless love, still more turned him in upon himself; he became a victim of introspection and brooding melancholy, and his aspiring spirit fretted his frail body until it broke it at the age of forty-three. Beyond unsuccessful efforts in the Westminster Hall competitions of 1842-3, the only outward incidents which mark his career after returning from Rome were the pictures he painted and the designs he made. These, although all are imaginative, can be divided into the historical and the abstract; those which represent some definite event, and those which embody some abstract idea or are suggested by some poet's fancy.

Much that has been written about David Scott's art seems the result of second-hand or insufficient knowledge of his pictures; for while justice has usually been done to the spirit and imagination revealed in his work, and his obvious deficiency as a draughtsman is never forgotten, his gifts as a craftsman in paint and as a colourist have often been unduly belittled. These are, of course, the elements which in any painter suffer in reproduction; and with Scott, who was a colourist of a high order, the loss is very marked, and has resulted in his claims as a painter being underestimated or misunderstood.

David Scott was a born painter, but fate denied him that early training without which the most splendid natural gifts are crippled and can hardly attain full fruition, and in his later years lack of means prevented (even had he wished, which is doubtful) frequent use of the living model. To a certain extent also the latter reason, or rather its cause, want of appreciation, tended to produce the feeling of protest which marks some of his work. But even without allowance for these circumstances, and criticism cannot be expected to allow for them, Scott's art is worthy of praise and high admiration. The splendid imagination of his conceptions in itself entitles him to them, but in addition he was a fine colourist and a good craftsman. His handling of paint is frequently masterly, and, broad, simple, and fluent in touch, the pigment is used of such a consistency as to produce admirable qualities of texture and colour. There are passages in his pictures which are worthy of a master, and among his Scottish contemporaries, at least, there was none who could employ oil-paint in so craftsmanlike a way. Even his earliest works possess this quality of breadth and power, which seems to have been innate, for the tradition of Dutch technique held the great majority of his fellows, and, although it matured later, his handling never altered in essential character. The colour in his pictures shows more variation. Those painted before he went to Italy are greyer in colour and heavier in tone than those executed there, and even afterwards. A certain glow within the dullness gave promise of the future, but 'Nimrod' and 'Cain' are monochromatic when compared with 'Sappho and Anacreon' and 'Time Surprising Love.' The pictures of the pre-Italian period are few in number, however, and scarcely enter into one's estimate of Scott's colour, which, rich, varied, beautiful, is full of imaginative significance and decorative charm. 'The Vintager' (National Gallery of Scotland) and 'Sappho' (Misses Carfrae) are outstanding examples of the second quality. In these and others of a similar type it is more abstract than imitative, and, while retaining clear relationship with that of Nature, it is less varied and gradated and used in simpler masses. Roundness of modelling also is less insisted upon. Although Scott's are more brilliant and fresher in colour, the effects aimed at and achieved may have been influenced by the example of the old Italian fresco-painters, whose work he had studied in Italy, where at that time, through the action of the 'Nazarenes,' it was much before the artistic community. 'Sappho' is superb in the contrast of the fair poetess and the sun-tanned companion of her revels, and in the harmony evoked from the scarlet of the hangings and the blue of the evening sky beyond. But a purely decorative intention is rare with him. He was peculiarly sensitive to the influence of atmosphere on colour, and used light and shade with dramatic effect. The deep and sombre hues of his tragic pieces and the rosy tints of his fairy episodes are alike appropriate. Indeed, feeling for drama frequently determined his whole treatment,

and often gives his designs a peculiar and compelling significance, which appeals powerfully to the imagination. At the same time, it led him into those extravagances of draughtsmanship which form the chief defect in his technical equipment. How far a severe academic training would have amended this one cannot say ; but with his distinct personality, it would certainly have been no hindrance to the expression of his personal quality as a thinker, and it might have saved him from many errors. Yet it is questionable if he could, or would, have bent his neck to the beneficent yoke. Even before he went to Italy fondness for vigorous pose and over-emphasised muscular action had declared itself, and there he felt the spell of the great Florentine who had animated the ceiling and walls of the Sistine Chapel with terrific visions of judgment and destiny. Perhaps it was because he could not, rather than because he would not, draw correctly, that he so often went wrong in proportion and construction ; but superficially it seems as if he, like the Gothic sculptors, had felt that exaggeration expressed his ideas better than the normal. But that which distorts the beauty of the body and forces expression to the verge of caricature cannot be counted to him for righteousness, and if the emotional result sometimes justifies his method, frequently only the high seriousness of his purpose enables one to overlook its defects.

The expressive parts of Scott's art—passion for colour, exaggeration of light and shade, and love of forceful action and eloquent gesture—are romantic, but the ruling elements in his mind were mystical, and, as became a Scot, metaphysical. In essence he was more akin to Blake (1757-1827) than to Delacroix (1798-1863), with whom, at first sight, he has more affinity. And an American friend says that to compare him to Washington Allston (1779-1843) will give people on the other side a good idea of his matter and style. He himself always judged painting by its sentiment and mental bearing, and thought most of new spheres of meaning ; and his own pictures and designs usually emerge triumphant from such tests. While he was apt to forget that 'art has its boundaries though imagination has none,' he possessed a wonderful power of embodying abstract ideas in pictorial form. Such a drawing as ' Self-Accusation,' in which Conscience, represented as the man's double, pursues him so closely as almost to step simultaneously in the same footprints, is a wonderfully vivid interpretation of an idea which, on the surface, seems beyond the limits of graphic art. Some of his ' Monograms of Man ' (published 1831), possess a similar quality, and in the designs to Professor Nicol's *Architecture of the Heavens* (designed 1848 : published 1850) he breathes the life of poetry into science and spiritualises it. Perhaps this characteristic is most evident in his work in black and white, but his pictures possess a quality which is somewhat akin. They are remarkable as studies in psychology, and reveal him as a painter of the emotion and thought which underlie human action. Further, his treatment of such things is typical rather than individual, so

that even when founded upon particular events his pictures have a general application. This has been felt by those who know his work. 'The Duke of Gloster entering the Water-Gate at Calais' is now known as 'The Traitor's Gate,' the 'Vasco da Gama encountering the Spirit of the Cape' as 'The Spirit of the Storm,' and the less particularised title is in completer harmony with the sentiment of each. He possessed the faculty of piercing to the heart of things, and if his mediævalism was not archæologically correct in its trappings, he caught the inner spirit of an age which believed in astrology, sought the philosopher's stone, was steeped in chivalry, and devoted itself to the crusades. And thus while the elaborate pictorial reconstructions of antiquity and mediævalism, which delight the archæologists of to-day, have become old-fashioned, Scott's pictures will still preserve their freshness and their power of emotional appeal.

'The Traitor's Gate' (1841 : National Gallery of Scotland) was painted to illustrate—if one may use that word in connection with a work which is in itself a creation—the closing episode in the life of the Duke of Gloucester, brother of King Richard ii., but it needs no historical knowledge to understand the meaning of the picture. It is an epitome of the way in which kings kept their thrones by might. The man in the boat might be any one, but his doom is as evident as if the inscription which Dante read above the door of Hell were written on the bars of the grate, which is about to descend between him and liberty and the daylight that is dawning over the sea. Admirable in composition, handling, colour, and sentiment, it is perhaps his completest achievement ; but his greatest is undoubtedly that noble composition, the 'Spirit of the Storm' (1842 : Trinity House, Leith), in which, although every part is full of interest, attention is quickly focussed on the figure of Da Gama standing calmly on the reeling deck among his agitated crew. There has been mutiny on board, and the ship labours heavily ; but here, in the quiet courage of one brave man amid the turmoil of a hurricane, and before a vision of the storm fiend which makes his companions quail, in this suggestion of heroic struggle with fate, the picture touches the highest note of great tragedy. But it is unnecessary to go on analysing picture after picture to demonstrate the habit of mind expressed in Scott's work; it was the significance of action that appealed to him. In his renderings of subjects from the Bible, however, impressive and even grand as they are, tragedy and terror are accentuated at the expense of other and more spiritual qualities.

Reference has already been made to Scott's sensitiveness to atmospheric effects, and here we may consider briefly what seems to me a very striking feature in his pictures. I mean, his feeling for landscape. Almost without exception the Scottish landscape painters of his day were realists, not of course in the same way as their successors, or the modern Frenchmen, but in intention. They derived from the Dutch, and were content with the immediate and the obvious. Scott, on the other hand, interpreted Nature

as he interpreted life. The landscape portions of his pictures are signifi-
cant in the emotional effect of the whole, and in themselves they are
beautiful. Peculiarly appreciative of the poetry of twilight and dawn, he
was also perhaps the first who felt, or at least gave pictorial expression to,
the serene calm and beauty of the night. There are passages in his pictures
that are almost as full of the magic and mystery of darkness as Whistler's
famous 'Nocturnes.' In the 'Traitor's Gate' the wan light of coming
dawn spreads over sea and sky, dimming the lustre of the stars and reveal-
ing, as in a dream, the vessel in the offing ; and one feels its beauty, not
only in its poignant relation to the still figure in the boat, but in itself.
The glamour of moonlight, in which fairies dance, floods the 'Belated
Peasant' ; the 'Russians burying their Dead' (Misses Carfrae) is enveloped
in the transparent gloom of night; and in 'Puck fleeing before the Dawn'
(Mr. James Campbell), perhaps his most beautiful flight of fancy, the
strange lambent light of a roseate dawn glows along a dark sea-horizon
and spreads impalpably over the darkness of a star-strewn sky. While
in all of these some minor chord of poetic suggestion is struck, in others,
such as the blithe summer landscape in which a crowd of gay figures
proclaim 'The Triumph of Love,' he sings a lustier and more joyous
song.

Scott was a really great illustrator, and the series of etchings made
by him to illustrate *The Ancient Mariner* (designed 1831 : etchings
published 1837) are amongst the noblest works of this kind ever executed.
He seems to have been fascinated by the weird and romantic spirit of
Coleridge's wonderful poem, and he has realised his mental visions with
quite startling vividness and force. Such designs as 'Life and Life in
Death,' throwing dice upon the riven wreck, through the ribs of which
one catches a glimpse of the setting sun, or that in which the dead souls
of his companions flash past the agonised mariner as he kneels upon the
deck, are supreme efforts of sympathetic interpretation ; and no higher
praise is possible. The designs to the *Pilgrim's Progress* (1841), which
were not published until after his death, are not so uniformly successful ;
but 'Christian entering the Valley of the Shadow of Death' is magnificent,
and one should not forget that they were not etched by the designer
himself, but 'freely' engraved by his brother, whose clearer, harder, and
more 'correct' line is much less expressive of the quality of the thought
than the ruder and more vigorous style of the originator. How much is
lost may be seen by comparing W. B. Scott's etchings with the repro-
ductions of some of the original drawings in J. M. Gray's appreciative
memoir. Yet even in their published state they retain much that is
striking in conception and design, and breathe a calmer spirit than the
'Monograms' or 'The Ancient Mariner.'

Emphatically of those whose reach exceeds their grasp, he was always
striving to express something beyond what he could convey to others by

his art. His life was pathetic in the very height of its ideals. He lived too much to himself, and his art was too far out of touch with the throb and beat of actual life to appeal to the great heart of humanity. Gifted with originality, imagination, genius, the suitable social and mental atmosphere in which these would have flowered freely was denied. An imaginative painter in a period of domestic and historical genre, a dreamer in an age of prose, David Scott was clearly out of place ; but to blame either him or his neighbours for what neither could help were absurd. Had he lived a few years longer he would not have been so isolated. The year preceding his death saw the formation of the Pre-Raphaelite brotherhood and the first clear indication of the rising of romance, which came with Madox Brown (1821-93), Rossetti (1828-82), Millais (1829-96), and Holman Hunt. To Rossetti Scott appeared ' the painter most nearly fulfilling the highest requirements for historic art, both as a thinker and a colourist, who has appeared among us from the time of Hogarth to his own,' and so he may be looked on as in some ways the precursor of a movement which overthrew the existing English school and remoulded it on new lines. And Scott himself was beginning to feel that he might, without sacrificing the essential element of personality, produce good work and yet meet the public more on its own ground. But as it is, his pictures are his own and not another's ; they breathe a particular intellectual and spiritual atmosphere, and hence, whatever their defects, they possess a life and therefore an interest of their own.

When one turns from David Scott to William Dyce it is to encounter a different character and a different art. Dyce (1806-64) was Scott's senior by a few weeks, and he outlived him fifteen years. Born at Aberdeen, where his father was a well-known doctor, Dyce was destined for either the Church or Medicine. But while he attended Marischal College, where he did well and took his M.A., his heart was set on being a painter, and, because of his father's opposition, he studied art secretly. At length, having saved sufficient money, he went to London with an introduction to Sir Thomas Lawrence, who was so struck by his talent that he gained the father's consent to the son's desire, and after working for a short time in the R.A. schools, Dyce went (1825) to Rome, where for nine months he studied the masters, particularly Titian and Poussin. Returning to Aberdeen during the following year, he remained about twelve months, and then went back to Rome. There he came into contact with the German ' Nazarenes,' Overbeck (1789-1869), Cornelius (1783-1867), and the others, who were in the full flush of a fine enthusiasm for early Italian religious art with its naïveté and pure devotional feeling, and gained their admiration by a picture of a ' Madonna and Child.' In a limited degree he returned their appreciation, but if their sincerity of motive and their piety must have been congenial to him, his discipleship to the Quattrocento was tempered by respect for more mature art and

personal feeling for Nature. In 1828 he was again in Aberdeen, but, his choice of themes meeting with little approval, he was thinking of abandoning art for science, when he made a hit with a portrait, which led to other commissions, and in 1830 he came to Edinburgh, where, during the next seven years, he painted more than a hundred portraits, and a number of sacred and mythological subjects. He paid a third visit to Italy in 1832, where he met David Scott, who has left a memento of their companionship in a sketch (Scottish National Portrait Gallery) of Dyce in a gondola, done at Venice. While in Edinburgh he also became associated with the Trustees' Academy, and this connection led to his writing, in collaboration with Charles Heath Wilson (1809-82), a pamphlet on the organisation of schools of design, which induced the Government to ask Dyce to make an inquiry into such schools abroad. His report (dated 1838) was acted upon : the Somerset House school was remodelled, and similar schools were established in local centres. Perhaps more than any one individual, Dyce, who held various appointments in connection with the new system before he finally resigned in 1849, was responsible for the form it took, but he was much hampered by official and departmental restrictions; for while the ' Fine Arts ' were specifically barred, so were subjects like mechanical drawing and perspective. The system thus inaugurated was later transformed, under Sir Henry Cole, into the Science and Art Department, which now bulks so largely in the technical education of the country. The duties of these offices made great inroads on Dyce's time, and his painting suffered in consequence ; but, about 1842, he determined to do some serious study from the life, and Etty (1787-1849) joining in his project, they entered Taylor's school together. This was the prelude to the period of his greatest activity as a painter, and its effects were at once evident in his work. ' King Joash shooting the Arrow of Deliverance ' (Hamburg Gallery),[1] painted shortly afterwards, is one of his finest pictures, and it was followed by a charming Madonna, ' The Virgin Mother ' (H.M. the King, Osborne), remarkable for purity and sweetness of expression, and by the works which he submitted at the Westminster Hall competitions. Ultimately Dyce was selected to paint a trial fresco (The Baptism of Ethelbert) in the House of Lords, which proved so successful that orders were at once given (1846) to different painters for five others, to be carried out in harmony with it. Two years later he was commissioned to decorate the Queen's Robing Room with scenes from the Arthurian Legends, a cycle he had suggested to the Prince Consort as one which Maclise (1806-70) should be asked to carry out ; and, although never completed, it remains his most important work. He also executed frescoes at Lambeth Palace, Buckingham Palace, and Osborne, but next to those at Westminster, the decorations in All Saints', Margaret Street, are, or rather were, for years of London fog have all but obliterated them, the

[1] ' Jacob and Rachel,' and a poetical mountain landscape, are also in the Hamburg Collection.

most interesting. To these latter years also belong a number of fine easel pictures in which the effects of the English Pre-Raphaelite movement can be traced.

A man of wide culture and varied attainments, of balanced judgment and clear perceptions, his art is eminently complete and accomplished. With far less inventive power and originality, with less even of the true painter's gift than Scott, his pictures, while never appealing to the imagination as his contemporary's rarely fail to do, are yet, within their more limited range, accomplished and satisfactory performances. Scott's daring conceptions and strong wilfulness of expression contrast strangely with Dyce's respect for tradition and precept. He was apt to learn, and as a rule he founded himself on good models. Three visits, two of which were of several months duration, to Italy between the ages of nineteen and twenty-six, could hardly fail to influence a youth of Dyce's disposition, especially as he had not been drilled into form in Academy schools, and the impress of Italy is on nearly everything he did.

At that time the artistic community in Rome was much exercised over the work of the young German enthusiasts who, abjuring Protestantism, were attempting to imitate the art and the life, as they conceived them to have been, of the early religious painters. To them, as to the English Pre-Raphaelites, art after Raphael went to Rome in 1508 seemed to have lost its purity, sincerity and truth, in academic accomplishment and mere technical display. But they sought artistic salvation in sacerdotalism and in imitation of the early masters, and not in a return to Nature as Holman Hunt, Millais, and Rossetti set out to do. This atmosphere, quickening as it did interest in mediæval art, and especially fresco painting, had a clear effect on Dyce, but it did not reach him directly through the Nazarenes. His 'Madonna,' already referred to, was painted before he became acquainted with them. Indeed, it was the cause of their coming together; Severn having taken Overbeck, who was followed by others of his *confrères*, to see it. And it may also be taken as an early indication of that temperament which afterwards made Dyce a leader in the High Church movement in England, and led him to promote the revival of ancient church music, in which he was an enthusiast and an expert, by the formation of the Motet Society. The study of the Italian wall-paintings and decorations which Dyce then made, and the knowledge he acquired of fresco, were of great service in his future career. They fitted him, as few were then fitted, for work in connection with the schools of design, and were invaluable in his decorative undertakings at Westminster and elsewhere.

Returning home he found religious pictures unmarketable, and for years had to paint portraits to live. But this seeming misfortune was advantageous to his art; it kept him close to Nature, and perhaps prevented his becoming, like the Germans, a mere imitator of old styles. His portraits, although not strongly marked in character, and lacking the

impress of a clear individuality, are simple and dignified in effect. Reticence of handling, grave yet rich sobriety of colour, and quiet but distinguished design are the qualities his finest portraits possess, and they are those which do not pale with the passing years. But unfortunately his portraiture is little known. The London galleries contain little or nothing which represents this phase of his talent, and, although the 'Dr. Hamilton' in Edinburgh is a good enough picture, it does not show him at his best, at or near the level of 'Sir James M'Grigor,' to name another which is available to the public, in his old college at Aberdeen. It was in painting children, however, that Dyce most excelled, and where —or at least it seems so to me—he was most himself. In such pictures as the exquisite portrait of his young son (Mrs. Benson Rathbone), and the scarcely less charming 'Youngest daughter of Lord Meadowbank' (Mr. Maconochie Welwood), he forgot everything but the charm and beauty of the child before him, and the result was at least two of the most lovely portraits in Scottish art. The 'Infant Hercules strangling the Serpents sent by Juno to destroy him' (1830), and the 'Francesca da Rimini' (1837), both in the National Gallery of Scotland, may be taken as representative of his subject-pictures at this period. The colour is fuller and richer, and more suggestive of Venetian influence than it was later in his decorative work. The handling also is broader, and the detail less elaborate than in such as the 'St. John' and the 'Titian,' where the effects of Pre-Raphaelitism are evident; but the gracefulness of form which was to win Ruskin's praise was an abiding quality in his work. Even then, however, his predilection for religious subjects and paler schemes of colour would assert itself, as in a tempera cartoon for tapestry which in 1836 gained a prize offered by the Board of Manufactures. A comparative blank of several years, during which Dyce's energies were devoted to the cause of art education, now occurred in his practice, but in 1844 he exhibited 'King Joash,' a picture remarkable for firm and fine realisation of detail combined with severity and grace of drawing and design, and, shortly afterwards, he commenced the series of mural decorations which chiefly occupied him until the end.

About 1848 the ideas which had been indefinitely expressed in David Scott's romantic mysticism, in Ford Madox Brown's strenuous realism, and in Dyce's sympathetic apprehension of the spirit of the early religious masters, took definite form in the formation of the Pre-Raphaelite brotherhood, and Dyce was one of the few older artists, and one of the still fewer members of the Royal Academy, who sympathised with the aspirations of the now famous coterie.[1] Holman Hunt especially drew his sympathy, and when in 1850 his 'Christian Missionary,' along with Millais's 'Christ in the House of his Parents,' was being jeered at, Dyce sent for him, congratu-

[1] W. Fred, a German critic, in his study of Pre-Raphaelitism (*Die Prae-Raphaeliten*, Strassburg, 1900), gives the credit of the inception of the movement to Dyce.

lated him upon his picture, and asked him to paint a small copy of one of his own. Later, when the restoration of Rigaud's wall-paintings in Trinity House was placed in his hands, he entrusted Hunt with the work. Dyce himself, although he had not that passion for reality and the essence of things which possessed the brotherhood, was yet powerfully influenced by its expression in their pictures ; and his own, from then onwards, were elaborate and conscientious in detail. This is particularly noticeable in the landscape passages in his pictures, such as the wilderness in the 'Man of Sorrows,' or the setting of the 'St. John,' and in 'Pegwell Bay' (1859), which was singled out by Professor Geikie as an example of perfectly truthful rendering of natural fact. At first Ruskin, who had early constituted himself the champion of the new movement, looked upon Dyce with suspicion, and pronounced 'Christabel' (1855) 'an example of one of the false branches of Pre-Raphaelitism, consisting in imitation of the old religious masters.' Two years later, however, 'Titian preparing for his first Essay in Colouring' drew forth the hearty exclamation, 'Well done! Mr. Dyce, and many times well done!' and he commended it as the first Pre-Raphaelite picture at all affected by a sculpturesque sense of graceful form. But Dyce was still and continued to be influenced by the past, and perhaps it was more the circumstances of his life than any strong originality which made him in some sort the earliest British artist to express the new ideals. Some of his work is more really Pre-Raphaelite in manner than that of the leaders of the modern brotherhood. In 'St. John leading home his adopted Mother' (1860 : National Gallery of British Art) he seems to have been imbued with the spirit of one of the greatest masters of the fifteenth century. The treatment of the draperies, the painting of the faces, and the care and precision of the landscape are evidently inspired by Mantegna. Where this and most of his easel pictures fail is in intensity of personal emotion and direct impression from Nature. He was too apt to see things with other people's eyes, and to embody them in a somewhat similar way.

But possibly the learning and culture of his style and the propriety of his thought fitted him better for the task of mural decoration than the possession of more original and strenuous qualities might have done. He was well on in years before he had his chance, and he all but missed it. As he said sadly to his young friend Holman Hunt, who had congratulated him on being employed to decorate a great national building, ' But I begin with my hair already grey.' And had it not been for the German painter, Cornelius, who, when offered the commission to decorate certain apartments in the new Houses of Parliament, told the committee that it was absurd to bring him over when there was an artist like Dyce available, we should not have possessed what, everything considered, is his most notable work.

It is questionable if the Westminster Hall competitions, which were in

reality an attempt to foster that type of art, heroic and religious in inten-
tion, which has always been an exotic in this country, were justified by
results. Beyond giving Dyce the opportunity of decorating the Queen's
Robing Room, and enabling Daniel Maclise to produce the two great
patriotic panels in the Royal Gallery, all that these competitions did
directly was to give a few men money rewards of some value and stamp
them as acceptable to those in authority. Indirectly, their effect was pro-
bably greater. They stimulated many of the younger men to efforts which
no doubt contributed to their future success ; but they disappointed David
Scott, who was perhaps the greatest man competing, and broke Haydon,
who certainly thought he was. At the same time, British art would be
poorer without the heroics of Maclise and the really beautiful and accom-
plished decorations of William Dyce—each of them, in its own way,
amongst the most remarkable products of their time.

The theme allotted to Dyce was the legends which have grown up
about the English king who held his court at Camelot and instituted the
order of the Round Table. Sir Thomas Malory's *Morte d'Arthur* was
the source from which the incidents were taken, and they were chosen and
designed to illustrate the cardinal virtues of chivalry. After much con-
sideration, and principally through German influence, it had been deter-
mined that true fresco should be used in the work, and although Dyce,
who had had more experience of the medium than any British artist,
thought it unsuited to this climate he had to conform to the conditions.
His objections proved well founded : it was only possible to work at
certain seasons of the year, and the delays due to this and to Dyce's failing
health produced friction between the committee and the artist and pro-
bably shortened his life. Of the seven principal compartments only five
were completed. These are typical of ' Hospitality,' ' Religion,' ' Mercy,'
' Generosity,' and ' Courtesy.' The most successful are those closest in
intention to the Italian art he loved so well : in ' Sir Tristram harping to
La Belle Isolt ' (' Courtesy'), where the influence of Perugino is evident,
and in the ' vision ' portion of ' Sir Galahad and his Company' (' Religion'),
which might almost be part of an early Italian fresco, he is at his best and
very charming. But he is less interesting when he had to rely more on
his own initiative, and the ' Admission of Sir Tristram to the fellowship of
the Round Table ' is only a more refined and better coloured Maclise. As
a whole, however, their merits far exceed their faults. If they do not
possess the austerity and simplicity which are such marked features in the
mural decorations of Puvis de Chavannes (1824-98) and his school, they
escape the too-pictorial effect of much modern decoration. The colour is
not rich, but it is strong and pure and used with great judgment in simple
masses, while the form is at once graceful and dignified. All are marked
by refined taste and accomplished design, and possess a quietude and
dignity in harmony with the purpose of the rooms they decorate. Before

them the eye is satisfied by agreeable colours, refined forms, and sweet expressions, and in absence they recur pleasantly to the memory. In every way they are worthy of a wider fame than they have yet attained.

The decorations in All Saints' occupy the east wall of the church above the altar. The wall is divided by Gothic tracery into three tiers, in the uppermost of which, in the space enclosed by the arched roof, Christ is shown in glory surrounded by golden rays and accompanied by golden-haloed saints. Each of the under compartments is divided into seven panels, three on each side of a larger central one. The side panels contain the twelve Apostles, the upper central panel a Giotto-like Crucifixion, the lower a Madonna with saints. Unfortunately the dim light in which they are placed, and blackening due to city smoke and fog, render them almost invisible. Yet despite this they possess a certain pathetic beauty, and it may be that they were once finer in colour than the better-kept frescoes in St. Stephen's.

To Dyce the decoration of a church was more congenial than the embellishment of a palace. Of all British, one might even say of all recent painters, he was perhaps the one who turned most spontaneously to religious art. His choice was essentially the outcome of reverent feeling, and in consequence his rendering of the sacred narrative is always pure and devout in spirit. To him the temper of the religious artist came almost as naturally as if he had been a fifteenth-century Italian instead of a nineteenth-century Scot. Although David Scott, Scott Lauder, and a few more in his day, and Sir Noel Paton in ours, have painted 'religious' pictures, Dyce is as isolated amongst his countrymen in this field as Scott is in that of imaginative romance. He is as sharply separated from Sir Noel by his pictorial interest as he is from Lauder or Scott by his regard for the spiritual import of the incident.

There is nothing distinctively Scottish about Dyce's art. It possesses neither the merits nor the defects which characterise Scottish painting. Eclectic, like most eclectic art, it is somewhat lacking in character and backbone. It was too much the outcome of culture and learning, and too little the expression of original thought, emotion, and observation to be quite convincing. Not that Dyce was wanting in personality of a kind. His work is coloured by a certain far-off feeling for life, and while he was influenced by diverse schools he compounded them in his art and never imitated directly. In method he occupies a place between the Nazarenes and the Pre-Raphaelites. The Germans despised colour as too sensuous, and concentrated themselves upon that beauty of form of which the Englishmen were too disdainful. Dyce valued both. He added colour to the form of the one and grace to that of the other. He was neither a great original artist nor a great party man, and so nondescript his reputation stands lower than its accomplishments deserve. It is difficult

to grow enthusiastic about his work ; but the innate refinement of his mind, his sense of beauty, grace of draughtsmanship and elegant simplicity of design are qualities which have their own appeal. He was the educated, as contrasted with the artistic, man's ideal of an artist. He had the training and the instincts of a gentleman ; he was genuinely cultured, and had many interests ; above all, he treated literary subjects in a learned way, and did not disturb by startling originality of idea, personality of expression, or a new way of looking at the world. To his connection with the founding of schools of design, and the ability he brought to that task, the education of this country is greatly indebted, and his decorative work, both as painter and as a designer of stained glass, as Gleeson White pointed out, is important in the history of the movement represented by the Arts and Crafts Society.

Amongst his countrymen his art finds its antithesis in that of the painter placed beside him in this chapter. The one was strong where the other was weak. Dyce was a draughtsman and an academic, Scott a colourist and a romantic ; and while the one was master of his ideas through education and accomplishment, the other was little less the master of his although the circumstances of his life left him to the bent of his temperament and the irresistible spur of a great imagination.

CHAPTER VII

LANDSCAPE

I⊤ is sometimes said that the feeling for Nature as a thing by itself scarcely existed in Scottish literature before Sir Walter Scott, but, like many another generalisation, this is only partially true. Applied to Scottish painting, however, the same statement would be substantially correct. Long ere the great magician had thrown his spell upon the people and opened their eyes to the wonder and beauty of the wilds, delight in certain aspects of Nature had found loving and spontaneous expression in Scottish verse. In the 'golden age' of Scottish poetry, in the days of Henryson and Dunbar, of Gavin Douglas and Sir David Lyndsay, this delight had been chiefly in the freshness and gaiety of summer, and in the softer and more ordered kinds of scenery—in trim pleasance of castle, and in tree-fringed meadow melodious with wimpling burn and singing birds. The descriptions of these poets combine the mediæval feeling for the decorative beauty of landscape[1] with that blending of Christian and Pagan allegory typical of the early Renaissance, and the influence of Chaucer and of the classics is evident in their style. At the same time their landscape is northern in many of its features, and their sentiment has distinguishing characteristics—'love of wild Nature for its own sake, love of colour, and wittier and coarser humour,' which Mr. Stopford Brooke describes as Scottish or Celtic. But for the most part Nature was subordinated to man, and served but as interlude or as setting to love idyll or heroic story ; and, as has been indicated, the feeling did not embrace the wilder features and more sublime aspects of the country. Gavin Douglas, however, devotes three of the prologues in his famous translation of Virgil's *Æneid* (1513) to descriptions of Scottish scenery at various times and seasons, even including winter. Vivid in detail, full of colour, and abounding in realistic touches, his word-pictures possess another quality of the greatest interest to students of painting, for the tendency to take in a large sweep and at the same time to over-elaborate detail, which is one of his defects, has been characteristic of much Scottish landscape art also.

The poets between Lyndsay and William Drummond of Hawthornden are of minor importance, but Drummond, although belonging essentially to the aftermath of the Elizabethan outburst, and although less national in

[1] This is very fully expressed in Flemish tapestries and Italian pictures of the period.

sentiment, as well as in style and language, than his great predecessors, reveals a delight in 'sweet solitary places,' which was new in Scottish song. Then for a long while after Drummond, save for snatches in stray ballads and folk-songs, there was silence as regards Nature. It was the beginning of the eighteenth century, indeed, before the old Scottish feeling for this, as for many other things which contribute to the joy of living, again found literary expression. But the revival of the vernacular school of poetry, which then came, issued in Allan Ramsay and Robert Fergusson, and many a minor singer, and culminated gloriously in Robert Burns. Ramsay's *Gentle Shepherd*, charming as it is, is not completely free from the conventional flavour of its period, but the landscape vignettes in which it abounds are delightfully intimate and spontaneous. Yet, admirable as Ramsay's original work is, his services in collecting the floating traditional ballads and songs were no less important. Not only did he save many precious fragments from oblivion, he stimulated a renewed interest in Scottish life and nature, which in turn found expression in song. In the old ballads—written by nameless makers in undated years—while never more than a setting, landscape is introduced with a vividness of perception and a just feeling for significance which are delightful in themselves, and which add greatly to the dramatic impressiveness of the story to which they are accessory. And the same is true in even greater degree of the love songs wherein this element, as all else in the sphere of the Vernacular Muse, reaches its climax in Burns, whose landscape is of course that of the west country he loved so well :

> ' Earth and the snow-dimmed heights of air,
> And water winding soft and fair
> Through still sweet places, bright and bare,
> By bent and byre.'

It is to be noted also that Burns's impressions are full of the spirit of place, and express an emotional and imaginative joy in wild and tempestuous weather such as had not hitherto found voice in Scottish literature.

As regards the feeling for Nature as a thing *per se*, however, the appearance of the poem in which James Thomson describes the cycle of the rural year was of greater importance. It was the first poem, English or Scottish, devoted wholly to Nature ; and, heralding the outburst of delight in Nature which came towards the close of the century, *The Seasons* (1730) marks an epoch in English poetry. Like the Bishop of Dunkeld's, Thomson's landscape is over-diffuse, but it is vitalised by vivid touches drawn from the scenery of Teviotdale, where he had spent his youth, and it is almost modern in susceptibility to effects of light and movement. Fifty years later the fragments of ancient Celtic poetry, which James Macpherson gathered in the Highlands and gave to the world as *Ossian*, brought

a new note into Scottish literature. They are pregnant with the very spirit of the West Highlands and Islands, full of their strange gladness and their haunting sadness. In them the sky is filled with hurrying cloud, white waves beat upon the sounding shore, sea-birds cry, the wind sings in the green woods, and shadows chase one another upon the high hills : or the stormy winds are laid, the murmur of the torrent comes from afar, moonbeams steal through gathering clouds and glimmer upon the grey mossy stones which mark the grave of a hero upon the dusky heath between the solitary mountains and the silent sea. And in this emotional landscape splendid heroes and lovely women and aged bards, half-realised, half-suggested by the glamoured atmosphere, fought and loved and sang and went to death. *Ossian* exercised an enormous influence upon European literature, especially in the sphere of man's imaginative relationship to Nature. In Italy and France, and, above all, in Germany, this influence was potent. But, while Scotland took a great interest in the sudden upwelling of ancient sentiment, immediate effects are difficult to trace, and in any case it was not until the poems and novels of Walter Scott touched the hearts and the imagination of his countrymen that delight in the wilder and grander, as well as in the gentler and more sensuously pleasing, aspects of scenery, and in its romantic or national associations became a more general possession. He was not alone, however. Leyden's *Scenes of Infancy* appeared two years before *The Lay of the Last Minstrel* (1805) ; Hogg (who had a finer and more imaginative apprehension of landscape than his master), Wilson and others soon followed. And in England there was Byron's ecstasy in the mountain glory and the mountain gloom, which he owed in part to the Braemar hills and his Gordon blood ; Shelley's lyric rapture in sky and sea, and far-spreading visions of landscape ; Keats's passion for the world's beauty, and best and most lasting of all, Wordsworth's 'sweet calm.' In depth of imaginative perception and in poetic gift Scott was not the equal of all, or even any of these ; but, as Professor Veitch said, ' He introduced into British poetry an interest in a range of natural objects such as no one had known or felt before,' and in Scotland at least his influence was paramount.

The change of attitude which coincides with Scott's reign was not less than a revolution. Less than a hundred years before, ' A Gentleman in the North of Scotland '[1] could write of mountains as ' a disagreeable subject '—' the clearer the day the more harsh and offensive to the sight,' and ' most of all disagreeable when the heather is in bloom.' To such feelings there is a complete contrast in Scott's ' I like the look of these honest grey hills, and if I did not see the heather bloom once a year I think I should die '; in Hogg's wonderful impressionism of the pastoral melancholy of Border scenery, and in Christopher North's exaltation amid the

[1] Letters written by Edward Burt, 1725-6.

gloom of Loch Etive-head or the solitariness of Rannoch Moor. And with this new feeling of wonder and delight in the sublimity and beauty of elemental Nature there came also a deeper and less material feeling for the flowery pastures and waving harvest-fields of the cultivated districts. To those susceptible to the sentiment, all Nature became a source of joy, and by this renewed and heightened sense of the visible world painting was influenced profoundly.

In the pictures, but even more, if tradition may be trusted, in the theatrical scenery of Alexander Nasmyth (1758-1840), we have the first evidence of the dawn of this feeling in Scottish painting, and from him some of those who were to interpret the spirit and character of Scottish scenery more truly than he received their early lessons in art. His career up to the point when, in 1793, he abandoned portraiture for landscape has been sketched in a preceding chapter, and what remains to be told is for the most part uneventful. Yet, if it was marked by no incident of seeming importance, in his capacity of teacher he did work of sterling value. Not only did he train his son Patrick (1787-1831), John Thomson of Duddingston (1778-1840), and Andrew Wilson (1780-1848), and give advice to men like Roberts, Geddes, and Clarkson Stanfield, who can hardly be considered his pupils, but he also, through the instruction he gave many amateurs, helped to spread an appreciation of art among his countrymen. Indirectly also he influenced John Ruskin. A drawing of Conway Castle made by that great writer's father when receiving lessons from Nasmyth, had, Ruskin tells us, considerable effect in moulding his own youthful ideas and impressions.

The scenery which Nasmyth painted for the theatres in Edinburgh and Glasgow has been eulogised by Roberts and Leitch, both of whom were at one time scenic artists, but unfortunately it has all disappeared, and Leitch's tribute, 'I never saw painting so like Nature,' cannot be paid to his pictures. These owe more to convention than to realism. Many of them represent the seats of the landed gentry with their environing woods and hills, but, being painted for the most part upon commission, they are apt to exaggerate the imposing features of the district at the expense of intimacy and charm of feeling. His uncommissioned work was more spontaneous and freer from exaggeration, and shows a considerable variety of landscape and effect, and a pleasant if unemotional feeling for Nature. But in it the treatment is too generalised, and the sentiment lacks the spirit of place possessed by the finer kinds of modern landscape. Although less important in the history of Scottish painting, his pictures of old Edinburgh streets and houses are probably the most accomplished things he did.

His composition was frequently well ordered on classic lines, his tone was harmonious and pleasant though mannered, and his drawing was careful, precise, and not wanting in character. But in detail his touch was apt to

be formal, and in foliage and such like even tea-trayey; and while his colour possesses considerable refinement and unity, it has, possibly from his practice of under-painting with burnt sienna, little variety, and is, whether the motive be spring or autumn, low, brown, and monotonous in tint. He seems to have founded his method upon the Dutchmen, particularly Wynants and Hobbema, with whose gaiety of spirit he was more in sympathy than with the grave and tender poetry of Ruisdael, but the influence of Claude has also to be reckoned with as regards composition and choice of effect. Yet if a certain elegance of design and tranquillity of lighting may be traced to the latter source, Nasmyth stopped short of introducing purely classic elements, such as temples and constructed ruins, into his pictures, and was true in the main to the elements of Scottish landscape. Still his pictures rarely suggest the atmosphere, colour, and character of Scotland. His preference was for placid sunshine and windless weather, and his colour seldom emerged from the then fashionable brown tone. These were characteristics of his day which he did not escape, and his importance in the evolution of Scottish art consists in the fact that he was the first fairly competent artist to paint Scottish landscape with any regard for truth. The landscape painted in Scotland before his day and by some of his contemporaries was decorative and conventional: Alexander Nasmyth, if he did no more, prepared the way for a treatment into which the natural features and character of the country entered. It is this that justifies the claim made on his behalf by Wilkie, that he was the father of Scottish landscape-painting.

Nasmyth's family seemed to take to art naturally: his daughters and his eldest son were painters, and his youngest son, the inventor of the steam-hammer, left a fortune to the Royal Scottish Academy to be administered for the good of decayed Scottish artists as a whole. While Anne and Charlotte painted pleasing landscape of no great merit in their father's manner, and assisted him in teaching, Patrick (1787-1831) achieved a reputation which gives him a foremost place among British artists who have worked under clearly marked Dutch influence, and an estimate of his work will be found in the second section of this chapter where he is grouped with other men of similar leanings.

If the painting of Scottish landscape as distinguished from landscape-painting by Scotsmen reaped no advantage, and made no advance in the work of Alexander Nasmyth's son, in that of another of his pupils it took a great step forward; for John Thomson's pictures, while still owing much to convention, are in many respects true to the spirit of the country which inspired them, and in many ways forecast the direction which Scottish landscape art has since followed. Born in a manse and brought up, against a strong natural inclination to be an artist, for the kirk—that being the hereditary profession—Thomson is usually accounted an amateur. But he was that only in name. It is true that he received little training beyond

the lessons he took from Nasmyth, while a divinity student in Edinburgh, and that he was popular with his parishioners and fulfilled his clerical duties to their satisfaction ; but his heart was given to landscape-painting, and his accomplishment places him high on the roll of Scottish artists. His first charge was his father's old parish, Dailly, in the charming wooded valley of the Girvan in South Ayrshire, where he had sketched as a boy, and where he continued to paint as an amateur until, in 1805, he was transferred, through Scott's influence, to Duddingston near Edinburgh. There, in the beautiful village which nestles on the loch-side at the foot of Arthur's Seat and looks towards Craigmillar Castle, with its memories of Queen Mary, he made his home until the end. Had he remained in Ayrshire it is probable, so genuine was his love of Nature and art, that he would have gone on painting, but removal to Duddingston brought him stimulus, appreciation, fame. He became a prominent figure in the cycle of Sir Walter Scott ; the manse was a centre for the intellectual society of the neighbourhood ; his pictures were soon in great demand,[1] and when, on account of his cloth, he declined to join the Scottish Academy, he was elected (1830) an Honorary Member.

A quickened feeling for Nature was already in the air, and might have manifested itself in Thomson's pictures had Scott never written, but the spirit of romantic association which after a time directed his choice of subject is clearly traceable to the latter's influence. When one thinks of his landscapes, it is such as 'Fast Castle' (Hon. Mrs. Maxwell Scott : given to Sir Walter Scott by the artist in 1823), perched high on beetling cliffs above the restless sea ; 'Newark Castle' (Duke of Buccleuch), looking out from Yarrow's birchen bower ; or 'The Graves of the Martyrs'—above which the whaups are crying—that flash upon the eye of memory. Yet while this mingling of romantic or historical association with the beauty and significance of landscape, this weaving of the memory of daring deed or calm heroism into one emotional whole with the agitation stirred by sombre cloud and angry wave, or by the splendid or pathetic beauty of the sunset-time, gives a national flavour to many of his most characteristic works, they are pregnant with personal feeling for Nature and especially for those moments in which she reveals her power. Contrast between what had been and what was, between the glamour thrown by romance about the memorials of the past and the continuance of Nature, permeates nearly everything he did ; but while the fierce onslaught of the charging seas upon the steadfast land and the fretting of the tides along the shores pervades his work before 1830, after that he, like Drummond of Hawthornden, found his chief joy in 'the mountain's pride' and 'the stately comlinesse of forests old.' To an extraordinary degree also he seems to have embodied

[1] It is said that for ten years (1820-30) he made as much as £1800 a year by his art, an income probably much greater than has been earned by any other Scottish landscape-painter resident in Scotland.

in paint the feeling for landscape prevailing amongst the distinguished writers of his time. Scott admired him hugely, and in the *Noctes* ' Mr. North' and the Shepherd sing his praises in duet. To the Shepherd his pictures gave ' the notion o' a man that had loved Nature afore he had studied art, and been let intil her secrets when nanc were by but their twa sel's, in neuks where the wimplin' burnie plays, in open spots within the woods where you see naething but stems o' trees—stems o' trees—and a flicker o' broken light interspersing itsel' among the shadowy branches,—or without ony concealment, in the middle o' some wide black moss—like the Moor o' Rannoch—as still as the shipless sea, when the winds are weary—and at nightfall in the weather-gleam o' the settin' sun, a dim object like a ghost, stan'in' alane by its single solitary sel'.' And though to us with our greater sensitiveness to light and colour and motion, or, at least, accustomed to the greater power with which these effects are expressed in the finest kind of modern landscape-painting, this praise sounds excessive, there is no doubt that Thomson's rendering of the character and aspects of Scottish scenery was at once far truer and incomparably finer than any that had preceded or was contemporary with it. While his sentiment was melodramatic at times, and he frequently exaggerated its features to attain grandiose effects, he felt its ruggedness and strength, understood the beauty of its wildness and the pathos of its bareness, and in some measure realised the never-ending wonder of its changing moods under its ever-varying skies.

At first, influenced by the prevailing fashion, Thomson was affected by the Dutch tradition, but, gradually coming to think that Scottish scenery ' was peculiarly suited to a treatment in which grandeur and wildness to a certain extent were the leading characteristics,' he appears to have founded his mature style upon study of the Poussins and Salvator Rosa (of whose work he possessed examples) and of Claude. And perhaps Richard Wilson, and Turner who visited him at Duddingston in 1822, should be reckoned amongst lesser formative influences. The artistic convention thus evolved always imposed itself on his thought, but at the same time he displayed much personality, and his work bears the impress of the romantic movement which has Scott and Byron as its central figures in this country. Less intimate in sentiment, and less regardful of the truth of Nature and the poetry of real light than Constable and the Frenchmen of 1830 who were influenced by him, Thomson's landscape possesses something of the same fine spirit, and R. A. M. Stevenson even ventured to compare him with Théodore Rousseau (1812-67). In reality, however, he was more romantic and less passionate and naturalistic than that great master ; and the romantic melodrama of some of his pictures, such as the ' Castle on a Rock' (Mr. A. W. Inglis), illustrated in Mr. D. S. M'Coll's *Nineteenth Century Art*, bears a remarkable resemblance to certain of Victor Hugo's drawings.

The lack of early and systematic training which crippled Thomson's powers as a draughtsman and prevented him attaining full command of his medium, also accounts for the unsound technical methods which have ruined many of his finest canvases. He was given to using bituminous pigments, and his custom was to paint upon a ground of flour boiled in vinegar, which he called 'parritch,' often insufficiently hardened. But, if an amateur in these respects, he was the greatest Scottish landscape-painter of his time, and the first to seize and express fitly the true character of Scottish landscape. Use of a broader and more expressive manner, although he was more or less subject to it, marked a fuller sympathy with its emotional elements ; his observation, within the range permitted by his convention, was fresh and original ; and he had a sense of the veiling and transmuting effects of atmosphere which was new and personal. Limited for the most part to schemes of deep-toned browns and blues and warm golden greys, his colour harmonies are usually arbitrary in values and more decorative than emotional, yet, associated with his dramatic use of chiaroscuro, they usually express a romantic conception of landscape with felicity and power. At times also the distances in his pictures—the half-revealed, half-veiled hills in 'Castle Urquhart' (Mr. Arthur Sanderson), and the shadowed sea and sky in 'Aberlady Bay' (National Gallery of Scotland) are instances—are bathed in subtly blended and atmospheric grey, and on a rare occasion, as in 'Castle Baan' (Mr. James Mylne), perhaps his most perfect work, this quality is carried right through with great gain to truthfulness of impression and without loss to that decorative balance which seems to have been an integral part of his gift. He was more concerned in the impression of the whole than in the beauty or the truth of the subordinate parts, and in arranging his masses he showed a rare perception of what made for beauty and significance. Pictorial motive united to personal feeling for Nature informs his finest things, and his achievement remains notable not only for the scenes depicted and the associations stirred but for inherent distinction of style. To these qualities his art owes a unity and beauty often denied to more competent and naturalistic work, and his influence upon his contemporaries was principally in the direction of design and subject.

Of Thomson's younger contemporaries Horatio M'Culloch (1805-67) exercised by far the greatest influence upon landscape-painting in Scotland. Born in Glasgow, he, like Roberts and many others who have figured or will figure on these pages, began life as an apprentice house-painter. But he had a natural bent for art, which was stimulated by associating with Macnee (1806-82) and W. L. Leitch (1804-83) at a class conducted by one John Knox (1778-1845), who had a certain local fame as a painter of panoramas. Knox's pictorial work partakes of the panoramic,[1] and is

[1] There are two landscapes of this type in the Glasgow Gallery. His smaller pictures are more successful, and occasionally show Dutch influence, and now and then that of Morland.

indeed a little like the bird's-eye views which were in fashion with the compilers of railway guides a few years ago ; but he had studied under Alexander Nasmyth, and one can imagine that his advice and encouragement were not unprofitable to the three young enthusiasts who met in his studio. Leaving Glasgow, M'Culloch, after painting snuff-boxes at Cumnock, came to Edinburgh, where for two years he was employed by W. H. Lizars, the engraver, in colouring anatomical and other plates. He then returned to the west, and, gradually making his mark as a landscape-painter, was elected an Associate of the Scottish Academy in 1834 and full member four years later, after which he lived in Edinburgh. The subjects of many of his earlier pictures were taken from the scenery round Glasgow, the banks of the Clyde, the Campsie Hills, and Cadzow Forest being favourite sketching grounds ; but later, although some of his finest pictures were still of the rivers and valleys of the Lowlands, he went farther afield, and in the Highlands found the material which pleased him most. This fondness for the North was fostered by his marriage in 1848 to Miss Marcella M'Lennan, of Gillean in Skye.

On the technical side M'Culloch's education was both incomplete and desultory. The only training he had was received from Knox, who had little skill, but he studied the work of his contemporaries, and in some respects his style may be said to be founded on that of Williams, and, specially, of Thomson. This is particularly notable in composition and in choice of subject, although the latter may have been influenced by the far-spreading landscapes of loch and hill affected by his early master. His method, however, inclines more to the Dutch, and therefore to Nasmyth, than to the classic manner, and his characteristic pictures are more elaborate in detail than those of the artist-minister. But he was no less conventional. He replaced a formula of simple masses by one of masses made up of little touches, each of which was in itself a formula for, rather than a suggestion or a realisation of the minor facts. At the same time his intention was more realistic, and in some ways his work, as realisation if not as art, marked an advance. He was more mindful of the actual appearance of things, he took fewer liberties with Nature, and, while his predecessors had worked from sketches (usually, only in black and white, for Williams thought it necessary to mark those coloured on the spot) he often painted in the open.

Passionately fond of 'The land of the Bens, the Glens, and the Heroes,' he revelled in painting lakes and mountains and moorlands, sometimes enriched by the associations which cling round ruined strongholds, or by memories of ancient feuds and battles, but more often in their utter loneliness. The expansive and panoramic specially attracted him. Often his subject was a loch with all its environing woods and hills ; a wide and desolate moorland, strewn with boulders and seamed with moss-hags, and bounded by a chain of mist-wreathed hills ; or a far-spread-

ing valley, with bosky woodlands, scattered homesteads, and clustering villages, ending in a glimpse of far-off mountains or of the sea. To a certain extent M'Culloch retained the power of composition which had marked Thomson, and some of his pictures show a largeness of conception and a sense of design by masses which, had they been expressed in a more distinguished and virile way, would have given them a high place. But his handling, if facile and deft, was neither sensitive nor powerful enough, his impasto was too thin and surfacy in quality, and his drawing and his idea of generalisation too conventional to attain really great results, while his sentiment fell short of the splendid solemnity of the tragic intensity his subjects often seem to demand. Yet his finer things are vitalised by love for what he painted ; at times he hovered on the very verge of a romantic idea, and not infrequently he expressed the character of certain aspects of Scottish scenery with substantial truth. In colour and tone his skies and distances frequently approximate to Nature, but his foregrounds being pervaded by the traditional heavy brown tone, his colour as a whole, never fine in quality and lacking in both richness and atmospheric envelope, falls short of the older convention in decorative balance and charm, without attaining the sparkling realisation of light and the brilliance of local colour, which have been features of more recent Scottish landscape-painting. In short, his art was largely transitional ; but, while it retained many traces of the past, it displayed much more than the germs of future developments.

M'Culloch's work was exceedingly popular and in great demand, and, during his later years, he is said to have put his name to not a few canvases, painted by scholars or assistants, to which he had done little more than add some finishing touches. To mention his more important landscapes would be to catalogue many of the most famous views and beauty spots in Scotland ; and as he is represented in the Glasgow Gallery by a splendid series, and in Edinburgh by two of his finest pictures, such a list would be superfluous. His pictures are little known south of Tweed, but in Scotland his example was fruitful, and even yet, beneath greater truthfulness of detail, colour, and atmospheric effect, there persists in the works of many a somewhat similar feeling for Nature.

Although M'Culloch is thus the dominating figure in Scottish land-scape art during his period, his immediate influence was circumscribed by the tendency of the more ambitious Scots to migrate to England, and by the prevailing preference for a manner of treatment and kind of subject founded upon Dutch or Classic models. Those who showed his influence most clearly added little of their own, and, for the most part, contributed nothing to the evolution of a national style in landscape. In the case of Montague Stanley, A.R.S.A. (1809-44), an interesting personality, and in that of D. O. Hill, R.S.A. (1802-70), much work done for the publishers have preserved names which had hardly floated on the intrinsic merits of

K

their pictures. Yet Hill had more talent perhaps than the rest, and it is possible that if he had devoted to his art the energies so ungrudgingly given to the Royal Scottish Academy he might have accomplished much more than he did. While his designs are usually more effective in black and white than in colour, his handling was often broader and his tone fuller than M'Culloch's. His name is also associated with a painting, containing some four hundred and eighty portraits, commemorative of the Disruption. But more interesting than that work of stupendous patience and misdirected zeal, and more artistic than the best of his landscapes, were the calotypes of many of the most eminent Scots of his day, which he took in conjunction with Robert Adamson. These are among the triumphs of photography, and attain effects so beautiful that they are still the envy and despair of the best photographers. If more modest in scale and intention, some of the loch and mountain landscapes of John Fleming of Greenock (1792-1845) possess finer artistic and emotional qualities. His work is so seldom seen, however, that it is difficult to estimate the real merit of his achievement. But the scenery in which James Giles, R.S.A. (1801-70), set his Border reivers and startled red-deer, the cast-iron hills and petrified moorlands of Macneil Macleay, A.R.S.A. (d. 1848), and the harsh and unsympathetic Highland panoramas of Arthur Perigal, R.S.A. (1816-84), are only so much inferior M'Culloch. Nor need we tarry over the landscapes with which Ewbank (1799-1847), and Fenwick (d. *circa* 1850), varied their far more successful pictures of the sea and shipping.

A much more personal and distinctive treatment of M'Culloch-like subjects appears in the work of John Milne Donald (1819-1866). A native of Nairn, he spent his youth in Glasgow, where he was apprenticed to a house-painter who did a little picture-dealing. Meanwhile he drew at nights from the casts of the Dilettante Society, and, in 1840, managed to copy for a couple of months in the Louvre, after which he was employed for some years as a picture-restorer in London. There he also painted a good many pictures which were much admired, Rogers, the poet, and others holding them in high esteem. But when about five-and-twenty he again settled in Glasgow, this time for good, and devoted himself to landscape-painting. He thus received little or no training, but technically he seems to have modelled his style on that phase of landscape-painting, founded on a modified Dutch tradition, which had influenced M'Culloch, and was practised largely in England; and, considering the few opportunities he had had, he used it with skill and judgment. Although his handling was over-mechanical at times, he possessed no inconsiderable technical freedom and dexterity, and a sound, if undistinguished, idea of design of the old-fashioned kind. M'Culloch once told Donald that he envied him his hands; and Bough is said to have expressed the opinion that he might have been surpassed by the Glasgow artist if the latter had lived longer.

Yet if he continued to build up his pictures on conventional lines, and his rendering of detail remained neat and deft rather than powerful or expressive, he expressed his own feeling for landscape, chose less ambitious subjects and more ordinary effects, and looked at Nature inquiringly and for himself. Association with Bough (1822-78) may have had some influence in these directions, but Milne Donald possessed instincts and eyes of his own, and, judging from the dates on his pictures, he had probably started upon his later development before the ex-scene-painter settled in Glasgow. In any case the best of his work is quite individual in character, singularly simple and direct in its rendering of Nature, and completely free from the scenic quality which vitiates much of Bough's far more effective landscape. After emerging from the transparent browns and somewhat forced chiaroscuro of his earlier style, his colour was much franker in intention and more real and atmospheric in effect than that of M'Culloch. Perhaps he was over-fond of a not very pleasant yellow-green in grass and foliage, and his colouration lacked vibration and quality ; but, without being correct in tone, or true as absolute, or beautiful as abstract colour, his later pictures reveal a closer study of the actual hues and lighting of Nature than had obtained hitherto. His feeling for Nature also, if somewhat commonplace and uncoloured by poetic apprehension, was simple and sincere. Many of his subjects were Highland, but, as a rule, he preferred the fringes of the wilds and the close touch of human habitations to the rugged and stern grandeur of granite mountains and the drear silence of desolate moors. The wooded banks of Clyde and Kelvin, and the lovely country traversed by the old Luss road, supplied motives for many pictures, and his happiest efforts are rich in suggestion of their charms.

It was Donald's misfortune to be little appreciated in his lifetime. Having to sell his pictures at small prices, he eked out an income by painting landscape panels as decorations for Clyde-built steamers, and, although far abler than many who were chosen, he died unrecognised by the Scottish Academy. Yet his influence on landscape-painting in Scotland, particularly in the west, was considerable, and his work is now regarded as forming an important link in the history of his school. Excepting Graham Gilbert, the portrait-painter, he was the first artist of real ability to spend his whole life in Glasgow, and Docharty and others who bring us down to the comparatively recent time, when new artistic ideals blossomed there, owed much to his example.

One may easily over-estimate the influence of literature and painting on one another, for artists are often little interested in any art except their own, and when new ideas appear contemporaneously or almost so in both arts, they are usually a result of a general intellectual movement expressing itself in different forms. But in the case of Scott, who was read and admired so universally, it is possible to trace a more or less direct connection. In the interval between the time when Nasmyth

forsook portraiture for landscape and M'Culloch's advent as a painter, the influence of Sir Walter's genius had assumed full sway. It revealed itself in a popular passion for the romantic past, and in the beginning of that ever-gathering crowd of tourists who stand upon the Silver Strand, visit Rob Roy's country, and even go to Melrose Abbey by 'pale moonlight.' And in painting, as was but natural, there immediately appeared the figure-painters with their incidents from the poems and novels and the national history, and the landscape men with their versions of that

> 'Land of brown heath and shaggy wood,
> Land of the mountain and the flood,'

which Sir Walter loved so passionately that he even taught others to see its beauties with his eyes. Thomson had felt, not only from the writings but from personal contact, the impulse of Scott's enthusiasm for Scotland and its story, and it is a notable fact in his choice of subject that the earlier pictures he exhibited were 'landscape composi- tions' with no particular associations, and that it was not until 1824 that he showed his first picture of a Scottish castle. But he had a personal view of Nature which was strong enough to assert itself, and the pictorial tradition in which he walked, while it bound him in some ways, safe- guarded him in others. M'Culloch was less personal and at the same time less restrained, and in the conception of landscape expressed by him and his followers one can see the influence of Scott clearly. To the essentially dramatic genius of the author of *Waverley* the vivid and spectacular aspects of Nature made most appeal ; and while he loved Nature and the sense of freedom it brought, it was not so much its spirit and significance as the romantic associations it conjured up that charmed. He possessed a wonderful power of description, and there are passages, particularly in his poems, which are perhaps unsurpassed in literature as direct transcripts from Nature. But they are surface-painting when com- pared with the exalted passion and imaginative insight of a Wordsworth or a Meredith ; and the *Quarterly* reviewer who remarked that Scott's descriptions are 'portraits,' contrary to his intention, indicated their weakest element. For art, whether in poetry or paint, is not description or imitation of reality, but expression of the essence of being which resides in it. Yet it was in the former direction, and in choice of scenes either exceptional in themselves or haunted by historic association (which has but a remote relation to pure landscape sentiment) that the painters followed Scott. His descriptive poetry, however, has an advantage over their pictures which does not belong naturally to his medium. He achieved finer, truer, and more beautiful colour effects. To a certain extent this power was a personal gift, but it was shared by Leyden and Hogg, and in exercising it he was but carrying on the tradition of early

Scots poetry. On the other hand, the painters were struggling with a medium hardly yet nationalised, and as regards manner at least largely derived from schools stronger in tone than colour. Still the earlier Scottish landscape artists possessed something of Sir Walter's simple and earnest delight in wild Nature, and their successors have given this feeling expression with increased directness and fullness.

So far Scottish landscape-painting, as a whole, had been more panoramic than intimate, and more descriptive than emotional. In Thomson of Duddingston's work there was indeed poetic motive, but while M'Culloch occasionally came near being romantic, he, as a rule, was merely rhetorical, and almost every one influenced by him had touched the outside of Nature only. The feelings expressed were simple and sincere enough, but they were shallow and unimpassioned. In the landscape of Sir George Harvey (1806-76), however, we have the beginning of a deeper and more personal feeling for the spirit of Scottish scenery, and with J. C. Wintour (1825-82) we pass into regions of romance. As Wintour was only beginning to emerge between 1850 and 1860, he belongs more properly to a later time, but Harvey, although his landscape was painted principally after the century reached its meridian, finds his true place here.

It would be as misleading to describe Harvey's genre pictures as distinguished as to call them commonplace.[1] While his conception of incident was the popular one, he added qualities of his own which make his pictures significant and interesting. But it was in landscape, or in pictures in which landscape formed a leading motive, that he most excelled. Much of the solemnity and emotional appeal of his Covenanting scenes is due to impressiveness and significance of landscape setting, and in his later years figure interest played an ever decreasing part, until in such pictures as 'The Enterkin' (1846), 'Glen Dhu, Arran' (1861), and 'Inverarnan' (1870), it all but disappeared.

Harvey's landscape possesses in considerable measure that sense of the spirit of place, which always marks the finest art. Sometimes sympathy had led Thomson to the fringe of this subtle sentiment, but in Harvey's work we find it at once more intimate and dealing with unnamed spots. So fragrant are his pictures with the essential charm and character of the scenery he loved that they appeal to the heart almost as closely as if they depicted places consecrated to us individually by personal memories. No doubt the landscape in 'We twa hae run about the Braes' (1858) was painted in a particular locality, but it awakens recollections of many a happy day by mountain streams. It is pregnant with the gentle fascination which haunts the burn-sides and the tiny hopes of the Border hills. A spirit of tender gravity exhales from his landscape, for communion with Nature had brought him something of that 'sweet calm' which Matthew Arnold so justly fixed upon as the essence of Wordsworth's poetry.

[1] See page 112.

Although not escaping from the brownness of his early environment, his colour is harmonious and refined in tone, and on occasion rich and beautiful in hue. But his compositions are wanting in the dignity of Thomson's, or even of M'Culloch's, and his drawing of detail, though more correct than theirs when he chose, is conventional and little more searching in character.

Decorative design, or construction of a distinctly realistic kind, his landscape does not possess. But more than any of his contemporaries Harvey felt the relationship between earth and sky and the fusing influence of atmosphere, and he attained, in such pictures as 'Sheep-Shearing' (1859), a truth and subtlety of aerial effect new in Scottish Art. One result of this, as was pointed out in connection with his subject-pictures, was the greater formlessness of these, his later works, but with him landscape-painting was the issue of feelings so deep and tender that such deficiencies are of minor account. He realised the pensive charm and pastoral melancholy of the Highland straths and the Lowland hills with an insight and sympathy which make recollection of his landscapes a precious possession. And with this promise of closer regard for Nature's truth and modesty and this earnest of deeper sympathy with her moods, we may leave the older painters under whose impulse Scottish Art became a medium of expression for Scottish emotion regarding the landscape of our native land.

II

During the time the movement towards a national and natural style in landscape just described was taking place in Scotland, a number of Scottish painters were devoting much of their talent to illustrating the scenery and monuments of foreign lands, and others preserved so much of the Dutch manner of painting and way of looking at Nature, that they contributed little to the advance marked by the work of Thomson of Duddingston, Horatio M'Culloch, Milne Donald, and Sir George Harvey. The break between the two classes is of course much less marked in reality than this sudden opposition suggests. In the beginning it was more a difference of subject than of style. Nationalist painters like Thomson and Donald employed respectively very similar artistic conventions to Williams, who painted the classic scenes of Greece, and Patrick Nasmyth, who found his inspiration in English hedgerows and commons. Gradually, but scarcely in the earlier part of the century, to which our attention is at present confined, Scottish landscape-painting became more defined in colour, lighting, and handling ; but, meanwhile, it was sentiment and subject which differentiated it most clearly from other contemporary landscape work.

In many respects the art of Hugh William Williams (1773-1829) resembles that of his friend Thomson of Duddingston. Founded to a great extent upon the same convention, it possesses a somewhat kindred character. But, while Thomson's principal work was done in oils, and

dealt with Scottish scenery and story, Williams was essentially a water-colourist, and the memories awakened by his drawings are of Hellas and the South. Like Phillip, partiality for a country earned Williams a name, and 'Grecian Williams' is as indicative of the one's inspiration as 'Phillip of Spain' is of that of the other. Born on board his father's ship on the high seas, he was legally a native of Wapping; but, as his father was a Welshman, and he was brought up by an Italian step-grandfather in Edinburgh, and made his reputation as a painter of classic scenery, he was perhaps as near being cosmopolitan as one can be. In any case, Scotland's share in him and his art is such that he is more at home in a chronicle of Scottish painting than elsewhere.

Williams was destined for one of the professions, but his grandfather, having discovered his talent for art, encouraged him to become a painter. How and where he studied is not on record, but he first came into public notice in Edinburgh as a contributor to the exhibitions of the Society of Associated Artists from 1810 to 1816. As early as 1808, however, and the fact seems to imply that his work had previously attracted some atten- tion in London, he had been one of those who joined 'The Associated Artists in Water-Colour' when that short-lived body was founded as a rival to the 'Water-Colour Society.'

Beginning the practice of his art when water-colour was still the province of the topographical artist, and just before Girtin and Turner commenced to add greatly to its expressive power, Williams's earlier work is of the nature of tinted drawing. His colour harmonies were restricted to tints of brown and grey and blue and blue-green superimposed upon a chiaroscuro ground, and, though he now and then escaped into a surpris- ingly broad manner of treatment, as in the 'Glencoe' (1812), and, later, used a fuller and warmer palette, his mature style continued to bear evident traces of his early environment. It was not, however, until a lengthy sojourn in Italy and Greece that he discovered subjective material exactly suited to his taste, and produced the long series of drawings with which his name is associated. Although the object of his book, *Travels in Italy, Greece, and the Ionian Islands*, published by Constable of Edinburgh in 1820 and dedicated to the Rev. John Thomson, was not to enter into disquisitions upon archæology or history but to describe the countries, scenery, and peoples as they appeared to him, 'the pictorial representation of external Nature,' to quote Lockhart, 'when linked with no subject of human action or passion,' seems to have had comparatively little charm for him, and when, two years later, he held an exhibition of his southern water-colours in Edinburgh, the catalogue teemed with quotations from the classics and the great English poets. Probably it was the glamour of the associations thus stirred that caused Lockhart to describe him as 'one of the most original, one of the most impressive, and one of the most delightful of painters.' But on purely artistic grounds his work has

definite charms. It is always accomplished and usually picturesque. His design, often exceedingly good in light and shade, is at once effective and dignified ; his drawing sensitive, and, as regards architecture at least, constructive ; his colour, within its range, refined and expressive. Occasionally influenced, specially in composition, by his great contemporary Turner, and now and then handling his medium with a force and fullness that reminds one of De Wint or David Cox, whose elder he was by a decade, Williams was mainly himself—a disciple of the classic convention and a believer in an ordered aspect of result. His more characteristic drawings, of which there are many in the Scottish National Gallery, are executed, as has been said, in broad transparent washes over a carefully pencilled outline, and, notwithstanding the fullness of tone he sometimes attained, he may be said to have been a worker in tinted drawing rather than a water-colour painter in the modern sense. His work deserves more notable mention in the history of the earlier water-colour school than it has received usually, and, in Scotland at least, his position as a pioneer of a delightful art deserves full acknowledgment.

To Andrew Wilson (1780-1848) Italy meant even more than Greece did to Hugh Williams. It was a lodestone which drew him southward again and again. Born in Edinburgh, he, after a short time with Nasmyth, went to London, and a few years later found his way to Italy, where he sketched in Naples and Rome, and, by close study, laid the foundation of that knowledge of the old masters which afterwards enabled him to secure and bring to this country many masterpieces of ancient art. This was the intention which took him back to Italy almost immediately after his return, and he attained his object, for among the pictures he then bought were the splendid Bassano in the Edinburgh Gallery, and the 'Brazen Serpent' by Rubens in Trafalgar Square. Back again in London, he painted Italian landscapes from his sketches and acted for some years as a drawing-master at Sandhurst ; but, being appointed master of the Trustees' Academy, he returned to Edinburgh in 1818. As a teacher he had no very marked success ; but he greatly extended the collection of casts commenced by Graham, and the influence of his fine taste may have counted for much to such pupils as Robert Scott Lauder and William Simson. At the end of eight years, however, longing for the South asserted itself so strongly that he resigned his mastership and thereafter, except for the brief visit to England during which he died, Italy was his home. While in Edinburgh he had become closely associated with the Royal Institution, acting as manager of its exhibitions, and when about 1830 it was determined to form a collection of pictures as a nucleus for a National Gallery for Scotland, Wilson was asked to purchase works in Italy. Sir Robert Peel, Lords Pembroke and Hopetoun, and other collectors also employed him to acquire pictures for them. Of the pictures which he painted himself during this period many have never been seen in this country.

Long residence in Italy left a distinct impress on Wilson's art, and his pictures of Scottish scenery are wanting in virility and artificial in effect. Delicacy, more than power, was the characteristic quality of his technique, and perhaps he is best seen in water-colours or in the pencil-drawings of Italian architecture and scenery of which he made so many. Still his pictures are often suffused in a gentle golden light, like that of a warm autumnal afternoon, in which outlines are softened and contrast subdued; and they are almost always informed by a refined perception of the pathetic element in tranquil beauty.

Another Scottish artist of this period, who made a reputation as a painter of foreign lands, is much more widely known than Wilson. The son of a poor cobbler in Edinburgh, David Roberts (1796-1864) was early apprenticed to a house-painter, and, when his time was out, widened his experience by becoming scene-painter to a troupe of strolling players. After again working at the domestic part of his business, he was engaged to paint scenery for the theatres in Glasgow and Edinburgh, where he met Clarkson Stanfield (1793-1867), and in 1822, having secured an engagement at Drury Lane Theatre, he settled in London. There he again met Stanfield, and the scenery they painted together brought them considerable notice and greatly improved Roberts's financial position. He now gradually abandoned the theatre and devoted himself more and more to picture-painting. Before leaving Scotland he had exhibited several architectural pieces, and in 1824 he joined the British Artists, whose vice-president he became. In 1836, however, he severed his connection with Suffolk Street, and, two years later, was elected A.R.A., full membership following in 1841. Meanwhile several short trips to the Continent had whetted his appetite for foreign travel, and in 1832-3, acting on Wilkie's advice, he spent a considerable time in Spain and Tangiers. In 1838 he went to Egypt and the Holy Land, where in less than twelve months he made sketches sufficient to keep him working for ten years; and in 1851, and again two years later, he visited Italy, which supplied him with subjects for the following decade. Shorter visits to the Continent were made in the intervals between the greater journeys, and in this way he saw and sketched most of the historic scenes of the Old World. The results of these many wanderings exist not only in the pictures he painted, but many of the water-colours made on the spot were lithographed and issued serially, in which form they became highly popular and brought him a considerable fortune. During his last years he stirred less from home, and he had commenced a series of pictures of London as seen from the Thames, when death brought his manifold labours suddenly to an end.

A week's attendance at the Trustees' Academy enabled Andrew Wilson to claim Roberts as a pupil; but he was self-taught, and the determining influences in his art were his early experiences as a decora-

tive painter and a scenic artist. These trained him to free and rapid execution. To a certain extent, also, they formed and limited his ideal of pictorial effect. Strictly conventional, his work neither expresses a personal mood nor gives a rendering of a particular atmospheric effect upon a scene. Still there is a simplicity, both of handling and effect, in his pictures which is pleasing, and his interest in architecture was real. Too frequently, however, they have the look of studies for architectural restoration. The softening and mellowing effects of time are rarely expressed, with the result that much of the charm of association is stripped from the venerable buildings and the storied cities he depicted. But his drawing of architecture is wonderfully intelligent, and usually informed by a sense of the essential construction underlying the detail which he frequently elaborated with great care.

Roberts's way of looking at things being that of the scene-painter, modified by an interest in architecture, his tendency to the conventional was intensified by his habit of working from sketches. This is particularly evident in those pictures in which landscape plays an important part, for he had little feeling for the subtleties of the atmospheric envelope or the play of natural light. He was happiest when dealing with interiors, and when he confined himself to a modest-sized canvas. And yet even here lack of sympathy with the beauty and revelation of light deprived even his most gorgeous cathedral interiors of the significance and poetry which Bosboom (1817-91) by its possession evoked from the simple plainness of a Dutch village church, or the rudeness of a country barn or workshop.

Although Roberts was not a colourist in any real sense, his earlier work is harmonious in its quiet schemes of brown and white, and quite a number of his Spanish and Moorish pictures show some skill in the management of more varied combinations. But the visit to the East, or rather the great number of pictures he painted from sketches then made, increased his inclination to arbitrary colour, and his attempt to gain effect by the introduction of gaily costumed figures was often unsuccessful, because they were introduced without due regard to the actual lighting of the picture. In his Italian period his colour became still colder and blacker, and when, in 1855, he showed his panoramic picture of Rome (National Gallery of Scotland), Ruskin warned him that he was fast becoming nothing more than an Academician. Yet it was not always so. Some of his Italian interiors, such as the ivory and golden-brown lacquer-coloured Milan Cathedral, in the Sheepshanks Collection, are as charming as anything he did. As a draughtsman he excelled in expressing architectural features with something of the accuracy of a mechanical draughtsman (he used ruler and set-square freely) combined with the more comprehensive and beautiful vision of the artist. Many of his Spanish subjects are charming in the delicacy and suggestiveness with which Moorish fretwork, jutting balconies, and picturesquely varied roof-lines are rendered ; some of his Gothic

churches unite richness of detail with breadth of general effect; and although never more than accessories, his figures are often touched in with great spirit. He also excelled in composition, choosing his standpoint happily, and frequently using light and shade in an expressive and delicate way. And if his brushwork lacked beauty and variety of impasto and was often thin, it was simple, direct, deft, and the methods and mediums he employed were sound and have stood well.

Roberts is the only Scottish painter of importance who has devoted himself to painting architecture, while amongst British workers in that genre, if Holland was more pictorial in manner, he holds the foremost place. At present his art is rather out of favour, but, in addition to subjective interest, it possesses, when dealing with the effects and materials he best understood, sufficient artistic quality to ensure it a permanent and honourable place in the achievement of his school.

Like Roberts, William Leighton Leitch (1804-83) began an artistic career by serving an apprenticeship as a house-painter and by painting theatrical scenery, and to an even greater extent than Roberts's, his work betrays the influence of early associations. His landscape usually looks as if it had been painted as a setting for romantic opera. With M'Culloch and Macnee, he received some instruction from Knox in Glasgow, but his style was formed to a great extent in the theatre and by associating with Roberts and Stanfield, who had been scene-painters. Foreign travel had an influence also, and the calling of drawing-master, which he pursued with great success for many years, had no doubt its effect in limiting the development of his considerable natural gifts.

Leitch has been described as 'perhaps the last of the classical landscape-painters, and certainly the last of the great English teachers of landscape-painting.' But while ordered upon classic lines and well balanced in line and mass, his compositions lack that breadth and dignity in the carrying out which gives distinction to those of Williams (to confine comparison to Scottish painters), with whom he may be more fitly compared than with Thomson of Duddingston, who possessed a finer and more original outlook, and a passion for Nature for which one looks in vain in the work of Williams and Leitch alike. Chiefly a water-colourist, and influenced by the late work of Turner with its marvellous range of colour and effect, Leitch's colour is much more varied than that of Thomson, Williams, or M'Culloch, but at the same time it inclines to be garish and spotty, and is not fused and graded in atmosphere as was that of his great exemplar. His method also was rather that of the skilled drawing-master, to whom every trick and turn of the medium, as used to express a certain definite, if wide, range of effects, is known, than that of the creative artist whose handling varies and is ever responsive to each successive aspect of imaginative apprehension. Still, when these discounts are made, Leitch's work remains interesting, and, in its own way, attractive. It is

scenic, of course, and suffers from the obvious and artificial picturesqueness inherent in scene-painting, but Leitch was a student of Nature and of style as exemplified in the art of the classic landscape-painters, and these qualities combine with his dexterity in water-colour and his powers of design to give his drawings definite character. But perhaps just because of this completeness of competence, his water-colours, judged from the point of view of emotional expression, are less satisfying than some of his oils in which technically he seems to have been less at ease. Numerous specimens in the Glasgow Gallery exemplify both his treatment of Scottish landscape and of the Italian scenes, which are in many ways the most characteristic expression of his talent.

It is in relation to Leitch, of whom he was a pupil, that Mr. James Orrock (b. 1829) should be mentioned, for his water-colour drawings are obviously related to those of the older school, and reveal very clearly not only the influence of his master, but of the earlier English masters of landscape, of whose work he has been a keen and discriminating collector.

William Simson (1800-47), already mentioned as one of Wilson's pupils, began as a landscape-painter, and it is principally for his landscapes that he is remembered. The son of a Dundee merchant, who was greatly interested in art and whose three sons became artists, his earliest pictures were of the coast and inland scenery about Edinburgh. But in 1827 he visited the Low Countries and painted a number of Dutch and Belgian subjects, which gained especially the admiration of his fellow-painters, Sir W. Allan, R. S. Lauder, H. W. Williams, and Sir Francis Grant being amongst those who purchased landscapes. A year or two later he was engaged upon portraits, some of which were groups of sportsmen on the moors, and also in painting dogs, for which he showed very considerable talent. Circumstances now permitted him to visit Italy, where the years 1834-5 were spent, and in 1838, having worked in Edinburgh in the interval, he settled in London. From then onwards his principal pictures were historical, with such subjects as 'The Murder of the Princes in the Tower,' and 'Cimabue and Giotto' (1838), 'Salvator Rosa's first Cartoon on the Wall of Certosa,' and 'The Temptation of St. Anthony' (1844). Wilkie had a high opinion of his ability, and, on that artist's death, his executors asked Simson to finish the portrait of the Sultan Mohammed, and gave him a hundred guineas for doing so. It is usually held that Simson made a mistake in abandoning landscape for figure subjects ; but on this point I am not certain that I am entitled to any opinion, for I am much more familiar with his work as a landscapist. At the same time, it seems to me that, while he never achieved such marked success in figure, his work in that field is frequently successful and often possesses the quality of beauty in a degree rare in that of Scotsmen of his time. Some of his portraits of women are quite charming, and subject-pictures by him passed into such collections as the Peel, the Lansdowne, and the Sheep-

shanks. Shortly after his death a series of lithographs from his drawings was made and published by his brothers. Principally studies of Highland peasants and gillies, it also includes two lovely sketches of children and two clever drawings of dogs ; and on the whole one is inclined to think that his ability to draw is more evident in them than in his pictures.

He died at the age of forty-seven—not old enough, perhaps, to have revealed the whole extent and quality of his gifts, and yet too old to be enshrined with those great in promise prematurely cut off. But, although represented in the Edinburgh collection by three or four admirable examples, his art has not received the attention it deserves. His name does not appear in Sir Walter Armstrong's interesting essays on *Scottish Painters*, and in Mr. Brydall's more elaborate *History of Art in Scotland* he is separated from his *milieu* and figures among later men in a biographical appendix. Of all Thomson of Duddingston's contemporaries Simson approached him most nearly in charm of sentiment. Perhaps his landscape was slightly lacking in strength. It was the quiet beauty rather than the lustiness or power of Nature that he loved. To him the desolation and vastness, which held Thomson enthralled, made little appeal ; but such a picture as the 'Solway Moss' is pregnant with meaning and beauty. The benediction it breathes is as significant as the turmoil of winds and tossing seas. But then 'Solway Moss,' by which he is represented in the National Gallery of Scotland, is by far his finest work.

Technically there is evidence of a modified Dutch influence in his style. This is apparent in his shipping scenes, and also in the manner in which he introduced figures and animals into his pastorals, and, although his drawing lacks the precision, his modelling the solidity, and his rendering of light the keenness of the Dutch masters, Simson bettered most of them in suggestiveness, colour, and intimate feeling for Nature. The landscapes painted before he went to Italy are higher in key and more aerial in effect than was usual, and the colour possesses a peculiar sweetness and clarity as if it were on a base of tarnished silver. Later, in some pictures dealing with the landscape and shepherds of the Roman Campagna, he became richer and fuller, both in tone and actual colour. There is at least one little sketch of this type which, in decorative charm, force of colour, and beauty of arrangement, reminds one of Diaz.

Simson was somewhat isolated amongst his contemporaries, and in virtue of his personal treatment of certain aspects of Scottish landscape he might almost have found a place in the preceding section as appropriately as here.

Turning to those Scots whose work, not only in handling and tone but in type of subject and even in the view of Nature expressed, was influenced very definitely by Dutch example, Patrick Nasmyth (1786-1831) has first claims on our attention. Dutch influence is far more marked in his art than in that of his father, whose pupil he was, and as he usually

treated subjects with which that convention is more in harmony than is the wild scenery of Scotland, and possessed considerable technical skill, his success was greater and his reputation stands higher. But as a man he cannot be compared with his elder. He was fond of low company and he was given to drink. For these habits he had the excuse that deafness cut him off from society, and want of inclination from books, and it does not seem as if they had interfered much with the quality of his work.

Going to London early in his career, Patrick Nasmyth found in the scenery of the home counties the type of landscape which suited him, and the method he had derived from his father. Although his ideas were of the prosiest, and it is rare that a picture of his suggests mystery or romance, his feeling for Nature was genuine of its kind. In a quiet unemotional way he delighted in the green lanes, hedgerow trees, and slow-running streams of the south ; he was pleased with the white clouds piling up in the blue and with the sunshine playing over the fringes of the common : but he never quickens one's perception of these homely beauties or gives one a more intimate sense of their reality. His formula is never vitalised by strong personality of observation or thought. It is this which differentiates Patrick Nasmyth from a master like Old Crome (1768-1821), who was also influenced by the Dutchmen. No one thinks of calling the Norwich painter, as we do the Scots, the 'English Hobbema,' for he was a greater master than the seventeenth-century painter to whose work his technique owed much, although not so much as has often been assumed. Crome added elevation of sentiment and breadth of handling to the Dutch convention. Nasmyth was simply an understudy. In that he resembles James Stark (1794-1859), one of Crome's pupils, who by the way was of Scottish extraction, although his art is too detached from Scotland and too closely associated with the 'Norwich group' to be included in this history. While Nasmyth's handling and choice of subject recall Hobbema and almost deserve the compliment of the name they earned him, he was deficient in that liveliness of spirit and of manner which are the charm of the Dutchman's work, and he never approached the originality and distinction of composition of such a landscape as 'The Avenue' in the National Gallery. The skies in his pictures have been praised for their truth and beauty, and in contrast with the dark landscapes over which they float they seem clear and bright, but they are monotonous in colour and wanting in sense of motion. His painting of foliage again is neat and conventional, and he was usually over-brown in colour, especially in the foregrounds with their balancing groups of trees, which are forced to throw up the distances and make them more aerial in effect. Neither the spirit nor handling of his work gains one's affections, and yet in his own way and in the fashion of his own day he was an accomplished painter. His colour, if negative and

monotonous, is frequently pearly in quality; his handling, if small, is refined and craftsmanlike; and these qualities added to a certain charm of serene lighting, which was usually his, make his art at least good of its kind.

With the Burnets, the predominating influences were Cuyp and Paul Potter. John's landscapes have been mentioned already in connection with his Wilkie-like genre. They are pleasing English versions of the cattle and meadow pieces of the Dutch masters, carefully drawn and delicately painted, but showing originality neither of outlook nor of handling. If less accomplished, the pastorals of James Burnet (1788-1816) reveal greater promise. Following his elder brother south in 1810, he devoted himself to painting rural scenes with figures and cattle, but died at the age of twenty-eight before his style was fully formed. He loved tranquil and delicate morning and evening effects, and, although tentative in character, his treatment is marked by considerable intimacy of feeling, and the incidental interest in his pictures is usually appropriate and true. The interest of the work of Robert Gibb (1801-37) is different. Wholly artless, its only merit consists in the evident sincerity with which the painter tried to set down the simple facts of the landscape about Edinburgh. Alexander Nasmyth described him as the chief of the 'docken school,' but, feeble as his work is, the jibe misses its mark, for it indicates that Gibb was trying to attain greater naturalness of detail. The very crudeness of his colour resulted in part from an attempt to paint grass and trees green.

Although some twelve years older than Patrick Nasmyth, John Wilson (1774-1855) was more modern in spirit and even in manner. 'Old Jock,' as he was called familiarly, was born in Ayr, and, after serving an apprenticeship to Norie, the Edinburgh house-painter, received a training from the elder Nasmyth which enabled him to teach in the neighbourhood of Montrose for some time and then go to London as a scene-painter. Like Roberts, however, he abandoned that calling, and it is as a painter of pictures that he figures here. He worked vigorously to the end, and died, within sight and hearing of the sea, at Folkestone, where for many years he had made his home. There, and on the shores of France and in navigable rivers of Holland, he found material for many of his most characteristic works dealing with the sea and shipping. Between 1807 and 1855 he exhibited five hundred and twenty-five pictures in London exhibitions (seventy-five at the Academy, one hundred and forty-nine at the Royal Institution, and no less than three hundred and one at the Royal British Artists, of which he was an original member), and many at the Royal Scottish Academy, of which he was an honorary member.

Wilson's work is more effective superficially and at a distance than when examined in detail. He was a careless draughtsman; his wave-forms are rather conventional; the cattle and horses with which he enlivened his

shore pieces are sometimes mis-shapen ; his figures are too often clumsy ; even his shipping, of which he possessed much knowledge, is not what it might easily have been. No doubt much of this was due to inadequate training and haste begot of much scene-painting, but in spite of obvious defects his art remains a vigorous and vital performance, and, if one can claim no more for him, he was more in sympathy with the sea than any Scot of his day except John Thomson. Fond of sharply contrasting effects, he delighted to flood one half of his picture in light or sunshine while the other was shrouded in darkness and gathering storm. A certain breeziness marks his work, and it has something of the spaciousness and unrest of the sea, often gained, however, more by effects of light and cloud than by the handling of the salt-water itself. The skies in his pictures are indeed finer and truer than the seas they overspread, and as a rule he chose a low horizon line. At its best his colour possesses a pleasant quality of silvery grey, but when he approached red it was apt to become hot and bricky, although owing to the swiftness of his touch and the clarity of his pigment it is rarely crude. His son, John James Wilson (1818-75), painted similar subjects, and was almost as prolific. Between them they were responsible for over a thousand entries in the catalogues of the three chief London exhibitions, and without a date or a signature it is often difficult to decide which of them painted a particular picture. As a rule, however, young Jock's work is harder and less facile, and, while somewhat fuller in colour, less atmospheric in effect. More than the old man, he varied his sea-pieces with landscapes and farmyard scenes.

Four years later than the elder Wilson, John Christian Schetky (1778-1874) was born in Edinburgh. But he (there was a younger brother, John Alexander Schetky, a surgeon in the army but also something of a painter) was the son of a foreign musician who came to Scotland in 1772 and played the 'cello in the Edinburgh Musical Society ; his art career was passed in England ; and, beyond some lessons from Nasmyth, he owed nothing to Scottish Art. His subjects were the achievements of the British fleet, his manner was an impersonal version of second-rate Dutch, his colour was negative, his whole art uninteresting. It is different with John W. Ewbank (1799-1847), another of Nasmyth's pupils, and his friend and fellow-apprentice Thomas Fenwick. Although their north of England birth precludes one claiming them as Scottish painters, they did their art-work in Scotland and on lines then prevalent in Scottish painting. They came to Edinburgh with their apprentice-master, Coulson, when he transferred his business from Newcastle, but their pictures beginning to attract attention they were soon able to leave house-painting and apply themselves wholly to art. Ewbank devoted himself principally to depicting the sea, and many of his pieces have charming atmospheric quality and pure and beautiful, if somewhat conventional, colour. His technique was modelled on the seventeenth-century Dutchmen, and in that and in choice

of subject he must have learned much from the pictures of the younger
Van de Velde, to whose exquisite silvery daylight effects over calm seas
studded with motionless shipping—the proverbial painted ship upon a
painted ocean—his bear considerable resemblance. In colour, however,
he inclined to a yellower tone, and his handling is slighter and more
perfunctory. Neither in his shipping nor his planes does he show the
mastery of the old master. But the general impression given by his
pictures is charming, and at his best he showed a true sympathy for his
medium and great appreciation of the picturesque. Unfortunately,
however, he spoiled his own career. By the time he was thirty, he had
attained a prominent position in Edinburgh and was making a splendid
income by his art ; but a few years later he suddenly gave way to drink,
and so completely that he seems, like some of the roystering Dutchmen,
to have lived and even painted in low pot-houses. He never quite lost
his pictorial sense or his technical power, but nearly all the inferior work
which bears his name belongs to this period. Fenwick also, although he
never had Ewbank's success, seems to have gone under in his later years.
The land rather than the sea was his choice, but he occasionally painted
coast scenes and now and then an architectural subject. Many of his
landscapes are bathed in a golden haze, artificial in effect but charming in
quality, and his sea-pieces, although less complete than Ewbank's, are fuller
of breeze and motion.

With Edmund Thornton Crawford (1806-85), who was born in the
beginning of the century, and died but twenty years ago, we return to
native artists. While attending the Trustees' Academy, then under
Andrew Wilson, he met Simson, and the friendship which ensued counted
for much to the younger man, who often accompanied the other on
sketching expeditions round Edinburgh. In 1831 he paid the first of
several visits to Holland, where he painted many pictures and, studying
in the galleries, formed his style. Exhibiting regularly at the Scottish
Academy, he was elected Associate in 1839, but it was not until the year
he was made a full member (1848) that he produced a picture which
attracted general attention. This was the first of a series, the subjects of
which were drawn from the harbours of the north-east coast of England
and the Forth, as well as the Dutch shipping rivers, which soon gave
Crawford a position as one of the leading painters in Scotland. But he
also painted landscape, much in the spirit of Patrick Nasmyth, fresher
and more varied in colour, perhaps, but less accomplished technically.
The determining influence in Crawford's art was Dutch. His pictures of
the sea with shipping have an affinity to Bakhuysen and the Van de
Veldes, and his woody landscape near relationship to Hobbema. Despite
the variety of his themes his treatment has little range. On every calm
sea overhung by pearly-grey sky the same grey, white, and brown sailed
ships repose ; every breezy coast-scene has the same stereotyped figures

and scudding boats ; every landscape the same orthodox trees and cattle. And yet Crawford's art has a certain mild charm. He added little of his own, but he understood the convention he employed, and in consequence his pictures possess unity and the satisfaction that quality rarely fails to give. Arrived just before the feeling for true and brilliant colour commenced to make itself felt in Scottish landscape-painting, his work never shook itself entirely free from the brown tone of his youth, and his technique remained more or less mannered to the end. Still, the one is pleasing in its quiet harmony, and the other always competent and, in its own way, refined. Moreover, his knowledge of wave-forms was considerable, and more than Wilson he combined observation with the suggestion of movement and something of the freshness and sparkle of reality. As a contemporary of the Nasmyths and Simson, his life links the beginning of Scottish landscape with the present, but in spirit and style his art belongs almost wholly to the past. He was a capable artist of his school and time, and in a wider survey his ultimate place should be somewhat similar to that occupied by the lesser men of the Norwich group. Living as he did until recently, his later pictures were in a sense the last survival of that Scoto-Dutch convention which had many followers in his youth.

CHAPTER VIII

WILKIE'S SUCCESSORS AND THEIR CONTEMPORARIES IN HISTORY AND PORTRAIT

IF the decade preceding 1855 produced few Scottish figure-painters of genuine artistic interest, it saw the advent of several who achieved remarkable popularity. A number of these carried on the tradition of Wilkie and were essentially painters of humorous and pathetic domestic genre. To them the anecdotal and story-telling side of painting was everything ; the pictorial a secondary consideration at most : and in this view of art most of their contemporaries who dealt with historical or imaginative subjects shared. Our grandfathers used to describe pictures with historical or learned subjects as 'high art,' and exalted them at the expense of those in which more homely scenes were represented ; and we, although not using the same terms, are still too apt to make the same distinction. The question, however, is not between high art and low on grounds of subject, but between good art and bad or inferior. It is not the nature of the subject but the way in which the subject is seen that is most important ; and the moral intention of a painter counts for little if he has not the capacity of expressing his ideas and his insight in beautiful and appropriate pictorial terms. Judged by such a standard, and it is the only one which can be applied justly to all works of art alike, the pictures of most of the painters named in this chapter will be found of comparatively little interest. On the other hand, if approached from the point of view of subject and incident, they are rich in instruction, laughter, and tears.

Of all Scottish painters Erskine Nicol (1825-1904) has supplied the greatest amusement. A native of Leith, he early escaped from house-painting to picture-making, and by the time he was one-and-twenty a sojourn in Ireland,[1] where he lived four years, had set him upon the line he afterwards pursued with such marked success. Some ten years before, Wilkie, just returned from the trip which produced the 'Peep o' Day Boy's Cabin' (1836), had written to Andrew Wilson enthusiastically about the pictorial possibilities of the western districts, which he described as 'untouched, simple, and picturesque in the highest degree' ; and it was

[1] A pupil of Sir William Allan and Thomas Duncan, he became drawing-master in Leith Academy, and subsequently received an appointment under the Science and Art Department in Dublin.

in Irish cabins and potato patches that Nicol found the life and the material with which his essentially humorous spirit made such lively play. You turn to a picture by Nicol, as you go to see a favourite comedian, expecting to laugh heartily, and you are seldom disappointed. He saw the comic in every situation, and, although over-fond of the Irishman of farce, his insight into certain types of character was great. But too often his jokes are such as are spoiled by constant repetition. The fixed predicament of the man just returned from market with his finances in a muddle, or the man doomed to all eternity to struggle with a new and too small pair of tackety boots, becomes a source of irritation at last ; the drinking and fighting and the play with shillelahs on fair-days cease to amuse when they occur every day of the week. Still, to give Nicol his due, he treated such incidents with unfailing zest, and entered fully into their spirit of boisterous fun. At times also an element of irony, as in the 'Rent Day' (which a French critic has compared to a page from Balzac), appeared in his work, and occasionally he touched the pathos, which is never far off in a humorous and sensitive people.

If deficient in breadth and gusto, Nicol's technique is very complete and craftsmanlike, and his colour, if somewhat patchy, is often agreeable. Broadly speaking, he used two schemes of colour—one based on brown and traditionally Scottish, the other grey and more personal, and in the latter he was more successful. Some of his early work is very fresh and luminous for its time, and there are sketches of his in both oil and water-colour which are quite modern in spirit. It was on Nicol's pictures of this character that Alexander Fraser, the landscape-painter, formed his method. His drawing also is spirited, and, while his modelling is inclined to be over incisive and his paint quality and tone are too hard, he almost invariably expresses character and situation with great vividness. As a rule he arranged his pictures with skill, both as regards telling his story and making a pleasant pattern, while his treatment of light, if less subtle, is somewhat similar to that of the Dutch genre-painters, whom he usually followed in choosing cabinet-sized canvases instead of the larger scale which many contemporary incident-painters use, and to which he fell a victim in his later years.

Possessed of ready invention and a retentive memory, many of his Irish incidents were painted in Scotland or London and from alien models, with no evident loss of the peculiar racial humour and character which they ostensibly depict. He was elected an Associate of the Royal Scottish Academy in 1855, and an Academician in 1859, and, having removed to London in 1863, was made an A.R.A. in 1868.

To Thomas Faed (1826-1900), on the other hand, the pathos of life appealed more strongly than its comedy. He called for tears as readily as Nicol did for laughter. If one may judge from his pictures his feelings were of the emotional order ; his work is the painted counterpart of *Beside*

the Bonnie Brier Bush. The sentiment is obvious, and the moral eminently applicable. At times he was tenderly humorous, but, more often than not, care and sorrow was the lot, or rather the aspect which he chose in the lot, of his cottagers. Yet through all there runs the spirit of love and resignation, and the people of his pictures are so comely and healthy and self-reliant that their troubles deservedly awaken sympathy. Conceived in the spirit in which he approached them, incidents such as 'The Mitherless Bairn,' or 'When the Day is done,' cannot fail to stir a responsive chord. He treated the primary affections with simplicity and respect, and the pure atmosphere of home sanctifies his cottage hearths. In a way his view of Scottish peasant life was that of *The Cottar's Saturday Night*, but the appeal of his pictures is mainly sentimental, and somehow—although, as has been said very wittily, he often painted 'departures for the colonies or heaven,'—it is less impressive and touching than one might expect. This ineffectiveness may be due to the quality of his sentiment, but superficially, at least, it resides in the way in which it is expressed. Neither colour nor handling seems suited to his themes : the one is over-bright and garish, the other too thin and surfacy, to express deep emotion ; and, while he usually harmonised his setting, whether interior or landscape, with the figure sentiment, his carefulness of accessory and burdensome detail, and his defective sense of atmosphere, interfere with unity of impression. His aim in painting seemed to be imitative rather than expressive. He was more concerned with the fact of a thing than with its pictorial significance ; his brushwork is accomplished but lacking in character, and if deft and sympathetic his drawing is without distinction or power. Yet his work marked an advance in realism, and entire absence of affectation, in both sentiment and method, saves his simple and naïve art from reproaches which more capable work frequently deserves. Simple and sincere, it is worthy of respect, if not of high admiration.

From first to last Faed's idea of picture-making, if less artfully carried out, was the same as Wilkie's before he went to Spain, but technically his early work was related more closely to that of Lizars. Adopting a more delicate and suave, though still precise manner, early in the fifties, he thereafter attained finer colour and richer and more fused tonal effects based upon a skilful use of chiaroscuro. These were the qualities which dominated his practice during his prime, and it follows that his most successful pictures are those dealing with indoor incidents. In them also he had the advantage of quaint and picturesque settings for his figures, and abundant opportunity for the exercise of his skill as a painter of detail. Later still, in emulation of the Royal Academy pictures of the year, he increased the scale on which he wrought with corresponding technical and emotional loss. The higher key and cooler colour he adopted concurrently made his colour appear patchier, and gave the comparative wooliness of his later brushwork greater prominence.

Born at Burley Mill, near Gatehouse-on-Fleet, he came to Edinburgh and studied in the Trustees' Academy under Sir William Allan, and when only twenty-three became an Associate of the Scottish Academy. Three years later he removed to London, where he soon became popular, and was elected A.R.A. in 1859, and R.A. in 1864.

Tom Faed's entry into art was smoothed by his elder brother John (1820-1902), who, after painting miniatures in Galloway, settled in Edinburgh about 1841 as a portrait and subject painter. In the latter his range was much wider than the other's, and included Biblical and historical as well as homely incident. But while both were illustrators, John was less inventive, even his domestic genre having its origin in literature ; his sentiment was less touching, his colour cruder, his technique of the same order but less able. Chosen an Associate of the Scottish Academy in 1847 and an Academician after only four years, he followed Tom to London in 1862, where he resided until 1880, when he retired to his native village. A third brother, James, has helped to increase the popularity of their pictures by engraving them in line. A similar conception of art and subject groups Robert Thorburn Ross (1816-76) with Nicol and the Faeds. Like them he found motives in cottages and dealt with the joys and sorrows of the people. But lacking the humour of Nicol or the pathos of Tom Faed, his work was merely trivial and commonplace. His colour is bright and patchy, his paint quality hard, thin, and tinny, his handling feebly careful. Yet, curiously enough, this was only in his pictures, in the works he exhibited and for which he was made an Academician (1869). He was a charming sketcher, particularly in water-colour. His drawings are frequently accomplished in manner, and reveal a genuine sentiment for light and certain aspects of landscape. But the lasting reputation these qualities might have won, had they had freer scope, was eclipsed by the meretricious quality of his work in genre.

The simplicity combined with the strangeness of the scenes which supplied Robert Gavin (1827-83) with his most characteristic subjects, serves as a transition from the social and domestic incidents of these painters, to the more romantic and far-off aspects of life in which Sir Noël Paton, James Archer, and one or two others delighted. Gavin, who was a native of Leith, commenced his studies in the Trustees' Academy a year or two after Duncan's death, and the subjects of his early pictures were incidents of child-life and landscape. But during a visit to America about 1860, he was struck by the pictorial possibilities of plantation life, and for a number of years painted the negro at work and play, principally the latter. In 1874, the appearance of some eight pictures in the Royal Scottish Academy indicated that travel had again supplied him with new material, and many of his finest works were either painted in Tangiers or were results of a lengthy residence there. These with some of his negro subjects show him at his best. Technically he had considerable facility

and power, drawing easily and painting with a full and fluent brush ; at its best his colour was rich and harmonious, and he possessed an eye for pictorial setting and brilliant and bizarre costume. In susceptibility to the impressions of unfamiliar life and surroundings he was more kindred to Phillip than to the men with whom he is bracketed here.

On the surface it may seem absurd to group a painter like Sir Joseph Noël Paton (1821-1901) with those whose work has just been described, but examination soon shows that the apparent difference is one of subject and not of approach. Like the Faeds, Sir Noël's real interest in subject was literary and sentimental. To him the ideas expressed were everything, the pictorial qualities and technical expression nothing. And, to a certain extent and in a particular sense, this is legitimate, for technique finds justification and significance only in a way of seeing. But it must be the seeing of the painter and not the thinking of the litterateur or the preacher. The aspects of thought and life and Nature chosen must be fitted for expression in paint : they must be arranged, focussed, accentuated, according to the effects proper to pictorial art, which is not narrative or homily, but representation in colour and light and shade, of the magic of vision. And the wonders to be seen by the eyes are such that literary story and moral precept may well be left to their proper media. Sir Noël Paton, however, bulked so largely in the history of art in Scotland during the latter half of the nineteenth century, and his painted, if unpictorial, thoughts held such sway over great masses of his countrymen, that even the greatest stickler for artistic purity must needs acknowledge that he possessed some elements of charm and power, some quality of popular appeal at least.

Born at Dunfermline in 1821 he was brought up in a home atmosphere which stimulated feeling for the past, the unseen, and the religious. Both parents claimed a long descent ; his mother was an enthusiast for traditional story and fairy-tale ; his father was a religious mystic and an antiquary, and in addition a collector of armour, engravings, casts, and curios, and a designer of patterns for the staple industry of Dunfermline. Young Paton did some designing for textiles in his youth, but from the first his intention and that of his parents was that he should be a painter. He had no regular training. He drew from the prints and casts in his father's collection, and was encouraged to express his ideas graphically, but except for a short time about 1843 in the Royal Academy schools, where he met Millais, who became a life-long friend, he did not study systematically. The effect of this is evident in his work, and no one was more conscious of the hindrance it was to his career as a painter than Sir Noël himself. D. G. Rossetti was disappointed when Ford Madox Brown set him to paint pickle-jars ; it was the great regret of Sir Noël Paton's life that no one had ever told him that he must learn ' to paint a pint-pot perfectly.' Yet he was a conscientious worker, and always strove to express his ideas

as perfectly as his command of his medium allowed and his conception of art demanded. He was senior to the Pre-Raphaelites, but in many ways he sympathised with their ideals, and it is probable that he would have joined the brotherhood had he not returned to Scotland before it was constituted formally. But he was not a thorough-going reformer like the young Millais or Holman Hunt. While he approved of minute and truthful detail, and practised it before they did,[1] he did not share their passion for reality, and claimed (what he applied not so much in a pictorial as in an intellectual and subjective sense) the right of selection. Thus his work being more conventional met with less opposition, and in Scotland his success in the Westminster Hall competitions (1845 and 1847) when he was twenty-four at once gave him a unique position which the great popularity of his pictures maintained for many years. He never captivated the painters, but he had such a great following amongst laymen that for long it was only possible to discuss his artistic qualities *in camerâ*, as it were. And now that the time has come when his completed work should be subjected to criticism, there is perhaps a danger that in reaction one may fail to do justice to the finer qualities of his art.

A man of great culture, full of knowledge of myth and history, of poetry and theology, these are the elements and the materials from which Paton loved to fashion pictures. He was essentially an illustrator and an allegorist, a painter of scenes and suggestions derived from history, literature, and the sacred narrative. And as his approach was principally intellectual, this deprived him of that close touch with reality and the sensuous aspects of Nature which sustain and stimulate the painter. Further, desire to express the idea suggested by author or incident as fully as possible, to convey not only the main issue but all subsidiary ones and leave nothing unexplained, led to neglect of the concentration of motive adapted to pictorial representation, while even from his own standpoint it confused the issue and deprived his pictures of those elements of suggestion and mystery which they often demand. On his technique also this conception of picture-making exercised a cramping effect.

Although Sir Noël commenced by painting a few religious subjects, his early successes were won in the realms of fairy-tale and history, and of the many pictures he produced, none have retained such popularity as 'The Quarrel' (1846) and 'The Reconciliation' (1847) from the *Midsummer Night's Dream*, and 'The Fairy Raid' (1867). In these he displays charming fancy and fertile invention ; he revels in complex grouping of graceful forms and exquisite surroundings, throws wreaths of fairies across dim forest vistas, and with prodigal hand embroiders elves and butterflies and bees upon the flowery tangle of summer wood-

[1] The 'Reconciliation of Oberon and Titania' (National Gallery of Scotland) was painted in the same year as Millais showed his 'Pizarro seizing the Inca of Peru,' which is in the conventional early Victorian style.

lands. Yet to Ruskin, who was brought up on fairy-tales, and was steeped in woodland magic, they seemed rather intended to display exquisite power of minute delineation than to arrest either in the painter's own mind or the spectator's 'even a momentary credence in the enchantment of fairy wand and fairy ring.' And as he said many complimentary things of Sir Noël's art, one may leave this criticism as it stands. In most of the ballad pictures of this period also one misses the glamour which transfigures the passionate or pathetic story of the ancient makers in hues of romance ; but in a few pieces from history he seems to have been more impressed by his subject, and succeeded in rendering the inner spirit of the situation. This is specially so in 'Luther at Erfurt' (1861), one of its author's most perfect things, in which the moment chosen is that in which the monk who shook the world, after a night of mental anguish, finds with the coming of dawn the light of a sure belief which was to revolutionise mediæval Europe. To the same period belong a few pictures from contemporary life. Of these the principal are 'Home from the Crimea' (1856), a wounded soldier just returned from the wars ; and 'In Memoriam' (1857), the motive for which was an incident in the Indian Mutiny. Painted on non-absorbent white panel, like some of Millais's early pictures, they are carried out with a certain intensity of realism which makes them more truly Pre-Raphaelite than anything else he did, while in some technical respects and in simplicity and directness of sentiment they mark the high-water of his performance.

Meanwhile Paton, elected A.R.S.A. in 1847, and R.S.A. in 1850, had settled (1857) permanently in Edinburgh. He had now attained a commanding place amongst his countrymen, and in 1866 he was appointed Her Majesty's Limner for Scotland and was knighted.

Before 1870 he had painted religious pictures from time to time, but from then onward he devoted his talent to that kind of work. Like the great apostle of Pre-Raphaelitism he even set moral purpose above æsthetic quality, and valued motive more than execution. Yet admirable as they are in intention, his religious pictures are illumined by no fresh and vivid light of thought, and place one in no unexpected and moving relationship to life. Correct and chaste but cold in feeling, high in aspiration but unimpassioned in conception, elegant in form and design, but lacking in spontaneous grace and compelling charm, his religious and allegorical creations are very kindred to those of the Nazarenes, who were his seniors by a generation. In German galleries and palaces which contain pictures by Cornelius (1783-1867), Overbeck (1789-1869), and the rest, one is reminded repeatedly of Sir Noël Paton ; and, though he is understood to have disliked their work, he possessed sets of the elaborate outline engravings published in Germany during the forties. But his large pictures were enormously popular in Scotland, and, sent on tour with footlights and a lecturer, attracted great audiences, and secured a long list

of subscribers for reproductions. They were a solace to many serious-minded people, and afforded the popular preacher many a coloured text.

In youth he had not received the technical training which later sustains a painter when struggling with his idea and enables him to express himself fluently and well while thinking principally of what he has to say, and his early surroundings had impressed him with the idea that execution is at best a secondary affair. His technique therefore is neat, deft, accurate, rather than easy, coherent, strong, while it is completely wanting in charm and variety of handling. Moreover, his work lacks the romantic and emotional elements of colour, concentration, and suggestiveness, essential elements in imaginative art. For imagination has more to do with aspect than with subject. It is a way of seeing and thinking, and more true imagination may be shown in the way a bare hillside is looked at and painted, than in the most elaborate invention and the most heroic subjects. Yet the confusion of thought, which confounds subject with spirit, has led some critics to speak of Noël Paton as David Scott's successor. Sir Noël's design is marked by somewhat the same defects as his handling and colour. Often exceedingly ingenious and involved, the elements of which it is compounded show great knowledge and are frequently beautiful in themselves ; but they are seldom related to form one pictorial and emotional whole, and one's attention is frittered away upon a thousand objects instead of being concentrated upon the dominant motive. His drawing gives less opening for criticism than his handling, colour, or design. In a restricted way, which however is not that of the painter but of the linear draughtsman, it is complete, and, if somewhat lacking in character and style, correct and even expressive.

It is as a painter only that we have considered Sir Noël Paton here ; but while he gave his best energies to picture-making, he was many things besides. He modelled with considerable skill and feeling, and wrote poetry of charm and beauty ; he was widely read and richly cultured ; he was a learned archæologist, and a connoisseur in arms and armour of exceptional knowledge. These tastes influenced his art, but to feel their full aroma you had to meet the man. He was a far more interesting personality than appears from his art.

The earlier work of James Archer, who was a pupil of Allan and Duncan, also shows the influence of the reforming movement with which Sir Noël Paton was at one time closely associated. Born in 1823, the first ten years of his professional life were given principally to the then fashionable chalk portrait, in which he displayed taste and skill, and it was not until 1849 that his first important oil picture, 'The Last Supper,' appeared at the Royal Scottish Academy. From then onward to his removal to London, six years after election as R.S.A. 1858 (A.R.S.A. 1850), and afterwards to a less extent, he was a regular exhibitor at the Mound. His subjects were taken from many sources, but in the

beginning he drew largely from romantic poetry such as Tennyson's *Idylls of the King*, and the ballads of the Border. In both spirit and execution these pictures showed great sympathy with the aims of the young English painters who were then struggling to combine realism of presentment with romantic feeling. The early work of Millais and his confrères was full of close observation of the delicate detail of Nature painted with great care and truthfulness ; but with this was united a feeling for subjects noble in sentiment and beautiful in themselves which differentiates their realism in a very marked way from that which some years later appeared in France and was carried to such perfection by Bastien Le Page. But while Archer's early work revealed much of this mood, his grasp on reality was slacker and his insight less searching. For many years after he settled in London (1864), however, his attention was turned to portraiture, in which he had considerable success. Yet he did not abandon subject-painting entirely, producing such charming things as 'How the Twins sat to Sir Joshua' and portrait-groups, like the 'Three Sisters' (1873), which had a distinct touch of the genre spirit ; and in later life he returned to figure-work founded upon similar motives to his early pictures, varied by scenes from the lives of the saints, and a few classic subjects. These for the most part are ambitious in aim and not wanting in imaginative intention, while with the exception of those painted in his old age they possess considerable technical merit, some of the simpler among them being in their own way quite admirable. In intellectual range and variety his pictures are certainly less interesting than Sir Noël Paton's ; but not a few of them show more regard for pictorial possibilities and greater feeling for the medium, while as a colourist he attained, at times, an opalescent quality or a rich glow in keeping with the character of his subjective motives. When he died at Haslemere in 1904, he was the oldest member of the R.S.A., and had been on the retired list nearly ten years.

From similarity of artistic purpose, but even more through intimate friendship with D. G. Rossetti, William Bell Scott (1811-90) is often mentioned in the literature which has grown up about that Pre-Raphaelite movement, the effects of which have just been traced in the work of Noël Paton and James Archer. Born in Edinburgh, he learned to engrave in his father's work-room, and studied art in the Trustees' Academy and with his gifted brother David ; but in 1831 he had worked for some months from the marbles in the British Museum, and six years later he went to London to seek fame as a painter. He exhibited at the British Institution and the Royal Academy with some success, and at the Westminster Hall competitions his cartoon, although unpremiated, attracted attention, and led to his appointment as master of the School of Design at Newcastle-upon-Tyne. There he took a great interest in all artistic and literary matters, and executed his most important work as a painter. This was the

decoration for Sir Walter Trevelyan of the inner court of Wallington Hall with eight large panels, illustrating the history of Northumbria, and nearly a score of smaller ones of scenes from the ballad of Chevy Chase. The water-colour designs for the principal series are in South Kensington Museum, and show considerable skill in composition, effective grouping, ready invention, and much knowledge of archæology. Another undertaking of a similar nature, carried out in encaustic upon the walls of a newel staircase in Penkill Castle, illustrates the *King's Quhair*. Similar subjects figure in his pictures, almost all of which deal with romantic aspects of the past. In these the technique is elaborate and mannered, the colour bright but crudish and thin, and the subjects, if fine in themselves and showing poetic feeling, are seldom grasped with power or insight. Much the same superficiality of sentiment, combined with a great deal of minute detail, marks his landscapes, which with those of Waller H. Paton (1828-95), Sir Noël's brother, form the Scottish contribution to what may be called Pre-Raphaelite landscape in a narrower sense than that implied by M. Chesneau. Bell Scott was, however, as much interested in literature as in art, and wrote verses which may do more than his pictures to keep his name in remembrance. He also wrote a good deal about the fine and applied arts, and edited a number of English classics. Yet his was that weak flavour of genius which the genial 'Autocrat of the Breakfast Table' thought so detestable and so apt to make its possessor envious of those more gifted. Unfortunately the latter failing appears in his *Autobiographical Notes*. He had a faculty for making and working up friendships with distinguished people, and his reminiscences are entertaining in a way and throw interesting sidelights on many interesting personalities. But the spirit in which they are written is beneath contempt. Had they been published in his lifetime, he would have died without a friend except Miss Boyd of Penkill, who saw them through the press. He had been a frequent visitor at her castle in Ayrshire, and died there.

While the flavour of literary or learned inspiration, present in the work of Paton, Archer, and Bell Scott pervades that of William Fettes Douglas (1822-91) also, it is expressed with a technical skill which none of them approached. Like many of his fellows he became a painter after spending years in business, and he received little academic training. Yet he drilled his hand so thoroughly by self-directed study that no trace of the self-taught man appears in his work. When he left banking for art he was twenty-five, but his pictures soon attracted notice, and in 1851 he became an Associate of the Scottish Academy, full membership following three years later. The earlier works he exhibited were portraits, but he painted frequently in the country with the Faeds and Alexander Fraser, and gradually turned to figure subjects, which soon assumed a definite complexion from the painter's interest in out-of-the-way things. In 1857 he made the first of several visits to Italy ; but his interests were too varied to permit of

heart-whole devotion to his chosen art, and less time was given to painting than to studying coins, ivories, enamels, missals, and bookbindings, of which he subsequently made a fine collection. He also possessed a wide and accurate knowledge of pictures, which fitted him peculiarly well for the curatorship of the National Gallery of Scotland, which he held from 1877 until his appointment as P.R.S.A. in 1882. Unfortunately his presidential reign was marked by internal dissensions and misunderstandings, and by some public appearances which are better forgotten ; but his precarious health and the fact that the Academy was passing through a crisis due to a greatly increased body of outsiders and the beginning of new influences in art are probably sufficient excuse.

In estimating Douglas's position as a painter his early portraits may be neglected. They are stiff and awkward in arrangement and pose, black in colour, and marked by no great power of handling or particular grasp of character. It is different with the studies of landscape and domestic incident, painted during his intimacy with Faed and Fraser. I have seen things painted about that time which in charm of colour and beauty of handling are scarcely surpassed by the work of his prime. But even then his distinctly antiquarian turn of mind was beginning to show itself in choice of subject, and his typical pictures are such as 'The Ruby Ring' (1853), 'The Alchemist' (1855), 'Hudibras and Ralph visiting the Astrologer' (1856), from Butler's little-read classic, a favourite source of subject with Sir William ; the 'Visit to the False Astrologer,' which he considered his masterpiece ; the 'Summons to the Secret Tribunal' (1860), and 'The Spell' (1864). In these the recondite subjects expressed one phase of his interests, the wealth of accessories another, which had freer vent, however, in many elaborate studies of beautiful things in his own collection. The way in which he painted still-life is incomparable in his own school, and perhaps unsurpassed outside. It is as complete and more satisfying than that of Tadema or Meissonier, and can be placed beside that of Terburg and De Hooch. His pictures of this type also possess a curious kind of life of their own, for he painted the objects as he would have handled them, with reverence and love.

In the matter of detail Douglas may have been influenced, as were other Scots of his time, by the English movement in that direction, and some of his subjects even, such as the Rossetti-like 'Whisper' and 'The Ruby Ring,' have a Pre-Raphaelite look ; but his method was more solid, his observation more comprehensive, his feeling for subject distinctly his own. His style is indeed a remarkable instance of the combination of analysis with coherent and masterly breadth. In addition he was a colourist of marked power, attaining at his best, as in 'The Rosicrucian,' glow and harmony of effect. Where his art failed was in interest in life. He frequently chose situations either dramatic in themselves or pregnant with suggestion of the mysterious and the unknown, and yet he rarely if

ever succeeded in conveying these sensations to canvas. Like Tadema he was too apt to paint his figures as still-life, and failed to grasp the human and emotional significance of the incident. Hence interest of accessories too often dominates the emotion of his pictures. But in landscape, for which he had a true sentiment, he attained results completely free from these limitations. For the most part they date after 1870, and the 'Stonehaven' and 'A Fishing Village,' painted in 1874 and 1875 respectively, are masterpieces of design and execution, atmosphere and colour. For a while after 1879, however, the effects of a serious illness laid him aside, and when he resumed his art it was to work in water-colour only. Some subtle physical cause had rendered the oil medium repugnant. Yet these water-colours are amongst his happiest efforts. Mostly small in size, they are often very beautiful, and show a true appreciation of the best qualities of water-colour, and a largeness of style which recalls such a master as De Wint. Perhaps their most obvious defect is an inclination to blackness of colour, probably a result of striving for fullness of tone.

The pictures and drawings of Sir W. Fettes Douglas are not yet appreciated at their true worth; but it is all but certain that his work is destined to be discovered by the dealers, and boomed into something like the position to which it is entitled without their interested assistance.

Although he was several years younger than Paton, Archer, and Douglas, and a pupil of Scott Lauder as well as of Lauder's predecessor, the art of Robert Herdman (1829-88) had greater affinity with that of the men already discussed than with the more modern and realistic work of the Lauder group. With him subjective interest bulked more largely than pictorial qualities, the manner in which he painted was related in many ways to that of his older contemporaries, and his colour was but slightly affected by the marked development in that element which appeared in the pictures of the most gifted of Lauder's pupils. A son of the manse, he commenced life with the intention of entering the ministry, but, after a University course in which he did well, he found that his bent was towards painting, and left St. Andrews for Edinburgh and the Trustees' Academy in 1847. He was thus a student of four or five years' standing when Lauder appeared on the scene, and his art bears little trace of that master's influence, although in subject it is perhaps nearer his than is the work of any other of Lauder's pupils. Some of his early pictures illustrated Biblical incidents, but after his return from a visit to the Continent in 1855, which supplied him with several Italian subjects, of which there is no better example than his diploma work 'La Culla' (1864), his greatest source of inspiration was Scottish history and song. But his education had given him a taste for the classics, which he retained throughout life, and occasionally he founded a picture on a suggestion in a favourite author. These, however, were usually single figurs, and more of the nature of studies of feminine beauty

than embodiments of the great thoughts and tragic situations of the Greek dramatists. And much the same is true of his pictures of Scottish peasant-girls, in which the bloom of health and the marks of toil were suppressed in favour of a more sentimental prettiness and grace. In subject-painting again his tendency was to employ art as a moral preceptor or a patriotic stimulus ; and regarded in this light, 'After the Battle' (1870 : Edinburgh Gallery), 'A Conventicle Preacher before the Justices' (1873), 'St. Columba rescuing a Captive' (1883), 'His Old Flag' (1884), and 'Landless and Homeless' (1887), are highly successful. They tell their stories well and appeal to the finer instincts of humanity. The ideas expressed are those of a highly cultured and intellectual man, whose outlook on the world was widely and wisely sympathetic. On the other hand, their conception was marked by few qualities which made them peculiarly and primarily fitted for pictorial expression. In their own way, however, they are well composed, and a certain sobriety and reticence, shown particularly in the management of his groupings and in the poses and facial expressions of the actors in his painted dramas, give his work of this type, which otherwise had easily been merely sentimental, pathos and dignity.

In portraiture, especially of ladies, refinement of character and feeling for beauty stood Herdman in good stead, and some of his most satisfactory work was done in that field. Latterly his handling and design in portraiture even, became somewhat conventional, but about 1870, to which period the fine full-length of Lady Shand (1867 : National Gallery of Scotland) belongs, he produced a considerable number of portraits not only charming in feeling and refined in characterisation, but painted with vivacity and much freshness of colour. While not a few Scottish portrait-painters have surpassed him in craftsmanship and in distinction of style, there has been none who has rendered the finer aspects of Scottish feminine beauty more sympathetically.

Technically Herdman's chief defects were a want of solidity and richness of impasto and a certain greasiness of touch which rather discounted the facility with which he wrought. His colour was harmonious and rich, but, lacking vibration and luminosity, neither sonorous nor delicate ; his composition was often good, occasionally dignified, and always explained the matter in hand ; his drawing, if deficient in incisiveness and style, was usually elegant, and in genre he chose his types with judgment mingled with sentiment. He did some charming work in water-colour, and many of the holiday sketches of wildflowers and boulders and sea-shores, made in Arran, are beautiful.

Elected A.R.S.A. in 1858 and Academician in 1863, Robert Herdman was one of the greatest ornaments of the Academy, and certainly the best educated and most highly cultured man of his group. His death was a great loss to the institution with which he had been so long connected, for,

in addition to the honour his personality brought, his counsel was of great value in the conduct of its affairs.

With the exception of Archer and Herdman, none of these painters painted portraits to any extent or with any great success, and, except Norman Macbeth, none of their immediate contemporaries became exclusively portrait-painters. The principal work of that kind remained in the hands of Watson Gordon and a few more whose art has been discussed in a previous chapter. But towards 1840 two men, born in the opening years of the century, began to come to the front—the one in London, the other in Glasgow. The former, a younger son of the laird of Kilgraston, Perthshire, began life by combining sport with art, but the expense of fox-hunting and forming a small collection of pictures soon exhausted the £10,000 he had received from his father, and Francis Grant (1803-1878) took to art as a profession. He had painted in an amateur way previously, and now he turned for subjects to the sporting scenes amongst which he had spent his fortune. Soon these pictures brought him considerable reputation and led to commissions, such as 'The Meeting of His Majesty's Staghounds' (1837), for Lord Chesterfield; 'The Melton Hunt' (1839), for the Duke of Wellington; 'A Shooting Party at Rawton Abbey' (1841), for Lord Lichfield; and 'The Cottesmore Hunt' (1848), for Sir Richard Sutton. Meanwhile, in 1840, a picture of the Queen riding with Lord Melbourne and others in Windsor Park had made him, at a bound, the fashionable portrait-painter of the day. Portrait-painting was at a low ebb in England, but Grant's was perhaps the best available, and it possessed the qualities which ensure popularity with society. Obviously the work of a man who moves in good society and belongs to it, the elegant air of his sitters did not suffer at his hands, and his portraits of ladies in particular have a certain mild charm. But he had little claim to rank as a serious artist. His characterisation was superficial and inclined to prettiness, and his drawing and brushwork were quite mediocre. He was at his best in sketches and small studies, in which he frequently attained considerable freedom of handling and fine colour. The sketch for the portrait of Lord Chancellor Campbell, once in Lord Leighton's collection and now in the Edinburgh Portrait Gallery, is an admirable example of his skill in little, and several cabinet portraits of ladies at The Inch are even finer and more vivacious. It was his social standing and connections therefore, rather than his artistic talent, which led to his election as President of the Royal Academy in 1866 in succession to Sir Charles Eastlake, but Sir Francis filled the office with dignity and acceptance. He is the only Scot who has occupied the chair of the London Academy, to which Scotland has given many members more gifted than he. But, while his portraits were fashionable, they were not the most notable in the annual exhibition. As Francis Turner Palgrave pointed out more than once in the *Saturday Review*, during the sixties,

the work sent from Scotland by Watson Gordon, Macnee and Macbeth, had 'a sort of force, which neither Grant nor Weigall, Richmond nor Buckner succeeded in putting into theirs.' In the portraiture of the Scots, personal characteristics were combined with the virile and masculine style which they inherited from Raeburn.

Born at Fintry in Stirlingshire, Daniel Macnee (1806-1882) was taken in infancy to Glasgow, and at the age of thirteen was apprenticed for four years to John Knox, landscape-painter, in whose studio he met Horatio M'Culloch (1805-1867) and W. L. Leitch (1804-1883), with whom he contracted enduring friendships. Apprenticeship over, he went to Cumnock with M'Culloch to paint the wooden snuff-boxes then in fashion, but after a month or two accepted an engagement with W. H. Lizars (1788-1859), an Edinburgh engraver, who in youth had painted some excellent genre pictures of the Wilkie type, to colour anatomical and other engravings. He continued at this for some years, but devoting his leisure to studying in the Trustees' Academy he gradually slipped into art, executing chalk portraits and painting a few simple genre subjects, which are suggestive of Harvey's influence. In 1832, however, he returned to Glasgow, where he quickly made a connection as a portrait-painter, at first in crayons, but soon in oil also. For many years he divided the patronage of the west with John Graham-Gilbert; and after the death of that artist in 1866—Watson Gordon, the most gifted of his contemporaries, having died two years previously—his claim to rank as the leading Scottish portrait-painter of the day was unchallenged. He had joined the Scottish Academy from the Institution in 1829, and when in 1876 Sir George Harvey died, he was elected president and removed to Edinburgh. The choice was in many respects happy. Sir Daniel's geniality of manner and sense of humour, his never-failing unselfishness and desire for the good of all, made his tenure of the office eminently successful. Keenly appreciative of character, that quality remained with him to the end, but technically, and therefore in characterisation, his finest things, such as Mackay the actor as Bailie Nicol Jarvie, and the Dr. Wardlaw, medalled in Paris in 1855, were painted between 1845 and 1860. At his best Macnee almost deserved to be described, as he has been, as 'an understudy of Raeburn.' His rendering of character was simple and direct, his posing expressive and unaffected, the air of his work sincere and well conceived. He got his form by direct modelling in tones, and his drawing, specially in heads and hands, was informed by a sense of construction; his colour was not rich, but it was quietly and broadly harmonious, and his handling, although lacking the power and decision of touch one admires in Raeburn, is related to that fine tradition. When beneath his best, as in most of his later work, his handling was apt to be fuzzy and indeterminate and his colour negative and grey; but he was usually happy in catching a likeness, and his sentiment, often commonplace enough, was never vulgar. From time

M

to time, however, he would produce a portrait almost worthy of his best days, and in design and characterisation and even in colour, I know few better works of his than the 'Lady in Grey,' a study in luminous shadow, in the possession of Lady Macnee, and the 'Principal Barclay' (1872), which hangs in the Senate Room of Glasgow University. In his own day, however, his reputation as a portrait-painter was eclipsed by his fame as a raconteur. Unfortunately, none of his stories were put into print, and the wonderful invention and the comic power which led Professor Masson—in one of those delightful rambling speeches crammed with reminiscences which he made occasionally after retiring from active duty —to describe them as Shakespearian efforts in Scottish story-telling, are now no more than a tradition.

The decline in the art quality of Scottish portraiture, from Raeburn through Watson Gordon to Macnee, continued in the work of Norman Macbeth (1821-88), who was more a contemporary of the men who figure here than Grant or Macnee. His apprenticeship was served to engraving in Glasgow, but, after studying in the Royal Academy Schools (London) and in the Louvre, he returned to his native town and set up as a portrait-painter. From Greenock he removed first to Glasgow, and then, in 1861, to Edinburgh, where the rest of his professional life was spent. He was industrious, and the number of portraits he painted is great. But few of them possess distinctive character or merit; his handling, though careful and in a way competent, was hard and unsympathetic; his drawing had no style, his colour no charm. Yet his conventional and completely undistinguished portraiture has certain solid qualities, likeness and simplicity and the unconscious impress of a healthy tradition, which are not without value. They are not much, perhaps, but they made Macbeth one of the better men of his time. Of the minor portrait-painters of that day only J. M. Barclay, R.S.A. (1811-86), who displayed considerable accomplishment, if no distinction, and William Crawford, A.R.S.A. (1811-69), whose best work was done deftly in crayons, need be mentioned. Both occasionally painted figure-subjects.

CHAPTER IX

JOHN PHILLIP

BEGINNING on the lines of Wilkie's earlier work and coming through somewhat similar experiences, John Phillip carried the ideals for which Wilkie had latterly striven, but had never quite realised, to a successful issue.

Born at Aberdeen, where his father, an old soldier, lived in humble circumstances, Phillip (1817-67) was apprenticed at an early age to a painter and glazier in his native city, and had already paid a visit to London, voyaging as a stowaway, to see the Academy, and had earned some little notoriety among his fellows for his sketches, when he attracted the attention of Major Lockhart Gordon by neglecting his work (he had been sent to replace a broken window-pane) to look at the pictures in that gentleman's dining-room. The Major kept an eye on the boy, who was meanwhile receiving hints from a local portrait-painter, and a picture he painted when about eighteen determined him to interest Lord Panmure in his protégé. The result was a cheque for £50 with a promise of further help; and after some time, during which he lived with his friend and painted several portraits, he went to London, where he studied in the schools of the Academy and exhibited for the first time at its exhibitions in 1838. In 1841 he was in Aberdeen, and exhibited at the Royal Scottish Academy; but settling in London he was not again seen in Edinburgh until 1855, from which date onward he was a regular exhibitor. Gradually he made a position as a painter of Scottish genre and history in the style of Wilkie, but it was not until his health gave way and he, like Wilkie, went to Spain to recruit, that he discovered himself. That was in 1851-2, and from then until the end the dominant qualities of Phillip's art were on a higher plane. During the fifteen years of life that remained to him, he executed a series of works notable for breadth and power, and attained a position as a painter in the front rank of his school.

'The Pedlar,' the picture which so interested Major Gordon, and was bought by him for Lord Panmure, who bequeathed it with others to the Mechanics' Institution at Brechin, is, even when considered as a juvenile production, of very little merit. Phillip had fewer opportunities than Wilkie, and at the time he painted this picture he was a year younger than Wilkie was when he produced 'Pitlessie Fair'; but, with these things discounted, 'The Pedlar' shows infinitely less promise. It is weak and

meagre in invention, the handling is fumbling, the drawing and character-
isation inexpressive, the colour muffled in a yellow-brown fog. Even
now, looking back from what Phillip achieved, it is difficult to detect any
germ of greatness, and one must conclude that Gordon either possessed an
extraordinary amount of insight or based his hopes on the character of the
youth rather than on the merit of his work. But Phillip made steady if
not rapid progress, and while the pictures of his pre-Spanish period never
approach the completeness and beauty of expression, or the richness and
keenness of observation of Wilkie's, by which they were obviously inspired,
his technique became more refined and able ; his colour, while remaining
yellowish-brown and foxy in key, more varied ; his drawing more graceful
and expressive. The 'Presbyterian Catechising' (1847), and the 'Scotch
Fair' (1848), in Mr. Jordan's collection, are excellent examples of his
work in this vein. His historical pieces of the same period were accom-
plished in the style of a time when superficial generalisation and little regard
for reality were in fashion. 'The Morning of Bannockburn' (1843 :
Mechanics' Institution, Brechin) is an admirable composition of the class
which influenced the young Millais (1829-96), not yet come into contact
with his Pre-Raphaelite brothers, when he painted 'Pizarro seizing the
Inca of Peru' (1846). It is worthy of remark also that Millais, then a
boy of thirteen, stood to Phillip for the page in the Brechin picture.

While one considers Wilkie's later work with regret, because it marks
decadence in accomplishment if not in ideals, one is pleased to pass rapidly
over Phillip's earlier period, because it was but the prelude to his real
career, which commenced with his first visit to Spain. The vivacious
people and the brilliant costumes, the glowing sunshine and the rich trans-
parent shadows of the South fascinated him, while the pictures of Murillo
and Velasquez opened his eyes to the beauty of breadth of conception and
technique, and gave him a truer sense of the possibilities of pictorial expres-
sion. These new aims were not mastered at once, and the pictures of his
transition period, in which he abandoned the delicacy of handling and the
reticent colour of his earlier work for a style more powerful and colour
more brilliant, err, as was to be expected, in excess of decision and force.
The detail is harder and more precise also, and suggests Pre-Raphaelite
influence.

A second visit with Richard Ansdell (1816-85) as companion,
steadied him—the 'Prayer of Faith,' praised by Ruskin, and 'A Huff,'
were the results ; but it was not until his third and last visit in 1860 that he
produced the works on which his fame principally rests. Phillip was now
at the height of his power ; he painted with marvellous rapidity, and his
output during this visit of less than six months was extraordinary. Some
five-and-twenty large and a score of smaller canvases, a number of copies
from Velasquez, and nearly half a hundred water-colour sketches came
home with him. The pictures were brought back in much the same state

as the unfinished 'Boys playing at Bull-Fighting' in the Edinburgh Gallery. It is painted, as his habit was, upon a fairly smooth canvas primed with a brownish tint ; and, after indicating his composition slightly in charcoal, he has swept his figures in swiftly and broadly with the brush, using the priming as a background, and here and there—as he did the tinted paper on which he sketched in water-colours—as an approximate half-tone. The only completed parts are several heads, but the action and grouping are fully indicated, and one is able to form a distinct idea of what the final result would have been. In these rapid 'knock-ins' he used a good deal of brown, and this has had rather a deadening effect in his shadows. The years after his return were devoted to completing these pictures and to painting others from sketches. 1864 may be said to mark the culmination of his career. 'La Gloria,' his most important, and 'Il Cigarillo,' his most perfect work, belong to it. 'La Bomba' is dated the previous year, 'The Early Career of Murillo' 1865, and 'A Chat round the Brasero' (Guildhall), perhaps the most piquant and the most Spanish thing he ever did, was shown in 1866. In 1866 he went to Italy, where he painted a few pictures and studied Titian, and returned to die in the spring before he had completed his fiftieth year.

In estimating John Phillip's achievement as a painter one may neglect what he did before he went to Spain. For sixteen or seventeen years he had painted second-rate pictures of the Wilkie type, and he might have gone on producing them until the end (and his name would now be forgotten) had his doctor not sent him abroad. The wider experience, which had been poison to Wilkie, proved a stimulant to him. He returned with quickened perceptions and heightened powers, and commenced to express his individuality in his work. His early pictures had for the most part been reminiscent of what he saw in Scotland, and of how it had been seen by Wilkie : his later are records of the life he studied for himself in Spain. In these respects they stood out from most contemporary work, for it was a time when most painters were dependent on literature for subject, and a picture was not a picture, but a painted illustration. Phillip's Spanish pictures are full of incident and story, but incident and story conceived and rendered in pictorial form. They may be dramatic or sentimental, but the drama and the sentiment are expressed, and express themselves, through colour, light and shade, and arrangement. At first the novelty of the people and costumes, the strong contrasts and the brilliant colour of Seville—for it was there he painted as a rule—seem to have absorbed him. And in striving for the effects he saw, his technique and colour gained in power. It was not until a later visit, however, that he copied and made a serious study of Velasquez, and it is from then that his finest pictures date. That after so many years of work in a narrow convention he should so fully have grasped and used so admirably the nobler methods of a greater school is infinitely to his credit, and

unlike many of the young men who in our day have come under the same influence, he remained true to himself. But although he was influenced by Velasquez in his method, or at least in the desire to attain a fuller, broader, and more expressive technique, his colour shows more affinity in its strong local hues to Murillo, and is all but lacking in the quiet beauty of aerial colouring which marks the greater Spaniard. Phillip was indeed purely objective in colour ; and a clearly imagined or conceived colour-scheme is rare in his work. His pictures are made up of so many patches of definite tint, and do not possess a dominant harmony or colour motive. They are representative rather than decorative in intention. Still he often used the brilliant and gaudy colour of the South to splendid purpose ; his finest work is opulent and glowing, and, although the shadow passages are often over-brown, his paint has matured and mellowed well. His technique is also marked by vigour and gusto, his impasto is rich but never unduly loaded, and his touch, dexterous, spirited, and masterly, is infinitely more expressive than the smooth mechanical finish then in vogue. An engaging combination of animation and grace characterises his drawing, and his designs are often happily inspired in mass and light and shade. As a craftsman he was perhaps the most painter-like of his time in England, and his idea of picture-making was more pictorial than obtained among contemporary subject-painters. Yet admirable as Phillip's art is in itself, and great as it appears when considered in relation to that of his day, it assumes a lower place when measured by that of finer artists. Not only when he is compared with the acknowledged masters of the past, but in Scottish art itself he has been surpassed. His technique, for all its fearlessness and power, is occasionally haphazard in brushing and lacking in charm ; his colour, though strong and brilliant, is wanting in refinement and subtle gradation ; frequently his drawing and design, if effective and striking, possess little distinction. And while it is true that he introduced new material into British art and approached subject from its pictorial side, he brought little insight or imagination to the interpretation of Nature, and his outlook on life was limited to the externals. 'La Gloria—a Spanish Wake' is almost the only picture in which he touched life below the surface.[1] Most of his others could have been imagined, although not painted, by any artist with a knowledge of Spain and a taste for pretty faces. Ruskin, when pointing out that Phillip missed the wayward, half melancholy mystery of Spanish beauty, found the reason in his technique, but, more probably, it originated in his temperament and his precarious health. Like one who whistles to keep his courage up, and much as Robert Louis Stevenson found an escape from a semi-invalid's lot in imagining stirring adventures, Phillip sunned himself in the vivacious and live-for-the-day side of Spanish

[1] In 1867 Phillip wrote, 'In my estimation this will be the picture on which my reputation in the future will rest.'

character. He gave himself over to sensuous enjoyment of the pretty faces, the picturesque costumes, and the piquant ways of the degenerate descendants of a once great people ; and this shallowness of sentiment lowers his position as a creative artist. His best pictures, however, possess the sterling quality of looking well in any company. In the retrospective exhibitions at Manchester (1887), the Guildhall (1897), and Glasgow (1901), they took a high place, and in the more exclusive rooms of the National Gallery of Scotland 'La Gloria' holds its own as a notable and even a great work of art. Some of his other works, 'Il Cigarillo,' 'La Bomba,' and 'The Chat round the Brasero,' at least surpass it in beauty of colour, grace of arrangement, charm of handling, and justness of scale, but as a conception 'La Gloria' is easily first. His art as a whole reveals no philosophy of life, but he saw simply and well, and expressed what he saw brilliantly and with consummate ease ; and while his technique gained the applause of his fellow-craftsmen, the obviously 'picturesque' character of his subjects gave his pictures a popularity which is likely to be permanent. The hold his Spanish scenes took of the popular mind is attested by the name, 'Phillip of Spain,' they earned him, and by the fact that most of our ideas of Spanish life, custom, and costume are derived from them.

A few Scottish subjects, painted during visits to the Highlands, and some admirable portraits belong to the latter part of his career. The former are principally interesting for the great advance in technical power they show when compared with his earlier essays in the same field, and are secondary in interest to his Spanish incidents : the latter include a few things which rank with his best. Never, in these last years, laying himself out for portrait commissions, and fully occupied on subject-pictures—he is said to have had orders amounting to £20,000 at the time of his death—the portraits he painted, such as the charming cabinet pieces of Mr. and Mrs. W. B. Johnstone (1861) in the Scottish National Gallery, and the brilliant and sparkling three-quarter-length of Miss Caird (1866), which is at once original and delightfully reminiscent of 'Nelly O'Brien,' were mostly of friends. But his most notable, although by no means his best efforts in this direction, were a picture of the House of Commons (1863), with 'Palmerston up,' and a ceremonial picture, 'The Marriage of the Princess Royal,' a royal commission which he would have declined if he could.

Technically his influence counted for much with many of his younger colleagues in England, and as regards choice of subject, it has been abiding. To his example, combined, at a slightly later date, with that of the Spanish Fortuny (1841-74), and the French Regnault (1843-71), we owe the many Spanish subjects to be seen in every contemporary exhibition of importance. Frank and generous, he sympathised with the young Pre-Raphaelites, whose work, superficially at least, was the antithesis of

his own, and his appreciation of Whistler took the convincing and tangible form of buying the now famous 'Piano picture.' At the Scottish Academy his pictures were for many years a conspicuous feature ; and he was and is regarded by his countrymen with respect and almost reverence. With an older generation than ours, it is a pious belief that 'our own John Phillip' is comparable to the masters of all time. Such praise is extravagant, but without going so far, one can heartily endorse the verdict of the German critic who describes him as 'a painter in the full meaning of the word.' In Scottish painting his work, in its developed interest in colour and its more pictorial conception of subject, forms a link between the earlier art of the century and that which succeeded it with the pupils of Scott Lauder.

CHAPTER X

NATURALISTIC AND PRE-RAPHAELITE LANDSCAPE

THE feeling for landscape, which, first in Scottish painting, began to reveal itself in the pictures of Alexander Nasmyth (1758-1840), slowly liberated itself from the artifice of the schools upon which the earlier painters had founded their technique. In a preceding chapter its progress from sentiment, which made itself felt in spite of an imposed convention, to a more intimate understanding and a fuller and freer expression of the essential charm and character of Scottish scenery has been traced; and what we have now to deal with is an art which, for the most part, owes its appeal more to the unfettered expression of personal delight in Nature than to graces of method and manner. Yet when one compares the pictures of Thomson of Duddingston, and even of M'Culloch, with those of many of their successors, it is not without regret that one marks a decrease in distinction of style. That is a loss for which more complete rendering of fact can never make complete amends. But all true progress is real gain, and when the modern painter, with his closer hold on reality, also possesses poetic feeling and gives it full and beautiful expression, he touches deeper and more varied emotions than the followers of a convention be it never so stylish. It is the art of such an one which leads from the older to the more modern school in Scotland. Until Sir George Harvey (1806-76) devoted the latter part of his career to landscape, Scottish landscape-painting with the exception of Thomson's, which was clearly and even highly romantic, and Simson's, which had a certain intimate charm, had been mostly artfully conventional or conventionally realistic. With Harvey, however, came realism in expression, intimacy of feeling, and poetic significance, for if few of his younger contemporaries possessed these elements of fine landscape art in full measure, the work of a considerable number was tinged with them. Feeling and poetic apprehension being individual gifts, the tendency towards realism was of course most widely marked. It revealed itself in an increase in pitch; in some regard for relative if not true tone; in a distinct advance in rendering local colour; and in much greater truthfulness of detail. Although less intimate in spirit than Harvey, in these respects, or in some of them, Alexander Fraser (1828-99), Sam Bough (1822-78), Docharty (1829?-78), and others came closer to Nature. Perhaps the influence of the

English Pre-Raphaelite movement had some effect on the Scots, but it was inconsiderable and indirect. Moreover, the advance towards realism was gradual, and in the case of John Crawford Wintour (1825-82) the difference between old and new was one of feeling rather than of expression, although that also was affected.

Born in Edinburgh and educated under Sir William Allan (1782-1850), Wintour began by painting portraits, literary subjects, and domestic genre, marked by considerable facility, graceful in design, and Etty-like in colour. The facility and grace were natural, and the Etty influence is accounted for when we know that he studied his work closely and made several admirable copies from the great canvases which belong to the R.S.A. But figure-painting was not his forte, and, about 1850, he found a real vocation in landscape, to which, except for an occasional picture of cottage children, he remained ever afterwards true. He carried the feeling for design and colour, and the easy, if too flimsy handling, which he had shown in figure-work, into the new field. But sketching and painting much out-of-doors, face to face with Nature, he gradually gained in power. His pictures increased in firmness of drawing and modelling, in truth of detail, and in mastery of the material facts with which he dealt. In this fidelity to and reliance on Nature, in style and composition also, the influence of Constable (1776-1837) is clear. Not the Constable of the magnificent blottesque manner of the study for 'The Jumping Horse,' or of the massive simplicity of the 'Helmingham Park,' but of more 'finished' things like 'The Cornfield' and 'The Lock.' Yet, as his colour retained much of the mellowness and rich brown tone of the older school, it is probable that his knowledge of the English master was derived mainly from engravings.

During a visit to Warwickshire in the autumn of 1861 Wintour seems to have felt that the time had come when he should let himself go, and from then onward the broad aspects of Nature and the emotional power of design and colour claimed his allegiance. He became enamoured of suggestion and mystery in Nature, and of design and unity in Art. It was some ten years later, however, before he fully realised his ideals. Until about 1870, while never losing his individuality, he had been dominated by Constable; after that he became wholly himself, and the Constablesque impulse became transformed into something very kindred in spirit to the work of the French romanticists who had found the same despised 'natural painter' a source of inspiration. Everything considered, Wintour was at his best during the last twelve years of his life, for if many works which are no more than suggestions of effects, inadequately realised, are due to this time, it saw the production of his finest and most individual pictures, including the 'Border Castle' (1872); 'Blairlogie—Moonlight' (1875); 'On the Ellwand' (1876); and the 'Gloaming on the Eye' (1880). Still, expressive and beautiful as these and others

almost as good are, it is probable that, in technique at least, they do not realise the full possibilities of their painter, whose last years were given to lower company and more drink than is good for any one. He had been elected A.R.S.A. in 1859, and it was his conduct and not any decline in his art, although that was too individual and too much out of sympathy with current methods to be popular, which kept him from full academic honours.

Having sketched the evolution of his method and style in oil so fully, it is unnecessary to say much about his work in water-colour, which followed the same course from detail to breadth, from fact to the poetry of suggestion. But while his finest oil pictures are those of completest intention, in water-colour he is seen at his best in drawings executed as memoranda of composition, effect, or colour. In some of these the pencilling is not obliterated or lost in the simply laid tints which are frequently modified by preliminary pencil shading; yet, abstract as they are, they suggest in abbreviated form the essential charm which arrested the artist.

In Wintour's work the old ideal of abstract beauty is mingled with that intimate and personal feeling characteristic of the best modern landscape sentiment. His colour, although retaining large bituminous passages and only approximating to that of Nature, has a range and variety undreamt of by Thomson, to whose example he may have owed some of his skill in design. Still, as a rule his daylight pictures are wanting in freshness and brilliance. This is specially so in the shadows, which lack vibration and atmospheric quality. But in the time when the sun sets and all the land grows dark, when after the glorious glow of the gloaming comes the mirk, and through the gathering darkness there rises in the east the silver disk of the moon to flood the world in solemn and subdued light, Wintour was at home. The romantic spirit of 'Moonlight in Killiecrankie,' the solemn beauty of mute moonrise which breathes from the 'Blairlogie,' the splendour of the 'Gloaming on the Eye,' have rarely been surpassed in art. With him formula is less conscious than with Thomson, for, if his compositions seem as considered and as balanced, they are more spontaneous. He had almost an unfailing sense of what makes for beauty of design; his slightest sketch shows this, and his more important pictures, such as 'A Border Castle,' delight by their balance of mass, graceful arabesque, and profound harmony of colour. The simplicity and dignity of his composition, and the noble repose in which his landscape is usually steeped, are essentially classic qualities, and, at his best, he almost tempts comparison with the incomparable grace of Corot. On the purely technical side he was less certain, but his method, if slightly flimsy, is expressive, and looseness of drawing and handling was perhaps inseparable from his intention, although it seems to me to hint what is really Wintour's weakness as an interpreter of Nature. With

all its charm, his work lacks the intense and fervid contact with Nature which the greatest landscape art always has. He loved Nature indeed, and worshipped her beauty, but he did not respect her enough or appreciate the vigour and strength of her being fully enough to penetrate to her heart or grasp the springs of her manifold life. What he felt he expressed consummately, however. The beauty of his compositions, the richness of his colour, the tenderness of his sentiment, the subtlety of his method are remarkable. Among his immediate contemporaries, English or Scots, Wintour was practically isolated. Neither his ideals nor his methods were theirs. In France he would have been considered a belated romantic, and might have shared the triumph of that school ; but at home naturalism was in the ascendant, and he was thought of little account. Of recent years, however, his pictures have become more appreciated, and it is probable that his finest will some day be prized as amongst the noblest things in Scottish Art.

The most prominent representatives in Scotland of the tendency towards realism, which Wintour felt but did not fully embody, were Alexander Fraser, James Docharty, and Sam Bough, that English Borderer who became so closely associated with Scotland and Scottish Art that it would be little short of affectation to exclude him from this history.[1] Before Bough came to Edinburgh in 1855, at the age of thirty-three, he had seen a deal of life, and had come under the influences which definitely shaped his art. A native of Carlisle, where his father, a Somersetshire man, had settled as a shoemaker, he had left a stool in a lawyer's office to sketch among the Cumberland hills, had travelled all over the north of England with gipsies, and had painted theatrical scenery in Manchester and Glasgow. It was while living in the latter place—where he married Isabella Taylor, a singer in the theatre—that, encouraged by Macnee, he took up landscape-painting as the business of his life. He had received no training beyond what could be got at an evening class in Carlisle, conducted by a local house-painter ; but his experience as a scenic artist was of service ; he had copied Poussin and Rubens, during a visit to London ; and he had picked up some technical knowledge through associating with painters. The years 1852-4, spent at Hamilton, were specially valuable to him, for there, working at Barncleuth and in Cadzow Forest, he often had the company of Alexander Fraser, who, although a younger man, was more completely educated. And in addition Bough's natural gifts were great. He was enthusiastic and indefatigable, resourceful and courageous ; he believed in his own powers, and soon people believed in him also. A year after he settled in Edinburgh he was elected A.R.S.A., and although he had to wait wellnigh twenty years for full membership

[1] The landscape of Sir W. F. Douglas (1822-91) belongs to late in his career, and possesses certain qualities which connect it with that of these men. It was dealt with in Chapter VIII.

(1875), he was one of the most prominent figures in Scottish Art all the time. He had little or no education in the ordinary sense, but he was well read, particularly in the drama and in the literature of the Queen Anne period ; he was fond of music ; he collected porcelain, bronzes, and enamels. His manner with its brusqueness, and his conversation with its coarseness and rough wit, were reminiscent of the close of the eighteenth century ; yet he could be all things to all men, and there are friends of his who declare that the Sam Bough of the current stories is not the real man. Perhaps it is because bitterness preserves wit as salt does butter that his ironical and often illuminative comments on men and things survive, while the pleasant and inoffensive side of his humour is forgotten. A biography of Bough, judiciously but not over edited, would be entertaining reading.

Many of Bough's early pictures (painted between 1850 and 1860) are remarkable for careful and delicate execution and minute detail; but, after 1860, his handling became broader and more assured, and he aimed at more synthetic expression. This was the period of his greatest power as a craftsman, and while his colour lost the mellow clarity and charm it had in the fifties, to it belong what are justly considered his most important and typical achievements. Their vivacity is wonderful. Pictures like the 'Review,' in the Edinburgh Gallery, and ' The Broomielaw from the Bridge : Let Glasgow Flourish,' convey in a strikingly vivid way the animation and kaleidoscopic change and variety of such scenes ; and ' Borrowdale ' and 'Edinburgh from the Canal ' are perfect triumphs of scenic landscape. These and suchlike, for there are a score or two almost as good, are eminently characteristic of Bough's talent in its power and in its limitation. In them his feeling for air and atmosphere and movement, and for broad and scenic effect are much in evidence, while his fine eye for effective design, power of dramatic conception, and lively instinct for incident and action, add greatly to their attraction. Painted with extraordinary verve and directness in very liquid pigment, used in rather a water-colour manner, and combining much detail with great effectiveness of ensemble, they also exhibit his virile and forthright craftsmanship at its very best. Yet if they show a wonderful range of subject and effect, splendid courage and great audacity, they are deficient in intimacy of sentiment and depth of feeling, and miss true subtlety of expression and largeness of manner. Moreover, their brilliancy of lighting is apt to be metallic, and as he was not a colourist of a high order, the white mixed with his tints to secure height of pitch affects the tone and harmony of the result and makes it somewhat common. This defective sense of colour became still more marked in the rather vicious greys of his later pictures, many of which are melodramatic and unworthy of his talent.

But if Bough's oil pictures, always effective, are often cheap and meretricious in effect, his water-colours are usually exceedingly good. His

method was kindred to that of such masters of the medium as Cox (1783-1859) and Müller (1812-45), yet he was always himself in design, conception, and choice of subject, bold, vivid, and full of vitality. What has been said of the feeling for Nature in his pictures is true of his drawings also, but his technical mastery was more sympathetic in the latter, and in them he attained qualities of colour and subtleties of atmosphere which he seldom reached in the other. His greys are often charming, and in sky effects he was peculiarly successful. The subjects of many of his water-colours he found along the populous shores of Fife, and rarely has the atmosphere of old-world civilisation which hangs about the coal ports and fishing villages of the ancient Kingdom, with their busy inhabitants, quaint streets, picturesque kirks and wave-worn harbours, been more vividly expressed. Nor was he less happy in dealing with effects of grey weather or alternating sunshine and shadow over pastoral, riverside, or moorland landscape in which men toiled or gipsies camped. His oil pictures may be more effective and striking, but his reputation rests more securely upon his mastery in water-colour.

Scottish artists have frequently influenced art south of Tweed, and they have been so often recognised and praised by English critics, that Bough's position and influence in Scottish painting deserves frank acknowledgment here. In his lifetime he was perhaps the most popular landscape-painter in Scotland—more popular than Wintour, Fraser, M'Taggart, men whose art was informed by a rarer spirit and cast in a finer mould. And this popularity was common to painters and public alike. When he settled here a rich but purely conventional colour-scheme was the ideal, and, if he did less than Fraser to insist upon the beauty of varied local colour, he helped to break up that convention, while his relish for air and motion quickened the sense of Scottish painters to these elements of effect, since carried to such perfection by M'Taggart and Wingate. Finally his preference for great panoramic views, falling in as it did with the example of M'Culloch, may not have been inoperative with men like M'Whirter, Graham, and Smart.

Scenic and effective, the adjectives which suggest themselves naturally to one describing the pictures and many of the drawings of Bough, cannot be applied to the work of Alexander Fraser. Singularly free from parade, both in subject and style, his art wins rather than forces its way to our regard. Landscape-painting has seldom come nearer the modesty of Nature. So unassertive and so simple is it, that his pictures seem mere transcripts of fact until one realises that the perfectly normal appearance they present is accompanied by careful, if spontaneous, regard for pictorial balance and harmony of colour. He did not interpret Nature's beauty, making it something new and wonderful, as the poet-painters do, but his pictures are steeped in the familiar and abiding charm of the beautiful facts of Nature. One can judge from the titles of his pictures that it was the

aspects of the weather and the seasons, with their accompanying work in field and wood and on sea-shore, which attracted him. From early spring to late autumn he lived with and painted Nature, but most of all perhaps summer and high noon in the forest had a fascination for him. To Fraser the country was never too green or the leafage too luxuriant. From the green landscape and the blue-and-white skies of summer he wove colour-schemes of great beauty, and often his colour has that brilliant enamel-like quality, clear and shining, bright yet harmonious, which one sees in Scotland after rain in spring or early summer. Yet he was equally successful with the more opulent harmonies which in autumn wrap tree and bracken and hillside in one glowing splendour of gold and russet and red. He seldom painted the sea, but his landscapes with their naïve and joyous delight in the country and its occupations, as in colour and handling, are very kindred to those of J. C. Hook. With Fraser, however, figures are accessories and not important elements. But his woodmen and harvesters, his gipsies and flower-gatherers, although never insisted upon, at once help to express the sentiment of the scene and the season and are used cunningly as factors in the pictorial design, giving necessary contrast or carrying certain colour-notes through the picture. In one of his pictures, I remember noting how the blue of the sky, peeping through the foliage of a forest glade, was repeated in the foreground in some flickering lights on a child's dress and on three little blue eggs lying in a nest. At first his colour inclined to a luminous low-toned grey enlivened by spots of red or brown, but this soon passed, and among his contemporaries, and compared with all his predecessors, Fraser was remarkable for the purity and freshness of his colour and for the variety and truth with which he rendered the local hues of Nature.

In determination to paint everything from the thing itself Fraser rivalled the most fervent of the Pre-Raphaelites, with whom it was a formulated principle, and, while he came to feel this habit a burden, he could not escape its domination. Constant painting out-of-doors had made it impossible for him to work without the actual scene before him. To this the want of design and concentration of effect in many of his pictures is probably due, for with Nature always before you it is difficult to obtain the detachment necessary to see your picture in its more purely pictorial aspect. Yet he had an instinctive feeling for the build and arrangement of a picture, specially in colour, and most of his work is balanced in effect. The landscape of his maturity, in which detail is less insisted on, is often forcible and even splendid, conceived in a truly pictorial manner and painted with rare grip and gusto. From time to time he varied landscapes with interiors, and during his later years he produced a number of remarkable still-lifes. Of the interiors, those painted at Barncleuth, an old Scottish house with a famous formal garden, near Hamilton, where he lived for several years, possess peculiar beauty

and a splendour and lustre of pure colour which gleams like an inlay of gems.

A born craftsman, there was never a time when Fraser's pictures betrayed the 'prentice hand. Those painted when he was five-and-twenty are almost as masterly as those of twenty years later. He handled his medium in a straightforward and, apparently, simple way, modelling in fluent and smooth impasto so modulated that it expressed delicate forms and subtle variations of colour. Upon this the more definite drawing of branches, prominent leaves, and suchlike delicate and sharp-cut detail was embroidered with unerring yet subtly expressive touches, which conveyed a sense of rich complexity without disturbing the unity of the masses. In particular he painted trees, oaks and beeches, willows and the rest, in a spirited and free way which expressed the character of the different species wonderfully and never became stereotyped. The results he obtained were homogeneous, rich, and luminous, and they have stood well, his earliest pictures retaining their brilliance undimmed. In a sense his style was founded, as was that of his older contemporaries, M'Culloch, Crawford, and Milne Donald, on the work of the Dutch landscape-painters (modified in his case by admiration for Cox and Müller), to which that of Erskine Nicol and Scott Lauder may be added as a more immediate influence ; but if he learned from others, he imitated no one. His art is the outcome of how he saw Nature, and a record of what he most admired. Neither poetic nor profound, and lacking in decorative effect, it yet revels in the gladness and luxuriance of this green earth, and expresses the familiar and everyday charms of the country in an unusually beautiful and triumphant way.

Fraser, who was born in Linlithgowshire in 1828, entered the Trustees' Academy when sixteen, but, while he studied there for some years, he really learned his craft by painting from Nature, by copying in the National Gallery, and through friendship with other painters. Among these early friends Fettes Douglas, who was six years his senior, was one of the closest, and many a sketching tour they took together. Until 1857, a year before he was elected A.R.S.A. (R.S.A. 1862), his subjects were principally Scottish, but in that year he visited Wales, attracted perhaps by the fact that David Cox, one of his favourite painters, had worked there, and for some time Welsh landscape engaged him. But the charm of Scotland came closer to him, and he returned to paint some of his finest pictures in Cadzow Forest and on Loch Lomond-side. In 1868-9, when in the full maturity of his powers, however, he was in Surrey and did splendid work, of which 'Amongst the Surrey Hills' and 'Eshing Bridge' are typical. Thereafter his old haunts in Scotland, with the addition of the Berwickshire coast (about 1875), and Ayrshire, where in 1881 he painted 'Rowallan Castle,' 'Fenwick Kirk,' and 'Arran from Skelmorlie,' supplied his subjects, and for the last fifteen years of his life,

during which he was partially paralysed, he painted round Edinburgh. Most of the pictures of his last period, although revealing his old sense of colour, fall far short of his average, and are in no way indicative of his achievement as a painter.

Less poetic than Wintour's, less vivacious and effective than Bough's, and less charming and accomplished than Fraser's, the landscape of James Docharty (1829-78) possesses a modest merit of its own. His personality, as shown in his work, was far less rich and vigorous than was that of any of these men, and it had to contend with more disadvantageous circumstances; but the conscientious and sincere nature of the man illumines his otherwise undistinguished work. Born in the Vale of Leven, he was trained as a designer for calico-printing, and was over thirty before he was able to follow his bent and become landscape-painter. Thus he had little education in the technical sense, and Glasgow had at that time few resident painters from whom he could receive advice or encouragement. In landscape Milne Donald (1819-66), then about forty years of age, was the most conspicuous practitioner, and Docharty, though he does not seem to have received any definite instruction from him, was at least influenced by his work. That, as already indicated, was founded to a great extent upon Anglo-Dutch convention, modified by a closer study of Nature, and Docharty pursued the same ideals with the tendency to realism intensified by the example of Fraser and Bough, and, perhaps, by what he had seen when working as a designer in Paris, where Gustave Courbet (1819-77) was making a prodigious stir.

To a certain extent Docharty's pictures mark the advent of the transcript from Nature in Scottish landscape art. While the earlier painters had been for the most part conventional, Wintour and Harvey were, each in his own way, romantics; Bough was eminently scenic and dramatic; Fraser, although remaining very close to reality, selected his material and arranged his effect; and Waller Paton, whose painting career pre-dates Docharty's by several years, combined close study of Nature with elements which make his work eminently conventional. Docharty, on the other hand, painted his chosen scene with simple fidelity, giving a close rendering of all the facts and conditions of effect, but leaving the result uncoloured by any marked personal preferences. He enjoyed a stretch of Highland moorland or glen, or a peep of tree-fringed and mountain-framed loch in a quiet way, but his record conveys little of that incommunicable thrill which R. L. Stevenson whimsically called the tuning-fork with which we test the flatness of art. It is because this is wanting that Docharty's landscape fails in emotional appeal, as does that of so many painters of to-day. Yet to leave the matter thus would be unjust, for his pictures are far more refined and tender in sentiment and technique than much realistic work of later date. They have not the developed sense of values and the realism of tone which have recently been in fashion, but if over-

hard and elaborate in handling, they are painted without affectation and swagger, and show a refined, if incompletely mastered, feeling for delicate form. Perhaps the most characteristic are of windless days by the lochside when the sky is filled with gently moving purple-grey clouds, which, veiling the sun, yet permit the passing of a softened sunbeam here and there to gladden the bleak hillsides with their craggy knolls and bracken-filled hollows, to glitter for a moment upon the tranquil waters on which wooded islets sleep, and more rarely to caress the green fronds of the foreground ferns, and the silver stems and nodding plumes of the birches which frame the vista. At times also he painted a roaring reach of tree-fringed and rock-bordered Highland river with felicity, and the view of the Lochy, with Ben Nevis towering over all, known as 'A Salmon Stream' (1878 : Glasgow Gallery), is probably his masterpiece.

Ordered south through failing health, Docharty went to Egypt in 1876, and the sketches he then made suggest that with greater experience and knowledge he might have developed into something more than his previous work had indicated. But he did not live to complete these projects or to paint much longer. In 1878 he died in Glasgow, having received recognition from the Royal Scottish Academy only a few months before the end.

While in Scotland these men were striving to give their impressions of landscape with fidelity and power, the Pre-Raphaelite movement, which had originated a few years before any of them attracted notice, had attained its zenith. It was many things besides, for the leaders were exceptionally gifted, but it was primarily an attempt to rid art of convention and to paint the world as it is. At the most obvious, this took the form of trying to imitate the variety and complexity of Nature's detail seen at close range. The effect of this ideal on some Scottish figure-painters has already been indicated, and it may have influenced the landscape of Fraser and Fettes Douglas ; but its direct effect in so far as landscape is concerned was confined to the work of three or four men. Of these William Dyce (1806-64), and W. Bell Scott (1811-90), whose landscape has been dealt with along with their figure-work, and Waller H. Paton (1828-95), were the most prominent. For some years Paton assisted his father in designing for the staple industry of his native place, but, in common with his brother Noël and his sister, afterwards Mrs. D. O. Hill, who became known as a sculptor of some merit, he possessed a feeling for art, and, when about twenty years of age, determined to become a painter. Except for a few lessons in water-colour from J. A. Houston, he was entirely self-taught, but his success was almost immediate. Six years after he exhibited his first picture at the R.S.A. he was elected an Associate (1857), and eleven years later a full member. He was an industrious worker and a copious exhibitor, and for many years his highly finished, prettily detailed landscapes enjoyed enormous popularity with the general

as distinguished from the art public. Although he painted a few foreign subjects, such as 'The Bridge of Boats, Cologne,' they are not sufficient in number to be accounted a variation in his work, which deals almost exclusively with the scenery of the Scottish Highlands. It was not, how-ever, the desolation of far-spreading moorlands under brooding clouds, or the wildness of jagged peaks emerging from weird and tortuous mist-wreaths, but the more obviously beautiful scenes and aspects of the hill country—wooded glens nestling into 'the roots of the mountains,' pictur-esque shielings sheltered by birch and rowan trees, pleasant valleys opening on the sea—that held his true affections and formed the subjects of his happiest efforts. To say that he lived in a land where it was always evening would be exaggeration, but his most characteristic pictures deal with the close of day and the up-coming of the moon. The lambent summer sunsets of the west had obviously a strong attraction for him, and he painted them, again and again, until repetition had blunted their appeal, as picture, to the public, and possibly dulled even their subtle and ever-varying beauty to himself. Still the sentiment of his work in this mood is often so genuine that one can really sympathise with it. Super-ficially at least, a characteristic Waller Paton sunset is not unlike what one sees, once in a long while, in the West Highlands. To a certain extent the colour, taken in isolated passages, is approximately true, and the separate elements, looked at one by one, are deceptively like Nature. But, like several of the Pre-Raphaelites in their earlier years he was passionately fond of purple, and the purple chords in colour were always and often dis-agreeably emphasised in his pictures, for he had little appreciation of the atmospheric envelope which in Art as in Nature means harmony. And while his earlier pictures were painted entirely out-of-doors—a practice he is said to have introduced into Scotland—and are full of carefully observed and minutely finished detail, his 'Mouth of the Wild Waters, Inveruglas' (1858), drawing a eulogy from Ruskin, his later work seems to lack the impress of fresh observation and to be handled in a spirit which savours of mannerism. Worst of all, the great relationships on which the moods of landscape depend are not observed, and the concentration of interest which holds one in Nature is ignored. Therefore it is to the unobservant and the prosaic that Paton's art appeals, for their remembrance of Nature is piecemeal and informed by none of that wonderful glamour which it is the mission of Art to reveal. Yet, if his pictures are not of a kind which any ardent lover of Nature or of Art would care to live with, they occupy a distinct place in any historical survey of Scottish Art.

CHAPTER XI

THE EARLIER ANIMAL-PAINTERS

ALTHOUGH the earlier Scottish animal-painters were few in number, and their work was undistinguished in an artistic sense, any chronicle of Scottish painting which neglected them entirely would be incomplete, for they demand the respect due to those who, if their own achievement was of little account, prepared the way for others who have accomplished more. The pictures of the Scoto-Dutch William Gouw Ferguson (1633 ?-90 ?) are remarkable indeed for the admirable way in which the form and fur and plumage of certain animals and birds are rendered and treated pictorially; but he does not seem to have painted other than 'still-lifes,' and it was not until rather less than a century ago that any Scot gave his chief attention, or perhaps any at all, to painting animals for their own sakes, and not for their lovely textures and their association with the larder. And, even after a beginning had been made, it was a long time before anything of real artistic interest was accomplished. To put it briefly, the period covered by this chapter produced no painter who combined taste and a gift for pictorial expression with the bent of mind which leads a man to choose the representation of animal life as the field of his labours. One might even say that everything of genuine merit achieved by Scotsmen in this particular kind of subject has been done by men still living or but recently deceased.

James Howe (1780-1836), the first Scottish animal-painter, like several of his contemporaries, commenced his career as a house-painter's apprentice. The son of the parish minister of Skirling, he early showed a love for drawing animals, and even the margins of his father's sermons were not sacred to him; but the best the poor parson could do to advance his son's artistic inclinations was to send him to the Nories in Edinburgh to learn their trade. He had considerable natural talent, however; before very long he had painted a panorama in his leisure hours for a Mr. Marshall, and when his apprenticeship was out he became a professional animal-painter. Lord Buchan was amongst his earliest patrons, and on his advice and introductions Howe tried his fortunes in London, where he painted portraits of some of the horses in the Royal stud; but George III. was suffering from defective eyesight at the time, and nothing definite resulting from the venture, he returned to Edinburgh. His portraits of horses and cattle were soon in considerable demand, for he possessed an instinct for the points and characteristics of breed that are

so highly esteemed by people interested in sport and cattle-raising, and in the Edinburgh Exhibition of 1811 he was represented by a frame containing 'portraits of different kinds of cattle, painted for and by order of the Board of Agriculture.' Some of his studies were also used to illustrate the *Encyclopædia Britannica*, and during his last years he began a series of 'British Domestic Animals' for Lizars the engraver, but it was never completed. The Highland and Agricultural Society possesses a number of these animal pieces; but they are studies, perhaps one may say side-elevations, of horses and cattle, and completely lacking in pictorial intention and even technical power. His work of a less representative character was more happily inspired, and reveals a range of subject and a certain rude power of execution and of pictorial characterisation which one would scarcely expect after seeing the other. One of the most finished of his pictures, engraved by C. Turner as 'Hawking,' and lent by Miss Fleming Hamilton to the historical section of the 1901 Glasgow Exhibition, represents Mr. Malcolm Fleming of Barochan, whose family held the honorary post of 'Falconer to the King,' on horseback and accompanied by several falconers and dogs, in a wooded landscape; another also engraved, but much inferior in drawing and design, illustrates the line 'Ca' the Ewes to the Knowes'; while a third depicts the pathetic story told in the ballad 'The Auld Man's Meir's Dead.' In the last the drawing, though clumsy, is fair, and in a certain way expressive, but the characterisation is of that exaggerated kind, awakening laughter rather than sympathy, which one finds in Geikie's etchings and some of Carse's pictures. But the most elaborate and, on the whole, the best example of Howe known to me is 'Skirling Fair,' into which, as Wilkie did in the 'Pitlessie,' the artist has crowded all the bustle and fun of a country carnival. The canvas simply teems with incident—bargaining farmers and drovers, excited cattle, idle onlookers and busy side-shows; and, if the drawing is rude, and the colour, pitched in a brownish key, monotonous, and there is a distinct lack of aerial lighting, the workmanship, if completely without refinement, is assured and bold, and the spirit of the scene is given with great gusto. Rural scenes and pursuits such as these he varied occasionally by painting studies of the animals to be seen in travelling wild-beast shows and by military incidents, such as 'Breaking up the Camp,' or 'Cossacks seizing a French Eagle'; while Waterloo was responsible for the only picture—a 54 × 34 canvas—he ever exhibited in London (British Institution, 1816), and for a panorama which, when shown in Edinburgh and Glasgow, brought him £15 a night as his share of the receipts. But he was too fond of drink and company, and his career in spite of times of prosperity was not brilliant. William Kidd (1769-1863), who is referred to elsewhere, served an apprenticeship to him, but otherwise he seems to have exercised little influence on the development of Scottish painting even in the department in which he was the pioneer.

If connection with the Academy be taken as a criterion of the esteem

in which an artist's work is held by his contemporaries, Howe's was considered of less moment than that of several of those to whom he had shown the way in the matter of subject, for Alexander Forbes, John Sheriff, William Shiels, and James W. Giles were all either Members or Associates of the R.S.A. None of these, however, possessed such natural talent or painted as boldly as Howe, though Forbes and Giles had probably a completer technical equipment, and it is probable that unsteady habits stood in the way of his being elected. Little is known about the lives of the first three, and neither their art nor that of Giles needs much comment. Forbes (d. 1839 : A.R.S.A. 1830), was probably the best of the quartette; at least, the few pictures by him that I have seen are more pictorial in intention, finer in colour, more expressive in action, and more refined in handling than those of the others. His rendering of dogs was particularly happy in combining a good deal of true pictorial motive with the interest in points which pleases the doggy man, and some of his portraits of horses have distinct merit and even some charm. William Shiels (1785-1837), who was born in Berwickshire, five years after Howe, became a member of the Scottish Academy at its formation, and John Sheriff (1816-44), who had been a clerk in Glasgow before he took to painting, was elected an Associate in 1839. The former divided his attention between painting animals and domestic genre of the Wilkie type : the latter was more exclusively an animaleur, but his pictures have no real merit, as may be seen from several specimens in the collection of the Highland and Agricultural Society. Although born in Glasgow, James W. Giles (1801-70) was the son of an Aberdonian, and he himself was connected chiefly with the Granite City. In his youth he lived for some time in Italy, but that advantage is not traceable in his art, which shows careful draughtsmanship, neat brushwork, and a desire to realise textures, but no feeling for finer or deeper technical qualities. He was one of the earliest Scottish painters, however, to paint the red deer amongst the hills, and landscape, which he often painted for its own sake, is frequently a feature in his pictures of animals. A keen angler, he was fond of painting the result of a successful day's fishing, and such studies are perhaps the best things he did. Giles was associated with the Royal Institution, and when the artists connected with that body seceded and joined the Scottish Academy, he became an Academician.

A much more prominent position than was attained by any of these men, was taken by Gourlay Steell, and, as his predecessors have been practically forgotten, he is usually regarded as the forerunner in his own branch of art in Scotland. Yet his handling had not Howe's gusto, nor his colour Forbes's quality, and it is questionable if he had as true a sense of pictorial fitness as either of them. His was a narrow and conventional view of picture-making into which ensemble and decorative effect did not enter, and even in his best time he did not grasp the

pictorial possibilities of his material or possess a true feeling for the proper use of paint. But he was interested in animals, and drew horses and dogs and cattle with considerable skill and distinct sense of character and form, painted with neatness and finish, and conceived his subjects in a manner that proved attractive to many people. Moreover, he had the good fortune to obtain the admiration and patronage of Queen Victoria, who appointed him her 'Animal-Painter for Scotland' in succession to Sir Edwin Landseer (1802-73), a position unfilled since Steell's death. A son of John Steell, a well-known wood-carver in Edinburgh, and younger brother of Sir John Steell (1804-91), the sculptor, Gourlay, who was born in 1819, worked in the round a good deal in his younger days, modelling many animal groups for silversmiths, and teaching modelling in the Watt Institute. But his personal taste inclined to painting, and he studied in the Trustees' Academy under Sir William Allan, and painted for a while in the studio of Robert Scott Lauder, though his art bears no trace of that master's influence usually so potent in his pupils' work. Elected A.R.S.A. when twenty-seven and Academician thirteen years later (1859), and appointed painter to the Highland and Agricultural Society, he had for many years a virtual monopoly of animal portraiture in Scotland, and was also much employed in painting sporting pictures, such as 'Lord President Inglis and a Shooting-party at Glencorse' (1868), one of his best-painted and designed works, or hunt groups like those of the Earl of Wemyss with his huntsmen and pack (1863), and Colonel Carrick Buchanan with his (1871). Highland cattle, sometimes belligerent, as in 'A Challenge' (1865), where two bulls are on the verge of a combat, sometimes passively feeding in their native wilds, or, as in 'The Pass of Leny' (in the Royal Collection), on the road to a Lowland tryst, were favourite subjects for his uncommissioned pictures; and in what was perhaps his most notable work, the 'Highland Raid,' in which a party of marauding Macgregors are making a stand against Government troops, they form one of the chief interests. The most popular things he did, however, were more sentimental in character: the 'Llewellyn and Gelert,' of 1857, 'Burns and the Field-mouse,' and, above all, 'A Cottage Bedside at Osborne' (1865), with the Queen reading the Bible to a sick fisherman. But popular and esteemed though he was, the fact remains that he was scarcely a painter, and his charcoal drawings and black-and-white designs are infinitely more satisfactory in an artistic sense than his more ambitious and pretentious efforts in paint. It should perhaps be added that he was curator of the National Gallery of Scotland from 1882 until his death twelve years later.

PART II

THE PRESENT—1860-1908

INTRODUCTORY

PAINTING IN THE FIFTIES AND LATER

WHILE the division of the history of painting into periods other than those marked by the prevalence of particular technical and emotional ideals, or the dominance of certain masters, is arbitrary to a great extent, some division is necessary to enable one to handle a mass of material, and it happens that the painting that can be described most fitly as Scottish begins with the close of the eighteenth century and can be divided almost naturally into two principal parts. With the earlier of these[1] we have already dealt, and, if certain of the painters previously discussed worked into the following period (which comes down to to-day), and the earlier ideals persisted in the art of not a few, even of the new men, the middle of last century synchronated with changes which make it a convenient point from which to survey the condition of art affairs in Scotland and the general lines upon which later developments have taken place. Briefly, the painting of the first half of the nineteenth century had shown the grafting of Scottish perception and sentiment upon the stock of old masterly traditions of method and tone. That which followed, although retaining traces of the earlier school in individual cases and in certain directions, was much more naturalistic and individualistic in spirit. In the work of the most important of the earlier groups it is marked by the development of a more expressive technique, a more pictorial treatment of subject, and fuller and far finer colour, and in that most characteristic of the last twenty years by experiment and modernity combined with regard for the great pictorial conventions of the past.

The earlier fifties were rather a dead time in Scottish painting. In portraiture, indeed, the Raeburn influence persisted in the work of the stronger men: Watson Gordon and Graham Gilbert were still in full practice, and Macnee was at his best, but in the portraits of others a meaner and more photographic manner had commenced to appear. Geddes and Duncan had died in the middle of the previous decade and David Scott at its close, and with Dyce and Phillip (the latter, moreover, had not yet painted the pictures which entitle him to fame) in London

[1] This embraces not only the artists who did the whole of their work between 1787 and 1860, but all who had definitely emerged and had attracted considerable attention prior to the later date. No living artist figures in it.

and Scott Lauder teaching, Harvey and Drummond and Houston, and the new *arrivées*—Fettes Douglas, Noël Paton, James Archer, Herdman, the Faeds, and Erskine Nicol—in whose work antiquarian, literary, or sentimental motive was prominent, were the figure-painters of importance. And landscape, although signs of more intimate feeling and naturalistic treatment were already apparent in the backgrounds of Harvey's pictures and in the early work of Bough and Fraser, lay under the spell of the grandiose but empty style of M'Culloch, or still conformed to the Dutch convention, which had influenced so many of the earlier landscape men. Technically also, the traditional methods retained their sway; but the majority of those painting at this time showed less accomplishment and painter-like quality than their predecessors. And while colour was making a nearer approach to reality and showing greater variety than before, it, for the most part, and specially in the pictures of such men as the Patons and the Faeds, was patchy, unrelated, and harsh in quality.[1]

As in England, where the Pre-Raphaelite brotherhood, originating in 1849, had come to regenerate a decadent school, art in Scotland was ripe for revolution or change, which came some years later, principally in the work of Robert Scott Lauder's pupils, and in that of a few rather older landscape-painters. The earlier movement in London had no doubt a certain effect in Edinburgh, as may be seen in the early pictures of some of the younger Scots,[2] but each possessed qualities of its own, and the controlling influence of a master with a genius for teaching and a respect for tradition rendered the Scottish rising less revolutionary. Lauder led his pupils gently from an outworn convention into a noble and higher one. It was more a reconstruction than a revolution that took place in Scottish Art.

The æsthetic development in England had been connected, more or less directly, with a ferment of ideas which affected literature, religion, and politics, as well as painting; but that in Scotland was not associated with any wide intellectual movement. Walter Scott and his contemporaries, who had made the first half of the century memorable in literature, were dead or dying, and Carlyle (1795-1881), by far the most outstanding Scottish writer of the time, master of the picturesque as he was, had no understanding of, if indeed he had not a contempt for, pictorial art. As often before, the intellectual and emotional side of Scottish character had been absorbed by a great religious and ecclesiastical controversy, and was now engrossed in settling the problems raised by the Disruption of 1843. But if art seemed to be uninfluenced by the religious conflict, the great stirring of feeling and the enthusiasm and devotion evoked by it, especially as it was primarily a claim for spiritual inde-

[1] As already noted, Phillip did not reach maturity until some years later; but Dyce, Fettes Douglas, and Nicol were admirable craftsmen in their several ways.

[2] *i.e.* some of Scott Lauder's pupils. The work of David Scott and Dyce, and of Douglas and Noël Paton was in some respects an anticipation of Pre-Raphaelitism.

pendence, must have had effects in every sphere of intellectual activity. Be that as it may, the artists who came about that time were trained entirely at home, and their art, besides being distinguished by many fine æsthetic qualities, revealed greater imaginative freedom than that of their predecessors. Orchardson and Pettie, M'Taggart and Chalmers, Cameron and MacWhirter and the Grahams, were of the number, and the work they have done in portraiture and genre, and in landscape and sea-painting, is not only considerable in quantity, but is instinct, much of it, with character and beauty. While the art of the earlier Scottish genre and landscape-painters and their immediate successors had been largely sentimental and discursive and tended to dissipate itself on side issues, Lauder's pupils, though retaining much of human and emotional interest, were definitely pictorial in intention and laid stress upon unity and concentration of conception and design. As a group, however, their most distinctive quality was colour, in which they have attained a modulated richness, a varied harmony, and a clarity of tone previously unknown among their countrymen, and unequalled in the work of any similar group of British painters. Developing individually without losing the common bond of technique, colour, and pictorial interest with which they began, the art of their maturity possesses a clear connection, not only with the past of each, but with that of one another. Yet no coterie of modern painters has been more varied in choice of subject-matter or has shown greater variety of temperament in conception ; and this is true equally of those who remained at home, and of those who, going to London early in life, have obtained more widespread reputation.

Born during the decade preceding that (1830-40) to which Scott Lauder's pupils belong, Wintour, Bough, Fraser and Docharty (all of whom are dead) did much of their best work contemporaneously, and sharing the naturalistic spirit which formed an element in the more complex art of their juniors, both influenced and were influenced by them. But their landscape was in some respects transitional in sentiment and style, and belongs rather to the past than to the developments with which we have now to deal.

The Lauder influence persisted until recently, and still forms part of vital artistic tradition in Scotland. But the blossoming of talent which had marked the later fifties was not fully maintained, and although painters increased greatly in number, few fine figure-artists emerged during the following five-and-twenty years. Sir George Reid, however, has produced a series of men's portraits remarkable for keen characterisation and virile handling ; W. E. Lockhart as a follower of Phillip, Robert Gibb with battle-pieces, and George Wilson and J. H. Lorimer, in genres of their own, have been prominent ; and a few others, chiefly pastoral-painters, have revealed considerable talent. In landscape, on the other hand, much of beauty or of power appeared. While the great majority of those

who arrived between 1860-65 and the appearance in Glasgow, some twenty years later, of a group holding different ideals were concerned with the facts rather than with the significance of landscape, and remained uninspired in their traffickings with Nature, the comparative barrenness of that period in promising recruits was redeemed by the high artistic and emotional quality of a gifted minority. Amongst these Cecil Lawson (1851-82), T. Hope M'Lachlan (1845-97), and Lawton Wingate, in pure landscape, and Colin Hunter (1841-1904) and Hamilton Macallum (1841-96) in pictures of the sea have been conspicuous for passion or charm of sentiment or for originality of observation. In the hands of Bough and Fraser and of one or two of the younger men the pitch of lighting was raised greatly, but here, as in brilliance of sun-illumined colour, vivid suggestion of movement, and vital impressionism of mood and effect, the lead was taken by M'Taggart, whose achievement in these directions is wellnigh unique, and anticipates that of Claude Monet and his followers. And animal-painting, which during the preceding fifty years had had scarce one practitioner of merit, found in Robert Alexander and Denovan Adam (1842-96) devotees who have achieved artistic results by very different methods.

Water-colour, which, except by ' Grecian Williams ' and W. L. Leitch, had been practised previously in Scotland principally as an auxiliary to oil-painting, for sketching and making projects for pictures, was now taken up and advanced to a place of its own. Bough and Wintour were probably the pioneers, but before 1870 Fettes Douglas, Lockhart, M'Taggart, and others had joined them, and George Manson had adopted water-colour as his medium. Thereafter it was followed for its own sake by an ever-increasing number, and in 1878 a Scottish Society of Water-Colour Painters was formed. At the time Scottish artists were turning to water-colour, the broad and noble tradition built up in England by the early masters, by De Wint and Cox, Cotman and Bonington, had been undermined by the influence of Frederick Walker (1840-75), Pinwell (1842-75), Houghton (1836-75), and their fellows, and was being superseded in the drawings of their imitators by insipid sentimentality and inane and pretty workmanship; but most of the Scots used it with true understanding of its special qualities, and of the effects best suited to bring these out. And although there has been a tendency of recent years to force the medium beyond its limits and to attain results irrespective of charm of method—so defeating the artist's own aim—a broad and expressive manner is still most in favour. It is to be regretted, however, that admiration for the fine pictures of Israels, Maris and their *confrères* has led in some cases to a halting and unsatisfying compromise between tone and colour. The Dutchmen, true to their best traditions, placed tone before colour, while these Scots in aiming at tone have lost to some extent the charm of colour and the bloom of

surface which belong to the earlier method, without attaining the depth of tone for which the Dutch sacrifice colour.

While the interest of Scottish painting until a few years ago is principally centred in Edinburgh, or in Edinburgh trained men who went to London, it is to Glasgow that its most recent developments are due. There, owing to a combination of circumstances which will be examined in detail later, a distinctive style, which has little superficial relationship to the art previously existing in Scotland, though still possessing certain qualities inherent in Scottish painting and character, has come into being. Broadly considered, the 'Glasgow School,' as it was christened, was an outcome of the Impressionist movement, initiated by Manet, Whistler, and Monet, of which the work of Sargent and his following, and of the New English Art Club group, are English phases ; but different conditions, and perhaps greater isolation, gave it characteristics of its own. The formative influences were complex, and included the example of two or three of their own countrymen, but perhaps the most operative were Whistler's exquisite art, in which the great traditions of the past are blended with the charms of the decorative arts of the Far East ; the wider horizon opened up through acquaintance with the work of the French and Dutch romanticists, which had come into favour with certain Scottish collectors ; and the training several Glasgow men received in Paris. Yet there is no doubt that the determining factor was the association of the men with one another. Young and enthusiastic, their ideals were narrow and excluded much that is excellent, but they believed in them and in themselves, and, working in this spirit and stimulated by friendly emulation, their work was almost certain to possess distinctive qualities. Briefly, these were preference for low and full tone upon a basis of naturalistic values ; concentration of motive gained by suppression of non-essentials ; a more decorative aspect of canvas than existed in contemporary Scottish painting ; vigour and power and a distinct feeling for style in the actual use of the medium ; above all, devotion to the purely pictorial elements in subject. In reaction from too much sentimental anecdotage, they would scarce touch the subject-picture at all, and even the success of the 'Kailyard' novel did not seduce them into dealings with genre. On the other hand, the fastidiousness of method and the striving for distinction of style, to which R. L. Stevenson's example gave currency in literature, found a counterpart in their painting.

As was to be expected, perhaps, this movement met with opposition and ridicule, but 'the boys' stood by one another; they were supported by a small but intelligent group of art-lovers, and, in the end, they achieved success. People became accustomed to the new methods, and eventually came to tolerate and even to like them, and the Royal Scottish Academy, after repulsing their early overtures, has taken the leaders to itself. Sir James Guthrie occupies the presidential chair, E. A. Walton, Alexander

Roche, John Lavery, George Henry, James Paterson, and W. Y. Mac-Gregor are no longer outsiders, and E. A. Hornel remains unlettered because he refused the honour.

Those named, with Arthur Melville (1855-1904), who began upon similar lines in Edinburgh rather earlier than the Glasgow men, and Joseph Crawhall, the Newcastle artist, who was also associated with them, were the most prominent figures in the early days, and while their prominence has never been challenged successfully, a large number of painters followed their lead, and the art of the West of Scotland took its tendencies from their example. The effects of the influences which moulded this new movement were not confined to Glasgow, however. But when, only a little later than there, foreign study and the wider horizon began to influence the work of the younger Edinburgh painters, the issue was rather different in form. Most of the men thus affected had been trained in the school of the Royal Scottish Academy, and the result of fresh impulses in their art was gentler. While profiting by the newer ideals, they combined with them more of existing tradition. For a considerable time even after the Academy began to recognise the leaders of the more advanced sections, this group-system persisted; but, gradually, new and old approximated, and the resultant art was enriched by study of the great masters of portraiture and landscape. The influence of this was wide-spread, and perhaps the finest aftermath of the movement as a whole is to be found in the work of a few men who belong to neither Glasgow nor Edinburgh.

It was not only at home that the younger Scottish painters were recognised and admired. Their pictures attracted much attention abroad, where many of them were medalled or purchased for public collections. And, by the confession of foreign critics, they have influenced the art of Europe.

Towards 1890, and owing very largely to the example of Whistler, Seymour Hayden, and Legros, original etching, which during the first half of last century had had but few followers in Britain and none of talent save Wilkie and Geddes, was taken up by quite a number of gifted artists, amongst whom several Scotsmen were prominent. Of these William Strang, D. Y. Cameron, and Muirhead Bone, each in his own way an artistic personality of distinction, have been the most notable, but others have done good original work; while in interpretation William Hole has executed a series of plates of quite exceptional merit, and Colin Hunter (after his own pictures) and R. W. Macbeth, and, in less degree, C. O. Murray and David Law have shown considerable accomplishment.

A revival has also taken place in mural decoration, in which indeed the only works of importance done previously by Scottish artists were the 'Ossian Hall' in Penicuik House, by Alexander Runciman (1736-85), and the Westminster and other frescoes by William Dyce (1806-64). But in

the mid-eighties Mrs. Traquair, an Irish lady married to a Scottish scientist, painted a series of panels in an Edinburgh hospital, and since then a serious attempt has been made to employ mural painting in the adornment of public buildings. Mrs. Traquair has carried out two great schemes with most happy results in Edinburgh churches ; William Hole has painted important series of historical pictures for the Scottish National Portrait Gallery and the Edinburgh City Chambers, and executed a number of decorations of an ecclesiastical kind ; and Glasgow commissioned four of the most gifted members of the local school to paint panels for its hotel de ville. The M'Ewan Hall and some of the University settlements in Edinburgh, the Music and Trades Halls in Aberdeen, and other buildings elsewhere have likewise offered a field for the exercise of this fascinating and most communal phase of art.

Art Societies and Exhibitions

For many years the annual exhibition of the Royal Scottish Academy held undisputed place as the chief exhibition in Scotland, and it remains the most representative of Scottish art. There have been times of course when too great conservatism has been shown both in the policy of the Academy and in the management of its exhibitions, but, on the whole, it and they have represented the dominating tendencies of Scottish art, and have recognised, tardily perhaps but eventually, new developments. When founded (1826), or at least after the artist members of the Royal Institution joined in 1829, the Academy included practically all the artists of any importance in Scotland, and this continued for the first thirty or forty years of its existence. During that period Milne Donald is perhaps the only conspicuous name absent from the roll. Continuous increase in the number of artists, however, gradually made the Academy an exclusive body, and, as it had grown up in Edinburgh at a time when art hardly existed elsewhere in Scotland, local prejudice, or more probably mere habit and tradition, led to it recruiting its ranks almost exclusively from those who had been trained in its school or who lived on the spot. For long, it is true, there were few Scottish artists outside the capital with indubitable claims for recognition, but there were several of whom it may be said that the fact that they did not live in Edinburgh prevented their election. Except Horatio M'Culloch (A.R.S.A. 1834), no artist had been elected to Associateship while resident in Glasgow until Docharty (1877) and David Murray (1881) were. And when seven years later—although in the interval quite a number of gifted painters had appeared in the West— James Guthrie was chosen (1888) there was not a single artist in Glasgow amongst the fifty Academicians and Associates. But since then a more liberal policy has obtained, and the Academy has become Scottish in composition as well as in name. In pursuance of this, a new charter, the

principal provisions of which made the number of Associates unlimited and gave them some say in Academic affairs, was obtained in 1891, and, being interpreted in a liberal spirit, resulted in considerable additions to that class. More recently, the old spirit of exclusion has reasserted itself to some extent, and elections have been less numerous. At the same time these have been judicious for the most part, and have represented different localities and interests with commendable impartiality.

As regards the exhibitions, in response to a general tendency of the times, an attempt has been made of late to raise the standard and to place everything accepted where it can be seen to advantage. Yet, desirable though this may be—and the members in restricting their contributions to three each while allowing outsiders the same have shown a real desire to accomplish it—the present galleries are too small to make it possible without unduly restricting the representative character which the exhibition of the National Academy ought to possess. Further, the limited accommodation available has been responsible for a good deal of friction within the Academy itself. But when the scheme for the better housing and equipment of the national art institutions, which the present Secretary for Scotland has in hand, is realised, these difficulties will be removed.

Since 1850, six artists have occupied the Presidential Chair. Sir J. Watson Gordon (1850-64), was followed by Sir George Harvey (1864-76), Sir Daniel Macnee (1876-82), and Sir W. Fettes Douglas (1882-91), all of whom died in office, and when Sir George Reid retired in 1902, he was succeeded by Sir James Guthrie, who worthily maintains the best traditions of his high office.

It was not until after 1861, when the Glasgow Institute of the Fine Arts (created Royal in 1896) held its first show, that the western city was provided with a continuous series of annual art exhibitions. Held in the Corporation galleries to begin with, they were transferred in 1880 to new galleries which the Institute had had built on the opposite side of Sauchiehall Street. In 1904, however, the Institute's rooms having proved too small, and the whole of the Corporation galleries being now available through the migration of the city collections to the new Art museum at Kelvingrove, the exhibitions moved back to their earlier quarters. Managed by a council of twelve, seven laymen and five artists, chosen by the members, who on joining contribute ten pounds to the funds, the object of the Institute 'is to diffuse among all classes a taste for Art generally, and more especially for contemporary Art.' With this end in view—while providing adequate facilities for the exhibition of local and contemporary work, and organising an Art Union, which has been very successful recently, in connection therewith—efforts are made to secure important and interesting examples of an educative kind and representative of different schools from private collections. This policy has been very successful in many ways, as is evident from the influence which

the work of the French and Dutch romanticists, which was often represented there in the eighties, has had on Glasgow painting, but it may not be out of place to suggest that some of those who have taken a leading part in its management have been unnecessarily disdainful of native talent.

Six years later than the Institute, the Glasgow Art Club was founded with a membership of nine, including William Young, David Murray, and William Dennistoun (1838-84), an architect who turned architectural painter, with whom the idea of association originated. At first a monthly meeting was held and a portfolio of drawings was circulated amongst the members, but in 1873, having received several recruits in the interval and feeling strong enough to make a public appearance, it held an exhibition, which for many years was repeated annually.[1] In 1878 the Club secured rooms of its own in Bothwell Circus, and gradually became the centre of art life in Glasgow. And this function it still performs in the splendid club-house in Bath Street, in which, after a sojourn further along the same street during which lay-members were first admitted, it settled in 1893. The work of its artist members at different times of its career is summarised, as it were, in the Club books published in 1881 and 1885.

The Edinburgh artists have likewise a club, but it is social rather than professional in character, and exhibitions other than loan in its own rooms have not been promoted by it. Founded in 1873, it was housed for many years in Queen Street, but in 1894 it was reconstituted as the 'Scottish Arts Club,' and removed to Rutland Square. Its professional membership includes literary men and musicians as well as artists and architects ; and laymen are also admitted.

Of all the art societies in Scotland, the Royal Scottish Water-Colour Society is perhaps the most representative in character. Originated in Glasgow in 1878 by a number of artists (Sir Francis Powell and Mr. A. K. Brown were specially active), who felt that the delightful art of water-colour painting was at a discount in the existing exhibitions, its headquarters have always been in the west. But its membership —at first twenty-five, now seventy-five, but unlimited—is drawn impartially from east and west ; the North of Scotland and the London Scots are represented, and, although beginning with an associate class, all its members are on an equal footing. Most of its exhibitions have been held in Glasgow, latterly in the Institute during the autumn, but shows have also taken place in Edinburgh, Dundee, and London. Sir Francis Powell, who was knighted five years after the society was created Royal in 1888, has been President since the beginning, and Mr. M'Taggart became Vice-President on the death of Sam Bough less than a year after it was formed.

The year (1891) which saw a new charter granted to the Royal Scottish Academy, saw also the formation of a new 'Society of Scottish

[1] These exhibitions have been resumed.

Artists.' Its declared objects were to induce the younger artists to produce more important and original works by providing opportunities to display them and to procure educative examples of modern and past art on loan for its exhibitions, and for some time it fulfilled these intentions admirably, and even influenced the Academy by the charming manner in which its exhibitions were arranged. But from the first to a great extent an Edinburgh society, and holding its exhibitions by permission of the Board of Manufactures in the Academy galleries, of late years, while frequently containing some excellent work by the younger Edinburgh painters, its exhibitions have not justified its existence except as a local society. And if this has been due in some measure to the Scottish Academy having elected the leaders to academic honours, failure of the members as a whole to reserve their best things for their own shows has made lasting success somewhat improbable. While its membership, numbering about five hundred, is, like that of the Glasgow Institute, both professional and lay, the artists have a preponderating say in its management.

Minor art societies in Glasgow are the 'Glasgow Society of Artists' (founded 1901) and the 'Society of Lady Artists,' the latter of which combines the social with the artistic elements in its pleasant club-house.

As one might expect of a city which has contributed many painters to the Scottish School, Aberdeen has an artists' society of its own. Only a year later than the Academy, an artists' society was formed there. It had but a brief career, however, and it was not until 1885 that the present society came into existence. At the inaugural exhibition pictures by the Glasgow and Newlyn groups were hung with examples of French and Dutch art from the collection of Mr. Young of Blackheath, and the organisation of several succeeding shows was marked by similar enterprise. After 1892 the association was reformed on a different basis, and since then exhibitions of a more general if less educative character have been held, mostly at intervals of two years. The membership of the Society numbers about 550, lay and professional.

Although not a centre of artistic activity like Edinburgh and Glasgow, or a cradle of painters like Aberdeen, Dundee has shown considerable interest in the arts. Beginning in the later seventies, an exceptionally successful series of exhibitions was held in the galleries of the Albert Institute. But of late, owing to the death of some of the more public spirited of the local collectors, this interest has been less apparent, and no exhibition on a large scale has been held since 1891. Notwithstanding this, there has been an increase in the number of artists practising in the district, and The Graphic Arts Association, formed in 1890 and fourteen years later converted into the Dundee Art Society, now holds an annual exhibition chiefly of works by its members, and conducts a class for study from the life. On the other hand, the function of the Paisley Art

Institute (founded 1875) is purely that of exhibition. Once a year it holds a show in which the contributions of its professional members, mostly artists resident in Glasgow and Edinburgh, are supplemented by a number of important pictures obtained on loan from collectors in the neighbourhood. It had a membership, artistic and ordinary, of about six hundred and fifty.

Occasional exhibitions organised by local Sketch Clubs or Art Societies in such towns as Dunfermline, Kilmarnock, Stirling, Ayr, and Kirkcaldy, indicate that an interest in Art is not confined to the large centres.

Permanent Art Collections

Of scarcely less importance than the formation of art societies and the provision of facilities for the public exhibition of current work was the formation of permanently accessible collections of good pictures and sculptures. Works of art existed before public galleries, of course, and there would have been nothing to put in our museums if the artists of the past had received no contemporary recognition of a tangible kind. And this is a lesson for the connoisseurs of to-day. If they fail in their duty to what is good in the work of the present, they not only deprive the living artist of necessary encouragement but rob posterity of so much of its heritage. It is to the priests and princes and merchants of Greece and Italy and Holland, who commissioned the artists and craftsmen of their own day to execute works of art, and not to the connoisseurs of later times who gathered them into private collections, that we are indebted for those masterpieces which are amongst the world's choicest possessions. Nor should it be forgotten that Reynolds and Gainsborough, Raeburn and Wilkie produced the pictures which are the boast of British art before the National Galleries of England and Scotland were founded. But the collector as custodian serves a useful purpose also, and the public gallery plays an important part in the education not only of the artist but of the public which forms the artist's audience and rewards his labours. Art has its fashions as well as millinery, and amid the constant change and contest of opinion, which is part of the price we pay for our greater freedom and wider knowledge as heirs of all the ages, it is well to have available collections of art work sifted and tried by time, as a touchstone of taste and accomplishment if not as an absolute standard of emotion and subject. The formation of the National Gallery of Scotland was therefore of great moment to Scottish art.

'Ill blows the wind that profits nobody.' The National Gallery was an outcome of a quarrel between the Scottish Academy and the Board of Manufactures. From 1836 the Academy had held its exhibitions in rooms in the Royal Institution rented from the Board, but in 1845, owing to the acquisition of the Torrie collection, it received notice to quit. The

Academy made representations to the Treasury, and, as a result, Sir John Shaw Lefevre held an inquiry and made a report which recommended the building of a gallery to house both the Academy and a national collection which was to be formed by bringing together several collections which were more or less public property. By an Act of 1850 the Board of Manufactures was empowered to proceed with the necessary buildings on the site on the Mound which the city of Edinburgh had granted for the purpose at the nominal price of £3500. Playfair was chosen architect, and the gallery, which was completed in 1859, cost £53,500, of which the Board provided £23,500 [1] and Government £30,000.

As already indicated, the collection was formed by the amalgamation of the separate collections formerly exhibited in the Royal Institution. These were the old masters collected by the Royal Institution; the pictures ancient and modern belonging to the Royal Scottish Academy; the paintings and sculptures bequeathed to Edinburgh University by Sir James Erskine of Torrie; the modern works acquired by the Society for the Promotion of the Fine Arts in Scotland; and the pictures in the possession of the Board of Manufactures. The western suite of rooms in the new Gallery was allocated to the National Gallery, and the eastern to the Academy; the general custody and maintenance of the whole building and of the National Gallery were vested in the Board, and the Curator of the Gallery was to be appointed by the Board from a list of four members submitted by the Academy. But no provision was made for increasing the collection by purchase as is the case with the London Galleries and in Ireland. Even the maintenance of the buildings and the salaries of the staff were ordered to be paid out of the exclusively Scottish monies in the hands of the Board. In this way Scotland had paid nearly £50,000 between 1859 and 1902 for services which in England and Ireland are supplied by the Treasury.

With no funds available for purchase, the expansion of the Gallery has been almost entirely due to the generosity of private donors. [2] That has been considerable, however, and the collection, although small, is of high quality, and contains several works of first-class importance. Moreover, as re-arranged (1897) by the late keeper, Mr. Robert Gibb, R.S.A., it presents an exceptionally charming appearance.

If the foreign pictures are comparatively few in number, the Van Dycks are amongst that artist's noblest works; Rembrandt and Hals and Ruisdael, and some of the minor Dutchmen, and Veronese, Bassano and Tiepolo are exceptionally well represented; and the group of French pictures, most of which were collected by Allan Ramsay and bequeathed by Lady Murray, includes very charming examples of Claude, Watteau,

[1] Including price of site.

[2] In 1890 the Treasury granted £5000, in instalments of £1000 a year, as an equivalent to the money given by Mr. William M'Ewan for the purchase of a Rembrandt.

Pater, Lancret, Boucher, Greuze, and Chardin. Amongst the few pieces
of sculpture are Michael Angelo's models in wax for the two principal
figures on the Medici tombs and the 'Madonna and Child' in San
Lorenzo, and several Greek fragments of beauty. Of the still fewer
English pictures Gainsborough's masterpiece, the beautiful 'Mrs. Graham,'
Etty's biggest and most famous works, the Judith series and the
'Combat,' which were bought from the artist by the Scottish Academy,
a couple of Richard Wilsons, two Cromes, and the Vaughan Bequest
of Turner drawings are the most notable. As is to be expected,
Scottish art is more fully represented. Amongst the earlier painters
Raeburn, in a splendid series of portraits, Allan Ramsay, Thomson of
Duddingston, William Simson, Geddes, Watson Gordon, David Scott,
Duncan, and H. W. Williams are admirably seen : of the later, Phillip,
Paton, Fettes Douglas, Chalmers, and Tom Graham are well if not
numerously represented. But there are many blanks. There is no
portrait by Wright or Scougall, no landscape by Harvey or Chalmers ;
and nothing at all by Jacob More, Wintour, Fraser, Pettie, or Tom
Faed. Nor are Wilkie, Roberts, or Bough, to name no more, seen to
advantage. And the diploma pictures of the Royal Scottish Academy,
which may be said to bring the collection up to the present, are not at all
representative in many cases of the names they bear.

Of recent years the prosperity of the Gallery has been very adversely
affected by lack of room as well as by want of funds. Even since the
collection was weeded of its less important and doubtful pictures in 1897
the walls have been crowded to excess, and it has been exceedingly difficult
to find places for new acquisitions. And this, no doubt, has cooled the
ardour of possible donors. In 1901, however, when at the instance of
Sir John Stirling Maxwell an attempt was made to secure a Parliamentary
grant for the purchase of works of art for the Gallery, a committee was
appointed by the Scottish Office to inquire into the administration of the
Board of Manufactures. This opened up the whole question of the condi-
tion of the National Art institutions of Scotland, and revealed the parsimony
of the Treasury and the great difficulties with which Scottish art had had
to contend. The committee reported that both the National Gallery and
the Scottish Academy must have increased accommodation, that both the
National Gallery and the Portrait Gallery had been starved and ought to
be maintained properly and given grants for purchase, and that a new
School of Art connected with the Municipality should be established.
Other societies, including the Royal Society of Edinburgh and the Society
of Antiquaries in Scotland and its museum, were involved also, and com-
plicated the Art problem greatly ; but with these we are not concerned.
After long waiting, Mr. Sinclair, the Secretary for Scotland (there had
been three in office since the Committee of Investigation had been
appointed), produced a plan which, if less ambitious than that recommended

by the committee, was possible and met the immediate needs of the situation. A new Art School was arranged for in a manner which will be mentioned later. And after many delicate negotiations, it was settled that the National Gallery should have the whole of the building of which it had hitherto occupied half, and that the Academy should be located in the Royal Institution, which was to be reconstructed to suit its special purposes.[1] Meanwhile a bill abolishing the Board of Manufactures was passed (December 1906), and a new 'Board of Trustees,' with Sir T. D. Gibson Carmichael as chairman, was created to administer the Galleries, which, as recommended by the committee, were to be maintained on a Parliamentary vote, including £1000 a year for purchase, while the annuity of £2000 secured to Scotland under the Treaty of Union was to be transferred from the Estimates to the Consolidated Fund and no longer treated as a grant from the British Exchequer.[2]

Beginning with a most admirable nucleus and increasing very considerably through important gifts and bequests, the National Gallery of Scotland, had it had from its foundation, like the National Gallery of Ireland, an annual grant for purchase, might by now have been a large as well as a charming collection. But regrets are vain. One must deal with things as they are, and highly desirable though the acquisition of fine examples of the great masters of all the schools, and particularly of men like Rembrandt and Titian, Velasquez and Tintoretto, Reynolds and Turner, Constable and Corot, whose work is of the highest artistic interest, would be, the Government grant is inadequate for the purpose, and most additions of that nature must continue to come, as in the past, from private generosity. Realising this, the Trustees have recently appealed for support to Scottish collectors in a report (prepared by Sir James Guthrie and the Director), which states the chief requirements of the Gallery and indicates the lines upon which it is intended to develop the collection. 'The resources at the disposal of the Trustees being limited,' says that report, 'your committee believes the ideal to be aimed at in connection with the Foreign and English sections is that of collecting examples of the more individual men or characteristic phases in each of the important schools rather than the attempt to form a large general collection illustrative of the history of painting in all countries. As regards the Scottish section, on the other hand, an endeavour might be made with hope of success to bring together a collection so fully representative as to present an adequate survey of Scottish painting in its historical development. In this also, however, it would be well to place quality before quantity, and to have an artist represented by one or two

[1] The committee had recommended that a new National Gallery be built and that the Academy should have the whole of the existing Gallery.

[2] The method in which this is to be spent is determined by the Secretary for Scotland.

highly characteristic works rather than by a larger number of less admirable works.'

The primary purpose of the Scottish National Portrait Gallery is other in kind. Devoted to the illustration of Scottish history by means of a collection of portraits of those who have made it, it appeals in the first place to historical instinct and patriotic sentiment. Yet while the collection stirs many memories of the romantic story of our nation, of its heroic deeds and great achievements in war and religion and statesmanship, in literature and art and invention, and helps to keep alive both pride of race and thankfulness for what our forebears did, it possesses considerable art interest, and provides an admirable survey of Scottish portrait-painting. From Jamesone and the incognito of the early period, through Aikman and Allan Ramsay and others of the eighteenth century, to Raeburn and Wilkie, Watson Gordon and Geddes and their contemporaries and on to the present, most of the Scottish portrait-painters and sculptors are represented, while there are examples of foreigners who have wrought here and portraits of Scots men and women painted in England or abroad. Most of the more important of these have been presented or bequeathed, for the interest on a capital sum of £20,000, provided, half and half, in 1882 by the late John R. Findlay of Aberlour and *The Scotsman* and by Government, was the whole income of the gallery, from its foundation until after 1894, when the first curator, J. M. Gray, left some £2000 to form a purchase fund, which has proved of distinct service to the institution which he did so much to develop. Since 1903, however, the gallery, which is under the same Trustees as the National Gallery, has had a Parliamentary grant of £200 a year for purchase. The splendid building in Queen Street, which was designed by Sir R. Rowand Anderson and contains the National Museum of Antiquities as well as the Portrait Gallery, was also the gift of Mr. Findlay and cost upwards of £50,000. The great central hall is decorated with a series of mural paintings of Scottish historical subjects by William Hole, R.S.A., and the niches on the exterior are filled with statues of illustrious Scots by the leading Scottish sculptors. Some of the latter were gifted by societies or private individuals.

This national collection of portraits is supplemented by the series of legal luminaries which adorns the Parliament Hall; the University possesses portraits of many of those who have contributed to its success; science is represented in the rooms of the Royal Society, medicine in the headquarters of the two Societies, art in the Council-room of the Royal Scottish Academy, and dissenting theology in the New College.

It was in connection with the Drawing Academy, which the Board of Trustees had established in 1760, that the collection of casts subsequently known as the 'Statue Gallery' was commenced, and it was through changes made a few years ago to provide better accommodation for that school's

successor that it ceased to exist as a public collection. A beginning was
made with a teaching collection in 1798, when John Graham was appointed
master, and, after the Royal Institution was built, this collection was
transferred there, and being added to greatly, principally under Andrew
Wilson about 1835, became the gallery so familiar to every one who had
studied the 'Antique' in Edinburgh. Consisting of casts of many of the
greatest achievements in sculpture from the age of Pericles to that of
Adrian, and of some of the more notable Italian works of the fifteenth and
sixteenth centuries, it was in many respects an admirably selected series,
and, representing as it did those claims of form too frequently neglected
by Scottish painters, of distinct educative value. As no substitute, in so
far as the public is concerned, has been or seems likely to be forthcoming,
its passing is to be viewed with considerable regret.

There is perhaps no city in this country in which the spirit of local
patriotism is more active than in Glasgow. 'Let Glasgow Flourish'
figures not only on the city arms, but is writ large upon the relation of
the individual to the communal undertakings of the citizens. And in
no department of civic life has this tendency been more obvious than in
relation to the art gallery. Its very inception was due to the initiative of
a private individual.

While the National Gallery was in course of erection, in 1856, the
Corporation of Glasgow purchased for £15,000 the fine collection, chiefly
of old masters, which Archibald M'Lellan, a local coachbuilder and an
ex-magistrate, had bequeathed to the city, but which, owing to the
embarrassed state in which his affairs were left, was claimed by his
creditors, and gave nearly £30,000 for the galleries in Sauchiehall Street
in which it hung. It is from the nucleus so acquired, and principally
through the gifts and bequests of local collectors, that the Glasgow
Corporation Art Gallery has grown until it is in some ways the most
important collection outside London.

The Ewing Bequest, which had been promised conditionally to the
acquisition of the M'Lellan collection, added some ninety works, and in
1877 the Graham Gilbert, formed by the artist of that name, more than
one hundred and thirty. The collection thus brought together, although
somewhat mixed, was of the greatest interest and was subsequently weeded.
Yet it was not until 1882, when Sir J. C. Robinson made a report on
the pictures at the request of the Town Council, that the citizens as a
whole became aware of the excellence of the gallery which had been so
long in their possession. This, and the rising interest in art created by
the appearance in the city of a group of vigorous young painters, directed
attention to the Corporation Galleries, and the Glasgow International
Exhibition of 1888 was promoted very largely in the hope that it might
produce a surplus which could be used for the erection of a building in
which the city's collections could be displayed adequately. The profits

amounted to £46,000, and converting itself into an 'Association for the Promotion of Art and Music,' the Executive of the Exhibition obtained an additional sum of over £70,000 by public subscription, and resolved to proceed (1893) with the building from designs by Messrs. Simpson and Allen, who had won the first premium in open competition. Ultimately it became evident that the money in the hands of the Association was insufficient, and the undertaking was transferred to the Corporation. Completed in 1900, the magnificent but over-ornate building in Kelvin-grove Park, which provides accommodation not only for the art and museum collections of the city but for organ recitals and concerts, which add greatly to its attractions as a popular resort, was first used in connec-tion with another great Exhibition in 1901, when it was filled with collections of Fine Art and illustrative of Scottish history and archæology. In its turn this Exhibition was a financial success, and the surplus of £40,000 is now available for the further development of the collections which were transferred from Sauchiehall Street in 1902.

Before considering the scope of the art collection, it might be advisable to indicate the sources of the chief additions made since 1877. The modern development began in 1896, when the sons of the late James Reid of Auchterarder, a great locomotive builder, presented ten highly important modern pictures as a memorial of their father. This was followed by the Teacher bequest in 1898, the Young gift in 1900, the Smellie, Macdonald, and Elder bequests, and, most important of all, in 1904, by the bequest by James Donald, a chemical manufacturer, of forty-two pictures principally by the French and Dutch romanticists. Other local collectors have given or bequeathed notable works, and the city has also added by important purchases of pictures and sculptures. Acting on a decision which, if judiciously interpreted and kept unaffected by local wire-pulling, would tend to encourage Art in Glasgow, these have been principally by West of Scotland artists, but work by others has been acquired also, including one of the most interesting and beautiful things in the gallery,—Whistler's famous 'Carlyle,' also a splendid sea-piece by Henry Moore, and several pieces of sculpture by Rodin. The future of the Glasgow Gallery is very bright, for in addition to the money in hand there is in prospect, subject to a life-rent, a bequest of £40,000. And further, the local patriotism which has made it what it is may be depended on to increase its importance still more.

Particularly rich in examples of the Dutch and Flemish masters, it contains pictures by artists whose work is rarely seen outside Holland. Amongst the more notable examples of these schools are several excellent Rembrandts—two of which belonged to Sir Joshua Reynolds ; good examples of Rubens, Hals, Ruisdael, Hobbema, Ostade, Teniers, Wouvermans, and Mabuse, and the wonderful 'St. Victor, with a Donor,' which has been attributed to all the greatest early Flemings and

claimed by French patriotism as a chef-d'œuvre of the 'Maître de Moulins.' By Italian artists are the splendid 'Woman taken in Adultery,' which, whether by Giorgione or another, is a masterpiece; an imposing and beautiful altarpiece of the Bellini school, and interesting examples of Titian, Palma Vecchio, Botticelli, Antonello da Messina, and others. Of the earlier English and Scottish painters, Reynolds, Zoffany and Wilson, Constable and Turner, Raeburn, Patrick Nasmyth, M'Culloch, Fraser, Bough, Milne Donald, and many more are well represented; and of the later, Whistler, Burne-Jones, Henry Moore, Millais, Tadema, Orchardson, Pettie, Docharty, Colin Hunter, Macallum, and some of the contemporary Glasgow men are to be seen in more or less characteristic works. Yet it is perhaps to pictures by the French and Dutch romanticists, who have influenced so much recent Scottish painting, that the gallery owes a distinctive place amongst British public collections. Half a dozen Corots, two of which are of exceptional quality; a magnificent Millet crayon, and a fine oil picture by the same master; several Rousseaus; four or five Troyons; a famous Israels; and examples of James Maris, Mauve, Diaz, Dupré, Monticelli, Daubigny and Decamps give the Kelvingrove Gallery a cachet quite its own.

The collection of sculpture is much less important, but contains some excellent work.

In addition to the Central Gallery, four branch museums are controlled by Mr. James Paton, whose services have contributed greatly to the success of the city's dealing with art since his appointment as superintendent in 1876.

With his anatomical and natural history collections, Dr. William Hunter left to Glasgow University his famous cabinet of coins and a number of old pictures which are now arranged in the saloon through which one enters the Hunterian Museum at Gilmore Hill. Most of the latter are indifferent in quality or of doubtful authenticity. But the collection is worthy of a visit were it only for a splendid landscape by Philip de Koninck, and two or three exquisite things by Chardin. There are a number of interesting portraits, and the University has others in the Senate Hall and elsewhere.

None of the other permanent collections in Scotland comes within measurable distance of those in Edinburgh and Glasgow in importance, but in the character of its collection Aberdeen occupies a unique place. In 1883 a small gallery and museum was erected by public subscription. To begin with, the growth of the collection was slow. In 1900, when the 'Kepplestone' collection, formed by Alexander Macdonald, a wealthy granite quarrier, came into the possession of the city under his will, the gallery contained but sixty pictures, a dozen pieces of sculpture, principally portrait busts, and a small collection of prints. Most of the pictures were by Aberdeen artists such as Phillip, Dyce, Cassie, and Sir George Reid, but there were also characteristic works by Robert Herdman, David

Murray, Sir James Guthrie, and other Scottish painters, and by Mollinger, Roelofs, Clays, Artz, and Legros.[1] In these circumstances the Macdonald Bequest added greatly to the interest of the gallery. It included examples of Orchardson, Pettie, M'Taggart, Cameron, Reid, Macbeth, etc.; of Millais, Watts, Tadema, and J. C. Hook, and of Israels, Artz, and Jules Breton. Some of these, although small in size, are of excellent quality, but the special feature of the collection is a series of small cabinet portraits of recent and contemporary artists, usually by themselves.

In 1902, however, the late John Forbes White, LL.D., made the suggestion which resulted in the Aberdeen Gallery assuming a character of its own. Dr. White's idea was to form a collection of casts which would represent the progress of sculpture throughout the ages. This was approved by the citizens in public meeting, and being taken up enthusiastically by Mr. James Murray, M.P., was brought to a successful conclusion in April 1905. The Clark Trustees had made a grant of £8000 towards the extension of the gallery, the members of the Granite Association had provided granite pillars and bases for the central hall, and 160 donors had gifted the many casts which were selected by Mr. R. F. Martin of the Victoria and Albert Museum. The intention of illustrating the great schools of sculpture from that of ancient Egypt to that of eighteenth-century France was admirably fulfilled, while the arrangement of many of the individual works is such as to give, as regards placing at least, an excellent idea of the sculpturesque treatment appropriate to certain positions. It would be difficult to imagine a collection which could give a better general idea of sculpture.

Amongst the many portraits in the possession of the two Colleges, a Reynolds and a series of portraits by Jamesone and Sir George Reid are specially notable.

The Dundee Art Gallery, which was built (*circa* 1888) at a cost of £15,000 raised by public subscription, forms part of the group of buildings known as the Albert Institute and adjoins the Public Library and the Museum. Like the Aberdeen Gallery, the Victoria Galleries were intended to afford accommodation for exhibitions of current art as well as for a permanent collection, and for a considerable period (1877-91) the Dundee exhibitions, which had been inaugurated in the old galleries, were perhaps the most successful in Scotland. But since 1891 these have been on a small scale, and have consisted for the most part of local work. The permanent collection contains some excellent pictures, but suffers greatly in effect from the quite unnecessary way in which it is crowded into one or two rooms. Amongst the more notable modern pictures are fine examples of M'Taggart, Pettie, Tom Graham, Colin Hunter, Lockhart, and others, and portraits by Orchardson, Sargent, and Sir George Reid. Turner, De Wint, Wilkie, and Sir George Harvey are also represented, and

[1] Since then numerous additions have been made by purchase, gift, or bequest.

there are a few interesting things by old masters principally of the Dutch School. The neighbouring town of Broughty Ferry, a fashionable suburb of Dundee, has in prospect the much more interesting collection formed by the late J. G. Orchar, to whom the Dundee Gallery, and indeed the cause of Art in the district, owed much. Including a dozen or more exceedingly good M'Taggarts, three or four fine Orchardsons, and as many admirable Petties, several excellent Boughs, and a series of characteristic examples of Cameron, Chalmers, MacWhirter, and others of that period, the Broughty Ferry Art Gallery, for the erection and maintenance of which Provost Orchar's will provides, will form a memorial not only of the donor's generosity, but of the art of the pupils of Robert Scott Lauder. Some of these men, and Lauder himself by his most important picture, are represented in the collection which formed part of Patrick Allan Fraser's bequest of Hospitalfield and funds to found there a School of Art. Arbroath, to which Hospitalfield is contiguous, has also the beginning of a collection in the gallery attached to the public library ; and it was to the Mechanics' Institute which he had given to Brechin, another Forfarshire town, that Lord Panmure presented a number of interesting if not very important portraits and pictures, including one of John Phillip's earliest efforts, and his ' Battle of Bannockburn' (1843).

A few other Scottish towns, such as Paisley and Perth, have the nucleus of a permanent gallery, but none of these except Stirling need be referred to in detail. Stirling owes its gallery, to which an interesting museum is attached, to T. S. Smith of Glassingall, an amateur artist of some talent, who died in 1869, and bequeathed £22,000 and a collection of pictures to found the Institute which bears his name. Opened in 1873, it includes an interesting cabinet of water-colours by David Cox, William Hunt, W. J. Müller, Harding, and others, and pictures by R. P. Bonnington, James Holland, Müller, John Phillip, Sam Bough, M'Taggart, Fantin, and James Maris, the last perhaps the first examples of the Dutch master to be placed in a public collection in this country. Mention should also be made of the Erskine of Torrie Institute, Dunimarle Castle, near Culross, Fifeshire, which contains a small collection of pictures, chiefly Dutch and Flemish.

The great increase in the number of public libraries throughout Scotland, due in part to Mr. Carnegie's generous interest, containing as these buildings frequently do a room or rooms designed for the exhibition of art or local museum collections, suggests the possibility of utilising the facilities so provided for the education of taste. Collections of fine pictures and sculptures, or even a few pictures of real merit, are not likely to be acquired by many towns except through the public spirit of local collectors, but a series of fine photographs and a few casts of masterpieces would be within the reach of each. Were such collections formed and shown in every library in the kingdom, and a short printed summary of

the characteristics and qualities of the masters so represented provided, it would do much to raise the standard of taste, and in doing so would react upon the art of the country.

ART EDUCATION

After a course of wellnigh a hundred years the Trustees' Academy came to an end, or at least ceased to exist in the form in which it had been such a beneficent influence in Scottish Art. In 1858, when arrangements for the establishment of the National Gallery and the appropriation to the Scottish Academy of the eastern suite of rooms were being made, the function of the Board of Manufactures came under review, and, while making due acknowledgment of the good work done in Art education by the Trustees' school, it was considered desirable to connect it with the Science and Art Department in London. That Department had been founded some twenty years earlier, as regards the art side very largely upon lines suggested by William Dyce and Charles Heath Wilson (both at that time connected with the Trustees' Academy) in a letter addressed to Lord Meadowbank, and the Edinburgh school was now the only one of the kind not affiliated to it. The Trustees did not approve of the change, but finally agreed to it, and retained what was described in the Treasury minute (February 25, 1858) as the 'immediate guidance' of the school under the Department. The Life-class, however, was transferred to the Royal Scottish Academy, who have since conducted it with much credit, many of the more prominent Scottish artists of to-day having been trained in it.

In the years between 1798, when John Graham was appointed master, and 1858, when its character was changed by order of the central government, the Trustees' Academy did splendid work for Scottish Art. Under a succession of able masters, all of them practising artists, and nearly all of them members of the Scottish Academy, it had trained a succession of able painters, and was at its very best when outside interference brought it to a close. Robert Scott Lauder was the last director under these conditions, and the brilliant band of painters he had trained was scarcely out of the class-rooms when the curtain fell on the old régime.

Under the control of South Kensington the results attained on the purely artistic side by the Edinburgh School of Art were marked by defects and failures inseparable from the system of examination and payment by results, to which the Department so long pinned its faith, and when the bonds were somewhat relaxed internal and local considerations prevented full advantage being taken of the liberty so tardily granted. Nor was the department of design conducted with even the success that had attended similar teaching elsewhere. More recently, however—since the Scottish Education Department took over the functions of the Depart-

ment of Science and Art in Scotland (1899), and with a new staff of masters—a distinct improvement has taken place in both the scope and the character of the work done ; and the excellent 'School of Applied Art,' instituted by a body of subscribers principally connected with the architectural profession, and a committee of the Board of Manufactures, and organised by Sir R. Rowand Anderson, which had provided a most admirable training for architects and others since 1892, has been combined with it. In 1902, with other questions involved in the administration of the Board of Manufactures, the condition of the School was inquired into by a Departmental Committee ; and four years later, acting upon lines suggested in its report and previously indicated as desirable by the Scottish Education Department, arrangements were made by the municipality for the formation of a new School of Art in Edinburgh. Under an agreement between the Scottish Office and the city, the Government undertook to grant £30,000 from the Education Department and £10,000 from the accumulated funds of the Board of Manufactures on condition that a local contribution of £30,000 was forthcoming. The city having provided a site valued at £15,000, the remaining £15,000 was raised by subscription within a month—Mr. Andrew Grant of Pitcorthie contributing £10,000. Planned very largely upon lines suggested by Mr. Pittendrigh Macgillivray, R.S.A., the building is to cost £40,000, and seems admirably designed for its purpose. But of its future in an artistic sense and of how it may affect Scottish Art, it is, of course, impossible to speak.

Although dating from 1840, it was not until comparatively recently that the Glasgow School of Art became a comprehensive and thoroughly organised institution. Founded as a School of Design, Charles Heath Wilson (1809-1882), who, as already indicated, had been connected with the Trustees' Academy in Edinburgh, of which his father, Andrew Wilson, had been director, was appointed headmaster in 1849 and retained office until 1864, when the Board of Trade Masterships were suppressed. He was an able man and came with a good record, being an Associate of the Royal Scottish Academy and having been Dyce's successor as Director and Secretary of the School of Art, Somerset House ; but his sojourn in Glasgow was chiefly remarkable for the part he took in filling the windows of the fine old Cathedral with realistic and unlovely pictures of painted glass made in Munich. Several good artists were trained under his successor, Robert Greenlees (1820-94), who was connected with the school from 1852 to 1881, latterly as headmaster ; but the group of painters which appeared in Glasgow in the eighties, and to which the city's reputation as an art centre is chiefly due, owed little to the local school. Apart from some elementary work there, the training of these men was obtained in London or Paris, or in a life-class conducted by themselves in the studio of one of their number. A little later, however,

a new spirit was infused into its affairs. In 1885 Mr. Francis H. Newbury was appointed director ; in 1887 Sir James Fleming became chairman ; and in 1894 the governing body, which had been made representative of the principal public bodies in the city two years previously, when the School had been registered under the Companies Act, appealed to the public for funds for the erection of a new building. The result was the splendidly equipped School opened in 1899.[1] Over £20,000 was spent on the portion of the building then erected, and the site cost £6000. Towards this the Bellahouston Trusts contributed £11,000, the city £5000, the Government £2000, and £7000 was raised by public subscription. Organised in four departments, devoted to drawing and painting, architecture, modelling, and design and applied art ; admirably housed and efficiently staffed (although there has been a tendency to introduce foreigners, and especially Belgians, to teach certain branches in which they do not excel the native talent available), the Glasgow School of Art has done good work, and in the decorative arts particularly has stimulated local effect and even stamped it with a definite character. Since 1901 it has been recognised by the Scotch Education Department as the Central Institution for Higher Art Education for Glasgow and the West of Scotland, and authorised to grant Diplomas to students and to teachers. There are numerous bursaries and scholarships in connection with the School, many of them being provided by the Haldane Trust, which also makes an annual contribution to the general funds. In 1902 the whole income was just under £5000, of which £1800 came from the Education Department, £1000 from the Corporation, and £1500 from fees. Quite recently steps were taken for the enlargement of the building, and funds, contributed half by Government and half by local subscription, were raised, which will enable the governors to double the existing accommodation.

Aberdeen is indebted for its excellently equipped School to Mr. John Gray, ironmaster, who in 1885 built and endowed, upon the site of the Old Grammar School, the handsome building adjoining the Art Gallery, which the city also owes to the generosity of private citizens. Here ' The school curriculum covers four years, and embraces a two years' course of general Art Training, and a further two years' course in which students give prominence in their studies to special branches of work—*e.g.* Painting, Design, Sculpture.' The School, like that in Glasgow, is recognised as a Central School of Art, and is empowered to award to students a Diploma bearing the stamp of the Scotch Education Department.

The art instruction obtainable in other Scottish towns is for the most part more elementary in character, but Edinburgh, Glasgow, and Aberdeen being the natural centres of the Eastern, Western and Northern

[1] When opened, the School occupied premises in Ingram Street, but from 1869 to 1899 was a tenant of the Corporation in the upper part of the Corporation Galleries, Sauchiehall Street.

districts, opportunities for training in the higher branches are accessible and well distributed.[1] Apart from the Central Art Schools there are, of course, in Edinburgh and Glasgow, private classes conducted by individual artists, and at Hospitalfield near Arbroath, in the picturesque old mansion which figures as Monkbarns in *The Antiquary*, there is an endowed school for painters. Founded in 1901 under the will of Patrick Allan Fraser, H.R.S.A. (1813-90), a pupil of Sir William Allan and R. S. Lauder, and a professional artist until after his marriage with Miss Fraser, the heiress of the Hospitalfield and other estates, whose name Patrick Allan adopted, the Patrick Allan Fraser College of Art affords at present accommodation for some ten or a dozen students, who are taught and boarded free under the supervision of a resident master.

Turning from education in the arts to education about them, which is a very different thing, one finds established in Edinburgh University a Professorship of the Fine Arts, having in connection with it courses of lectures, which, since 1894, may be taken as qualifying classes for the M.A. degree (ordinary and honours), and are the only courses of the kind in the colleges of this country with a recognised academic standing. But, while the gain to learning is obvious enough, the advantages to art are less apparent, and the academic standard almost implies that the occupant must be a university man. Founded in 1879 by the heirs of Sir John Watson Gordon, P.R.S.A., the chief candidates for the professorship were P. G. Hamerton (1834-94), artist and critic, William Bell Scott (1811-90), painter and poet, and Mr. Gerard Baldwin Brown, a Fellow of Brasenose, who was chosen, and still occupies the Chair.

Any account of the facilities for art training in Scotland would be incomplete without reference to the fact that, beginning about 1880, many Scottish artists found their way to Paris. There in the Ecole des Beaux Arts or the Julien Ateliers, visited by some of the most famous French painters, they came into contact with methods and ideals different from those which prevailed at home. The effects of this and of acquaintance with French art are traceable in much recent Scottish painting, but they can be more adequately indicated in connection with the actual work in which they appear. Of late years, however, Parisian studios have been less frequented by Scottish students.

Encouragement

As late as the fifties, Scottish painters, with few exceptions besides the portrait men, took pupils or taught in schools ; but growing taste for pictures led gradually to their being able to devote all their time to art. The introduction and improvement of photography, however, although stimulating observation in some respects, resulted in a decrease in portrait-

[1] In 1907 steps were taken for the formation of a large Art School in Dundee.

painting, which, in the light of increased production in other directions, was not to be regretted, had it not at the same time deprived young artists of the excellent discipline such work involves. A great increase in the standard of comfort and wealth had been going on for years, and now the commercial and manufacturing classes commenced to patronise native art with a generosity and enthusiasm the aristocracy had never displayed. While exceedingly few of the great Scottish nobles and landowners possess fine modern pictures, many professional and business men, merchants, manufacturers and engineers have formed noteworthy collections of Scottish art, or have brought together choice specimens of the French and Dutch romanticists whose work has been a potent influence in the later developments of Scottish painting. The wealth of such art gathered by Scottish connoisseurs was strikingly revealed in the Edinburgh Exhibition of 1886 and the Glasgow Exhibitions of 1888 and 1901. But with much judicious patronage there was also a good deal of indiscriminate buying, and the years of great commercial prosperity, which preceded the failure of the City Bank in 1878, brought into being a crowd of painters who had no real aptitude for art. The demand for pictures created the supply. Men who had been in business and had painted in an amateur way went in for art as a profession in much the same way as they would have gone into any other business opening; and, relaxing the old prejudice, parents sent their sons 'to be artists' as they might have apprenticed them to a trade or sent them to sell calico or tea. Some of these possessed the true feeling, but with more it was simply a pleasant and honourable calling, and save that they could find a market for their wares, there seemed no justification for their existence. In the hard times which followed the crash of the great Glasgow bank artists suffered severely, for pictures are among the things that people think they can do without, and in consequence of the increase in numbers the struggle was all the severer. At the same time the activity of many, and the ferment so created, seem necessary to produce the conditions which make the advent of real artists possible. Encouragement, however, is almost as indispensable. No amount of enthusiasm for the art of the past can foster that of the present. Too frequently indeed it is due to fashion, or to the prestige created by rarity or costliness, and leads to that superior attitude which finds virtue in nothing that is not old or rare. But all the old is not excellent, and all the new indifferent. The former has been sifted by time, however, and has been appraised by many valuators, while the latter is fresh and unstrained, and its ultimate commercial value problematical. Further, the certainty of great profits, arising from the high prices now ruling for things of certain periods, has influenced most of the professional dealers and attracted that curious hybrid, the 'dealer-connoisseur,' who poses as collector and loves art cheerfully for what he can make by it. Yet, as William Hunt remarks in his racy *Talks about*

Art—'Let us remember that Art, like jelly, has always been more easily recognised when cold. In fact, most people prefer it *canned*. . . . Give me the fellow that can find some honey in the flower that grows!' And, one may add, that the fellow who sees no good in the art about him, which embodies the ideals and feelings of his own day, is little likely to appreciate the finest qualities in that of the past. In Scotland there has been some of this, but for the most part Scottish collectors, recognising that 'old masters' really worth having cost a great deal, have left acquisition of them to the very rich, and have bought modern work. Some charming collections of French and Dutch pictures were formed, as has been indicated, before these became fashionable and expensive, and while many have passed out of the country since the great enhancement in their value has taken place, a goodly number remain, and happily some splendid examples, gifted to the Glasgow Gallery, have become a permanent possession. Admiration for the work of these fine artists has had a secondary result which is much less admirable. For certain dealers, finding that the prices of pictures by the greater men were becoming too high for some of their clients, have taken to booming the colourable but uninspired imitations of less gifted painters of the same schools.

But the chief buying has been of Scottish pictures, of which there are many private collections, both large and small, throughout Scotland. The remarkable collection illustrative of Scottish art, which was the feature of the Edinburgh Scottish National Exhibition, 1908, was lent almost entirely by Scottish collectors. The municipalities, however, except that of Glasgow, have not shown such zeal in forming art collections as the chief towns in England or abroad, and there is not a single gallery in which one can obtain a comprehensive view of Scottish painting in all its developments and phases. This might be one of the ideals cherished for the National Gallery of Scotland, which already possesses a most admirable nucleus for such a collection.[1] Moreover, the proportion of painters to population, or at all events to patronage, is such that London, with its greater scope and more brilliant rewards, absorbs some of the best Scottish talent, and that many Scottish artists, especially of recent years, have depended in part upon Continental or American admiration for tangible encouragement. The attraction of London is not new, of course. Ever since Scotland had artists of her own, since Wilkie went to London a hundred years ago, Scotland has suffered from the southward flight of gifted sons. And while the fact that despite such circumstances she should be able to count so many capable artists at home is good proof of her artistic vitality, this constant drain is much to be regretted. Greater encouragement at home—to quote the words of the President of the Royal Scottish Academy when pleading before a Government Commission

[1] It was in hopes of helping to realise this, and to encourage contemporary art, that the 'Scottish Modern Arts Association' was formed in 1907.

(Oct. 1902), ' would save to the heart of Scotland a great deal of good blood, and would be the means of enabling strong men to remain here. It would make it unnecessary for a man to think that if he is to occupy a high position in art matters he must become an exile. That is perhaps a strong term to use as between Scotland and England, but that is really very much what has been the case. One longs for the day when a man will be able to do his own work in his own country without being placed under a great disadvantage because of his absence from London.'

Section I.—THE PUPILS OF ROBERT SCOTT LAUDER

CHAPTER I

TRAINING AND ENVIRONMENT

TOWARDS 1860 the work of a group of talented young painters began to appear on the walls of the Royal Scottish Academy. It was not of a nature to advertise itself or to attract attention at once. Neither in subject nor handling was it very original or very striking—the themes were those in common use, the technique had nothing wilful or of conscious protest about it. Yet the sensitive observer must have been conscious of certain essential differences between these pictures and the majority of those among which they were hung, and on inquiry he would have learned that they were the work of past or present pupils of Robert Scott Lauder, the Master of the Trustees' Academy.

By experience, taste, and temperament Lauder was eminently qualified to be a successful teacher. A good though not a great craftsman himself, he had given years of heart-whole study to the mature art of Italy, and he possessed a contagious enthusiasm for all that was beautiful, which acted as a splendid spur to the students who soon gathered round him when, in 1852, he assumed the Mastership of the Trustees' Academy. These classes had had a succession of able teachers, and Lauder (1803-1861), who had been a student there under Andrew Wilson, proved the ablest of all. Alexander Christie, the previous director, a man of very mediocre ability, had confined his attention to the school of design, leaving John Ballantyne (1815-1897) to conduct the antique and life classes; but Lauder, associating Ballantyne with him in the work, gave his best energies to the latter. The school, which since Duncan's death in 1845 had been falling off, now regained its prestige, and soon the class-rooms were crowded. Orchardson, M'Taggart, Cameron, Chalmers, MacWhirter, the Grahams, and the Burrs, to name no more, were all there in 1853-4.

Lauder's influence as a teacher did not lie in example and precept. Contact with him did not mean learning to draw and paint in a particular way. Although his pupils are marked by certain technical affinities, he was not an expounder of a method but the source of a vitalising artistic atmosphere. Not that craftsmanship was neglected. For the antique class he arranged the fine collection of casts, which is so well known to

every one who has studied in Edinburgh, in beautiful groups, thus at once cultivating the student's taste and giving him ideas of ensemble and tone relationship; and in painting from the life he encouraged careful realisation of actual fact combined with pursuit of colour. And the precision and expressive completeness of the studies then made show what sincere and conscientious work he got from his pupils. Even without these, however, the matured style of the best of his school reveals the admirable character of their early training. But he rarely touched their work with brush or pencil. He criticised and indicated in what direction they ought to go, and for what they should strive, and, more inclined to praise strong points than to censure weak, he developed and strengthened their artistic individualities. At the same time his outspoken admiration for what was really fine kept baser tendencies in check. Sometimes he scarcely looked at what a student was doing, but, sitting down beside him, he would speak of great art and artists. In these 'talks about art' he rarely mentioned contemporaries, and of the old masters he spoke most of Titian, Tintoretto, and Michael Angelo. Yet, while Lauder's was the commanding influence in the school, Ballantyne's share should not be forgotten. His own productions are of no great merit, but his academic draughtsmanship and preference for completeness made an excellent supplement and foil to Lauder's inspiriting enthusiasm and devotion to colour. It was to Ballantyne also rather than to Lauder that the students were indebted for hints as to technical methods and procedure.

Hitherto colour had not been a marked element in Scottish painting, and it is perhaps impossible to determine definitely how it became the distinguishing quality of Lauder's pupils. The master's influence must have counted for much, for he was a colourist himself, and he turned his pupils' attention from the Dutchmen and the 'classic' painters, on whose work Scottish painting had mostly been founded, to the Venetian colourists. Tintoretto, Veronese, Bassano, Tiepolo, and Van Dyck in his Italian period, they could study in the National Gallery of Scotland, and at Manchester in 1857, at the 'Art Treasures' Exhibition, which most of them saw, they made acquaintance with many masterpieces of that school and of Rubens, another of Lauder's admirations. Nor must one forget the delight in pure and vivid colour which was an inherent part of Pre-Raphaelite art, specimens of which, particularly by Millais (1829-96), Holman Hunt, and, later, Madox Brown[1] (1821-93), had been seen from time to time in Edinburgh. This affected the Lauder group less than it did some other Scottish artists, and in the spirit in which subject was conceived, and in quality of colour, there was an essential difference between their work and that of the young English painters ; but it was an influence which it was almost impossible to escape. Before it, as one of

[1] He was a grandson of Dr. John Brown, founder of the Brunonian system of medicine, who was driven from Edinburgh by the medical profession because he was an innovator.

the coterie said, they had seen Nature through a fog. Yet I am inclined to think that, while these were contributory causes, the real source lay deeper, and that they were but sparks which lit a train already laid in the national character. From the beginning of Scottish literature feeling for colour had been a distinguishing feature, and that it had not revealed itself definitely in painting at an earlier date may be traced to the fact that the schools by which Scottish painters had been moulded or influenced were schools of form and tone rather than of colour. Where, as in the cases of Phillip[1] and Lauder, Scottish painters had come into intimate touch with the work of great colourists they had responded spontaneously, and now that the horizon was widened for students rather than for those whose style was already partly formed, the dormant feeling fully awoke. It would therefore appear that this outburst of colour was the expression of a national sentiment ; but whatever the cause, colour it was which, through this group, now became the dominant characteristic in Scottish Art. Vibrating and luminous and often exquisite in quality, the rich broken colour-chords in which Lauder's pupils delighted presented a marked contrast to the chiaroscuro-charged colour of their predecessors. The gamut of colour in their work is much greater also, and, whether deep and sonorous or clear and silvery in tone, the harmonies achieved are at once charming and significant.

While style in drawing, as in other things, is an incommunicable gift, the effect of constant drill under a master with an instinct for form and construction is great, and tends to stimulate the powers of his students in that direction. Lauder's drawing, however, was not of a character to impress. It was elegantly conventional rather than incisive and vigorous ; and, although one of his pupils is a draughtsman of unusual distinction and several of the others draw in an easy and very expressive way, as a whole they exhibit no great mastery of form. And this has some bearing, perhaps, on the fact that of the many students who passed through the class-rooms in Lauder's day only two or three became sculptors. Nor have the painters excelled in composition. With the exception of Orchardson, none has shown a notable faculty for design on its purely decorative side. At the same time, most of them possess a distinct gift for arranging their material in an effective and emotionally significant way.

Their technical method differed but little from that used by the best of their predecessors, but in their hands it became richer and more expressive, and, as the men matured, they modified it to suit their individual view of things, which, being inventive and personal, led to a great development in the expressive qualities of touch and handling. At their best, the best of them display great sensitiveness and dexterity, and their manner has been admirably suited to what they had to say. Broadly speaking, their developed style is somewhat kindred to the traditional

[1] Phillip's work was an influence among Lauder's pupils.

Flemish in clarity, flexibility, and swiftness. In the beginning, however, it showed little modification on that of Duncan, who—as may be seen by comparing his ' Anne Page ' with their earlier pictures—influenced them in other ways also. Neither in subject nor scale did Lauder directly influence his pupils. He urged them to paint subjects from the Bible and Shakespeare on a large scale, but, as a rule, they preferred motives of less exalted inspiration, and painted historical and domestic pictures of moderate size as their elders had done—but with a difference. Whereas the older Scots and those, such as Paton, Herdman,[1] Nicol, and the Faeds, who may be regarded as their successors, had chosen incident for its own sake and looked at it from the anecdotal standpoint, the younger men saw in subject, not occasion for sentimentality or coloured illustration, but opportunity for picture-making. They were interested in subject, of course ; they conceived situation and character admirably, and, if one cares, one can find their pictures a criticism of life : but their choice was for such themes as are suited for pictorial treatment, and in result their pictures possess the dual interest of art and subject. In this they may be said to have followed their master, who possessed the pictorial as contrasted with the anecdotal sense. But while he had taken, almost invariably, his subjects from books, they in many cases, less perhaps at first than later, invented their motives or owed but a suggestion to literature or history. On the landscape-painters amongst his pupils his influence is perhaps less marked. Although the landscape passages in his pictures are often beautiful, Lauder was essentially a figure-painter, and he could not affect their dealings with Nature in the open. Yet they also bear the impress of their school in colour, technique, and taste. Other influences, however, combined with this, and as regards detail their pictures, although marked by far greater regard for ensemble, show the effects of Pre-Raphaelitism and, in less degree, of the revelation of photography. The Liverpool painters, Robert Tonge (1823-56) and J. W. Oakes[2] (1820-87) seem to have won their admiration by freshness of feeling ; and Sam Bough (1822-78), who came to Edinburgh in 1855 with his style practically developed, undoubtedly helped them towards an increase in pitch and more vivid effects of lighting, and Alexander Fraser (1828-99) towards brilliance of local colour and a refined naturalism.[3] Moreover, admirable landscape was being painted by J. C. Wintour (1825-82) and by Sir George Harvey (1806-76), the latter leading the way to more intimate feeling for Nature and increased regard for atmospheric effect and unity.

[1] Herdman was in Lauder's class for some time, but his art has a closer relationship to that of the men referred to.

[2] Oakes was elected an Honorary Member of the R.S.A. in 1883.

[3] Through Bough and Fraser, whose art was influenced by that of Müller, Constable, Cox and Linnell, the younger men were brought into touch with English landscape. In its turn the work of Lauder and his pupils affected that of Fraser and Bough.

But great as the formative influence of a master may be, that of students upon one another is no less potent, and Lauder's young men were fortunate in that also. Several of them possessed exceptional talent, and the friendly emulation thus awakened stimulated all and raised the standard of accomplishment. A feeling of comradeship existed ; they learned from and helped each other ; the experiment, success or failure, of one was an experience shared by all. And here Orchardson, who was several years older than most and certainly the most accomplished, exercised an influence. Outside the schools they associated much together, and Orchardson, M'Taggart, Cameron, MacWhirter, Graham, Hutchison, and Ebbsworth (who later gave up art for the Church), formed a Sketch Club, 'The Consolidated,' which met once a week to make designs for a subject given out at the time of meeting. The Club existed in this exclusive form for a year or more, and then, after a threatened split, it was reorganised in a more liberal spirit, Pettie, Chalmers, Hay and others being added to the membership. Altogether it lasted ten or twelve years, and when early in the sixties several members went to London, they established a similar club there and invited other London Scots to join them. It was a practice which stimulated invention. Many of the sketches made in this way are exceedingly interesting, and, now and then, one can see in them germs of ideas which were worked into pictures later. And here one may refer to the part these young men took in the remarkable outburst of fine design for woodcut illustration which marked the sixties.

One of the earliest indications that art had touched illustration and given it new life was the publication of Moxon's edition of Tennyson's poems in 1857. There Rossetti, Millais, and Holman Hunt revealed the birth of a new spirit, more imaginative and less conventional, closer to Nature and finer in art than that which had prevailed in the fashionable annuals and ' Beauty Books'; and with the appearance of *Once a Week* in 1859, followed next year by *Good Words* and *The Cornhill Magazine*, it became evident that this new spirit was not confined to the Pre-Raphaelites. Lauder's pupils had been much impressed by the Tennyson, of which, poor though they were, each secured a copy, and their illustrations—contributed for the most part to *Good Words*, the publisher of which, Mr. Strahan, was a good friend to some of them—were influenced in some measure by the pictures in that volume. But their work as illustrators is less accomplished and beautiful than that of the Pre-Raphaelites or of Walker and his group. Pettie's was full of character and action, and spirited and selective in draughtsmanship, and Tom Graham did a few charming things ; but neither Orchardson, whose illustrations are both stiff and timid, nor M'Taggart, who seems to have found the *métier* irksome, showed to advantage. In addition to drawings for *Good Words* and *The Sunday Magazine*, Pettie and MacWhirter made illustrations for a *Wordsworth for the Young* (1863), and one or two other books, and M'Taggart, MacWhirter, Cameron, and

several others, some of the pictures for a Burns (Nimmo: 1868) designed on similar lines to the famous Tennyson. Thus their share in the illustration of the sixties, about which Gleeson White wrote such a charming book, is small and comparatively unimportant. Its importance is chiefly in relation to their work as a whole. For disinclination for illustration, and maybe small success in it, were due in part to their preoccupation with colour and their desire to paint. None of them illustrated longer than he could avoid.

In this atmosphere of enthusiasm and good-fellowship progress was rapid, but of material encouragement there was still little enough. Patrons were few, and from the younger men, at least, they would buy nothing but little pictures. Some of the most beautiful things they produced in these early years failed to find purchasers, or were sold for a trifle. I know of one picture, since sold for a couple of hundreds, which brought its painter nine pounds; and he had devoted months to it. But in one way or another, principally, perhaps, by portraiture, they managed not only to live but to paint pictures which gradually gave them a position, and in 1859 M'Taggart and Cameron were chosen Associates of the Scottish Academy. Next year Peter Graham was elected, but when in 1862 Orchardson and Pettie went to London they had not received official recognition at home. Later, the R.S.A. made the *amende honorable* by electing them and their old comrades, Tom Graham and G. A. Lawson, who had also gone south, Honorary Members; and in the long run all the more prominent of Lauder's pupils became connected with the Academy.[1]

As was to be expected, those who have figured upon the bigger stage of London have gained a wider fame than those who remained in Scotland. While Chalmers, M'Taggart, Cameron have a Scottish reputation, Orchardson, Pettie, Graham and MacWhirter are known at home and abroad as distinguished British artists. That, however, is no absolute criterion of merit. Often it has more to do with publicity than with deeper and more lasting qualities. Still, there is no doubt that the London contingent has given the Lauder group a contemporary prominence which it would not have had if all had remained in Edinburgh.

[1] Academicians: G. P. Chalmers, William M'Taggart, Hugh Cameron, W. F. Vallance, George Hay, J. B. Macdonald, and J. Hutchison (sculptor).

Associates: Peter Graham (resigned when elected A.R.A. 1877), John MacWhirter (resigned when elected A.R.A. 1879), G. Aikman, and David Robertson (architect).

Honorary Members: Sir W. Q. Orchardson, John Pettie, John MacWhirter, Peter Graham, Tom Graham, and G. A. Lawson (sculptor).

CHAPTER II

ORCHARDSON AND PETTIE

In Art personality counts for more than all else. Affecting both manner and matter, for there is a technical as well as an emotional gift, it is the quality which differentiates one man's work from another's ; so that the same subject painted by two men may be distinguished or commonplace, entertaining or deadly dull. And among Scott Lauder's pupils, trained side by side, with the same facilities for learning their craft and similar opportunities for self-development, personality is so strongly marked that their work is proof, if such be needed, that in Art equality of opportunity does not result in equality of performance. The work of the whole group is interesting and of more than average merit, but when you have passed it all in review, when you have noted the technical merits and defects, the qualities of colour, light and shade, and composition, the pictorial sense, and the subjective and emotional elements in each man's work, the names of four detach themselves from the rest. These are W. Q. Orchardson and John Pettie, G. P. Chalmers and William M'Taggart. But, while merit groups them together, the two former are much more widely known than the latter. Yet the explanation of this is simple : Orchardson and Pettie went to London ; Chalmers and M'Taggart remained in Scotland and seldom exhibited away from home.

Sir William Quiller Orchardson,[1] who is an Edinburgh man, was the first to leave (1862), but he had been only a short time in London when Pettie joined him. A little to the surprise of their friends in Scotland, the younger man was the first to attract attention, and his election as Associate and as full member of the Royal Academy preceded Orchardson's—the one by two years, the other by four. It was a preference shared by critics and public alike, and not without apparent reason. For one thing, Pettie commenced to show at the Academy three years before Orchardson, and his work was of a kind which commanded notice. Each of his finer things, 'The Armourer' (1860) ; 'What d'ye lack, Madam ? What d'ye lack ?' (1861) ; 'A Drumhead Court-Martial' (1865) ; 'An Arrest for Witchcraft' (1866) ; and 'Treason !' (1867), was a *tour de force*. In the long-run, Orchardson more than justified the brilliant promise he had given as a student ; but accomplished as his early pictures are, they

[1] Knighted 1907.

had not the arresting quality of the other's, particularly as regards subject.

Orchardson commenced his studies in the interregnum between Duncan's death and Lauder's appointment, and was already an accomplished student when the latter assumed the mastership of the Trustees' Academy. He had left the classes indeed ; but he returned, and, although irregular in his attendance, came under Lauder's influence, and in turn influenced Lauder's pupils. From all accounts he was not a hard worker, and seldom finished a life-study, but, when he did so, it was complete and masterly, and evoked the applause of his fellows. As a painter also, his output has always been restricted, and, in the early days, he often painted little more than the pictures which represented him annually at the Scottish Academy, where at that time he was none too well treated. From the first his pictures were marked more by a fine sense of design and beautiful draughtsmanship than by power of brushwork, and his colour was delicately harmonious rather than full and rich. But, within his limits, he was a consummate craftsman from very early in his career, and his conception of subject and situation has ripened and deepened with the passing years. For the subjects of his earlier pictures he was indebted chiefly to literature or history. Some were illustrations of incidents in Shakespeare, Scott, and other writers, and, while others were less directly inspired, in nearly all the actors wear the costume of the past. Yet if he could thus be described as a costume-painter, his treatment was essentially artistic, and the interest did not reside in the clothes. The subject was conceived in pictorial terms, the story was told or re-told by the means proper to pictorial art, and charms by beauty of form, composition, and colour. And, while most of them depict incidents of a romantic character, many are informed by a subtle sense of irony, which distinguishes them from sentimental genre. In 'Napoleon on board the Bellerophon' (1880), however, he touched a far more profound and dramatic note than he had yet attained, and it is the stronger flavour of this quality which, more than anything else, separates his later from his earlier work.[1] At the same time, he developed greater independence in choice of theme, his invention of situation became more original and at the most owed but a suggestion to literature, and he frequently introduced figures clad in the garb of to-day. Such are the 'Mariage de Convenance' series (1884-86) ; 'The First Cloud' (1887); 'Her Mother's Voice' (1888) ; and 'Trouble' (1898). And although Orchardson has painted 'Her First Dance,' 'The Queen of the Swords' (1877), and such-like incidents, with evident enjoyment, his true quality as a thinker is more clearly marked in these more dramatic pieces. Possessing true pictorial instinct, he always chooses the moment in which an

[1] His social subjects, as distinguished from his romantic and literary, may be said to begin with 'A Social Eddy : Left by the Tide' (1878).

action culminates in a self-explanatory situation, which, while complete in itself, will yet suggest the past and the future, what has led to it and its result. With him the sense of things passing away and of the tragic issues of life is never far off. 'A Tender Chord' (1886) has its awakening memories for the young girl who strikes it, the song sung of an evening in the drawing-room recalls 'Her Mother's Voice,' and even the ball-room with its 'Social Eddy' leaves some one stranded with a pain at the heart.

Two more elements in Orchardson's choice of subject are worthy of remark : it is rare that he has found motives in the lives of the humble, or that he has set his figures out-of-doors. Excepting a few pictures, nearly all of which belong to his earlier years, his work has dealt with Society, well-dressed, well-groomed, and, to all appearance, well-mannered. His people may do questionable acts, but they carry them through with finesse and aplomb. But while this adds subtlety to his satire and makes it more biting, it would also seem to imply a certain want of sympathy with the simple and spontaneous expression of natural emotion. On the other hand, it may be accounted an artistic virtue, in that it saves him from any element of hysteria or morbid sentimentality. It gives his characters, and therefore his pictures, something of that repose which marks the caste of Vere de Vere. Scope for a favourite colour-scheme and interest in the graceful forms of furniture no doubt account for his choice of backgrounds and setting ; but another and no less powerful reason is his lack of interest in effects of light and atmosphere. Yet deprived of the furnishings of boudoir and drawing-room, of Venetian glass and plate, of Empire toilets and the creations of M. Worth, of all that elegant still-life which, painted as he paints it, would make his art interesting without his ideas, in dealing with those who face the real elements of existence in their nakedness, he has felt that Nature itself forms the true setting of their lives. But, as I have said, it is seldom that he has touched such subjects, and it is well, for he is not there at his best. The few pictures of this kind which he has painted have not borne the marks of clear and direct impressions received from Nature, and are lacking in the robustness of constitution and the sympathetic insight, which seem appropriate to such themes. His 'Toilers of the Sea' (1870), or 'Flotsam and Jetsam' (1876), cannot bear comparison for a moment with a Millet, an Israels, or a M'Taggart.

As one might expect from an artist so deeply interested in the *comédie humaine*, Orchardson has excelled in portraiture. From a purely technical standpoint his method is not the best for such a purpose. The convention in which he works has to be accepted for what it is : one must not expect the marvellous rendering of planes and surfaces, or the full round modelling held together by the wonderful sense of true values and atmosphere, which mark the work of such a master of realistic portraiture as Sargent. But

insight into character, subtlety of drawing, and distinction of design make his portraits exceedingly fascinating. His mood here differs from that in which he approaches genre. Orchardson does not treat the individual as he does society. He is analytical and even quizzical, but never ironic. Although his analysis is keen, it is not unkindly; he dwells more upon the finer than the lower traits of character, and is more sympathetic and appreciative than censorious. And, as a rule, he has been as fortunate in his sitters as they have been in their painter. The 'Lord Peel,' the 'Sir Walter Gilbey,' the 'H. B. Ferguson, Esq.,' the 'Sir Samuel Montagu, Bart.,' the 'Howard Coles, Esq.,' the 'Mrs. Orchardson,' the 'Mrs. Joseph,' and the 'Master Baby,' to name only these, present a range of character and type of the greatest interest. But admirable as his portraiture is, and the latest examples are not the least admirable, it would be regrettable if (as the tendency has been of late years) it should monopolise too much of his time and deprive us of these scenes of social tragic comedy, which are so peculiarly expressive of his talent both as painter and moralist.

To the expression of these views of life Orchardson brings a technical equipment, limited in kind, but in its way wellnigh perfect. He appears to have hit upon the style which suited his subjects at once, and has never been tempted to experiment with his medium. In his pictures everything is calculated—the tone, the colour, the placing of figures and furniture. He never lets himself go. We are never surprised, and then delighted, by a new combination, a novel arrangement, a startling and unlooked-for passage or effect; but we are always charmed by distinction of style and unfailing refinement of taste. As a rule he works as if he had seen the end from the beginning, and, sparing no pains to attain it, he maintains a wonderfully high level of achievement. There is no exuberance in his handling; it is always restrained, the work of a man of keen intellectual perceptions, not of nervous energy or muscular force. In his early pictures it was fuller in impasto than it afterwards became, but it was never loaded or marked by expressive brushing, and now he does little more than delicately tint his drawing with thin pigment, scratched rather than brushed upon the canvas. Nor does the emotional significance of his pictures depend much upon colour or chiaroscuro. He does not arrange them in masses of light and shade as the Dutchmen did, but chooses high-pitched harmonies in pearly white or golden hues, against which he throws spots of stronger colour and tone—sometimes in the costumes of his figures, sometimes in a piece of furniture or a musical instrument, and here and there, as in the 'Salon of Madame Recamier' (1885) or 'Her First Dance,' in large patches of curtain or wall-hanging. Occasionally he reverses this and brings his figures in relief against a dark background (of this the 'Young Duke' (1889) and the 'Voltaire' (1883) are instances), but he will use the same scheme for a dance or a disaster, for Minna Troil walking haughtily beneath the uplifted swords of admiring gallants, and Napoleon taking his

last look at France. But his colour, if conventional and limited, is, in M. Chesneau's happy phase, 'as harmonious as the wrong side of an old tapestry,' and possesses a delicate charm in keeping with his refined sense of draughtsmanship and design. And the gesture of his figures and the expression of their faces, the suggestiveness of his grouping and the disposition of his masses are so fully expressive that the restricted character of his colour passes almost without remark. He possesses an architectonic appreciation of the value of empty and undecorated spaces. In his elaborate compositions this gives character and animation to his groups, while in his simpler designs and portraits it accentuates the interest of the single figure. The 'Salon of Madame Recamier' is an admirable example of the one, the 'Lord Peel' an even finer example of the other; and analysis of any of his pictures reveals how much the distinction of his design owes to these simple passages, which not only enrich the more complex parts by contrast but knit everything into a harmonious whole, in virtue of which his work possesses a strength and clearness of impression as telling as can be won by the most bravura handling. Further, it is in this consummate sense of design that the decorative effect of Orchardson's art lies, for, combined with unity of colour (which is in this aspect only one element in the whole design), it results in that repose of colour, mass, and line which makes a painted oblong of canvas a satisfying ornament without regard to its intellectual and emotional import. But his drawing is even more fascinating than his composition. It is at once the most distinguished element in his art, and that by which he is most closely related to Nature. While his colour, tone, and lighting are often arbitrary, his drawing is constructive and real. Yet it is also marked by the greatest elegance, and possesses that delicate accent and due proportion which constitute the greatest qualities in style which is both significant and dignified. Spontaneous, yet perfectly controlled, it is the ultimate flower of Orchardson's personality on its artistic side.

Intellectual, emotional, sensuous, Sir W. Q. Orchardson's art unites intellectual and æsthetic qualities in such rich measure and fine equipoise that the one reinforces and intensifies the other without subordinating it. To the exquisite sensation one receives from perfect mastery and refined taste there is added poignant human emotion, and while possession of either would have entitled him to a distinguished place, their union has given him a position so unique that he is without a rival in his own field.

Although one of the youngest of his set, John Pettie (1839-1893) was the earliest to attract attention on the other side of the Border. Brought up at East Linton,[1] he came to Edinburgh to live with an uncle, who was a drawing-master, and at the age of sixteen commenced his studies at the Trustees' Academy, where he formed life-long friendships with many of his fellow-pupils, and specially with M'Taggart and Orchardson, the latter of whom

[1] He was born in Edinburgh, but when he was ten his parents removed to East Linton.

he followed to London in 1862. He had commenced to exhibit at the Royal Academy two years previously, but the immediate cause of his migration was an offer of £100 a year for one drawing a month, made by Mr. Strahan, the publisher of *Good Words*. Pettie's, however, was a nature which craved a wide field, and it is likely that London would have claimed him in any case. Gaining a footing as a painter almost at once, he did not long continue to do illustration in black and white, and his pictures had such rapid success that he was elected A.R.A. in 1866, full honours following in 1873. His strong and healthy personality, which was eminently refreshing in the social sphere, and, in relation to his fellow-painters, strongly stimulating, found fit expression in the verve and vigour of his art.

Pettie was not a man of ideas in the sense that Orchardson is : characterisation and subtle analysis of motive were not his forte. While Orchardson seems to evoke a sense of the far-reaching effects of incident and of the motives underlying it, Pettie represented its present dramatic effectiveness. The conduct of a situation by the one is like a chapter from Meredith ; the other carried a scene through with something of the swagger and abandon of Old Dumas. He preferred the spectacular to the subtle, and his pictures deal with the melodrama rather than the true drama of life. Even in his reading, I have been told, he was not contented with stories of ordinary life, but must have them teeming with incident. He would rather have read a dramatic novel indifferently written than a supreme work of fiction dealing with more everyday events. And a like bias is evident in his selection of pictorial subject. It used to be said in jest that his friends had to restrain him from making his pictures red with blood, and, exaggerated though it be, the saying gives some indication of the genuine delight in warfare and contest which marks many of his pictures. Others are informed by a rich vein of humour, sometimes grim and sardonic, as in 'The Gauger and the Smuggler'; sometimes whimsical, as in 'Two Strings to her Bow,' or 'The Jester's Merry-thought.'

For the most part Pettie drew his subjects from the days of chivalry, the cavalier period, and the pages of old English comedies, but, whether inspired by the romantic past or a scene by Sheridan, his conception was that of a painter. He possessed the historical imagination which, in picture-painting, makes the people and the incidents of other days live again before our eyes. To clarity of conception he added ease and directness of expression, and, interested as he was in history, he was even more interested, as a painter should be, in motion and colour. These were indeed the determining cause of his choice of periods, for the unrestrained and forceful action of mediæval camps, the sharp contrast of Cavalier with Puritan, the studied grace of the eighteenth century, and the picturesque and brilliantly coloured costume of the past supplied motives exactly suited to his talent.

Some of his early work shows Dutch influence, and a number of his pictures recall Teniers and Ostade (evidence perhaps of the strength of the Wilkie tradition), but a far more abiding force was study of the St. Sebastian by Van Dyck in the Scottish National Gallery. Painted during the earlier part of Van Dyck's career, that picture has strong traces of Rubenesque, modified by Venetian, influence; and from it, it may be, Pettie derived that full rich tone and colour and force of handling which at times recall the greater of the Antwerp masters. He used colour boldly and with something of the intense delight of a child; but he usually displayed great skill in its management, and, at his best, was a colourist of a high order. The colour of his finer pictures possesses rare and emotional significance, and is grave or gay as suits the subject. It sparkles in 'Sir Peter and Lady Teazle,' and is dainty in 'Dost know this Waterfly?' It is sombre yet rich in the 'Death Warrant' or 'The Sally,' and austere and grave round the knight at his 'Vigil.' Indeed, it is difficult to say in which direction he most excelled, the force of certain colour-schemes being nearly equalled by the charm of others, in which he achieved remarkable delicacy by clever handling of clear blues, yellows, and greys, not subdued, as in Orchardson, but used at full pitch. In these respects, as Sir Walter Armstrong has pointed out, the work of his best period has seldom been excelled. Deep and resonant, or clear and silvery in tone, the quality of his colour is nearly always fine. It is full and luminous, the play and scintillation of its vibrating and broken hues fusing into harmonies which, whether rich or tender, satisfy while they stir the senses. And his brushwork was of a kind which helps the quality of colour from the first, and in maturing takes a charming patina. It was also appropriate, and varied with the character of his theme. The element of handling, which has been mentioned as characteristic of the technique of the group as a whole, is admirably illustrated in Pettie's work. The verve of the 'Sword and Dagger Fight,' the bravura of 'The Chieftain's Candlesticks,' the delicacy with which he treated an episode from the *School for Scandal*, or such a head as 'Sylvia,' show wonderful range and dexterity of handling. On the whole, however, vigour, both of brushwork and colour, was more characteristic, and with this his effective and expressive rather than distinguished drawing and dramatic sense of light and shade were in complete accord. There is a good deal of the *tour de force* in many of his pictures, but, behind this appearance of dashing ease, there was a capacity for hard work and for taking pains without which he could not have carried his finest things to completion. Pettie arrived early, and some of his ablest work was done even before he left Edinburgh. 'Cromwell's Saints' (1862), and 'What d'ye lack, Madam?' for instance, contrast favourably in some essential qualities with much later work, and, although his technique gained in breadth and power, perhaps management of light and shade, which developed rapidly

after 1870 (*circa*), was the quality which showed most marked improvement in the work of his prime, the fifteen years between 1870 and 1885. To that period belong 'A Sally' (1870) and 'The Flag of Truce' (1873), in the latter of which the influence of Rembrandt—the Rembrandt of 'The Night Watch'—is clearly marked ; 'The Step' (1876), 'The Sword and Dagger Fight' (1877), 'The Death Warrant' (1879), 'The Vigil' (1884), and 'The Chieftain's Candlesticks' (1888), all of which are remarkable for combining splendid colour with rich chiaroscuro.[1] On the other hand, it also claims 'Sir Peter and Lady Teazle' (1885), and a few other pictures in which the more delicate and higher-pitched colour-schemes of his earlier period are reverted to and treated with enhanced finesse. The work of his later years, during which he produced a considerable number of striking portraits, many of them fancy dress, shows a tendency to force effects of light and colour, and is marred by somewhat coarse and careless handling. Sometimes, even earlier, he had strained pictorial effect and struck a note more suited for the stage than a canvas ; but from first to last his fine sense of colour, effective design, dexterous handling, and immense verve were fascinating, and his best pictures are amongst the happiest efforts in historical genre in our time.

[1] Quite a number of Pettie's finest pictures are in the Mappin collection in the Sheffield Art Gallery.

CHAPTER III

G. P. CHALMERS

WHEN one turns from the art of Orchardson and Pettie to that of the two most prominent men who remained in Scotland, it is to breathe a different atmosphere. Beyond the technical affinities and the interest in colour and pictorial problems due to a training under the same influences and conditions, they possess little in common. While the former found their subjects in the storied past, the latter were inspired by the people and the places among which they were brought up. Instead of the lords and ladies, the fighting men and courtiers and society dames, who figure on the canvases of the London Scots, we find peasants and fisher-folk and children ; instead of courts and camps and drawing-rooms, the dim sweet light of cottage interiors, the charm of summer landscape, and the fitful beauty of the sea. But the resemblance between Chalmers and M'Taggart ends here : their interest in subject, and the direction in which they approach it, present a contrast almost as great as their subjects make with those of their early comrades.

A native of Montrose, George Paul Chalmers (1833-78), after some years' servitude in a ship-chandlery, managed to come to Edinburgh and enrol himself as a student at the Trustees' Academy. He was twenty then, and the two years and a half he spent under Lauder was all the academic training he received, for circumstances took him back to Montrose, and when he returned to Edinburgh it was to set up a studio for himself. Absorbed in his art, his life until its tragic and mysterious close was singularly free from incident. He was never married, and, save for a visit to Brittany in 1862 with Pettie and Tom Graham, and a fortnight's trip to Paris and the Low Countries in 1874, when he renewed his acquaintance with Josef Israels whom he had met previously in Aberdeen, he was never abroad.

After some years of careful and detailed handling, Chalmers settled down to a style founded upon a simple and concentrated treatment of light and shade. This he may have acquired from the close study he gave to the pictures in the National Gallery (he copied there much more than the others), but more probably it was an outcome of his own preferences. Excepting Pettie, who frequently employed a similar method in his mature work, and Cameron, in whose pictures painted about 1870 we find it,

Lauder's pupils as a whole have inclined to broad and sweeping effects of light with little shadow rather than to a mass of shadow with little light. But, while the general aspect of Chalmers's pictures was thus early established, his technical power was uncertain, and he had not gained full command of his medium when his career was suddenly ended. Exceedingly fastidious and never satisfied with the results he achieved, he was ever striving to give fuller expression to the ideals which haunted him. What Sainte Beuve said of Balzac might be applied to him : 'In the course of the printing of his books,' the great critic wrote of the great novelist, 'he altered, he rewrote each proof in never-ending fashion. With him the mould itself was always at boiling heat and the metal did not set. He had found the desired form and sought it still.' Chalmers's method was likewise a series of attempts at expression. But besides this desire for completer expression there was a second cause, not quite so definite, yet perhaps as fully responsible for his hesitation. As a picture grows, new ideas which clamour for expression come to the worker, who, if he is not careful to preserve his first impression and tries to graft new ones upon it, will obscure the first motive and (except he paint a completely new picture) fail to realise the others. So it was partly because Chalmers tried to put all his feelings into each of his more important pictures that he seems wanting in the conviction necessary to carry work to completion. 'The Legend' (National Gallery of Scotland) in this, as in other respects, the individual work most characteristic of his gifts, was fourteen years on his easel, and when he died it was still unfinished.

Of all the Scott Lauder group Chalmers was the most interested in purely artistic problems. His greatest gift was an exceedingly subtle feeling for pictorial light and shade. It was on this that his design was based, and in virtue of it he not only occupies a distinct place in his own group, but forms a link with more recent developments of Scottish painting. To it his pictures owe their simplicity of effect, and in swamping detail in chiaroscuro, as M'Taggart does in light, he attained, though in a different spirit and by a different method, something of the directness of appeal which marks impressionism. In his hands chiaroscuro, which had been used by earlier Scots as a means of mapping out design and placing masses, became a subtle vehicle of emotion. Without the profound imagination and illumining insight, or the deep interest in humanity of Rembrandt, he yet evokes, by a somewhat kindred use of light, a feeling of pathos and mystery. And, while he delighted in rich and broken colour, in result it was subordinate to light and shade. As his figures emerge from and lose themselves in the background, so his colour, which usually occurs in the lights and half tones, gleams against and disappears again in the warm golden brown which is the groundwork of his arrangements. This is so even in many of his landscapes, which are quite arbitrary in colour and tone. Unlike his life-long friend M'Taggart, he

preferred harmony of pictorial effect to the thrill and ecstasy of Nature worship. But, as abstract colour, his is often beautiful. Although at times he inclined to over-warm and somewhat hectic hues, at its best his colour possesses great subtlety and charm. Like his light and shade, it is luminous and rich, yet soft and mysterious. As a draughtsman, his defects are allied to his merits in colour and light and shade. Having little academic training, and his interests being early concentrated on effects of light and colour, in which form only existed in the soft and blending tones, he never became certain in delineating the constructive elements, and his figures are in consequence often weakly drawn. But at the same time, and in the same way as his handling, his drawing possesses suggestive qualities, which cannot be discounted because they are no more.

Beauty of light and shade and of colour almost absorbed him, and, in one sense, it may be said that subject mattered nothing to him. Yet he saw these elements of effect so finely and subtly, that his record of a youthful or an aged face, an incident in ordinary life or a landscape, included much that was most significant in the subject. His sentiment for Nature was not deep enough perhaps to vitalise big studio landscapes like 'The End of the Harvest' (1873) and 'Running Water' (1875), but his more spontaneous pictures and sketches from Nature are often charming and expressive and now and again highly poetic. In figure also he was usually most successful when most simple. Many of his studies of old people and children are very beautiful, and some of his portraits, such as the 'J. C. Bell, Esq.' (1870 : Dundee Gallery), or the 'John M'Gavin, Esq.' (1875 : Glasgow Gallery), are not only richly pictorial but are instinct with character. The simplicity of his motives in genre (his greatest picture represents an old woman telling a story to some children) recalls Israels, with whom he has been compared more than once, but, to me at least, the Scot seems to have understood less of the meaning of life than the Hague master, to have looked at it more than experienced it, while in some points of craftsmanship he is also behind him. He never attained the subtlety of character expression in the head of the widower in the great Israels in Herr Mesdag's collection, nor the power of expressive draughtsmanship in the two men carrying the anchor ; but as a master of light and shade, as a colourist, and even as a craftsman in paint, Chalmers will not suffer from comparison with the man he was glad to call his friend.

When an artist of ability is cut off in the middle of his career the question of what he would have done, had he lived, is undoubtedly interesting. A critic's and, even more, a historian's business, however, is not speculation but analysis and narrative : he has to deal with what is, not with what might have been ; and Chalmers's position as an artist is determined by his pictures and not by the impression his personality made upon those who knew him. Yet any account of Chalmers and his art would be incomplete without mentioning that those nearest him, and best

capable of forming an opinion, believed that the mastery for which he strove so earnestly would have come, that he had indeed just reached the point when his greatest and completest work would have been done.

It is difficult for any one who did not know him personally to understand fully the fascination he seems to have possessed for those who did. Although certain of his own ideals in art, he was open-minded, sympathetic, and helpful about the work of others, and his approbation was highly prized by his fellows. What Chalmers thought of a picture was looked upon by many as a test of its quality, and his spontaneous and catching enthusiasm was a spur to those who came in contact with him. As one of his friends once said to me, 'We could have better spared a better man supposing we had had one.' These qualities gave him peculiar influence over the younger artists of his time, many of whom studied under him in the life school of the Scottish Academy. He ever set the beautiful before the students as the ultimate aim of Art, and his posing of the model and the treatment he inculcated turned upon the splendour of light and shadow, and the vibration of brilliant and broken colour. On the whole, it may be said that they might have benefited more from a severer and more academic régime; from greater insistence on the necessity for truth of aspect and tone; from a demand for more student-like faithfulness and less pictorial effect. But in doing as he did he certainly gave of his best, for the ideal he placed before them was that for which he had striven himself.

CHAPTER IV

WILLIAM M'TAGGART

IT was at Aros, a little farm within sight and sound of the Atlantic, where it flashes and thunders on the sands of Machrihanish, that William M'Taggart was born in 1835. Yet, cut off as he thus was from all direct artistic influence, he early realised that he must be a painter. Although he had spent two or three years in a doctor's surgery in Campbeltown, he was only sixteen when he came to Edinburgh and enrolled himself as a student with Lauder. Seven years of hard and successful study followed, during most of which he supported himself by painting portraits in Ireland in the summer vacation, and in 1859, along with Hugh Cameron, he was elected an Associate of the Scottish Academy. Full membership came in 1870, and since Sam Bough's death in 1878, a few months after the Society was founded, M'Taggart has been Vice-President of the Scottish Water Colour Society. He is also—and in this there is an indication of the admiration in which he is held by his younger contemporaries—an original Vice-President of the Society of Scottish Artists. For a good many years, however, he has exhibited but little, at the R.S.A. nothing at all ; and even the Scottish public had had little opportunity of seeing the most recent developments of his fascinating and most original art until the wonderful exhibition of his work which attracted so much attention in Glasgow, Edinburgh and Dundee during the spring of 1901.[1]

In common with several of his fellows, particularly Cameron and Mac-Whirter, M'Taggart began with a style which reminds one of the most Pre-Raphaelite period of the Pre-Raphaelites. In his early pictures the drawing of the figures is careful and precise, and the faces are painted like miniatures ; in the thoroughness of the modelling there is something of the spirit of the primitives, and the accessory detail is wrought with devoted earnestness to a wonderful completeness. But while 'The Wreck of the Hesperus' (1861) and 'Spring' (1864), to name two typical examples, are elaborate in detail, the interest of the separate parts does not overweigh completely the whole effect, and gradually his work begins to broaden. This tendency appears first in his landscape backgrounds, for, unlike the pupils of Lauder of whom I have already written, he is essentially a painter of figures in the open air. And it was in water-colour

[1] In 1907 there was in Edinburgh another exhibition of some thirty of his later pictures.

rather than oil-paint that he began to liberate his hand to express the sparkle and flicker of light, the purity and brilliance of colour, and the dancing and rhythmical motion, which mark all the work of his prime. Even his diploma picture, 'Dora,' exhibited as a twilight piece in 1868 and altered to the present lighting during the following year, shows discrepancy between the treatment of figures and setting. While the autumn landscape is handled with much of his characteristic sense of light and subtle breadth, there are still hints of Pre-Raphaelite care in the painting of Dora and the sunny-haired little boy, who sit on the flower-spangled mound in the foreground. But every year now saw an increase in power and simplicity, and soon drawings like 'Following the Fine Arts' (1870), and such pictures as 'The Bathers' (1874), 'Through Wind and Rain' (1875), and 'The Village, Whitehouse' (1875) proved him a master of impressionistic effect. To attain this he had gradually modified his technique, and, before the seventies had run out, he was accused of being 'bold to the verge of licence.' But, sure of his goal, he held on his way undisturbed by censure or applause, and drawing inspiration direct from nature, he has given an ever-growing revelation of the wonder and bloom of the world.

With Orchardson the pre-occupation is principally drawing and situation, with Pettie colour and situation, with Chalmers pictorial light and shade, and colour. M'Taggart is less interested in drawing than the first, and in light and shade than the last, but he shares these and the other qualities with them, and adds a wonderful sense of real light and of movement, and an intimate and profound feeling for Nature. To these, the dominant characteristics of his genius, all else is subordinate and contributory, and the development of his technique and style is the logical outcome of desire to express them. It is this and the character of the surroundings in which he passed his youth, and in which he has found material for his art, which have made him an impressionist. And if, at times, there have been indications of protest in his work, if his passionate love of liberty and strong desire for self-expression have occasionally resulted in exaggeration of handling and drawing, they have never been simulated, but issue from the perfect sincerity and originality of his outlook.

Most of the pictures produced during the earlier years of M'Taggart's career are bathed in clear, tranquil light, and deal with effects of windless weather ; in them there is little motion either of figure or landscape. Everything is carefully studied and drawn, and the painter, absorbed in and held by his subject, has been unable to grasp, or at least to express, the full emotional significance of his observation. But the work of this period is wonderfully intense in feeling and in its grasp on certain aspects of reality, and the experience gained by patient and elaborate study has been of the greatest value since. The material forms of Nature and the means of expression thus mastered were then turned to more personal and

more poetic uses. Synthesis began to supersede analysis, emotion to colour observation, and in the pictures dating from the middle seventies onward we have the full flavour of M'Taggart's temperament. In them figures, although usually introduced, are of less importance than in his earlier work, while in the most recent and most characteristic phase of his achievement they are often only items in the great harmony of Nature as a whole.

The morning and the evening have had their inspired poets in paint, but, while M'Taggart has felt their beauty, he is more distinctly the poet-painter of the sunshine and the wind. In the hours between dawn and twilight he has touched the full gamut of emotion. Although he still paints effects of tranquil light and calm, and with infinitely greater power and breadth and finer colour than before, his later work deals more specially with the sparkle and fitful dance of light, with its transmuting and transforming as well as with its fusing qualities. These he loves to catch as they play on the responsive face of the sea, over corn-fields, over great breadths of landscape. His pictures, therefore, are usually pitched in a very high key, but, unlike Claude Monet and his followers, he attains his end without crude colour, chalky light or disagreeable and repellent handling. Before the Frenchmen in point of time, and working in a more artistic way and a more poetic spirit, he has yet surpassed them in rendering those vivid effects of light, which they have made the sole object of pursuit. And the same is true when a like comparison is made between his work and that of Mr. Wilson Steer, the most gifted and refined of the English painters of light. With this unique feeling for light, M'Taggart's sense of colour is allied closely. In the shadow passages of his earlier pictures there are hints of the conventional mellowness of earlier Scottish painting, but soon, eliminating the browns beloved of Thomson and M'Culloch, he attained effects of light and colour undreamt of by his predecessors, and fully realised by none, except himself. Every part of his colour became full of life and sparkle, and shadow and light were alike tremulous with atmosphere. Evading the limitations of effect one finds in Corot, and the conventional yellow-brown foreground which mars some of Turner's finest landscapes, he has also avoided the garishness of the Pre-Raphaelites and the crudities of the *vibrists*. His colour, without being abstract in the sense that Whistler's or even Orchardson's and Chalmers's is, is very clearly selective. It is naturalistic and yet far more than a chance effect. He seems to lie in wait until Nature herself suggests both the theme and the chromatic accompaniment which will harmonise with it. At his best, subjective interest and colour are one and indivisible. And yet, considered as a thing by itself, his colour is a delight to the eyes as is that of Watteau or Gainsborough. Meaning much to the lover of Nature, it has also a decorative value which makes his pictures delightful panels of inwrought and subtly contrasted blues and greens, reds and yellows, whites and greys. Still it is principally for its significance and emotional

quality that one prizes it, and in these respects his work of the last twenty years stands easily first. The colour of these recent pictures is almost intoxicating in its brilliance and clarity, in its superb vitality and potent harmony, for, relying entirely upon the colour impression created in his mind by reality, he has thrown it boldly upon the canvas.

This is not the place to discuss the question of motion in pictorial art. It may be admissible or it may not ; but it is, at least, a distinctive feature in the art of to-day, and it has no abler exponent than M'Taggart who suggests motion as vividly as he renders effects of light and colour. His pictures of the sea seem to move and pulsate with the heart's beat of the tides ; his burns dance amongst the boulders or steal in smooth transparent flow over pebbles and sand ; his hay and harvest-fields sway to the impulse of the wind ; his figures are eloquent with the significance of gesture. And possession of power to combine light, colour, and movement to produce one effect, makes M'Taggart's rendering of Nature wellnigh incomparable in vividness.

To attain these results his technique, as I have already said, has been bent. The precision of handling, and the carefulness of drawing and detail, which were present in his early work, have been supplanted by breadth and power, and his later is marked by a swiftness and lightness yet an incisiveness of touch which imply rather than imitate. In some of his latest pictures indeed the process of elimination and looseness and suggestiveness of handling are carried so far that those who do not understand his point of view and the effects for which he now strives are apt to be puzzled. Yet swift and summary as his method may appear, it is never careless. He seems never to place a touch on canvas or paper which is not significant and essential. He says in half a dozen words, as it were, what most men would need double or triple the number to say ; but they are so fitly chosen, so apt and suggestive, that they give completer and more trenchant expression to the idea than would most elaborate and involved paragraphs. This freshness of handling and directness of touch are a constant wonder to those who know the care with which he works. For his more complex pictures, such as the magnificent ' Storm,' perhaps the most wonderful representation of a great elemental disturbance ever painted, he sometimes makes a cartoon, a colour sketch, and many studies of separate parts ; but this is never traceable in the result, which retains all the freshness and vitality of a first sketch. The way in which he handles oil-paint seems to have been influenced, as was Turner's, by his practice in water-colour, in which medium he has done much exquisite work. It is used of a consistency fluid enough to work without the slightest drag, and yet, in virtue of beauty of quality and fullness of colour, it never seems thin.

There is perhaps no gain in art without some loss, however, and the figure-drawing in M'Taggart's later work will not stand detailed analysis.

Yet it is usually wonderfully suggestive. Moreover the positions, in which he captures his figures, are such that if a model were posed in them and correctly drawn, the drawing would not suggest the subtle flow of line and transition of pose as does this seemingly defective drawing in which the attitudes are observed with passionate emotion, and expressed in a few simple and forceful lines significant of action and often full of grace. And if it did, it would be impossible, perhaps, to combine it with the other qualities of his art, with the freshness and spontaneity which charm one in all his work. Besides, the figures, unlike those in Hook's charming pictures, belong to their environment—sunshine and wind affect them as they do sea and land. So when you stand back to see the whole, the figures fall into their places, the defects of drawing disappear in a wider truth, and the combined emotion of incident and setting occupies your whole attention.

As a composer M'Taggart is perhaps less successful than in his dealings with light, colour, and movement. While he is careful of design and loves sweeping lines and culminating masses, they are marshalled less to produce a decorative result than to express the emotion awakened by the spectacle of life and Nature. But the outcome of his apprehension of subject and not the pattern into which his subject has been fitted, his compositions, if deficient in the decorative balance so justly prized by some of the younger Scots, possess that inherent vitality which comes of authentic vision, and are far more expressive than scholarly mimicry of great styles which have been the issue of alien thought. Composing, as he does, in colour and line rather than in chiaroscuro, the design of his pictures suffers as much in black and white reproduction as the subtly wrought harmony of his colour would in colour-process.

Turning from these methods of expression, which are of course but indications of his way of looking at Nature, to the subjective element in M'Taggart's art, we find a great variety of theme. He paints genre and portraits, landscape and the sea, and in each he has been wonderfully successful and original. In portraiture he has been happiest in rendering the beauty and charm of women and children, for there he is able to introduce those touches of sentiment and that feeling for story which are essential elements of his gift. Nothing could well be more delightful than the portrait of two children by the sea, known as 'Summer Breezes,' or the Madonna-like group of mother and child, which he called 'Moss. Roses'; but, as if to show that he was not dependent on the interest of such motives, which make his portraiture a kind of genre, he has painted a number in which he has produced notable and beautiful effects from the simplest elements. Such are the 'Mrs. Orchar,' the portrait of his mother, and the charming full-length 'The Belle.' But since 1888, when he left Edinburgh to live in the country, he has painted few portraits, and although, I dare say, his reason was to escape the trammels such work imposes, it was wise for

other reasons also, and particularly because his technique, having been directed towards attaining the effects described, had become too impulsive and suggestive to give certain qualities, which the public demand, and perhaps rightly, from portrait-painters.

It is seldom given to a pioneer in art—to one experimenting with new material and forging for its expression an appropriate manner—to produce complete and satisfying art. Constable and Millet are rare examples of triumph in this difficult venture, and in our own time M'Taggart has achieved a similar success. What Constable did for landscape and Millet for peasant people, M'Taggart is doing for the sea and fisher-folk. He stands with Millet and Israels—a poet of the everyday event and of the common people. But while they all deal with man's struggle with Nature, and his wresting from it with exceeding toil the means of sustenance, M'Taggart's attitude to life is different from theirs. They seem to see in life nothing save the toil and weariness of it all : he is not insensible to its sadness, but he feels its joy and gladness too. In his pictures the wind blows lustily across the sea and the waves dash themselves upon the rocks or weave a fringe of white along the sands : the possibility of disaster is there. But from the sea comes the spoil by which the fisher lives, and on the shore there await him a quiet haven and a happy home. The emigrant leaves his native land with tears and sighs, but through the rain-squalls which sweep the sound gleams the bow in the cloud. His conception is full of the compensation of circumstance and the solace of Nature. Most beautiful of all, perhaps, are the many pictures in which, with rare insight and sympathy, he has recorded the unpremeditated happiness of children— their laughter, quaintness, and roguish glee.

As M'Taggart conceives man and Nature as a unity, it is difficult to separate the strands of human interest and landscape sentiment of which his art is wrought. Yet he paints the sea with a passion and insight, a profound knowledge of Nature and an assured mastery of expression, which make him incomparable. Other men paint the form and colour of the sea ; he expresses its apparent life. Compared with his, the seas of Vandevelde or Turner are but conventions, and the pictures of Henry Moore or Claude Monet mere studies. Each of his finer pictures is a revelation of some aspect of the sea never before realised in art, and, however similar two pictures of his may seem, each possesses something spiritual and indefinable, as well as visual, which differentiates it from the other. More than any man who ever painted the sea, he possesses the power of appealing to the imagination. Without the dramatic invent- iveness of Turner, he touches the innermost chords of feeling more poignantly because more directly and simply. In the broad daylight of his pictures the immensity and mystery of the sea knock more clamantly at the heart than does the reality save in twilight and storm. And while his sea pictures linger in the memory like the haunting and evanes-

cent beauty of the west coast, which inspires them, his landscapes also seem to breathe the vital breath of Nature. Although he has painted landscape, more or less, all his life, it is only of late years that he has devoted much time to it, and he has given it specially to the lanes and burn-sides, and the spreading fields and swelling distances of the Lothians on which he looks every day. The dewiness and freshness of Nature exhale from these pictures, they gladden the heart as sight of Nature herself on a sunny morning, they are full of the lyric rapture of running water and floating clouds, of whispering leaves, waving grass, and rustling, yellow corn.

If little known outside Scotland, where, however, he is looked up to by all, M'Taggart is one of the few really great artists of his time, and one with whose work the future will have to reckon. His art has limitations and defects, but generally speaking his range is wide, and within it he has done noble things. Style of the grand or decorative kind it may not possess, but it is impregnated with so original and beautiful a view of man and Nature, so fitly and powerfully expressed that it has a clear and convincing distinction of its own. In his pictures the problems of modern impressionism pass from the region of experiment into the realm of art, for in them the observation of the realist is coloured and glorified by poetic thought. He has his uninspired moments, but the impress of inevitableness is on almost all he does. At his best, as Matthew Arnold so finely said of Wordsworth, ' Nature herself seems to take the pen out of his hand, and to write for him with her own bare, sheer, penetrating power.'

CHAPTER V

OTHER PUPILS OF LAUDER

ALTHOUGH the preceding chapters deal with the most gifted of Lauder's pupils, with those whose art seems to possess most of enduring interest, the work of several others has attractive and sterling qualities and presents an even greater variety of style and subject.

Of this second flight also London has claimed tribute, and more than tribute, for, excepting Cameron, all its notables, including the two who of all the group have devoted themselves most exclusively to landscape, have become voluntary exiles. Like Orchardson and Pettie, Peter Graham and John MacWhirter have attained English Academic honours, but, while they have made their homes in London, both have found their happiest inspiration in the scenery of their own country. Of recent years, however, while retaining his London studio, Mr. Graham has lived principally at St. Andrews.

Graham, who was the first to go, belongs less to his group and has retained more of the spirit of the older Scottish landscape painters than the other, whose work is typical of Lauder's influence in many ways. His earlier pictures revealed him as an acute observer of Nature, as a careful student of atmospheric effect and natural form ; but his technique showed much of the hardness of touch and mechanical finish of the older men, while his colour has always lacked the vibration and luminosity which belong to that of most of his own contemporaries. And if he possesses much of the skill in composition which marked his seniors, and occasionally uses chiaroscuro with good effect, as a rule his view of Nature, like theirs, is rather superficial. The picture with which he leaped into fame, however (it was the first he sent to the R.A.: 1866), was vital with the impress of Nature in her wildest mood. Compared with the landscape of M'Culloch and Milne Donald, 'The Spate' was a revelation of close observation, fresh colour, and pure atmosphere : to look at it was to be transported from the hot and crowded city to the heart of the Highlands in a day of wind and rain. Technically its merits were not quite equal to its inspiration, perhaps, but it gave so clear and vivid an impression of Nature that that mattered little. But alas ! it marked the high-water of its painter's accomplishment. Never again did he bring Nature and the *habitués* of picture galleries so close together. For a time he came near doing so,

and in the 'Wandering Shadows' of 1878, a mountain valley along the
sunlit slopes of which shadows of clouds chase each other waywardly, he
certainly succeeded. But as the years passed the vividness of these impres-
sions faded, and gradually he developed a tendency to repeat himself, and,
what is worse, his work has looked as if he were doing it from recollection
and without fresh stimulus from Nature. Yet he has never quite forgotten
what Nature was to him in youth, and, although his style has become
more mechanical and mannered and his sense of colour less active, there
are recent pictures of his which are not without appeal. While many of
them, particularly those in which he depicts Highland cattle on misty hill-
sides and moors, or crossing foaming burns, are painfully suggestive of
the oleograph and possess little painter-like quality, those dealing with the
rock-bound Scottish seaboard are frequently informed by deeper sentiment.
The sea he paints sings but one song, and in it there is none of the
grandeur of Henry Moore's blue tossing waters of the Channel, and
nothing of the dancing beauty or the elemental force of M'Taggart's
western seas. His is of melancholy mood. Wind-swept and grey, it
breaks sadly and monotonously against dark, sea-bird-haunted cliffs, and
sobs wearily amongst the long, dank tangle on half-tide rocks. But this
pathetic appeal exists apart from the way in which it is expressed, and,
carrying, as it does, into reproduction, a photogravure is often as complete
as, and frequently more pleasing than, the original. At the same time it is
not difficult to account for the attraction which Mr. Graham's art possesses
for a large section of the public. The material with which he deals is
beautiful in itself, and he paints it with understanding of its more obvious
aspects and with a completeness and clarity of statement which appeal to
many to whom more imaginative and interpretative art is a stumbling-
block. Further, by confining himself to a definite range of subjects and
effects, expressed in a clearly marked manner, his pictures have become
easily recognisable, and seem familiar wherever they may appear.

In many ways MacWhirter's feeling for landscape presents a contrast
to Graham's. Neither has fulfilled his promise perhaps, for MacWhirter's
brightest visions of Nature also came to him in youth. On Graham she
turned the face she wears when anger is in her soul, and mountain calls to
mountain across the mist-filled valleys, and the roar of swollen torrents
thunders a tumultuous accompaniment to the howling wind. MacWhirter
surprised her in different mood. Once on a June morning he spied her
as she lay smiling among the flowers, beside the delicate green of brackens
and beneath pale birch leaves, fluttering gently in the breeze which played
capriciously upon the surface of the blue loch far below ; and, once again,
in autumn, he saw her sitting dreaming of departing summer and decking
herself half sadly in russet and gold for her winter's sleep. This is the
spirit which breathes in such things as 'The Lady of the Woods' (1876)
and 'The Three Graces' (1878). Moreover, the memory of these visions

remains and is still the inspiration of his highest moments. He has tried lustier and more heroic strains ; he has painted Glen Affric in storm, and Goatfell emerging from the morning mists, and witch-like wizened trees lit by lightning ; but the result is more often melodrama than tragedy. But on occasions, as in 'The Sleep that is among the Lonely Hills' (1896 : Mrs. George M'Culloch, London), he has expressed a certain dirge-like beauty of a high order, and now and then revisited by dreams of his early inspiration he paints pictures, not strong in fibre or deeply poetic perhaps, but full of charm and marked by refined perception of colour and graceful drawing and design.

While, as Sir Walter Armstrong has pointed out, MacWhirter's feelings are most readily enlisted by all that has to do with trees, it is not the sentiment of the forest that we find expressed in the idyllic dreams of Corot or by the trumpet blasts of Rousseau that he evokes. Rather is it the charm of the fringes of woodlands clambering on hillsides, or the beauty of solitary birch or sentinel pine that he loves. He delights in the exquisite lace-like tracery of leaves and ferns, in lichen-covered rocks, heathery banks, blossoming hawthorns and flowering valleys. This is particularly marked in his earlier pictures, which present a great contrast to the conventionality of detail in those of his predecessors. Essentially Pre-Raphaelite in spirit, they seem as if painted in response to Ruskin's wish that William Hunt would lose himself for a summer in Highland foregrounds, 'would paint the heather as it grows, and the foxglove and the hare-bell as they nestle in the clefts of the rocks, and the mosses and bright lichens of the rocks themselves'; and years later, as if to fulfil the other part of the master's wish, he brings back 'a piece of the Jura pastures in Spring with the gentians in their earliest blue and a soldanelle beside the fading snow.' Still his foreign pictures (he has travelled and painted much in Europe and America), if sometimes brilliant and usually effective, are wanting in the charm of colour and intimacy of feeling with which he renders Scottish scenes and skies, and it is as the painter of the Trossachs and Arran, rather than of the Golden Horn and the Rocky Mountains, that he has won his spurs.

The daintiness of colour, delicacy of drawing and elegance of design, which mark his art at its best, are well suited to express his feeling for scenes of gentle sentiment, but unfortunately his work frequently verges on the merely pretty, and, being an unequal executant, he has produced, especially of late years, not a few pictures both meretricious in sentiment and weak in technique. When in the mood, however, and with Mac-Whirter sentiment and technique go hand-in-hand, he paints with deftness and is a charming colourist, occasionally producing pearly effects of great delicacy. In its high pitch and slight yet subtle modulation, his colour reminds one of Orchardson's, but it is less conventional in kind, and reveals greater sensitiveness to atmospheric effect.

Born in Edinburgh—the one in 1836, the other in 1839—Graham and

R

MacWhirter had been elected Associates of the Royal Scottish Academy before they went south. Each was thirty when he left, and they had not been long in London before their work attracted attention. In 1877 Mr. Graham was made A.R.A., and two years later Mr. MacWhirter was elected. A longer period separated their advancement to Academician rank, for while the former obtained it after waiting only four years, it was 1894 before the latter joined the inner circle. Having resigned Associateship of the Scottish Academy upon election in London, they were made Honorary Members.

The work of Thomas A. Ferguson Graham (H.R.S.A. 1883) and Hugh Cameron possesses qualities which link it with that of John MacWhirter. Like his, their preference is for high tone, pearly colour, and tender sentiment, but, being figure-painters, the last tendency seems more active, and is at least more obvious. It reveals itself in disinclination to face the actual, in inclination to be pretty rather than truthful, to be pleasing rather than profound.

Tom Graham (1840-1906)—no one who knew him ever thought of calling him anything else—was probably the youngest of his set. He came from Orkney to the classes in Edinburgh when very young, and was but three-and-twenty when he went to London, where for some years he shared a house in Fitzroy Square with Orchardson and Pettie. But although he painted pictures which rank amongst the finest achievements of his school, his work seemed to lack arresting qualities for the public, and, less distinguished than Orchardson's and less assertive than Pettie's or Mac-Whirter's, attracted comparatively little attention. A man of charming character and winning manner, but deficient in self-assurance, encouragement would have done much to strengthen his art, but it never 'caught on,' as the phrase is, and latterly he gave much of his time to portraiture in which the finest qualities of his talent had little scope.

To begin with, he betrays Pre-Raphaelite influence. Delicate and refined in conception and with more than a touch of that delightfully quaint naturalism which informs the earlier work of Millais, the pictures he painted in the early sixties, if the lovely 'Young Bohemian' (1864), recently acquired from Mr. Sargent for the Edinburgh Gallery may be taken as typical, are marked by a rare perception of beauty and by charming handling, looser than that of M'Taggart and Cameron at the same period, yet finished and precise. Gradually broadening, his manner became in some ways more expressive, and the best work of his middle period is somewhat kindred to M'Taggart's more developed style in charm of suggestion and beauty of colour. But neither as a draughtsman nor as a craftsman in paint could he be depended on. While he could draw with incisive elegance, and paint with dexterity and charm, there were times when the power to do either seemed to desert him. His gift as a colourist, however, was almost unfailing. Chiefly a painter

of figures out-of-doors, sometimes in picturesque French harbours, some-
times on our own coasts, and occasionally in hay or harvest fields within
sight of the sea, his colour, although pitched in a high key and with
passages prismatically bright, is usually held together by a sense of atmo-
sphere which gives it a lustrous and opalescent quality of real charm.
The colour of such pictures as 'The Passing Salute' (R.A. 1880 : Mr.
W. Gibson, Broughty Ferry), or that which bore the motto

> ' Alas ! what dangers do environ
> The man who meddles with a siren ' ;

the one of fishers waving to the keeper of a white lighthouse, the other
a flirtation scene in a white-walled fishing town, is exceedingly pure, fresh,
and delightful ; while that of the dramatic 'Last of the Boats' (Grosvenor,
1890 : Dundee Gallery), if graver, is no less beautiful. In these and
others of a similar character figure, incident and setting are happily related,
and occasionally his design, as in 'The Clang o' the Wooden Shoon'
(Mrs. Stewart), associates rhythmic play of line, enriched by much beautiful
and delicately drawn detail, with an exquisite colour-scheme.

Now and then Tom Graham indulged in pathos, but usually he was
tenderly sentimental over fisher-folk or peasants. He rarely touched the
deeper currents of life, but he played gracefully with its surface ripples,
and, dealing with things in that spirit, the elegant trifles of dress and
touches of manner which he gave his sailors and their sweethearts, out of
place as they might be in a more realistic art, seem appropriate and give a
daintiness as of the stage to his entertaining and piquant comedy. Still
it is for colour that his art will be prized, and, at its best, that is beautiful
enough to ensure that his work will not be forgotten.

Sentiment is also the dominant quality in Hugh Cameron's art. His,
however, is less humorous and more tender and intimate than Tom
Graham's, and, if we were to confine our attention to his more recent work,
we could almost focus his feeling, as expressed in paint, in one word—
paternity. Love of children prompts and colours all or nearly all that
he has produced during the last twenty years. This feeling was evident
from the first, but gradually (except for an occasional portrait, and more
rarely a subject from poetry, such as ' Kilmeny ' or ' The Last Minstrel ') [1]
his horizon became bounded by visions of children at play on the margin
of rippling seas, or in sunny meadows. His is a land where it is always
afternoon, a world where all is sunshine, smiles, and good temper.
There are no naughty little girls or boys in his dream, for he has
exorcised all taint of original sin from out these joyous descendants of
stern Calvinists. But this partial view of life is apt to cloy. It has no

[1] During the seventies Mr. Cameron painted a few portraits, treated with a power and simplicity,
both of arrangement and colour, which recall the portraiture which Fantin La Tour was producing
about the same time.

richness of contrast, either in the children themselves or in their surroundings, such as often in M'Taggart's pictures suggests the struggle, toil, and triumph of life. Yet while the vein of sentiment which Cameron works is too thin to sustain a whole series of pictures, one cannot be insensible to its charm and beauty, to the tender and loving spirit it breathes, as if in benison on life's spring-time. And now and then, as in the picture of a woman standing in the shadow of her cottage-door watching children pass from school in the sunshine, he touches a chord of emotion which has a certain pathetic appeal reminiscent of some of the work he was doing about 1870 when his subjects, taken from country and cottage life, were much more varied than now. In some ways the pictures of that period remind one of Edouard Frère (1819-86). Technically they are weaker in drawing, though not in characterisation, and less certain and fused in handling, though richer in light and shade and finer in colour than the Frenchman's ; but in tenderness of sentiment and in sympathetic apprehension of the unconscious air of serious business, which gives the play of children and the simplest acts of humble folk a significance beyond the mere matter in hand, they come close together. On the whole, however, Cameron's feeling was deeper and more intimate, and such pictures as 'Maternal Care' (1870 : Aberdeen Gallery), 'The Village Well' 1871 : Aberdeen Gallery), 'A Lonely Life' (1872 : the late Mr. A. Rose), or 'Rummaging' (1873 : Mr. Hugh Brown), have rarely been surpassed in their kind. Of these 'A Lonely Life' is justly the most famous. The subject is simplicity itself: it is evening, and in the dying light an old woman, bending under a load of sticks, is about to enter her cottage. That is all ; and yet without the least parade of sentiment, the picture is wonderfully suggestive of the lot of the aged poor, with that blending of weariness and content which makes up its spirit of resignation. Seven years later, in 'A Child's Funeral on the Riviera' (Dundee Gallery), he touched a somewhat similar feeling, but reached it through contrast instead of harmony of setting. While the combination of old age and coming night affected you in the one, in the other it was the contrast between a young life snuffed out and the flowers and sunshine of a southern land. These two pictures also show a marked difference in method of treatment. Like M'Taggart he had commenced by painting effects of bright light ('Going to the Hay' (1858-9), in the National Gallery, is an admirable example of his early work), but after a few years he began to incline to more pronounced effects of light and shade, lower tone and broader handling. Later, he again reverted to his first choice, and it may be that the visit to the Riviera, which prompted this and other high-toned pictures, had something to do with the change. At all events, many of his pictures have since been pitched in a higher key, and in a way his latest work again approximates to that of M'Taggart.

Cameron is best seen on a small canvas, his recent work especially, for

technically he is less interesting than he was. When a picture of to-day is compared with ' Rummaging ' or ' A Lonely Life,' or his diploma work, ' Play,' you feel that the drawing has become looser but no more suggestive, the handling less coherent, the tone higher and thinner without being much fuller of true light ; that the colour even, delightful and opalescent as it often is, seems less beautiful than the delicate low-toned harmonies of browns and greys and blues he gave us in the past. So those who look for accomplished expression in painting will always prize the pictures of his middle period most, and after them the early ones painted under Pre-Raphaelite influence. Yet the majority, to whom sentiment makes the most direct appeal, may perhaps be pardoned if they prefer his recent work.

For a few years after 1876 Mr. Cameron lived in London, but it seems as if the conditions of life there had not suited him. His work fell off in quality, and it was not until he returned to Scotland, where he now divides the year between Edinburgh and Largo, that it regained something of its old charm. He was born in Edinburgh in 1835, and, elected A.R.S.A. in 1859 at the same time as M'Taggart, he became an Academician in 1869.

Of Lauder's other pupils who have attained some prominence, it is unnecessary to write in such detail. Neither their technique nor their subjects demand extended analysis. For the most part, they are neat and competent rather than accomplished and expressive craftsmen, and their pictorial motives are usually pretty or commonplace or both. Yet nearly all share in some degree the gift of colour and the sense of beauty which characterise the work of the group as a whole and differentiate it from that of earlier Scottish painters.

Although at its best weak in fibre and artificial in sentiment, the art of George Hay even at its worst possesses qualities which connect it with that of the group. Never a sound draughtsman or a vigorous or expressive craftsman in paint, and seldom grasping the real significance of a situation, whether dramatic or humorous, the pictures and drawings of his best time seldom failed in delicacy of colour or in a certain touch of beauty, frail though that might be. Finding subjects chiefly in the past or in the Waverley Novels, so much drawn upon by his master and his master's contemporaries, he ensured picturesque costumes and setting for his incidents of gallantry, superstition, or adventure, and so added to their charm. Such were ' The Jacobite in Hiding ' (1865), ' Shopping in the Sixteenth Century ' (1867), ' Tea Tattle ' (1871), ' A Visit to the Spae-wife ' (1872), ' Caleb Balderstone's Ruse ' (1874), and ' The Haunted Room ' (1875). A native of Edinburgh, Mr. Hay was for some time in an architect's office, but, adopting painting as a profession, he was elected A.R.S.A. in 1869 and R.S.A. seven years later. And from 1881 to 1907 he acted as Secretary to the Academy.

These qualities are perhaps less marked in the case of the brothers Burr, for while influenced by the tendency of their fellows to pure delicate

colouration, their local colour, though definite enough, is struck over a ground of chiaroscuro, frequently dull greenish grey in quality, and lacks luminosity and vibration. The older brother was the more gifted. Born in 1831, John Burr was a few years the senior of most of his fellow-students, and his earlier pictures, such as 'The Poor helping the Poor' (R.A. 1862: Mr. John Kennedy, Glasgow), in the careful precision of their handling, the character of their impasto, and the pleasant patchwork of their colour, like a Paisley shawl, are somewhat kindred to those of Tom Faed (1876-1900), which they also resemble in the tender pathos of their sentiment. Later his brushwork became freer and his colour softer, while his feeling, although now and then inclining to the obviously pathetic, as in 'Home Shadows' (1883), took a more humorous turn. Two pictures in the Glasgow Gallery, 'The Fifth of November' (1871), and 'The Dominie's Visit' (1879), are typical of his work in this lighter vein. Sentimental, pretty, and well-intentioned, his comedy, if somewhat superficial and unreal, is pleasing enough and good in its kind. To him, as to his older contemporaries, interest of story was more important than pictorial beauty; but lacking the tenderness of Tom Faed, the rich humour of Erskine Nicol, or the intellectual quality of Herdman, he failed to give his pictures the impress of a definite personality. Even the few portraits he painted, and a study like 'From Norfolk' (Mr. Joseph Henderson, R.S.W., Glasgow) shows his talent as a craftsman at its best, are deficient in that respect. In 1861, five years after he first exhibited at the Royal Scottish Academy, he went to London, where he made a considerable reputation, being elected an Associate of the Old Water-Colour Society and serving for several years as President of the Royal Society of British Artists. But for a few years before his death in 1893 he was of comparatively little account. Alexander Hohenlohe Burr (1835-99), who accompanied his brother to London, was in many respects his elder's understudy, and, painting kindred subjects in a very similar manner, each produced pictures which might be attributed to the other. As a rule, however, A. H. Burr's colour-schemes were gayer in hue, and pitched on a higher key, and in picture after picture one finds a combination of pinkish-red, citron or orange yellow, grey-green and white, which would make a series of his pictures monotonous. While less anecdotal, perhaps, he was also less inventive than the other, and his handling was softer and less assured.

Even more than the Burrs, J. B. Macdonald (1829-1901) retained the chiaroscuro of the earlier school. Neither his sense of colour nor his sense of values was active, and heaviness of hue and dulness of tone tended to give a common look to the forceful handling which he brought to bear upon his animated conception of the Jacobite episodes which formed the subjects of his principal pictures during the years he was a prominent exhibitor at the Scottish Academy. In later life he abandoned

figure for landscape in which, if he never revealed fine feeling or good colour, he did some vigorous work of the transcript order. His early promise had brought him Associateship in 1862, and in 1877 he became a full member. On the other hand, although attracting practically no attention, the little genre pieces of John Wallace possessed considerable quality and charm. He, however, won recognition by the clever and entertaining drawings in black and white which, as 'George Pipeshank,' he made for Cope's *Tobacco Plant* and other publications.

W. F. Vallance (1827-1904)[1] is the only other student of Lauder's school who need be mentioned. Unlike the men with whom he is grouped here, he was chiefly a landscape painter. He commenced indeed with portraiture and genre, and during the early seventies he painted a series of pictures of Irish life and character, humorous in figure incident and fresh in landscape setting ; but he had been brought up at Leith, and it was as a painter of the sea and seafaring life, to which he had turned his attention as early as 1860, that he eventually became most widely and favourably known. In the earlier of these pictures, 'What care these roarers for the name of King' (1866), 'Break, Break, Break' (1867), 'Scarborough Bay' (1868), and others, his work seems to hover between that of his seniors and that of his contemporaries. Retaining something of the Dutch convention which underlay the transitional art of E. T. Crawford (1806-85), he tended to paint in a freer manner and in a higher key. These tendencies gradually asserted themselves more fully, and in such things as 'Reading the War News' (1871), 'The Busy Clyde' (1880), and 'Knocking on the Harbour Walls' (1884), he expressed with considerable dexterity, and in swift and easy if somewhat flimsy brushwork, much of the charm of silvery light playing over delicate grey-green surges, or of sunshine filtering through summer haze upon calm waters busy with shipping. Yet his pictures never quite emerged from the conventional, and his feeling for Nature found a more vivid and interesting expression in the many water-colours, often in body colour, which he painted out-of-doors.

[1] Elected A.R.S.A. 1875 ; R.S.A. 1881.

SECTION II.—THE MIDDLE PERIOD AND ITS AFTERMATH

CHAPTER I

THE SUBJECT-PICTURE

As the wind bloweth when and where it listeth, so the informing spirit, which makes the art of one generation interesting and leaves that of the next flat and unprofitable, comes and goes we know not whence or whither. The ten years which coincided with Scott Lauder's mastership of the Trustees' Academy had seen the advent of a group of gifted painters, the bloom of whose work is as fresh to-day as when it began to appear on the walls of the Scottish Academy ; the twice ten years which followed that fruitful decade were marked by the appearance of comparatively few who have made notable contributions to Scottish Art. But while the work described in the last few chapters bulks large in any survey of Art in Scotland during the past half-century and dominates the period between its beginnings and the next important movement, popularly, if inaccurately, described as that of the 'Glasgow School,' several conspicuous names were added to the roll of Scottish artists, and, while the majority were those of painters of landscape or the sea, much good and some excellent work was done in subject-painting, the pastoral and portraiture. It is to this that the following chapters will be devoted.

I

When William Ewart Lockhart (1846-1900) entered the Trustees' Academy at the age of fifteen Lauder's active reign was practically over, and, beyond a strong desire for colour, different in kind however from that of Lauder's immediate pupils, his work bears no direct impress of that school. His real and practically sole instructor was J. B. Macdonald, who had been a pupil of Lauder ; but of even greater importance than his teacher's influence was that of John Phillip's latest and most accomplished pictures. On most of Lauder's scholars, new from his moulding influence, the broad simple treatment of 'La Gloria' and 'The Early Career of Murillo' acted as a stimulant; but on Lockhart, who was less

experienced, their effect was intoxicating. While the others worked towards breadth and incisiveness gradually, he jumped for them at once ; and after 1867, when he made the first of several visits to Spain, he applied them to such Phillip-like subjects as the 'Muleteer's Departure' (1871), the 'Orange Harvest, Majorca' (1876), 'Alnaschar' (1879), the 'Swine Herd' (1885), and the 'Church Lottery in Spain' (1886), the last a striking effect of artificial light in a Seville street. He also found subjects in the literature and romantic history of Spain, illustrating several incidents in *Don Quixote* and *Gil Blas*, and finding in the story of the Cid material for one of his best-known works. Episodes in Scottish history, which combined opportunity for rich and strong colour effects with dramatic situation, were another source of inspiration. The 'Bride of Lammermoor' (1878) and 'Cardinal Beaton' (1880) are typical of this phase. These and other pictures with a literary genesis—even his invented motives incline to story-telling—were further varied by occasional landscapes and by portraits, which greatly increased in number after Queen Victoria commissioned him to commemorate the Jubilee of 1887 in a picture of the ceremony in Westminster Abbey. Considering the difficulties of such an undertaking, his Jubilee picture is a highly creditable performance, and one of the best of such records in the collection in Windsor. In ordinary portraiture, however, and in his work as a whole, he seems never to have recovered from the strain of that exacting task.

As may be seen by comparing the subjects Lockhart painted in both oil and water-colour, he was more successful in the latter medium. In it his handling is subtler and more sympathetic, his drawing more expressive, his always potent colour finer in quality and hue. In oil he was apt to forget that there is a strength of delicacy as well as of power, and erred in over-emphasis both of handling and of colour, which he employed too often in separate masses unrelated by a sense of decorative design. Yet those pictures in which he may be said to have abused his medium are more characteristic than those in which assumption of delicacy and refinement has frequently given, in his later work at least, an artificial and even a feeble look. His faults and merits are in kind comparable to Pettie's ; but he had scarce so brave a spirit, his pictorial sense was less acute, his handling less subtle and dexterous, his colour far less harmonious and charming.

Elected A.R.S.A. in 1871 and full member seven years later, he continued to reside in Edinburgh until the royal commission took him to London. He was then too old to take kindly to new conditions, and one cannot but think that he suffered as an artist by the change.

Since his death, Lockhart's reputation has rather dwindled. To this various causes, of which the chief are the present disfavour of subject and the stress laid upon tone by the newer school, have contributed ; but,

slightingly as it has been thought of recently, the best of his work is marked by a relish for colour and a gusto of handling which may eventually ensure it a good, though not a first-class, place amongst that of his school.

Contemporaries of one another and of Lockhart, Robert Gibb and William Hole, the one born at Lauriston in 1845, the other at Salisbury during the next year, began to challenge attention in the Royal Scottish Academy shortly after 1870 with a series of pictures of semi-historical or romantic incident. Both had been trained to a quasi-artistic business and both had studied Art at the Edinburgh classes and in the life-school of the Scottish Academy, and of both it may also be said that they approach subject from the intellectual rather than the æsthetic side and are stronger in form than in colour. Gibb's earlier pictures, of which the more notable were the 'Death of Marmion' (1873), the favourite incident from 'Elaine'—*The Dead steered by the Dumb*—(1875), the 'Death of St. Columba' (1876), and 'The Bridge of Sighs' (1877), were marked by indications of that earnestness of purpose and unsparing research, that good drawing and thorough technique which have since won him a prominent place among Scottish artists, while a later picture, the 'Last Voyage of the Viking' (1883), showed him in more romantic mood. In 1878, however, he had broken new ground and found the entry to the series of military pictures on which his reputation, in a wide sense, rests. 'Comrades' was followed by the 'Retreat from Moscow,' which was finished in Paris in the Exhibition year, and in 1881 'The Thin Red Line' created a perfect furore at the Royal Scottish Academy and, sent on tour, carried his name far and wide. He was an associate of only three years' standing, but promotion to full membership followed at once. An interval, marked by a few minor military pictures and a number of portraits, succeeded this big effort, and then, concentrating himself, he painted another thrilling episode in the annals of the Highland Brigade,—the charge of the Forty-second up the Heights of Alma. But, admirably conceived and carried out as that picture was, the diffuseness of the composition and the comparatively smaller size of the figures rendered it less impressive than its predecessor or its successor, 'Saving the Colours,' an incident in the third great Crimean battle, which, in technique and design, showed a distinct advance on all he had previously done. And this advance was more than maintained in the 'Hougomont' of 1903, which in turn the 'Dargai,' now nearing completion on his easel, promises to eclipse.

Less pathetic than Lady Butler, whose chief successes, apart from 'Scotland for Ever,' have dealt with such touching incidents as the 'Roll Call' of a shattered regiment, and less vivacious and immediately effective than Caton Woodville, who finds his most congenial subjects in cavalry charges and galloping horse artillery, Gibb deals more powerfully and realistically with another and not less stirring phase of fighting—infantry in their moments of sharpest trial, receiving cavalry in 'The Thin Red

Line,' charging in ' The Alma,' dashing with splendid courage across a fire-swept zone in 'Dargai.' And of all British battle-painters he is the best equipped technically. Lady Butler, despite her gifts, is apt to show herself the talented amateur. Woodville's *chic* and easy method is frequently suggestive of the hurry of the weekly illustration, and Croft's handling is too wanting in homogeneity and power to be convincing. On the other hand, Gibb, within his range, is an accomplished craftsman. He is indeed the only one who can be compared with the military painters of France.[1] If his drawing, especially of horses, lacks the spirited touch and perfect mastery of De Neuville and Detaille, it is constructive and expressive, and the handling of his later pictures has a solidity and breadth which that of neither of these talented artists possesses. Further, the sense of reality he conveys is almost equally great. To this realistic result, for unlike the Frenchmen he has never been under fire, the great care which he takes to ensure truth of circumstance and detail contributes greatly, the appearance of his uniforms, torn and soiled and worn, as if by much campaigning, specially helping the effect. The weak points of his equipment do not lie in draughtsmanship or ability to build up a big figure composition, qualities very rare amongst Scottish painters, but in a rather deficient sense of the decorative possibilities of his material, and in colour, a blue-grey bloom frequently impairing the vitality of his ensemble. In the class of picture to which he is chiefly devoted purely æsthetic qualities are less important, however, than clear setting forth of the chosen incident, pictorial realisation of the heroic spirit of a courageous act, and appeal to the patriotic emotions : and in these respects he never fails. His portraits are marked by the same qualities as his pictures, for here also his approach is more intellectual than æsthetic. But to a fine sense of character, he adds a simple and dignified idea of pose, excellent and incisive drawing, and broad and powerful brushwork ; and his portraits of Sir H. M. Stanley, the explorer, of Dr. Joseph Parker of the City Temple, and other people of importance, are in many respects admirable and complete performances. The outstanding qualities of his art as a whole are the clarity and coherence of its conception on the intellectual side, and the high level of its accomplishment in certain technical respects, while the scale on which he works and the complexity of the material with which he deals are exceptional in the Scottish school. These characteristics made his appointment (1908) as His Majesty's Limner for Scotland particularly appropiate.

In 1895 Mr. Gibb was appointed keeper of the National Gallery of Scotland,[2] and the re-arrangement and re-cataloguing of that collection are not the least of his services to Art in Scotland. It is not too much to say that the interest now taken in the Gallery dates from the time he assumed office.

[1] Mr. A. C. Gow, with his handling *à la* Meissonier, is less a battle-painter than a painter of genre subjects in military costume. [2] Retired 1907.

When, on the same day in 1878 as Robert Gibb, William Hole was elected an Associate of the Scottish Academy, he was known chiefly for what were described by a contemporary critic as 'Ambitious efforts in the direction of high Art.' He had painted 'Medea in the Island of Circe,' and several episodes in the Arthurian legend, and he was recognised by his fellows as a man of exceptional artistic appreciation ; but, it was not until a year or two later that he caught the public eye by his picturesque renderings of Jacobite story : 'The End of the '45,' 'A Straggler of the Chevalier's Army,' 'Culloden,' and 'Prince Charlie's Parliament,' and still later before his etchings of pictures brought him the applause of the discriminating. But to pursue his development as a painter, in 1883 and 1884 he showed several excellent pictures of West-Coast fisher-life, and in 'The Night's Catch' and 'The fill of the two Boats' attained the highest point he has reached as a picture painter. They bore the impress of personal impressions of Nature, and they were painted with vigour and directness. To Hole, however, Art is more than Nature. He did not follow up his success in dealing with realities, and returned to myth and history. The work which he now did was often well conceived and carefully designed, but too often it lacked the smack of originality, which in art is worth all the scholarship in the world. Yet the gift of appreciation, which was hurtful, perhaps, to his personality as a painter, was meanwhile revealing itself in a series of wonderful reproductive etchings. Except the portraits in *Quasi Cursores*, published in connection with the Tercentenary of Edinburgh University (1884), I cannot recall any etched work of his before the appearance of W. E. Henley's Memorial Catalogue of the French and Dutch Loan Collection in the Edinburgh Exhibition (Meadows) of 1886, but he must have been etching for some time. The plates in that volume are the work of a master. Brought together by the late Mr. R. T. Hamilton Bruce, who contributed many of the finest examples to that notable gathering, the collection contained some of the finest work of Millet and Corot, of Rousseau and Troyon, of Diaz and Monticelli and other leaders of the romantic movement in France, and of the Maris brothers, Israels, Bosboom, and Mauve among the modern Dutchmen who have carried on the tradition of that great school to our own day ; and Hole made reproductions of representative pictures by all these masters. The method employed was etching, but not of the ordinary and orthodox style, for line was combined with something that looks uncommonly like mezzotint, and use was made of any means which would convey the surface and paint quality of the impasto. The results in these reproductive respects were wonderful, but even more admirable was the interpretative power displayed in seizing and rendering the spirit and individuality of conception of the different artists. And in two series of plates, the one from pictures in the National Gallery of Scotland (1888), the other of the landscapes by Thomson of Duddingston (1889), which

he made for the Society for the Promotion of Art in Scotland, he showed as great a flexibility of method and an even wider range of sympathy. In addition to these and others on a comparatively small scale, he has executed a number of much larger plates, of which those after Millet's 'Wood Sawyers,' Matthew Maris's 'He is coming,' Constable's 'Jumping Horse,' and Velasquez's 'Admiral Pareja,' must be mentioned as particularly important. Of these it is difficult to speak too highly. They are perhaps the most wonderful translations of colour and handling, of design and conception and spirit, into another artistic medium ever made, and entitle their author to rank with creative artists of the highest class. Unfortunately, so at least those of us who prize his work of this kind think, this incomparable interpreter has since shown an inclination to abandon the field in which he has won such triumphs, and is again devoting his talents to more original, but no more honourable work. For the most part this has not been easel picture-painting but mural decoration. Some of it has sprung from the religious instinct, which prompted him to paint 'If thou hadst known'—one of his most successful pictures—in 1885, and to produce, after a visit to Palestine, a series of water-colour drawings illustrative of 'The Life of Christ' marked by reverence and simplicity of feeling (published, with an introduction by Professor G. A. Smith, 1906). His most important decorations, however, deal with the earlier epochs of Scottish History, and are to be found in the Central Hall of the Scottish National Portrait Gallery and in the Edinburgh Council Chambers. In these the artist has maintained a rather happy compromise between the rival claims of decoration and representation, and, if rather wanting in charm of colour, the Portrait Gallery cycle is one of the most notable essays in mural decoration ever accomplished in this country. If it were in a Continental capital, British visitors would make a point of seeing and of being duly impressed by it.

Mr. Hole, although brought up and trained in Scotland, and devoting much of his energies to Scottish national subjects and purposes, and to the illustration of Scottish literature in the novels of Stevenson and Barrie and in the 'Centenary Burns,' is an Englishman and an Episcopalian. Perhaps the student of racial characteristics in art may be able to detect the influence of these things in his work.

II

Informed by less intellectual grasp of subject, or marked by inferior taste or feebler technique than that of the artists just considered, the work of a number of other men whose subjects range from historical or quasi-historical to domestic incident is less interesting and calls for briefer comment. A few among them show the influence of Orchardson or Pettie, of Nicol or Faed, but, broadly considered, their art is commoner in sentiment, style and

handling, while it is often almost wholly dependent for such interest as it has on subject. Those who paint historical incident frequently illustrate their chosen themes closely and cleverly, and the sentiment of the domestic painters is as a rule simple and sincere, but before many of their pictures one feels that the principal preoccupation of the painter has been story in its literary or sentimental aspect ; that beauty of form and colour, harmony of mass and line, significance of ensemble, the means through which an artist appeals to the emotions and intellect, have concerned him in a very secondary way. Thus the popularity of C. Martin Hardie's 'Burns in Edinburgh' (1887), a picture designed on Orchardsonian lines, was largely due to the fact that it contained portraits of the poet and his friends, and represented—from the worldly point of view—the most successful episode in the inspired peasant's career. A legitimate interest in itself, indeed, but one that has no existence in a picture without reference to a catalogue and a key to the chief figures. And the motives of his pictures are not infrequently of this over-specialised kind. 'Scott finding the MS. of *Waverley*' (1891), 'The Childhood of Sir Walter Scott' (1893), 'The Meeting of Burns and Scott' (1894), for instance, are incidents which appeal to the imagination in virtue of associations which cannot be expressed pictorially. But Hardie is not alone in this tendency —the 'Voltaire at the Café de Procope' (1890), perhaps the ablest big picture ever painted by the artist whose work will be considered next, fails dramatically for exactly the same reason—and all his special subjects do not demand special knowledge. Before the happily titled 'Unrecorded Coronation' (1889) you may have the pleasures of association added if you are told that the children playing on the green lakeside are the young Queen of Scots and her Maries ; but no historic lore is required to appreciate the charm of these young girls crowning one of their number Queen of the May with a coronal of hawthorn blossom, and the contrast between their gaiety and the subdued air of the nun, who sits not far off watching their play, speaks for itself.

Subjects such as these Hardie varies with incidents of country life, sometimes of his own invention, and sometimes suggested by song or ballad, for he is a student of Scottish literature. Such were 'The Kirkin'' (1885), 'The Judgment of Paris' (1897), 'Ca' the Yowes to the Knowes' (1887), and 'A Pastoràl' (1891). In them, however, the Scottish peasant is rather apt to be endowed with the airs and graces of drawing-room comedy, and in consequence the natural piquancy of the situation becomes tinged with artificiality. And intelligently conceived, carefully designed, and correctly drawn as the best of his pictures have been, their merits are to a considerable extent discounted by commonness of feeling, mechanical if competent painting, and want of refined tone and colour. Unfortunately, too, these defects have become more apparent in the work of his maturity, for pictures like 'The Shoemaker's Pansies,' painted in the early eighties,

showed a sincere attempt to paint things as they are, and a higher type of craftsmanship. They are seen at their worst in some of his recent portraits, and more particularly in several pretentious portrait-groups of many figures and large dimensions which will be fresh in the memory of all who saw them.

Mr. Hardie, who was born at East Linton in 1858, received his training in the Scottish Academy Life School, where he took several prizes, and in 1895, having been an Associate for nine years, he was elected Academician.

George Ogilvy Reid's choice of subject also includes historical and domestic incident, and if one had to differentiate between his work and that of Hardie, it might be done perhaps by saying that the latter is more intelligent in conception, and the former more painter-like in quality. Hardie gives somewhat greater consideration to truth of circumstance, detail, and *mise en scène* ; Reid is not careless of these things, and he has touched a higher point in characterisation, in design and in tone, and in the Meissonier-like handling which at one time seemed the ideal of both.

A native of Leith, Mr. Ogilvy Reid passed a ten years' probation as engraver before he was able to devote himself entirely to painting. He had exhibited at the Scottish Academy, of which he was subsequently a student, as early as 1872, but it was not until 1884 that he gave definite indication of the qualities which have since marked his art. The pictures then shown were small costume-pieces painted with considerable technical dexterity and power of characterisation, and continuing to work in a similar vein with increasing skill, specially in the management of colour which had tended to be crude, he was elected Associate in 1888 and full member ten years later. And in 1891 he was commissioned to paint the ceremonial picture of the baptism at Balmoral of a grandson of Queen Victoria.

Handled in a spirited manner with a certain sparkle and vivacity of touch, excellently designed and full of carefully observed incident, his cabinet-size renderings of the social life of the eighteenth century are admirable in many ways, and only require greater subtlety of seeing and feeling, a finer and more delicate sense of colour and tone, and more finesse and style of touch and drawing, to give them something of that artistic distinction which they usually lack. Although his types are neither very refined nor sufficiently varied, his character-painting is often good, while, as a rule, the facial expressions of the actors in his little comedies and their attitudes and gestures are in accord. And possession of these qualities gives his pictures of the wits, beaux, and politicians of the past (it is curious how seldom women appear in them)—gossiping about the latest social or political scandal, discussing the merits of an unpublished MS. just read by its author, fighting their battles over again

as Esmond did with Addison and Steele, or quietly engrossed in a game of chess—distinct interest and a certain psychical quality.

On much the same moderate scale—and that, by the way, is the most suitable for such motifs—and in a similar spirit and manner, Ogilvy Reid has also produced a few pictures of homely Scottish life. Indeed, in these good examples of the Wilkie-Faed tradition, 'Oor Laird's Coort Day' (R.S.A. 1888), 'The Catechising' (R.S.A. 1889), and 'The New Laird' (R.S.A. 1891-2), he attains a fuller reading of character and shows a finer comprehension of the matters at issue than when dealing with the beaumonde of the Augustan or earlier Georgian reigns. It is to the past, however, that he is chiefly devoted, and nearly all his recent work has dealt with it. But while he continues to paint cabinet pieces of intimate social intercourse, and they remain his most characteristic and pleasing achievements, he has at times been more ambitious in both subject and scale. Of the larger things in his earlier style the 'Voltaire,' already referred to, was a really notable performance, which he has never surpassed in design, in colour, and in spirit and deftness of brushwork; but the dramatic element, if tense, was less obvious than in 'After Killiecrankie' (R.S.A. 1897: Diploma room), 'The Prince's Flight' (R.S.A. 1899), 'Kidnapped' (R.S.A. 1902), a scene from Louis Stevenson's novel, or 'The Smugglers' (R.S.A. 1903). In the three last also one notes the appearance of a different kind of background—stately saloon and reposeful library giving place to moving sky and never-resting sea. Coincident with this greater spirit of adventure, and probably connected with it, he has likewise been striving for a broader and more powerful manner, and, if he has not yet attained the same measure of success as in his earlier and daintier way, it is a move in the right direction and an indication of development.

As the tendencies noted in the work of Reid and Hardie are present in varying degree in the Jacobite subjects of James Hamilton (1853-94), an Associate of the Academy, whose early promise was not fulfilled; in the sentimental love scenes and the incidents from Old English Comedy and the Waverley Novels in which Duncan MacKellar (1849-1908) and his friend Alexander Davidson (1838-87) delighted, and in the painted jests of Mr. Watson Nicol, a son of Erskine Nicol and in some ways a follower of Pettie, it seems unnecessary to analyse them in detail. Nor need one linger over the work of Mr. Payton Reid, who, however, deserves praise for the sincerity and knowledge displayed in treating themes of a classical or mythological kind, varied by cavalier subjects; nor over that of Lockhart Boyle or Mr. Graham Glen, who find their themes in Gaeldom. And a word in passing must also suffice for Mr. Skeoch Cumming's watercolours of episodes in the annals of the Highland Brigade, or in the South African War, in which he took part, though the latter have shown an aptitude for rendering incident and action which, assiduously cultivated, might result in something much finer than he has yet achieved.

For the most part, in the pictures of these men and in those by others of a similar habit of mind, the picturesque element depends very largely on costume and accessories, and the emotional on the halo of association which tradition has woven about the past. Of true pictorial imagination, as one finds it in Orchardson's or Pettie's pictures, the work we are discussing shows little trace. To say this is not to deny these painters their legitimate claims as illustrators or craftsmen, it is only indicating the position their pictures occupy in relation to creative art. But as technique and thought, the vision of the painter and the means of expression are inextricably bound together, the ordinary way in which they see is echoed in the way they paint. Within its range and of its kind, the technique of the more accomplished among them is fairly complete and competent enough, and they usually tell their stories effectively, but of even the best it can scarcely be said that he is a distinguished draughtsman, a fine colourist, or a gifted designer.

Somewhat the same defects mark the domestic genre of this period. Dealing with ordinary events and everyday surroundings it is necessarily more complete in conception, and makes less demand on the inventive faculty than the other. Yet as a rule it is no more touching or profound. This, however, is not surprising when one remembers that the interpretation of the familiar demands even higher qualities than the reconstruction of the past. Slight exaggerations of expression or gesture, and trivial anomalies in setting, which would jar in a familiar scene, pass without remark when the actors wear the clothes and move among the trappings of an age we know only from other pictures or the stage. But the everyday event demands sympathy and insight in its treatment if the result is to give lasting pleasure. We have seen how a touch of artificiality vitiates many of Mr. Hardie's genre subjects, and if we turn to Mr. Tom M'Ewan's we shall find that sympathy and sincerity can inform work that makes little appeal as art. For M'Ewan is not an accomplished craftsman. Trained as a pattern-designer in Glasgow, he made his way into art with difficulty, and had to be content with such study as scanty leisure and opportunities allowed. He believes, indeed, that ' True painting is taught in one school only, and that school is kept by Nature,' but none the less his own work would have gained much from a thorough grounding in drawing and the expressive use of paint. It might then have possessed something of that constructive power and richness of effect, without which the finest sentiment is only half-articulate. But Mr. M'Ewan is an individualist, and the strong and tender feeling for the joys and sorrows of humble folk which illumines everything he does has given him a distinctive place amongst those who follow Wilkie's lead in its most national phase. It is, however, with the pathos of Tom Faed rather than with the humour of Erskine Nicol that he is most in sympathy. His old women are ' contented with little and

S

canty wi' mair,' and draw their chief consolation from the Bible and the helping hands of sunny-haired grandchildren ; the breakfast or dinner of porridge or potatoes is eaten with thankfulness, and the cup of tea drunk with relish ; and the never-ending round of household duties is sweetened for the weary mother by the unceasing prattle of 'the bairns.' And it is all so simple and true, and so sincerely felt that it seldom fails in its appeal.

The genre of Mr. J. E. Christie is quite other in spirit. A Fifer by birth, he was trained in the Art Schools at Paisley and South Kensington, and finished a more than usually brilliant career as a student by winning two gold medals (1876 and 1877) at the Royal Academy amid academic applause and prophecy. But a few years later, coming under French influences in Paris, he, on his return, took a studio in that hotbed of artistic dissent, Chelsea, and disappointed the prophets by joining the New English Art Club and by producing work in the best opposition style. In 1893, however, he left London for Glasgow, where he has since occupied a prominent place. But his best work was done before he returned to Scotland. His idea of subject has always been much what it now is, but as the refinement and sense of style, which gave his earlier pictures charm, ebbed, his rich and jovial Philistinism asserted itself fully. Yet the existence of 'The Pied Piper' (1881) makes one wonder if its painter has done his gifts justice. An epitome of the finer elements of his art in genre and allegory, taken as either it rises to a far higher plane than anything he has since done. Compared with it his later genre pictures are coarse and crude ; and pretentious allegories, like 'Vanity Fair' (Glasgow Gallery), or 'Suffer Little Children,' or 'The Golden Stairs,' to which he has devoted much of his talent of late years, are completely lacking in the spiritual fascination and suggestiveness of that picture of a crowd of children spellbound by the playing of a passing minstrel. Technically also, the descent from 'The Piper,' 'In Time of War,' 'A Lion in the Path' and other of his earlier pictures is very marked. But he seems to enjoy painting as much as ever, and his pictures of childhood and of scenes from Burns, his allegories and his portraits have their circle of admirers.

In a brief statement, such as is attempted here, of the characteristics of a group of men whose chief bond of union is a similarity of standpoint, individual merit is apt to suffer from the more generalised method involved, but exigencies of space and proportion forbid my treating the work of each in more detail. Nor does the scope of this book permit of dealing with sojourners in our midst, such as Keeley Halswelle (1834-91), who did some of his important figure-work in Scotland, or Otto Leyde (1835-97), a German, who found in Scottish ballads and cottage life material for his most characteristic pictures, and lived so long in Edinburgh that one came to look upon him almost as a Scot. On the other hand,

consideration of the genre-painting of several younger men, in whose work other influences are combined with much of the sentiment of the earlier Scots, has only been postponed.

There is one Scottish figure-painter of this time who cannot, however, be grouped with any other. In choice of subject, in temper and in technique, George Wilson (1848-90) stood apart from the general tendencies of Scottish painting during the period to which he belonged by accident of birth. Save for Noël Paton and James Archer (his seniors by many years), who were fanciful and inventive rather than poetic or imaginative, he was quite alone amongst his countrymen. If linked in a remote way to the romantic phase of English Pre-Raphaelitism, he was essentially an idealist and a highly personal artist.

Born near Cullen, where his father factored the Seafield estates, he was educated there and in Aberdeen, but, after a year or two at Edinburgh University, he decided to be a painter, and, going to London, entered Heatherley's and the Royal Academy schools, which he deserted later for the Slade School, then under Sir Edward Poynter's direction. Student days over, London remained his headquarters, but he was much away, appearing among his friends in town and disappearing to sketch in the country or in Italy as the spirit moved him. He is described as having been singularly sensitive and shy, and he shrank from publicity; but he was much beloved by his intimates, and his pictures, seldom seen in exhibitions, were purchased eagerly, if at moderate prices, by a little coterie of admirers. For many years, however, he was a victim to a gastric disease which frequently incapacitated him for work, and, in the end, killed him before he was forty-three.

Although an admirable and distinguished draughtsman in chalk or pencil, and frequently attaining great beauty of line and delicacy of modelling combined with a real instinct for style, the figure-drawing in some of Wilson's pictures is uncertain and in others very obviously faulty. For this, desire to capture the exact nuance of gesture or attitude, which would express the sentiment involved, was responsible in part no doubt, but he had little facility in oil-paint and obtained his effects in that medium with considerable difficulty and consequent loss in spontaneity. Yet he had a wonderfully subtle command of expression in both figure and face. The poise of the figure and the facial expression in 'Asia' (Mr. Halsey Ricardo, London), a splendid pictorial interpretation of a noble passage in Shelley's *Prometheus* and in some respects the painter's *chef d'œuvre*, are at once powerful and subtle; the attitude of the girl listening to the 'Song of the Nightingale' (Mr. Charles Wilson) beside the moonlit sea, is eloquent of rapture not unmixed with pain; and the face and eyes of 'Alastor' (Dr. Todhunter, London) as he comes to his doom in the twilight wood are haunting in their melancholy intensity. And the same quality of spiritual expressiveness combined with greater ease of handling is evident

in his rendering of landscape, particularly of those intricate woodland places with flower-spangled grassy glades which he loved so well. In these his drawing is exceedingly delicate and spirited, and his realisation of detail quite Pre-Raphaelite in its intensity, but unified by a finer sense of tone and atmosphere than was usual with the brotherhood. In colour, again, his more elaborate work occasionally suffers from the same causes as his drawing ; but he had a natural gift for colour, seen best perhaps in his water-colour landscapes or projects for pictures, and that usually carried him through.

Study of Renaissance Art is evident in Wilson's work. In such a thing as the quaint and delicately spirited tempera picture, 'Summer and the Winds' (Mr. Halsey Ricardo, London), one can see the influence of Botticelli ; flame-haloed 'Eros' (Mr. Hubert Young) is of the long, lithe type of youth one associates with cinque-cento bronzes ; and the wonderful rocky background with the foreground blossoms in 'Asia' recalls the primitives and Mantegna ; but, unlike the neo-Pre-Raphaelites, he was no imitator, and his treatment of his themes and forms and settings was definitely modern and his own.

CHAPTER II

THE PASTORAL

A COMBINATION of figure and landscape was not new in Scottish painting when, in the seventies, a number of young artists began to win publicity by pictures of rural life. From time to time domestic and history painters, from David Allan to Tom Faed, from Sir William Allan to Sir Noël Paton, had employed it in a more or less conventional way ; it had formed a most striking feature in the Covenanting and social scenes of Sir George Harvey ; and it was being used to excellent purpose by Hugh Cameron in his village idylls, and splendidly by M'Taggart in his fascinating and powerful rendering of fisher-life and childhood. Yet, while M'Taggart and Cameron exercised considerable influence on the younger men, the pictures of the latter reveal a more direct interest in the farm-work of the varying seasons, which stamps them more specially as pastoral painters. Curiously enough, however, while the Scottish painters in whose work incident is accessory to landscape, as in Wingate's and Mackay's pictures, have usually remained true to their own country, those who have made it the prominent feature have, for the most part, found their subjects furth of Scotland. This pastoral element reaches its most distinctive manifestation in the art of Robert W. Macbeth.

Born in Glasgow in 1848 to Norman Macbeth, R.S.A., the portrait-painter, he had the good fortune, which few Scottish painters have had, of going direct from school to study art. So when he went to London he was exceptionally well trained for a youth of twenty-two or three, and at once secured work on the *Graphic*, then a very nursery of talent. But, in addition to the discipline in draughtsmanship and design which illustration involved, his settling in London at the time he did brought him under influences which vitally affected his whole development. George Hemming Mason's career (1818-72) was almost over, and Frederick Walker (1840-75), and G. J. Pinwell (1842-75) had only four years to live ; but these few years were to see the appearance of some of their most lovely pictures. In the year that Macbeth went up, Mason's 'Girls Dancing' was at the Royal Academy ; while 1872 was memorable for the exhibition of Pinwell's 'Pied Piper,' of Walker's 'Harbour of Refuge,' and of the culminating work of the English idyllic school, Mason's 'Harvest Moon.' Still, while he was influenced by these men, in choice

of subject and effect his pictures are essentially his own. Distinctly less tender and charming than theirs, Macbeth's work is at once lustier in sentiment and more trenchant and direct in handling. Yet, if he escapes, to a considerable extent, that over-idealisation which is at once the fascination and the weakness of their work, he fails to endow his creations with the real poetry and profound significance which belong to those of the truly great interpreters of rural life and toil. Taken, however, in relation to their own time and school, which is in some respects as much English as Scots 'The Lincolnshire Gang' (1876), 'The Potato Harvest' (1877), and 'A Flood in the Fens' (1880), and later pictures, such as 'In a Somerset Cider Mill,' 'In the Cider Orchard,' and 'The Schoolmaster's Garden,' are accomplished and powerful performances. Drawn easily and gracefully, yet with incisiveness and style, his figures are admirable in type, and combine appropriate and finely conceived attitude and gesture with beauty of form and largeness of contour, and they are woven into designs which, springing from an incident or occupation in which all are interested or are taking part, possess emotional and subjective *raison d'être* as well as rich and closely knit rhythm of line and mass. These qualities, seen in his illustrations and original etching and in his pictures alike, are enhanced in the latter by a real, if occasionally over-active, delight in brilliance and variety of colour, which obtains very full expression through his handling. And if at times desire for resonance and purity of colour has led to excessive use of transparent pigment or resulted in hotness of tone, the colour-schemes of his finest oil-pictures and of most of his water-colours are harmonious and frequently charming. In his earlier work full and luminous though inclining to lowness of tone, his colour soon became richer, more varied and higher in pitch, and in his most characteristic things it is vivid and vital with an opalescent and sparkling quality which conveys very happily his joy in radiant sunshine, whether in the open or reflected into the great shadowy barns which are frequently the scenes of his cider-making or sheep-shearing incidents. His brushwork, again, is very dexterous. Deft and sparkling, yet fully under control, it is that of a born craftsman and a pleasure to those interested in such matters. Both by the character of his handling and by the quality of his colour, he is related to Scott Lauder's pupils.

From 1875 to 1887, and frequently since, the fen country supplied Macbeth with motives for many fine works, in which a sense of beauty mingles with admiration for strength in man or woman, or in Nature. Then the brighter skies and more luxuriant scenes of Somerset, where life flows more gently than on the wind-swept flats of Lincolnshire, brought a softer charm and more gaiety into his pastorals. But in each almost equally, he is substantially true to certain aspects of rural life, and extracts fine pictures from them. The difference between the two phases is not unlike that presented by the life and surroundings of Tess upon the upland farm

and amid the lush pastures of the soft green valley. Indeed, if somewhat artificial in its graces and not taking such a close grip of reality, his art is a not inadequate pictorial counterpart of Mr. Hardy's Wessex novels.

Living chiefly in the country, as he did for years, and taking an interest in its people and occupations, the whole rural year with its round of duties figures on his canvases, but best of all perhaps he loves to contrast the quiet, settled ways of country-folk with the wilder, freer life of gipsies and travelling showmen. Now and then also he has painted pretty episodes of fisher-life in very attractive fashion, and has varied his studies of English gipsies with pictures of Alsatian girls set amid the glory of flowers only less lovely than their dark eyes, while of recent years he has made occasional excursions into quite other fields. But brilliant and accomplished technically, and, in their own way, highly successful as are 'Sparklets' (1898), a whirl of fancy-costumed skaters in a blaze of electric light, and 'Naval Manœuvres' (1899), an evolution in flirtation on the 'Captain's Walk' of a training-ship, they do not show the best and most personal side of his gift in relation to life and Nature.

Nine years before Mr. Macbeth was elected A.R.A. (1883), and twenty-nine before he was advanced to full membership, he had joined the Old Water-Colour Society, in whose rooms in Pall Mall he has shown many charming drawings in which his debt, in a technical sense, to Fred Walker is much more marked than in his oils. He has also won distinction as an etcher, having interpreted the chief works of Mason and Walker with real sympathy, and reproduced powerfully, if with less insight, some of the masterpieces of Velasquez and Titian in the Prado.

Although George Manson (1850-76), unlike Macbeth, had no direct contact with the work of the English idyllists, his art possesses a closer affinity to their ideals. His subjects were rarely pastorals, but something of the engaging tenderness which transfuses their pictures is found in his also, while his method, if somewhat more direct, is not without kinship to the stipple, which they made fashionable and which their successors have, as a rule, abused. And his life was even shorter than the shortest of that short-lived band. He was one-and-twenty, having been five years in the employment of Messrs. W. and R. Chambers as an apprentice, when he gave up wood-engraving to become water-colour painter, and he died before other five years had passed. But during his apprenticeship, which in itself was excellent training, he had been an indefatigable student, rising in the summer dawns to sketch in the wynds and closes; working in the classes on the Mound; copying in the National Gallery whenever he had a chance : and he did enough, in the time that remained to him, to prove himself a true artist. His work was not fully developed, perhaps, and his latest drawings reveal an increase in breadth of conception, but it was peculiarly ripe for one of his age, and it appears to have been a fairly adequate expression of his nature and aspirations. A refined sense of

colour and instinctive regard for beauty of form combine with acute sensibility of feeling to give his art delicate and individual quality. Most of his drawings deal with childhood or youth in a dainty way, and nothing could well exceed the delicate charm of the fair-haired, blue-frocked baby standing on a chair gazing in questioning wonder—'What is it?'—at a quaintly-fashioned clock, in the Orchar collection ; of the girl kneeling in 'Devotion,' or of the groups of children in some of his Edinburgh street scenes. Yet exquisite as these are, they betray a super-sensitiveness of spirit and an excess of refinement, which make one wonder if the contemporary estimate of his talent has not been heightened by the pathos of his early death and the distinct dearth of fresh talent about the time of his coming.

Less mature than Manson's, the art of Peter Walker Nicholson (1856-85), who was drowned at the age of twenty-nine while boating on a Highland loch, was perhaps fuller of promise. To the qualities which Manson possessed, he added a larger measure of dignity and restraint. While his sentiment was as tender as the other's, his knowledge of life was deeper. Much of his work seems tentative, and it is probable that he never found the most suitable technical method for his ideas, or at least mastered it. His drawing was a little angular and awkward, and his brushwork a little weak ; but his idea of ensemble was admirable, his compositions have now and then something monumental about them, and his colour occasionally touches a chord of glorious golden brown. Influenced, perhaps, by a sojourn at Barbizon, he combined touches of the sombre poetry of Millet with much of the lyric quality of Mason and Walker, but through all there shines the charm of his personal view of things. He was in love with the beauty of the world, with the beatitude of lingering twilight and the gay promise of spring sunshine, with the joyous summer woodlands and the pensive autumn fields, and among these he set groups of happy children, or of peasants toiling at their work or wearily returning home. His work, incomplete though it be, is pregnant with poetry and full of charm. Nicholson was bred to the law, and was twenty-two before he decided to become a painter. He then studied in the Ruskin Drawing School, Oxford, where, inevitably, he came under the influence of Turner ; but, in 1881, he went to Paris for the winter, and it was during the last three years of his life that he did the work, principally in water-colour, which makes one regret so greatly his premature and tragic death. Like Manson, he is the subject of a sympathetic monograph by J. M. Gray, himself cut off before his prime.

Consideration of these lives, linked together by the poetic intention of their work and the pathos of their untimely ends, has led me from the true sequence of events. Macbeth's pictures were little seen in

Scotland after he went to London, and when Manson died the painters, whose art has now to be analysed, were only beginning to attract notice. In 1876 and 1877, J. M. Gray, at that time art critic for *The Edinburgh Courant*, writing about the exhibitions of the Scottish Academy, mentions John R. Reid, John White, J. C. Noble, Robert M'Gregor, E. H. Murray, and A. M. Macdonald as devoting themselves to rural scenes with figures and presenting something of the aspect of a school. Murray and Macdonald came to nothing and drop out of sight, and M'Gregor, having ideals of his own as regards treatment, pursued an independent course. The other three were close companions, and for some years their pictures were marked by very similar characteristics. The subjects they chose were of the simplest : country-folk or children set amid old gardens and orchards, about cottage-doors, or in the village street, and their treatment was marked by an increase in perception of values, fullness of tone, vigour of handling, and an inclination towards lumpiness of form. A few years later, however, all three began to develop the individual tendencies which had underlain the superficial likeness of their pictures. Noble gradually made the figure element less prominent, and by stages became landscape-painter. White, although retaining incident in a more important place than Noble, tended towards increased relative prominence of setting, and, perhaps influenced by his English surroundings (he and Reid had gone south), gave greater play to his pleasure in prettiness of detail and incident and brightness of effect. Reid carried the more realistic qualities and the best elements in the technique of the little coterie, in which his was the most robust talent, to completer and more powerful results.

During the transition, however, Mr. White, who was born in 1851 and entered the R.S.A. schools at the age of twenty, painted some exceedingly promising pictures of an idyllic kind. Things like ' Labour O'er,' ' Gold and Silver,' ' Caller Herring,' and ' Surrey Colts ' possessed charming sentiment, grace of design and beauty of handling, and attained an exquisiteness of silvery colour and atmosphere unequalled by either of the others. And while, as has been indicated, his art has become over-prettified, it still retains a good deal of these fine qualities.

Even as a student in the Edinburgh life-classes under Chalmers and M'Taggart, the latter of whom he claims in a special sense as his master, the work of John R. Reid (b. 1851) had been remarkable for vigour of handling and truth of relationship, and in the series of big pictures painted in the decade which followed his going to England, these, combined with a rather pretty vein of sentiment, are the most notable qualities. While his renderings of rural life are often marked by contrast, the toil of the field-worker finding a foil in the sport of the squire, and the homelessness of the vagrant in the cheery home-going of cottage children, his pictures of life in the old seaports of the English Channel, in which sailors lounge

about between voyages—the old men playing with the children or telling them stories, the young ones flirting with pretty, dark-eyed girls—are touched with the languorous charm of gently moving waters and soft grey skies. And the way in which he painted was so vigorous and manly that one scarcely noted that all this sentiment savoured somewhat of sentimentality, and was perhaps an indication of weakness. Simple and effective in arrangement, with the figures happily set in their environment, belonging to it, and telling their stories well ; admirable in strength, if not in delicacy, of drawing ; extraordinarily powerful and homogeneous in handling, the pigment being boldly used and very full in impasto ; and unconventional and distinctly good in colour, his pictures also possessed great unity of effect, truth of value, and fullness of tone. The latter qualities are not only remarkable in themselves, for Mr. Reid had not studied abroad, but the cult of values having scarcely made itself felt in this country when he commenced to paint, they make his relationship to the Glasgow movement, which has never been insisted on or even pointed out, exceedingly interesting. Technically and in relation to subject the 'Country Cricket Match' (1878 : Tate Gallery), 'Toil and Pleasure' (1879 : Tate Gallery), and other of his pictures of that time are' exceedingly like the subsequent 'Old Enemies' (1880) of Arthur Melville, and the 'Highland Funeral' (1882) of Sir James Guthrie, and as they were exhibited in Glasgow and several of the 'Glasgow boys' knew him personally, John R. Reid deserves the credit of having been a factor in stimulating the new movement which has bulked so largely in the more recent developments of Scottish painting.

Although as early as 1879 the Chantrey Trustees had purchased 'Toil and Pleasure,' and his work was being admired at home and medalled abroad, Reid remained an outsider while less gifted men were selected for academic honours. Perhaps this had something to do with the alteration which began to show in his pictures during the later eighties. Be that as it may, breadth and coherence of handling and effect, which had been the most sterling qualities in his style, were now superseded by a more clamorous manner, by a coarser method of painting, and by bizarre and forced effects. This begins to be evident in the 'Shipwreck' of 1886, and 'The Smugglers' of two years later is sheer melodrama. But, Reid's vein being sentimental and not tragic, he did not continue to paint such subjects. His art, however, had lost direct relationship to Nature, and although he continued to show great ability as a craftsman, the exaggerated lighting and colour in which he indulged gave his coast-pieces with figures an abormal and, at times, a coarse and repellent look. But of late years he has shown a disposition to combine brilliance of lighting and force of colour with greater coherence of effect, and some of his recent pictures renew hopes one had almost abandoned. No more powerful pictures of their type exist than Mr. Reid's earlier ones, and should he now unite

the results of his experimentalism with something of his previous manner, the issue might be very fine indeed.

A very similar method to his earlier one is used by his sister, Miss Flora Reid, and if in her hands it lacks the strength it had in his, she paints exceedingly well. Her subjects are often drawn from Continental market-places, the bargaining or gossiping groups supplying incidental interest, and the black, blue, and white costumes, the sunlit houses and shadow-chequered pavements, the green trees and the canvas booths scope for her favourite colour-scheme, in which a blueness of tone predominates.

As already indicated, Robert M'Gregor occupies a place by himself in this group of painters. His father had gone to Yorkshire as a manufacturer, and there the son was born in 1848. Trained as a designer for textiles he came to Scotland, to Dunfermline his father's native place, to pursue his calling, and, later, settled in Edinburgh, where he was engaged for some time in making illustrations for Messrs. Nelson's publications. Before this he had had no regular art training, but, while still very young, he had received some instruction from a Frenchman; his experience as designer of patterns and as illustrator was of considerable value; and in the schools of the R.S.A., which he now attended, he made rapid progress. By 1882 his pictures had attracted such attention that he was elected an Associate, and seven years later he became a full member of the Royal Scottish Academy.

While M'Gregor never wrought in a foreign atelier, and he was too young to have been influenced permanently by the hints of his French friend, his style has a certain likeness to that of some Continental painters. But if he has learned something, perhaps much, from foreign work, the resemblance is far more a result of affinity and personal bias than of imitation. From the first he was interested in tone, but, unlike Reid and his confrères who also gave particular attention to this quality, instead of combining it with that love for full local colour which is so marked a feature in much Scottish painting, he sacrificed brilliance of colour to truth of value, and brightness of light to justness of tone. And these being his preferences, he usually chooses effects of sunless weather in which a diffused grey light overspreads everything and restricts the range of values to one which can be represented in paint without resource to the conventions demanded by a more extended scale. It is in these respects that he resembles a number of his French and Dutch contemporaries, the former more than the latter, for the Dutchmen attain a fullness and resonance of tone which neither the Frenchmen nor the Scot approach. His colour is of course conditioned by his feeling for light, and if its appeal is limited and it can scarcely be described as highly emotional, it is usually pleasant enough to escape the reproach of being merely negative in effect, while at times its subdued harmonies result in quiet yet positive charm. Further, neither his handling nor his drawing is marked by

emphasis. Content to render effect and incident simply and directly, he paints with an equal and fairly smooth impasto and draws without fuss or flourish. And if it must be confessed that his method seems to indicate a lack of strong preference and a want of eagerness in perception, his technique is usually accomplished and complete.

For many years he found his subjects mainly in the country districts of Scotland. Field-workers going to or returning from labour, toiling in the fields or resting for meals, and children idling by the hedgerows or gathering flowers or brambles in the woods, were varied by incidents of more vagrant life, with pedlars and knife-grinders plying their crafts, or the excitement and expectations awakened in a village by the advent of travelling showmen or wandering minstrels. Occasionally he represented the more domestic side of country life also, and in these interiors, of which 'The Story of the Flood' (1886) was one of the finest, he frequently used a richer chiaroscuro than in his out-of-doors subjects. More recently Mr. M'Gregor has painted a great deal on the northern coasts of France, finding among the fishers motives exceedingly well suited to his taste. Here, as in his pastorals, he deals with the more passive aspects of life ; moments of thrilling peril or strenuous action never figure in his canvases, and the sorrow of the sea is at most dimly hinted at in the lines about some old woman's mouth and eyes. Yet, simple and sincere as this sentiment undoubtedly is, his pictures have a cosmopolitan air which makes them less fully expressive than those of the great masters in this field. Pathos and significance they do not lack, the contrast between youth and age in such a picture as 'Evening' being at once refined and obvious ; but in them one misses that local accent and atmosphere, that close intimacy of feeling and quick insight, which touch one so profoundly in the art of Millet and Israels, of Wilkie and M'Taggart.

It is here, rather than with the men of the Glasgow movement who have also painted pastorals, that David Fulton and William Pratt should be mentioned, for, while they have certain affinities with the younger group, their sentiment and style are related more nearly to those in the work we have been considering.

At one time Fulton, who commenced to exhibit in 1874, painted almost nothing but landscape, but gradually he came to associate figures with it, and latterly he has devoted himself chiefly to pictures in which figure incident is an important factor. Painted with considerable freedom and breadth, though with a touch too heavy and lumpy to express the subtler beauties of form and colour, his cottage and byre interiors with figures and sometimes animals, and his pastorals of rustic children gathering flowers or faggots, herding cattle on the braes or fishing in the burns, are good in tone, simple and pleasing in design and sincere in sentiment. Mr. Pratt, like Mr. Fulton, paints both indoors and out. An accomplished craftsman in his own way, painting with vigour,

drawing soundly and well, putting complex material together with commendable skill and not deficient in ideas or sympathy, a dull and monotonous sense of colour negatives the effect of much of his work and renders his pictures much less interesting than they would otherwise be.

CHAPTER III

PORTRAITURE

OF the artists of this period who have devoted themselves principally to portrait-painting, Sir George Reid is much the most conspicuous. In the earlier part of his career his seniors, Sir Daniel Macnee (1806-82), Norman Macbeth (1821-88), and Robert Herdman (1829-88) had most of the presentation work in their hands, while Chalmers (1833-78), M'Taggart, and a few more of his immediately older contemporaries, whose portraiture is distinguished and of great artistic merit, had a considerable share of the less formal kinds, but gradually the future president's claims to consideration gave him a distinctive place as a painter of men which he has retained ever since.

Born in 1841 in the city of Jamesone and Dyce and Phillip, George Reid served an apprenticeship to lithography there ; but a feeling for art seems to have been natural in his family, two of his younger brothers having become artists also, and aided by a local portrait-painter, William Niddrie by name, he had already acquired some technical knowledge and skill when he came to Edinburgh to study. Lauder's career as a teacher was just closing, and Reid's only recollection of him in this connection is the last visit he paid the school he had conducted so successfully. But if study in Edinburgh, like his previous experience in Aberdeen, was a stepping-stone in his career, a more definite bent was given to his talent through seeing a landscape by G. A. Mollinger (1833-67) in the house of a friend. Something in the sobriety of tone and sentiment, in the technique and manner of the young Dutchman, who had been a pupil of Roelofs and had been considerably influenced by the French romantics, fascinated Reid, who wrote asking if he would receive him as a pupil. The reply was affirmative and hearty, and he went. In the sixties the Dutch, after a long, dull interregnum of imitation and affectation, were reawakening to the artistic possibilities of the actual and the contemporary. Like their great ancestors, they were finding in the life and landscape about them the inspiration for a national, intimate, and emotional art. James Maris (1837-99) had just gone to Paris, and his brother Matthew was still at the Antwerp Academy, Anton Mauve (1838-88) was as yet unknown, Mesdag had not left his father's bank, Neuhuys and Blommers were newly out of their teens, when Reid arrived in Utrecht ; but Bosboom

(1817-91) and Roelofs (1822-97) and Weissenbruch (1822-80), the first inside the other two out-of-doors, were already expressing the new ideals which had attracted him to Holland. Above all, Josef Israels (b. 1824) had a few years before shaken the trammels of historical convention from him, and found in Dutch cottages and in the work of Rembrandt the material and the method which have yielded such a rich harvest for so many years. Apart from intimate feeling for Nature and sympathetic rendering of humble life, the work among which the young Aberdonian now found himself was marked by qualities different from what he had seen in Scotland, and in tone and light and colour even more than in handling, Dutch training left permanent traces on his style. Study with Mollinger, when he had D. A. C. Artz (1837-90) as a fellow-pupil, was followed by a year in Paris under Yvon (1817-93), and then he painted for some time with his friend Israels at the Hague.

Returning home and devoting himself principally to portraiture, Reid immediately attracted notice by the power of his workmanship, the solidity and strength of his tone, and an almost unfailing knack of likeness-making. In 1870 he was elected A.R.S.A., seven years later he became Academician, about 1884, retaining St. Luke's, his Aberdeen house, as a summer residence, he removed to Edinburgh, and in 1891 he was selected to succeed Sir W. Fettes Douglas as President of the Royal Scottish Academy and knighted. After occupying the presidential chair for eleven years he retired, and since then he has painted much in London as well as in Edinburgh and Aberdeen.

Essentially a painter of men, Sir George's portraits are of the kind which command attention wherever they appear. In London, even more than in the Scottish exhibitions, his work tells in virtue of vividness of characterisation, power of expression, and simplicity of design. In his earlier pictures the colour inclined to blackness and the tone was over-heavy, but while, except in flower-pieces, the former has never been brilliant, it has become silvery and atmospheric, and the latter, while preserving its fullness, has increased in range and variety. His technique is expressive and trenchant, for he is a sound and constructive draughts-man, and if his handling is somewhat deficient in suavity, he possesses a very complete mastery of his medium, while his simple and effective design serves to accentuate the keen appreciation of character which is the immediate inspiration of his work. Yet, powerful painter as Sir George Reid is, there are unsatisfactory elements in his style. Frequently his colour is either crude or negative; occasionally the lighting of his heads is forced; now and then the detail drawing in his faces is over-incisive and hard. And with all his ability as a biographer he sometimes fails to catch the finer shades of character, and is occasionally content to paint a sitter as he first appeared in the studio without much consideration for the sitter's habitual mood. But the more obvious defects of his style are of a kind

with which time deals kindly, and in his later work there is evidence of greater regard for pictorial arrangement and of increased freedom in handling which has always been masculine and virile. Moreover we, in Scotland, have become so accustomed to his great power of rendering character and likeness that we are apt to undervalue it, and to ask for a more purely decorative expression than is compatible, perhaps, with the qualities which his work possesses in so uncommon degree. If prosaic in tone and lacking somewhat in distinction and grace, his portraiture is always exceedingly vigorous and vital, and at its best shows technical mastery and intellectual grasp of a high order. Artistically and as biography, portraits such as ' John Mackenzie, Esq.,' ' Professor Mitchell,' ' The Marquis of Tweeddale,' ' Macleod of Macleod,' ' Principal Hutton,' and ' The Earl of Halsbury ' are amongst the most masterly and complete achievements of their kind and time. Moreover, the fact that he makes little personal comment gives his portraits something of the value of authentic documents. Posterity is certain to prize exceedingly his powerful and expressive portrayal of many distinguished Scots. A collection of his portraits would be almost as complete a representation of the eminent lawyers, doctors and divines, the scholars and scientists, the lairds and men of affairs of our day, as the Raeburn exhibition (1876) was of those of a hundred years ago.

It is matter for regret, however, that the growing demands which Sir George's practice as a portrait-painter has made upon his time, have withdrawn him more and more from landscape, in which his most charming work has been done. Before he was elected President and became in consequence painter-in-ordinary to presentation portrait committees, he from time to time produced landscapes of distinct and personal beauty. Unlike his Scottish contemporaries, who have gloried in the sunshine and delighted in the pomp of sunset, he has usually chosen effects of grey weather and brooding skies, and his colour has been silvery and restricted in range rather than opulent and richly varied. Thus, it may be, he was perhaps the first Scottish painter to show appreciation of the modern use of values as a basis of pictorial design. Of the landscapes in his normal mood none is more charming than his diploma picture ' Dornoch,' for although the earlier ' Whins in Bloom ' and the later ' Norham Castle ' and ' October ' rival it in some respects, they fall short of it in others. But in depth of sentiment and poignant appeal the ' St. Mary's Loch ' of 1888 stands easily first. Here pensiveness is mingled with profound pathos, and another link is added to the girdle of glamour and romance which poetry has woven round the Braes of Yarrow. Pitched in a minor key, his sentiment is more kindred to the melancholy of Mauve than to the splendid solemnity of James Maris, but it is pensive rather than pathetic, and is less dependent on the associations of humanity and toil than that of the Dutch master.

Notable as a painter of portraits and landscapes and flowers, Sir George Reid has appealed to an even wider public as a draughtsman in pen and ink. The series of drawings of scenes on the Tweed and the Clyde, which he did for the Association for the Promotion of Art in Scotland ; the illustrations to Mrs. Oliphant's *Royal Edinburgh*, and to Samuel Smiles's *Thomas Edward* are known everywhere for their excellence ; and, if more restricted in circulation, the studies of character and scenery which adorn *Johnnie Gibb of Gushetneuk* are even more remarkable. The insight revealed in these heads of Aberdeenshire men and women of the common people is quite exceptional, and it is expressed with an unequalled clarity and charm of method, which has drawn applause from such different critics as P. G. Hamerton and Joseph Pennell, the latter of whom describes him as the best pen-draughtsman in Great Britain to-day. 'He can in a pen drawing,' writes Mr. Pennell, 'give the whole character of northern landscape, so different in every way from that of the country of the great southern pen-draughtsmen, while his portraits contain all the subtlety and refinement of a most elaborate etching by Rajon. . . . He is one of those exceptional draughtsmen who can combine breadth with delicacy.'

James Irvine's (1824-89) entry into art was so much delayed that it was not until after the future President had been elected an Associate that his work began to be noticed. A native of Menmuir, Forfarshire, he had received some instruction from Colvin Smith (1795-1875) before, under the influence of G. P. Chalmers (1833-78), he really commenced to develop an artistic personality. Towards the middle seventies, however, his style was formed, and for the next ten years his were among the most notable portraits in the Scottish exhibitions. They were distinguished by powerful light and shade, by low-toned but rich colour, and by expressive, if somewhat ragged, brushwork. In characterisation, also, they were often very good, and he was almost equally happy in dealing with men and women. Among his portraits of men mention may be made of the powerful study of the old sailor who steered the *Shannon* into action in the memorable duel fought off Boston on 1st June 1813 (R.S.A. 1874), and the striking three-quarter-length of 'Greek' Veitch, which hangs in the Scottish Portrait Gallery ; among those of ladies the dignified and beautiful portraits of Mrs. C. J. Pearson (1880) and Mrs. Gunn (1886).

Except in the case of Irvine and Reid, and a somewhat younger painter than either, R. C. Crawford, portraiture has not been a specialised branch of painting among the artists who figure in this section. W. E. Lockhart, Robert Gibb, and Joseph Henderson, to name no more, have painted many portraits, but they are better known for their work in other fields, and their portraiture is referred to as a branch of their varied activities ; but Crawford is better placed here. While he paints land-scape and the sea with considerable truth of observation and lighting, if

with little imaginative perception or beauty, his exhibited work during the past thirty years has been chiefly portraiture. A man of quiet and unobtrusive character and seldom showing his pictures outside Glasgow, his reputation is purely local, and even there it is not so general as is that of many painters of less account. Well drawn, soundly modelled, and painted in an able if undistinguished manner, reposeful, though not fine, in tone and colour, simple in design, and marked by appreciation of character, his work is admirable in its own way and maintains a good average standard of accomplishment in the Scottish tradition. Occasionally also, as in 'A Duet' (1887), 'Daughters of R. K. Holmes-Kerr, Esq.' (1890), or 'Rev. R. Boag Watson, LL.D.' (1900), Mr. Crawford has attained, through sincerity of seeing and frankness of style, a simple dignity of presentment which is nearer being distinguished than a good deal of would-be 'stylish painting.'

Something of the same realistic spirit, which is indeed very much that of Scottish portrait-painting throughout its entire history—which the greater men illumine by profounder insight, finer taste, and greater artistic skill, and from which the lesser draw their chief strength—appears in the work of a number of the younger generation, and makes it more kindred to the older tradition than to the more decorative manner in favour with certain of their immediate contemporaries. This is the distinct if modest merit of the portraits of men like Mr. John A. Ford or Mr. Marshall Brown, Mr. John Henderson or Mr. W. G. Gillies, who place respect for the sitter and completeness of statement and realisation before decorative balance and stylistic effect ; and, with less of veracity and more conscious striving after daintiness and attractiveness of *motif*, it is what gives those of Mr. Duddingston Herdman, A.R.S.A., and Mr. J. D. Peddie a claim to mention here.

ILLUSTRATION 291

CHAPTER IV

ILLUSTRATION

ONE cannot well leave the figure-painters of this period, which may be defined roughly as from 1865 to 1885 with its aftermath, without some reference to a few men who have done their chief work as illustrators. And of these the earliest and the most interesting, as man if not as artist, was William Simpson (1823-99), whose activity coincided indeed more nearly with that of the Faeds and Patons than with that of the men with whom he is grouped here. The son of poor parents, he received a very meagre education, and, after some odd employment, was apprenticed at the age of fourteen to a firm of lithographers in his native city, Glasgow ; but, having removed to London in 1851, he was commissioned by Messrs. Colnaghi, on the outbreak of war with Russia, to proceed to the Crimea to make a series of water-colour drawings of the operations for publication.[1] It was the first time an artist had been despatched on such a mission, and Simpson was thus the precursor of the corps of 'special artists' we have come to take as a matter of course. The novelty of this adventure and the work he then did made his reputation, and earned him the name ' Crimean Simpson.' After the fall of Sebastopol he travelled with the Duke of Newcastle in Circassia, and then, public interest having been stirred greatly by the Mutiny, he was sent to India to make sketches for a projected work on the great dependency. In 1866 a meeting with Sir William Ingram led to a connection with the *Illustrated London News* which lasted until the artist's death. For the *News* he saw and sketched much of the fighting and many of the chief formal historic events of the next twenty years. He was with Napier in the Abyssinian campaign ; he accompanied the Germans in the war of 1870 and was in Paris during the Commune, when he was described as 'an old campaigner who sketches as coolly under fire as in his own room'; and he went through the Afghan war of 1878, when he had a very narrow escape in the Khyber Pass. More pacific missions took him to Northern Russia, Palestine, Egypt, China, Japan, and America, and he revisited India (1875) in the suite of the Prince of Wales. His last long journey was in 1884, when he accompanied the Afghan Boundary Commission to Penjdeh, and the latter years

[1] *The Seat of War in the East,* eighty lithographs from Simpson's drawings, was published in 1855.

of his life were devoted to completing the series of water-colour drawings, 'Glasgow in the Forties' (from sketches made in his youth), which was acquired by the Glasgow Gallery in 1898.

The mass of work he did is enormous, and, considering the conditions under which it was produced, possesses considerable merit. The special artist of to-day is usually a man with a camera, or at least a draughtsman who depends for much of his result upon what he can snap with a 'kodak.' Simpson, on the other hand, had to rely on his own observation, and had to do much of his sketching under fire. Moreover, the quality of his work cannot be gauged from the woodcuts in the *London News*, where too often the engraver—process had not been invented—has stiffened the figures, deadened the action, and destroyed the spirit of the originals. It is true, of course, that he was not a fine or powerful draughtsman, and that his design has little decorative quality, but he sketched with ease and a certain spirit, related what he had seen with vivacity, and produced an impression of immediate contact with what was in progress which much accomplished illustration and nearly all photography lacks. It was, however, in water-colours of subjects in the portrayal of which speed was not the first consideration, although readiness was a great gain, that he was at his best. Many of his drawings, such as the Indian series, are pleasing in themselves, and are informed with that rapidity of vision and chicness of expression which are perhaps the highest qualities that travel sketches can possess. In method and style they have a good deal of the old water-colour convention about them, and they are executed with much of the off-hand dexterity of the drawing-master. But when all is said, it is the romance of his career, from lithographer's bench to the suites of princes and the staffs of famous generals, as one might say, rather than the quality of his art that makes appeal. He would make a more illuminating figure in the pages of *Self-Help* than in those of an art history.

Romance and adventure, which entered so largely into Simpson's career, are conspicuously absent in that of William Small. Outside his art there is little to say of him. A native of Edinburgh, he entered Messrs. Nelson's publishing house as an apprentice wood-engraver, and while there executed some charming work for their publications. This training of eye and hand was supplemented by study in the school of the Royal Scottish Academy, and he early acquired a facility, certainty, and finish of draughtsmanship which had been comparatively rare amongst his countrymen. After winning the chief prizes for drawing and painting from the life in two successive sessions, he gained the Stuart prize for design, then first awarded (1865), by a pen-and-ink drawing of 'The Wrestling Match between Mondanim and Hiawatha' of such exceptional merit that the Academy's annual report records that 'his design very adequately illustrates the scene, and is admirable in spirit and masterly in style of execution'; and, going to London the same year,

ILLUSTRATION 293

he secured employment as an illustrator almost at once. In 1866 drawings by him appeared in *Once a Week*, *Good Words*, *London Society*, and other magazines, the illustrations of which make the 'sixties' memorable, and ever afterwards he remained in the first rank of illustrators. For many years and indeed throughout his active career, however, while black-and-white illustration continued to form the larger part of his output, he painted in both oil and water-colour, and showed much dexterity in each. But in oil his handling, admirably exemplified in 'The Last Match,' purchased by the Chantrey Trustees in 1887, is over-hard and leaves a good deal to be desired as regards the material beauty of the medium, which is used more in the manner of the Faeds and Noël Paton than in that characteristic of Lauder's pupils who were more nearly his contemporaries. His drawings, which, after his settlement in London, gradually approximated to those of the Fred Walker group in style, are more satisfactory in quality and colour, and very accomplished technically. But his work in colour yields precedence to his black and white, and it is as an illustrator and draughtsman and by his contributions to such volumes of the 'sixties' as Jean Ingelow's *Poems* and Robert Buchanan's *Ballad Stories of the Affections*, or *Golden Thoughts*, *Two Centuries of Song*, and *Touches of Nature*—the last a series of illustrations reprinted from Messrs. Strahan's publications—to Dalziel's *Bible Gallery* (1880), and to many magazines, amongst which, in addition to those previously mentioned, *Cornhill*, *Cassell's*, *Harper's*, and *The Graphic* are conspicuous, that he has earned a distinctive place.

For the most part his illustrative work has been done in monochrome 'body' water-colour, in which he obtains a very delicate yet full range of tone combined with much refinement and precision of drawing, but he is a charming draughtsman in pencil or pen and ink also. Even when engraved, his work is marked by most admirable drawing and complete but unfussy finish, but the engravers are responsible for certain mannerisms in the way textures are produced—seen in most woodcuts of his period—and as, unlike those of later illustrators, his drawings have seldom been reproduced by process but have continued to be engraved, it is only when one sees the originals that one can appreciate the fine quality of his art to the full.

Beginning his career in the 'sixties,' he belongs in many ways to that illustrious band of idyllic and romantic illustrators in which Fred Walker, G. J. Pinwell, A. Boyd Houghton, Rossetti, Millais, and Frederick Sandys were conspicuous; and surviving them or their activity as illustrators, he influenced very strongly the so-called *Graphic* school which, dating from the founding of that paper at the close of 1869 and numbering R. W. Macbeth, Luke Fildes, Herkomer and F. W. Lawson in its ranks, was so prominent during the following decade. Contrasted with the illustrations of Walker or Pinwell his are less poetic in spirit and

less graceful in design, and compared with those of Rossetti or Sandys they are wanting in decorative richness, romantic inspiration, and intensity of passion, deficiencies which place them on a lower plane ; but they are highly accomplished technically, possess much quiet and unobtrusive beauty, and are very perfect embodiments of many aspects of refined English life. He is somewhat literal, and lays over-much stress on verisimilitude perhaps, tendencies which are apt to make his earlier drawings look old-fashioned, but his work is much more than capable illustration. It tells the chosen incidents in the stories it illustrates with wonderful comprehension and in all detail, exactly as the author would have done had he been a finished artist, but the figures and accessories are put together with the intention of producing a pleasing and pictorial ensemble. Refinement of taste and feeling are quite as conspicuous as certainty and completeness of expression. His feminine types are charming ; his men are at once good-looking and manly ; his accessories, whether domestic or sporting or pertaining to the arts, are just as they should be ; and his interiors and landscape settings are appropriate, finely arranged, and charming in themselves. His whole work bears the impress of good breeding. Highly accomplished and workmanlike, his illustration makes no parade of dexterity, as does that of too many of his successors, and it is pervaded by a sense of beauty and a healthiness of sentiment in which much clever contemporary illustration is deficient. Gleeson White in his *English Illustration—The Sixties*, where Small's illustration is repeatedly referred to and praised, speaks of ' its admirably sustained power and its constantly fresh manner,' and that, of course, is but another way of saying that Mr. Small is a master in his own sphere. For sustained power is the outcome of disciplined natural talent combined with a high ideal of what one has to do ; and a fresh manner in illustration, and indeed in all art, depends on sensibility to new situations and combinations and on constant observation of life and Nature.

Compared with the finished art of William Small, the illustration of Alexander Stuart Boyd is that of the quick and facile sketcher. For this contrast differences in training and in the kind of work each has had to do are largely responsible. It is unlikely that Mr. Boyd, even under similar conditions, could ever have been Mr. Small's equal as a draughtsman, and having received little training and coming into illustration by way of journalism, the style he has developed bears traces of its origin. Born in Glasgow in 1854, he had been six years in a bank before he took to art professionally, and in 1882, having studied in the life-class of the Art Club and for a short time at Heatherley's, he became a member of the Scottish Water-Colour Society, to which and the Glasgow Institute he contributed many water-colours of genre subjects. But in 1881 with the advent of *Quiz*, he found a more congenial field for his talent in a pictorial chronicle of the locally important events of the day. Every week for seven years he

ILLUSTRATION 295

did a page of pen drawings for *Quiz* and then transferred his services to
that paper's older-established and pawky rival, *The Bailie*. Executed over
the signature 'Twym,' an entirely arbitrary name possessing no imagina-
tive or symbolic significance, the most interesting of these sketches were
collected and published in 1905 as *Glasgow Men and Women*. In 1891,
however, having acted as Glasgow correspondent for the *Daily Graphic*
during the first year of its existence, Mr. Thomas suggested that he
should go to London, and for many succeeding years he did for the
metropolis what he had done previously for 'the second city,' and acted
as representative at important functions elsewhere. Since 1894 he has
also been an occasional contributor to *Punch*.

In addition to journalistic black and white, Mr. Boyd has done much
magazine and book illustration. While still in Scotland he had illustrated
a serial in *Good Words*, and, with Guthrie, the future P.R.S.A., drawn
pictures for Dr. Blatherwick's *Peter Stonnor* (1884), and of late years he
has illustrated many novels and poems and pictured his wife's charming
travel-book *Our Stolen Summer* (1900). Chiefly Scottish in subject, one
could perhaps sum up the effect of these illustrations by saying that they
are 'very Scotch.' In all the artist has caught the local and national
characteristics and types, and, if now and then inclining to caricature, he
has suffused his renderings with an impregnating Scottish atmosphere.

Most of his work having had to be done at speed—executed on the
spot to-day to appear in the papers to-morrow, as it were—his style has
necessarily been evolved to suit the exigencies of such conditions. Yet,
in great measure, it must have been spontaneous, for his early *Quiz*
drawings possessed quick comprehension of incident, shrewd observation
and considerable facility. With greater experience and constant practice,
however, these essential qualities of journalistic art became strengthened,
and in the newspaper drawings of his maturity they are very marked.
And as is but natural, his book illustrations have partaken of the same
character. The majority, of which those to that masterly study of West
Highland character, 'Gilean the Dreamer,' are typical, are free and
spirited pen drawings, but in what are probably the most charming
and important of all, those to Stevenson's 'Lowden Sabbath Morn'
and Burns's 'The Cottar's Saturday Night,' the originals were drawn
in chalk or pencil, in which mediums the more sensitive qualities
of his observation and technique find fullest and most sympathetic
expression.

Mr. William Ralston differs from the others in being primarily a
comic man. Born near Dumbarton something like sixty years ago, it
was not until he was about five-and-twenty, and after some years spent
in assisting his father, a Glasgow photographer, and in trying his fortune
in the Australian gold-fields, that his gift for humorous illustration
asserted itself. In 1870, however, a drawing of his was accepted by

Punch, to which he soon became a frequent contributor, upwards of two hundred drawings by him appearing subsequently in its pages. Some of his earlier works appeared in the *London News* and *The Graphic* also, and then, the manager of the latter having asked him to join his staff, he resided in London until about 1890, when he returned to Glasgow to take up his father's business. But admirable and amusing as Mr. Ralston's work for these journals was, he is seen at his best in the three brochures most intimately associated with his name. No one who has seen 'A Tour in the North,' 'North Again—Golfing this time,' and 'A Yachting Holiday' is likely to have forgotten the pleasure they gave him, for the situations invented by the artist, who was his own librettist in the two latter, are genuinely funny and germane to the matters in question, and they are depicted with infective gusto and expressiveness. At times sly and pawky in temper, at others broadly comic, his humour is ever unforced and, while always entertaining, never merely farcical. As draughtsmanship, again, his work, if undistinguished, is facile and well suited to what he has to say. He tells his story graphically, so that his drawings amuse without the text, which, however, in many instances, heightens the fun and gives it more definite point. Almost any of these in the series mentioned, or in 'Sport for all ages and limited purses,' 'The Queys was goot,' or 'The Demon Cat,' possesses this quality, but if one had to select a single drawing as typical of his particular vein of pictorial comedy one could not do better perhaps than choose 'Cheek— A Graphic Comparison,' in which a pigmy 'Artist journalist (occasionally)' is contrasted with a gigantic 'Literary journalist (from B.C. to present time)' which figures in the account of Mr. Ralston given in 'At the Sign of the Brush and Pen' (1898).

CHAPTER V

LANDSCAPE

If in landscape, as in figure-painting, during the period covered by the preceding chapters, much of the finest work was done by men who had attained some prominence before 1865, it does not dominate the survey to the same extent, for among the younger landscape-painters were several of considerable talent and two or three of great gifts. For the most part the older painters were modern in spirit and set truth of natural effect high among the qualities for which they strove. This is very marked in the landscape of Bough (1822-78), Fraser (1828-99), and M'Taggart, and in the finer pictures of Docharty (1829-78), MacWhirter and Graham, while even those, such as Harvey (1806-76) and Wintour (1825-82), who had inherited a good deal of conventional picture-making from the earlier school, were more or less strongly influenced by the realistic movement. And amongst the younger men, who were not only further removed from the brown and formal tradition, but had the stimulus and example of the more advanced of their older contemporaries always with them, the tendency to naturalistic treatment was of course accelerated, and in consequence a good deal of work done by them is of the nature of transcript. Yet, for one reason or another, the older ideals lingered awhile in the work of a few of the younger generation and in some cases persisted throughout their whole careers.

Personal pupilship to Horatio M'Culloch (1805-67), for instance, gave the earlier pictures of John Smart (1838-99) their character, and left an impress on his ideals which continued to the end. His earlier landscape is drowned in a deeper dose of brown than his master ever used, and in it one notes that love of Highland scenery, and that regard for arrangement, which had been M'Culloch's and were to be Smart's most outstanding qualities. Painting much out-of-doors, however, the brown gradually lessened on his palette, and, though he never attained real success as a painter of light or as a colourist, a dark substratum vitiating his tones and hues, his pitch became truer and his colour fresher and more naturalistic. His handling also gained in boldness and breadth, and towards 1880, when he was at the height of his powers, if rather heavy-handed, it was marked by verve and incisiveness quite in harmony

with the rugged scenery and striking effects of which he was so fond. With 'The Graves o' our ain Folk' (1874), 'The Land of the MacGregor,' 'The Gloom of Glenogle' (1875), 'Where Silence Reigns' (1885), and other pictures, he seemed to have left conventionalism behind. If coarse in handling and wanting in subtlety of feeling, they are simple and effective in design, vivid in effect, and powerful in execution, and breathe an ardent passion for the landscape of his native land. For some years he continued to paint in this fashion the hills and moorlands, the lochs and straths, the clachans, crofts, and farmsteads of the central Highlands with their incidental interests of cattle-droving, shepherding, and rude tillage, their aspects of sunshine, mist, and snow. But later, as his technique and sentiment weakened, conventionality reasserted itself, and after 1890 he appeared to be working less from fresh impressions than past experience, and his pictures, while retaining the higher tone and fresher colour he had acquired face to face with Nature, resumed a more studio-like and unconvincing air. A fervid enthusiast for everything Scottish, he wrote and sang Scots songs, played the pipes, and wore the kilt. Smart was elected R.S.A. in 1877, six years after he had received the Associate-ship, and, being a believer in combination and a water-colourist of con-siderable power, if little delicacy, he was also an original member of the Scottish Water-Colour Society.

While Smart, to some extent, escaped from the conventionality of the past, a living painter, who was often bracketed with him in art, talk, and criticism, remains unshaken in his old beliefs. As becomes one of his persuasion, Mr. W. Beattie-Brown has considerable skill in composition ; but forty years' contact with Nature has left him contented with a brown world, and a technical method, which takes no account of true detail, natural textures, or atmospheric tones. Neither the general tone or colour of his pictures, nor the conventional markings with which he renders mountain corries and foaming torrents, bosky woodlands, and heathery moors, can be said to represent Nature as she is. Yet his art seems to give many people pleasure ; he is an R.S.A., and his are amongst the most popular landscapes of the year. If explanation be difficult, the fact remains, but perhaps as plausible a reason as any is that his indubitable liking for Scottish, and particularly Highland, scenery—he is as narrowly national as Smart—makes itself felt in spite of the poor and 'fushionless' way in which it is expressed. This also is the redeeming quality of the hard and unatmospheric moors and mountains of Arthur Perigal, R.S.A. (1816-84), who, however, was English by birth ; of the rather effective sketches of Highland straths and rivers painted with facile emptiness by J. B. MacDonald, R.S.A. (1829-1901) after he abandoned the Jacobite subjects by which he had made his reputation ; and of the somewhat formally handled and conventionally composed loch and glen and wood-land pieces with which Mr. Pollok Nisbet, A.R.S.A. (b. 1848), varies

those pictures of the market-places, mosques, and palaces of Morocco and Spain which are his best and most characteristic productions.

It is rather different with Mr. William Young, one of the three artists who founded the Glasgow Art Club in 1867, and perhaps the foremost authority on Old Glasgow, who carries on the tradition of Milne Donald and Docharty in the west. That, as has been indicated, was more natural- istic than M'Culloch's, and Young's work possesses considerable truth of detail, careful noting of atmospheric effect, and a sentiment of brooding melancholy which is not without chastened charm.

But it is not amongst painters of Highland landscape, even when Peter Graham, MacWhirter, and Docharty are included, that the realistic tendency shows most strongly ; nor, when one considers the difficulty of rendering the mingled complexity and vastness which make up mountain scenery, is it surprising that a closer reading of Nature has been attained by those who have taken the less overpowering Lowlands for their themes. While no landscape ever *sits* to a painter, the richer and more companionable scenes of the southern and eastern districts of Scotland are less dependent for pictorial and emotional effects on evanescent atmospheric conditions than the bigger and barer scenery within the Highland line. It is in the Lothians and the Border counties, at least, that W. D. Mackay (A.R.S.A., 1877 ; R.S.A., 1883), who has painted Scottish landscape more realistically perhaps than any of his contemporaries, has invariably worked.

A native of Gifford in East Lothian, Mr. Mackay came (1860) to Edinburgh at the age of sixteen, and made his earliest successes some ten years later by a series of pastorals, in which figures played an important part. Always a conscientious and eager student, he painted his pictures out-of-doors, and realised to the utmost of his powers the facts and effects before him. But while many of his early works are admirable transcripts of reality, they are something more. He had a genuine and naïve joy in natural beauty and rural life, which transfuses his work and infects the spectator with something of the same feeling. A few years ago I chanced to see 'Guddling for Trout' (1870), one of the first of his pictures to attract much attention. In a dancing streamlet, thinly fringed with willows and with a tree-bordered meadow on its further side, three barefoot laddies are guddling, while a little boy and girl sit in the grassy foreground watch- ing the sport. It is a still, sunny day of late summer, with no marked feature of brilliance or of flying light and shadow, and the artist has taken Nature as he found it ; but the tranquil truth of the lighting, the tenderness and charm of the drawing, the delicacy with which filmy tree and seeded grass, purling burn and pebbled water-course are rendered ; the simplicity and appropriateness of the incident, and the unaffected rusticity of the children, make a picture which lingers pleasantly in one's memory. Painted as if he counted it ' crime to let a truth slip,' this and other pictures wrought in a similar spirit gave him a precise knowledge of the material of Nature,

and eventually brought greater capacity for expressing it in paint. But, while his technique grew in subtlety and he gave rather greater play to the selective faculty and acquired greater power of composition, the art of his maturity remains at heart one with that of these early days.

Balance of interest in the pictures of his best period makes it difficult to say whether he is a painter of figures in landscape or of landscape with figures. Yet this very equipoise renders him more essentially a pastoral painter perhaps than if either had predominated, for each interprets and gives significance to the other. All sorts of farm-work and all seasons, except harvest perhaps, figure on his canvases, and are rendered with know-ledge, the figures and cattle and horses being introduced with skill and sympathy. But with all its truth one misses in his art that spirit of per-sonal and emotional interest in the workers and in the deeper relationship between man and the soil which kindles one before the pictures of men whose greater insight and profounder thought confer not only greater significance but more distinguished pictorial aspect on their work. Yet, at its best, his technique, if undistinguished and lacking in brilliance and power, has spirit and precision, and with it his drawing, more deft than learned or elegant, is in close sympathy. As a colourist again, he is frank and representative, rather than forcible and emotional. Glowing opulence and pearly charm are alike outside his range, and he seems to avoid sub-jects in which either is the dominating element, but his colour is usually true, and almost always in keeping with his conception of subject.[1]

The landscape of A. K. Brown is likewise closely studied from Nature. His, however, is more an art of selection and mood than of transcript, and, being without the incidental interest which adds animation to Mackay's pastorals, depends entirely for appeal upon personal sentiment for pure landscape. Pitched in a minor key, pensive rather than sad, the attraction of his pictures is not immediate, and in the glare and bustle of a big exhibition one is apt to pass them by. Yet the delicate intimacy of feeling which pervades them is amongst the more precious gifts of art, and enables its possessor to interpret the spirit and beauty of land-scape which at first sight seems uninteresting and unsuited for pictorial record. However simple the scene, and no matter how lacking in the elements one has come to associate with the picturesque, A. K. B., as he signs his pictures, by the alchemy of this faculty, transforms it with a tinge of poetry which gives significance and charm. Not a great artist, perhaps, for he has neither dramatic intensity nor lyrical witchery at its highest, but a tender interpreter of certain moods and emotions stirred in man by Nature, his art has a distinctive and personal note, which ensures it an honourable place in the history of his school. Full of gentle con-templation and unhurried thought, it breathes the spirit of contentment

[1] Mr. Mackay has been Secretary of the Royal Scottish Academy since 1906, and is the author of a book upon 'The Scottish School of Painting.'

and might be described as 'The Harvest of a Quiet Eye.' His subjects are exceedingly simple. A sketch of moorland or pasture under a big cloudy sky ; a river winding softly among grassy hills or broad, bare meadows ; a cluster of trees beside a burn or on the shore ; a little wooded glen, or a cottage nestling on the edge of a wood, with no incident save a few sheep or cattle feeding, one or two white-pinafored children gathering flowers, or, at most, a tinker's camp, satisfies him fully. Summer landscapes, such as these, he varies by delicate dawn or twilight pieces with new-fallen snow upon the mountains or among the moors. The result, as has been said, depends more on sentiment than fact, and not infrequently—particularly in his earlier work—this centres in the sky, which, of all the elements that enter into landscape, seems to touch him most nearly. And if judged by the newer Scottish ideals his method in both oil and water-colour is wanting in emphasis and gusto of handling and in fullness of tone, he combines delicacy of drawing and touch with breadth of atmospheric effect and design, and, as a rule, his pictures charm by harmony of ensemble as well as by refinement of feeling. A native of Edinburgh (born 1850), Mr. Brown has lived almost all his life in Glasgow, where, although purely personal in his methods and ideals, he has been for many years one of the most notable painters. He was trained in the west as a designer for calico-printing, but in the early seventies he took professionally to landscape-painting, in which he had long dabbled, and becoming intimate with Docharty visited Egypt with him in 1876. From the beginning, he has been one of the most active supporters of the Water-Colour Society, and in 1892 he was elected an Associate of the Royal Scottish Academy.[1]

While the delicacy of feeling and subtlety of atmosphere in A. K. Brown's modest and personal art occasionally suggest study of the French romanticists, the landscape of E. S. Calvert (1844-98), an Englishman who spent his art career in Glasgow, is obviously that of a disciple of Corot. Beginning by painting coast and fishing-scenes with considerable verisimilitude and care for values, his later work, much of which was in water-colour, was pastoral in subject and idyllic in character. Often painted in the north of France, these pictures owed something of their reminiscent quality to subjective elements, but the grey and pensive colour-schemes, the balance in design obtained by contrasting masses of foliage on the one hand with slighter growths on the other, and the way in which shepherdesses and sheep are introduced, are clearly traceable to the fascination of the French master. Pitched in a minor key also, it is Dutch rather than French influence which appears in the work of A. D. Reid, A.R.S.A. (1844-1908). Born in Aberdeen, he entered the life-class of the Royal Scottish Academy when twenty-three, and subsequently studied in Paris, but probably the influence of his older brother, Sir

[1] Promoted Academician, 1908.

George, with his Dutch training and friendships, was more effective than that of his own masters. In any case, the fullness of his tone and his fondness for grey atmospheric colouration were in a way more Dutch than French or Scottish. His feeling for Nature was Scottish, however, and his northern landscapes, with thin woodlands and austere distances, and his coast-pieces, with fishing-villages perched on dark cliffs above little harbours, and fisher-folk busy amongst nets and fishing gear on the green braes, are very true to the district which inspired them. Of his foreign pictures, results of sketching tours in Holland, France, and Spain, none are so memorable as several of high French cathedrals rising on the margins of tranquil waters.

The art of G. W. Johnstone (1849-1901), a Forfarshire man, who came to Edinburgh as a cabinetmaker and ended as a member of the Academy, was more native and less complex. Simple and ingenuous delight in fine weather and pleasant scenes is perhaps its most distinctive characteristic. A lover of dancing streamlet and soft-flowing river, he was at his best by a waterside, half tree-shadowed, half open to the sky, where the eyes are charmed by the near intricacies of bough and leaf, and imagination leaps through the vistas to suggestions of far-off valley and hill. At other times he was happily inspired by a stretch of Fifeshire moorland under a sunny sky, a peep of St. Andrews Harbour, or a bit of the shore at Largo with nets drying on the bents and a calm sea spreading to a horizon dimmed in summer haze. Unfortunately, however, the instinctive though unimpassioned feeling for Nature, which these preferences indicate, was not backed by a sufficiently sensitive and expressive technique. While many of his pictures are harmonious in design and fresh and pleasant in colour, his handling was marred by a clumsy mannerism of touch which results in a rough-hewn and unpleasantly marled surface, specially noticeable perhaps in his rendering of summer woodlands. On the other hand, competence of technique is more evident than fineness of feeling in the art of Tom Scott, one of the few Scottish painters who work exclusively in water-colour. Not that Mr. Scott is without sentiment. He has a real feeling for Nature, not unlike Johnstone's, in quality and degree, and in his earlier pictures, at least, was peculiarly sensitive to the charm of early spring, when leafless trees stand clear-cut against the brilliant blue and white of showery skies or tremble delicately in the dusk of April evenings. Yet with him it is only at rare moments that sentiment dominates technique. One is usually more conscious of the competence and completeness of his method than of the emotion it should express, and this, one is afraid, is only another way of saying that his inspiration is wanting in depth and fullness. And a similar defect militates against the effect of the figure-pictures with which he began, and which, from time to time, he still paints. A native of the county in which Sir Walter was 'the Shirra,' these, like his landscapes,

have usually been inspired by the Borders. Several dealt in spirited fashion with field-sports, but more frequently the legendary lore, which gilds with glamour every waterside and hill-top of the Borderland, has supplied a motive. They are excellently designed in a formal sense. The drawing of horses and dogs and landscape setting, as well as of figures, is admirable; the colour pleasing, and sometimes fine; the mechanical mastery of the medium very marked; but, excepting 'Moss-Troopers returning from a Raid' (1886), which remains in many ways his most notable work, his more ambitious drawings have missed the intense life and passion which surge through the riding ballads themselves and stir the blood like the blast of a trumpet. His work as a whole is so well done in its own way that it offers little opening for positive criticism, but the deeper things, which give art real significance and lasting charm, seem to me outside his gift.

Born at Selkirk in 1854, Mr. Scott assisted his father in the tailoring trade for several years, but in 1877 he came to Edinburgh where he studied in the schools on the Mound, and some six years later his drawings became amongst the most conspicuous in the exhibitions of the Academy—of which he was elected Associate in 1888 and member in 1902—and helped both to mark and to advance the quickened interest in water-colour painting, which may be dated from the formation of the Scottish Water-Colour Society in 1878. Excepting George Manson, he and R. B. Nisbet and William Carlaw (1847-89), the sea-painter, were the first Scottish painters of prominence, since 'Grecian' Williams's time,[1] to devote themselves entirely to that medium, and their example was followed by several of their contemporaries, of whom P. W. Nicholson (1856-85) whose idylls are referred to elsewhere; Mr. James Douglas who has done clever work of an over-pretty kind; Mr. T. M. Hay who is a good colourist and now and then reveals a poetic apprehension of atmospheric effect; and Mr. G. S. Ferrier, whose very complete if rather mechanical technique is used to express a pleasant vein of sentiment, may be named.

The simple and sincere feeling for Nature expressed in the pictures of these men is to be found also, in varying degree and quality, in the landscapes of Wellwood Rattray, A.R.S.A. (1849-1902), whose large canvases may be said to have been forceful rather than robust, and to have attracted attention more from their size and a certain peculiarity in colour than from any deeper qualities; in the sombre and over-brown moorland and fir-wood scenes of George Aikman, A.R.S.A. (1831-1905), and in the work of Messrs. James Kinnear, Duncan Cameron, George Gray, Hector Chalmers, and other painters who cannot even be mentioned here.

[1] Although it has never attracted much notice, the water-colour landscape of Thomas Fairbairn (1820-84) deserves mention. A friend of Fraser and Bough, he painted chiefly at Hamilton, and his rendering of woodland and burnside scenes is marked by care, skill, and good colour, and is very pleasant in its simple and unforced sentiment.

It is indeed the dominating characteristic of Scottish landscape-painting between the flowering of Scott Lauder's pupils and the advent of the 'Glasgow School,' but as it reaches its best in the art of those already dealt with and in that of a number of Anglo-Scots, who have yet to be discussed, no purpose would be served by prolonging the present section.

<p style="text-align:center">II</p>

While the work of the chief painters already mentioned in this chapter may be taken as typical of the realistic tendencies in landscape-painting in Scotland at this time, a number of Scotsmen of about the same age carried very similar ideals to London with them. Of these Mr. David Murray is the most gifted as well as the most conspicuous.

Born in Glasgow in 1849, David Murray, the son of an Appin man, spent eleven years in business ere, despite the doleful prophecies of friends, he plunged into that career of landscape-painting in which he was to win success. Even before he gave up commerce, however, he had shown distinct proofs of talent and had acquired considerable technical skill ; and, pushing rapidly to the front, he was A.R.S.A. by 1881, and, going to London the following year, was elected A.R.A. in 1891.[1] He had studied under Robert Greenlees in the Glasgow Art School, and it has been suggested that Docharty's friendship influenced him, but the latter seems unlikely, for delight in fresh and sparkling colour and in movement was early characteristic of his art, while Docharty's inclined to monotony, and, with all its truth, savoured of still-life.

Gifted with a fine sense of colour, frank and unprejudiced vision, and genuine, if not deep, appreciation of the more brilliant aspects of Nature, these, with much dexterity of handling, are the qualities which distinguish Murray's work at its best ; and recollection of the pictures painted by him in the earlier eighties suggests that they were more marked then than now. The gaiety and gladness of 'Springtime, Tillietudlem' (R.S.A. 1882), with its fleecy-white clouds afloat in the rain-washed and sun-steeped blue, its blossoming apple-trees and flower-spangled grass, its calves and milk-maids ; the pageantry of sun-irradiated storm-clouds over hushed lush meadows, and unheeding busy workers in 'Haymaking in the Scottish Fens' (Grosvenor, 1883) ; the brilliance of broken heathery foreground and distant blue waters in 'My Love has gone a-Sailing' (R.S.A. 1883 ; R.A. 1884), bought by the Chantrey Trustees ; the more than brilliance of the original and beautiful 'Loch Linnhe near Port Appin' (R.A. 1884) ; the sheen and opalescence of things like 'Sannox Sands and Shallows' (Glasgow, 1882), 'The Ferry Rock, Corrie' (R.S.A. 1882), and 'Gathering for the Tow-out, Tarbert' (R.S.A. 1884), and the charm of many a lovely water-colour remain vividly with one ; and that preference for them

[1] R.A. 1905.

is no trick of memory is proved by the undiminished pleasure they give
when seen again after an interval of more than twenty years. Vivid and
brilliant, sometimes audacious, in colour and atmospheric effect, these
pictures attain a wonderfully full and rich harmony, and convey a striking
impression of those brightly beautiful aspects of Scotland in which, as
Millais said, the colour, like that in a wet pebble, is brought out by the
rain. Inevitably you are reminded of the word-pictures of another
Glasgow man, for William Black's descriptions and Murray's pictures
have similar qualities and effects. In both the more tangible charms—the
inlay of colour detail showing brilliant as enamel in the clear air, or
gleaming delicately through a veiled atmosphere—of the Clyde valley and
the West Highlands are very truly mirrored : in both the more subtle
and elusive beauty and the spiritual fascination of that enchanted land are
only hinted at.

Up to 1886 Murray had painted mostly in Scotland, but in that year
he spent a long season in Picardy, the results of which were seen in a
charming one-man show at the Fine Art Society, and since then he has
worked for the most part in the southern counties of England. Towards
1890, also, a new ambition became pronounced in his art. Although in the
past he had shown much skill in dealing with complex landscape, his
designs had usually been an outcome of immediate impression of reality,
and were subordinate to those colour effects which gave coherence to the
whole, and were in reality his chief concern. Now, however, he began to
compose more in light and shade and line, and, perhaps as a consequence,
his colour dimmed its glow and assumed a rather metallic quality. And
what was gained in dignity and style (the new departure was modelled on
some great masters) being alien to the natural bent of his mind, weakened
rather than strengthened his art, which became at once more ambitious in
intention and more meretricious in sentiment. Still, his later work includes
many excellent things, such as 'Willows' (New Gallery, 1889), 'The
Meadow Mirror' (New, 1890), 'In Summer-Time' (R.A., 1895), or 'A
View of Windsor' (R.A., 1900), in which the soft charm and winning
prettiness of English scenery are united to graceful and admirably con-
ceived compositions, and within the last three or four years, during which
he has worked a good deal in the North of England, his colour has
regained much of its early charm. Frequently, however, his very real
delight in delicate and dainty detail, particularly in tree forms and foliage
and flowery foreground growths, which he draws beautifully, is allowed to
disturb the breadth and unity of an otherwise well-ordered design, and
while a tendency to that over-prettiness, so characteristic of English land-
scape-painting as a whole, is shared to some extent by other Scots who have
settled and worked much in London, it is specially to be regretted in the case
of a man of such distinct gifts as Mr. Murray. On the other hand, his
influence upon many of his English contemporaries has been quite marked,

U

and, considering the superiority of his vision and sentiment to those dominating popular landscape art in England, it has been distinctly healthy.

In a far more literal sense than that of Murray, Joseph Farquharson's art is a matter of transcript. He has reduced the pictorial representation of certain aspects and effects of Nature to the exactitude, and almost the certainty, of a science. His wan sunsets over weary wastes of snow through which half-frozen streams soak their sluggish way, his driving snowstorms with half-blinded shepherds and forlorn-looking sheep, and his winter woods, through the intricacies of whose bare frosted boughs and tangled undergrowths rich red after-glows gleam and burn, are well drawn and admirably put together, studied in every detail, refined in tone and wonderfully true in general effect. And the same is true, though in lesser degree perhaps, of his renderings of home landscape at other seasons, in which he is less a specialist, and of the many pictures he has painted in foreign countries. Nor is his attention confined to landscape. He has occasionally painted Oriental mosques and Eastern market-places, and, now and then, portraits, in all of which he has shown considerable accomplishment. Yet even the best of his work leaves one strangely unmoved, for it is wanting in glamour, in poetry, in that personal perception of reality which is worth all the realism in the world. It has its own claims to consideration, however, and in its particular way it is excellently done, while reproduced in black and white, in which their cleverly contrived light and shade comes out effectively, his winter-scenes have attained wide popularity. Mr. Farquharson, who was born in 1847 and comes of an old Aberdeenshire family, studied in the schools of the Royal Scottish Academy and with Mr. Peter Graham, and in 1900, after being for years in the running, he was chosen A.R.A.

David Farquharson (1839-1907) an Associate of the Scottish Academy (1882), who went south four or five years after he was elected, brought a more instinctive feeling for tone, cultivated perhaps by study of the Dutch tone-painters, and much greater facility of handling to bear upon the imitative faculty which he shared to some extent with his more widely-known namesake. Of facility, indeed, he was one of the most striking examples in Scottish painting since Sam Bough, whom he also resembled in variety of subject-matter and in the spontaneity and ease with which he invented and introduced incident. He painted Highland hills and moors and peat mosses, Lowland river-valleys and tidal estuaries and rich farming lands, found subjects on Dutch flats and polders and among the shipping of the Maas and Scheldt, and rendered with felicity the charm of English commons and coasts, streams and lanes and pastures. And these varied scenes are depicted at all seasons and under all sorts of atmospheric conditions, from fog to sunshine, and from dawn to dusk or moonlight. His sense of subject was immediate and effective also as regards both ensemble and incidental interest, whether that be the work of field or harbour.

Moreover, his brushing was marked by ease and certainty; his drawing was that of a brushman, free and bold if only approximately true; and his colour, without being fine in quality, was fresh and true in tone. Equally at home in oil and water-colour, feeling for tone was perhaps more pronounced in the one, and feeling for light in the other; but in both he made consistent progress, and the best and most refined things he produced were the work of his last decade. But as facility of execution in itself holds no very lasting satisfaction, and David Farquharson's sense of the life and beauty of landscape was rather superficial and his design was wanting in true significance, his art is of less account than appears on first acquaintance.

Amongst these Anglo-Scots Mr. Leslie Thomson (born in Aberdeen, 1851) occupies a place not dissimilar to that filled by Mr. A. K. Brown at home. Compared with his fellows, he has much of that intimate and quietly poetic conception of Nature in her everyday moods which distinguishes the Glasgow man amongst his. But in Leslie Thomson's case this feeling is associated with a predilection for deeper tones and more simplified masses, gained through early and more conscious study of the masters of the Barbizon and Dutch schools, which gives the more formal side of his art a rather more distinguished air than that of the other, whose colour, however, in its tenderer quality and more delicate modulation is more charming in itself, and, perhaps, more in harmony with the spirit in which they both approach Nature. The subject-matter of Leslie Thomson's pictures being derived, for the most part, from the pleasant and gently-varied scenery of the southern and eastern counties of England, they partake of that character. Fair meadow-lands with girls listening to skylarks singing, slow-flowing rivers in which boys bathe in the early summer days, wide open expanses in the Broads, where barges, laden with new-mown hay, lift their high narrow sails against quiet skies as they drift by, and stretches of flat Essex landscape, with a bouquet of trees here and there, and, perhaps, a great cloud floating in the blue, are probably his favourite motives, and those with which he has secured his most conspicuous and characteristic successes. Sometimes he paints the sea, but his habitual mood is too reposeful and his sympathies too closely held by the land to permit successful achievement in this field also, except where the sea is accessory to the coast, or where, as in several notable canvases with groups of nude bathers, an opalescent calm possesses both sea and sky. Informed by sincere love for Nature and a personal note, his pictures occupy a distinct, if modest, place in contemporary landscape, and possess qualities which led R. A. M. Stevenson to say that 'a good Leslie Thomson has a character of its own which makes it as recognisable as greater and more beautiful works. Leslie Thomson is essentially an English landscape-painter—one might almost say the English landscape-painter. Amongst really good living men of the younger

schools he is perhaps the one upon whom the all-pervading Continental influence has worked in the gentlest way, and with the least perceptible alteration of natural sentiment. It is for this reason that he seems to recall Constable, Cox, De Wint; while he uses oil-paint rather according to the later French fashions.'

The French influences in the work of W. J. Laidlay are those of the realistic school rather than of the romantic phase which early won Leslie Thomson's admiration. Affected by the impressionistic interest in light, his manner is yet more kindred to Cazin than to Monet, and expresses with considerable accomplishment and suavity of brushwork a personal though unimaginative feeling for effects in which a gentle diffusion of light reduces tone contrasts and produces delicate harmonies of tawny browns and greys. His treatment of such themes is seen at the best perhaps in the studies of sedgy meres and watersides with which he first attracted attention, and in certain of his recent Nile pictures. Yet it is perhaps rather through active participation in movements of protest against the domination of the Royal Academy that he has bulked in the public eye. This has taken form in various pamphlets, in a novel with a purpose, and, from an artistic standpoint, most convincingly in the prominent part he took in founding the New English Art Club in 1886.[1]

Differing from their predecessors, Peter Graham and MacWhirter and their contemporaries, none of these London Scots has really ' taken to the hill,' though, now and then, one or other of them has painted amongst the mountains. Mr. Colin Bent Phillip (b. 1856), son of ' Phillip of Spain,' and pupil of David Farquharson, is an exception, however, and a complete one, for his drawings are concerned almost entirely with Highland scenery. A water-colourist and a member of the Royal and the Scottish Water-Colour Societies, he is perhaps more draughtsman than painter, and his landscapes, often large in size, are marked by careful and learned drawing of mountain form and structure rather than by justness of tone, fullness of colour, or fineness of atmospheric relationship and effect. Hence he is apt to sacrifice the emotional aspect of landscape to smaller, if not unessential, considerations ; a tendency, however, less noticeable now than some time ago.

III

The work of the Nobles and one or two others presents more complex problems, for in it the feeling for Nature, which predominates in the landscape-painting we have been considering, is subordinated to considerations of style, and the balance between these elements and the proportion of personality to convention in the latter have to be analysed. But although one contrasts naturalist and stylist thus sharply, and the strength of their

[1] See *The Origin and First Two Years of the New English Art Club*, by W. J. Laidlay, 1907.

different attitudes would seem to be utterly opposed, the unpardonable weakness in each is not dissimilar, for realism untransfused by personal perception is arid and uninteresting, and style uninformed by personal distinction is futile and purposeless. And while lack of style is a grave defect in the one, deficient respect for reality is a no less serious flaw in the other. In the case of the men mentioned, however, while one may say not unfairly that they are concerned chiefly with achieving stylistic results within chosen formulas, the feeling for Nature is never absent, and almost always serves as part of the foundation upon which their designs are built.

J. Campbell Noble is the senior of this group, and his earlier work has already been referred to in the chapter dealing with the pastoral painters. Born in Edinburgh in 1846, he studied in the schools of the Royal Scottish Academy under Chalmers and M'Taggart, and, being a favourite pupil of the former, was considerably influenced by him. He began with figure-subjects, some of them, such as ' The End of the Weft' (1878) which was bought by Chalmers, homely or pathetic incidents in richly shadowed cottage interiors, but more frequently idylls of country life out-of-doors painted in the company of John R. Reid and John White, and remarkable, as theirs were, for powerful handling, strong tone and full colour. But once elected A.R.S.A. (1879: R.S.A. 1892), and his bosom companions having migrated to London, Noble abandoned figure for landscape, of which he has since painted many varieties and phases. Devoting attention in the first instance to scenes in shipping rivers and ports, he painted a series of powerful pictures on the Medway, Tyne, Seine and Clyde, in which picturesque wharves, boat-building yards, or groups of shipping were relieved in strongly contrasting tone against reaches of busy river under luminous or sunset skies. Admirably designed upon a clearly conceived basis of chiaroscuro, full in tone if not closely studied in values, with definite colour-schemes, abstract rather than naturalistic in quality, and painted in a broad and powerful manner, they were coherent in ensemble and pictorially effective. In the early eighties, however, he went to live at Coldingham, and for twelve or fifteen years thereafter found inspiration on the wild, richly coloured rocky coasts, and amid the wide-vistaed rolling landscape of that part of Berwickshire. At first figures of considerable importance were introduced, but soon they were reduced in prominence, and before long eliminated entirely in many cases. Gradually also his colour gained in range and variety, and his design in richness and complexity. Some of his coast-pieces, especially those painted in harvest-time, are rich in sonorous chords of red, blue, and yellow, harmonised by decorative massing and cunning balance of parts ; but his feeling for the sea itself was lacking in spontaneity, depth, and passion. He was more absorbed in its flux and change of hue, and in forcing these to a great intensity of decorative colouration, than in

interpreting its might and magic or in wresting from it that baffling secret which exercises so potent a spell upon its true lovers. A higher plane is touched in the landscape of this time. Based to some extent upon the practice of the older school of British landscape, pictures such as ' The Vale of Clyde' (1885), ' Springtime,' and ' Actæon and Diana' (1886)—an autumnal landscape with classical figures—are elaborate and balanced in design, opulent and glowing in colour, powerfully if some-what coarsely handled, and are instinct besides with a feeling for natural beauty deeper and more sympathetic than is to be found in his seaside studies. Two or three years later these influences were modified by others —in ' Wharfedale' and ' Barden Tower' (1887), and in ' The Morning Star' (1888), one of its painter's finest and most expressive works, by Cecil Lawson ; and then, after a period during which his art was very distinctly below its best, came a series of brilliant sea and coast pieces, painted in Brittany, with tender and fleeting skies, and delicate or vivid aerial distances, which were in some ways Turneresque. In 1900, some five-and-twenty years after a first visit, Campbell Noble found his way back to Holland, and, incidentally, to a variation on the motives of his earlier landscapes, for since then his most characteristic pictures have been of the quaint craft, romantic old cities, and charming country vistas on Dutch water-ways. Here, as is unavoidable perhaps, one is reminded of some of the greater modern Dutchmen ; but similarity of theme rather than likeness of treatment or sentiment evokes the reminiscence, and his Dutch pictures are not only quite individual and marked by the qualities which have characterised his art in all its phases, but are, except the High-land landscapes he has been painting simultaneously, the fullest and richest results of his gifts. Still, interesting and artistic as all Mr. Campbell Noble's work has been, many of his pictures seem just to miss that depth and weight of conviction and that flavour of immediate per-sonal impression which sometimes give art inferior to his in resource and skill the vital element which Tolstoi describes as ' infection.' But his art has charms and merits of its own—felicity of execution, richly toned and luminous colour, and a sense of pictorial beauty somewhat rare in the work of his immediate contemporaries.

A cousin and, in some degree, a pupil of Campbell Noble, Robert Noble (b. 1857) shows traces of these connections in his art. To him also the formal and more consciously artistic elements bulk more largely than emotional significance and freshness of impression ; but he wears the family preferences—there was a third Noble (David, a younger brother of Robert) of promise, but he died early—with a difference, and applies them to quite a different type of landscape with a skill which suggests that the indebtedness was not altogether one-sided. The scenery of his choice is a combination of sylvan and pastoral, and preferably the tree-fringed meadows, variously wooded watersides, rocky linns and

foliage-embowered water-mills of the Haddingtonshire Tyne near East Linton, where he has made his home for many years. Landscapes such as these he varies with orchards in blossom and harvest-fields in stook, with quaint villages and farmsteads; and in the later eighties, under the influence of Monticelli, whose art was so admirably represented in the Edinburgh Exhibition of 1886, he produced a series of pictures with brilliantly costumed figures amongst the blaze of the Tynninghame rhododendrons in full bloom. But the feeling for Nature and the moods of atmosphere, which shows clear in his sketches and slighter pictures, is weaker than his pictorial predilections, and in many of his more elaborate works it is checked and muffled by artistic convention. A devoted student of design, especially as exemplified in the pictures of the Norwich group and of some of the French romantics; interested in technical processes and learned in the results obtainable by glazing and such-like methods; and with a very distinct leaning to warm and luminous colour forced to an unnatural intensity, these qualities impress themselves upon the spontaneous outgoing of his sympathies when face to face with Nature, and give his pictures a certain artificial and made look. On the other hand their refined handling, rich low tone and varnished quality, added to the respect for and skilful use of traditional design, which is such a notable feature in his work, fit them admirably to hang with pictures of the older school, and even, though he lacks the romantic conception and the depth of feeling which made the Barbizon men great artists, with those of that noble brotherhood.

Gifted with an instinctive feeling for technique, Mr. Noble had scarcely emerged from the Scottish Academy school[1] when he attracted notice by a number of large cottage interiors with figures. They had domestic incidents for subject; yet their real motive was the attainment of rich and deep-toned harmonies of colour and transparent and richly contrasting effects of light and shade, and in these respects and technically they were eminently successful. But it was as a landscape-painter that he ultimately took a distinctive position, and was elected to the Academy (A.R.S.A. 1892; R.S.A. 1903). It was largely on his initiative that the Society of Scottish Artists was formed in 1892, and he was its first chairman; and, while his pictures attracted much attention in London for some years about 1890, he subsequently ceased exhibiting there, and now his work is seldom seen outside Scottish exhibitions.

Associated with a slighter and less spontaneous vein of poetic sentiment, something of the consideration for design and fondness for varnished quality of mellow colour, noted in Robert Noble's work, are present in that of J. Coutts Michie. Subjectively his preferences are for summer twilight stealing softly over meadow and sheepfold, for harvest-fields lying in the golden light of autumn afternoons, for unrippled water-ways

[1] Study there was supplemented subsequently by work in the Carolus Duran atelier.

fringed with tall poplars and silvery willows, past which picturesque barges glide silently. But, while the attraction of such motives is obvious, and this artist takes pleasure in them, his treatment, if refined and able, is somewhat artificial and cold, and his sentiment lacks the intimacy, the gusto, or the imaginative quality necessary to make them pictorially convincing and satisfying. And kindred merits and defects mark the portraits, between which and landscape he divides his attention. Mr. Michie painted in his native city, Aberdeen, until some fifteen years ago when he removed to London, where his work is now well known and esteemed. He was elected A.R.S.A. in 1894, and since its commencement he has been an active and influential member of the Society of Scottish Artists. The renewed activity of the Aberdeen Society is also largely due to his influence.

Compared with the Nobles, R. B. Nisbet (b. 1857) is concerned with results rather than with methods. He also has studied the art of the earlier English masters intently; but while the influence of Girtin, Cox, and De Wint—Turner in his most characteristic mood seems to leave him unmoved—and of Constable, as seen, more probably perhaps, in David Lucas's fine mezzotints, is clearly traceable in his design and distribution of light and shade, his method is less direct and spontaneous. To judge from their work, the old English masters of water-colour considered that their medium was at its best when used simply and directly in fat washes and touches, which preserve the surface of the paper and so allow the colour to dry with bloom and freshness. And to this there is little doubt that much of the charm of a fine De Wint or Cox is due, for, not only is the actual texture so obtainable beautiful in itself, it tends to a finer quality of colour and a more subtle rendering of atmosphere than is possible on a tortured and broken surface. To Nisbet, however, even though he is almost exclusively a water-colour painter, this seems of little account. Most of his important drawings are rubbed and scrubbed until little of the original surface remains and the texture of his colour has become gritty. It is fortunate, therefore, that his choice is for low tone and dark colouration, for, had it been otherwise, his method would have interfered more than it does with one's enjoyment of the fine qualities which his art possesses. Although his apprehension of Nature is neither very personal nor very profound, and it has been chastened unduly by respect for certain traditions and restricted by exercise on too limited a range of effects, his work is refined in tone, broad and harmonious in effect, and marked by considerable dignity of style. Sobriety is, indeed, the dominant quality of his art. His low-horizoned landscapes of far-spreading valley, bounded by distant hills, or near seen pastures or hay-fields, usually lie dark under a cloud-piled sky, and when he paints the sunset it is 'the quiet coloured end of evening' that finds favour in his eyes. His favourite colour-schemes are dark brown and low-toned blue or grey, and dull saffron and grey-green ; and his compositions, as a rule, are built upon simple but

distinguished lines. And so if his more elaborate drawings (his sketches are much fresher in handling and breezier in effect) have frequently failed to suggest the charm and life of Nature, they are seldom far from a fine convention, and never offend by attempting more than is within the artist's reach. Mr. Nisbet lives in the country, but he is a member of many societies; of the Royal Scottish Academy, of which he was elected Associate in 1893 and Academician in 1902; of the Scottish Water-Colour Society; of the Royal Institute and the Society of British Artists; and of the Royal Belgium Water-Colour Society. His art has been greatly appreciated abroad; he has been medalled frequently; and a good many of his drawings have found places in public collections.

<center>IV</center>

Marked by genuine love of Nature, and, here and there, a touch of poetry as is much of the landscape just described, one would scarcely single out a rapt and passionate appreciation of either the beauty or the significance of the world as its distinguishing quality. That were indeed too much to expect. Such exalted sentiment is to be found only at rare intervals in the work of any school and then only in the pictures of a few painters. A particular way of painting, a preference for certain qualities or harmonies in colour, a special stress on decorative or representative elements in picture-making, and even a common feeling for style may distinguish a group of painters and form the characteristic touch in their work, but poetic apprehension of Nature cannot be cultivated or counter-feited—it is an individual and inalienable possession. Something of this is present in the landscape of one or two of the painters discussed in the preceding chapter, and something of it is to be found in the work of as many of the sea-painters, still to be spoken of; but there are three land-scape-painters of this period who have been dowered indubitably with the authentic gift, and, as is usually the case with men so possessed, their art has a distinction which no amount of study or culture can ever confer. Although born in Shropshire, Cecil Gordon Lawson (1851-82) was the child of Scottish parents, and the strain of his blood revealed itself in his art. The family, in which he was the fifth and youngest son, was excep-tionally artistic. His father, William Lawson, was a portrait-painter, his mother painted also and had been an exhibitor at the Royal Scottish Academy when they lived in Edinburgh, and two of his brothers are not unknown to fame. Wilfred has attained consider-able distinction as a painter of allegories and of incidents in the life of poor city children, treated with a touch of symbolism which makes them homilies; and to Malcolm we owe the arrangement of the music in that golden treasury of Scottish melody, 'Songs of the North.' Wellington, where Cecil was born, was but a stepping-stone to London, where, in his

father's studio, he acquired the rudiments of his craft. Otherwise he was
self-taught. But he was a devoted student of Nature, making many
sketches in oil at Hampstead, and later, many elaborate studies of fruit
and plants in water-colour in the manner of William Hunt, while he
frequented the National Gallery and learned from the masters there.
When eighteen he took to oils again, and a year later he had a 'Cheyne
Walk' picture hung on the line in the Royal Academy. 'The River in
Rain' and 'A Summer Evening at Cheyne Walk' were equally well treated
in 1871, but in the following year his 'Lament' was skied and 'A Hymn
to Spring' was not hung at all, and for some time thereafter the Academy
played battledore and shuttlecock with his work, one year placing it at
the roof, the next hanging it on the line or refusing it outright. But the
opening of the Grosvenor Gallery in 1878 brought ample amends, for
'The Minister's Garden' and 'In the Valley, A Pastoral,' then secured
a triumph such as has fallen to few artists of his age—he was only twenty-
seven. It was none too soon, however. He had but four years to live.
Yet this short time saw the appearance of a succession of pictures which,
added to those previously painted, give Cecil Lawson high place amongst
the few really great British landscape artists.

Lawson attained artistic maturity very early in his brief career, and,
while the many elaborate studies of his youth contributed greatly to his
knowledge of the detail of Nature and his ultimate grasp of effect, there is
little doubt that study in the National Gallery shortened his period of
probation and stimulated his native sense of style. Mr. Gosse, his earliest
biographer, says that the Dutchmen received much of his attention, but
his mature work reveals him clearly as a pupil of Rubens, as seen more
particularly perhaps in the great 'Autumn' landscape presented to the
nation by Sir George Beaumont. In less degree he was indebted to
Gainsborough, Constable, and other of his English predecessors ; but he
was of his own time also and was deeply influenced by the realistic and
impressionistic tendencies about him. Yet, above all, his outlook was
personal, and in his landscape realism, which was the end of most con-
temporary effort, and style, which he had cultivated so successfully, were
united to give an impressionistic and decorative expression to a highly
poetic apprehension of Nature. And as it happens, it is possession of
this exact combination of qualities which renders Cecil Lawson's work
important in any survey of recent landscape art. During the decade in
which he did his life's work English landscape-painting as a whole was
devoted to realism divorced from poetry on the one hand and from
decorative effect on the other. It was the period of Millais's 'Chill
October' (1870), 'Winter Fuel' (1874), and 'The Fringe of the Moor'
(1875), and of the aftermath of uninspired Pre-Raphaelitism garnered by
Vicat Cole (1833-93), John Brett (1830-1902), and Mr. B. W. Leader ;
it saw the completion of Frederick Walker's (1840-75) idyllic landscape,

so charming in spite of obvious faults of manner, and the blossoming of the sentimentality and stipple with which his imitators overlaid the splendid tradition of English water-colour. Broadly speaking, these were the dominating forces in English landscape. To Lawson, on the contrary, the rendering of a mood of Nature was of more importance than the realisation of a particular scene, and the broad effect of reality came before its detail, well though he could paint that, while, in pursuit of these primal elements of fine landscape, he never forgot that decorative aspect, which, in combination with them, issues in complete pictorial unity. As Mr. George Clausen pointed out in his charming address on Landscape (*Six Lectures on Painting*, 1904) he was very like Rousseau in his austerity and fine sentiment and in his large view of Nature. The immediate effect of his example was not great in England however, and when a few years later ideals somewhat similar to his became those of a considerable number of painters, they were received, not from him, but through study of the French and Dutch romantics and realists and of some of the earlier English masters. But in Scotland, where his art was always greatly admired, and particularly in Glasgow, where the Institute had made a point of securing examples of his work from year to year, Cecil Lawson must be reckoned a formative influence in the evolution of the style of the younger men. Indeed his pictures seem more at home in exhibitions in which much of the work is Scottish, as was evident, to take a particular occasion, in the Glasgow International of 1888, where he was represented in great strength. The glow and volume of his colour, the vigour and the occasional sketchiness of his handling, the virility of his realism, and the breadth of his style, are qualities which in some degree he owed to his descent.

It was Lawson's laudable ambition to make landscape express emotion without the introduction of incident or other explanatory accessory, and in many cases he succeeded to admiration. Close in touch with Nature herself rather than with a particular mood or phase, as some great landscape artists have been, he loved high summer with its thick leaved greenery and somnolent blue skies as well as the gaiety and glad freshness of spring or the mellow or seared passing of autumn, was as fond of moorland and marsh as of woodland and meadow, and was as much at home in the stone-strewn 'Valley of Desolation' as in the luxuriant 'Hop Gardens of England.' To pass from the tranquil beauty of 'The Minister's Garden,' with its foreground of old-fashioned flowers and beehives and its distance of rich rolling country, to the anticipation of disaster which frowns in the lurid sunset called 'A Pause in the Storm,' or from the breadth and expansiveness of 'Barden Moors' lying under an heroic sky to the elegiac tenderness of 'Strayed,' or the sylvan grace and charm of 'In the Valley' is to feel the extraordinary width of his sympathy with the spirit of inland landscape. His pictures are pregnant with the life and change of Nature, with its growth and lusty life, its decay and its perenni-

ally renewed youth, and with those emotional symphonies which the ever-changing sky plays upon the enduring features of the earth. And these he painted with an impetuous and broad yet assured and masterful touch, which, if sometimes coarse, was ever expressive and significant, and in a style usually distinguished and always pictorial. His sense of colour again, although somewhat lacking in delicacy, as his tone was rather wanting in fineness of modulation, was at once effective and beautiful, specially in those rich deep harmonies of blue and brown or of lush greens, blues and whites, which were the most characteristic expression of this side of his gift.

An artist who had learned much from the masters of the past and yet was in touch with the best elements in the work of his own time, a realist who had yet a passionate and original perception of the beauty and poetry of the world and a distinguished sense of style, Cecil Lawson, whether or not he had achieved the best that was in him when he died at the age of thirty-one, remains one of the greatest landscape painters of his century.

If Lawson's mantle fell upon any of his contemporaries, it was upon Thomas Hope M'Lachlan (1845-97), who had laid aside a lawyer's gown to become landscape-painter a few years earlier. Like Lawson he came of a Scottish family settled in England. His father was a banker in Darlington and Hope M'Lachlan was educated at Merchiston Castle School, Edinburgh, and at Trinity College, Cambridge, where he was bracketed first in the Moral Science Tripos. Choosing law for a profession, he studied at Lincoln's Inn, and, being duly called to the bar, practised for some years in the Court of Chancery. In 1878, however, prompted by his own desires and encouraged by John Pettie and other artist friends, who believed in his gifts, he took to art. He had had no academic training, and a short time spent in the Carolus Duran atelier at a later date was of little account, but he possessed a natural talent for painting, and this he cultivated by studying the early English masters, while, later, he was influenced considerably by the work of the French romantics, and of George Mason and Cecil Lawson. To the end, however, his technique remained rather lacking in the spontaneity and ease which can be acquired only in youth. It was apt to be somewhat heavy handed and deficient in mastery, and his paint, as paint, cannot be counted fine. Yet he painted in a manner that expressed his feelings wonderfully well, and they were such that one would readily overlook far graver defects of method than can be laid to his charge. Moreover, he was a refined colourist of wide range and great expressive power, and possessed a sense of design which never failed in dignity and sobriety, so that the ensemble of his pictures is ever distinguished and complete and never commonplace.

Peculiarly sensitive to the grave and impressive emotions which pertain to twilight, night, and solitude, M'Lachlan is seen at his best in pictures of which these are the themes. Usually he introduced simple incidents of

rural life and toil, but the figures, while giving a note of human interest, only add to the feeling of immensity and solemnity with which Hope M'Lachlan invested those bleak hillsides, bare upland pastures, and solitary shores where his imagination made its home. 'The Wind on the Hill,' with the storm-buffeted peasant so Millet-like, yet so personal, in its mingling of strength and resignation, standing upon the hill-top silhouetted against the surly sky, is an exception perhaps, for there the sentiment associated with the figure predominates; but 'Orion,' in which a shepherdess and her dimly revealed flock only enhance the serene and august beauty of night brooding over far-spreading plains, 'Weary,' a girl crossing a desolate moor under a breezy sky, 'An Autumn Storm,' where the curve of bare hill, with a blown tree at one side and a shepherd and his sheep on the other, sweeps grandly against a sky filled with flying cloud, the whole forming a singularly beautiful design, and 'Ships that pass in the Night,' that oceanic symphony played, as it were, on muted instruments, in which the transitoriness of a meeting far from land is contrasted with and then swallowed up in the unity and continuance of the illimitable sea heaving beneath the solemn silence of the star-strewn heavens, may be selected as eminently representative of his achievement. In them, incident, vividly and characteristically as it is conceived and beautifully as it is introduced, is vitally related to setting; each belongs to the other; the harmony between man and Nature is complete. Yet I am not certain that he did not give as full utterance to those profound moods of Nature to which his spirit was attuned in a few pictures without incident. These were not inland landscapes, however, but shore-pieces. Two in particular linger hauntingly with me. One showed ebb-tide upon a lonely shore; the sea was far withdrawn, and the wet sands, broken here and there by dark rocks, reflected the splendour of 'The Evening Star,' glittering brightly low down in the paling but still lambent gold of the western sky. The other, now happily in the Guildhall collection to which it was presented by some of the artist's admirers, strikes a different note. 'Isles of the Sea' is also a sunset-piece; but, instead of tranquillity, agitation pervades both land and sea. Along a high horizon and against a sky streaked with dusky, purple clouds, from which darkness is fast stealing the glory, a chain of rocky islets raise their jagged forms, while the sea, dark where it cuts against the sunset light, surges amongst the shoreward rocks, catching in its hollows some radiance from above.

Hope M'Lachlan's sympathies were not limited to moods such as these, as pictures like 'Bathers' and 'Idleness' show, but they were those to which he gave most convincing expression, and it is in virtue of the poignant way in which he interpreted them that he occupies a place in the affection of all who love fine landscape. But although he had been an exhibitor in the chief London Exhibitions for a good many years, and had made a few ardent admirers amongst the discriminating, it was not until

shortly before his death, and perhaps not adequately until the memorial exhibition organised by his friends, that his refined and poetic art drew the attention it so fully merited. He worked in both oil and water-colour, and mention should also be made of a number of admirable and highly expressive etchings executed by him. Several of the last were reproduced in an article in the *Magazine of Art*.

While much of the best and all the pretty and most characteristic work of purely English landscape painters is concerned with the gentle charms of the Southern districts, with tree-dotted hedgerows and pleasant water-meadows and willow-fringed brooks, blossoming orchards and bosky summer woodlands, flower-embowered cottages and immemorial church-yard elms, Hope M'Lachlan found his happiest inspiration in the expansive and comparatively bare landscape of the North ; and this appreciation of the wilder and less-tamed beauty of Nature, no less than the subordination of prettiness of subject to the moods and sweep of atmospheric effect and the fondness for depth of colour and tone, which are so conspicuous in his work, one may trace, not improbably, to his Scottish blood.

Both Cecil Lawson and Hope M'Lachlan died comparatively young, and, perhaps, before their gifts had attained complete maturity, but fortunately J. Lawton Wingate,[1] the third of these poetic painters, has been spared, and is now in the fullness of his artistic powers. Born in the neighbourhood of Glasgow in 1846, Mr. Wingate spent several years in a merchant's office before he was able to devote himself entirely to the art he loved. In 1864 he exhibited his first picture in the Glasgow Institute, and three years later he celebrated his majority and his new found liberty by spending six months in Italy where he commenced to paint out-of-doors, his work previously having been executed principally in water-colour from elaborate pencil drawings made on the spot. Until 1872, however, when he suddenly decided that it would be well to learn his trade, and removed to Edinburgh to attend the Antique school conducted by the Board of Manufactures, he had little technical instruction. When a man is twenty-six before beginning serious study, it cannot be expected that he will ever gain the surety and facility of draughtsmanship attainable in youth, but the life-class of the Royal Scottish Academy, to which Wingate was admitted a year later, was a stimulating influence, Chalmers and M'Taggart being visitors, and he gained much from it. But the desultory nature of his training has crippled his power of expression in certain directions, and, in consequence, detracts from the artistic completeness of his pictures, while it seems to render work on a large scale difficult to him.

Nearly all great artists have been actuated in the beginning of their careers by profound respect for the material of Nature, and this they never

[1] This estimate of Mr. Wingate's art is founded in part upon an article written by the author for the *Art Journal* of 1896.

lose, although in the course of years they enter into its spirit more and more, and express the emotion produced rather than the material facts which create it. And it has been so with Wingate. At first the growth was exceeding slow, for some years there was little apparent, one elaborate picture succeeding another: the artistic nature of the man was long encased within a sheath of excessive conscientiousness. But it was constant and consistent, one petal unfolded after another until now the flower is in full bloom.

If in figure-work it is hard to forgive feeble and defective drawing, one is less exacting in landscape, and Wingate's, while lacking profound knowledge and constructive power, is sensitive and possesses the subtle charm of suggestiveness. What his drawing really misses is style. Although he seems to observe form carefully and to be quite alive to the claims of characterisation, his rendering in the matter of line is rather undistinguished. His sense of composition also is not very strong. Hung beside a good Corot, the finest thing Wingate has done might seem wanting in beauty of arrangement and grace of line : it would not be perfectly balanced, for the severe yet passionate melody of line and mass, which mark the masters of design, is not his. Yet it is a quality for which he has striven, and in many of his later pictures he has come very near success. Delicate play of brushwork and subtle modulation of tone and colour—the elements in painting kindred to turns of expression and inflection in speech—are the qualities which give charm to his work on the technical side, and through which he expresses the sentiment which prompts his skill. He often attains a quality of surface and a suggestiveness of handling of peculiar charm, and his colour possesses the compelling fascination which comes of a pervading harmony through which brilliant hues glow without asserting themselves. And that he reinforces by a refined and suggestive use of the romantic element of chiaroscuro.

When one turns from consideration of Wingate's means of expression to the matter expressed, there is little but praise to bestow. At first sight it appears as if his art were peculiarly fitted to find ready acceptance with the public. It demands little technical knowledge for its understanding, while the sentiments and subjects with which it deals suggest common ground for all. On further consideration, however, one finds that his feeling for Nature is too subtle and deep to be widely popular. The popular painter is he who paints the pretty and the obvious, and sees Nature as the vulgar do ; not he who, through greater appreciation of beauty and more refined and penetrating perception, sees into the life of things. But if Wingate's art cannot be really popular, these elements ensure it a wider audience than art merit alone could. It charms the artist and delights the lover of Nature. In much Scottish landscape-painting topographical interest counts for a great deal, but his depends solely on emotional and æsthetic charm, on beauty of sentiment and

expression. In an attitude like this, subject is of far less importance than the conditions under which it is seen, and Wingate has the happy knack of seizing the fortunate moment when the forces of Nature combine to produce a beautiful and memorable effect. To few men has a more beautiful vision of the world been granted than that revealed in his pictures. His landscapes bring us close in touch with that poetry of earth which Keats assures us is never dead, and, if one loves Nature well, they assuredly must awaken a responsive thrill. They are reminiscent of all times and seasons, but most of hours when winds are soft and Nature smiles. They breathe of country lanes and sunlit fields, of dewy pastures and twilight valleys, of quivering leaves and hay or hawthorn-scented breezes. To the majority of men, consigned by fate to toil in stony cities, communion with Nature, and the content and joy it brings is granted seldom, but, if they may not often meet her face to face, pictures such as these, drenched in her spirit, bring her very near.

Wingate's art reaches its culmination in his sunset pictures. In a homelier but not less real sense than Turner, Corot, and Whistler, he is a chosen priest at the shrine of dying day. It is not the evening which flames and burns and glows on Turner's magnificent canvases, nor the lovely grace, the voiceless yet perfect melody of the day which dies beyond the stream, behind the trees in the enchanted land where Corot dreamt, nor that ominous and pregnant hour, when twilight is conquered by the night, which haunts one at memory of Whistler's nocturnes, that has inspired Wingate, but the glamour of gloaming falling on pasture, copse, or hillside, and hushing all things to sleep in our own northern land. 'Tis the midtime between the glory and the dark that he loves best ; the hour hallowed to Scottish poetry by Kilmeny's return. Here he touches many a chord,—the clear solemn glow of winter twilights, the wan flush that closes days which herald ' The wa' gaun o' Winter,' the serene calm of golden summer sundowns or the rich quiet of afterglows which follow the splendour of autumn sunsets. But, while Wingate has achieved his chief successes in the past when dealing with evening, and he remains a master of sunset in all its moods, from the elegiac tenderness of mellow and subtly graded greyness to the imposing pomp of scarlet and gold and purple, his studies of these effects do not now outshine, as they used to do, his painting of daylight. Sometimes the colour in his daylight pictures was slightly dusty, as if it had come with difficulty and in repeated painting lost its first freshness, but some of his recent harvest scenes and pastorals, in which chords of silvery white, and yellow, blue and grey, are interwoven to produce cool, delicate harmonies, are as full in tone and carry as well as the most glorious of his sunsets. And in several moonlight pictures, painted during recent years, he has succeeded in great degree in the all but impossible feat of painting the colour of night illumined by the moon, in a way a more difficult problem

than the moonless night from which Whistler evoked such poignant beauty.

The appropriateness, born of a habit of harmonious thought, which distinguishes the introduction of incident in the landscapes of the masters already mentioned, is present in Wingate's pictures also. Beneath the pageantry of Turner's skies 'The Fighting Téméraire' is tugged to her last berth, Ulysses derides Polyphemus, or Leander swims to his doom.; Corot peoples his fairy woodlands with sprite and nymph; under the transfiguring touch of darkness the figures in Whistler's night-pieces become dim, shadowy, phantom-like; and in Wingate's pastorals we have the plough turning on the head-rig, reapers in the harvest-fields, or the cattle coming home.

A fellow-Academician once remarked that Wingate was too easily satisfied in the matter of subject, and never painted the grand or the exceptional. It is true, but not as a reproach. The grand and the elemental do not appeal to him : he does not delight in mountains, pathless woods do not charm him, he has never felt the fascination of the sea ; but the beauty he distils from simple and everyday things is wonderful. As for the exceptional, it seems to me that the highest as well as the most useful function of art is not the creation of the fanciful and the far-off, but the revelation of the meaning and the beauty in the commonplace. The former may drug our senses for a while, but the latter once revealed is ours for ever. As works of art Wingate's pictures may be defective in design and lacking in monumental impressiveness, but like snatches of the most exquisite song they are pregnant in suggestion and thrilled with the rapture of intimate contact with Nature—qualities as precious and as rare as the architectonic beauty of classic art. These little pictures of his, so simple in motive, so slight in subjective interest, are like to retain their charm far longer than most of the ambitious art which makes a stir in the world to-day. Scarce more than sketches many of them, but of a spirit so rapt and so attuned to Nature's harmonies as to possess qualities of enduring fascination.

During the eighties Mr. Wingate lived at Muthill, a lovely village near Crieff, and in the more important pictures of that period, 'Wanderers' (1879), 'Quoiters' (1880), 'Winter Twilight' (1882), 'The Poachers' (1885), 'Watering Horses' (1887), to name no more, interest was divided between figures and setting ; but since then the former, while still contributing to the sentiment, have been subordinated to the emotional moods of landscape and sky, which may be said to play upon his refined and sensitive perceptions as the winds pipe amongst the reeds. He was elected A.R.S.A. in 1879, membership following seven years later.

CHAPTER VI

PICTURES OF THE SEA

A PICTURESQUE and mountainous country surrounded on every side, except the seventy miles between Berwick and the Solway, by the sea, and so penetrated by firths and estuaries and sea-lochs that only four out of her thirty-three counties are not touched on some part of their margins by the tides, Scotland has a coast-line of exceptional extent, variety, and beauty. The high red rocks and little sandy coves of Berwickshire; the golden fringes and green sea-braes of Fife ; the dark forbidding cliffs of Aberdeen and Banff ; 'the desolate islands and roaring tide-ways of the north' ; the magical and haunting charm of the western sea-lochs bosomed in the green hills of Appin or Morven or brooded over by the rugged peaks of Skye ; the broad expanses of sand, yellow and white, that meet the onslaught of the Atlantic at Machrihanish or Iona or in far-off Barra ; and the long lowlands bordering the fast-running Solway—each with beauties of their own, and all touched with the glamour and romantic suggestiveness of the infinite sea with its unceasing ebb and flow : these to a people sensitive to the aspects and the emotional appeal of Nature have a never-ending fascination. Yet, from causes which were discussed in the chapter dealing with the rise of a national school of landscape, it was not until about a hundred years ago that the feeling for Nature found expression in Scottish painting. From that time, however, her shores and seas, as well as her inland places, have not failed to find devotees, and in this, as in pure landscape, Thomson of Duddingston was a pioneer. In love with unrest and mutability no less than with the enduring monuments of history, the prisons of the Bass, the solitary keep of Fast Castle, and the towers of Tantallon or Castle Baan, perched high, like eyries, on the cliffs above the never-resting sea, drew him again and again, and inspired some of his finest works, which, if not free from conventionality, breathe the freer air of reality also. The Schetkys, who, however, although born in Edinburgh, were of foreign extraction and did most of their work in England, produced sea-fights in the style of Clarkson Stanfield and the Dutchmen, from whom in part he derived, while Ewbank, Fenwick, and Simson, also influenced by Van de Velde, Bakhuysen, and Cuyp, painted pictures of the trading fleets of the North Sea : collier-brigs and schooners stealing

out with the tide from Tyne or Tees on a still day, mixed coasters flitting up Forth to Burntisland or Leith before a spanking breeze, or, crossing over to Holland, gabbards and barges sailing with decks awash or lying becalmed in the Scheldt or Maas, in which, although the shipping took precedence, the sea had perforce to be painted. Then came Jock Wilson with that freer and fresher treatment of shipping incident and greater interest in the movement of clouds and waves, which made him and E. T. Crawford, who excelled him in naturalness of effect, if he did not surpass him in animation of conception, and whose range of subject was greater, transition men, in whose work the convention of the past is seen becoming transfused by the modern spirit with its greater love of reality and its greater power of realising it. Sam Bough, too, if modern in many respects, and never more so than in his East of Fife drawings, stood at the parting of the ways, while Fraser and Fettes Douglas, although occasionally painting the coast, cannot be counted amongst those who have painted the sea. And this brings us to M'Taggart and what are, everything considered, the finest sea-pictures ever painted : pictures pregnant with the sea's hidden witchery, its haunting secret. In them unique imaginative apprehension is combined with an equally wonderful power of rendering in pictorial terms the material and dynamic qualities of the sea : its vastness and unity ; its liquidity and the endless variety of its evanescent forms ; its marvellous colour, compounded of its own tinted transparency, local conditions and reflections from the sky ; its never-ceasing and irresistible movement, whether that be the heavy and sullen heaving of a mighty swell which explodes angrily in hissing white but now and again, or the joyous dance of innumerable wavelets sparkling and chattering amid the blue of June ; the mad but ordered career of ever-recurring lines of rearing and plunging white horses, driven by the sea-wind, coursing one after the other to spend themselves in a last glad spurt of creaming foam upon the shining shore ; the never-stilled laughter of sun-illumined ripples playing over sandy shallows ; or the unruffled but inevitable incoming of a tide in which floating clouds and flying birds and passing ships are reflected as in a burnished mirror. As reference has been made elsewhere to the influence of his art as a whole, here it must suffice to say that it is quite evident in the work of several of the men discussed in this chapter.

Trained in the same school as M'Taggart, and his contemporaries, but choosing a narrower outlook, and each developing for the most part an individual mood—grey-green, foam-flecked, and sad ; opalescent and gay ; and sun-lined grey respectively—Peter and Tom Graham and W. F. Vallance likewise found the impulse for some of their best pictures in the sea.

The work of all these has been discussed, however, in its relationship to the group to which each belongs by training or affinity. But in a

chapter devoted to Scottish sea-painters, James Cassie's many pictures of calm dawn or chastened sunset over still, or at most slightly stirred, waters must not be forgotten. Cassie (1819-79), indeed, was an artist of some talent, in his limited way, and the very quietude of mood which marks his most characteristic work and gives it distinct charm, is apt to blind one to its true, if modest, merit. An Aberdeenshire man, and spending most of his life in the Granite City, he was elected A.R.S.A. in 1869 and Academician ten years later, only three months before his death. William Carlaw (1847-89) also, though he died before his art was fully developed, left a number of fine water-colours in which the sea and incidents of fishing or harbour life are depicted with much freshness and some power ; and Robert Anderson (1842-85), after devoting many years to line engraving with a success which secured him his Associateship (1885), gave the last six or seven years of his life to water-colour, in which, if never quite freeing himself from the precision and hardness of his engraver's training, he produced many large and powerfully handled drawings concerned with fishers engaged in their perilous calling ; while, a year before he died, he painted a large oil picture, ' The Harbour Bar,' which gave indication of distinct ability in what was a new medium to him. And amongst more recent men who, although principally painters of landscape, have painted some aspects of the sea, one may name Hope M'Lachlan, whose few sea-pieces are amongst the noblest and most imaginative of their kind ; Mr. John R. Reid, whose finest canvases of down-Channel ports are redolent of the salt breath of the open ; Mr. David Murray, in his pictures of the Loch Fyne fishing area ; Mr. Campbell Noble, in the earlier results of his sojourn near St. Abb's ; Mr. Robert M'Gregor, in whose pictures, however, it is accessory to figure incident and interest ; and, anticipating a little, Messrs. Roche, C. H. Mackie, and Whitelaw Hamilton.

To return to those who have not only painted the sea but have found in it their liveliest interest, we must go back to men who are contemporaries of M'Taggart—to Colin Hunter, Hamilton Macallum, Joseph Henderson, and R. W. Allan.

Colin Hunter (1841-1904), to begin with the most prominent, was born in Glasgow, and, being brought up at Helensburgh, where the Clyde opens into its noble estuary, received his boyish impressions amongst the lovely sea-lochs and hills which bring the beauty of the Highlands to the very doors of the western capital. He began, however, by painting landscape in the company of Milne Donald, one of the best of the earlier Glasgow artists, and for some years pictures, closely studied from Nature and carefully wrought, of scenes in the Trossachs district and Glenfalloch were shown by him in the Royal Scottish Academy ; but, while he afterwards produced some excellent landscapes, of which ' The Pool in the Wood ' (1897) in the Liverpool Gallery is perhaps the best, the finest and

most characteristic work of his maturity was inspired by the western seaboard.

Towards the end of the sixties Colin Hunter took seriously to seascape. The first picture he showed at the Royal Academy (1868) was called 'Taking in the Nets'; and by 1872, when he left Edinburgh, where he had had a studio for three or four years, for London, his work as a sea-painter had attracted some attention, while a year later, when 'Trawlers Waiting for Darkness' was seen at Burlington House, the strength and originality of his talent was fully recognised.[1] It is said to have been upon the phenomenal success achieved by that picture that the artist's friend, William Black, modelled the equally sudden, but less-worked-for, acceptance of Lavender, the kid-gloved hero of his most notable story, whose pictures, it may be remembered, were also painted at Tarbert.

To Colin Hunter, more than to any equally eminent contemporary, the sea was a wonderful quivering mirror rather than a mass of moving water with a mission and an apparent life of its own. At least it is with its marvellous flux and change of colour under certain conditions of atmosphere, more than with its subtleties of motion and form, though these are suggested also, that his pictures are chiefly concerned. To some extent this may have been due to want of definite training, for sketching with Donald, while no doubt stimulating his natural taste, meant little in a technical sense; and the few months spent in Leon Bonnat's studio at a later date, though probably doing something for his drawing, left no obvious trace on his style. His actual painting seems the direct and instinctive outcome of personal vision and, taken as a thing in itself, is not to be admired. Somewhat heavy-handed and summary, it lacks flow and flexibility, and his paint quality is apt to be 'stodgy' and smeary. His drawing also, while robust and expressive even in the figure incidents which often enrich and complete his happiest designs, is without delicacy and elegance. On the other hand, he was a master of ensemble and harmony of effect, had a keen perception of certain poetic qualities of light and chiaroscuro, and was a powerful colourist within a rich and low-toned if limited range. Further, deep feeling and original observation make his finer achievements significant and memorable. 'He is as original as Claude Monet,' writes Mr. D. S. M'Coll, who owns to being no great admirer of Hunter, though he is of Monet; and, as matter of fact, he painted emotional effects of Nature which none had previously attempted. He did not possess that combination of spiritual insight and flexible technique which makes M'Taggart's sea-pictures incomparable in their kind, nor had he at command the melting yet decisive touch which is the crowning quality of Hook's marines and gives them their peculiar charm of limpid surface and colour; Henry Moore excelled him

[1] Elected A.R.A. 1884. He was also a member of the Scottish Water-Colour Society.

in painting the mad and giddy nod and sway of the open sea heaving under the impulse of a coming or going gale, and Napier Hemy surpassed him in sheer realism of the visual effects of which he is such a master. Hunter, however, possessed a quality of his own in which he was without a rival. This was a perception, not so much of the tragic sorrow as of the immemorial sadness of the sea which washes the Celtic fringes and sunset shores of these islands. His west-coast pictures, painted in Scotland or Ireland, are instinct, as perhaps no others have ever been, with that brooding melancholy, half in love with sadness and wholly resigned to fate, which is frequently spoken of as characteristic of Celtic sentiment; a melancholy deeper and more poignant than one finds in the conventional 'sad sea waves' of Peter Graham, in the grey yeasty tumble that foams and frets in Mesdag's Scheveningen pictures, or in the bare and desolate and wind-swept Nordsee of the German and Danish painters. It is in pictures such as 'Trawlers Waiting for Darkness' (1873), 'Their Only Harvest' (1879), one of the few wise purchases of the Chantrey Trustees, and 'Signs of Herring' (1899), where the sentiment of dying light is associated with some incident of sea-toil with its perils and uncertainties, that this pathetic quality is most marked; but in other pictures of the western sea-lochs, seen under conditions of daylight and atmosphere which appealed to the most sensitive side of his nature, it is present also in rich measure. When he painted a hillside of grey rock and green brae and purple peak, lying under a quiet but rather sullen grey sky, reflected in deeper tones in the still loch across whose unrippled surface sheep were being ferried in a clumsy boat, or a load of bracken, which cast a long quivering shadow of tarnished gold, was being slowly rowed home, a glamour seemed to lie upon the land. One felt the air pregnant with a suggestion of mystery, and knew that the silences were unbroken save by the bleat of sheep, the crying of sea-birds, or the rare pulsation of distant oars.

His rendering of bright daylight and the sea running in crisp curling waves upon the shore is less successful, for there his tendency to dark colouration, his somewhat clumsy drawing in paint, and a want of delicacy in his touch militate against attainment of the impression he sought to convey. Yet the 'Herring Market at Sea' (1884) is a wonderful presentment of the radiance and clarity of early morning light over a great stretch of calm water; and his etchings reveal a certainty and decision of draughtsmanship which, combined with great skill in arranging darks to suggest brilliance of light, make them admirable examples of that difficult art.

Hamilton Macallum (1841-96) was original also, but he had not the fortune to be favoured by the Burlington House coterie; and when he died the only letters he could append to his name were the rather insignificant ones R.I. Yet, as letters are not a patent of ability, and

Macallum was a true, if not a great, artist, his work may be remembered when that of many more honoured has been forgotten. After a boyhood spent on the Kyles of Bute, he was for some years in a Glasgow merchant's office, and was twenty-three before he obtained his father's consent to become a painter, and, going to London, entered the schools of the Royal Academy. Though thus late in beginning serious study, he acquired considerable technical skill in both oil and water-colour, and came to use paint in a manner which gave full expression to the genuine delight in light and sparkle which was the essential quality of his gift. His actual brushwork, however, although producing a broad and fused effect of light and colour when seen at a little distance, consisted of a series of what may be called 'pattering' touches with smallish brushes, which can scarcely be counted masterly, his drawing, if frequently expressive, was not powerful, and at times his colour was apt to fall short of complete harmony.

Like Colin Hunter, he painted many of his pictures in the West Highlands, where he cruised a great deal in a small yacht of his own; but, unlike that artist, he loved their brightness better than their gloom. For him the sea irradiated by the sun had the most lively fascination, and 'the shattered sun-gold of the main,' as a poet has phrased it, was painted by him with wonderful success. It was the mood of frolic rather than of pathos or reverie that he delighted in, and he enlivened his pictures of dancing and glittering sea with boys bathing from boats or fishing from the rocks; with brown-sailed smacks beating to the fishing-grounds on fine afternoons, the crews shouting in chorus or singing to the strains of a melodeon; or with fisher-girls waiting for the return of their sweethearts, or helping gaily to land the sparkling catch upon the shining sands. More rarely, as in 'Setting the Storm Jib' (R.A. 1875), he showed the sea in sterner mood; and now and then, as in 'Cutting Wrack in the Sound of Harris' (R.A. 1876), or 'The Crofter's Team' (R.A. 1896), in the Tate Gallery, which strikes a less joyous note and has less sea than usual, he dealt with other phases of life amongst the crofter-fishermen of the Isles. Invariably combinations of figures and sea, the figure interest, which predominates in some of his pictures, is usually conceived in a vein of sentiment which inclines to verge on sentimentality. Nor was it otherwise when, seeking the sun, he worked at Capri surrounded by the brilliance of the Mediterranean, where he painted that wonderful study of luminous sea and sky, 'Coral Fishing in the Gulf of Salerno,' shown at the Grosvenor in 1884, and other notable things, or in Heligoland, which inspired 'A Kiss from the Sea' (1886), and some lively bathing-scenes.

As a painter of the sea Hamilton Macallum just missed the first rank, for, real as his love of it was and wonderfully as he painted certain of its phases, especially its 'multitudinous laughter,' his pictures lack a sense of

that seeming inward life and power and of that unbroken continuance of elemental existence which are perhaps the strongest elements in its appeal to the imagination. But his painting of sun-steeped atmosphere over sun-illumined salt water attained an extraordinary quality of luminosity and revealed a touch of genius, which are strong claims for remembrance, and justify Sir Walter Armstrong's opinion that Macallum was one of the most original landscape-painters of his time.

Compared with M'Taggart and Hunter and even Macallum, Joseph Henderson and R. W. Allan reveal a less deep passion for the sea, and express a more ordinary view of its beauty. Henderson, indeed, seemed to care less for its profounder meanings and subtler aspects than for the feeling of holiday repose and expansion it brings to jaded denizens of cities. Looking at his pictures, painted in Cantyre or on the Ayrshire shore at the Maidens or Ballantrae, one is reminded pleasantly of many a delightful day at the coast. But the sea magic with its rapture and its tragedy he rarely captured. To Mr. Allan, also, though he usually deals with the sea in its relationship to the daily vocations of fishing communities, its more elusive phases and associations are as a sealed book. Still if their pictures seldom appeal to the imagination or intoxicate the senses, each is a faithful recorder of some aspects of the sea's manifold charm which, like Cleopatra's infinite variety, age cannot wither, nor custom stale.

A native of Stanley, Perthshire, Joseph Henderson (1832-1908) was well on in his career before he gave his attention to sea-painting. He was brought up in Edinburgh and studied at the Trustees' Academy just before the advent of Scott Lauder, but in 1852 he removed to Glasgow where he settled, and where for the last twenty years or more of his career he was looked up to as the doyen of the local artists. His earlier pictures were genre in character, and, when seen at the special exhibition organised by the Glasgow Art Club in the beginning of 1901 in honour of his jubilee as a professional artist, they came as something of a revelation to those who knew only the work of his maturity. Incidents of domestic life set in cottage interiors or, more rarely, in the open air, and treated with touches of sentiment or humour eminently characteristic of their painter, they were closely studied in detail, admirably drawn, and told their stories well, while they were painted with a delicate precision of handling and a refinement of tone, charming in themselves and typical of the best elements in the tradition in which he had been reared. 'The Ballad' (1858), a beautiful country girl standing in a delicately suggested woodland landscape—the first out-of-doors picture painted by the artist ; 'The Sick Child' (1860), one of the few pathetic but perhaps the most important of his genre subjects ; and the study 'An Old Highland Kitchen' (1870), which shows his earlier method at its very best, may be instanced as typical of his early aims and attainments. Pictures such as these, and portraits, mostly ill remunerated and some frankly commercial in purpose—for the art public

in Glasgow was still small and artists had to accept any commission that would help them to cling to their art—were the chief products of the first twenty years of Henderson's career, but during a holiday at Saltcoats in the early seventies he discovered that his real bent was towards the sea. Thereafter while portraiture, in which a rising reputation and unfailing skill in catching a pleasing likeness secured him many commissions, continued to engage a large share of his activities, genre was for the most part abandoned for pictures of the sea. At first, figure incidents of considerable importance, as in 'From the Cliffs of Ailsa' (1879), where sailormen land sea-birds caught on the cliffs of the craig seen in the offing, or 'Kelp Burning' (1885), in which crofters are at work amongst masses of burning wrack, were introduced frequently into his larger canvases ; but gradually these were reduced in scale, until latterly one or two children sailing boats in the shallows or playing on the sands, a steamer's smoke on the horizon, a fishing-boat heeling to the breeze, or, perhaps oftenest of all, a salmon cobble bobbing at the nets, of little moment except as points of colour or as suggestive accessories, was all that competed with the interest of sea and sky. Gradually also his colour and handling, which in his earlier seaside studies had inclined to blackness and stringiness, gained in freshness and fusion, and in these respects and in spirit his seascapes of the last decade, of which 'The Flowing Tide' (1897) in the Glasgow Gallery is a fine example, are distinctly the best he ever painted. Except M'Taggart, traces of whose influence may be detected in his work, Henderson painted a greater variety of sea effect than any other Scottish artist, but he seemed to find his chief pleasure in days when the wind blows briskly from the west and a promise of rain hangs on the horizon.

Joseph Henderson's career has a significance beyond its personal bearings, for during the fifty odd years he painted in Glasgow the western city become a centre of artistic activity, and his personality and influence helped in no small degree to make that possible. Before him, no artist of equal prominence had lived the whole of his professional life in the city ; the ideals of artists were misunderstood and distrusted, and few thought it worth while not to misunderstand them. Circumstances had taken him to Glasgow, and, making the best of them, his earnestness of purpose, strength of character, and devotion to art won respect for himself and his craft, and, in combination with the work of a few other painters and art enthusiasts, gradually prepared the way for a new and vigorous movement in Scottish painting.

In the year that Henderson went to Glasgow Robert W. Allan was born there, but when about thirty he abandoned his native city for London, where he has since taken a good and even a prominent place. One of the leading members of the Old Water-Colour Society, he is also associated with the group of landscape men who show each year in the

Dudley Gallery.[1] Study at home had been supplemented by study in Paris, and Allan possesses very considerable technical dexterity which is seen at its best perhaps in the pictures he paints on the north-east coast of Scotland and among the fishing-villages which nestle in the coves or hang upon the ledges of the black Banffshire cliffs. There the east wind eats the warm colour out of things, and the sun seldom sparkles on the sea ; the boats are black and the water oftenest cold grey-green marbled with white ; and the rare touches of richer colour are supplied by tanned sails and painted buoys, by red pirnies and tiled roofs. But while this is a description of the district which R. W. Allan paints, drawn from his pictures, it does less than justice to his cool harmonies of colour, which, if rarely brilliant, are always fresh and seldom cold ; while his deft and facile, if rather undistinguished, drawing, fluent brushing, and effective grouping and design are not even hinted at. Turning to his subjects, one finds them animated in conception and full of incident admirably introduced and related to the principal motive. In one picture he will show the bustle attendant on the departure of a fishing-fleet ; in another the boats—a feather at every bow, and a white following track astern—will be seen well under way ; while a third may depict the catch being landed in some little creek round which red-tiled cottages cluster. Perhaps the most notable of his fisher-pictures, however, are those in which he has dealt with the boats safely in harbour when a storm is raging outside and big grey-green waves are knocking on the harbour walls or spending themselves in spurts of cold and angry white upon the dark rock-bound coast. But while coast and harbour pieces such as these—he very rarely paints the sea except as seen from the shore—are perhaps the most characteristic things Allan does, they represent but one phase of a very versatile talent. He has painted many able Scottish landscapes, amongst which that in the Aberdeen Gallery, which shows great droves of cattle crossing the far ebb-tide perspective of the fords between two of the Outer Hebrides under a vividly realised effect of sunshine, is one of the most remarkable ; and he has sketched much in Holland, Belgium, France, and Italy. It is in water-colour, however, that his finest foreign work has been done. Possessing a sound technical grasp of that medium and using it with verve and brilliance, which would gain in effect if the individual markings were more fused in the play of light, and employing a warmer palette than he does in oils, his rendering of the market-places and quaint buildings of the old cities of the Low Countries and of Italy are particularly animated, and the series of drawings of cities and temples and crowds made during a tour in India (1891-92) may also be commended for vividness of effect.[2] But while more reticent in colour and less dexterous in touch, his earlier water-colours painted on the quays of Paris or in

[1] In 1907 'The Landscape Exhibition' was removed to the rooms of the Old Water-Colour Society. [2] Mr. Allan visited Japan in 1907.

French fishing harbours are marked by a charming quality of silvery light and a daintiness of handling which place them amongst his happiest efforts.

Though tending to prevent an artist becoming stereotyped, a wide variety of interests almost necessarily implies a certain lack of clearly defined personal preferences, and it is possible that Mr. Allan's work would have gained from greater concentration. In any case it is depth and richness of technique, design, and emotion that his art chiefly lacks, but whether he could have attained these without sacrificing the more immediate and effective qualities which it possesses is a different question. It is probable, however, that they are outside his gift.

Having discussed the work of the older and better-known Scottish sea-painters at such length, it is impossible, even though it were desirable, to deal with that of the rest in any great detail. The marines and shore-pieces of Messrs. J. D. Taylor, Andrew Black, John Nesbitt, J. D. Bell, Alexander Ballingall, and one or two more of somewhat similar age and standing, if unaffected in feeling, possess no qualities of technique or emotion calling for comment ; but there are a few others, mostly younger men, who may not be dismissed by mere mention of their names.

No Scottish painter of his time was more various than J. Thorburn Ross (1854-1903), and of none while he lived was it more difficult to form a satisfactory estimate. Each year something new and unexpected came from his easel, and if the variety was bewildering, the gusto which animated each different phase was no less remarkable. Nor was the originality of the point of view less notable ; 'Joe Ross' was always personal and never commonplace. And being a bold and instinctive, and at his best a refined and subtle, colourist, and using paint with a distinguished sense of its material beauty, his work had often a delicate and charming bloom. His method in water-colour also was marked by an artist's instinct for the proper use of his medium. Yet in his larger pictures these admirable qualities were associated with others, which tended to give the impression that they expressed the outlook of a distinct but incomplete and somewhat erratic artistic personality. Although he could paint detail with delicacy, his draughtsmanship was weak, as may be seen in his portraits and important figure-subjects, and, while usually fine in colour and mass, his design frequently lacked simplicity and cohesion— a defect which, combined with fondness for decorative effects of striking character, gave a rather confused and puzzling effect and a bizarre look to his more ambitious pictures. It was with pleasure and something of surprise, therefore, that one saw the exhibition of his works, held in Edinburgh a few months after his death, for there, with a number of the big pictures he had shown in his lifetime, were a series of studies and sketches which revealed the essence and finer qualities of his gift and placed it in a new light. While the feeling for decorative placing was visible enough in most of these, one saw at once that in elaborating his exhibition pictures

in the studio, it had been allowed to override the spontaneity and fresh-
ness of impression and the zest in the loveliness of Nature which were the
deepest elements in his nature. One also became aware that he had
found his truest inspiration in the sea and things connected with it. Some
of his little seaside bits, often with bathers or paddling children or flutter-
ing sea-birds, are very charming in feeling and exquisite in colour and
handling, and even his larger pictures with similar motives, though the
impression they convey is weakened by the immobility imposed by decora-
tive convention, retain some of the fascination which these spontaneous
sketches have in rich measure. At the same time, his delight in the sea
was stirred more by its brilliant purity of colour and the sparkle of
light upon its sheeny surfaces than by its deeper meanings and august
attributes.

Thorburn Ross belonged to an artistic family—his father was R. T.
Ross, R.S.A., and his sister, Miss Christina P. Ross, was one of the most
accomplished of Scottish lady artists—but he spent some years in business
before he was allowed to turn painter, and he was not elected A.R.S.A.
until 1896. One of the most sympathetic and most amiable of men, his
tragically sudden death in his Edinburgh studio was deeply regretted by
all who knew him.

Mr. R. M. G. Coventry also, although he painted landscape before he
took to the sea, has done some of his most successful work upon the shore.
His earlier pictures of this kind, drawn from the lower reaches of Loch
Fyne and from Kilbrannan Sound, were vitalised by a fine sense of luminous
atmosphere, and by true, if not deep, appreciation of the beauty and move-
ment of the sea when it dances in a jabble of pale blues and silver whites,
or runs in crisp green wavelets upon light-grey shingle or delicate grey-
blue rocks, amongst which he often introduced a fisherman or two, quietly
busy mending nets or baiting lobster creels, as notes of stronger tone to
accentuate the high pitch of lighting for which he strove. More recently,
however, the long, flat beaches of Holland, with huge and clumsy-hulled
fishing smacks lying on level keel upon the ebb-tide sands under wan or
windy grey skies and dwarfing the crowd of fisher-folk which clusters about
them—a motive compounded to some extent from those of James Maris,
Mesdag, and Blommers, but marked by less impressive sentiment and tech-
nique, and treated in brighter colours and higher tone—have supplied his
subjects. Many pictures of Dutch waterways, sometimes in the country,
but oftener in the old-world cities, and nearly always with shipping incident,
have likewise resulted from his many foreign sojourns. These, however,
are usually in water-colour, which seems the more sympathetic medium in
his hands, and, despite a certain want of co-ordination amongst the parts,
and a too spotty manner, they show distinct feeling for brilliant light and
high-pitched colour. But Coventry never abandoned landscape completely.
From time to time he painted scenes in the Highlands, usually in the

autumn when golden birches rise gracefully against grey skies, and of late years the grey-green landscape of Noord Brabant has figured frequently on his canvases. Compared with Coventry, who was elected A.R.S.A. in 1906, Alexander Frew (d. 1908), a considerably younger artist, was more concerned with the deeper tones, richer impasto, and more closely knit technique, typical of the newer Glasgow ideals, and in the studies of sea and atmospheric effect, which resulted from much cruising amongst the islands, over-insistence on these qualities detracts from an otherwise salt and stinging savour. Yet painted, or at least studied, in the open, with a sailor's eye to wind and tide and weather—he sailed his yacht himself— they possess a distinct character of their own. Mr. Mason Hunter, too, if his drawing is on the heavy side and his observation is slack as regards the more subtle elements in colour, light, and form, has a considerable relish for the sea, and his broadly massed and impressionistically touched pictures and drawings, which are often enlivened by the presence of fishing-boats, express certain of its aspects with some power and charm. And similar methods applied to landscape issue at times in impressive mountain pictures like ' In Alan's Country of Appin.' The sea and shore pieces of Mr. Marshall Brown, if also undistinguished in technique, and dominated in colour by a slightly over-brown but rather pleasant mellow grey, are carefully studied, and the figure incidents which he introduces, if commonplace in conception, are well enveloped in atmosphere.

A fuller and more significant rendering of the might and magic of ocean than that given by any of these, and indeed by all but two or three of those mentioned in this chapter, has been attained by Mr. R. C. Robertson, a young Edinburgh painter, of West-Coast birth and breeding, in the few pictures he has brought to successful completion, for he is a most erratic workman, and many a splendid beginning has come to nought on his easel. Yet, if he could but curb his ambition, which, including portrait and figure as well as landscape and marine, is too diverse for his present technical equipment, specially in draughtsmanship, and would concentrate his energies upon those phases of Nature, and particularly of the sea, in the interpretation of which his true strength lies, he might achieve something really memorable. As it is, the half-dozen big sea-pieces which stand to his credit are so instinct with the majestic sweep and motion of the open ocean as it rolls on the Atlantic side of the Outer Hebrides, so fragrant of its briny freshness and so steeped in its pure and pearly colour, that he must needs find a place in any account of what the Scottish school has achieved in painting the sea.

Association of ideas rather than similarity of subject make this the appropriate place to mention the work of Mr. James Kay, who, although he has painted ' down the water,' has made his distinctive place as ' the painter of the Clyde ' by pictures of the shipping on the upper reaches. The stretch of river between Bowling and the Broomielaw cannot com-

pare in picturesque elements with the tidal Thames. It has not the wide perspective or the far vistas, the quaintly wharved and warehoused quays or the wonderful and varied profusion of craft, which make a trip from the Temple Pier to Tilbury a fascinating panorama and an ever-changing kaleidoscope of maritime life ; but it has a lively interest and picturesque elements of its own, and of these James Kay makes excellent pictorial use. His subjects are as varied as the life of the harbour itself. At one time he may paint a great liner coming up the river in charge of two tugs, and at another a dirty ocean tramp full-up to Plimsoll-mark dropping slowly down on the first of the evening ebb ; now it will be a hopper barge hard at its seemingly ceaseless dredging, and again the inter-mittent but never suspended movement of small craft passing to and fro amongst the big ships which line the quays, while occasionally he makes a picture of a launch with its striking shipyard accessories of ship-frames and scaffolding, derricks and sheer-legs, and its background of boiler-shops and chimneys and smoke. He is more monotonous in his weather, and dull and foggy days are even more frequent in his pictures than in reality. But a more genuine ground for complaint than the want of glitter, for, after all, griminess is a characteristic of busy riversides, is that the toil and the shipping as well as the setting are conceived in too matter-of-fact a fashion, and are unillumined by that touch of imaginative perception which gives the representation of reality significance, and in com-bination with fine craftsmanship—like his point of view, Mr. Kay's technique is purpose-like but without distinction—issues in Art. A more joyous but no deeper note is struck when he paints amongst the Loch Fyne herring-fishers, and a number of his pictures of the quaint streets and harbours in French coast-towns are very effective in gayer colour and more brilliant effects of lighting. Mr. C. J. Lauder, a clever sketcher in water-colour of bright shipping scenes on the Clyde, and a facile, if not very vivid, recorder of the busy London streets and of picturesque views in Venice and other foreign cities ; Mr. Patrick Downie, who paints both in Glasgow Harbour and along the coast ; and Mr. David Martin, the author of a book upon 'The Glasgow School of Painting' (1897), whose chief work has been done in the Fife fishing-villages, may be grouped with Mr. Kay.

When one considers what Sir Francis Powell has done for water-colour painting in Scotland, and that his own work has dealt principally with the sea, it may seem strange that no account of his art appears in these pages. But Sir Francis is an Englishman by birth and his achieve-ment is essentially English in character, and for these reasons it has been thought advisable to do no more than emphasise the fact that the develop-ment and practice in Scotland of the charming art to which he is devoted owes much to the enthusiasm, tact, and courtesy with which he has advocated its claims, and has advanced the interests of the Royal Scottish Water-Colour Society over which he has presided since its formation.

CHAPTER VII

ANIMAL PICTURES

IF the earlier Scots who painted animals deserved some consideration as precursors in a kind of subject in which some excellent work has been done of recent years, it was not until Robert Alexander arrived that animal-painting in Scotland became a real and vital art. The interest of his predecessors' pictures had been objective in the baldest sense. With Gourlay Steell (1819-94), the most conspicuous of these men, it had turned on the representation, with realistic purpose probably, but on very conventional lines, of cattle, horses, sheep and dogs, as specimens of breed. Any pictorial quality possessed by the result had come, accidentally as it were, from story-telling or sentimental motive unsupported by feeling for beauty of design or colour, or for the charm inherent in a fine use of paint. In Alexander's work, on the other hand, while interest in animal life for its own sake is always apparent, pictorial motive is a primary quality.

Born at Kilwinning, Ayrshire, Robert Alexander was a considerable age before he felt in a position to give up the craft of house-painting for pictorial art. He had not been idle, however, and although his work may show, now and then, signs of technical weakness, which a more fortunate beginning might have modified, he entered upon his professional career better equipped than most men who have spent as long in a master's atelier as he did in business. For he had a natural aptitude which he had cultivated with enthusiasm in his leisure hours, and that is better than whole days passed in half-listless content before an easel.

Perhaps to some extent because there are no opportunities in Scotland, such as are afforded by the Zoological Gardens and the Jardin d'Acclimatation for studying foreign beasts, almost all Scotsmen who have made animals the chief object of their art, have devoted themselves to the domestic species. Except deer, even the indigenous wild animals of Scotland have been painted but rarely by Mr. Alexander. He prefers horses and donkeys, dogs and cats, and in dealing with them he displays wonderful knowledge and insight. Unlike Landseer, he does not endow them with attributes that they do not possess, humanising them and appealing to that instinct for sentimental story which is a sure road to popularity ; but he uses their beauty of form and colour, associated with

some simple motive of action or repose resulting from natural instinct, as the subject for a picture. To him, animals are in themselves of sufficient interest and beauty to make a picture, and in result his pictures possess the vital sentiment which comes of a subtle and sympathetic observation of actual life. And this sentiment is further accentuated by the fine pictorial instinct which leads him to suppress needless detail, and concentrate atten- tion upon his leading motive by purely artistic means.

The only picture of his in which the sentiment is equally divided between man and beast is the beautiful 'Wat and Wearie' (1886), in the diploma rooms of the Royal Scottish Academy. It represents an old man, bent with many a year of toil, impassively leading a grey horse home in the gathering twilight. The day has been one of heavy rain, and still it pours ; the ground has been heavy, and man and horse are completely tired out and dripping wet. The man trudges stolidly on, his head bent to shield his face from the driving rain ; the horse, water streaming from its flanks, and its breath showing white in the damp air, follows, splashing heavily through the overflowing ruts on the road, which runs beside a low hedge-crowned bank, and then, rounding a corner, into an open plain. Only here is there ought to mitigate the miserableness of their plight—a light gleams in a cottage window a little way off, and over the low hills which bound the horizon a wan flush suffuses a rift in the dull grey sky. All this may be said to be as literary as a Landseer ; but, while lending itself to description, the picture depends for its charm not only upon the story told, but upon the manner of the telling—on its pictorial qualities, on expressiveness of colour and tone, sympathetic and suggestive drawing, significant design, and able handling. The emotional appeal of 'Wat and Wearie' is wider and more immediate than anything else Robert Alexander has done, but such pictures as 'Orphans' (1878), two motherless lambs watched by a collie dog, or 'In the Highlands—Evening' (1882), in which birds of prey hover over a dead stag lying in a desolate glen, possess a pathos of their own. In his later work, however, he has usually struck a more joyous note. 'The Happy Mother' of 1887, and the 'Two Mothers' of the following year, are instinct with the joy of life, and the former probably remains, what it was considered at the time of its appear- ance in the Royal Scottish Academy, 'the most masterly piece of animal painting yet produced in Scotland.' Admirably designed and splendidly painted, he here carries characterisation to a very high pitch. The collie and each of the many puppies that play upon and about her amongst the kennel litter are wonderfully individualised ; and the subtly graded blacks, browns, fawns, greys and greens form a colour-scheme which he has never surpassed in delicacy, and never equalled in richness and strength. Amongst more recent pictures, in none of which it may be noted is action prominent, 'The Warreners' (1894), a group of purple-grey terriers sitting beside a game-bag ; 'Watching and Waiting' (1893), a boy with

terriers and greyhounds ; 'Drowsy Cronies' (1898), in which a collie and a terrier sleep beside an occupied cradle in a shepherd's cottage, and the delightful comedy entitled 'Cat and Dog Life' (1899) may be named as little less successful. They would have delighted Dr. John Brown, who would have written as charmingly of them as he did of ' Our Dogs.'

Alexander has been much employed as a portrait-painter of dogs and horses, but his fine artistic sense almost invariably converts what in less able hands would be of interest to his clients and his clients' friends alone into a picture. When opportunity offers, as it did in the group of ' Favourite Mares and Foals' painted for the Duke of Portland, he produces something that might have been painted without a commission, and even when the subject is limited to a particular horse or dog, his treatment shows definite and pictorial intention.

As a rule Scottish painters have been finer colourists than draughtsmen : often they have been possessed by the idea that colour alone was of any account, and, in extreme cases, that the only colour worthy of notice was positive and local. Mr. Alexander's preference in colour, however, is for the grave rather than the gay. I do not mean that he paints in a dark key, the reverse is nearer the truth, but his colour nearly always inclines to a grey and quiet harmony ; it is not local but fused and generalised. The dark or tawny browns, the whites and greys and fawns of his animals, the greens of his landscapes, and the dark-shadowed spaces of his interiors are all silvered over and harmonised in a delicate pervading grey, and it is in this pensive quality that the appeal of his colour as such lies. But at times it seems as if he were afraid of using colour of anything like a positive nature, and restricts himself to tints in which little more than a residuum of pure colour remains. Sometimes also he handles paint in rather indecisive and tentative fashion, but as a rule he shows a genuine feeling for the medium, and his pictures possess the material charm which results from expressive brushwork and a skilful blending of impasto and thinly used pigment. These qualities of colour, tone, and handling are united to, and to some extent controlled by, a subtle perception of form and character expressing itself through sound and sympathetic drawing, which does not record shape and proportion only, but is searching in character and full of knowledge, and at once sensitive and constructive. And this expressive draughtsmanship pervades and gives distinction to everything he does, though it is most marked perhaps in the way he renders the exquisite lines and clear-cut forms of high-bred animals.

Most of his work has been done in oils, but the water-colours he has painted are exceedingly charming and possess to the full that delicate sense of form, colour, and tone used to express a sympathetic, yet pictorial, observation of animal life, which gives vital interest to his pictures. In its combination of artistic accomplishment and felicity with refined and

unforced sentiment, Robert Alexander's achievement claims a high place in modern painting, and no native of these isles has done quite so finely in the particular domain he has chosen for the exercise of his gifts.[1]

In most respects the art of J. Denovan Adam (1842-96) presents a contrast to that of Robert Alexander. While the strength of the latter lies in refinement and subtle simplicity of sentiment, colour, and technique, that of the former was robustness and directness. In subject also there was difference—the one preferring horses and dogs, the other less domesticated animals ; and while setting for its own sake bulks but little in Alexander's pictures, it is as important as the animals themselves in Adam's most characteristic work. Son of Joseph Adam, a landscape-painter of some merit who was resident in Glasgow when Denovan was born, he was brought up in an artistic atmosphere and no check was put upon his desire to be a painter. He learned a good deal from his father, and in London, whither the family had removed, he studied at South Kensington and in the Langham life-class. Before long his bent toward animal-painting asserted itself, and, his admiration having been specially stirred by the Highland cattle he saw during summer visits to Scotland, he determined to make particular study of these magnificent animals. Early in the seventies he went to live in the Crieff district, and in 1887, after some years in Edinburgh, he settled near Stirling and established an atelier for animal-painting. The facilities of Craigmill with its byres and fields and live-stock were great, and not only the students who gathered round him, but the master himself benefited by them. His work had begun to attract attention in the Scottish exhibition about 1875 ; in 1880 he joined the Water-Colour Society, and in 1884 he was elected A.R.S.A., full membership following eight years later. During his later years he exhibited occasionally abroad, and there also his pictures met with much appreciation. In 1892 he was awarded a gold medal at Munich ; two years later he had one at the Salon ; and in 1895, having been disappointed the previous year (the picture then wanted was his diploma work), the French Government purchased a picture by him.

Although Denovan Adam's work was always personal and powerful, it was not until after he went to Craigmill that it attained that unity of effect without which individuality of conception and vigorous technique alike are ineffective pictorially. His natural taste in colour was rather crude and garish, and his drawing more facile and vigorous than stylish and constructive ; his compositions inclined to be crowded and tumultuous, and the vigour of his brushwork, although not unpainter-like, was truculent and at times repellent. Yet in his later pictures, in part due to maturing powers, and in part, perhaps, to the influence of the more decorative ideals pursued by some of the young Glasgow painters and

[1] Mr. Alexander was elected A.R.S.A. in 1878, and R.S.A. in 1888, and is a member of the Royal Scottish Water-Colour Society.

Mr. Austen Brown, who painted a good deal at Cambuskenneth, these elements, while remaining characteristic, became fused into a style which, if lacking in refinement and distinction, was coherent and distinctive. Apart from technical considerations, and even these are conditioned by the way in which subject is looked at, this greater unity was the consummation of the stress laid by the artist upon the relative importance of the elements with which he dealt. With Adam, as with Troyon (1810-63), incomparably the greatest animal-painter of this kind, animals and their environment were of equal importance and together formed the pictorial motive, light and colour playing upon each equally and expressing both through the unity thus achieved.' His treatment of landscape was fresh, broad, and vigorous, and, while helping to give significance to the bucolic incidents in which he delighted, forms in itself a considerable part of the attraction of his work. The series of pictures called 'The Months in Scotland' is at once illustrative of the phases of animal life most evident at particular times, and of the march of the seasons amongst the hills and glens and along the seashores of our own country. It was in landscape, indeed, that Adam's taste was most catholic, for, while he showed a clear preference for Highland cattle and hill-sheep and seldom painted horses or milk-cows, he seems to have taken equal pleasure in wild snow-clad uplands and flower-spangled fields, in lush tree-fringed loch-sides and bare far-spreading moors.

A prolific and a strenuous worker, many of Adam's canvases are of large size, and as his vigorous method was best suited for a considerable scale, his big pictures are often his finest. Everything considered, his diploma work, 'Evening—Strathspey,' a really admirable rendering of an autumn valley, through which a great mob of cattle and sheep is passing, seen in the effulgent glory thrown athwart it by the setting sun, is his masterpiece, and a complete epitome of what he was capable of at his best. Amongst other notable pictures 'Going to the Winter Tryst' (1890), a herd of kyloes in a snowy glen, painted with great truth and real appreciation of the beauty of the scene, 'Fording a Highland River, Glen Finlas' (1891), 'Summer, Loch Ard' (1894), with his favourite Highland cattle resting in the shadows of the trees or cooling themselves in the quiet waters of the loch on a warm day, 'Balmoral, Autumn' (1896), in which landscape is the dominating feature, in the Glasgow Gallery, and his Luxemburg picture may be named as specially characteristic.

Denovan Adam's art lacks the distinction of outlook and the masterly craftsmanship and design essential to win a painter a place in the first rank, but vigorous personality and execution entitle him to a distinctive and honourable position not only in his own school but amongst modern animal-painters as a whole.

Although no Scottish painter has paid so much attention to Highland cattle, or made quite so much of them in a pictorial sense, others besides

Denovan Adam have used them in their pictures. Messrs. Peter Graham, John MacWhirter, and Joseph Farquharson have introduced them with excellent effect into moorland and mountain pieces, but with these painters, as with Horatio M'Culloch and John Smart, they are almost invariably accessory to the landscape, and of less interest than the float of the mists, the rush of the torrents, and the play of light and shadow upon the hills. To Thomas Hunt, however, they seem almost as interesting as they were to Adam, and in such pictures as 'From the Hills' (G.I., 1901), and 'Wanderers' (G.I., 1904), the cattle are the chief thing. But Hunt's interest in animals is more inclusive perhaps than that of most of his Scottish contemporaries. The famous white cattle of Cadzow have formed the motive of several large pictures, and horse-fairs and cattle-markets have supplied him with subjects ; and in 'Old Mortality,' 'The Auld Man's Meir's Dead,' and other pictures, he has touched the humorous-pathetic element in the relationship between man and beast. He is also a figure-painter of considerable skill, and some of his single-figure studies, especially when of a humorous kind and in water-colour, are happy in characterisation. But Mr. Hunt is a Yorkshireman, and though most of his artistic life has been spent in Glasgow, the limits adopted in this book preclude extended notice of his pleasing but undistinguished art. In Edwin Douglas, on the other hand, we have the case of a Scot whose nationality, except in a work like this, is almost obscured by long residence in England. Born in Edinburgh (1848), and trained in the schools there, he went south in 1872, and, being in some sort an understudy of Sir Edwin Landseer (1802-73) in sentiment and technique, he was spoken of, for a while after that artist's death, as an aspirant and even as a not unworthy successor to the great man's place. And their work certainly possesses a good many points in common. Both were better draughtsmen than painters ; both painted in a superficial and surfacy manner and obtained little richness of impasto or depth and fullness of colour and tone ; and both were fond of the well-groomed and sleek-coated, and loved sentiment better than reality. In some points of technique, indeed, Douglas was little behind the famous Englishman; but, on the other hand, he was far inferior in inventive power, in design, in control of complex motives, and in that humanising sympathy which gave Landseer such a strong hold upon the affections of his countrymen. Mr. Douglas, however, has painted many attractive pictures of horses and foals, and of Jersey cows and milkmaids in lush pastures, and some of them have been very popular in reproduction.

When Mr. D. G. Steell, A.R.S.A., son of Gourlay Steell, whose work shows an interest in animals for their own sake but little artistic quality or power ; John Glass, A.R.S.A. (d. 1885), who, after doing what was considered promising work, went to Australia and disappeared; Mr. W. G. Stevenson, R.S.A., sculptor and story-teller, who has painted incidents

amongst puppies and poultry with obvious humour but in a hard and uninteresting style, and cold and unsympathetic colour ; Mr. John Carlaw, whose principal work is done in water-colour, and Mr. Robert Monro, a painter of moorland and Highland cattle, are added to the artists already dealt with, most of the older generation who have painted animals have been mentioned.

SECTION III.—THE YOUNGER GENERATION

CHAPTER I

DEVELOPMENT AND CHARACTERISTICS

DURING the last five-and-twenty years a change affecting both technique and the standpoint of the artist as regards subject has been passing gradually over Scottish painting. After what has been said in preceding chapters it is unnecessary to go elaborately into the character of the pictorial ideals which prevailed in the early eighties. An indication will suffice. Although many good and some noble pictures were being produced by Scottish painters, the great majority were concerned with incident and fact for their own sake rather than with their artistic possibilities and the problems involved in their pictorial presentation. Despite the contribution of Scott Lauder's pupils and a few others, some of the best of whom had gone to London, sentimentality dominated genre, and the early Victorian ideal of anecdote and incident conceived in a literary way still held sway ; portraiture, except in the hands of a few, had lost its fine tradition and had become mechanical and photographic ; and landscape, although here there was, as there had ever been, a sincere love of Nature, and many of the pictures of the period possessed truth of observation and a careful noting of the phenomena of light and colour, dealt for the most part with the superficial and the obvious and was lacking in distinction. Diffuseness, the elaboration of parts without relation to the whole, was in fashion, and by the great majority the oil medium was used with little sense of style. Technique was neat and deft rather than powerful and expressive, draughtsmanship was undistinguished, colour, though strong in the primaries, often lacked the harmonising influence of fine tone, while the key and manner in which most men wrought tended to thinness and poverty of result.

Among the older Scottish painters of that time, however, in addition to Orchardson and Pettie, Cecil Lawson and John R. Reid, and a few more in London, there were, as has been indicated, artists of a higher order —Wintour (1825-82), Fettes Douglas (1822-91), and Fraser (1828-99), M'Taggart and Wingate, Robert Alexander and Sir George Reid, to name the most prominent ; but one or two of them were past their best,

and the art of the others, interesting and vital, even splendid, as much of it is, presents no very coherent artistic creed. Sir George Reid, Robert Alexander, and, one may add, Robert Macgregor, a slightly younger man, have an appreciation of tone, not full in pitch perhaps, but true in values, and in colour their preferences incline to grey and subdued harmonies, while M'Taggart and Wingate love more splendid colour and are more concerned with the beauty and significance of Nature than with purely naturalistic representation. Depending for unity of effect upon focus, concentration of material, and expressiveness of handling, the method of M'Taggart and Wingate, as was that of Chalmers, is essentially impressionistic also ; but, although impressionism and regard for values were to become characteristics of the new school, it is unlikely that their practice by the older men had any direct effect upon their younger contemporaries, whose art in addition possesses qualities which are not very evident in the pictures of their elders. They had a great admiration for M'Taggart, indeed, but the high pitch of his lighting, the brilliance of his colour, and his very personal sentiment for Nature make any influence he may have exerted difficult to trace. On the other hand, there is no doubt that his work, and that of Chalmers and Wingate, being free from foreign taint, had, in its gradual unfolding, prepared the public for the art of the younger painters and made its acceptance easier.[1] It is different as regards John R. Reid. Strongly realistic in spirit, full and strong in tone with the values studied, and painted with great power in heavy impasto, his pastorals, such as 'Toil and Pleasure' (1879 : Tate Gallery) and 'Homeless and Homewards' (1882), are exceedingly like the work produced by some of the more conspicuous Glasgow men in the early eighties ; and as Reid was attracting great attention and was regarded as the coming man, it is all but certain that he influenced them directly. Be that as it may, he anticipated their earlier style by several years, and was a painter of note before they were even heard of. But leaving the work of these men out of account, it was in reaction from the predominating ideals of their day that the new movement—for it soon assumed such proportions—originated by a group of young men in Glasgow, had its beginnings. And as what was being done locally by Joseph Henderson, William Young, and Tom M'Ewan, and by David Murray and R. W. Allan, who had recently come into prominence, belonged in its essentials to the prevailing school, revolt was directed against it as much as against the traditions of the Royal Scottish Academy. The influence of the Academy, however, owing to jealousy of what the Glasgow papers sometimes describe as 'the capital of the other side of

[1] 'The best of these men [the Scottish painters of about the time of the Lauder group]—the man whose influence and whose reputation has lived longest—is unquestionably M'Taggart. Indeed, his art and that of G. P. Chalmers may be said to have passed on into the new Scottish school, and we may rather regard these two as precursors of the present men than as chief among the old.'—R. A. M. Stevenson, *Pall Mall Gazette*, June 16, 1897.

Scotland,' was much less powerful in the west than if that institution had been located in Glasgow.

If at first sight it seems strange that a vital artistic movement should have had birth in the great commercial city of the west, further considera-tion shows that this is not so. Although one now visits Florence and Venice, Bruges and Ghent for the monuments of art which they contain, and speaks of them as if their art exhausted their interest, what we admire was the flower and crown of their commercial and industrial activity in the days when they really lived and influenced the world as much, and even more, by their trade relationships as by the might of their fighting patricians and burghers. It was the strife and stress of commercial and communal life which made the ferment from which art sprang and flourished in these old cities, and it was the love of art or the public spirit of their merchant princes and trade-guilds that endowed them with those artistic memorials which have outlasted the greatness of their commerce and have given them enduring fame. The precise social conditions of one epoch cannot be repeated in another, of course, but within limits, and given a racial capacity for art, there is nothing to prevent somewhat similar conditions producing not dissimilar results. It has been so in Glasgow at least. There, amid crowds of eager, busy men, working to the stirring accompaniment of hundreds of hammers ringing upon mighty ships and big boilers and bridges, and beneath a canopy of smoke, which witnesses to the energy which has built up great industries and brought wealth to many citizens, the latest and one of the most interesting and vital phases of Scottish painting has taken form. Inducing independence, initiative, and adventure, this strenuous life with its world-wide interests has played its part in the evolution of the Glasgow School. Accustomed to act for himself and free from binding tradition, the Glasgow business man, with that instinct for backing his own opinion or acting upon skilled advice which has brought success in his own field, when he turned picture buyer bought as fancy or commercial instincts prompted, while the tendency to look beyond one's immediate environment, also produced by this spirit, resulted amongst the younger painters in an inclination to widen their horizon and strengthen their art by studying what had been done elsewhere. Thus it came, and to some extent through the fine taste of one or two local picture-dealers, that splendid examples of two of the greatest schools of modern Europe—the French romanticists and their successors, the group of gifted Dutchmen, now almost past—were brought to and bought in Scotland, where at the Glasgow Institute, in the manage-ment of which a number of laymen took much interest, they were seen by artists and in due time produced an effect. Moreover, in 1882, a renewed interest was awakened in the fine collection of Old Masters, which had been bequeathed to the city many years before by Bailie M‘Lellan, a local coach-builder, and had been added to in the interval by the Ewing and

Graham Gilbert bequests, by the report in which Sir J. C. Robinson declared that 'the Corporation Gallery when better known will take rank as a collection of European importance.' This also had its effect, and I remember a young and enthusiastic hanger-on of the movement saying that the genesis of the Glasgow landscape could be found in the background of the Giorgione—an exaggerated statement with some elements of truth. The formative influence of these pictures and of Whistler's, however, was not apparent until later. At first the most notable characteristics of this new phase of Scottish painting, and those which differentiated it from most of the pictures amongst which it appeared, resulted from a regard for tonal relationship—for what is called values— and for breadth and unity of effect, induced in some cases by study abroad and in others by that more subtle influence which one can only describe by saying that 'it was in the air.' For in a more comprehensive survey the Glasgow School was but a phase of a far-extended and greater movement. Its beginnings coincided with the commencement of the influence of the Parisian atelier in England, which has its most marked expression in the work of the Newlyn men ; with the early admiration for the French impressionists and specially for Degas and Monet, shown by certain of the men who originated the New English Art Club in 1886 ; and with the enthusiastic acceptance of Whistler as a master by many of the younger generation. Abroad also the rebel forces of modernity and impressionism, which had already exercised an influence in this country, were gathering for revolt against academic convention and official repression of individuality and experiment, but it was some years longer before it issued in the formation of the New Salon (1890) in Paris and in numerous 'Secessions' in Germany, at whose exhibitions the Glasgow painters were to win many honours. But this is scarcely the place in which to attempt even a summary of the extended movement : it is sufficient to have indicated the broad relationship in which the Glasgow group, at its emergence, stood to it. Yet it is curious to reflect that, although levelled against the detailed painting then prevalent, which had been inherited from Pre-Raphaelitism and its wonderful elaboration, the essential intention of the new movement in England and Scotland alike was, as was that of the condemned methods, realism. But now the truths of ensemble and the relationship of the parts to the whole rather than to one another coming uppermost, the results achieved were so different that the similarity in intellectual intention was not apparent, and, as time passed, the inclination to regard unity as of primary importance led, under the artistic influences already mentioned, to pictorial considerations superseding pure realism while making it contributory.

It was about 1880 that the new elements which were gradually to gain and now possess the ascendency in Scottish painting, first gave definite signs of existence. They were most marked in the work of two landscape-

painters, W. Y. Macgregor and James Paterson, the one a pupil of James Docharty (1829-78) and the Slade School, the other Paris trained, but similar tendencies were to be traced elsewhere. Little later than the earliest of the Glasgow men, John H. Lorimer, James Cadenhead, and Robert Noble, who had been Royal Scottish Academy students, had found their way to Carolus Duran's atelier. Yet it was in Glasgow that the more cosmopolitan influences thus evoked were given a special character and eventually issued in a definite development. There they soon commenced to dominate the pictures of the ablest of the younger painters, and by 1885 the movement may be said to have been fully under way. During these years those who shared the new technical ideals and pictorial aims, finding a rallying-point in the Bath Street studio of W. Y. Macgregor, had come together as a group. A man of great tenacity of purpose and of strong, if somewhat narrow, convictions, and a few years older than the rest, Macgregor exerted great influence upon the early development of his confrères, and at a life-class started by him, and attended by Walton, Henry, Nairn, Paterson and himself, and one or two others, prettiness, sentimentality, and subject in the old anecdotal sense were condemned, and broad, powerful painting, full in tone and true in value, was cultivated.[1] And in the summer they painted together in the country. In 1881 James Guthrie, E. A. Walton, George Henry, and Joseph Crawhall, a Newcastle youth of great ability who had become associated with them, were working at Brig o' Turk, and then, after spending the summer of 1882 with Crawhall at Crowland, Guthrie went to live in Berwickshire,[2] which became the country centre of the movement for two or three years, and where the Glasgow boys came into contact with Arthur Melville (1858-1904), an Edinburgh painter of strong personality and about their own age, who, at least as early as any of themselves, had formulated very similar artistic aims. Kirkcudbright followed Cockburnspath, and there the next striking departure in development was initiated by Henry and Hornel, the latter a local man who had studied in Edinburgh and Antwerp. But that was not until some years later than the point we have reached. Meanwhile a number of Glasgow men had been working in Paris, whither they had been attracted by the splendid facilities for studying form and tone offered by the Ecole des Beaux-Arts and the outside ateliers visited

[1] At that time Mr. Paterson was the most experienced and, in an artistic sense, the completest painter. He did finished things—pictures—while the others were struggling with theirs as life-studies ; but the extraordinary zest for reality revealed by Mr. Macgregor in a series of studies of still-life exercised greater influence.

[2] Pursuit of true tonal relationships or rather of values, for it included colour as well as tone, had become by this time a leading preoccupation with the group, and, as this involved the obtaining of a range of effect which could be rendered absolutely in paint, the eastern counties—at St. Andrews, Stonehaven, Nairn—where, as on the west coast, the eyes were not for ever fascinated by the sun sparkling on the sea or setting in glory beyond purple mountains, came into favour, and, when Guthrie settled there, Cockburnspath assumed special prominence, and became for the movement much what Barbizon had been to the romantic landscape-painters of France.

by distinguished French artists, and the return of Roche and Lavery in 1884 greatly strengthened the movement. Yet it should be noted that some of the most gifted never studied abroad, and that the modifying power of local influence was such that, from the work itself, it was difficult to say who had or had not been to Paris. Foreign training counted for a good deal, of course, and the study of pictures other than Scottish for as much more, but the determining factor in the development of the group as a whole was the association of the men with one another. This focussed the movement and gave it a special character without interfering with the individuality of those concerned, or, while modifying their attitude to subject, depriving them of their national sentiment as regards life and Nature. They went, as those who have initiated vital artistic movements have ever done, to tradition or the best contemporary practice for technical inspiration and style, and to Nature for emotion and subject, and, blending these together, each of them produced, according to his gifts, pictures which, whatever they had in common with those of his fellows, possessed individual quality. Completely free from the tendency to choose sensational subjects which will attract attention for their own sake, or to paint on a size of canvas that cannot be missed in the most crowded exhibition, or to exhibit big Academic 'nudes' as pictures—in a word showing no inclination to emulate the 'machine' which is a characteristic element in French painting, and has of late years infected that of England, they dealt with the simplest and most everyday scenes and subjects.

At the inception of the movement, as we have seen, the Glasgow men were concerned chiefly with tone, pursuit of which led for a time to pitch being unduly lowered ; with direct, vigorous, and expressive painting, preferably in solidly modelled pigment, which in some cases induced a tendency to coarseness and heaviness of handling and effect ; and with a broad and related style of presentation in which small things were sacrificed to ensemble ; but, if these and other technical qualities seemed to monopolise their attention, and literary, historical, and anecdotal interest of subject was strictly barred, their sentiment for reality was profound, and, in not a few cases, coloured by imaginative perception. Enthusiastic and young—even in 1885 most of them were nearer twenty than thirty—they believed in themselves and in the æstheticism embodied in their pictures, and denied any merit to work not in obvious sympathy with their own. This apparent narrowness of view naturally created a feeling of irritation amongst the more conservative section of the artistic community, and the extravagance of certain pictures and the novelty of others amused and puzzled the general public and supplied sport for critics who shared the popular views. Still, if there was a deal of ill-natured talk, and the pioneers suffered a little at the hands of Institute committees, it is extraordinary how well placed many of the early pictures were, and how

soon some members of the coterie were elected to the Glasgow Art Club
and the Scottish Water-Colour Society. Moreover, they early won the
appreciation and support of an intelligent, if small, group of older artists
and amateurs. As for the Royal Scottish Academy, it was held in such
contempt by these militant young painters that they disdained having
anything to do with it. And perhaps one should add that, with a
few notable exceptions, the Academicians of that day reciprocated the
sentiment.

Although a number of men had previously shown pictures embodying
the new tendencies or approximating to them, it was at the Glasgow
Institute of 1885 that the group first impressed the public with a sense
of the virility and independence of its work as a whole. This impression
was due more to divergence from the popular and accepted type, perhaps,
than to any true appreciation of the fine qualities inherent in the new, but
it served a purpose in directing attention to the School, helped to con-
solidate it and spread its influence. But the pictures themselves were
highly interesting and full of promise. Macgregor, Paterson, and
Walton had characteristic landscapes, Guthrie's 'To Pastures New,'
painted in 1882-3, and Lavery's 'Bridge at Gretz' and 'On the Loing—
an Afternoon Chat' were there, and Roche and Henry showed their earliest
considerable pictures. Arthur Melville sent a powerful portrait of a
little girl, and Millie Dow a dreamy landscape and two fine flower-pieces,
and Nairn, Alexander Mann and a few more, in or on the fringe of the
movement, were represented. In these pictures, the striving for fullness
of tone which, in such things as Guthrie's 'Sheep Smearing' (1881), and
Walton's and Henry's landscapes painted about the same time, had re-
sulted in blackness of colour, and the desire for powerful brushwork, which
had been evident in the work of all, still remained, but the national
feeling for colour had reasserted itself, and study of Bastien Lepage
(1850-84) was now apparent in a wider and juster range of values and
in tone which, while remaining low in pitch, had become more aerial.
Yet, even while influenced by Lepage and the plein-airists, they were
never completely carried away by definite and almost scientific realisation
as were the Newlyn men, who applied the method to the anecdotal picture
which had delighted generations of visitors to Burlington House, and the
coloured sunshiny atmosphere of many of the Glasgow pictures presented
a distinct contrast to the dull, level greyness of most French and English
work in this vein. And in some of the landscapes particularly there was
an element of romance and a feeling for decoration which were personal
and novel.

The spirit underlying most of this work had been realistic, but within
the next few years, while realism was retained as a primary and essential
element, and the *plein-air* influence was still active, one could trace a
distinct increase in regard for distinction of design, harmony of pictorial

result, and refinement of tone and handling, due in some measure to natural growth but also to study of the great portrait-painters of the past, of the French and Dutch romantics, whose art was represented magnificently at the Edinburgh International Exhibition of 1886,[1] where it was studied eagerly, and of Constable (1776-1837), and of such moderns as Cecil Lawson (1851-82), William Stott of Oldham (1858-1900),[2] and, above all, of James M'Neill Whistler (1834-1903), the wonderfully gifted American cosmopolitan, who, when made LL.D. by Glasgow University a year or two before his death, wrote to Principal Story that he regarded the honour as in some degree a recognition of the strain of Scottish blood in his veins. It was from Whistler in the first place, and later from Velasquez and Hals, that they learned the lesson that selection and concentration are the chief elements in distinction and style, and, to some extent, acquired that preference for quiet and subdued harmonies which has been more or less abiding with certain of the Glasgow portrait men.

Two years later than the Edinburgh show, a great exhibition was held in Glasgow, and in the art section the rising School had the opportunity, not only of seeing many masterpieces of modern painting, but, several of its members being well represented, of comparing their own work with that of men from whom they had received some part of their inspiration. In this year also, and largely on the suggestion of Walton, they started a magazine to advocate their special views on art, and to educate the public to appreciate their pictures and those that they admired. Several of the boys turned critics for the nonce. Roche, Paterson, Lavery, Henry, Stevenson, and M'Gillivray, the sculptor of the movement, contributed, and Mr. George Clausen, Mr. Walter Crane, and Mr. Frank Short helped their comrades in the north, while R. A. M. Stevenson, Gleeson White, R. T. Hamilton Bruce, John Forbes White, and Principal Caird, Mr. William Archer, Prince Kropotkin, Mr. J. M. Barrie, Mr. John Davidson, and others showed their sympathy by writing articles of great interest. Unsigned papers dealt with such topics as 'Art in the West of Scotland,' and 'How I became an A.R.S.A.,' the latter a pleasing satire expressing the attitude of young Glasgow to the Scottish Academy. Decorated pages by Roche, Henry, and Selwyn Image, and reproductions of pictures by Constable, Corot, and the Marises, by Lepage, Stott, M'Taggart, and Whistler, by Besnard and Puvis de Chavannes, and by Rossetti and Burne Jones, as well as by themselves, were given. Alto-

[1] Seen there in a series of splendid examples, brought together by R. T. Hamilton Bruce, an Edinburgh amateur (Memorial Catalogue edited by W. E. Henley), and hung in a separate room, these schools, already seen in isolated specimens at the Glasgow Institute, made a great impression upon the younger Scottish painters. It is remarkable, however, that so few Edinburgh men—T. A. Brown and R. Noble may be named specially—should have been influenced.

[2] The appearance of Stott's 'La Baignade' at the Institute in 1883 was an important event in the evolution of their ideals.

gether *The Scottish Art Review* was a notable and interesting production, but, proving too heavy a burden for the coterie and their friends, at the end of a year and a half they were glad to get Messrs. Walter Scott to take it off their hands. Rechristened *The Art Review* by its new sponsors, it lived a year or two longer and then disappeared.

Macgregor, having gone abroad for his health in 1886, did not again exhibit at the Institute until 1891, and during that period the names most often mentioned in connection with the movement were those of Guthrie and Walton, Roche and Lavery. The reason for this exact arrangement, which was almost stereotyped, was not very apparent at the time, but while others exhibited admirable work, it was the appearance of a series of pictures by those four men that marked this stage of development most clearly. Guthrie's 'School-mates' (1884) and 'Apple-gatherers' (1887) showed the continuance of the *plein-air* phase, as did Lavery's 'Tennis' (1887), which was medalled at the Salon, but in 1886 the former showed his first portrait, 'Dr. Gardiner,' which was soon followed by others in which the influences of tradition and realism were combined, and the latter painted his 'Ariadne' (1887) and commenced the refined and graceful series of ladies' portraits with which his name has since been associated. The romantic realism, decorative sense, and fine colour which had informed Walton's earlier landscape, were now displayed in richer measure in a succession of pictures and drawings of great beauty, while a number of portraits culminated for the time being in 'The Girl in Brown' (1889), in which Whistler influence, although marked, was assimilated and modified by personal feeling. And Roche in 'The Shepherdess' (1887) and other pictures, in which figure and landscape were combined, revealed an individual and poetic apprehension of life and Nature which was to find even more lovely expression in the 'Idyll' of 1892. But while the pictures of this quartette were the most notable painted by men resident in Glasgow, Arthur Melville was producing many splendidly vivid water-colours and some striking portraits, and Joseph Crawhall was displaying his remarkable talent in a number of wonderful studies of birds and animals. Fine things were also being done by James Paterson, George Henry, Alexander Mann, and T. Millie Dow, who had found his way from Fife to Glasgow, and, while William Kennedy, Macaulay Stevenson, Harrington Mann, D. Y. Cameron, George Pirie, and Stuart Park were amongst the local recruits of promise, in Edinburgh T. Austen Brown, James Pryde, and a few more had come under the sway of the new ideals. The work of Lorimer, Cadenhead, Robert Noble, and R. B. Nisbet, although affected to some extent by the same influences, possessed characteristics which make its definite inclusion with that of the Glasgow group inappropriate.

During the later eighties novel elements commenced to appear in the work of George Henry, and their emergence as a phase and influence

in the movement may be dated from about 1890, when he and E. A. Hornel exhibited a number of very striking and, to most people, disconcerting pictures at the Institute. That particular exhibition had indeed special significance. Not only did the hanging of such an 'advanced' picture as Henry's 'Galloway Landscape,' which provoked much discussion and no little ridicule, show the influence the new School had gradually gained, but the powers which were, driven desperate perhaps by the very articulate claims of the younger men, decided to devote a gallery specially to them and their friends. Hung by Paterson, the 'impressionist room,' as it was called, included, besides local pictures, work by William Stott of Oldham, the 'London Impressionists' flank of the New English Art Club, and other sympathisers with the movement.

Hitherto realism, at first to a considerable extent upon a naturalistic, but increasing upon a personal and pictorial, basis, had been the dominating element in the art of the group; but now, conspicuously in the pictures by Henry and Hornel, but also to some degree in those by a number of others, decorative, as opposed to pictorial, ideas took foremost place. The painter's task being to express his impressions of man and Nature and his feelings concerning the world about him upon a certain shaped space of canvas or paper in a manner which will give them full utterance, and yet be pleasing to the eye as a mere pattern of particoloured and differently illuminated masses, pictorial design is, in a certain sense, only so much decoration. But with Henry and Hornel, and those most obviously influenced by them, purely decorative quality took precedence, and, consciously or unconsciously, was given a prominence which, to the outsider at least, seemed to imply the suppression of everything save brilliance and variety of colour, and richness and juiciness of loaded impasto. Decorative beauty of colour spacing and depth of tone had been elements in Glasgow painting before this, but the justness of value, the regard for form and for expressive craftsmanship, the intimate sense of Nature and the appreciation of character, which had been conspicuous in the pictures of the earlier members of the group and remained distinctive elements in their art, were of small account to the protagonists of the newer phase, who may be said to have regarded Nature only in so far as she supplied suggestions for decorative colour harmonies and elementary forms for decorative spacing. In this departure the influence of Monticelli's[1] romantic fantasies and of the exquisite sense of design in flat-coloured masses revealed in Japanese prints was obvious enough, but, curious though it may seem, the work of the man who claimed fundamental brain-work as the distinguishing quality of art, D. G. Rossetti (1828-82), and of that decorative idealist, Burne-Jones (1833-98), must also be reckoned with. Yet under all lay the abounding delight in colour so characteristically Scottish, and the potent colour harmonies achieved, brilliant

[1] Adolphe Monticelli (1824-86), a French painter of Italian parentage.

and fantastic as they frequently were, bore clear relationship to the magnificence of local and atmospheric colour one often sees in Scotland. Together in the 'Druids' (1889) and 'The Star in the East' (1890), and separately in many a daring picture, Henry and Hornel elaborated their theories and methods for some years; but eventually, after a visit to Japan (1893-5), with Hornel as a companion, Henry returned to the more reticent and realistic mood in which his earlier and all his mature work has been done, and Hornel, without abandoning the coloured patch as a working basis, has since been adding greater truth of aspect, relationship, and form to his exceptional feeling for luminous and jewelled colouring. It is upon lines suggested by the later development of Hornel's art that a little knot of painters connected with Kirkcudbrightshire— William Mouncey (1852-1901) in pure landscape, and W. S. MacGeorge, T. B. Blacklock (1863-1903) and a few more in figure and landscape in combination—have formed themselves.

The novelty and arresting quality of this departure was such that for some time the public, and even some of those who should have known better, insisted upon regarding it as typical of the School in which it was but a phase. Yet in addition to its direct result in producing a number of pictures of out-of-the-way interest or beauty, the undue insistence upon purely decorative elements which underlay it, has been advantageous in less obvious ways to Scottish painting as a whole. It demonstrated in an unmistakable manner the charms and legitimate claims of colour for its own sake—a demonstration little needed perhaps since the time of Phillip and Scott Lauder—and in passing left a more conscious feeling for the desirability of arrangement in mass and colour as the basis of pictorial design. Technically, however, it was not innocuous, for it induced a disposition to secure a strong and striking effect without consideration of the means employed. Hornel and his comrades almost succeeded in forgetting all that had been done by the masters of technique in the past and treated oil-paint as if it had been some new material; and when reaction from the forced and loaded result came a few years later it was carried to an opposite extreme, resulting, in some cases, in a tendency to paint in too thin a manner and use the medium like a stain, and in others in a futile attempt to attain the dexterity of Mr. Sargent without his gifts and the necessary knowledge. The inclination to slur drawing and definition, which had also been a feature in the work of those influenced by the decorative phase, if it has not quite disappeared, has diminished, and a desire to obtain constructive drawing and dignity of design has appeared in the pictures of a number of men led by W. Y. Macgregor, the original father of the School, now restored to artistic activity.

In respect of draughtsmanship and design, however, admirable work was being done not only by a number of the older men but by several painter-etchers more or less connected with the group. William Strang

indeed had gone to London before the 'Glasgow School' was heard of, and there he has remained, but he was a fellow-student with W. Y. Macgregor at the Slade School under Professor Legros, whose influence has counted for so much in the development of many of the younger generation of British artists, and he has never lost touch with the West of Scotland to which he belongs. Rather later than Strang, and more intimately connected with the Glasgow group, though holding himself somewhat aloof, D. Y. Cameron revealed exceptional talent for impressive pictorial design ; but interesting as all his work is, the best elements in his gift are seen in black and white rather than in colour. On the other hand, although almost purely an etcher and draughtsman, Muirhead Bone, a more recent arrival, puts more colour into his prints than either of the others. Frank Laing, and a few more of less moment, may be bracketed with these men, whose productions form no inconsiderable part of the vital achievement which has attended that renaissance of original etching and design in monochrome which has been one of the most interesting features in contemporary British art. Drawing inspiration from many sources, from Rembrandt and Meryon as well as from Whistler, Seymour Haden, and Legros, whose example may be said to have created the revival, the work done by the Scots is at once distinguished in style and personal in sentiment.

The later history of the movement, as regards the leaders and the more individual of the recruits at least, is a story of personal rather than of collective development. Most of those who had emerged between 1880 and 1890 had either arrived or had ceased to be of much account by 1895, and after that the general tendencies of the movement had so permeated Scottish painting that younger artists were at complete liberty to pick and choose among them and to mould them, if they could, to the requirements of their individual needs and temperaments. As was inevitable, perhaps, a considerable proportion of the newer men, both in Glasgow and outside, were unduly influenced by the work of some artist of greater power amongst the leaders or themselves, or by that of certain of the masters who had been an influence with the whole group. After years of literalism and too much of an inartistic convention, there arose a danger of too much affected artistry. The copying of Nature became unfashionable, and in its place we were like to have an artistic convention indeed, but one which, like other conventions, has no real significance until illumined by individual thought and emotion. Having seen incident treated so often as anecdote and not in its pictorial fitness, the younger painters became afraid to tackle it at all, and among a certain set a belief grew up that it was illegitimate in painting. They failed to grasp the fact that art resides not in subject or the want of it, but in the way in which subject is conceived and in the manner and style in which it is treated. With some of the landscape-painters, again, there appeared to be a disposition to stereotype Nature upon certain lines, to use a formula which is not only out of keeping

with her infinite variety but which tends to limit art itself. The greater of the older men, M'Taggart and Wingate, possess an individuality of vision and a passion for Nature, beside which the artistic interests of all but one or two of the younger generation pale and become colourless. Yet, as a rule, beneath these defects—which are perhaps an outcome of the transition through which painting has been passing—there is a genuine, if not a profound, love of Life and Nature which, as the manner becomes more familiar, is likely to assert itself more and more.

There are others however who, possessing a deeper understanding of the finer elements in the new movement, have impressed their individuality upon them and made them a vehicle for personal expression. Amongst these the finest and most distinguished talent was that of W. J. Yule (1869-1900), a Dundee artist, who dying very young yet left a few pictures of rare charm and beauty. In a short career also, Robert Brough (1872-1905) painted many brilliant and, in their own manner, fascinating portraits. The death of these gifted young artists was a distinct loss to the potentialities of the newer school, and indeed to Scottish painting as a whole. Each in his respective way possessed temperament and style in a degree probably unequalled by any of their contemporaries except S. J. Peploe, whose gift is that of virtuosity expressing vivid visual impression rather than imaginative apprehension of reality, and Edwin Alexander, who is too isolated and personal both in the conception of his subjects, birds and animals, and in the completeness of his methods, to be included in the impressionistic developments which have been characteristic of modern Scottish painting. Talent of as fine quality has been rarer in the work of those who have devoted themselves to landscape. Still J. Campbell Mitchell has produced some admirable pictures, exceedingly able in craftsmanship and marked by a feeling for the moods of atmosphere which hovers on the verge of poetic apprehension, and George Houston, turning from the ordinary Glasgow methods of decoration and low tone, has painted transcripts of the quiet scenery of the south-western counties under everyday effects of light, with considerable sentiment and attractive simplicity.

A good deal has already been said about the prominent part played in the evolution of the type of picture most closely associated with the younger Scottish painters by the awakening of a sense of decoration—of how in combination with other elements it formed the basis of many pictures, and in the hands of certain painters became for a time almost the sole aim ; but it remains to group with them a number of artists in whose work decorative qualities, while not asserted to the exclusion of all else and frequently associated with some intellectual or poetic motive, predominate over the more purely pictorial elements. Those thus brought together are very diverse in character, for, while T. Millie Dow and Robert Burns belong more or less directly to the Glasgow movement, Mrs. Traquair,

Miss Katherine Cameron, Miss Jessie King, and one or two more are in some respects products of the aftermath of Pre-Raphaelitism, John Duncan and George Dutch Davidson (1879-1901) show clear evidence of Celtic and Italian primitive influences, and Robert Fowler, in pitch of tone and colour and in the combination of figure and landscape, unites something of Puvis de Chavannes with a little derived from Glasgow and a good deal that is his own. For the most part these artists have produced either pictures or book illustrations, but Mrs. Traquair, while she has illustrated a few volumes, and executed many charming illuminations, has found the true *métier* for her fine talent in mural decoration. As she is of Irish birth[1] and her art has no direct connection with Scottish painting, no detailed analysis of her work will be made in this book, but perhaps it may be mentioned that the present writer contributed an estimate of it to the *Art Journal* for May 1900. William Hole, R.S.A., whose work has already been dealt with, has also done much decoration of serious interest during recent years. A more competent draughtsman, if a less charming colourist, than Mrs. Traquair, his conceptions are intellectual rather than imaginative, and his work in the hall of the Scottish National Portrait Gallery and elsewhere interests and instructs more than it fascinates. It was in Edinburgh too that John Duncan executed the panels (in Ramsay Lodge, University Hall) which are the most characteristic result in painting of the much-talked-of, but short-lived, 'Celtic Renascence'; and, although W. M. Palin was an importation from London and his work is more competent than pleasing—trail of the Atelier Julien mocking the Italian inspiration—the decoration of the M'Ewan Hall should be mentioned. In Aberdeen Douglas Strachan, a young local artist, has carried out important and appropriate schemes in the Music Hall and the Trades Hall, and in Dundee Stuart Carmichael has done some work of a similar nature. But while these are the most important mural decorations painted by individual artists, the Corporation of Glasgow showed its interest in the revival by employing four of the most talented of the local men to paint panels, illustrative of the history of the city, for the banqueting-room in its chief civic building; and, if the result lacks the unity which belongs to the work of one man, Alexander Roche, E. A. Walton, John Lavery, and George Henry have produced things beautiful and notable in their kind. George Walton, who designs charming interiors and furniture, has also executed some refined and personal mural decorations, and interesting work of a similar nature has been done by W. S. Black, Harrington Mann, C. S. Mackie, Robert Burns, and others.

[1] Mrs. Traquair is a daughter of a well-known Dublin doctor and wife of Dr. Ramsay Traquair, F.R.S., the Scottish zoologist.

CHAPTER II

RECOGNITION AT HOME AND ABROAD

CONSIDERATION of the genesis and characteristics of the most recent phase of Scottish painting has necessarily taken precedence of any account of the recognition it has won at home and abroad, but before proceeding to discuss the work of individual artists connected with the movement, it would be well perhaps to say something of that aspect also. The earliest artistic impression was produced in Glasgow, of course, but, while this was soon evident in the work of painters contemporary with or immediately junior to the original group, the pioneers were subjected to considerable ridicule, and it was not until a good while later that the movement commenced to be taken quite seriously. Being out of sympathy with the ideals then dominating Scottish painting, the 'boys' ignored the Royal Scottish Academy completely, and, although one or two of them exhibited a few pictures in the Royal Academy during the early eighties, the tendency was to look past both Edinburgh and London to Paris. To have a picture hung in the Salon was the prevailing ambition, and even some of those who had never been in Paris cherished a belief that there was no other show worth exhibiting at. But, when love of progress and hatred of convention led to the formation of the New English Art Club in 1886, most of them joined, and for some years exhibited there in association with men like Mr. Sargent, Mr. Clausen, Mr. Edward Stott, Mr. Muhrman, Hope M'Lachlan (1845-97), and Charles Furse (1868-1904), with the 'London Impressionists,' amongst whom Mr. P. Wilson Steer, the brothers Sickert, Professor Frederick Brown, and Mr. Francis James were prominent, and with immediate followers of Whistler such as Mr. Roussel and Mr. Paul Maitland. These were indeed the palmy days of the New English, for the forces then gathered under its banner represented most of the newer and vitally progressive elements in British painting ; but, as time passed, it became less inclusive through the opening of other channels of publicity, and, while it has retained many elements of interest, its later successes have been those of a talented clique rather than of a representative body. To the Glasgow men wider recognition came from a change in their relationship to the Royal Scottish Academy, and through the great success they achieved at the last exhibition of the Grosvenor Gallery in 1890.

Various medals and honours awarded at the old Salon to individual workers,[1] and the praise of distinguished French critics, had gradually produced a feeling that there was really something meritorious in the new style, and, while it had been the fashion in Scotland to belittle the movement as a French imitation, it was discovered with surprise that French interest in these Scottish pictures arose from the fact that they possessed novel and distinctive qualities of their own.[2] Moreover, familiarity with the work itself, and, to some extent, the advocacy of certain leaders of artistic taste in Scotland, such as Dr. Forbes White and Professor Patrick Geddes, of *The Scots Observer*, then in its hey-day, and of the artists' own organ *The Scottish Art Review*, had placed the public more *en rapport* with their aims. The position of the Glasgow men having thus been established in a measure, their more youthful scorn of the Scottish Academy relaxed. Actuated in part by personal motives, but in part also by a patriotic desire to do the best they could for the art of their own country, some of them commenced to send to Edinburgh, and when, in 1888, Guthrie was elected A.R.S.A.,[3] it was accepted as an olive branch, and young Glasgow was strongly represented at the Academy of the following year. Their pictures were badly hung, however, and at the annual dinner of the Academy's Life-School, Roche, in replying for what he described as the ' Wild West,' gave expression to the wrathful feelings of his confrères. But the Rubicon had been crossed. Walton was elected in 1889, having Austen Brown as a fellow; Lavery and Henry followed in '92 ; and then Roche, Paterson, and W. Y. Macgregor were chosen at intervals of two years. And this recognition of the claims of Glasgow and the west, which has been followed by other elections, by the advancement of most of those named to full membership, and by Guthrie's selection as President (1902), has

[1] Salon awards gained by the early group: Alexander Mann, M. H., 1885 ; Lavery, M. H., 1888, med. br. 1889, E. U. ; Guthrie, M. H., 1889, 3rd medal, 1891 ; Paterson, M. H., 1890 ; Roche, M. H., 1892 ; Walton, M. H., 1892.

[2] 'The so-called Impressionists have, unfortunately, some followers in Scotland. There is quite a school of them at Glasgow. It is the influence of the modern French School of painting. But what is this impressionism except, among the younger artists, the offering of admiring incapacity in the shape of more or less dexterous imitation of some of the better-known leaders of the movement in France.' Sir George Reid, whose words are quoted, added, however, ' Our young Glasgow men who called themselves impressionists are just feeling their way, and when they are able to walk on their own feet there will be some fine results. Hitherto the Scottish artist has been as " A pagan suckled in a creed out-worn." ' And a year or two later he bought some of their pictures for the Auckland Art Gallery.

It is difficult to find an equally inclusive opinion in French criticism, for it dealt mostly with the work of individuals, but here is an Italian one written a few years later than Sir George's, and contrasting the pictures of these young Scottish painters, seen in the Venetian International Exhibition of 1897, with those of some of the men they were supposed to have imitated. ' Whoever has passed an hour before these pictures and then enters the other halls (where the work of Claude Monet and Besnard, Liebermann and Gola, for instance, is displayed) is forced to acknowledge that he finds himself not only in the presence of a different genius, or, as they say, of a different temperament, but rather before a quite different notion of art and its expression.'—Professor Enrico Panzacchi in the *Tribuna*, Rome. German and American estimates are quoted later in different connections.

[3] After considerable opposition, Arthur Melville had been elected in 1886, but, as he was resident in Edinburgh, his case was not identical.

not only strengthened the Academy greatly in an artistic sense—sculptors and architects have shared in the honours—but has made it more really representative of Scottish Art than it had been for many years, and opened a future to it which would have been impossible had it remained national in name only.

Yet as regards the attainment of a far-spread reputation, the last Grosvenor show, to which the more notable[1] of the new school were asked to contribute, was much more important. The reception with which their art met in London was somewhat mixed. There was a good deal of head-shaking. *The Athenæum* hurled anathema at them and all their works, ' being compelled to wonder how they could have obtained admission into a gallery with such honourable traditions as the Grosvenor !' ' The worst of them,' it proceeded, ' are outrages on the cardinal laws of art, and are not redeemed by any intrinsic merit.' And *The Portfolio* dismissed the whole exhibition with the curt remark that ' Among purposeless eccentricities, and even impertinences, such as the bottesque " Audrey and her Goats " by Mr. Arthur Melville, and among mediocre contributions of artists better seen elsewhere, are one or two fine things such as Mr. Clausen's " Waiting at the Gate " ; also the portrait of W. Q. Orchardson, R.A., by himself.' But the praise far exceeded the blame. Sir Walter Armstrong wrote : ' This spring Sir Coutts Lindsay was happily inspired to bring a number of their works together at the Grosvenor Gallery. They form the distinctive feature of what is, beyond a doubt, the most interesting of the three chief exhibitions.'[2] The opinion of *The Times* (May 5, 1890) was that ' For the first time since the famous split, the Grosvenor Gallery exhibition is equal in interest to its rival in Regent Street, though it need hardly be said that the interest is of a different kind. This year the managers have struck a comparatively new vein. It has occurred to them to go northwards, and to search among the studios of the young Scottish artists of the day for work that should excite at least the curiosity of the London public. Reinforced by pictures from a group of well-known Academicians and others, the display in Bond Street has thus a decidedly Scottish character, works by such young men as Mr. Lavery, Mr. Melville, Mr. James Guthrie, Mr. Coutts Michie, and Mr. E. A. Hornel hanging side by side with pictures by Messrs. Orchardson, Pettie, David Murray, Tom Graham, J. R. Reid and Swan. With many points of difference these pictures have a kind of family likeness to one another ; they indicate that existence of common tradition and common methods which constitutes a school of painting. Trained draughtsmanship, combined with a preference for strong and sometimes heavy

[1] The following list, compiled from the catalogue, includes all those exhibiting (other Scottish artists were represented) who can be described as belonging strictly to the movement. Austen Brown, T. M. Dow, James Guthrie, George Henry, E. A. Hornel, William Kennedy, J. Lavery, Arthur Melville, T. C. Morton, James Paterson, G. Pirie, Alexander Roche, E. A. Walton.

[2] *Magazine of Art*, 1890.

colour, a tendency to impressionism, a fondness for dark tones relieved by very high lights, are to be noticed in the majority of these pictures, specially in the works of the younger men, who have not yet entirely decided upon their own individual path.' And the *Saturday Review*, in an article which, if not quite accurate as regards the history of the movement, was highly appreciative of its artistic qualities, said, ' The Grosvenor Gallery has asserted its right to exist by producing a decidedly original and, in some respects, a very interesting exhibition this year. What is most noticeable is the work of a group of young Glasgow painters, whose names are entirely unknown in the South, and who, if we are not mistaken, have never exhibited their pictures in London before. . . . The colour of these Glasgow pictures is, in particular, extraordinary ; it is never really bad, it is often superb. . . . They are sometimes remarkably happy in their combinations of figures with landscape.' But, while praise such as this must have been gratifying and good heartening to a band of young artists not yet fully understood and inadequately appreciated in their own town and country, the Grosvenor exhibition served an even more important function in their development. It was, as it were, the mirror in which they first saw themselves, and realised that they had evolved a distinctive art of their own.

It happened, also, that the organisers of the Munich exhibitions, dissatisfied with what was being sent from England, had come to London to see for themselves what was being done ; and Herr Adolf Paulus, being greatly attracted by the pictures from Scotland, determined to introduce them into Germany. Glasgow men having been chiefly represented at the Grosvenor, it was but natural that the Munich people should make their selection in the west, and, although this resulted in a few of the finest Scottish artists being omitted, it certainly gave great unity to what was sent to Germany in the autumn of 1890, when, with the opening of the doors, Glasgow pictures became the rage with critics and connoisseurs. Munich, however, was not the only place in which they were to be appreciated. Success there was followed by a series of equally great successes in such centres as Dresden and Berlin, Vienna and Buda-Pesth, Venice and St. Petersburg, Bruges and Brussels ; in a word, it became European. And this Continental approbation has been lasting, and has taken a form which promises to preserve the names of these young Scottish painters for many years to come. A number of them were elected members of leading Societies and Academies, including those of France ; their pictures were given prominent places in the exhibitions and medalled ; and, in many cases, they were bought not only by collectors, but for public galleries. And later, beginning at St. Louis in 1895, much the same thing happened in America. Mr. Charles M. Kurtz, the Director of the St. Louis Art Expositions, who has organised a series of remarkable collections illustrating different phases of European art, in the preface to the catalogue of the

exhibition of 1896, at which the Glasgow men were again very fully represented, tells the story of his previous venture. 'Last year,' he writes, 'the first organised exhibit in America of the work of the painters of " the Glasgow School" was made at the Saint Louis Exposition. These artists, already prominent in Europe, almost absolutely were unknown in America before last year's Exposition. The collection brought here was carefully formed and was representative, and it attracted more attention from the press and the people than ever before, perhaps, had been extended to a foreign school of art upon its first presentation in a new country. Applications to secure the collection for exhibition came to the Director of the Art Department from all parts of the United States, and, with the consent of the artists represented, the pictures, after the close of the Saint Louis Exhibition, were shown at the Art Institute of Chicago ; the Art Museum of Cincinnati ; the Pennsylvania Academy of the Fine Arts, Philadelphia, and at Klackner's Gallery in New York. The success of these exhibitions was such that " the Glasgow School" is now almost as well-known in the cities where the works were exhibited as any other school of contemporary art expression ; and, moreover, thirty-three and one-third per cent. of the collection was purchased by discriminating amateurs, and remains in America. This is especially remarkable, considering the newness of this art development, the unconventional character of many of the works, and the fact that the paintings were of a nature to appeal to the connoisseur rather than to " the average citizen." '

When this outside approbation began, Glasgow had not half realised that it had given birth to a group of painters of real artistic importance. As some one put it at the time, these pictures had been painted in Glasgow but they were praised and purchased abroad. Acting in the business spirit engendered by the place, however, the young men of the west did not hide their lights under bushels, but had their new honours recorded, and translations of their foreign praise inserted in the local papers. And knowledge of the very tangible successes won giving a hall-mark, as it were, to their art, redoubled the importance of the School in Scottish estimation. Yet although, as R. A. M. Stevenson once said to me, it was not every day that people had an opportunity of fostering a vital school of painting, and it would be a misfortune for Scotland and a disgrace to her rich men if, through lack of direct encouragement, these artists had to leave home, it seemed, for a time at least, as if the great south road was to be taken by quite a number. The attraction of the wider reputation and greater prizes to be won in London, combined with slowness of bread-and-butter recognition in Scotland, which had depleted the Scottish school of Wilkie and Geddes, of Orchardson and Pettie and the rest, commenced to affect the rising generation also. The Grosvenor success had been followed three years later by an equally conspicuous triumph at the first exhibition of the Grafton Gallery (1893), where they were

associated with many of the most distinguished artists in the newer and more vital art movements abroad ; and at the shows of the Society of Portrait-Painters (founded in 1891) those who painted portraits became well known. Meanwhile also the trend of art criticism,[1] powerfully affected by R. A. M. Stevenson, who was pioneer, Mr. D. S. M'Coll, Mr. George Moore, and a few more, was setting strongly in favour of appreciation upon pictorial instead of sentimental or literary grounds, and, being primarily pictorial, the Glasgow pictures obtained a good deal of prominence in critical discussion. Eventually these things, combined, as has been indicated, with somewhat meagre support at home and, in a few cases, with the offer of commissions in London, induced several of the new men to tempt fortune there. Melville, who was the first to go (1890 *circa*), was followed at intervals by Walton, Austen Brown, Lavery and Guthrie who, however, retained his Glasgow connection, and by two or three of the most promising of the still younger painters ; and when in 1898 'The International Society of Sculptors, Painters, and Gravers' was formed, with Whistler as President[2] and with a list of eight-and-twenty honorary members representative of the best talent in 'foreign schools, the Glasgow immigrants, who had had no dealings with Burlington House, took a chief part in its organisation, and with their friends in the North they have contributed in no small measure to the success of the series of interesting, if less than international, exhibitions since held. Simultaneously with the later migrations to London, however, there were other signs that the original Glasgow group was ceasing to exist as a separate entity. M'Gillivray, the sculptor of the movement, Roche and Paterson removed to Edinburgh, and Macgregor and Cameron and one or two others went to live in the country.[3] Moreover, they were no longer aliens to the national academy. The later history of the move-ment, as I have said elsewhere, is a story of individual rather than of collective development, and these were amongst the signs that that period had arrived. The ideals for which the Glasgow men had striven had by this time permeated to a great extent Scottish painting, and henceforward they were to become part of its tradition.

The first conspicuous successes in London and abroad had been obtained by the earlier group—by those who were in reality the leaders of the movement and, with a few exceptions, its ablest exponents—but as time passed the demands of many Continental exhibitions became greater

[1] The influence of the 'new art criticism' as it was called by its detractors—it was the product of the same influences as the more modern developments in art—was greatly enhanced by the con-troversy thrust upon it through a frontal attack by its opponents, including Mr. Harry Quilter, Sir W. B. Richmond, and Mr. Walter Crane. The occasion was the appearance of M. Degas's 'L'Absinthe' at the Grafton Gallery in 1893.

[2] M. Rodin is the present president.

[3] Guthrie, who had given up his London studio about 1900, removed to Edinburgh after his election as P.R.S.A. (1902), and Walton settled there in 1904. Lorimer also has returned to Edinburgh.

than could be supplied, and, gradually most of the painters in Glasgow and eventually other of the younger Scottish painters were included in these invitations, and became known abroad. In this way the later honours have been shared by a number of artists but indirectly connected with the 'Glasgow School,' while quite apart from this exhibiting in groups, if perhaps stimulated to send abroad by it, individual artists, such as J. H. Lorimer and R. B. Nisbet, have gained high distinctions. But Glasgow had been associated so intimately with the early impression made upon foreign opinion that usage had made, in Germany at least, 'the Glasgow School' the popular generic title for all work sent from Scotland. It should be pointed out, however, that not only were the London-Scots [1]—except the younger men from Glasgow—never included in these special Scottish sections, but that some of the most gifted artists in Scotland, M'Taggart, Wingate, and Alexander, to name no more, have never, or at least so rarely as to justify the phrase, been seen abroad. This is perhaps less their loss than that of foreign art lovers; but, at the same time, there is no doubt that foreign opinion of Scottish painting would have been even higher than it is, if it had been founded also upon the work of the men named and a few more. It is true, of course, that Professor Cornelius Gurlett's excellently illustrated articles, 'Die Malerei in Schottland,' which appeared in *Illustrierte Deutsche Monatshefte* (1893-4), deal in an exceedingly able and sympathetic fashion with Scottish painting both past and present, and that an earlier French critic, M. Chesneau, wrote appreciatively of certain Scottish painters in his interesting work, *The English School of Painting* (translation published by Cassell and Co., London, 1884); but any distinctive attention given to Scottish painting, and any influence exerted by it abroad have been of recent years, and have been earned and exercised by the young painters of to-day.[2]

Without belittling the success achieved by those artists, or depreciating the excellence of their art, it might be well, however, to indicate that the standard of painting, whether as regards technical accomplishment or emotional appeal, in central and southern Europe specially, is not very high, and that Scottish pictures possess qualities of tone, colour, and handling, and a sentiment for Nature which stamp them, particularly when seen amongst those of foreign schools, with a special character which gives an element of novelty, and appeals to those satiated with the art with which they are familiar. At the same time, no one sensitive to

[1] Some of these, such as Orchardson and Pettie, John R. Reid and Robert Fowler, have been greatly admired in Paris and elsewhere, but they have exhibited either individually or have been seen in English sections.

[2] The commission Wilkie received from the King of Bavaria to paint a picture ('The Reading of a Will,' 1820), and the contemporary reputations enjoyed abroad by W. G. Ferguson (d. 1695), Gavin Hamilton (1730-97), Jacob More (1740-59), and one or two more of the earlier artists, are instances of foreign appreciation far too isolated and dependent upon too special circumstances to be considered seriously in this connection.

pictorial charm can see really fine Scottish pictures in such surroundings without being struck by their beauty, and in France, where technical standards are high, and people are accustomed to endless variety of motive and unending experiment, the best of the younger Scots are held in high esteem. But as regards the feeling that has been aroused abroad, it were better to transcribe the opinion of a foreigner who has made a specialty of the comparative study of modern painting, and for this purpose nothing could be better than Professor Richard Muther's *History of Modern Painting*.[1]

'The powerful effect, which was made when the Scotch gallery was opened in the summer of 1890 at the annual exhibition in Munich, is remembered still. All the world was then under the spell of Manet, and recognised the highest aim of art in faithful and objective reproduction of an impression of Nature. But here there burst out a style of painting which took its origin altogether from decorative harmony, and the rhythm of forms and masses of colour. Some there were who rendered audacious and sonorous fantasies of colour, whilst others interpreted the poetic dreams of a wild world of legend which they had conjured up. But it was all the expression of a powerfully excited mood of feeling through the medium of hues, a mood such as the lyric poet reveals by the rhythmical dance of words, or the musician by tones. None of them followed Bastien Lepage in the sharpness of his " bright painting." The chords of colour which they struck were full, swelling, deep and rotund, like the sound of an organ surging through a church at the close of a service. They cared most to seek Nature in the hours when distinct forms vanish out of sight, and the landscape becomes a vision of colour, above all in the hours when the clouds, crimson with the sunken sun, cast a purple veil over everything, softening all contrasts and awakening reveries. Solitary maidens were seen standing in the evening sunshine on the crest of a hill ; and there were deep golden suns sinking below the horizon and gilding the heath with their last rays, and dark forests flecked with fiery red patches of sunlight, and clothed with shining bronze-brown foliage. One associated his fantasies with the play of the waves and the clouds, with the rustling of leaves and the murmur of springs of water ; another watched the miracles of light in the early dawn upon lonely mountain paths. And upon all there rested that mysterious sombre poetry of Nature which runs so sadly through the old ballads.

'But it was not merely the glow and sombre sensuousness of Nature which appealed to the Scotch ; for they were also attracted by sport and merriment, by waywardness and whim. . . . And the wonder increased when, in the following year, the Glasgow Boys came forward with other performances, and these of a far more positive character. On this occasion they exhibited portraits which cast into the background almost every-

[1] English translation : London, Henry and Co., 1896.

thing exhibited by the English. They rendered old towns of story where the chime of bells, the burst of the organ, and the tones of the mandoline vibrate in the air, while glittering trains, festally decked with gold and colours, surge through the broad streets. They displayed soft or terrible representations from old-world tales, which really breathed that true legendary atmosphere for which we were so pining, since it seemed to have vanished out of art for ever. They brought water-colours of amazing ability, vivid and sparkling in technique, and bold to audacity. Almost all of them seemed to be born colourists who had been gifted with their talent in the cradle. . . . As the Scotch have made an annual appearance at German exhibitions since their first great success, the clamorous enthusiasm which greeted them in 1890 has become a little cooler. It was noticed that the works which had been so striking on the first occasion, were not brought together so entirely by chance, but were the extract of the best that the Glasgow School had to show. And in regard to their average performances it could not be concealed that they had a certain outward industrial character, and this, raised to a principle of creation, led too easily to something stereotyped. The art of the Continent is deeper and more serious, and the union between temperament and Nature to be found in it is more spiritual. With these decorative palette pictures, this Scotch art approaches the border where painting ends and the Persian carpet begins. For all that it has had a quickening influence upon the art of the Continent. Through their best performances the Scotch nourished the modern longing for mystical worlds of beauty. After a period of pale " bright painting," they schooled the painter's eye to recognise Nature in her richer tints. And since their appearance a fuller ground-tone, a deeper note, and a more sonorous harmony have entered into French and German painting.'

The widespread influence of this movement at home having been traced in the preceding chapter, here it will be sufficient to repeat that Glasgow, as the home of the new ideals, has been pervaded, more or less, by them for years, and that Scottish painting as a whole has gradually become pregnant with a new spirit. And these effects are visible not only in the pictures of the originators and their followers, but in those of men who in the beginning were strongly opposed to the movement. A stronger and more expressive technique is in fashion ; a desire for truth and fullness of tone is generally evident ; and a new feeling for decorative charm, an increased regard for unity of pictorial effect, and a heightened sense of style have appeared.

CHAPTER III

GUTHRIE, WALTON, ROCHE, AND LAVERY

THE preceding chapters having been devoted to the history, characteristics and recognition of the more recent phases of Scottish painting and to the relationship of the leading aspects and men to the movement as a whole, we are now in a position to consider the work of those concerned in greater detail. As already indicated, the names most prominent in the early days were those of Guthrie and Walton, Roche and Lavery; of the landscape-painters, W. Y. Macgregor and James Paterson; of Arthur Melville; and of Henry and Hornel, and perhaps the most convenient method of treatment will be to divide this section into chapters dealing with these artists and others who, in subject or style or for other reasons, may be grouped with them, and to add others which will include those who cannot be so grouped. The nature of this group system is suggested by the chapter headings. Consideration of the very varied work done by Guthrie, Walton, Roche and Lavery is followed by chapters treating of the land-scape-painters swayed more or less by the new ideals; of Arthur Melville who, save for a few imitators, stands somewhat apart; of the decorative aspects which embrace, in addition to that of Henry and Hornel and those more immediately influenced by them, the work of several whose chief bond of union is the ascendency of decorative elements in their art; of the figure-painters; of the animal-painters; of a number of artists whose association with the newer School is evident enough, but for whom no appropriate place could be found earlier; and, finally, of a group of men who have made their mark as painter-etchers or draughtsmen.

All those whose work will come up for discussion being young, and all but three or four alive, these chapters must necessarily be more tentative in character than those in which artists deceased or more mature or fixed in their art have been dealt with, and, as the movement in which they have borne a part is still in progress, it has been considered more desirable than in previous sections to concentrate attention upon the more conspicuous or characteristic figures and treat the others in more general terms.

The movement, which issued in what became known as 'the Glasgow School,' had already commenced in the landscapes of W. Y. Macgregor and James Paterson and, independently, in the French pictures and Eastern

water-colours of Arthur Melville, before Guthrie and Walton, and Roche and Lavery, all of whom were a few years junior to the initiators, joined it ; but, during the eventual years in which it crystallised, the quartette named took the most prominent place, and to-day, as then, their work is typical of much that is best in the art of the younger generation. As it happened, also, they represented the diversity of personality, influences, and training which made the movement a force in art. Of their personalities it would be impertinence to write, but they were all keen students and enthusiasts, and their work reveals radical differences in temperament, education, and culture. Guthrie and Walton were to a great extent self-taught, and such likeness to Continental practice as their art possesses is due more to observation and similar ideals than to direct influence ; Roche and Lavery studied for several years in Paris and came into close contact with French painting at the time the younger generation was dominated by the influence of Bastien Lepage (1848-84) and the plein-airists. The home-trained men were the first to emerge, and, although Walton had already for some years been an exhibitor at the Glasgow Institute, he and Guthrie, who were close personal friends, may be said to have appeared simultan-eously, for the latter's first Institute (1882) was that in which the former first showed the new influences. But the 'Highland Funeral,' partly because of its subject — figure incident being ever more immediately noticed than landscape by the public—gave Guthrie special prominence, and from then till now he has retained the headship of the School.

Born in Greenock in 1859, the son of the Rev. John Guthrie, D.D., a well-known Scottish divine and one of the founders of the Evangelical Union Church, James Guthrie was educated at the High School and the University of Glasgow with the intention of proceeding to the English bar at which no doubt his business capacity, tact, and oratorical gifts would have ensured conspicuous success. But his desire to be an artist was not gainsaid. In 1879 he left Glasgow with the intention of studying in Paris, but, meeting John Pettie (1839-93), who, greatly struck by his ability and promise, advised him to defer foreign study and offered to keep an eye on him, he remained in London and never worked abroad. At first, as was but natural, Pettie's influence counted for a good deal. This is evident in 'The Unpublished Tragedy' (1881), and some cavalier pictures ; but Guthrie's natural bias was toward realism in subject and treatment, and probably he found himself more in sympathy with the ideals of John R. Reid, then painting his best and strongest pastorals, and of George Clausen, who was working more in the manner of Lepage. In any case, on returning to Scotland, it was to country-life that he turned for material for his art. The summer and late into the autumn of 1881 were spent near Callander working in the company of E. A. Walton, Joseph Crawhall, and George Henry, and it is with the pictures then painted that Guthrie's career as a creative artist really begins. Four of

these, of which 'Gipsy Fires' and 'Sheep Smearing' (the one a three, the other a five-foot canvas) were the most important, appeared in the Glasgow Institute of 1882 and attracted considerable attention. Very low in tone, and dark and, if luminous, inclining to be black in colour, they were not immediately attractive ; but, as I remember them, they were strongly and expressively painted, and impressed one with a sense of the artist's power and of his profound sentiment for reality. And this feeling was much deepened by the 'Funeral Service in the Highlands' (Glasgow Gallery),[1] seen in the Royal Academy of 1882 and at Glasgow the following year. Marked by power and pathos, pregnant with the grave and austere spirit of Calvinism, and close in touch with the great realities of life, the 'Highland Funeral' was peculiarly moving, and, restrained and without a touch of sentimentality as it is, its appeal to the public was immediate. Moreover its sterling technical qualities, tentative though the handling was in some respects, won the applause of the cognoscente, and recollection of the impression it had made upon public and critics alike did much to secure toleration for the experimental work of the insurgent group then forming amongst the young painters of the west. The pictures produced during the following season, when Guthrie and Crawhall wrought together in Lincolnshire, while very similar to those which preceded them in spirit, conception and handling, revealed, in addition to very evident increase in painting power and draughtsmanship, an interesting development in tone and colour. Although remaining low in tone, when compared with the pitch then prevalent in Scottish painting, they had gone up considerably in key, had become clearer and more varied in colour and more marked by studied attention to naturalistic values. Of this the most outstanding instance was 'To Pastures New' (R.A., 1883, now in the Aberdeen Gallery), in which a little girl drives a flock of geese across a flat, low-horizoned landscape, the whole scene suffused in sunlight, but less prominent pictures bore the same characteristics, and, with increasing mastery and assurance, they appeared in the work done in Berwickshire between 1883 and 1885, and at Kirkcudbright and Stirling during the next few years. While unimpassioned and lacking in the quick personal sympathy and insight which make M'Taggart's and Mason's pictures of children so charming, 'A Hind's Daughter' (G.I., 1884), 'Schoolmates,' (1884 : Ghent Gallery), and 'Apple Gatherers' (G.I., 1887) were pervaded by that finer aspect of the realistic spirit which sees not alone the appearance of facts but something of their significance ; and, delicate and just in observation, deliberate yet sympathetic in drawing and modelling, very powerfully painted in solid impasto, which had, however, a tendency to be overloaded, excellently and simply designed, and at once truthful and beautiful in colour and full in tone, they were notable in

[1] Purchased by Dr. Forbes White of Aberdeen, it was acquired later by Mr. James Gardiner, a cousin of Guthrie and a good friend of the 'boys,' who bequeathed it to the Glasgow Gallery.

themselves and a very complete expression of the aims of the younger men at the time. Further, they possessed style, the style which issues from perfect sincerity of impression expressed by a technique expressly fitted to the matter in hand, and so remain amongst the most satisfying and convincing things inspired by modern realism. Curiously enough also, they were much nearer Lepage in temper than the pictures of those who had been trained in France.

About 1885 Guthrie commenced to turn his attention to portraiture, and after 1890 devoted himself to it almost entirely. During the transition, however, in addition to the *plein-air* pictures already referred to, he executed a considerable number of drawings in pastel, that medium having come into transient favour both in France and with the younger artists at home, in which his earlier and later interests were represented, and in which he revealed a feeling for elegance of motive and design which hitherto had been rather lacking. While some dealt with country-life or incidents of toil in rope-walks or among railway navvies, the majority of those brought together in the one-man show held in Messrs. Dowdeswell's Bond Street Gallery in 1890, and in Glasgow shortly afterwards, owed their inspiration to observation of society. Yet, whatever the subject, each was vital in virtue of impressionistic selection, fine taste, and exquisite workmanship. Marked by a wonderful sense of the possibilities and limitations of the medium, they made no attempt to rival the completeness of modelling attainable in oil-paint, as the famous pastel portraits of the eighteenth century too often do, but display pastel as it is—a material in which to sketch swiftly and suggestively, subtly and strongly if you will, but to draw rather than to model in. The subjects chosen were suited admirably to the medium, the sentiment was charming, and, the handling being spontaneous and firm, the colour was vital and unblurred; but perhaps the most delightful quality of a delightful series was the frugality with which the actual material was used, and the unworked-on ground made to contribute to the final result. It is with these, rather than with his oil-pictures, either earlier or later, that that charming piece of impressionism, his diploma picture, 'Midsummer' (1892), must be grouped.

Technically, the 'Rev. Alexander Gardiner, D.D.' (G.I., 1886), with which Guthrie broke ground as a portrait-painter, although very powerfully drawn and painted, was rather heavy handed and lacked ease and elegance in the actual brushwork; but it was instinct with the sense of reality, the strong perception of character, and the gravity of sentiment which were so marked in his subject-pictures, and, pictorially, it was conceived on exceedingly simple and dignified lines. Some little time elapsed ere its great promise was fully confirmed. His next few portraits, while able and vigorous performances, were more experimental and less significant and inclined to be grimy in colour; but, stimulated by study of Whistler and some older masters, and influenced by the experience gained when

working in pastel, he followed them by several, notably 'Mr. Ritchie,' 'Miss Spencer' and 'Miss Wilson,' the last a particularly charming picture, which, although slighter in characterisation and modelling than the 'Dr. Gardiner,' marked a great advance in flow and expressiveness of handling and in gracefulness of design and colour, and in 1893 the 'Major Hotchkis,' combining the solidity and intellectual realism of his earlier work with the technical subtlety and ease recently acquired, gave unmistakable evidence that he had arrived. And since then he has produced a series of portraits, not great in number but of exceptionally fine quality —for he has remained a sincere student, and retained his high ideal of what a portrait should be—which has ensured him a very high place indeed. In power to express the personality of a man in a way at once convincing in character and refined and distinguished in art, Guthrie has perhaps no living rival, and his portraitures of women, and specially of children, are equally satisfying and perhaps more charming. While rather deficient in spontaneity, his strong personal sense of reality being frequently subordinated to considerations of conscious artistry and to a refined and scholarly sense of style which is less quick than his observation and intellectual grasp, his work unites two great qualities of artistic strength, force and delicacy. At times, it is true, his handling of paint bears traces of overwork and of what looks like indecision. Sometimes the brushwork is wanting in limpidity and fusion, and the flesh tints are dirty and over-dark ; now and then, in the draperies specially, there are touches of light or dark that lack complete significance, and occasionally form is not fully accounted for. These, no doubt, are the defects of his qualities, and result from a fastidious taste which declines to be satisfied with an approximation, and urges the painter towards a fuller expression of his ideal, but none the less the actual painting suffers when compared with that of a consummate brushman like Sargent. Still, if he does not possess the extraordinary power of unhesitating and significant brushwork —each stroke not only falling into its place in the colour-pattern but having clear and definite meaning as representing some particular object modified by light and atmosphere—or the wonderful gift of facile and directly expressive drawing, which together make Mr. Sargent's work unique in modern art; Sir James Guthrie's technical equipment is ample and his portraiture is marked by an unfailing refinement of feeling and a rare appreciation of character, a subtle sense of low-toned and harmonious colour and tone, and a reposeful and distinguished sense of design which render it completer and more satisfying than that of the gifted American. Indeed there are few painters of any school who have excelled him in the balanced blend of æsthetic, intellectual, and technical qualities which go to the making of great portraiture. His achievement has been so fine, and, while he has had some obvious enough failures, so equal in quality, that one need not single out particular pictures for

special praise. It may be said, however, that he is at his best when truest to his own perceptions of reality, and when most simple and direct in intention and design.

Elected Associate of the Royal Scottish Academy in 1888, the first of the Glasgow group to be so honoured, Guthrie became a full member four years later, and in November 1902 he was chosen President unanimously, knighthood following. Nor has recognition been confined to his compatriots. Sir James has a great reputation abroad ; he is one of the few foreign members of the Société Nationale des Beaux-Arts, Paris (Associé, 1893 ; Sociétaire, 1895), and belongs to other Continental academies.

If Sir James Guthrie had no academic training, his friend, Mr. E. A. Walton,[1] had little more. A winter or two at Dusseldorf, when he was about seventeen, which may be ignored as a formative influence, and a few years in the Glasgow Art School, then very indifferently housed and equipped, sum up all the direct instruction he received. He had a natural gift for painting, however, and he was fortunate in his environment. His beginnings coincided with those of the new movement ; he shared its ideals and enthusiasms, and disciplined his talent in its stimulating and exacting atmosphere. But from the first he was an individualist. Influenced, as his early work is, by his immediate surroundings and by study of some great painters, notably, perhaps, Cecil Lawson and James Maris, there is in it always an individual note which makes it unmistakably his own. He possessed an outlook on the world which found expression in personal qualities of colour, design, and handling.

Commencing as a painter of landscapes, it was not long before he added figures to them, and soon portraits likewise received much of his attention. Variety of subject is, indeed, very marked in his work. He has tried many mediums also, and, working in oils, water-colour, and pastel, has used each with consideration for the material beauty which belongs to it when employed with true comprehension of its essential character. At the same time this has not deterred him from experiment, especially in water-colour, of which he early acquired great mastery. In oil, however, in portraiture at least, it is probable that a completer technical training would not have been amiss, for he might then have arrived at his final results in a simpler and more direct way. Yet it is as a portrait-painter that he has made most noticeable advance. Vigorous and bold in handling, full in tone and well arranged as his early portraits were, they are, on the whole, too summary and insistent in method and rather heavy in tone and colour to be accounted completely successful. But they showed indubitable promise, and in 1889 he sent a portrait, the 'Girl in Brown,' to the New English Art Club, which marked its

[1] The substance of this appreciation of Mr. Walton's art appeared in *The Studio* for August 1902. Born at Glanderston House, Renfrewshire, in 1860, he was elected A.R.S.A. in 1889, and full member in 1905, shortly after returning to Scotland from London, where he had resided for some years. His studio is now in Edinburgh.

fulfilment. Whistler's influence was beginning to be more felt in Glasgow by this time, and with it there came a greater desire to secure refinement of execution and design. The feeling was Walton's already, for within the vigour of his presentments of people and landscape one felt that a fine spirit was at work ; but acquaintance with Whistler's exquisite art brought it more obviously to the surface and gave it more definite direction. At the same time he assimilated and turned to his own uses only so much of the older artist's methods as was compatible with his personal feeling for Nature, and developing on these lines he has since achieved an even more refined art.

In portraiture Walton is more sensitive to beauty than to character, which he subordinates to the decorative pattern and harmonious pictorial ensemble, which are his chief concern ; and this is at once the weakness and the strength of his work as portraiture or art. It deprives the one of that quick human interest which the greatest portrait-painting, as such, always has ; and in the other it weakens the spontaneity of impression and expression which is one of art's greatest charms. On the other hand, he invariably achieves a considered and balanced beauty often lacking in work which possesses either or both the other qualities. To reticent and tender colour, subtle tone, and delicate drawing and modelling, sometimes overwrought, he adds exquisite feeling for colour spacing and a distinguished sense of decorative effect. Moreover, an instinctive refinement of sentiment, specially evident in his pictures of women and children, almost makes amends for deficiency in intellectual comprehension of character.

It is, however, as a painter of landscape, or of figure associated with landscape, that Walton has won his most distinctive success. His earliest efforts were in this field, and it remains that in which he is most happily inspired. Here also, as might be anticipated, he is at his best technically. The vital and vigorous painting, the depth of tone and richness of colour, the simple and somewhat naïve design of his earlier work, and the more dexterous use of the medium, the daintier colour and tone, and the more elegant disposition of mass and management of pictorial motive in his more recent pictures are in their different ways very characteristic of his talent and of the direction in which it has developed. As in his portraits, progression has been towards greater charm of arrangement and more deftness and subtlety of handling. Now and then in his earlier landscapes the final result suffered from tentative efforts to express an ideal or an impression rather beyond the painter's powers ; but in those of more recent years, and specially in water-colour, he seems to elaborate the idea completely in his mind before expressing it. There is no fumbling and little reaching after something not fully realised. What is put down is relevant to the matter in hand ; what is omitted is non-essential, and yet its absence acts as a stimulus to the imagination. Specially artful, too, is his use

of various grounds for water-colour. Sometimes he chooses a tinted paper, sometimes a material like cork-carpet, of which both colour and texture can be taken advantage of, as in the delightful 'Gate of the Fens' (1901); and this device, in which body-colour is largely used, he has also employed with exquisite results in a number of semi-decorative studies of girlish beauty set amid subtle suggestions of romantic landscape. His sense of design has also matured. In the eighties contest between the claims of decoration and those of the immediate impress of reality had gone mostly in favour of the latter, but since then, while his pictures have retained a subtle aroma of the freshness and beauty of Nature, he has shown a disposition to court her less for her own sake than as a source of decorative inspiration. Selecting those elements and aspects of landscape which lend themselves to decorative treatment, he has woven them into patterns of elegant or pleasingly quaint design.

Yet one may prize his later pictures highly and admire the greater skill and exquisiteness of the 'White Horse' (1898: Mr. J. J. Cowan) or 'The Rendezvous' (1899: Dr. Von Ditel) to the full, and still hanker after his landscapes of the earlier time. It is so with me, at least. The subjective interest of such water-colours as the beautiful little 'Pastoral' (1883) in Mr. Gardiner's collection, or the wonderful drawing with an oak-tree for hero, another harmony in the blue and green he loves so well, which was shown in 1887, and of pictures like 'Berwick-shire Uplands' (G.I., 1884: Mr. T. G. Bishop) or the vivid little 'Landscape' with cattle seen in Glasgow in 1891 is of the slightest, but the fervid glow of passion which animates them is irresistible; and the superb vitality of their conception, splendidly expressed in the verve and gusto of the handling, issues in unconscious dignity and coherence of style with which the rich yet aerial colouration and resonant tone are in complete harmony. There is more than the visible beauty of the world in such pictures. They are imbued with that informing spirit which makes Nature more to us than mere inert matter. The sap and substance of growth and life seem to run through them, the imagination which animates them is deep-rooted in the earth, and beside them most con-temporary landscape-painting looks poor and lifeless. There have been few landscapes painted in our time in which subject is so little and seeing so much. It is with delight then that one finds this impassioned perception of Nature at her strongest and maturest, of the rich brown earth full of sap and pregnant with vitality, of the passionless yet full and vigorous life of grass and trees and flowers, of the wide blue sky with its great white clouds laden with refreshing rain, once more asserting itself in his art.

Amongst Mr. Walton's more recent efforts a distinctive place is taken by the large panel executed for the banqueting-hall of the Glasgow Corpor-ation Buildings, in the decoration of which he was associated with three of his old confrères. The subject, 'Glasgow Fair in the Fifteenth Century,'

was such as Walton might have chosen for himself, and as a consequence the result is eminently characteristic. By judicious selection of a few types the artist has suggested variety without crowding his canvas. A crowd—for the few figures hint the presence of more—is gathered about a pair of Clydesdales led by a rough farm-hand; beyond the sun-browned haughs stretch along the curve of the river to where a bridge spans it; and overhead is an aerial sky of mellow white and grey. The whole scene savours of the country and a primitive pastoral life; and, if one is not quite certain of its decorative fitness, it remains a fine achievement, vivid, verveful, convincing: a real work of art.

The third of this quartette, Mr. Alexander Roche, was seventeen when, in 1880, after a year or so in an architect's office and some preliminary work in the local art school, he went to Paris to study painting, but, young as he was, and much as he benefited technically, specially in readiness of draughtsmanship and breadth of handling, from the instruction of MM. Boulanger and Lefebvre at Julien's and of M. Gérome at the Beaux Arts, the pictures painted after his final return to Glasgow in 1883 bore the marks of distinct individuality.[1] He had sent a few things to the Institute before 1885, but 'The Dominie's Favourites' was his first considerable picture, and, naïve in sentiment and good in colour, it was painted in the broad, strong, solid fashion and with the attention to values then in vogue with the Glasgow group to which he was an important accession. This was followed by a number of studies of girls loitering in gardens or dreaming indoors, which showed increasing powers, and with the appearance of 'The Shepherdess' at the Royal Academy of 1887 the full quality of his gift was revealed. By this time he had gone to live in a picturesque old house upon a high wooded bank above the Luggie, the Dumbartonshire stream which had prompted David Gray's finest verses, and there many beautiful pictures were painted. The most striking qualities of these are a quaint and decidedly romantic element in the informing sentiment, an exceptional grasp of the material aspects of Nature, a fine and personal feeling for sumptuous colour and design, and technically an exquisiteness of handling and of surface that are delightful. Now and then he gave us glimpses of girls in a garden and occasionally of some charming interior with figures, such as 'Miss Loo' (1888) and 'Tête-à-tête' (1889), but the most exquisite and characteristic work of that period was inspired by the woodlands and meadows amongst which his home lay, and by the simple fancies stirred by life in the country. Tinged by a genuinely poetic strain, his landscapes were often fascinating in themselves, and, when he introduced figures and was at his best, his work possessed a quaintness and charm almost mediæval in flavour. Such is the feeling in that picture of 'The Shepherdess,' kneeling at the foot of a tree-clad bank on which her sheep are feeding, whilst the moon rises solemnly behind the

[1] Mr. Roche and Mr. Lavery were much together when in Paris.

stems, and the sleeping earth seems to listen with the child to its wondrous story. 'Can it be Jeanne d'Arc herself?' a critic queried, and the question gives some indication of the compelling glamour of the picture. And the same somewhat mystical sentiment breathes in his rendering of the beautiful old carol of 'Good King Wenceslaus' (1886), where the page, a crow fluttering behind him, trudges through the snow in the footprints of his gold-haloed master by the frozen river. In 'Springtime' (1892), typified in the freshness and beauty of a girl with a handful of blossom, and mirrored in the landscape setting, and other pictures of children and the country, the measure is sprightlier, but the feeling scarcely less romantic, while in the 'Idyll' (1892 : Auckland Gallery)—a group of maidens, a youth, and a young mother and her child set amid the fresh greenery and opening blossoms of early summer, beside a tranquil stream which mirrors the heavenly blue of May—there is a combination of blithe romance and spirituelle fascination, and also something of classic dignity, which make it his most memorable work, and one of the most beautiful produced in our generation.

The love of beauty and the delicate fancy, which have been singled out as characteristic of these pictures, are present also in his treatment of pure landscape. Things like 'Eventide' (G.I., 1888), 'The Hill-Top' (G.I., 1889), and 'Among the Trees' (G.I., 1891), were delightful in their mingling of realism and poetic apprehension, and, if this was less marked in his West Highland sketches, which somehow missed the spell the sea weaves round those solitary shores, the many sketches and pictures painted at the fishing-village of St. Monans, at intervals between 1892 and to-day, have been distinguished by rare instinct for the picturesque elements and the characteristic accent in impression, and are redolent of the old-world charm which hangs over the green-mantled and gold-fringed kingdom of Fife.

In 1888 Roche executed a series of charcoal or chalk drawings from notable modern pictures, which he interpreted with great sympathy, to illustrate Henley's Memorial Catalogue of the Glasgow Exhibition (*A Century of Artists*, Glasgow : Maclehose and Sons, 1889), and in 1891 he went to Italy to see the galleries. The effects of increased acquaintance with Italian art is traceable perhaps in the 'Idyll,' but a more direct result of this visit was that it led to a second, during which he lived for several months amongst the Sabine hills and painted a number of delightful pictures of contadine. Indirectly, it probably influenced his next departure in subject also, for a year or two later he settled down as a painter of women.

Previous to removing to Edinburgh in 1896, Roche had painted only a few portraits, and these little larger than cabinet-sized full-lengths marked by something of the intimate character of domestic genre, but since then he has devoted much time to portraiture of the usual type. At first the claims of individual characterisation and increase in scale, trammelling his liberty

and involving greater demands in draughtsmanship and modelling, told adversely upon the quality of his work and affected even his colour and handling ; but, setting himself resolutely to face these difficulties, he overcame them, so that now, whenever he is fortunate enough to have a sitter, sympathetic in type and character, he produces a thing of charm and beauty.[1] Yet, admirable as much of his portraiture has been, his uncommissioned pictures, as one might expect with a painter of his ardent temperament, are finer as art and far more characteristic of his very personal talent. In these later years the fascination of figure-painting and, perhaps, its seemingly greater importance have seduced him, as they have Mr. Walton, to a great extent from those motives in which figure and landscape were associated, which were his first-love, and in dealing with which he is ever at his best. Yet every now and then he returns to them, and while the engaging *naïveté*, the romantic mood, and the slightly mystical thrill, which charmed one so in his more youthful pictures, are less frequent in their successors—the impressive riverside 'Landscape,' brooded over by a noble sky, medalled at Munich in 1897, the subtly graded 'Low Tide' (R.S.A., 1900) with its purple shadowed fore-shore of rocks and tangle, amongst which children are playing, and its golden distance of sunlit sea-brae and village under a serene sky of palest blue, the delightfully designed and charmingly lit 'Old Harbour' (1907), and a few more—the latter are more dignified in design, completer in expression, more ambient in atmosphere, and in their different way perhaps equally beautiful in colour and handling. The work most typical of his achievement during recent years has been done, however, in the borderland between picture and portrait. Chiefly studies of feminine loveliness, these pictures possess a rare combination of pictorial and subjective beauty. There is a suggestion of the dignified grace of the eighteenth-century English masters in the management of the pictorial motives and in the frequent use of a convention which combines indoor lighting of the figure with a semi-decorative landscape background, but this, while contributing to the reposeful aspect of his canvases, is subordinated to the expression of personal feeling as regards what he is painting, while his technique, colour, and sense of tone are frankly modern. Their attractiveness is due, then, to something more and far deeper than a scholarly use of a fine pictorial convention and an alluring prettiness obtained at second hand. It issues from a delicate and wholesome sentiment regarding women, working through a refined and disciplined pictorial taste, an instinctive yet cultured love of beauty, and a determination to give adequate expression to both feeling and observation.

A member of the Royal Scottish Academy (Associate, 1894 ; R.S.A., 1900), Mr. Roche has also been much medalled abroad and has had a goodly number of pictures purchased for public galleries. And, what is even a

[1] Some of his finest portrait work, including a group of Mrs. Andrew Carnegie and her daughter, has been painted in America.

greater compliment, several of his pictures have been acquired by distinguished artists. Herr Liebermann bought 'A Scottish Town'; M. Gaston La Touche 'The Clyde'; and Sir George Reid commissioned him to paint a portrait of his wife.

Like Walton, he painted (1900) a panel for Glasgow's Hôtel de Ville. His indeed was the first commissioned, and it is an open secret that he might have had the whole series had he not desired that others should share in the important undertaking. The subject allotted to him was the legend of the city arms, and his treatment of St. Mungo's miraculous recovery of Queen Languoreth's ring in the mouth of a salmon taken by his orders from the Clyde is marked by decorative beauty, sumptuous colour, and the romantic sentiment appropriate to the theme.

Although a native of Ireland, having been born in Belfast in 1857, Mr. John Lavery was brought up in Scotland and was associated intimately with the Glasgow School from the beginning of both its and his own artistic career. He is, however, the most cosmopolitan of the group. A Royal Scottish Academician since 1896 (Associate, 1892) and Vice-President of the 'International Society of Sculptors, Painters, and Gravers,' under Whistler and M. Rodin, he is also Cavaliere of the Crown of Italy, member of the Société Nationale des Beaux-Arts, Paris, and of the Sécessions of Berlin, Munich, and Vienna, and enjoys the widest reputation of any of the 'boys.' He has journeyed to Rome and Berlin and Madrid to paint portraits, and he is represented in the Luxembourg, the Pinakothek, Munich, the National Galleries of Berlin and Brussels, the Uffizi, the Modern Gallery, Venice, and the public collections of Philadelphia and Pittsburg, as well as in the Glasgow Corporation Gallery, in the Diploma Room in the National Gallery of Scotland, and in Liverpool. Trained so far in Glasgow and at Heatherley's, London, he went to Paris in 1881, and, remaining three years, principally under Bouguereau and Fleury, laid there, and at Gretz—where he joined the painters' colony and became acquainted with Frank O'Meara (1853-88), the gifted young Irishman, who was amongst the first to reconcile realism and decoration and whose work influenced Lavery considerably—the foundations of a fluent and accomplished style. His earlier pictures had been sentimental and anecdotal in type, but the influences under which he came in France turned his attention to realism in subject and to a method which would render the breadth of effect and the justness of tonal relationship which had become *le dernier cri* in Paris. A man of great adaptability and tact, Lavery learned his lesson quickly and well, and at the same time preserved his individuality of taste and outlook. Of less sensitive and poetic temperament than Walton or Roche, his traffickings with Nature are less marked by insight and beauty of perception, and his pictures lack the touch of glamour and distinction of feeling present in theirs. The essence of his gift lay rather in a flexibility and modernity which enabled him

to dip into contemporary life at many points without being absorbed by it.

A number of pictures, chiefly figure and landscape, painted at Gretz and exhibited at the Glasgow Institute in 1885 may be said to have marked his juncture with the rising school, and notable even among its work for obvious stress upon values, combined with a semi-decorative simplification of planes and a delicate level grey tone of colour, they seemed 'most impudently French' to people of the orthodox persuasion. But there was no denying their cleverness, and after the more realistic 'Tennis' (1885), which was seen in Glasgow in 1887, had been medalled at the Salon, he became an artist of consequence and was commissioned to paint the official picture in commemoration of Queen Victoria's visit to the Glasgow International Exhibition of 1888. 'The Bridge at Gretz,' painted in 1883, but not shown in Glasgow until 1891, 'Tennis' and 'The Queen's Visit,' on which he was engaged for the greater part of three years, may be selected as typical of his work during this period, and each in its respective way shows his clear and unemotional perception of reality and his capacity for expressing it with real artistic skill, his adroitness in the management of complex subject, and his technical resource. But of recent years, except for an occasional riverside landscape, painted with great charm and fluency and full of sparkling light, and his share in the Glasgow decorations, to which he contributed the panel illustrative of the city's contemporary activities—and choosing the building of a ship with a distance of busy river under a cloudy sky, he did so aptly and well if not epically as Meunier might have done—he has devoted himself to portraiture and to picturing feminine charms.[1] Before proceeding to discuss his achievement in that direction, however, one had better say something of a few pictures of the earlier time which differ in character from those already mentioned. The 'Ariadne' (1887 : Mr. Robert Strathern, Edinburgh), which shows the Cretan princess, half nude and gauzily attired, standing upon the island shore watching with despairing gesture her errant lover's sails sink below the far blue horizon of the morning sea, was a delightfully modern treatment of classic story, in which realism and decoration were happily harmonised ; and the large pastel of 'Aphrodite' (1889), floating in the crystal depths with fish sporting about her, was poetically conceived and admirably wrought. And two historical pictures, 'The Night after the Battle of Langside' (Brussels Gallery) and 'Dawn, 14th May 1568' (Mr. James Mylne, Edinburgh) awakened memories of the fateful story of the ever fascinating Queen of Scots, with its glamour of beauty and tragedy, as much by appropriateness of landscape setting and atmosphere as by figure action.

[1] An occasional visitor to Tangier in the past, Mr. Lavery has spent the last few winters there. These sojourns have resulted in a number of pictures of Tangierian life and landscape, many of which were collected at a 'one-man show' held in the Goupil Gallery, London, in the summer of 1908.

Although perhaps not a portrait in the strict sense, a delightful study in greys, green, and black, called ' An Irish Girl' (G.I., 1891), may be regarded as the beginning of the long series of portraits of fair women Lavery has painted, for, while he had exhibited a few portraits previously, it was the first in which he showed those qualities of pictorial taste and artistic finesse which have given him a distinctive position as a painter of women. He has painted men, of course, but as few of these, except the well-known and dashing full-length of Mr. R. B. Cunninghame Graham (Glasgow Gallery), and, in less degree, the three-quarter-length of Mr. Fitzmaurice Kelly, have been really satisfying, we may confine our attention to the ladies.

Gifted with very distinct and delicate artistic sensibility, Lavery also possesses the gift of being able to use his talent to the full, and has made more of it perhaps than any of his fellows have made of theirs. Concentrating himself upon the things he has naturally, and seldom straining his limitations, while doing the utmost to do himself justice, he has developed a brilliant and facile manner, and, widening his gamut by study of Whistler and Manet, and of Goya and Velasquez, has added to the completeness of his style. The influence of Whistler may be traced in increased refinement in an originally fine sense of tone and in greater delicacy and flow of manner, while that of Manet seems to appear in elimination of shadow and simplification of planes. With Manet, however, these were results of a personal way of looking at subject rather than a pictorial device. Direct influence of the older masters is more difficult to trace, but it also has been technical and pictorial rather than intellectual and subjective.

Of all those connected with the Glasgow movement Lavery has retained most traces of French training. If less searching and intimate in draughtsmanship than some of his fellows, he draws with the assurance of an atelier trained man, and handles paint with an ease and fluency unequalled by any of them, while his turn for elegance and his taste in colour, values dominating quality and restricted harmonies prevailing, are in great measure French in their kind. Yet this combination of intuitions, training, and careful cultivation has resulted in a style at once captivating and personal, marked by great elegance of design, wonderful sweetness of never potent but always subtly harmonious colour, and unassertative yet attractive dexterity of handling.

If art were nought but decoration, and portraiture had nothing to do with life and character, Mr. Lavery's work would call for very high praise indeed, but, significance being one of the essentials of great art and portrait-painting having intimate relationship to life, in so far as his achievement falls short in these respects, one must qualify what has been said. And the truth is his portraiture seems to show a superficial interest in life. His sense of feminine charm is acute, but lacking in depth. He

paints a pretty woman not as she is but as the rather vague ideal of an inept smart society would have her. To all he gives the same elegant and chic air, and the same complexion of dull ivory and palest pink roses, and, slurring over the less obvious and more intimate passages of modelling in face and figure, he lets a graceful arabesque play against a cleverly toned setting. He seems more absorbed in filling his panel beautifully, and in weaving subtle harmonies of delicate colour than in recording sympathetically and fully his sitter's individual beauty and character. And this is the more obvious, because when the type is less familiar and the drawing less known, when he has to paint a lady who is not obviously pretty, or a child, where the modelling cannot be accommodated by his convention, and has to concentrate himself upon the drawing to secure a result, his work is less mannered. Moreover, he is at his highest when painting a woman who, besides being pretty, has interested him. The 'Lady in Black' in the Berlin Gallery, the 'Miss Mary Burrell,' the young girl in white carrying the great bunch of blossoms in the Luxembourg, and the 'Ladies Hely Hutchinson' are pictures that any one might have been proud to sign. But, as a rule, he gains his effects so easily and his facility is so unfailing, that he lacks the stimulus to that complete expression which comes from a knowledge and feeling in excess of present accomplishment. At the same time his keen appreciation of the distinction conferred on portraiture by the masterly placing of the subject on canvas, his fine eye for subtle schemes of grey and white or black and lavender, his able handling, in short his ideal of picture-making and his technical gift are of such a high order, that, despite deficiencies, his work possesses notable and beautiful qualities of its own.

CHAPTER IV

THE LANDSCAPE PAINTERS

IN considering the landscape painters connected with this movement one naturally thinks first of Macgregor and Paterson, for, while the landscape of Walton and Roche, which has necessarily been dealt with in relation to their work as a whole, is more beautiful, it was in the pictures of these two that the new ideals made their earliest appearance. And here, of course, ' the Father of the Glasgow School,' Mr. W. Y. Macgregor,[1] takes precedence. The son of a shipbuilder, he did not enter the famous yard at Meadowside, but, adopting art as a career, helped to make the Clyde known for something besides ships. Studying under Robert Greenlees in the local art classes and as a pupil of James Docharty (1829-78), a competent but unemotional artist by whom the M'Culloch convention, carried forward by Milne Donald (1819-66), had been still farther naturalised, he was brought up in a good though narrow tradition, and then worked for three years with M. Legros at the Slade School, where he imbibed stylistic tendencies which did not reveal themselves in his art, however, until considerably later. His early landscapes, wrought much in Docharty's mood and method, were accepted and well hung at the Institute Exhibitions, but count for little in his development except in so far as they were careful studies of Nature and vehicles for technical experience. In 1878, however, being at St. Andrews with Paterson, who had been studying in Paris and was painting in a broader and bolder fashion, Macgregor began to reconsider his relationship to Nature, and, as a result, commenced to paint effects rather than facts. Then, about a year later, it came to him all at once, like an inspiration, he says, that for him at least the primal quality in painting, as in Nature, was fullness and richness of tone. And getting big brushes he attempted to attain this forcibly and directly. The result was disastrous to any little position he had made : his pictures were refused at the following Institute and his ideas were ridiculed by the local artistic coteries. But possessed by a sense of the importance of what was to him a discovery—he learned later that he might have found it in the work of certain of the Old Masters and of some of the early English landscape-painters and the Barbizon men—he bent all his energies to

[1] Born in 1855 Mr. Macgregor joined the Royal Scottish Water-Colour Society in 1885, and was elected A.R.S.A. in 1898.

express what he felt in his pictures and to impress his beliefs upon his immediate circle. In Paterson he had already a coadjutor, and amongst the crowd of young enthusiasts then beginning to paint in Glasgow he soon found gifted disciples ; but the development of the movement as a whole having been traced already, here one need only emphasise the prominent part played by Macgregor in its origin and in the direction it took.

Permeated with the fervour of deep conviction, the studies of still-life, such as 'Apples' (1883), a rendering of a couple of plucked fowls hanging against a deal board, and a big canvas of vegetables, made by Macgregor about this time, are amazing in their power of realism and strength of tone and handling, and his landscapes of the same period are veritable slabs of Nature so truthful are they in value, lighting, and colour. Gradually, without abating the strength of his statement, he added greater subtlety to his technique, and in 'Crail' (1884) and 'Pollards on the Tyne' (1885), and in some charming water-colours, amongst which 'On the Stour' (1888) may be named specially, he attained a very delightful expression of personal sentiment for landscape of the pastoral kind, pitched as it were in minor key and marked by fine feeling for cool, silvery colour.

From 1886 to 1890, Macgregor, being in indifferent health and much abroad, exhibited little, and that chiefly in water-colour ; and for some years after he returned his pictures did not possess their old arresting quality. Cut off from pursuing his own propaganda, his ideas had gradually undergone a change, and the effects of Legros's training commenced to appear in his work. Without losing that strong grasp on reality, which is the most personal element in his gift, the more pictorial qualities were now considered also, and style and dignity of design were cultivated assiduously. In 'A Tidal River,' 'The Towing Path' and a number of others the intention was more commendable than the result, for the handling was stodgy, the colour rather dead, and the stylistic tendency too obvious, and it was not until 1896 that he produced a quite satisfactory picture in his new mood. 'A Rocky Solitude' was followed by 'The Quarry' (1897 : the Pinakothek, Munich), 'The Walls of Stirling' (1901), 'An Avenue' (1903), 'Durham, Evening' (1904 : Glasgow Gallery), 'The Cathedral' (1905), and 'The Wye at Chepstow' (1906), and if all were not equally successful each showed great earnestness of purpose, and a high ideal. Those that did not 'come off,' as the expressive phrase has it, might be clumsy in mass and lacking in suavity of handling and colour, but they remained worthy of respect. Those that did were notable for a certain grave dignity of sentiment which was impressive, a balanced weightiness of design which possessed real distinction, and a restrained yet subtle sense of colour and a firmness and vigour of drawing and brushwork which expressed the mood and aim of the artist admirably. And the same holds good of many of the drawings in pencil or charcoal or in pencil or charcoal washed with water-colour which he has

produced of late years, though here his solid simplicity is sometimes archaic and at times even savours of artificiality. It is to be regretted also that, in striving to obtain largeness of form and dignity of mass, he should think it necessary to strip Nature of her verdure and more delicate beauty, and to solidify forms, such as trees, of which mobility is an essential characteristic. And if in this later phase his art has become such an abstract thing, and, while full of reality, so little realistic that an apparent solicitude for design and a certain want of spontaneity in feeling as regards Nature are, perhaps, inevitable, it is certain that one would derive greater pleasure from his pictures if these tendencies were less noticeable. Still we must needs take what we can get, and when a thing is as fine in its kind as 'A Rocky Solitude,' 'The Quarry,' 'A Winter Landscape,' and 'The Cathedral,' we ought to be thankful. It is remarkable testimony to the strength of Macgregor's personality and the power of his art that his later work, like his earlier, has influenced a number of his contemporaries profoundly.

If Mr. James Paterson's style has been marked by less obvious change than Mr. Macgregor's it has undergone gradual modification also. Born in Glasgow in 1854, Paterson had been some time in business before he got his way and went to Paris to study painting. Going in 1877, he was among the first of the younger Scots to work in a French atelier—his masters were MM. Jacquesson de la Chevreuse and J. P. Laurens—and he soon acquired a bolder and broader style of painting than was customary in Scotland at that time, and an idea of values, which, as we have seen, were to give Macgregor the impulse that was to make him the leader of a movement in Scottish Art. Although not a protagonist in the same sense as Macgregor, he believed in and practised the new ideals, and shared in the ridicule they incurred. But he applied them in his own way and to his own kind of subject, and, possessing a feeling for decorative effect and an appreciation of landscape style as practised by Corot and the romanticists, he never made realism the sole objective of his art. His earlier work included both figure and landscape motives, but the former were not very convincing or successful in treatment, and, though he has never quite given up figure-painting and occasionally essays a portrait, it is as a landscape painter that he has made a position and demands consideration here.

Sylvan and pastoral scenery had special attractions for him, and at Moniaive in Dumfriesshire, where he settled in 1884, he found the type of country exactly suited to bring out the best elements in his refined and personal talent. In love with harmonies of grey or blue and gold or brown, late Autumn or early Spring before the delicately tinted buds as burst into tender green leafage, inspired him to such charming things 'Autumn Morning—Moniaive' (1887), 'Glencairn in Autumn' (1888), and 'Spring's Delay' (1893), but other colour-schemes and seasons had their

appeal also, as is evident in 'Alders' (1887), one of his loveliest water-colours, 'The Moon is up' (1890), 'Sundown' (1891), and the impressive 'Winter on the Cairn,' which received Mention Honorable in the Salon of 1890. The whole rural year is pictured on the canvases and in the water-colours painted at Moniaive between 1885 and 1896 or 1897, and, pregnant with the spirit of place, the cycle breathes a sense of the quietude, the unhurried charm, and the freedom of a pastoral district. Before them one loitered by shallow streamlets fringed with alders and mirroring the blue sky in tranquil pools, or sat in woodland places quick with the mutely-stirring sap of Spring; looked across lush summer pastures dotted with cattle towards a whitewashed steading nestling amid trees, or watched the lambs skip and the shadows sleep in some happy valley amongst the green sheep-hills of Nithsdale. Engaging in sentiment and instinct with a true, if not specially deep, feeling for Nature, painted with style and freedom, usually good and occasionally quite beautiful in colour and tone, and designed on lines in which decoration and realism were happily blended, these pastorals possessed an idyllic quality of their own and occupy a distinctive place in the work of the Glasgow group. Since then, however, other and more ambitious elements have appeared in Paterson's work. Choosing larger canvases for the most part, he has aimed at more striking pictorial effects and, perhaps stimulated by Macgregor's example, at more distinguished design. Some of these, such as the 'Edinburgh' in Mr. Erskine of Linlathen's possession, are both dignified and striking, but others, and specially those in which he has attempted most—'A Dream of the Nor' Loch' may be cited as an example—tend towards melodrama in sentiment, lighting, and colour, and show obvious traces of mannerism and forcing in the actual handling. Fortunately his less ambitious undertakings retain much of the charm of his earlier mood, and his work in water-colour, in which medium he has always been more successful than in oil, has been but little affected.

Elected a member of the Royal Scottish Water-Colour Society in 1884, he was chosen an associate of the 'Old' Society in 1898, and has contributed many fine drawings to the exhibitions in Pall Mall, while since 1896 he has been an Associate of the Royal Scottish Academy. Mr. Paterson's occasional writings and the few lectures he has delivered upon art subjects reveal a cultured and refined personality, and the letterpress which he wrote to accompany a series of photogravures from his own drawings of 'Nithsdale' (published 1893) is fragrant with love of country sights and sounds.

Landscape being one of the fields of Art most cultivated in Scotland, and the work of Macgregor and Paterson and of Walton and Roche possessing interest and beauty as well as novelty of method and style, it

is not surprising that the movement, in which they were so prominent, exercised a great influence on Scottish landscape-painting. Amongst the group that found a centre in Macgregor, in addition to Paterson, Walton, and Roche, there were several artists who either then or later painted landscape with distinction or style. One or two of these, notably T. Millie Dow and William Kennedy, have made their distinctive reputations in other walks, however, and consideration of their work must be postponed; but James Nairn, Alexander Mann, Macaulay Stevenson and a few more find their natural place here.

Nairn (1859-1904), who was one of those who studied at the life-class in Macgregor's studio, had shown distinct promise and considerable accomplishment before 1889 when he had to go to New Zealand in pursuit of health. The pictures painted in this country, of which 'Harwich Green,' 'The Sound of Mull,' 'Twixt Sun and Moon—Auchenhew,' and 'Kildonan' (Glasgow Gallery) may be named, showed a healthy sense of colour and tone, good feeling for Nature and workmanlike craftsmanship; and when he died he was described as 'the most brilliant artist in New Zealand.' Out there they said he 'loved the sun and had an affection for the cloudy "southerly." His landscapes are not microscopic studies of trees or hills or plants—they are bits snatched out of the wide, open day, with light and air palpitating through the picture.' Moreover 'His artistic influence was lasting and deep to those that came to know his aims and ideals. Among those whom he drilled to look at " Nature as she is " his influence for the best and truest will never be forgotten.' His best picture is said to be 'A Summer Idyll' in the Wellington Gallery, but his portraits were more popular than his landscapes, which were considered 'a little rougher and uglier than is necessary' by some Colonial critics.

Alexander Mann (1853-1908) commenced by painting landscape, but, having studied in Paris, took to figure for a time, and with considerable success—'A Bead-Stringer, Venice,' was selected for Mention Honorable at the Salon of 1884. This was the first Glasgow picture to be so honoured and the earliest outside success achieved by an associate—he was never an active member—of the rising School. Like the 'Tapestry Workers of Paris' (1883) it was an effect of clear, bright sunlight and excellent in drawing and colour. But by 1886 he had returned to landscape, and in a number of pictures, painted during the next few years, of which 'By the Findhorn' (1887) and 'Nearing the Sea: Findhorn' (1888) were the most prominent, he revealed a fine feeling for light and atmosphere, reserved but harmonious colour, able drawing and brushwork, and a real appreciation of the sentiment of tranquillity in landscape. These were followed by some Tangier subjects, including a portrait of Kaid Maclean (1894), and after settling in London in the mid-nineties, he painted English landscape chiefly, and, for the most part, its least

picturesque and superficially attractive features. But in virtue of a refined sense of tone and a real, though unimpassioned, feeling for the hush of dusk and the brooding quiet of night, he touched, now and again, in pictures of sheep being folded in wattled folds beneath the smooth uplifting of a green down seen in grey twilight or lit by a crescent moon, or of a stretch of level country under the star-strewn heavens, a true and affecting note. Neither powerful nor exquisite, nor even quite attractive, for his colour inclined to be negative in kind and was rather deficient in quality, there is yet a certain quiet and unassertive charm about his work which, without riveting individual pictures in one's memory, leaves a pleasing impression of Nature seen sympathetically and in a personal way.

Although he did not become openly connected with the movement until after it had taken definite form, R. Macaulay Stevenson has been such a prominent figure in its later phases that one is apt to forget that he can scarcely be reckoned a member of the original group. Before he became associated with the new school in the public eye, however, Mr. Stevenson had been active in the ferment of ideas that was going on below the surface. Enthusiastic, volatile, voluble, he was a great talker, and, being interested in all sorts of pictorial and technical problems, from dignity of design to the texture of canvas, and in the politics of art, he was a stimulating influence in the coterie to which at that time he belonged through affinity of feeling rather than through actual performance.

He had shown landscapes at the Institute before 1883, but from then until 1891, with the exception of 1885 and 1887, he was unrepresented, and when he again took to exhibiting his art had changed completely. While his early work had been quite ordinary, if scarcely common, he had shown no special aptitude for style either in composition or handling. What he was now painting revealed a great increase in sensibility to the poetic aspects of landscape and a much more distinguished sense of style. In the interval, like many of his contemporaries, he had been influenced profoundly by the work of the French romanticists and by the new science of values; while, living much in the country, he had come into close contact with the inner spirit of Nature. It was these things, and more particularly the inspiration he received from study of Corot, that formed the style of his maturity, which is indeed the only one known to most people.

More than any painter of equal reputation among his fellows, and he has received several medals and is represented in many important public galleries in Europe and America, Macaulay Stevenson is an artist of one mood and subject. The mood is elegiac and somewhat mystical; the subject woodland and water at dawn or dusk or in moonlight. Yet within these limits he has attained considerable variety (less of effect and colour than of design, however), as may be seen in the three reproductions in Mr. Martin's book on the Glasgow School, which represent his range very well indeed, except that on occasions, as in 'A Spring Morning'

(1898) or 'Summer on the Seine' (1904 : Glasgow Gallery), he has attained greater elegance of line. But, in spite of charm, one feels his art limited and tending to become stereotyped. The sentiment is vaguely poetic rather than imaginative and truly suggestive, the harmony of colour betwixt green and grey is attained by a unity of tone which avoids the difficulties of more full-blooded colouration and a greater range of values, and the drawing of the graceful shadowy forms would scarcely stand the broad light of day. Still, if showing comparatively little original force, his art is in the line of a noble tradition, and gives expression to refined sentiment in a distinguished way, while the unifying influence, which is his own, is not to be lightly esteemed.

Working from the life in Macgregor's studio and painting at Cockburnspath when it was the country rendezvous, T. Corsan Morton, who had previously been a pupil of Legros in London and of Boulanger and Lefebvre in Paris, was closely identified with the early group. Without any outstanding qualities to make his view of Nature notable or his expression memorable, he has been a sincere and devoted student of Nature and Art ; and, while seldom distinguished, his pictures are never commonplace. And this, of course, is exactly the most trying position for an artist. Too good to be popular and yet not quite good enough to appeal strongly to people of fastidious taste, Mr. Morton's work has perhaps not received sufficient attention. It shows ability to give pictorial interest to subject and to attain balance of design and unity of effect that is none too common.

This also is perhaps the place to include Mr. J. Whitelaw Hamilton, for although rather younger than most of the others, he was making good claim to be included in the group very early in the nineties. His training in Glasgow was supplemented by study with Dagnan-Bouveret and Aimé Morot ; but, while his technical equipment is considerable, there is in his work a want, not so much of individuality, as of distinction of feeling. Yet his composition is carefully considered and, if occasionally too lumpy, well knit together ; his colour, personal and not unpleasing in itself, is subordinated to perception of values ; and his sentiment for Nature, while not very profound, is sincere. Perhaps the happiest picture he has produced as yet is 'Night on the Clyde,' a late evening effect sympathetically interpreted ; but the landscapes painted upon the bare and windy green uplands above the red Berwickshire cliffs or in the rocky coves at their feet, with fisher-cottages clustering round the little harbours and brown-sailed boats going to sea or returning, are more characteristic, and many of them, and not least those in water-colour, have been successful in their own way. Mr. Morton and Mr. Hamilton have been more appreciated abroad than at home : both are members of the Munich Sécession, and several of the latter's pictures have been acquired for public collections.

While the new movement centred in Glasgow and attained its widest influence and most marked developments there, the highly contagious atmosphere generated in the west, and the fashion of going to Paris to study had an influence all over Scotland. Thus Mr. James Cadenhead (b. 1858), the son of an advocate in Aberdeen, after studying in the school of the Royal Scottish Academy, went to Paris, and, entering the studio of Carolus Duran, where he remained two years, came under similar influences to the Glasgow men then working in Paris. Returning home in 1884 he stayed there until seven years later, when he settled in Edinburgh, and in 1902, having been a member of the Royal Scottish Water-Colour Society since 1893, he was elected an Associate of the Academy. He is said to have been the first R.S.A. student to study in Paris, and it is significant of his early sympathies that he joined the New English Art Club when it was founded in 1886. His earlier pictures, both landscapes and portraits, were marked by considerable power in the handling of oil-paint and by careful study of *plein-air* values ; but, after some years, he devoted himself principally to landscape-painting in water-colours and began to develop that decorative tendency which is now the most marked feature of his style. In the work of his maturity, the design, like that of the Japanese by whose exquisite colour-prints he has been influenced quite evidently, is largely founded upon combinations of decoratively coloured spaces, in favour of which light and shade, full modelling, and even true atmospheric effect are frequently suppressed or overlooked ; and, although not lacking in sentiment, his drawings neither thrill nor enthral, while frequently the process of reasoning upon which his designs are based and the striving to attain balanced harmony are too obvious. Yet within the limits of his chosen convention he has done good work, marked by scholarly qualities, and of late years he has been infusing greater truth of aspect and a closer study of Nature into his renderings of woodland, seashore, or far-spreading vistas amongst the hills.

Affinity with the ideals of the Glasgow men is more obvious perhaps in the work of Mr. Robert Little. While both he and Cadenhead share the decorative tendencies and the regard for ensemble and breadth of statement which are Glasgow characteristics, cool and deliberate planning, less of pictorial than of formal decorative effect, flattened tones and taste for colour simplified rather than rich and full, and a considered technique, in which there is little scope for the sheer joy of painting, give the latter's pictures a character which, superficially at least, makes affinity less marked. Little's art, on the other hand, is more in sympathy with the movement as regards tone, colour, and handling. A student of the R.S.A. like Cadenhead, he did not go to Paris until he had had considerable experience in picture-painting at home and in Italy, where he had studied at the British Academy in Rome. Indeed, in the year (1886) during which he

worked under Dagnan-Bouveret, he was elected a member of the Scottish Water-Colour Society, and French influence had no appreciable effect upon his point of view. A painter of both figure and landscape, and in oil and water-colour, his work presents considerable variety. In the earlier part of his career he painted a great deal abroad, and many of his subjects were Italian in origin, but more recently, while occasionally returning to that source of inspiration, he has found material nearer home. Without abandoning the oil medium altogether, he has also been working more in water-colour, and since 1892, when he was elected an Associate of the Royal Water-Colour Society (full member 1899), his principal work has been shown in Pall Mall. His earlier style was dainty, refined and careful, but lacking in definiteness of conception and, in oil painting specially, in power and convincing quality of expression. But during the last decade he has produced a series of drawings of distinct charm and considerable power, marked by a certain romanticism of sentiment and by a pleasing mingling of decorative quality and of classic balance and restraint in design. Combining a good deal of that feeling for dainty prettiness, which has been characteristic of English water-colour since Fred Walker's time, with a robustness of handling, a unity and fullness of tone, and a breadth of effect and a feeling for colour which are at once personal and related to the later developments of Scottish art, his recent drawings have possessed admirable and distinctive qualities which bring them and those of James Paterson into closer relationship than exists perhaps between the work of any other two members of the old Society.

Marked by some of the characteristics of the newer school, Mr. P. W. Adam's landscape might perhaps be spoken of now, but it will be considered in relation to his work as a whole and to that of Mr. Lorimer, who, it should be noted, was a pupil of Carolus Duran. Another R.S.A. student who worked in Paris, Mr. Robert Noble, might also have found a place here, but his landscape and that of Mr. R. B. Nisbet, the water-colourist, and of Mr. Coutts Michie, if touched in some measure by the influences which moulded the Glasgow men, is more on traditional lines, and was dealt with in a preceding chapter.

By the middle of the nineties quite a crowd of younger landscape painters, influenced more or less directly by the new ideals, were at work in both Glasgow and Edinburgh ; and as they have been joined by recruits every year since then, one cannot treat them in chronological order, or deal in detail with the characteristics of the work of each. Broadly speaking, they may be divided into those in whose pictures the more definitely formulated artistic elements are more pronounced, and those who, influenced by the general tendencies of the movement, have employed them less consciously in the expression of a more naturalistic view of landscape. From these

categories I propose, however, to exclude a number [1] who have inclined to make decoration the predominating element in their treatment of Nature, and to include them in the chapter devoted to 'Decorative Phases.'

As one would expect, it is by the more naturalistic wing that the most vital work has been done. While the art of men like Messrs. John Lochhead, Harry Spence, Taylor Brown, Kerr Lawson, A. G. Sinclair, C. H. Woolford, and a few more possesses many of the characteristics of the 'Glasgow School' and shares the air of distinction which a stylish use of paint, a decorative convention, and a feeling for ensemble have conferred on the pictures of the group as a whole, one must agree with Professor Muther, that 'it has a certain outward industrial character, and this raised to a principle of creation has led too easily to something stereotyped.' No doubt some of them possess well enough defined qualities of their own, but as to discuss their work in detail would be to repeat in diluted form, with less praise and more blame, much that has been said of that of the stronger men in the movement, it seems unnecessary to do so. Turning from these, then, we may consider the landscape of Messrs. George Houston, J. Campbell Mitchell, A. Brownlie Docharty and some others who, while benefiting to some extent by these formulas, have attained something more personal and expressive. And as Houston has been less influenced than the others, we had better begin with him.

Superficially, at least, Mr. Houston owes little to the influence of the newer school. But his care for actual tonal relationships and for the broad effect of atmosphere may be traced to the movement, and the simplicity of vision and clear definite statement which give his landscape its peculiar quality are in great degree a reaction from the decorative formula, which has shown a distinct tendency to become stereotyped in the work of the lesser men of the younger generation. Quietly keen in observation, serene and unforced in lighting, tender in colour, and delicate in drawing and handling, his pictures possess a tranquillity of sentiment and an abandonment to the mood of unruffled contemplation which, while it makes little immediate claim for attention in a big exhibition, deserves consideration when once noticed. He had been painting landscape in this spirit for a number of years before 1904, but 'An Ayrshire Landscape,' then shown at the Institute, being on a large scale attracted much attention and was purchased for the permanent collection. If a more 'important' picture than any he had shown previously, it was in reality one with the smaller canvases—'Winter Sunshine' (1899), 'Ness Glen' (1900), and 'Waterfall near Dalry' (1901)—that had led up to it, and, while giving him a wider reputation, made little difference in the appreciation of those who knew his work. The names of these pictures give an idea of the type

[1] Principally the Kirkcudbright group. The landscape of Millie Dow and Robert Fowler, being subordinate in a sense to their figure work, will also be dealt with there. T. A. Brown's pastorals and William Kennedy's landscape will be considered in Chapter IX. The few marine painters among the younger generation figure in Chapter VI. of the preceding section.

of scenery which appeals to him most, and for the most part he prefers the leafless seasons, when the grey and purple boughs and the dulled undergrowths make a delicate tracery of form and a tender and subdued harmony of colour. Delicate rather than exquisite, and more contemplative than actively poetical, his art has not shown much emotional power or high passion, but in its own modest way it possesses charm and a certain significance.

Something of the same simple enjoyment of the country animates the landscapes of Mr. A. Brownlie Docharty—who, by the way, is a nephew of James Docharty—but in them the expression is more emphatic because the painting is more masculine and virile. Working with a fuller brush and a fatter impasto, he has also more of that fullness of tone and colour which marks the later developments, and, without attaining distinction of design or much charm of decorative placing, his compositions are weightier and more effective. For long his home was in the lovely district where Thomson of Duddingston had his first charge and painted his early pictures, and amid the park-like pastures and the tree-fringed meadows, and on the sylvan watersides of the Girvan and its tributary streams, and among the hanging woods and rolling hillsides which bound that charming valley, he found material for many good pictures. Of recent years, however, the landscape of Carrick has figured less frequently on his canvases than that of the nearer Highlands, where he has painted hill and glen and rushing torrent—'Winter in Glenfinlas' (1902), 'Ben Venue' (1905), and 'September, Glen Falloch' (1907 : Glasgow Gallery). An all-the-year-round landscape man, perhaps he likes green summer best. At least it is in pictures like 'Lady Glen' (1896) and 'Old Auchans' (1902)— and the colour problem involved in a sun-illumined glade or a bouquet of trees in summer's livery is one of great difficulty—that he has achieved his most notable successes. Painted with gusto, but not without refinement, in frank, fresh and harmonious colour, and good in drawing and design, Brownlie Docharty's landscapes preserve the aroma of a sincere, if unimpassioned, love of the simple and everyday aspects of Nature, and awaken pleasant memories of the country.

While the pictures of Houston and Docharty, although coloured quite obviously by personal preferences, are in large measure transcripts, those of Campbell Mitchell reveal a more noticeable surrender to the evanescent moods of Nature and a quicker response to the ever-varying play of light. A good deal was expected of him by his friends, but it was not until two or three years before he was elected A.R.S.A. (1904), at the age of forty-two, that his pictures began to attract the attention of a wider circle. Since then, however, appreciation has grown rapidly, although not faster, perhaps, than the work itself, for he has been steadily progressive both on the technical side and in the emotional quality of his art. Possessing a fine appreciation of the sentiment of landscape and of the subtle charms of

atmospheric effect, he expresses them with distinct power and feeling. Moreover, he is more concerned with the moods than with the transcription of the facts of Nature, and that is an attitude of genuine promise for his future. Specially he is in love with wide expanses of moorland or rolling country seen under the change and play of great masses of floating cloud, and with twilight falling softly upon stretches of upland pasture or reaches of ebb-tide sands and low horizoned shores. These effects he renders expressively, one might almost say subtly, filling his canvases with air and light, with motion or that stillness which is but motion in passivity, and, without subordinating the landscape emotion to a decorative convention, obtaining a pleasing rhythm of pictorial design. Yet, hovering on the verge of poetry, he has never quite penetrated to the inner sanctuary ; but it may be that by quiet and reverent waiting in the outer courts the revelation may come, and the crowning gift of poetic apprehension be added to his art. As it is, pictures like 'Knockbreck Moor,' his most important work and one of the most imposing of its year 1904, 'Where the Whaups are Crying,' 'An Old Village,' 'A Scottish Moorland,' purchased for the Munich Gallery, and 'April in Galloway' are at least fine prose, and complete and satisfying in their kind. A Campbeltown man, Campbell Mitchell was trained in the life-school of the Scottish Academy, and in Paris under Benjamin Constant, and is settled in Edinburgh.

There are others of the younger generation of landscape painters whose work might be analysed, but as all are young and their art in some respects still in process of formation, it has been thought better to concentrate attention upon a few of the more notable than to crowd these pages with a list of names. Still, this record would be incomplete without mention of a few others : of Mr. John Henderson, who shows a refined feeling for woodland and burnside landscape and a cultured ideal of design, in which balance of mass and rhythm of line are combined with respect for those tender and characteristic beauties of natural form and growth which charm one so in Nature ; of his brother, Mr. J. Morris Henderson, whose chief delight seems to be in flowery foregrounds and weeded watersides, pale blue streams rippling over white pebbles, and distances of hayfields or softly swelling country under bright skies ; of Mr. W. M. Fraser, whose art, though somewhat weak and unconvincing in technique and limited in range, is pervaded by a sentiment for beauty ; and of Mr. James Riddel, another Edinburgh painter, in whose work feeling for delicacy of tone is perhaps the most attractive quality. With these Miss Meg Wright may be grouped, for, if frequently slack in observation and careless in handling, she possesses a real and charming feeling for landscape. Now and then, as in the solemn 'Neidpath Castle' or the beautifully conceived Tweedside 'Bend of the River' (1903), she touches a true romantic note in colour tone and design, as well as in sentiment, and many of her water-colour sketches are delightful in their suggestion

of space and movement. Nor should one forget the moonlit waters and harbours of Mr. Tom Robertson, one of whose pictures hangs in the Luxembourg ; the tender daylight-suffused pastorals with sheep resting or feeding in the sun-dappled shade of leafy trees of Mr. William M'Bride ; the engaging and tender vein of feeling revealed by Mr. Walter M'Adam in his more recent work ; the water-colours of woodland and riverside of Mr. A. M'Bride and Mr. E. Geddes ; or the lustier and more vigorous method if less refined perception of Messrs. Archibald Kay, Russell Macnee, and Henry Morley, and of the Aberdeen men, Mr. Alec Fraser and Mr. G. R. Gowans. Within the last two or three years, also, Mr. William Wells, by a number of sensitively observed and skilfully painted landscapes, marked by much quiet sentiment and fine feeling, and Mr. Alexander Jamieson, by a series of clever and vividly impressionistic sketches of French harbours, towns and gardens, have attracted a good deal of attention.

A somewhat special position is occupied by Mr. J. G. Laing, for he has found the material most suited to his taste in architecture rather than in landscape. Trained as an architect in Aberdeen, and engaged in that profession for wellnigh a decade, he had an expert knowledge of buildings when he turned water-colour painter ; but as was only natural, having just achieved freedom, his earlier work was usually concerned with pure landscape or picturesque views in old towns or on navigable rivers. Well set down and vigorous as they were, however, the handling in these drawings showed little regard for the beauty of pure wash, and the colour was monotonous and over brown. Painting frequently in Holland and coming into personal contact with some of the Dutchmen, whose art he admired greatly, Laing gradually came under the sway of their ideals, which, if not particularly fitted to correct the tendencies indicated, helped him to attain a broader conception of art and a more atmospheric statement of effect, without destroying his individual idea of subject. With maturing powers there came also a more prominent appearance of architecture in his pictures. He continued to paint landscape, of course, including a good many Dutch coast-scenes, but in drawings like ' Middleburg Market' (1900) and 'St. John's, Warwick' (1901) he showed to more advantage, and in a series of interiors, among which 'Haarlem Church' (1904) and 'The Hour of Prayer in St. Jacques, Antwerp' (1905) may be named specially, painted during the last few years, he has attained in a personal enough manner something of the rare and solemn beauty of which Bosboom was such a master. It is in a similar connection, perhaps, that Miss Emily Paterson's work should be considered. If more interested in effects of light, colour, and atmosphere than Mr. Laing, and treating the material in a less specialised manner, her subjects are usually views of cities intersected by canals or lying upon broad waterways busy with shipping. Her many charming water-colours of picturesque prospects or peeps in Dordrecht,

Venice, or Berwick-on-Tweed are marked by very considerable technical dexterity and a fine sense of atmosphere, excellent quality of grey colour, against which more definite notes are often happily struck, and an admirable instinct for picturesque placing. And here also, although he is more a specialist than either, and his art turned to professional rather than pictorial use, Mr. Hamilton Crawford should find a place. An admirable and accomplished architectural draughtsman, he is best known to the unprofessional public as the author of the fine drawings of Edinburgh which illustrate the larger edition of R. L. Stevenson's *Picturesque Notes*. The charm of Mr. James Herald's water-colours is more decorative and imaginative. Influenced in his earlier drawings by Arthur Melville, he eventually developed a more personal style, and, while continuing to deal with facts in a selective manner, attained great unity of result through harmonious envelopment and decorative treatment. It is, however, to the latter quality that his art owes a distinctive character, for the former is over heavy and too lacking in sparkle to suggest the living beauty of atmosphere, and is subordinate to the decorative ensemble of rich if low-toned colour, in which his renderings of old harbours and towns and of landscape are steeped. Although lacking in vitality of idea and vividness of expression, his work is always artistic and finely felt, and, were he less of a recluse, his reputation would not be confined to the Arbroath district and to those who have chanced on something of his in private hands.

CHAPTER V

ARTHUR MELVILLE

THE relationship between Arthur Melville and the Glasgow group is somewhat difficult to define with exactitude. On one side there is the claim of a number of critics, both home and foreign, that Melville was either the pioneer or the originator of the movement, and on the other the inclination of certain of the Glasgow men to minimise, not his talent, but his connection and influence with the original group and its development. But, as usually happens in such cases, examination of the facts, derived for the most part from the dates on pictures and contemporary catalogues, and through careful comparison of the characteristics of the actual work, shows that there is some degree of truth in both attitudes, and that a combination of them represents what actually happened. What is certain is that the movement in the west was well under way before Guthrie settled at Cockburnspath in 1883, and meeting Melville shortly afterwards brought him into personal contact with the others, and that, quite as early as any of the Glasgow men, Melville had arrived independently at a view of art and even a technique which had considerable resemblance to theirs. At the time of meeting, however, Melville was in some ways a more mature artist and had achieved a more distinctive style, and, being a man of exceptionally strong personality and driving force, his impact upon the movement helped to accelerate and to some extent to mould it. But he also in his turn was influenced, and profited not only by the enthusiastic atmosphere in which they moved, but by the experimentalism which was one of the vital elements of the young school.

Born at East Linton, Arthur Melville (1855-1904) studied in the Edinburgh schools, and from 1875 to 1878 painted oil-pictures of homely incident in cottage or garden or by the wayside, not very unlike what was being done by J. R. Reid and the Nobles,[1] but marked by certain qualities of their own which attracted the attention of two or three picture collectors, and led to his going to France (1878). There he worked in Julien's atelier, but learned more perhaps through sketching on the quays of Paris and at Fontainebleau, Mont St. Michel, Grenville, and elsewhere. Probably he had painted, though he had never exhibited, in water-colour

[1] To some extent he was a personal pupil of Mr. J. Campbell Noble.

previously, but in any case it was chiefly by the vivid and powerful water-colours then executed that he commenced to make a distinctive place for himself. Yet the oil-pictures, amongst which 'Old Enemies' (Mr. J. T. Tullis) and 'A Shepherd' (Mr. Heseltine) may be named, were remarkable also, and it is in them rather than in his drawings that approximation to the Glasgow methods is apparent. Dated 1880, 'Old Enemies,' a scene in a French market-place with a woman protecting two frightened children from a flock of turkeys, is painted in a vigorous and broad manner in full, strong impasto, loaded in shadows as well as in lights, and, distinctly darker in tone than was usual in Scottish painting, shows considerable regard for values, which are lowered all over, through desire to obtain a true range of tone, but also perhaps through that half-closing of the eyes which was a device with all when values first became the fashion. The movement had commenced in Glasgow before that picture was painted, of course, but, except that it was browner in colour, it was in many respects exceedingly like the work the 'boys' did a year or two later. Yet precedence of a year or a day, when there was no direct contact, is of little moment, and the fact that one finds it difficult to say who was first in the field only goes to prove that the 'ideas were in the air,' and that they grew to the importance of a movement in Glasgow very largely because there there was a group of gifted youngsters who were unrestrained by the accepted conventions of an organised Academy.

Something Melville may have learned from M'Taggart, who is incontestably the initiator of impressionism in Scotland, as he is its greatest exponent, and for whom this young rebel had the profoundest respect and admiration ; something he probably picked up through study of the work of Fortuny, with its gleaming light and scintillating colour, and its delight in the striking and the bizarre ; and no doubt the influence of Japanese art had an appreciable effect. But his water-colour work, even in the earlier French drawings, was very much his own, and a long sojourn in the East, whither he was attracted by his love of the sun and brilliant colour, and (perhaps this is where Fortuny comes in) by the kind of subjects it offered, gave him the opportunity and the material for the development of a form of artistic expression which must rank as one of the most original and personal of modern times. Going to Egypt in 1881 he painted there for a period, and then passed on by Suez and Aden to Kurrachee, whence, tarrying a little at Muscat, he found his way up the Persian Gulf and on to Bagdad, and then, travelling through Meso-potamia, reached the Black Sea and Constantinople, and got back to Edinburgh after an absence of two years. During this period he sent home several fine water-colours—'A Cairo Coffee-House,' 'Past and Present,' and 'The Sphinx' appearing at the R.S.A. in 1882, and a 'Cairo Bazaar,' 'A Bagdad Coffee-House,' and 'Achmet,' and an oil-picture, 'Arab Interior,' in 1883—and brought back a great number of sketches

and a wealth of impressions which were to appear or bear fruit in future years.　His method in water-colour, as is evident from the masterly 'Interior of a Turkish Bath,' painted in Paris in 1881, was practically formed before he left for Egypt, but his technical dexterity and his command of splendid colour increased greatly during these years of travel and went on ripening right up to the end, though latterly, feeling that he had reached his limit in water-colour, he was devoting much greater attention to the other medium.　But the most important work executed immediately after his return was a portrait of one of Mr. Sanderson's daughters (dated 1883), which was shown at the Grosvenor in 1884 as 'The Flower Girl,' and in Glasgow in the following spring, when the young school made a very strong appearance, and it was perhaps the 'clou' of their sending.　Splendidly strong, if a trifle brutal, in painting, full in tone and, while low pitched, rich in colour, though that is but black and white, flesh colour and fair brown hair, with a touch of pink in the pale yellow roses set in a vase at one side, and a dark warm grey background, that picture was a *tour de force*, and attracted great attention. The 'Miss Ethel Croal' (R.S.A., 1886) and the 'Portrait of a Lady' (R.S.A., 1889), which followed before he left Edinburgh for London at the end of the eighties, were notable for the same qualities, and for the defects—a lack of interest in character, too forcible expression and a lowering of the flesh tones to suit the decorative motive—which had marked that achievement ; and in his later portraitures, 'Mrs. Greenlees,' 'Mrs. Graham Robertson,' and the rest, not only did the decorative tendency assert itself unduly, but it was marred by an inclination to the extravagant and the bizarre which destroyed dignity and true harmony. These also were the tendencies which detracted from the success of such daring or amazingly clever performances as 'Audrey and her Goats,' which was painted at Cockburnspath, and 'The White Piano' (1892 : Mr. Margurison, Preston), and other decorative exercises of more recent years, so that one may affirm that his oil-pictures, while remarkable in themselves, are much less satisfying and complete than his water-colours, in which motive and treatment are in complete accord.　Yet this must be said with a reservation, for few of his drawings of home-scenes, except the 'Kirkwall Fair' (R.S.A., 1886) and one or two other street-scenes, were wholly successful ; and his treatment of pure landscape, apart from undoubted charm of decorative colour, is wanting in significance and appeal.　It is by his work in the East and upon the Mediterranean littoral, in Spain, Morocco, and Italy, in crowded market-place, mosque, and bull-ring, and on desert sand and still gleaming canal and lagoon, that he proved himself a consummate artist.　The glamour of the sun-steeped South was upon him.　Again and again he heard it calling, and it was from the after-effects of typhoid contracted in Spain that he died in 1904.　He had been an Associate of the R.S.A. since 1886, and he

was also a member of the Royal Water-Colour and the Royal Scottish Water-Colour Societies.

From the first Melville's water-colours were remarkable for the intuitive skill with which the accents of form and tone and the notes and masses of colour, which give vitality to impression and express the dominating qualities which render a scene or an incident characteristic, were selected, and for the verve and dexterity with which they were set down. Highly suggestive rather than powerful in draughtsmanship, and, though drawn with an abandon which seems to imply great knowledge, making out objects more by what surrounds them than by rendering constructive form, superb and vital in colour raised to great intensity, if deprived of some subtlety, by powerful light and contrast, but ever balanced and held in check by a fine taste for harmony, and at once unconventional and convincing in design, the drawings named already were both distinctive and distinguished, and with others, such as 'The Snake Charmers' (Sir James Bell, Bart.), 'The Camel Market, Aden' (Mr. Cox), and 'The Call to Prayer, Bagdad' (Mr. J. H. Annandale), shown later, form a series of glimpses of the Orient which is unequalled perhaps outside the pages of the *Arabian Nights*. And finer were to follow. These had been dexterous, vivid, masterful; the Spanish and Moorish and Venetian drawings produced from 1890 onward were more subtle, attained a higher distinction, and were stamped by the indefinable quality of mastery. Moreover, many of them were on a greater scale. 'A Moorish Procession, Tangiers' (R.S.A., 1894: National Gallery, Edinburgh), 'Outside the Bull-Ring' (R.S.A., 1899), and 'Garnet Sails' (dated '98: R.S.A., 1904) may be selected as typical of this, his fully developed phase; and when compared with even the finest of his earlier things, they reveal energy as great as ever but more disciplined and refined, greater freshness and beauty of colour often laid in broad simple masses sharply juxtaposed, and always retaining the glow and sparkle obtainable from the paper, which in many passages is little more than delicately stained, and a more matured and masterly sense of disposition, which, working on a more imposing scale than formerly, made more of the great plain spaces and used accent more sparingly but with greatly enhanced cunning.

An impressionist in the more restricted sense, keenly and sensitively appreciative of light, colour, and movement, living in the external show of things, and expressing himself with vitality and assured mastery, Arthur Melville brought the scintillating splendour and many-coloured movement of the South before one with the vividness of dreams or the intensity and freshness of impressions one might have received at first hand in moments of exceptional receptivity. While the splendid conceptions of Delacroix (1798-1863) and the more realistic and less passionate, but still romantic, work of Décamps (1803-60), and, in virtue of that

wonderful 'Execution in the Alhambra,' one may add, of Henri Regnault (1843-71), give a more impressive and significant interpretation of the life of Oriental peoples, and the pictures of J. F. Lewis (1805-76), Fortuny (1838-74) and Tissot (1836-1902) tell one more about its details and accessories, Melville's drawings, possessing more immediate appeal to the senses through the eyes, are, in their own way, more vivid and arresting.

The character of Arthur Melville's relationship to the Glasgow men having already been indicated, one need only add that the influence of his example is much more apparent in the work of a few painters unconnected with the movement than in that of any of the original group. These being for the most part imitators, no purpose would be served by discussing their pictures or even by mentioning their names. But in one instance the effect of contact with him was so dramatic that it can scarcely be ignored. Before he went to Spain with Melville in 1892, when they voyaged in a barge on the Ebro valley canal and painted together at Passages, Saragossa, and elsewhere, Mr. Brangwyn had shown no marked tendencies toward colour. He went away the painter of 'The Burial at Sea' (Glasgow Gallery) and other grey sea-pictures, and came back to paint the 'Buccaneers' (Salon, 1893), 'A Trade on the Beach' (Salon, 1895), and the many potently coloured canvases of the South and East, to which he owes his reputation and in which he turned to powerful and personal use in oil-paint the lessons he had learned from Melville's water-colours.

CHAPTER VI

DECORATIVE PHASES

TOWARDS the end of the eighties the feeling for decorative quality in subject and arrangement which had marked the art of the Glasgow men as a whole, except when in its most realistic phase, was taken up and developed by two artists who had attracted no great attention previously. Hitherto an inherent part of the emotional and pictorial conception of Nature rather than an end in itself, this element was now to be exploited for its own sake, and before long in the work of George Henry, E. A. Hornel, and their immediate following everything else became subordinate. And this, being accompanied by relaxation of the close study of values, which had been a prime factor in the earlier days, and a resurge of delight in brilliant colour, led to what promised to be a new type of picture in Scottish art. From a cloud ' no bigger than a man's hand ' in 1887 or 1888, it grew with tremendous rapidity until, descending in a series of amazingly clever and arresting and in some respects beautiful pictures, it seemed for a few years after 1890 to fill the whole western horizon, and threatened to engulf the more solid achievement of the older group. Then, having quickened but not annihilated the parent movement by its animation, freshness, and vitality, and leaving Mr. Hornel to pursue his course in trailing clouds of colour, it passed almost as quickly as it had come.

George Henry had no easy entry into art, and, having succeeded in escaping from formal business, had to work for the publishers of trade catalogues and suchlike to preserve even the modified freedom he had won. He worked in the Glasgow School of Art, and later was one of the life-class in Macgregor's studio, where, and through painting with others of the younger men at Brig o' Turk and in Berwickshire, he received the most valuable part of his training. He never studied abroad. Although personal from the first, his earlier pictures, of which ' Playmates ' (Mr. W. Y. Macgregor : painted at Cockburnspath in 1884) was the most important, bore the characteristics common to the work of the group, and it was not until a year or two after he began to paint at Kirkcudbright (1885) that he commenced to show the qualities which were soon to make him conspicuous. It is difficult to say what influences contributed to the direction his art now took. Among the members of his coterie, while almost all possessed fine feeling for colour

and tone, Arthur Melville was perhaps the only one in whose work bold, vivid, and brilliant colour predominated, and probably Henry owed something to his example ; the magnificent display of Monticelli's rich and glowing colour in Edinburgh in 1886 no doubt helped ; and the sumptuously decorative pictures of Rossetti and Burne Jones, frequently seen at the Glasgow Institute, had in all likelihood a certain effect also. But these influences, even though their effect was provable instead of presumptive, are not sufficient to account for the style subsequently elaborated. It is more likely that, the preliminary difficulties of realistic representation having been so far mastered, Henry's latent love of sun-illumined colour began to assert itself, and that he found in the luxuriant and potently coloured and often sun-steeped countryside about Kirkcudbright, material peculiarly fitted to stimulate this natural taste. And then, gradually finding himself, he studied the colour combinations in the work I have suggested as probably influencing him, and, meeting a congenial spirit in Hornel, felt encouraged to develop upon the lines he had adopted tentatively.

The other pioneer in this development, E. A. Hornel, was born at Bacchus Marsh, Australia, in 1864, but, having been brought home at an early age, grew up at Kirkcudbright, to which district his parents belonged. Determining to be a painter, he studied for three years in Edinburgh with little profit, and then spent two years under M. Verlat in Antwerp, whence he had but recently returned when, in the autumn of 1885, Henry and he met. At this time, as we have seen, Henry was only beginning to feel his way towards a more characteristic style ; and Hornel, although his work showed some traces of Antwerp training in tone and handling and in deficiency in colour, was painting simple genre subjects and landscape much in the traditional Scottish mood. But some subtle feeling of sympathy drew them together, and, if it is almost impossible to disentangle the part played by each in what followed, I am inclined to think that while Henry is to be credited with the initiation of the idea which they worked out side by side, Hornel not only made it his own, but gave it more definite direction and stamped it with its most marked characteristics. A few years passed, however, before these were formulated fully.

Developing more rapidly, Henry was the first to attract public attention, but he and Hornel may be said to have arrived simultaneously at the Glasgow Institute of 1890 and the last Grosvenor exhibition of a few months later. They had collaborated upon 'The Druids'[1] (Mr. Robert Strathern, Edinburgh), a gorgeously coloured picture, with gold leaf used in parts, of a priestly procession bringing in the sacred mistletoe, painted with great verve and fullness, but unfortunately never exhibited

[1] 'The Star in the East,' another large picture on which they worked together (1890), was less successful.

publicly in Scotland (it was sent to the Grosvenor)—but Henry's 'Gallo-way Landscape' appearing in Glasgow and creating an extraordinary talk and much angry discussion, the chief honours were his. His smaller pictures, the quaint and beautiful 'Cinderella' and the richly coloured 'Autumn,' shown at the same time were more charming, and it is possible he has never done anything quite so delightful as the former. But, as indicated elsewhere, 'The Galloway Landscape' marked an epoch in the history of the 'Glasgow School.' An autumnal scene, the leaves of the scrubby trees, which dotted the sunlit slopes of a green valley lying beneath a blue sky in which sun-irradiated clouds floated, were brilliant red and yellow; black Galloway cattle browsed here and there; and through the lush green grass and the golden masses of withering bracken in the hollow a burn meandered in dark blue links. Boldly carried out, and, with all its boldness, rich and decorative in effect, the picture was not without sentiment for the fecundity of Nature. It was false in values, however, and as, like most of Henry's work at that time, it owed little or nothing to light and shade and almost everything to colour, this led to a confusion of planes which deprived it of the success so nearly attained. Yet it was very largely in virtue of greater regard for Nature that Henry's pictures were differentiated from Hornel's. While the former were founded, as a rule, upon specially chosen effects in Nature, the latter were marked by a more wayward fancy, a tendency to flat colour-spacing in the Japanese manner, and a disposition to twist Nature to suit decorative effect. Where they came together most closely was in an obvious and engaging delight in splendour and fullness of colour, and in the manner in which they attained it, though here again Hornel was less painter-like in his use of the medium and rapidly developed a very marked mannerism, in which the accidental effects gained by loading and scraping, and roughening and smoothing and staining played a great part.

Henry followed the 'Galloway Landscape' by a succession of pictures conceived on somewhat similar lines but attaining finer and more beautiful results. Amongst these, 'Blowing Dandelions' and 'Springtime' (G.I., 1891); 'Through the Woods' (R.S.A., 1891); the vividly beautiful 'Poppies' (G.I., 1892); and two splendidly virile studies, 'Girl in a Straw Hat' and 'A Gipsy' (R.S.A., 1893), may be named specially. Strong and vivid yet richly harmonious in colour, full and sonorous in tone, decorative in ensemble and dexterous in handling, they also possessed personal feeling for Nature, keen relish for certain aspects of her ever-varying beauty, and now and then a touch of imagination which makes them live in one's memory.

To return to Hornel, the interest awakened by the pictures which first drew special attention to his work in 1890 was soon greatly increased by the more potent and arresting qualities of those shown during the next few years. Pictures of children in flower-spangled landscapes, 'Among

the Wild Hyacinths' (first seen at the Grosvenor, 1890), 'The Brook,' and 'Butterflies,' the trio exhibited in Glasgow in 1891 ; 'Summer,' which, after exciting much comment in Glasgow in the spring of 1892, was purchased after a very lively and bitter controversy for the Liverpool Gallery in the autumn ; and 'Springtime,' shown at the Scottish Academy in 1893, were animated by such vital and sincere delight in colour and by such a mastery of potent and intoxicating harmonies, that the sheer joy evoked by these qualities was enough to make one condone their very obvious deficiencies of form and their remote relationship to Nature. During these few years his instinct for decoration had been asserting itself more and more ; the influence of Monticelli and of Japanese art, while always penetrated by personality, had become more marked, and showed itself in the invention of ornament and costume, and the patterning of natural forms as well as in colour and in flat spacing ; and his technique, which now consisted very largely of an inlay of gleaming pigment, having come into greater harmony with the decorative intention, the result was an art singularly personal and almost unique. Deriving his subjective motives from Nature, it would have been strange indeed if his pictures, unrealistic as they were, had not in their turn suggested Nature and the thoughts she stirs ; but there was no passion in his feeling for her, only for her colour, and the decorative aspect always dominatèd the sentiment and controlled its expression. At times, however, he, like his more realistic confrère, came to grief through the claims of decoration and of Nature having been unconvincingly compromised.

Early in 1893 Hornel and Henry, already in debt to Japanese art, went to the Land of the Rising Sun, and, remaining there a year and a half, brought back many pictures. But while Hornel seemed greatly stimulated by the life and colour about him and worked assiduously, Henry, who was already in doubt as to the wisdom of the artistic course they had been steering and was struck by certain elements in the life and by the delicacy and restraint characteristic of the finest Japanese art, found further reason to reconsider his position and painted comparatively little.

When Hornel held an exhibition of his Japanese pictures in Glasgow, it was evident that close contact with the decorative arts of the East had clarified his ideas and emboldened him to express them frankly. He had succeeded, if not entirely yet to a great extent, in forgetting all that had been done with oil-paint by Western civilisation. Velasquez, Rembrandt, the great Venetians need not have existed so far as he was concerned. Truth of observation as regards contour, modelling and perspective, relationship to life, and poetic imagination, were all eliminated, and there remained only a charming faculty for the invention of colour-pattern in brilliant patches laid on the canvas in lustrous impasto with great skill in juxtaposition and real knowledge of colour-harmony. Perhaps one can best convey an idea of these pictures to those who have

not seen them by saying that they were like archaic and richly coloured windows with the leading removed. But neither in colour nor design is there repose; each colour is at its greatest intensity, every form is contorted and confused. It is in this that they contrast most strongly with the simple, restrained, and balanced art of the country which inspired them, and the colour, if richer in tint and fuller in tone, is not nearly so delicate. There was so long a remove from Nature, so little sustaining thought, and such an exclusive sentiment, that even as decorations they fell short of being really fine. Yet as panels of wonderfully wrought and skilfully harmonised potent colour, which were only in pictorial form through accident, as it were, they were delightful. The colour was as enchanting as an Arabian Nights' tale, as brilliant as a parrot-house, as varied as a flower-garden.

Settled down once more at Kirkcudbright, Hornel returned to the motives compounded of children in fancy dresses, flower-decked woods and watersides, and rich autumnal landscape which he had painted previously, but for some years he seemed to be in a cul-de-sac and made little or no progress. Towards the close of the nineties, however, one noticed a growing effort to obtain greater truth of form and more restrained colour effects. The children were still placed in haphazard attitudes and unlikely situations, but the heads were less misshapen and the expressions less grotesque; natural forms, although still used for decorative purposes, were more respected; and the colour, while preserving glow and richness, was becoming more tender, refined, and atmospheric. A lovely little picture, 'Echo,' which appeared in a Glasgow Art Club show in 1899, was an example of this, and in the more important but less beautiful and satisfying 'Fair Maids of February,' children gathering snowdrops in a wood, purchased for the Glasgow Gallery in the following year, it was also apparent; while since then it has become more marked, attaining in things like 'The Dead Peacock' (G.I., 1901), 'Mushroom Gatherers' (G.I., 1902), 'Water-Lilies' (International, 1901), 'Autumn' (G.I., 1905), and 'The Music of the Woods' (R.A., 1907), real charm, and giving his art emotional and poetic significance as well as sensuous appeal.[1]

Before Henry went to Japan he had in 'Mademoiselle' (G.I., 1893) a clever and chic but 'slangy' full-length of a girl in walking costume, giving indications of turning towards greater realism; and while after his return he painted several pictures, including 'Rowans' (R.S.A., 1896: Auckland Gallery), a brilliant and beautiful study in greens and blues and reds of two girls carrying great sprays of scarlet berries, which approximated to his pre-Japanese style, his work was henceforward more

[1] In 1901 Mr. Hornel was elected an Associate of the Royal Scottish Academy, but, greatly to the annoyance of his friends, who understood that he approved of their advocacy of his claims, he declined the honour.

realistic in spirit. Realising that east is east and west west, he seems to have determined that, while profiting by what he had seen in Japan, his course should be shaped more in conformity with the great traditions and the conventions of picture-painting as established by the masters of oil-paint, and, as he soon devoted a good deal of attention to portraiture, this was the more necessary. His earlier portraits, such as 'The Children of T. G. Arthur, Esq.,' were painted with much the same richness of colour and fullness of impasto as had marked his semi-decorative pictures, but before long, although retaining a distinct leaning to flatness of tone and of modelling which tended to deprive the figures and faces of his sitters of some of their essential bulk and character, he adopted more reticent colour-schemes, and for a time reduced the volume of his paint until it was often little more than a delicate low-toned stain. More recently he has been modelling more roundly and using rather greater range of tones and a fuller body of pigment, but the charm of his work continues to be feeling for decorative disposition, and for refined colour and tone in broad masses.

With all its cleverness and charm there is yet an element in Mr. Henry's work, and most obviously in his portraiture, which mars one's enjoyment. This may be described as a want of refinement not so much upon the technical side, though that also is affected, as in the way in which he looks at a sitter. Witty and shrewd as he is, his portraits of men are neither searching nor subtle in characterisation, while deficiency in sympathetic insight and some want of delicacy in perception taint his feminine portraiture and militate against its appeal. More than in anything else the charm of his work resides in tone. Often his colour is beautiful, sometimes in clear and pearly, sometimes in warm low-toned harmony; but in either case its charm depends upon quality of tone. In a general way this, of course, is always so, but it is particularly the case in Henry's recent work, in which the modelling is abbreviated and the painting as direct as possible. Where, as in some of his male portraits, such as the two in the Glasgow Gallery, which, however, show him at his worst, he has struggled to obtain definite character, both tone and colour are apt to be dead and the result distressing ; and when, as in some of his portraits of ladies, he has attained charming tone and colour, the character has been sacrificed to artistic effect. It is therefore in work done for himself that he is at his best, and the charm of such things as 'Harmony,' 'Gold Fish,' and 'The Blue Gown' (Cape Town Gallery) is great. Colour, rich and harmonious ; tone, delightful in quality and swimming in effect ; handling which, character not being in question, expresses what he has to say suavely and easily ; and design, simple in its component parts but well knit together by decorative instinct, give these pictures and others of similar mood beauty and distinction. Mr. Henry, who was chosen A.R.S.A. in 1892 and R.S.A. ten years later, now paints in London.[1]

<hr>

[1] Elected A.R.A. in 1907.

Strong in personality as well as individual and powerful in art, Messrs. Hornel and Henry,[1] through their connection with Kirkcudbright, influenced a little knot of painters belonging to the Stewartry, and attracted other painters to the district. In the local coterie a prominent position was taken by William Mouncey (1852-1901), Hornel's brother-in-law. Like 'Old Crome,' Mouncey was a house-painter, and for a good many years worked as an amateur, but having attained a measure of independence, he retired from business about 1886, and thereafter devoted himself to landscape-painting. Already he painted with considerable skill and assurance, and considerable feeling for Nature, and with his whole heart and time to give to his beloved pursuit he made definite progress, and eventually achieved a style which, while influenced to some extent by the technical methods favoured by Hornel and pictorially by study of the French and Dutch romanticists, was in some respects personal and dignified. Using a fat, loaded impasto, built up in separate touches rather than laid down broadly and boldly with a full, sweeping brush, the ensemble of his pictures owed little to brushwork and nearly everything to harmony of tone, which was full and strong, and to design into which light and shade entered more largely than was the case in most work associated with what was sometimes designated the 'Kirkcudbright School.' The last quality was to some extent his own, but it had been cultivated by study of Corot, Diaz, and James Maris, whose influence may be traced quite clearly in certain of his pictures. His sense of colour, again, while stimulated by what he saw in Nature and broadly representative of the season of the year dealt with in any particular picture, was more decorative than atmospheric and naturalistic, and his drawing, if easy, was over-generalised and lacked subtlety and definite characterisation. But a sentiment for Nature, not very profound or passionate, perhaps, but sincere, and a simple delight in the beauty of fields and woodlands and riversides gave a pleasant quality to an art which otherwise might have become empty formula.

The Kirkcudbright influence turned to personal uses is evident also in the pictures of W. S. Macgeorge and T. B. Blacklock. A native of Castle-Douglas, where he was born in 1861, Mr. Macgeorge, after some preliminary training in Edinburgh, went to Antwerp, where he spent two years (1884 and 1885) under Verlat about the same time as Hornel, Reid Murray, and Walls were there. For some years after returning home he painted incidents of child-life, such as 'When the Simmer Days were Fine' (R.S.A., 1890), 'A Turnip-Lantern' (1891), and 'Hallowe'en' (1893), and an occasional portrait in a broad and fused manner, with considerable delicacy of modelling in the faces, and in luminous low-toned colour in which tint was subordinated to values, and light and shade. But painting, as he does, principally at Kirk-

[1] As this influence became more active after their return from Japan, it may be traced to Mr. Hornel rather than to Mr. Henry.

cudbright, he came under the spell of Hornel's far more vivid and potent style, with the result that his paint became impasted and lustrous, his colour more brilliant and varied, and his sense of decoration greatly increased. He retained, however, his own feeling for Nature and incident, and adapted to his own uses, rather than imitated, the Hornel method and ideal of picture-making. In his work one finds study of atmospheric effect and respect for the forms of Nature combined with delight in full-blooded colour and decorative ensemble. Still it is not in pictures in which a penchant for sun-glow falling upon and intensifying vivid local colour is most marked, though that mood is perhaps the more frequent, but in those in which lower-toned and more reticent harmonies prevail, that he is most charming and satisfying. Children at play amid the sunshine and the flowers of early summer, or in the richly tinted autumn woods, or foresters or salmon-fishers engaged at their craft among the trees, or by shadowy pool or twilight estuary, are perhaps his favourite themes ; but now and then, as in ' She sought him East, she sought him West' (R.S.A., 1899), and ' The Water-Kelpie' (R.S.A., 1900), he has turned for inspiration to the ballads and legendary lore of the Borders with happy results. In 1898 he was elected Associate of the Royal Scottish Academy.

Although Thomas Bromley Blacklock (1863-1903) was a Kirkcudbright man, it was not until he had been exhibiting for a decade that the local influence became obvious in his art. Trained in Edinburgh and painting chiefly at East Linton, then and since a favourite sketching-ground with east-country artists, his work during that period had been landscape, marked by feeling for the sentiment of tranquillity in Nature and refined in colour and handling, if conceived with little passion or distinction. In 1896, however, into one of those still autumn evening landscapes of which be was so fond, he introduced a fairy-like figure of ' Kilmeny,' and within the next year or two, working at Kirkcudbright, he developed a personal variant upon the themes of children and landscape which Hornel, Macgeorge, and a few others were painting. Borrowing, but more through stimulus than by imitation, something from Hornel's brilliance of colour and inventiveness of pattern, he added a touch of fancy of his own. He became a painter of fairy tales, of ' Red Riding Hood,' ' Bo-Peep,' and ' Snowdrop,' and, in pictures like ' The Fairies' Ring,' ' The Sea Maidens,' and ' A Winter Song,' an inventor of variations upon the old stories in which children and fairies and the creatures of the wilds and the sea-shore live on terms of intimate companionship in an enchanted land. And these pleasant and tender fancies were expressed with a daintiness of colour and design, and an ingenuity and quaintness in costume and accessory, which, if occasionally verging upon mere prettiness, gave his pictures a definite if modest place amongst the more realistic or more artistically powerful and decorative work of his fellows.

Decorative intention as exemplified in the pictures we have been

considering is present also in varying degrees, and in combination with more or less realism and personality, in the strongly painted evening pastorals with girls and goats or nibbling sheep of J. Reid Murray, who has been mentioned as a fellow-student with Hornel in Antwerp; in the sentimental idylls of English village-life of Mr. John Lochhead; and in the landscape of Messrs. Harry Spence, Taylor Brown, H. Ivan Neilson, and Harry Macgregor, a clever amateur, and several others; but having analysed its methods and intentions from the work of more interesting painters it is unnecessary to consider theirs in detail, and we may turn to the phases of decoration practised by Messrs. Millie Dow and Robert Fowler, Burns and Duncan, Miss K. Cameron, Miss Jessie King, and others. But before doing so something should be said about the landscape of Mr. W. A. Gibson, for his method, although not directly connected with the Kirkcudbright influence, is somewhat kindred in its derivation and procedure. Painting by receipt rather than from the impulse received from Nature demanding a corresponding and truly expressive technique, and influenced by Corot in his woodland landscapes and by the Dutchmen in the views of the old Dutch towns and waterways he has been painting more recently, his work has frequently lacked spontaneity and freshness. A personal element appears, however, in his feeling for light and for schemes of colour, which, while somewhat negative in tint—ranging through silver-whites, greys, grey-greens, and cool browns—and deficient in values, are yet lustrous, harmonious, and suggestive of richness and variety.

Allegory and Romance

If allegory and symbolism appear to dominate many of the pictures of T. Millie Dow and Robert Fowler, and those of Robert Burns and John Duncan seem now and then to have been inspired by ballad poetry or romantic story, consideration shows that their *raison d'être* is as much decorative beauty as intellectual and emotional significance. Moreover, the leading characteristic of the decoration one finds in their work is exactly that mingling of realism and naturalistic beauty with careful balance of design in rather flattened masses of tone and colour which forms the basis of much of the art already discussed in this chapter. At the same time, while all four are Scotsmen and are connected in some degree with recent developments in Scottish painting, the art of none is what may be described as characteristically Scottish. Mr. Dow's artistic connection with the 'Glasgow School' was definite enough, however, to give him an important place in Mr. Martin's book, and Mr. Burns's and Mr. Duncan's art possesses certain qualities which make its inclusion here quite natural. The case of Mr. Fowler is rather different, for in some respects he is one of the most detached painters of to-day. He

has never been associated personally with any group ; his art, although influenced from many sources, is personal and distinctive ; and it may be said at once that he is placed here because there was no other place seemingly more appropriate. Yet, as will appear later, there is a certain fitness in considering his work in relation to the decorative phases in recent Scottish painting.

With Millie Dow we return to the early days of the new movement. The son of the Town-Clerk of Dysart, he served an apprenticeship to the law before going to Paris to study painting at the Ecole de Beaux-Arts, under Gérôme, and in the Atelier Carolus Duran, and after his return, although living in Fifeshire, he became closely associated with the 'boys,' while from 1887 to 1895, when he removed to Cornwall, he had a studio in Glasgow. I do not remember the pictures shown by him at the Institute between 1879 and 1884, but believe that, while more tentative, they were on much the same lines as 'The Hudson River' and 'Twilight at Rye,' and 'Chrysanthemums' and 'Roses,' which in 1885 drew definite attention to his art. In Paris he had become intimate with William Stott of Oldham (1858-1900), whose original and powerful work was the talk of the studios, and these pictures showed some traces of Stott's influence in both mood and method. They were, however, less virile in conception and less vigorous and masterful in handling, while their greater abstraction and more definitely decorative intention had affinity with the later phase of Stott's art rather than with the qualities then dominating it, and seem to suggest that he in turn influenced the other. For some years landscape and flowers continued to supply Dow with motives for pictures, in which he showed increasing command of technique and gave fuller expression to his refined and delicate feeling for natural beauty treated in a decorative spirit. Painting in solid but unloaded impasto, subtly fused and wrought into suave unity of surface, and with the component parts telling as such in virtue of subtlety of tone and delicacy of colour rather than through emphasis of light and shade or accent of brushwork, his manner expressed his feeling admirably.[1] Visions of the sentiment of tranquil dreaming Nature rather than realisations of her passion and her power, his finer things, such as 'The Hudson River' (1885), 'Spring in Morocco' (1890), 'The Enchanted Wood' (1892), and 'Valley in the Apennines' (1896), are steeped in an atmosphere serene and calm, as of a summer twilight, and in tenderness of colour bear out Gleeson White's statement that the keynote of his palette is to be found in a certain study of blossom against a delicate blue sky. This somewhat abstract quality of sentiment is accentuated further by the way in which the material of Nature has been used to decorate the canvas, and more especially perhaps when flowers are in question, whether as a dainty

[1] About 1890 he worked a good deal in pastel, which he used to attain the same effects as he obtained in oils, and not as a medium with a definite character and limitations of its own.

diaper in a landscape or, as in many charming water-colours, when forming the sole subject of a picture.

Previous to 1893 or 1894 figure-painting had claimed but little of Dow's attention—the few portraits he had shown were of no great interest or merit—but since then his chief efforts have been of a romantic-allegoric character, not unlike that which Stott had begun to develop in 'The Wood Nymph' (G.I., 1890) and 'Iseult' (Grafton, 1893). Into dreamy visionary landscapes he now introduced figures symbolic of some legendary or romantic incident or idea, and from being completely subordinate to the setting, as the little nymph in the 'Enchanted Wood' had been, they became the leading motifs, and the landscape little more than an accompaniment. As with his earlier pictures, the temper of these is more delicate and refined than powerful and profound, the allegory is gracefully rather than significantly conceived, and decorative intention dominates and minimises its emotional and poetic appeal. With the possible exception of 'The Kelpie' (1895), which, however, is less pleasing as decoration, none of his work of this kind is really profound in idea.

Charming as the triptych of 'Eve' (1898) is in many respects, the principal figure is a graceful slip of a girl, and not 'a mother, a mother of men,' and the angelic and devilish beings who occupy the side panels are not greatly moved themselves and leave one unthrilled; 'The Herald of Winter' (1894), standing on a rocky pinnacle against a sky filled with swans flying South again, is charming but inexpressive; and 'A Vision of Spring' (1901) walks but languidly amongst the irresistible flow of life she has awakened, and is less significant of the season than the child who gazes at her with wonder and surprise. Still, if Mr. Millie Dow's essays in this kind are not very convincing or satisfying as allegories, and seldom stir the deeper associations connected with the themes dealt with, they possess charm as decorations, bear the impress of cultured and refined taste and personal feeling, and are marked by sensitive perception of tone and colour and by rare delicacy of execution which give them a distinction quite their own. His work has been seldom seen outside Glasgow exhibitions, except on the more special occasions when the 'Glasgow School' exhibits abroad or in America as a separate entity.

On the other hand, Mr. Robert Fowler's connection with the Glasgow men is remote and indirect, for his chief work was done in Liverpool, and he has had little or no personal contact with the group; but his art has certain affinities with theirs, and it was the appearance of their pictures at the Walker Art Gallery in the early nineties that stimulated him to return to the oil medium, in which he has since done his most important and characteristic work. And it is to Millie Dow that he is most closely related. To both pictorial allegory expressed through a decorative but only slightly conventionalised treatment of Nature makes

appeal, while, compared with most Scottish painting, theirs shows a pre-ference for flat blondness of tone and cool and silvery colour-schemes. But the resemblance goes little further. Dealing with moods of the spirit rather than with the personification of natural powers and seasons, Fowler's ideas are more abstract and generalised than Dow's, and at the same time his conception is so much more significant that the pic-torial issue is actually more concrete and convincing as allegory. And while Dow's art is all dainty exquisiteness, Fowler's, although delicate rather than vigorous in technique, and not too certain in drawing, possesses severer qualities of form and line derived from study of the Greeks.

Born at Anstruther, in the same county as Dow, Fowler was engaged in business before he took to art, and studied in London, whence after some years he removed to Liverpool, where his people were settled and where he remained until about 1904, when he returned to London. During the five-and-twenty years he lived in Liverpool his studio had been a chief centre of artistic life and a meeting-place for musicians and poets and painters, amid the bustle of business which pervades the northern city, and his leaving was another item added to the grudge which the English provincial towns, as well as Scotland, owe London for her attractiveness for talent which she rewards but scarcely stimulates. The earlier decade of the Liverpool period was given chiefly to water-colour in which he executed many pleasingly designed, carefully elaborated, and richly coloured pictures taken from classic myth or romantic poetry. They partook, however, more of the character of illustrations than of works of creative art, and it was not until he took to oils seriously that he found himself and attained the characteristic manner by which he has become known both in this country and abroad.

Influenced by Albert Moore and Leighton, but even more by study of the Greek marbles in the British Museum, in his dealings with drapery and the nude, impressed by the suave breadth and unity of atmospheric effect and the simplicity of design and colour in the decorations of Puvis de Chavannes and in the pictures of Whistler, and touched by the discoveries of the plein-airists and impressionists in tone and colour and by the colour-spacing and decorative charm of the Japanese, he has combined these diverse elements into a style which gives admirable expression to his personal conception of life and Nature. Designed with little light and shade and in a very limited range of tone and colour, and painted with little gusto, his work seems at first sight somewhat lacking in vigour of presentment and clarity of idea ; but its personality of colour is arresting, its quiet unobtrusive decorative quality engaging, and, on examination, one finds that his thought is expressed with felicity. The pale, sweet mist of his colour—pearly and opalescent greys, bluey greens and greenish greys, faint blues and delicate purples—resolves itself as one looks into the

creatures of heroic myth or pregnant dream set amid the beauty of silent woodland, by hushed lake-side or in the calm depths of the sea. Differing from most painters of myth and allegory, in this country at least, in virtue of the more abstract and less illustrative and didactic quality of his conception, his treatment of such themes is generalised, suggestive, and decorative rather than detailed, definite and academic. His pictures breathe the atmosphere of 'Some enchantment old, whose spells have stolen my spirit,' as the fortunate title of one of them says of its story, and he is most happily inspired when least directly influenced by definite incident or tradition.

As late as 1902 Mr. Fowler looked upon landscape-painting as a recreation, and until 1903, when he showed a large 'Conway Castle' in the Royal Academy, few, except his personal friends, had seen any of his work in this field. Since then, however, he has held a landscape exhibition, and many of his Welsh pictures have been reproduced in one of Messrs. A. and C. Black's colour-books. For the most part, sketches, completed in the open in one painting and in as brief a time as possible, and, ostensibly, direct and unembroidered impressions of Nature, his landscape possesses certain qualities in common with the profounder and far more puissant art of M'Taggart and Monet; but, impersonality in art being impossible, it bears the inflection of his preferences. Yet charming as these impromptus often are, he cannot be counted a great landscapist, and it is in virtue of his romantically suggestive figure-work that he ranks as a painter of interest and personality.

Compared with the work just reviewed, that of Mr. Robert Burns is almost purely decorative in intention. While Robert Fowler and, in less degree, Millie Dow are interested in the poetic and dramatic elements in subject, and their pictorial treatment, decorative though it is in result, is conditioned to a great extent by desire to attain significance of expression, Burns seems to regard subject as primarily a pretext for pleasing design upon lines sanctified, for the most part, by tradition.

A native of Edinburgh (b. 1869), he had tried several art schools in this country with little satisfaction to himself before, at the age of twenty, he went to Paris, where for three years he drew from the life in the Académie Delecluse and worked in the Jardin des Plantes. Returning to Edinburgh in 1892 he commenced to exhibit at the Scottish Academy[1]; but for some time much of his attention was occupied in designing iron and silversmith's work, stained glass, and book illustrations, and, although he was considered a man of promise by his friends, his pictures did not commence to attract general attention until several years later. His training under M. Delance had given him an insight into the broad principles of decoration, and these had marked the mural pictures he had executed in the Roman Catholic Church at Dalkeith, and the drawings in

[1] Elected A.R.S.A., 1902.

massed black and white which he contributed to Professor Geddes's short-lived 'Northern Seasonal'—*The New Evergreen*—as well as his cartoons for coloured windows and his designs for other phases of applied art, and when he came to devote himself to easel pictures they remained the dominating quality. The greater freedom of treatment permissible in picture-making, giving greater scope for personality of expression, had, of course, an effect on his art. A fine sentiment for landscape made itself felt, and combining with something derived from Hornel's audacious handling of Nature, his own refined feeling for tone and colour, and a real instinct for the qualities of oil-paint, gave his carefully designed and balanced work a stylish and distinguished air. Influenced in his earlier designs by certain of the earlier Florentines, as is evident in some of his windows, his pictures retain traces of that admiration or are reminiscent of that languorous mood, the *dolce far niente*, which breathes in Giorgione's 'Pastoral Symphony.' But seldom do they possess that calm intensity of passion and that sensuous significance which, together or separately, make the pictures of the great Italians so much more than delightful exercises in decorative design. The young girl bathers or embroiderers, the ballad-singers and lute-players, even the parting lovers and the weeping 'ladyes' of old romance, who figure on his canvases, leave one unmoved. Yet, lacking in poetic appeal and relationship to life, as they too often are, his pictures are usually admirable as decorations, and, charming in tone and pleasing in rhythmic design of mass and colour, the eye falls gratefully upon them amid the undistinguished stuff that forms the bulk of most modern exhibitions. There are moments also when, as in 'Adieu' (1907), a touch of human sentiment is added to loveliness of design and colour, and occasionally in a landscape, such as the charming 'Lonely Shieling' (1908), he attains real significance of expression.

Mr. Burns's connection with *The New Evergreen*, already referred to, may serve as a link with Mr. John Duncan, who, besides contributing to its pages, has done much of his most important work in connection with other schemes of Professor Geddes. One of these was the revival of mural decoration. In 1884 the Professor had suggested to Mrs. Traquair that she should decorate the mortuary of an Edinburgh hospital, and in so doing had indicated the direction in which a remarkable talent was to find its true outlet, and since then he had been associated, more or less directly, with other schemes of a similar nature. But meeting Duncan he took the art home with him to the many gabled and red-roofed pile that he had built, about the old 'goose-pie,' in which Allan Ramsay, the poet, had lived, to enliven with a touch of mediæval gaiety the sombre and characteristic silhouette which succeeding generations had reared upon the ridge that runs from the Castle to Holyrood. A native of Dundee, Duncan's earlier work had shown decorative tendencies and a good deal of ingenuity in invention, and in a frieze (round the hall of

Professor Geddes's house), representing the 'Evolution of Pipe Music,' these qualities were clearly evident, although certain archaistic elements gave the whole an air of somewhat affected *naïveté*. His next undertaking was the decoration of the common-room in Ramsay Lodge with a series of large panels, the subjects of which were taken from Celtic and Scottish history, and 'gravely chosen withal, and for reasons manifold ; poetic, historic, academic, even personal to the student's life, of which they shadow forth the possible stages.' But to discuss, as 'The Interpreter' did, the meaning and stories of these seven pictures 'of imagination, of magic, and romance' is scarcely the province of this history, and we must e'en content ourselves with a general indication of their artistic qualities. By the time they were being painted the 'Celtic renascence' had become part and parcel of the Geddesian propaganda, and their painter had come fully under its sway. But the elusive spirit, which issued in the glamoured beauty of 'Fiona Macleod's' stories and snatches of verse, was incommunicable in pictures which had necessarily to conform to decorative convention, and, beyond the taking of some of the subjects from the heroic poetry of the Gael, the employment of a certain convention of patterning and decorative enrichment derived from Celtic ornament, and the surrounding of the figure-panels with elaborately interlaced and coloured borders of knot-work, there is little really Celtic about them. Nor can one feel that they embody that return to Nature and to simplicity which was claimed as the leading characteristic of the movement. Rather do they show a conscious return to the naïve and unconscious, and therefore delightful, archaism of primitive art. In the previous cycle Duncan had given rein to humorous fancy and feeling for movement, but now he curbed them before the exigencies of a more reasoned and sophisticated style in which the influence of Botticelli and Aubrey Beardsley and Puvis de Chavannes mingled with Celtic elements. These, combined with gayer and richer colour and an increased tendency to the grotesque, were also the characteristics of the 'Orpheus' decorations executed somewhat later for Mr. Beveridge of Pitreavie Castle, Dunfermline, but since his return from America, where he executed several decorative commissions, Mr. Duncan has been painting cabinet pictures, many of them with subjects from the Cuchullin and Finn cycles of romance, in the greyer tones of the Ramsay Lodge series, but showing with a continuation of seemingly affected but evidently temperamental naïveté a growing sense of beauty and now and then a touch of romance.

It is for his decorations rather than his pictures that Robert Douglas Strachan also claims attention. With him the scene shifts from Auld Reekie to Bon Accord, where he was born in 1875 and where he has executed some notable work. After serving a term as an apprentice lithographer in the office of the *Aberdeen Free Press*, at that time edited by Dr. Alexander, the author of *Johnny Gibb*, who took an interest in his artistic

aspirations, he studied for a single session in the life-school of the Royal Scottish Academy and then went to Manchester as black-and-white artist for several papers. In 1898, however, being in Aberdeen, he volunteered to paint two panels in the Trades' Hall, then nearing completion, and they were so much appreciated that the Trades Council commissioned him to decorate the whole hall. Externally an unpretentious and unprepossessing building in a narrow street, one is unprepared for the wealth of decoration lavished upon the spacious although too low-roofed interior. Facing one at the sides of the recessed platform are the panels of 'Ancient Labour' and 'Modern Labour' in which the scheme originated, between the windows on each side are figures typifying the chief industries, and in the cove of the roof, the lasting satisfaction and enduring good achieved ' In the way of Greatness, by honest labour, whether of mind or hand, for the common weal, and the engrossing and more selfish, if not always ignoble, strivings of those engaged in the Pursuit of Fame' are depicted in two series of seven panels. This was followed after an interval by a more extensive and important piece of work—the decoration of the great public hall of the city. Dedicated chiefly to music, the story of Orpheus was chosen as the most appropriate theme for its adornment, and the cycle promises when completed to bring much credit to the artist and to prove worthy of the public spirit in which it was conceived. Upon the half-dome roof of the apse-like recess behind the organ, above which it shows, a great figure of Apollo with attendant Muses strikes the dedicatory note, and round the side and end walls of the great room run the myths of Orpheus with his magic music which delighted the hearts of men, led captive the untamed creatures of the wilds, and even overcame the spells of the Sirens with an enchantment greater than they could weave. In 1904, however, the artist went to London for a time, and since returning he has been so much engaged as a designer of stained-glass that little progress has been made. His glass is so exceptional in spirit and colour that one hesitates to hope that he should lay its designing aside to complete these decorations, but Aberdeen, so nearly in possession of an interesting achievement, should see that sufficient inducement is forthcoming to induce him to do so.

Although starting with meagre technical training, Douglas Strachan's art bears little obvious evidence of this initial handicap except it be the rather suavely conventional character of his drawing and handling, which are more facile and easy than constructive and significant. He draws fairly well indeed, but, as it were, 'out of his head' rather than from knowledge, and tells his stories, as a decorator may, more by the general sweep of his groups and accessories than by mastery of facial expression or of the essential character of things. His sense of design, however, is admirable in line and mass ; his invention and grouping spontaneous and fanciful ; his use of colour, in which a fondness for greyness of tone gives

unity without depriving it of glow, pleasing and harmonious ; and being designed and painted (in oil on plaster) in place, his decorative schemes are at peace with themselves and their surroundings.

Inventive, fanciful, decorative, and withal clear and unaffected in meaning and sentiment, there is yet in Mr. Strachan's work a lack of real distinction in idea and in treatment which tempers one's admiration for its high endeavour and actual accomplishment. The Trades' Hall and the Music Hall series remain notable achievements in their kind, however, and when one considers the youth of their painter one awaits with interest the development of a talent which seems to promise fine things.

The decorative idealism, which connects the work of Duncan with that of Strachan, is found also in that of Stewart Carmichael, a young artist, who has executed a few decorative paintings for some public buildings in Dundee. Mr. Carmichael's art, however, does not possess any very arresting qualities beyond the somewhat mystical spirit in which he conceives subject, and the hesitating yet rather charming way in which he expresses his spirituelle but somewhat nebulous ideals. His most important work is a large panel, some thirty feet by ten, of 'The Leaders of Scottish Liberties,' in the Liberal Club, Dundee, but his style is not vigorous enough for such a great canvas, and one gets his best in sketches and projects.

Fairy Tale

The combination of some degree of intellectual import with more or less formally decorative beauty, which has been noted as characteristic of nearly all the art just discussed, is replaced in that now to be considered by a combination of less purposeful fancy and more sportive decoration. Broadly, the difference is that between romantic allegory, which retains relationship to life, and fairy tale, which is sheer enchantment and charming but merely decorative embroidery and invention. An atmosphere of make-believe and unreality, and beauty of fantasy and invention being the very essence of the latter, one need not expect those qualities of imaginative realism, observation, and insight which belong to the former. It is a case of there's nothing true but everything's new and charming, and that's all that matters. And in the drawings of two Glasgow girls, Miss Katherine Cameron[1] and Miss Jessie M. King, one gets these qualities in rich measure.[2] It is true, of course, that Miss Cameron's design is frequently loosely knit and that she draws but indifferently ; that her figures are not put together constructively, and that her faces, though charmingly pretty, are lacking in character and depth of expression ; but like R. L. S. she prefers the coloured to the plain, and in virtue of engaging fancifulness of idea, deep delight in soft rich colour, and unending

[1] Miss Cameron is a sister of Mr. D. Y. Cameron.
[2] T. B. Blacklock's work was of the fairy-tale order, but owing to its technical affinities it was discussed in the first section of this chapter.

variety in invention of decorative patterns, her pictorial telling of tales is quite fascinating. For these with her are genuine gifts. Her colour is all pervading and brilliant like that of a summer sunset; her fancy as fresh and unexpected as the trills and cadences in a bird's song; her invention of pattern as sportive and as varied as the play of the wind in a flower-garden in June. Irresponsible and spontaneous, yet graceful and expressive, her art yields real delight. She is *par excellence* a painter of fairy tales, and no more beautiful pictures of the adventurers and adventures one meets with *In Fairyland*, can well be imagined than those she made for Mrs. Louey Chisholm's charming collection of old favourites which bears that name, and its sequel *The Enchanted Land*. More charming than these, however, is a series for a retelling of *The Water-Babies*, and curiously enough it is just because of a greater infusion of that human element, which I have indicated as somewhat lacking in her work as a whole, that it is so. These are of course the most widely known of Katherine Cameron's works, but, admirable as the reproductions are, no process can quite reproduce the exact quality of colour and texture upon which the effect of painting ultimately depends, and her colour (although, being brilliant and founded on the primaries, it suffers less than that of some others) cannot be judged finally except from the originals. There one finds a tenderness and softness of colour and tone, a delicacy in the toned whites, a refinement in the golden greys and yellows, a fullness in the rosy pinks and reds, a depth in the blues and purples, and a clarity in the greens which contribute much to the romantic quality of her art, which, apart from fairy story and fantasy, deals with flowers and bees and butterflies. And in most things of hers there is a feeling for decoration—for spacing and balance—which, added to the fine qualities of colour, fancy, and invention with which she has been credited already, makes them, in spite of obvious deficiencies, things of beauty and romance.

With Miss King, on the other hand, a glamoured atmosphere is attained by means in which colour has little or no part. Less significant perhaps than Katherine Cameron's water-colours, for Fairyland without the tinctures of the rainbow is scarce the land of enchantment and dream where wonder is at home and the improbable becomes highly reasonable, the effects she achieves in the limited medium of pen and ink are wonderful. Borrowing some of the technical devices of Aubrey Beardsley (1874-98), and influenced, as is very evident in the accessories in such drawings as that of the girl reading 'The Magic Grammar,' which might have been taken from one of Miss Cranstoun's æsthetic tea-rooms, by the peculiar style of decoration—'the swirl and the blob'—associated with a group of Glasgow designers, it would yet be absurd to describe her art as decadent.[1] That has far more to do with the underlying spirit than with elements such as those indicated, and Jessie King's work is untainted

[1] Miss King herself is a designer of fabrics, wall-papers, tiles, and such-like.

by that distressing morbidity and moral unhealthiness which are the signs
of the real decadent, be he never so skilful a craftsman or decorator.
The vein in which she works—for, although Rossetti has been suggested
repeatedly as an influence, her sentiment lacks depth of imaginative
passion and sensuous quality to justify that inference—is in some degree
kindred to that of Maeterlinck. It is mystical, illusive, decorative. The
action is slow, rhythmical, and symbolic ; passion, such as it is, is expressed
by the evocation of a general atmosphere rather than dramatically and
through the play of character ; the effect is like that of faded tapestry
seen in a dimly lit interior, where what is seen counts for less than what
the mind conjures up for itself. Some of her admirers have found that
in her illustrations to the poets 'the hidden meaning stands revealed, and
the artist translates into beauty of line and form the thoughts and ideas
which the pen has expressed,' but to me their appeal is different in
kind. They tell little about the poet's thought, or the drama and
character about which his thought has played, and her landscapes have
little relation to the actual and significant beauty of the world. Rather
taking a passage from a poem or a fairy-story, or a scene in Nature as a
text, she embroiders upon it and weaves something, less beautiful and
moving than is possible to art in which incident or Nature is imaginatively
and reverently seen, but charming in its individuality of delicate fancy
and its wonderful daintiness of design and execution. And this being so,
she is at her best when dealing with 'old, unhappy, far-off things, and
battles long ago.' Yet, as one might expect, it is only in certain aspects
of these that she is fully successful. On her own ground, however,
Miss King has done exquisite work, and that she should produce so much
charm by such simple means is clear evidence of the quality of her gift.

Miss Annie French, another Glasgow lady, is in some degree under-
study for Miss King, but in her work the influence of Beardsley's
technique is more pronounced, and the sentiment is her own. Executed
for the most part in black and white pen and ink with the blacks massed
but played through by many spots and lines of white, and the whites
patterned or spotted in black, she at times introduces colour into her
drawings, tinting the faces and splashing the draperies with spangles of
iridescent colour. But her art, as a whole, possesses neither the delicate
taste nor the dainty and exquisite handling which marks that of Miss
King.

The fairy-tale, although these ladies have made it their own, is not
without devotees among the men. They, however, have dealt with the
landscape rather than with the denizens of these magic realms. And
mingling a good deal of charm derived from personal sentiment for Nature
with considerable ingenuity in pattern, Messrs. W. Brown Macdougall,
J. J. Guthrie, and Will Mein have produced some dainty things in
decorative black and white.

It was after attracting some attention in Glasgow and at the New English Art Club in the late eighties by finely felt and coloured landscapes in oil or pastel that Mr. Macdougall turned to decorative illustration. In illustration, however, he became more abstract and definitely decorative. Landscape was used as an excuse for pattern, and when figures were introduced the treatment was apt to be archaistic and affectedly unconventional. Yet in a rather *outré* and artificial manner his black and white possesses personality and is not without charm. And much the same may be said of that of Mr. Mein, who, however, prefers pen and ink as a medium. Mr. J. J. Guthrie, unlike either of the others, is engraver as well as designer. His landscapes of tall waving trees by shadowed waters, of castles perched on high tree-clad hills silhouetted against moonlit skies, or of light and shadow flecked woodlands, are at once engaging in design and feeling and inventive in treatment, the pattern being wrought out and the sentiment expressed by a clever use of white lines and dots on a solid black ground. But, as most of them have appeared in private publications issued from the 'Pear-Tree Press,' they are little known to the public. His book-plates, some of which have been reproduced in journals devoted to that cult, are executed on similar lines, but are more massed and emphatic in manner.

Mr. Robert T. Rose's treatment of Bible story, while decorative in pattern, is much austerer in spirit and more dignified in form than that of Mr. Macdougall. To the latter the Book of Ruth was but a pretext for pleasing but meaningless pattern : the former found the Book of Job a source of imaginative inspiration, and evoked from its wonderful narrative a series of significant designs. Pictorial art cannot, of course, stir the same sensations as literature, and the story of Job is too abstract and too perfectly expressed in and fitted for its medium to be translated into another. Where Blake, greatest of pictorial visionaries and most mystical of painters, failed to attain, Mr. Rose was not likely to succeed ; but, treated in simple masses of black and white, rich and full in tone and balanced with fine decorative effect, his drawings are frequently so arresting that whether one comprehends their actual meaning or not, one receives from them an impression of seriousness and sincerity. This also is the quality which asserts itself in his illustrations to 'Old Testament Stories,' where colour is introduced in broad, flattened masses, and in the delicately tinted water-colours, with motives of religious or symbolical bent, which he exhibits occasionally. His most characteristic designs are based upon a frank and bold use of solid blacks on a pure white ground. Marked by instinct for the points calling for accentuation and feeling for decorative ensemble, the results attained are frequently both significant and pleasing. The art of George Dutch Davidson (1879-1901), a Dundee artist, whose work during a very short career showed considerable promise, is more complex. Influenced by Beardsley in treatment of reality and manage-

ment of black and white, Davidson's drawings have yet a character of their own, specially marked when the tesserae-like patterns formed by a conventionally decorative treatment of natural forms, expressed in delicate pen or pencil lines, are filled with faint flat water-colour tinting. In some of his work of this kind study of Persian and Celtic art is evident, and, when to these sources of inspiration, admiration for the Italian primitives is added, it is apparent that his was a nature peculiarly susceptible to decorative impressions and abstract expression. Although somewhat neurotic in temper and exotic in kind, his art is not definitely morbid, and the impression he and it had made on his immediate circle was expressed by the publication (1902) of a memorial volume in which a number of his most important designs are reproduced.

CHAPTER VII

THE FIGURE-PAINTERS

PREOCCUPIED by the problems of realism and decoration, the pioneers of the new movement cared little for subject and sentiment, in the sense that their predecessors and older contemporaries had done. To say that they would have none of them would be to exaggerate the tendency of an attitude, but to the great majority the historical and costume picture seemed little more than literature or archæology in the flat, and domestic genre of the homely and pathetic order was only so much 'bleat.' Avoiding these trodden paths somewhat ostentatiously, as if they had been inartistic in themselves, which of course they are not, though the way in which they have been trodden has often been, the 'Glasgow boys' gave most of their attention to landscape and portraiture. They did not, however, disdain simple figure motives associated with landscape, or set in pleasant everyday interiors, and combined refined feeling and sentiment with powerful handling and study of real lighting and values, or of decorative effect in their treatment, while one or two of the more independent spirits even adventured into the realms of myth or history. But for the most part anything savouring of literature or of old-fashioned sentiment was tabooed in the west. In Edinburgh and the east, however, when the influences that had affected the Glasgow group came into play, and later, when the impulse of the movement itself began to be felt directly, there was less dread of ' story ' ; and in consequence the figure-picture, restricted in range and modified in many respects, has in these latter days found most of its exponents there. Of Glasgow painters who might have been included here, most of the more notable have been dealt with already in connection with previous groupings, or will appear in later ones, and this may be commenced by study of the work of several artists, chiefly of Edinburgh origin, who have cultivated a kind of genre little exploited by earlier Scottish painters.

Although he has retained a great deal of the spirit in which Scott Lauder's pupils regard subject, and in portraiture is more concerned with character than with decoration on Whistlerian lines, John H. Lorimer has learned much, particularly as regards light and tone, from contemporary movements, and, while preserving his individuality of outlook to the full, has combined pictorial effect with sentiment. A native of

Edinburgh, where he was born in 1856, he was trained in the schools of the R.S.A. under M'Taggart and Chalmers, and, scarcely out of his teens when he commenced to attract attention, became an Associate in 1882.[1] Before his election he had visited the Continent repeatedly, and was a devoted student of the Old Masters, and two years after it he went to Paris and, entering the Carolus Duran atelier, came into close contact with the formulated theory of values, and the study of true tone. Already, however, his art was shaping in the direction it has since followed, and study in Paris only added to his experience and power. The 'Sir David Chalmers' of 1883 shows many of the qualities of his matured style. It has much of the regard for the character and personality of the sitter, and of the searching drawing, thorough modelling and breadth of lighting, which give such distinction to the splendid portrait of Professor James Lorimer, painted seven years later. Still, if he has never achieved in it anything quite so fine as the picture of his father, there is another kind of portraiture—that with a strong genre element in its conception—which seems to me more characteristic of his talent. Of work in this vein the 'R. C. Munro-Ferguson, Esq.,' the 'Colonel Anstruther Thomson,' and 'Pot Pourri,' a mother and children filling a great vase with rose leaves, are typical. Mention of the last reminds one that in his earlier days he was a painter of flowers also, and that some of the finest and most personal things he has painted are either studies of sprays or blossoms, or of great clumps of flowers growing in the garden.

It is as a subject-painter, however, that Lorimer has won distinction. Almost without exception Scottish genre-painters, following Wilkie's lead, have devoted their art to the life of the peasantry, or to incidents in which costume is an important factor. None except Sir W. Q. Orchardson, and he chiefly as a dramatic satirist, had painted the more refined and cultured side of modern society, until Lorimer took up figure-subjects and gave delightful glimpses of life as it passes in many a Scottish home. Instinct with a deep and tender appreciation of the genuine charm of refined domesticity, such pictures as 'Sweet Roses,' 'Winding Wool,' 'Lullabye' (1890), and 'Grandmother's Birthday — Saying Grace' (1893) attain a high degree of quiet beauty and intimate charm. But, if peacefulness and quietude are characteristic of Lorimer's feeling, 'The Eleventh Hour' (1894) showed grasp of dramatic situation, and that his sympathies are not confined to his own class is evident from the charming drawing he did for 'The Songs of the North,' and from 'The Ordination of Elders' (1892). The last, a scene in a country kirk, is indeed one of the most national pictures ever painted. While the

[1] R.S.A. 1900. For many years Mr. Lorimer divided the year between London and Fifeshire, but in 1900 he gave up his London studio, and took one in Edinburgh. He is a corresponding member of the Institute of France.

separate figures are exceedingly fine types of character, the whole picture goes deeper and touches the very heart of Scottish piety and reverence.

In Mr. Lorimer's pictures sentiment depends greatly upon a very refined and acute sense of light. Amongst Scottish painters, at least, none has handled the effects of interior illumination with such charm as he has done at his best. He holds the balance between the over-emphasis of Pettie, or the purely pictorial abstraction of Orchardson, and the too murky and dead tone of some of the younger school. However brilliant a Lorimer may be, it is certain to be harmonious and indoors in effect ; however dark, it will be luminous and transparent. It is the combination of this delicate truth of lighting with refinement of sentiment and design that has won him the applause of artists like Besnard and Ary Renan, and has charmed the French Government into buying ' Grandmother's Birthday' and ' Colonel Anstruther Thomson' for the Luxembourg. His colour, also, whether a scheme of cream and yellow, orange and blue, or of deep browns and reds, is usually very delicate, exceedingly luminous, and subtly graded. Curiously enough, however, the technique, by which he attains these exquisite effects of light and colour, is in itself lacking in quality and beauty of surface, and at times unpleasing. Yet it accomplishes its end wonderfully, and, while he is an admirable draughtsman, a graver fault is an inclination to over-model detail, and insist too strongly on subordinate markings. Seeing with unusual surety, he is apt to be too closely bound by what is before him, and never lets himself go. This tendency became somewhat painfully marked in the later nineties, especially in portraiture, in which over-precision frequently gave a hard and rather grim look to his sitters ; but of recent years he has rcovered himself. The symphony of pale blue and delicate gold in ' Interior—Moonlight Evening,' and the harmony of flushed yellows, cool greens, and dusky whites in ' Midsummer's Eve : A Reverence to Roses '[1] (R.A., 1905), almost equal the best of their predecessors. The latter is perhaps the most accomplished, if not the most satisfying, picture he has ever painted. The quaint and half-rhythmic grace of its sentiment—the white-robed maidens making obeisance less to the Roses than to the statuette of Cupid (who, as the Voltairean verse on the frame indicates, is master of all), in the centre of the flower-spangled parterre—the poetry of its setting of old garden and lambent sky, and the linked rhythm of its scholarly design unite to produce a glamoured and fascinating atmosphere. ' Hush ' (R.A., 1906 : Rochdale Gallery), a mother seated beside a sleeping infant in a white room, the window of which opens on sunlit fields and sea, and ' The Flight of the Swallows ' (R.A., 1907 : Scottish Modern Arts Association), illustrated here, which were the finest achievements of the following years, are at once simpler and more intimate in feeling, and are associated with even subtler realisation of the poetry of light and lovelier

[1] Title was altered to ' Jardin de Cupidon,' when the picture was shown in Paris, 1907.

colour. Marked by keenly sensitive perception of light and unusual feeling for beauty, the spirit revealed in the best of Lorimer's pictures is more kindred to the fascinating intimacy of Vermeer of Delft than is that of any modern with whose work I am acquainted.

Like his friend Lorimer, Patrick W. Adam (b. 1854), the son of an Edinburgh lawyer, was a student of the Royal Scottish Academy, and was elected Associate (1883 : R.S.A., 1897), before the new movement was of much account ; but he also has affinities with the more recent phases of Scottish painting, with the leaders of which he has always been on intimate terms. Something of the same refinement of feeling as regards subject, noted as characteristic of Mr. Lorimer's work, is found in Mr. Adam's ; but, while his genre motives are exceedingly simple and frequently dainty, as in his diploma picture ' Morning ' (1895), a scheme of whites and greys with a pink note, they are seldom informed by inventive fancy, novel insight, or dramatic spirit. And his preferences in technique, and specially his desire for breadth of brushwork and impressionistic to effect, approach the western ideals more nearly. This is most obvious perhaps in landscape. Indoors, although his drawing and brushwork lack distinction and decision, the daintiness and charm of ladies and children and their surroundings hold him, and he is apt to be a trifle sentimental ; outside he is more originally observant and more resourceful technically. The series of Venetian pictures painted in 1889, amongst which ' The Ducal Palace ' in the Aberdeen Gallery, and ' Santa Maria della Salute ' were notable, possessed distinct interest, but probably the most striking things he has produced are a number of winter landscapes executed about 1896-7, in which snow under many effects was rendered with freshness, vigour, and considerable subtlety.

Charles H. Mackie is more varied than either Lorimer or Adam, and belongs more obviously to the newer school, but some aspects of his career and some phases of his work suggest his inclusion here. An Edinburgh man (b. 1862), and trained entirely at home, Mackie burst upon the public gaze in the Scottish Academy of 1888,[1] with ' E'ening brings a' Hame,' and ' Weaning Time,' two pictures which attracted great attention and inspired many prophecies as to his future. In these he seemed a devotee of Nature and close in touch with her poetic significance. If somewhat heavy and clumsy in handling, they were rich and full in colour and tone, lusty in sentiment, and pregnant with the emotion of time and place. And other pictures of about the same period, if less immediately arresting, possessed very similar qualities, and raised hopes that in their painter there had arrived one who, in his own way, would be a worthy colleague and successor to the most charming of Scottish landscape artists, Mr. Lawton Wingate. But a few years later, fascinated

[1] Elected A.R.S.A. 1902, and became member of the Scottish Water-Colour Society the same year.

by the more formal interests of decoration, which either arose or issued in a series of mural decorations executed for Professor Patrick Geddes and Mr. Beveridge of Dunfermline, he seemed to become possessed by an idea, true when kept in its proper place, that Art was not Nature, and in pursuit of an ideal of picture-making, founded upon scientific theories of colour harmony, began to plan his pictures on a system. The immediate result was a decrease in both the emotional content and the pictorial quality of his art. Gradually, however, he became more certain of what he desired, or rather of the means by which to attain it. Yet his work continued to give, and on occasion still does so, the impression of a man more interested in the methods to be used in expressing a thing, than in the thing itself, or in finding the way in which to express a natural emotion fitly and emphatically. In a word, he appears more taken up by conscious analysis of æsthetic and technical problems than absorbed in emotional expression upon ordinary pictorial terms. To this decorative and half-scientific preoccupation he adds an interest in true values, a desire for dignified composition, and a curiosity in effects of lighting, natural and artificial, which show him thoroughly alive to many modern art problems. The results are interesting, for the effort, always sincere, is backed by keen analytical instinct, but as a rule his pictures have been wanting in that depth of sentiment, and that union of spontaneous feeling and expression, which belong to art of the more creative order. Still from what has been said, it is evident that Mackie's art is the reverse of commonplace, and when his intuitive feeling for Nature plays through the æsthetic problem and vivifies it, the issue is much more than merely interesting. And of late years in landscapes such as ' Moonlight in the Bay ' (1902), ' The Sheepfolds ' (1905), and ' Flock returning to the Fold ' (1907), and in interiors with figures like ' Musical Moments ' (1905), and ' Gold Fish ' (1906), he has shown an increased tendency to rely on his instincts, and a disposition to express his personal and immediate impressions of reality. With more courage and theory duly subordinated, Mr. Mackie's naturally fine taste and feeling would have freer play with great advantage to his work, which is never without interest and often possesses charm.

Subjective interest in the sense of incident and drama bulks more largely in the art of Mr. George Harcourt, though he also is preoccupied with effects of illumination. Born in Dumbarton in 1869, he studied in the local art school while engaged in decorative work for the ships built by the Messrs. Denny, and after 1889 wrought at Bushey under Professor von Herkomer, whose assistant he was for a number of years previous to 1901, when he was selected by the Allan Fraser Trustees as governor of the Art School at Hospitalfield, near Arbroath. The scope of that rather curious foundation having been indicated in an earlier chapter, we are here concerned only with Mr. Harcourt as a painter. A

good and strong, though perhaps not a stylish draughtsman, and a capable painter with a method at once powerful and complete, he shows distinct ability in the design and conduct of pictures complex in subject and of great size ; while his colour, if not quite captivating on its own account, is usually sound and expressive, and is combined with a just appreciation of tone. And these qualities he uses for the expression of his interest in life and light, for in his work these elements are usually found in combination. In his earlier pictures, 'The Leper's wife' (1896), 'Too Late' (1898), and 'Forgiven' (1899), of which the first was probably the finest in colour and conception, dramatic situation was perhaps the dominating quality, but even then the opposition of warm and cold colour and of artificial and natural light had a fascination for him, and in his later pictures, where quietude prevails and the subject is often a portrait group or a single figure in a spacious setting, problems of light are prominent, and are solved, if not subtly as by Mr. Lorimer, with commendable power and skill. Perhaps his most important work is the panel, commemorative of the founding of the Bank of England, which was presented to the Royal Exchange by members of the London Stock Exchange in 1904, but many of his pictures are on a far more imposing scale than is customary with Scottish painters.

In their treatment of simple every-day incidents, sometimes not unlike those in Lorimer's and Adam's pictures, David Muirhead and Peter Mackie, two young artists with Edinburgh connections, combine delicacy of perception and brushwork with breadth of impressionistic effect and balance of design. Trained in Edinburgh and at the Westminster School under Professor Fred Brown, Mr. Muirhead painted for a time at home, but in 1894 settled in London, where, a few years later, he became a member of the New English Art Club, at whose exhibitions he had, and has since, shown his most important work. Thoroughly artistic, he understands what goes to make a picture, and is keenly appreciative of what has been nobly done in art, but, conceived in a fine tradition, and touched with modernity of sentiment as his pictures are, they reveal little depth of passion or originality of vision. His drawing is sympathetic rather than virile or distinguished, his handling more suave and easy than expressive and stylish, and his sense of design, pleasing though it be, somewhat lacking in grasp and lucidity. On the other hand he has a fine instinct for tone in its broader relations, a real feeling for sweet low-toned colour of limited range, and a pensive tenderness of sentiment as regards the things he paints, whether these are home-like interiors with girlish figures or rustics in landscape, tree-shadowed mill-ponds or peeps of quaint villages by the sea, which give his work aroma and charm. Peter Mackie's gifts are not unlike David Muirhead's in kind. Influenced by Whistler, in his striving for fluent delicacy of handling and impasto, subtle gradation of tone and refined quality of colour, he shows distinct if not very robust,

personality in his view of subject and considerable refinement in his treatment of light. Painting in a higher key than Muirhead, his colour inclines to be silvery rather than sombre in quality and particularly in his landscapes, which are usually enlivened by happily placed and tenderly drawn figures, composed into some simple incident, he sometimes attains a charmingly delicate vibration of colour within the atmospheric envelope that gives unity to the ensemble. 'The Sand Haven,' 'Evening at the Ferry,' and 'Evening at the Fair' were charming examples of these qualities, and, while scarcely so harmonious, his indoors colour-schemes are always refined and are now and then associated with a very pleasing genre treatment of portrait-groups of cabinet-size. If as yet no more than minor, Mr. Peter Mackie's talent is real in its degree.

A not dissimilar sensitiveness to the beauty of ordinary things and much the same delicacy of perception are present in the pictures of a young Edinburgh lady artist. In her treatment of bird and animal life Miss Anna Dixon has shown charming delicacy of drawing and handling, refined tone and colour, and considerable feeling for design, while in some of her later pictures there is the added charm of novelty. For from incidents which, witnessed any summer day on the sands at Portobello, would seem commonplace, she has evoked beauty. Composed with quaintness, yet perfectly naïve in feeling, her little canvases of shabby donkeys, admired silently and ridden joyously yet with fear by 'quite common' children on the sands between the uninteresting promenade and the sparkling sea are as charming as they are modest and unpretentious.

<div align="center">II</div>

Remembering the debt of the earlier Scottish genre-painters to the seventeenth-century Dutchmen, it is not surprising, at a time when Continental influences have been active, to find their successors of to-day influenced by the example of Israels and his confrères. In a general way, of course, modern Dutch painting was a power in the formation of the newer school, but, in addition to its influence in that sense, one can trace its effects in a special manner in the work of a number of young painters who have retained many of the traditions of the Scottish School. Like Wilkie and his following, they use what they have learned for the expression of their own feelings and observation anent the life about them.

With Mr. Henry W. Kerr (A.R.S.A., 1893), the process has been gentle and assimilative. When first he attracted notice, it was by delicately handled little heads in water-colour not unlike George Manson's in method, but broader in touch and fuller in character if less tender in feeling, and the colour-schemes of his earlier subject pictures were traditionally Scottish in their combination of the reds, blues, and yellows of local colour with brown shadows and mellow backgrounds. Gradually his

handling became bolder and more homogeneous, and, without losing the feeling for colour with which he started, the general tone of his drawings grew greyer and more atmospheric and showed finer observation of the play and unity of light. To this result study of the Dutch water-colourists and sketching trips in Holland contributed, but they were no more than influences quickening the evolution of his style in a direction natural to it and left his outlook on life unchanged. Some of his drawings, which are often of large size, like many of the best national stories, touch upon things connected with the Sabbath : the congregation ' skailin',' the gauche air of a young man getting his first bairn baptized, or, that indispensable element of Church life in Scotland, taking the collection. Or crossing the Irish Channel they deal with the humorous side of cabin life in Connemara, Galway, or Donegal in a strain less uproarious, but scarcely less entertaining than that of Erskine Nicol. Indeed, one is not certain that they are not more genuinely amusing. For he gives us less the Irishman of farce or comic opera than of reality, and there is a subtleness and a kindliness in his view of life, which come nearer the Irish heart than the whisky gaiety or exaggerated pathos too frequently apparent in Nicol's accomplished productions. The keen sense of character and the quaintly humorous vein of feeling, which underlie Henry Kerr's work, are admirably expressed by his fine drawing, broadly delicate modelling, and quick sense of how to combine the story-telling elements in a generally pleasing design ; but technically he is seen at his very best in the direct and virile yet subtle studies of heads or single figures made for his more important drawings or in his water-colour portraiture. Of recent years, though he has not yet attained complete mastery of the medium, he has also been painting good portraits in oil.

Mr. R. Gemmell Hutchison, another Associate of the Royal Scottish Academy, has also an appreciation of the fusing influence of tone and atmosphere, and brings a broad and vigorous method of painting, good drawing, and effective design to bear upon a rather fresh view of village life. Despite a certain commonness, his pictures are usually well thought out, and, logically put together in a pictorial way, tell their stories with considerable point. His feeling again, although lacking in charm or novel insight, is sympathetic, and his treatment of childhood, if somewhat literal, fresh and individual. To some extent these qualities and defects may be due to that fear of the ' pretty,' which has been one of the dreads of the younger school, and has led in some instances to the elimination of not only the sentimental airs of the Faed and Hardie group, but of some of the natural graces to which rusticity has a right. In their own way, however, such pictures as ' Hallowe'en,' ' The Cricket on the Hearth,' ' The Gundy Man,' ' The Young Laird' (Oldham Gallery), ' Bairnies, Cuddle doon' (Gold Medal, Paris Salon), and ' When Strings o' Stories Grannie tells' are able and powerful renderings of certain aspects of Scottish life,

and in the later of them one could see a distinct increase in refinement of handling and feeling alike. Both technically, and in the way in which subject was regarded, his work had for long approximated in some ways to that of the modern Dutch genre-painters, but recently the influence of Israels' latest phase has been very apparent, and, while affecting the subjective elements to no great extent, has led to the use of a rather inexpressive, rotten, and crumbly impasto of disagreeable quality. Apart from other reasons, this is to be regretted, because it has deprived his art of the finer qualities, for him that is, which the natural development of his own method should have brought.

On the other hand, the subjects of many of John P. Downie's pictures as well as his methods, show Dutch influence, for he has painted much in Holland, principally at Laren, the village associated with the names of Anton Mauve and Neuhuys. It is with the latter that Mr. Downie, who was trained in Glasgow and at the Slade School under Legros, reveals most affinity. Working with delicacy and feeling, as regards both the technical and emotional elements, and using chiaroscuro, combined with regard for values and pleasant though rather negative colour, with power, his Dutch cottage scenes, and those in a similar spirit dealing with 'characters' or domestic incidents at home, possess considerable merit and appeal. Technically Miss H. C. Preston Macgoun also has profited much by study of the Dutch genre-men. Her drawings are marked by a pleasing union of breadth and delicacy of tone and local colour, her draughtsmanship, if not very constructive, is gracious and expressive, and her handling of water-colour bold yet refined. But it is her sentiment for the incidents of home-life, and specially for the ways of children, which forms the most attractive quality in her art. Sincere and sensitive, her water-colours, whether of Dutch or Scottish children, are informed by a tenderness of feeling and a quiet joy in the soft rounded forms and radiant faces of childhood which make them charming in a feminine way, and give one more real pleasure than much work of a more pretentious kind. And in black and white, in such things as the illustrations she did for *Rob Lindsay and his School* and *The Little Foxes*, she is equally happy.

In the pictures of Mrs. A. R. Laing as in the drawings of Miss Macgoun, a feminine and rather charming sentiment as regards children and their relationship to one another and to 'grown-ups' is united to considerable beauty of colour, lighting, and handling ; but in those of Miss J. M. M'Geehan a sentiment, not unlike in kind, is rather overlaid and negatived by a gusto of handling and a forcing of colour which come near rudeness.

With Christina P. Ross, a daughter of R. T. Ross, R.S.A., on the other hand, neither feeling nor method was pronouncedly feminine. A water-colour painter, she used the medium with force and directness,

and often obtained very powerful effects of lighting and colour based over-much on rich brown tone but showing some of the finer qualities of the medium. This was most apparent perhaps in the treatment of the shadowed sail-lofts with jerseyed men at work on great billowy spreads of canvas, or of the interiors of fishers' cottages which supplied motives for some of her best drawings, but her studies of old towns and buildings at home and abroad, and of fishing harbours were frequently both vigorous and true.

Affected in his technique by Dutch example, and now and then painting homely incident, W. Fulton Brown (1873-1905), although a good part of his work dealt with costume subjects, may be mentioned in connection with this group. He died when only thirty-two ; but for some years previously he had shown a distinct gift for expression in water-colour. Drawn with considerable facility, good in tone and agreeable if restrained in colour, and handled expressively and with breadth, his studies of old-world statesmen, or magicians or singing pages, or of the showmen or herds of to-day were simply and pleasantly designed, admirable in character and good as art. They gave promise of better things to come.

The influences in the work of Miss Mary Cameron (Mrs. Alexis Miller) are French and Spanish rather than Dutch, but as most of her pictures are subject in kind, they may be considered here. Trained in Edinburgh and Paris, she began with military subjects, but first attracted attention by painting certain aspects of sport at home and abroad. For a good while these were selected from the race-course and the hunting-field, but since her first visit to Spain (1900) she has devoted herself principally to the bull-ring and its accessory life outside, and has frankly, but unnecessarily perhaps, recorded its sordidness as well as its glitter. Already an able craftswoman in certain directions, during one of her subsequent visits to the South she met Señor Ignacio Zuloaga, the painter of many exceedingly clever but repellent pictures of Spanish life, whose pupil she, in some degree, became. Thereafter, adding fearlessness to courage and to a great extent abandoning the arena, she painted life-size groups of bull-fighters and grisettes or of peasants on immense canvases, but, despite the ability they display and their wonderful vitality as the work of a woman, the artistic results attained are not commensurate with the ambition that inspires or the energy involved in the making. Vigorously drawn and painted forcibly and frankly, her portraiture, if there is little charm in the doing or insight in the seeing, is vital and so convincing that one of her finest effects of this nature, the ' Portrait de Mme. Blair et ses borzoïs,' received ' Mention Honorable ' in the Salon of 1904.

III

Already the portraiture of many artists, connected with or influenced by the recent movements in Scottish painting, has been considered, but the tale of those who have devoted themselves chiefly or to a great extent to portrait-painting is not yet exhausted, and while, for the most part, those remaining are neither such fine artists nor so conspicuous, they include a few painters of real merit.

Although his work is never seen in the exhibitions and his name is practically unknown outside a very limited circle in Glasgow and the west, Mr. James Torrance is one of the most vital painters of the younger generation. It was somewhat late ere he gave himself wholly to art, and he had studied little in the schools, but, pursuing his ideals with singleness of purpose, he has gradually built up a style which expresses his convictions in a way as distinguished as it is personal. Drawing with incisiveness and style, and handling paint with vigour and a real feeling for its material beauty, he is also a fine colourist with a sense of values : but these gifts are not used primarily for their own sake and never in parade but as the means for embodying that appreciation of life and character which underlies his attitude to the things of sense. A painter of virile and subtle portraits of men, Torrance is equally successful in dealing with the softer beauty and more elusive character of women, while some of his portraits of children are pregnant with sympathy and possess beauty of that simple kind that comes near being great. Apart from portraiture, he has painted a number of charming studies of girls' heads with foliage or floral and latterly simple backgrounds, and a few subject-pictures which, like his illustrations to two or three books of fairy-tales published a good many years ago, show imaginative qualities of a fine kind.

The strenuousness of Mr. John Bowie is different in kind. Compared with Torrance his painting is vigorous but without subtlety, his design simple but without significance, his rendering of character frank and downright but without insight. Yet in its own way Bowie's work is interesting and competent. Powerfully and slickly handled with big brushes in paint of good quality, the forms are indicated with breadth ; the colour, if wanting in delicacy and charm, is harmonious in a silvery key and not unpleasing ; the design, though lacking somewhat in significance and decorative beauty, is effective and well knit together ; and the expression of character, if limited to the more obvious and external features, satisfactory in its degree. Portraits, such as those of Dr. Walter C. Smith, the poet, Principal Rainy, the statesman-cleric, and Bishop Dowden, the ecclesiastic, show these qualities at their best, and proclaim their author a portraitist of some merit and considerable power. But portraiture is only the more recent phase of Bowie's art. A brilliant student of the Edinburgh Schools he was taken up by the London Scots in the mid-

eighties and for a time painted genre and costume pictures in the Orchardson-Pettie style and would have nought to do with the younger school or foreign influences. Later, however, he worked in Paris, became a convert to tone, studied Hals and Velasquez and arrived at his present manner. In 1903 he was elected A.R.S.A., and two years later he removed to London.

The portraits of Harrington Mann and Fiddes Watt, of Sholto Douglas and E. A. Borthwick, and of a few others are more on lines which have become a convention with the younger school. In their work one finds, in varying degree and with more or less personality, decorative effect combined with the Whistlerian idea of tone and repose and the Sargent conception of technique and liveliness. With Mr. Harrington Mann, who, after a long course of study in the Slade School with Legros, worked in Paris under Boulanger and Lefebvre, the inclination is toward Mr. Sargent and modernity. He first attracted attention by conscientiously observed and elaborately executed renderings of scenes in Yorkshire fishing villages, varied by subjects from Scott's novels, a series that may be said to have culminated in the able, animated and very large 'Attack of the MacDonalds at Killiecrankie' (1891), for, while he has since painted realistic studies of Italian peasants, and executed a number of semi-decorative pictures and at least one important scheme of decoration (that illustrating 'Scottish Song' in a girls' institute in the Vale of Leven) he began to specialise on portrait-painting during the early nineties and is now best known for his work in that field. Designing his portraits in simple masses and to a certain extent in a decorative way and drawing with quite remarkable facility, he paints with considerable bravura and dash in bold and slashing, if not always significant, brush strokes, and tries to give his sitters that air of animation and fashion of which Sargent is such a master in his finest, though not most clamant, achievements. Naturally, however, Mann inclines, as was evident from the 'Miss Florence Sabine Pasley' (1891), a girl in evening dress and opera cloak sitting quietly in a room, to intimacy of characterisation, refinement of sentiment and completeness of realisation, and he is seen at his best, perhaps, in portraits of children such as 'Ian' (1897), and 'Little Bare-Feet' (1900), and groups like 'A Fairy Tale' (1904), and 'Good Morning' (1905), where these tendencies have fuller play, than when painting smart society people in the flashier style so much in vogue with Sargent's large following.

The somewhat similar tendencies which appear in the work of Fiddes Watt are derived less directly from the master than through the medium of Robert Brough's example. Connected with Aberdeenshire, like Brough, the meteoric success of that clever young painter must have appealed to Mr. Watt with special force, and a considerable number of his portraits, although less attractive and brilliant, bear a superficial resemblance to Brough's in conception and manner. In these he shows very considerable

technical facility, abandon, and style, but his own instincts seem to find expression in the more careful and caressing, if less dexterous and swishing, handling, and the more delicate drawing and modelling which marked the charming 'Portrait' of a dark-haired lady in white shown at the Scottish Academy of 1905, and the 'Isabel, daughter of Hugh Young, Esq.,' of the following year. Fuller in characterisation and more personal in manner, it is by development on these lines that he would probably attain an individual and satisfying style. Brough's influence is also noticeable in the portraits of Mr. John Greig and a few other young artists mostly of northern origin, and the purely Whistlerian in those of Mrs. Macaulay Stevenson.

On the other hand Mr. Sholto Johnstone Douglas unites Whistlerian tone and chicness of brushwork with a good deal of old-fashioned likeness-making. His work, however, is somewhat lacking in that straightforward, if often undistinguished, grasp of character which gives much old-fashioned art an interest of its own, and frequently it fails to reach the conventional distinction possessed by much modern portraiture. Still, this combination of qualities makes his portraiture acceptable to those who care for neither of these elements alone, and, a scion of a Dumfriesshire county family, he has painted many people of social standing. Very similar qualities appear in the portraits of Mr. A. E. Borthwick, but, a favourite pupil of Bouguereau, his inclination is towards allegory, and in such pieces as 'Consulting an Oracle' and 'The Shepherds' one finds sound academic draughtsmanship underlying the richer tone and more atmospheric colour he owes to association with the younger school. In some of Mr. P. A. Hay's earlier work, such as the 'Miss Blackwood,' there was more of that decorative intention and striving for fullness of tone which characterised much of the Glasgow art of its period; but, since he left Edinburgh for London, these qualities have concerned him less, and his later portraits, though with something of the Sargent air about them, may be grouped with those of Douglas and Borthwick. Many of them, however, are executed in water-colour of which he shows very considerable mastery, and in that medium also he has painted a number of pleasing costume-studies such as 'The Tapestry Worker' (1906).

Charm, rather than vigour, is the note which dominates the art of Mr. Robert Hope, a young Edinburgh painter, and this being so, he is seen at his best when painting ladies. Refined in observation and feeling, designed simply, and painted suavely in delicate tones, the few portraits he has exhibited show considerable gifts for portraiture in both its artistic and representative aspects. Still, it is in the border-land between portrait and picture—in the kind of subject in which Andrew Geddes excelled and of which Roche is probably the ablest present-day exponent—that Hope is most at home and attains his happiest results. If somewhat lacking in distinction of draughtsmanship and expressiveness of modelling, and

deficient in vitality of sentiment, a feeling for beauty pervades his pictorial conceptions and is expressed with appropriate tenderness and reserve. Mr. Graham Glen's treatment of similar motives is also marked by fine taste and good colour.

Other of the minor portrait-painters, having retained more of the attitude of the older generation as regards both sitter and technique, were dealt with in an earlier chapter.

IV

Amongst the work of the younger artists, that of W. J. Yule (1869-1900), Robert Brough (1872-1905), and Bessie MacNicol (1869-1904) stands somewhat apart, for, not only is it highly interesting in itself, it is finished—finished but broken off sharp with its promise incompletely fulfilled. All three died young.

Yule was the greatest loss to art. Broken by sickness during the last years of his short career, he left comparatively few evidences of his talent, but what he did was of exceedingly fine and rare quality. The son of a well-known whaling captain, he was born in Dundee and studied in Edinburgh and in London, at the Westminster School when Professor Fred Brown was master, and subsequently worked in Paris under M. Jean Paul Laurens with whom he was a favourite. Admiring the accomplishment of French draughtsmanship but not caring much for French painting, he devoted his time there to drawing. Later he studied Velasquez in the Prado and painted for a while in Seville; and it was when returning from Spain that he contracted the illness which after a time, during which he worked in Edinburgh and London, led to the breakdown to the effects of which he succumbed three years later.

From the first Yule's work was personal and distinguished. It had won the warm admiration of his fellows in the schools, and, when he took to exhibiting, his pictures attracted the attention of artists and lovers of fine painting. But being singularly free from parade and indeed from all meretricious and showy qualities—and the style was the man—their appeal to the public was not immediate, and it was not until just before his final illness that tangible recognition promised to come to him. Nor was he greedy of publicity. He exhibited but little, while even some of the things he showed he subsequently destroyed as wanting in the qualities he valued.

For the most part his exhibited pictures were portraits and principally of children or young girls, for even those such as 'Spring' and 'Summer,' the titles of which might imply something else, were of that nature. Expressing very subtly that *naïveté* and unconscious grace which are amongst the most winsome charms of childhood and youth, the 'Portrait' head, which was the first picture he exhibited (1892), the beautiful 'Girl

2 E

in Crimson' (1893) ;[1] a delightful picture of a little girl in yellow seen in
the Royal Scottish Academy of 1895 ; the charming harmony in green,
white, and tawny called 'Spring' (1895), and 'Jack, son of Mr. Justice
Darling' (1896), the last complete picture he painted, to name the more
prominent, are pervaded by a certain shy beauty which gives them a
quite distinctive place. Intuitively he got what is far more difficult to
catch than formal likeness—the air of his sitters, and each of his portraits
is pregnant with a curiously subtle rendering of personality. And to
insight, beauty of perception was added. He saw the world about him
in a way at once exquisite and synthetic, in its large contours as well as in
its delicate nuances. Moreover, although an impressionist, he possessed
that simple, serious and scrupulous style which, according to Sainte-
Beuve, goes far. His drawing, which in line was distinguished and
delicately incisive, was in painting wedded to a subtle mastery of tone
and beautiful, if restrained, colour, the morbidezza of his flesh-painting
was tremulous with the gentle pulsation of normal life, the result as a
whole marked by a dignified sense of style and a refinement of an excep-
tionally high order. But while he was known to some extent to the art
public as a painter of portraits or of single figures set against flowery or
suggestive landscape backgrounds, his landscape sketches were seldom
seen except by his friends. Usually effects of subdued light and oftenest
perhaps of dusk, many of these little pictures, into which children were
frequently introduced most happily, are exquisite in colour, tone, and
feeling, all in a minor key but rich and harmonious and steeped in a
fascinating tranquillity of sentiment. His pictures of Spanish market-
places and interiors (1895) are also very original, for as he wrote to me,
' It is not the Spain of John Phillip,' and he sought always to record his
own impressions in his own way.

Yule's art was not of that brilliant and facile order which commands
immediate success, but it contained the elements of lasting reputation.
Gradually ripening, as his talent was, it had not attained full maturity
when he died : but he had done enough to show that he possessed the
authentic gift, that he was one of those rare spirits who now and then
glorify art by revealing beauties hidden from ordinary eyes. This was
equally evident in portrait and landscape, and in the two big subject
pictures, one of girls dancing in a meadow, the other of the last sleep of
Savonarola, which he left unfinished, he was beginning to break new
ground. The quality of distinction, which most men labour for, was his
by nature, and he had increasingly at his command a technique broad,
significant, refined. Laurens said that he painted like a 'cello, and the
phrase gives happy expression to the rich, full sweetness of the low-toned
colour harmonies he loved. It is at all times difficult to gauge promise
(and he was my friend), but, trying to look dispassionately at what he

[1] Reproduced in Mr. D. S. MacColl's *Nineteenth Century Art*.

accomplished and what he was, it seems to me that W. J. Yule had the potentialities of a master, and that in his death Scottish painting lost not the most powerful or brilliant perhaps but certainly the most subtle and distinguished talent it has thrown up of recent years.

Brough was much more widely known. A native of Invergordon, Ross-shire, he was brought up in Aberdeen, where he served an apprenticeship to a firm of lithographers with whom Sir George Reid had been many years before ; but, an ardent devotee of art from his early years, he was no sooner out of his time than he found his way to Edinburgh; and in 1891 he was admitted a student of the Royal Scottish Academy life-school. During the two years he remained there he won several prizes, and then, after some months in Paris under Laurens and Constant, he returned to Aberdeen where he painted portraits for three years, at the end of which (1897) he took a studio in London, and became a neighbour and friend of Mr. Sargent. Thereafter, his success was rapid and almost phenomenal. He was medalled in Munich and Dresden and Paris ; commissions poured in on him, and, never having given up his Aberdeen connection, he was elected A.R.S.A. in 1904, only about a year before his tragic end in a terrible railway smash near Sheffield.

His first success was gained with a portrait of ' W. D. Ross, Esq.' (1893 : National Gallery of Scotland), which, seen and admired in Edinburgh previously, attracted great attention at the New Gallery in 1896, and the following year the interest thus awakened was greatly increased by the appearance of ' Fantaisie en Folie ' (Tate Gallery) and ' Sweet Violets.' Fluent and charmingly suggestive, if very slight in handling and drawing, very refined in colour and tone, and elegant in design, these pictures possessed a captivating sense of beauty, which, carried into portraiture, soon made Brough one of the most fashionable of portrait-painters. The ' Childhood of St. Anne of Brittany ' and ' 'Twixt Sun and Moon,' semi-decorative pictures in a luminous key, inspired by a visit to the north of France and now in the Modern Gallery, Venice, which were painted about 1895, are probably the only other important works not portraits that he executed. For some years, although always touched with beauty of design and colour, and painted with extraordinary dexterity, his work with all its sparkle and charm was superficial and unsatisfying. It were folly, of course, to belittle the engaging quality of things like ' Kathleen, daughter of Theodore Crombie, Esq.' (1898) and ' Edie, daughter of O. H. Edinger, Esq.' (1899) ; but their attraction was immediate rather than lasting, and the bravura handling, with its slight and unsearched modelling and its yard-long brush strokes, seemed to indicate some lack of seriousness. The ' Viscountess Encombe ' of 1900, however, uniting fuller characterisation and completer expression to brilliant grace and lovely colour, was a very stylish and delightful portrait, and though he subsequently painted some emptier things, such as the mere-

tricious 'Mr. George Alexander in the "Prisoner of Zenda"' (1902), and the *portrait d'apparat* of 'The Marquis of Linlithgow, K.T.' (1904), in others, of which 'Lord Justice Vaughan Williams' (1901), 'Lord Torphichen' (1904), and the unfinished group of 'Mrs. Edward Tennant and her son David' may be mentioned specially, he showed increasing knowledge, firmer and fuller technique, completer characterisation, and a chastened and more dignified style.

Like many young musical virtuosi, but to a degree very rare among painters, Robert Brough possessed an intuitive feeling for the technique of his art. Drawing and painting came easily to him, and, being a fine colourist, even his earliest efforts possessed an air of maturity and seemed to imply mastery. And when the opportunity of studying other men's work came he was quick to seize it. Less influenced than most of his fellows by Whistler, and having a natural affinity for things alert, sparkling and chic, he found Sargent and Boldini greatly to his liking, and for a while the effect of this was traceable in his work. He had, however, a sense of elegance and beauty, not deep, perhaps, but true in its kind and quite his own, which always made itself felt, and, as he gained experience, his work tended, as has been indicated, to become more sober and dignified until, in some of his latest portraits, it looked as if he might have developed into a lesser Raeburn with something of Romneyesque grace added. It is possible, of course, that great natural facility enabling him to attain the appearance of mastery without effort would have prevented him adding those qualities of depth and strength required to make him a master in the real sense, and, for a time at least, he made rather a parade of dexterity and painted with a swagger and abandon not fully informed and rather disdainful of character : but he died young ; he seemed to be striving for fuller expression, and who can say what might have been ? Compared with the work of the very best of his Scottish contemporaries, his portraiture is lacking in depth of characterisation and intimacy of sentiment while technically it tends to be a little superficial and facile. Still, his best was brilliant and marked by style, and the clarity of his flesh tones and the purity of his colour were rather a reproach to the dinginess and dullness which emulation of Whistler's exquisite tonal quality had brought into fashion with too many of the younger school.

It was less as a portrait-painter than as a painter of charming studies of femininity that Bessie MacNicol (Mrs. Alexander Frew) made her reputation. Probably the most accomplished lady-artist that Scotland has yet produced, she drew with ease and style, if not very constructively, handled her medium with delicate dexterity, designed with elegance, and possessed a personal and feminine feeling for Nature which made most things she did interesting and charming. So much may be said with little hesitation, but she died when only thirty-five, and what she might have done can only be conjectured. Trained in Glasgow and in Paris,

her first notable picture was a delightful study in flashing greys and creamy whites of 'A French Girl,' seen at Glasgow in 1895. Piquant and chic, but with a delicacy to which chicness is usually alien, that picture was followed by others in which the decorative influence of Hornel and the technical tendencies of Park and Gauld were evident to some extent. But if she assimilated certain elements in the art about her, she made them her own and informed them with a brightness and gracefulness and a tenderness of colour and of sentiment of distinct charm. As Mr. George Moore might have said, she carried the art of the Glasgow men across her fan. The sentiment for reality expressed in her work is neither compelling nor profound, but it is engaging and real in its degree; and if her technique lacks constructive qualities in design and drawing and is over-facile, perhaps, to be distinguished, it is at once stylish and expressive of her moods. Moreover, the feeling for beauty which pervades her work, and finds vent in handling, design and colour as well as in sentiment, is personal, and, marked by sex (not aping a virility she did not possess but expressing herself gracefully and well), her actual achievement was considerable. In portraiture, and in her more ambitious pictures, desire to account for the facts and the character and paint as strongly as a man was somewhat apparent perhaps, and tended to grow on her, so that it was in her slighter and more spontaneous things that she was most charming and most herself. Bessie MacNicol did not possess that uniquely feminine winsomeness which makes Berthe Morisot (1840-95) the most charming of woman-painters; but in pictures like 'A Girl of the Sixties,' 'Autumn,' an exquisite study of girlhood seen in the delicate flicker of sunlight and shade wrought by swaying yellow chestnut leaves; 'In the Orchard,' a dainty little full-length of a mid-Victorian girl walking among trees; and such charming nudes as 'The Toilet,' and 'Vanity,' she comes nearer her in spirit than does any Englishwoman I can think of.

CHAPTER VIII

THE ANIMAL-PAINTERS

GENERALLY speaking those of the younger generation who have painted animals have been less obviously affected by the new ideals than those who have given their attention to portraiture, the pastoral, or landscape. As with the group of subject-painters discussed in a preceding chapter, most of them have been influenced in some measure by the movement and have learned something from its experimentalism and wider outlook, but, like the others in this also, they have for the most part made the new qualities subservient to interest in subject for its own sake or for its human relationships and associations. And this direct delight in the life and beauty of the things they choose to paint rather than in decorative abstractions or technical bravura, which connects their work with that of the best of their predecessors, is most marked with the more gifted of the younger men. Amongst these Mr. Edwin Alexander is the most notable, for Mr. Joseph Crawhall (whose work in its more vivid and arresting way is perhaps even more interesting), although he was associated intimately with the leaders of the 'Glasgow School,' and painted in Scotland in their company, is a Northumbrian by birth, and has never had a permanent studio north of Tweed. Those who know the splendid accomplishment and virility of his remarkable art will understand how strong the temptation to include it is, but one cannot have it both ways, and limitations already set make it impolitic to do so.

Although Edwin Alexander was born as recently as 1870, the work he has done is considerable in quantity and remarkably fine in quality. Eldest son of Mr. Robert Alexander, he inherits his father's love of animals, and shares some of his artistic preferences particularly in tone and colour, but, if these be traceable to heredity, the art in which they form a part is highly personal. His style is indeed one of the most distinctive in contemporary Scottish painting. Yet it is singularly modest and refined. At a time when the general tone and tendencies of painting in Scotland have been influenced profoundly by the art of the leaders of the Glasgow group, he, while not insensible to the finer qualities of that movement, has not only maintained his independence but has achieved a distinguished personal style.

The variety of subject-matter with which Edwin Alexander has dealt

makes it inadvisable to label him as specially a painter of this or that, but it may be said that hitherto his most characteristic things have been of birds. Keenly sensitive to delicacy of form and colour, the beautiful contours of birds' bodies and the subtle nuances of form, pattern, and colour in their plumage offer him congenial material, and the charm and delicate precision of his method make his expression of these a lasting delight. Fonder of repose than of movement, as his father is, and greatly interested in natural history, his drawings have been somewhat deficient in vivacity at times, and, while invariably admirable in characterisation, they have seemed now and then to be ·more analytical studies than synthetic expressions of life and beauty. At his best, however, he combines subjective interest with wonderful observation, and expresses himself with consummate technique and rare regard for decorative placing. His sense of design is as refined and active as that of a Japanese master of the best time, and includes the arrangement of the feathers in back or breast or wing, as well as the larger pattern made by the grouping of the birds themselves, and their relationship to their surroundings ; he draws with the utmost delicacy yet constructively, in a manner that would have charmed Ruskin ; and he handles water-colour (his medium in all but two or three big pictures in oil, which medium he has not yet quite. mastered) with delightful but unobtrusive dexterity. Moreover, his tone is refined, and his feeling for colour, though restricted, fastidious and harmonious. And these things, even when he fails to appeal to one's human sympathies, make his work of unfailing artistic interest. From that point of view also his use of linen and silk and various textured papers, particularly grey packing-paper, and the admirable results he obtains by using body-colour like wash, should be noted.

Animals figure more rarely in his work, but he has made exquisite drawings of rabbits and hares and painted several large canvases of deer, while two prolonged visits to Egypt resulted in some notable water-colours of camels and donkeys, sheep and goats. But his Egyptian sketches are interesting for other reasons. They express another aspect of the East to that usually chosen by artists, who, as a rule, have seized upon the brilliant and spectacular phases of life, upon the sparkle and glitter of the many coloured crowds in market-place and mosque rather than upon the serene and quiet existence of the children of the desert. But this young painter dwelt among the Arabs, living their simple life in the tents, and sharing their daily duties, and the record he has made is more intimate, therefore, and serves as a foil not only to the work of those who have painted in the towns, but to that of men who have painted impressions of a mode of life they have seen in the passing, or have shaped to conform to the conception of the East held by those who have not seen it for themselves. In this connection, however, the most remarkable of Edwin Alexander's drawings are those which depict the normal

Egyptian landscape as distinct from the groups of temples and palm-trees by the Nile which offer the most obvious points to painter and photographer alike. Serene and tender in sentiment and colour they are pregnant with the very air of the illimitable desert, spreading league beyond league in the still, delicate, heat-permeated atmosphere. 'The keynote of this landscape,' Lord Leighton wrote in the *Journal* of his trip up the Nile in 1868, 'is a soft, varied, fawn-coloured brown than which nothing could take more gracefully the warm glow of the sunlight or the cool, purple mystery of shadow; the latter perhaps especially deep and powerful near the eye (the local brown slightly overruling the violet), but fading as it recedes into tints exquisitely vague and so faint that they seem rather to belong to the sky than to the earth.' And this epitomises the essence of Edwin Alexander's drawings so succinctly that it might have been written to describe them, and renders further comment unnecessary. A somewhat similar charm belongs to his occasional renderings of home landscape, for here he selects scenes and effects of atmosphere in which delicacy of tone and refined harmonies of faint colour predominate. Low-horizoned ploughed lands with birds on wing in the high airy sky; long ebb-tide sands glimmering in the deepening twilight; and bare uplands with nibbling sheep seen in the delicate harmony wrought by a grey spring day—these and such-like are the themes he loves.

But it is perhaps in little drawings of wayside flowers and seeded grasses about which bees hum and butterflies flutter that he attains his most perfect results. In them he joins a daintiness of touch and a delicacy of colour, spacing, and design, quite Japanese in charm, to truth of structure and searching draughtsmanship, and with all retains that breath of sentiment which sight of the things themselves evokes.

To some Mr. Alexander's drawings may seem lacking in strength of tone and splendour of colour, and a more vivid suggestion of life and movement in those of birds and animals would sometimes be a gain, but his art has the rarer strength of delicacy, and it may be that greater liveliness of impression could not be combined with the qualities he possesses in such rich measure. As it is, wonderful certainty of technique, charm of colour, and exquisiteness of design, united to rare delicacy of perception and refinement of feeling, make his slightest sketches interesting and his more finished drawings unique and well-nigh perfect in their kind.

He spent a few months in a Parisian atelier, which he did not relish greatly, but otherwise his studies were pursued in Edinburgh, to some extent under his father's eye; and an Associate of the Royal Water-Colour Society since 1899, he was elected A.R.S.A. in 1902.

If none of the younger Scottish animal-painters possesses the refinement of feeling and perfection of method which make Edwin Alexander's

drawings so remarkable, several are producing work of individuality and accomplishment. Two of them, William Walls (b. 1860) and George Smith, a man of about the same age as Alexander, supplemented their Edinburgh training by study in Antwerp, and of this the pictures of each have shown traces in different ways. With Mr. Walls a rather restricted feeling for colour and a tendency to suppress colour in favour of tone, specially evident in his earlier work, might be set down to Antwerp influence, but it is rather in choice of subject than in treatment or technique that the effects are most noticeable. If the fine collections in the Zoological Gardens are an attraction to the ordinary visitor to the Flemish city, they must have been much more to a young artist interested in animals, who had seen little of 'wild beasts' except in travelling menageries ; and, having spent much time sketching and studying there, the principal pictures shown by Walls for some years after returning home were of wild animals. Although somewhat deficient in style, they were capable and not without refinement, while they revealed much sympathetic observation. But after a few years, the vividness of these impressions having faded, or perhaps simply because there were no facilities in Edinburgh to continue such studies, lions and jaguars and parrots gave place to horses and goats and donkeys, but oftenest to dogs : sometimes, as the collies in 'Waiting and Watching,' at rest ; sometimes, as in 'Hark ! Bellman, Hark !' and other otter-hunting pictures, in motion. While subsidiary to incident, setting, usually landscape in character, counts for a good deal in these pictures, and, helping to explain the matter in hand and to complete the design, is significant in both a subjective and a pictorial sense. Occasionally, although his most ambitious effort of the kind was not successful, he painted landscape also with considerable charm and feeling. Technically, his work showed steady, if slow, advance, for he was ever a student of reality and a conscientious craftsman ; but, admirable as it was, one was scarcely prepared for the notable progress he has made during the last few years. The 'End of the Chase' (R.S.A., 1905), a couple of panting hounds in a rocky dell beside their quarry ; 'A Kildalton Group' (R.S.A., 1906), a cluster of hackneys in a park near the sea ; and the 'Death of the Swan' (R.S.A., 1908), while in some respects on very similar lines to their predecessors, were far finer in every way. If one might not go so far as to describe them as distinguished or masterly, they are at least remarkably able and accomplished. Drawn with refinement and a vital sense of form, painted with much quiet dexterity but no parade of cleverness, arranged simply and with fine feeling for the relationship between the animals and their landscape environment, and instinct with appreciation of animal life and of its pictorial possibilities, the sum of their qualities is very considerable. And the water-colours executed on tinted paper in somewhat the same method as Edwin Alexander's, which have been appearing co-incidentally, being

larger and simpler in style and handled with delightful ease, are on even a higher plane. In them he also attains a finer kind of colour, more delicate and vibrant in quality, than in his oil pictures. Moreover, they mark a return to those studies of wild animals in which Mr. Walls[1] is almost alone amongst Scottish painters.

If preference for fullness and unity of tone and powerful handling are evidences of his training under M. C. Verlat (1824-90), Mr. George Smith (A.R.S.A. 1908) has escaped that penchant for slatey and uninteresting greys which many Englishmen acquired in Antwerp in the eighties and nineties, and his pictures show a true, if somewhat sober, taste in colour. Working more in mass than detail, and establishing form by tonal relationships rather than by delicate drawing, his draughtsmanship, like his brushwork, is more effective than subtle, but it seldom lacks a sense of construction, and usually his animals are admirably characterised and typical of their special qualities. Then they are happily related to their backgrounds, sometimes of byre or stable, but more often in the open, for he is of those who, while painting animals for their own sake, find them more significant and fuller of pictorial qualities when grazing in the meadows or at work in the fields. And it is perhaps in incidents in which man and beast are associated, in shepherding or milking, and reaping or ploughing scenes, that he finds his most congenial motives. Such are 'Feeding Time,' 'The Thrashing Mill,' 'At the Forge,' 'Sheep Shearing,' and 'The Wood Carts.' Effective in design, good in colour, and very powerfully painted, these pictures and others of a similar character, mostly of considerable size, are able performances and specially notable for fullness of tone and for ensemble—figures, animals, and setting being conceived as a pictorial whole. Yet admirable as is the expressive forcibleness, which is perhaps the dominating quality in his art, it is obtained too often by sacrifice of those subtler qualities in perception and execution which give charm to frankness and grace to strength.

In the pictures of George Pirie and David Gauld one encounters the more conscious striving after a particular technical method, which marks the work of certain of the younger Glasgow painters. Mr. Gauld employs it with considerable skill in the studies of Ayrshire calves, in which he has specialised of recent years, but his earlier pictures having dealt with a variety of subjects, consideration of his work is postponed to the following chapter. It is otherwise with Mr. Pirie. He is essentially an artist interested in animals. The son of a Glasgow doctor, he varied college studies by sketching animals in the cattle-market, and then, after three years in Paris under Boulanger and Lefebvre, made his *début* at the Glasgow exhibitions in the later eighties as a painter of dogs. Drawn with knowledge, and modelled with crisp, expressive brushwork in solid pigment of good quality, these studies of terriers and bull-dogs and

[1] Elected A.R.S.A. in 1901 ; R.S.W. 1906.

foxhounds were instinct with qualities which, while appealing to the doggy man, gave promise of artistic development in the future. They were followed after 1891 by a series of pictures, largely drawn from what he had seen during a sojourn in Texas, of incidents in horse and cattle ranching, in which he combined increase in ease of handling, finer and more delicate colour, and growing power of design with the study of form and character, which had marked his previous work. A little later, however, reaction from the loaded impasto characteristic of much Glasgow painting, specially of the decorative kind, came, and Pirie, whose Texan work had been shaping in that direction, was carried away by the gospel of *premièr-coup*. His subjects were now barn-door fowls and Highland cattle, as well as dogs and horses, and in the actual use of paint, in suave sweep of brushwork, and in heightened tone and more varied colour, his work was perhaps an advance on what it had been previously. Yet preoccupation with this special phase of handling tending to deprive them of other qualities, and particularly of that grasp of reality and that personal interest in animal life, which were in reality the prime cause of his choice of subject, these later pictures were less convincing and satisfying than the less consciously artistic ones which they succeeded. Since he settled in England, a few years ago, his work has been so little seen in exhibitions, that one has been unable to form an adequate idea of its later development. Before passing to the work of two or three Scotsmen, whose associations are chiefly in England, reference may be made to that of Miss Anna Dixon, which has been noticed in another connection, to Miss A. M. Cowieson's pictures of cats, and to the strongly painted cattle-pieces of Mr. Andrew Douglas.

Of the Anglo-Scots, Mr. Archibald Thorburn, a son of Robert Thorburn, A.R.A., the miniaturist, is the most widely known. Inheriting a love of detail from his father, and devoting himself ardently to the study of game-birds, of their forms and plumage, their habits and their flight, he has made a reputation and a *clientèle* amongst sportsmen by the truth of his observation and the accuracy of his renderings. But when these qualities and a certain command of water-colour and, now and then, a happy arrangement in line or colour are conceded, the interest of his work is pretty well exhausted. It has neither the exquisite charm and perfection of Edwin Alexander's nor the pictorial sense and accomplishment of William Walls. On the other hand, the appeal of Mr. J. R. K. Duff's pastels and pictures is chiefly artistic. A pupil of the Westminster School under Professor Fred Brown, he has latterly shown an affinity to the modern Dutchmen in tone, colour, and handling. This is specially noticeable in his oil pictures, and may account for the success of his work in Holland, where it has been much appreciated. But in such a picture as ' Down to the Shearing,' a long, narrow canvas, admirably designed and tenderly felt, the sentiment is true to the misty mountains ; and in pastel,

whether the motive be an English pastoral of leafy trees and lush pasture, with browsing cattle and nestling homesteads, or a bleak hillside, strewn with grey boulders and dotted with nibbling sheep, both feeling and pitch of tone and colour are in harmony with the more sober aspects of his own country.

CHAPTER IX

OTHER PAINTERS OF THE YOUNGER GENERATION

AMONG the younger generation there still remain for consideration a number of artists of talent or promise for whom, because of their type of or relationship to subject, or for reasons connected with technique, no appropriate place could be found in the preceding chapters. These include a few painter-etchers of great gifts and several able illustrators, but as their work can be discussed more fitly by itself it is reserved for the following chapter and this devoted to those who are primarily painters.

In the first instance one turns naturally to three artists more or less directly connected with the earlier days of the Glasgow movement. With Mr. William Kennedy indeed we come pretty near its beginnings. A Paisley man, he studied in Paris in the early eighties and counts Bouguereau and Tony Robert Fleury, Bastien Lepage, Collin and Courtois among his masters. Yet one cannot say that his work shows the influence of any one of these. Personal in merits and defects alike, it is eminently typical of his outlook on life which is vigorous and self-reliant if somewhat deficient in delicacy of perception and subtlety of feeling. This is apparent equally in choice of subject and in treatment. Passing over his earlier and more tentative work, one finds him about 1885 turning his attention to military subjects, and impelled by a strong sense of reality, seeking them not in the more popular, because more moving and significant, incidents of warfare, but in those of the barrack yard, the camp, and the training ground, which he could see for himself. The issue was a series of pictures which fully justified his choice. Sharing the desire for the decorative disposition of subject characteristic of his group, his pictures were concentrated in design and well massed and balanced in colour and light and shade ; but their dominating quality came from the courage with which he abstracted the essential facts which created the impression which interested him from the mass of material and detail presented by soldiering, and from the emphasis with which he threw these selected elements upon canvas. Technically he was heavy-handed, his handling of paint was vigorous but coarse, and his drawing possessed little subtlety or style : but, if his method of expression lacked charm, he had a real feeling for richness of tone and truth of values, a fine eye for bold effects of colour, and an appreciation of the typical characteristics of

Tommy Atkins seen broadly and in their relationship to the work on hand. Things like 'The Cooking Trenches' (1889), 'The Deserter' (1889), and 'Waiting to Mount Guard' (1890), which may be taken as representative of his earlier work in this field, and later pictures, such as 'Horse Artillery returning from Manœuvres' and 'Hussars returning to Camp' (1901), both evening effects, in spite of obvious deficiency in certain qualities, are marked by a vitality of conception, a skill in arrangement, a breadth of characterisation in men, horses and movements, and a unity and vigour of impression and expression which make them excellent records of certain phases of soldiering, and, in their own way, genuine works of art.

The careful study of light, weather, and tonal relationship noticeable in his earlier military subjects is more evident perhaps in the episodes of farm and village life and in the landscapes painted contemporaneously at Stirling, at that time a favourite painting centre with the Glasgow 'boys' and a few Edinburgh men, and, although he has not altogether abandoned the material which supplied him with his most characteristic pictorial motives, most of his recent work has dealt with the vocations of peace. Discovering an untouched 'Auburn' in the Thames Valley, but remote from both river and rail, in the late nineties, he has since painted the picturesque rural life of old England as it still exists in out-of-the-way districts with much of the force and vividness which endow his rendering of camp and barrack life with interest; but, whether touched by the gentler beauty of the country or through ripening and mellowing taste, he has treated it with greater delicacy of handling and with a more refined sense of colour and tone. If one cannot describe these rustic pictures of his as beautiful without unduly stretching the meaning of that word, they display a sensitiveness to the glamour wrought by sunlight, or evening, or the uprising of the moon upon quaint village street, picturesque homestead, and homely but significant incident expressed in a personal and forceful way which makes them far from commonplace.

The individuality of feeling, abstracting from the material of Nature the elements of immediate and personal appeal and expressing them vigorously and emphatically, if with little charm or dexterity, which is characteristic of Kennedy's art, finds an interesting foil in the pictures of an Edinburgh painter who was working in the Stirling district at the same time. A son of a drawing-master, Mr. T. Austen Brown was a brilliant student of the Royal Scottish Academy School, and early attracted attention at the exhibitions by the pleasing and deft quality of his pictures. Bright in colour, joyous in sentiment, and marked by considerable grace in design, drawing, and handling, they were scenes of country life much in the mood and manner of R. W. Macbeth's work at that period, with a *soupçon* of Orchardson's elegance and colour added. Dainty and sentimental rather than strong, beautiful, and significant, things like 'The

Strawberry Harvest' (1884), 'Love lightens Toil' (1885), 'Hark ! the Cuckoo' (1886), and 'Playmates' (R.A., 1886), had a certain attractiveness if little depth ; but in 1886, coming face to face with the work of Millet and Jacque, and of Israels and the Dutchmen at the Edinburgh International Exhibition, and appreciating its high artistic quality—the beauty of full sonorous tone and low-pitched harmonious colour, the broad significant draughtsmanship and the unity of result which are amongst its most obvious qualities,—and it may be, impelled by a feeling that here was a point of view with which he was in completer sympathy, he became a sudden convert to realistic romanticism. Already the Glasgow men had profited by study of these masters, and the exhibition referred to increased their influence ; but whereas in the West their art was only one influence among those that were moulding the pictorial expression of the realistic tendencies in which the new movement had originated, with Austen Brown the result was imitation rather than assimilation. From daintily clad rustic girls with something of added grace, set amid sunny summer fields, or against radiant sunset skies, he turned all at once to aged labourers 'Toiling to the End' (1888), and ragged herds tending cattle in 'Scanty Pastures' (1889), to sad shepherdesses seen in sorrowful twilights, bedraggled tinkers resting from their wanderings by wan rivers, and weather-worn fisher-folk on grey surf-beaten shores, and, gifted as he is with skilful hands, a fine colour sense, and quick appreciation of pictorial effect, produced a series of pictures marked by powerful handling, rich full tone and decorative quality. And working much at Cambuskenneth, he came into close contact with the Glasgow group, of which he became, as it were, an extra-mural member, and in whose early London and Continental success he shared.[1]

Yet, admirable in many ways as many of Austen Brown's pictures have been, when one settles down to analyse their real drift and purport it is to be disillusioned and dissatisfied. With a sudden chilling of pleasure you realise that you have seen something very like them elsewhere ; that from the contemplation of similar scenes and subjects in the work of other men you have experienced fuller and more poignant emotion. And this explains both the immediate attractiveness and the essential poetic weakness and fleeting significance of Mr. Brown's art. Every artistic nature is impressionable, of course, for otherwise there would be nothing to say, nothing to reveal or interpret, but if outside impression—the influence of other men's work—become master, then alas for that individuality of character which is the most precious thing in art. Unfortunately, too great sensibility in this direction seems to have dominated Austen Brown ; and, though he has since, in some of his work, come under the sway of other and more recent ideals, he has never

[1] Mr. Brown was elected A.R.S.A. in 1889, but went to London a few years later. Much of his later work has been done in the north of France.

really arrived, and achieved something of which one can say truly 'That's him.' He has discipled to the great pictorial masters of 'the still, sad music of humanity,' but he has not as yet formed a style of his own, one expressive of real individuality on either the seeing or the technical side. In addition to the craftsmanship which is admirable, the appeal of his pictures resides in colour, which he inclines to treat in a decorative manner, and it may be that his natural vocation is that of a decorator rather than of a maker of things at once beautiful and significant.

The only other Edinburgh painter, with the exception of Arthur Melville, of course, intimately associated with the earlier Glasgow group was Mr. James Pryde. Son of the genial headmaster of the Queen Street Ladies' College, he was educated in Edinburgh, and studied art there and in Paris under Bouguereau, but for a good many years he exhibited little publicly to justify the reputation for cleverness he enjoyed amongst his friends, particularly in Glasgow. It was not indeed until he became associated with his brother-in-law, Mr. William Nicholson, in the posters that bore the signature 'Beggarstaff Brothers,' that he became known to the public to any extent, and even yet his work is seldom seen, and such fame as he has is amongst a limited circle. Born in 1866, he is Nicholson's senior by six years, and it is difficult to say exactly in what relationship they stood artistically to one another; but, judging from what each has done apart, the fantastical and the bizarre elements in their joint work were Pryde's, and the decorative and scholarly Nicholson's. This combination of qualities made their posters eminently noticeable upon the hoardings, as posters should be, but at the same time it gave them serious artistic merit. Bills such as those for *Harper's Magazine* and some of Irving's plays were at once good advertisements and excellent decorations, and their authors soon came to occupy a unique place in this branch of design ; but, other channels of expression opening, they abandoned it and worked independently. Nicholson found his way gradually through his widely known colour-prints to well-deserved position as a painter, and Pryde returned to those drawings in pastel and other mediums in which he had achieved some success previously. Apart from his share in the Beggarstaff posters, he is, says *Who's Who*, 'perhaps best known to the man in the street by his drawings of Theatrical Characters, Notable Rascals, etc.' Not exactly imaginative but inventive in an unusual way, he expressed himself in these with a cleverness that seems to cry aloud for applause and yet delights to slap the public in the face. Nor is it greatly different with his less-known oil-pictures. Marked by harmony and fullness of tone, boldly handled, and dramatic yet well-balanced in light and shade, they possess arresting distinction and effectiveness. Into tall settings of architecture reminiscent of Guardi and Piranesi, and lit with the abruptness of limelight, though without its high pitch in the illuminated passages, he introduces little figures busy, like actors seen from the

gallery of a huge theatre, over some incident one cannot quite grasp—gathered before a gloomy-looking house, or grouped in a dismal frowning square—but with an ominous suggestiveness in their placing not without appeal to the imagination. A little consideration, however, shows that these effects are gained on somewhat easy terms. A conventionally melodramatic tendency reveals itself in the balanced fantasy of the designs, and one begins to feel that the tonal relationships have been preserved by the simple device of eliminating local and atmospheric colour. Moreover, as in nearly everything he does, something droll and repellent, if whimsical, grotesque, and fascinating, with an element of romance in the mental attitude but sordid and mean at heart, marks his pictures as morbid and decadent.

Although Mr. Stuart Park is one of the most limited of recent Scottish painters in outlook, subjects and method, his talent, though circumscribed, is real, and he has cultivated a speciality with an assiduity which has ensured success. Born at Kidderminster to Scottish parents, he was brought up in Ayrshire, and while engaged in business gave his leisure to painting. After some six years, however, he found himself in a position to take up art professionally, and in 1888 he exhibited the first of those flower-pictures which have earned him reputation. Fascinated by the delicate forms, the rich velvety or soft fleshy textures, and the tender or rich but always pure colour of roses and lilies, orchids and azaleas and other garden or hothouse flowers, he set himself to master the difficulties of painting *à premier coup*, which seemed to him the only method by which what he admired could be expressed, and in a few years attained exceptional dexterity in the use of paint. Arranging his selected blossoms—for he never by any chance paints a mixed posy—in a decorative mass, so lighted as to bring out his favourite qualities, and relieved against a low-toned and indefinite background, he lays them in directly and at once with a swift sweeping brush, controlled with great delicacy, in fluent creamy impasto (into which half-tones and lights are subtly broken) of a texture that, giving his feeling for pure clear colour full play, represents the colour delicately and suggests the quality of the petals. The skill with which this is done is remarkable. At its best, his touch is so certain and deliberate yet seemingly so spontaneous, his tones and colours so delicate in value and subtle in tint, that one would think ' the flowers had been breathed on to the canvas,' were it not that in some elusive way you feel that they have been of less importance to the artist than technical dexterity, and are but a pretext for it. To some extent this may result from the swishing brilliance of the actual brushwork, a brilliance that in his later pictures shows a tendency to run to seed ; but the decorative convention used—the massing of light spots upon a dark background, from

which they often emerge as from a vacuum or like a breaking wave on a dark night—is an equally disturbing element, suggesting, as it does, a lack of sentiment regarding the flowers themselves. His admiration for flowers is not that of the simple-hearted who love to see them growing, and handle them with affection—the kind of sentiment which combined with great artistry makes Fantin incomparable in this field. Yet, if not nearly so human and tender, his feeling for their colour and texture is vital enough in its own way, and, as has been said, it is expressed with much obvious dexterity. Transferred to other subjects, however, his method and outlook are much less happy in result. A girl's face may be flowerlike, but if one paints it for its bloom and colour alone one does not get very far, and Mr. Park's essays of this kind and in portraiture cannot be counted successful.

If decorative intention is much less marked in the flower-pictures of Miss Louise Permain and one or two other ladies, it seems fit that they should be mentioned here. In the work of Miss Permain, Park's influence is traceable to some extent, but while she has evidently learned much from him both in technique and in the management of lighting, her sentiment is her own, and her pictures evoke much of that feeling which has been indicated as wanting in his. Loving flowers, and specially roses, for their own sake, she paints them lovingly, and if with less skill than he displays, still with charm and a tenderness which expresses their inherent character and cherished associations more fully. To Mrs. Hartrick, on the other hand, it is less the loveliness of perfect blooms than the beauty of great clusters of old-fashioned flowers that makes appeal. Now in big bouquets put together with an eye to colour but preserving something of the charm of accident, and now in clumps as they grow in a garden, a vista of which comes in as background, she paints them in water-colour with considerable dash and abandon and something of decorative effect. With Miss Constance Walton, again, one finds a spray of one or two blossoms prized for themselves, yet wrought into a little decorative panel by tasteful placing and management of light and shade.

The virile and beautiful flower-painting of Sir George Reid and Mr. J. H. Lorimer, the exquisite and masterly drawings of wayside flowers and grasses of Mr. Edwin Alexander, and the daintily charming little pieces of Miss Katherine Cameron have been referred to in connection with their work as a whole.

David Gauld's art bears a considerable resemblance to that of his friend Park. He came to it, however, less directly and instinctively. Apprenticed to a Glasgow lithographer, he first attracted attention in artistic circles in the west through a series of very clever pen drawings, illustrating stories and verses, which appeared in the *Glasgow Weekly Citizen* during the later eighties, and then found fuller scope for his instinct for decorative pattern in designing stained glass. Excellent in

method and fine in colour, the pattern being massed in simple but full tints boldly outlined by the leading and with little painting, many of his church windows were admirable as decorations ; but, significant story and sanctified symbol not being much to his taste, he was more successful in domestic work, where he was less trammelled by tradition and could be more purely decorative and fanciful. Soon he carried the decorative quality, the striking and rich simplicity of cool, lustrous colour, and the quaintness of invention that marked his glass into pictures of wood-nymphs or dryads, or of daintily dressed girls loitering by streams or wandering in summer woodlands. But this phase of his art was little seen by the public, and, making his first palpable hit ('Changing Pastures,' Art Club, 1893), as a painter of cattle and landscape, he has since developed into a specialist in Ayrshire calves, painted à premier coup, as Park paints flowers, upon a decorative basis of simplified and sharply juxtaposed tones of brown, black and white set against a flattened background of lush green grass and darkened hedgerow. Possessing unity of effect, and fresh and limpid though somewhat cold in colour, and free and clever in handling, his pictures in this vein, of which 'Contentment' (G.I., 1903) in the Glasgow Gallery is an admirable example, have been much admired, but when one passes from these qualities to look for others, for constructive draughts-manship, vibrating and vital colour and tone, truly expressive brushwork or depth of sentiment, it is to be disappointed. And for similar reasons his girls' heads with flowers or wavering leaves for setting, and his portraits, though in the latter he strives for character, are not very interesting or convincing. It is as a painter of decorative landscape, indeed, that he is at his best pictorially. A series of pictures painted at Gretz in 1894-5 were charming in their kind, graceful in design, delicate and elusive in colour and atmosphere, and refined, if aloof rather than intimate, in sentiment : and in others of more realistic mood, such as 'Amberley Church,' and a number of low-toned snow scenes, he has struck a sombre chord of feeling not unlike that of which James Maris was so great a master.

Painting à premier coup forms a link between Messrs. Park and Gauld and Messrs. S. J. Peploe and J. D. Fergusson, for while the work of the latter is marked by greater intensity of purpose and more profound realism, the means employed are not dissimilar. To both of these young Edinburgh painters the most engrossing thing in the world seems to be the play and beat of light, the relationship of tone and colour wrought by it, and the technical means by which this aspect of the things of sight can be best expressed. And if few of Mr. Peploe's studies are informed by that savour of refined or profound emotion awakened by the spectacle of life and Nature, and that quest of beauty which together or separate are the very life of the higher forms of art, almost everything he does is remarkable for the virile, fresh and vigorous way in which it is painted.

His vision is not very subtle, and he is possessed by a perverse taste for the ugly or the bizarre in figure and landscape. Some of his landscapes, too, cleverly though they are placed upon the canvas and admirably as they sometimes record flashing effects of light, are too reminiscent of such masters as Sisley and Pissarro to be quite convincing. In figure, however, if here and there one fancies he can trace the influence of Manet, the observation, although unpleasing and tending to caricature, is personal, direct, and vital, and is expressed with remarkable virtuosity and power in paint, which while preserving the bloom of direct and *premier coup* handling yet escapes the superficiality so often associated with that method. But if one excepts his flower-pieces, which fail through deficient perception of beauty, his still-life studies show him at his best and completest. Simple but strikingly effective in design, frank and untroubled in colour and surface, and admirably drawn in true painter-like fashion with the brush and by juxtaposition of closely observed tones, the best of them are in their way triumphs of executive skill, and attain quite exceptional excellence in the restricted field and manner to which they belong. And if Mr. Fergusson is scarcely Mr. Peploe's equal in technical gift or in the courageous use of his eyes, he possesses a considerable share of these qualities, and is perhaps a finer colourist. Like his confrère he is seen to most advantage in still-life pieces, and, though he may think it no compliment, on occasions, as in 'The Silver Salt-Cellars' (S.S.A., 1904), and 'The Japanese Statuette' (S.S.A., 1905), the former a delightful harmony in white, grey and pink, done with great verve and considerable subtlety in fat, creamy impasto, he evokes beauty from very simple objects. In some respects, though placing the light before the things on which it plays and neglecting the detail entirely for the ensemble, the spirit in which these two artists work reminds one of the still-life painters of seventeenth-century Holland. But limiting his interest to the superficial aspect of things and scorning sentiment and association, Fergusson's figure-studies are chic but empty and insignificant, and his pictures of southern cities, painted some years ago, in which the influence of Melville was apparent, clever enough, but not very convincing.

The art of J. Young Hunter, Campbell Lindsay Smith and Andrew Watson Turnbull is the very antithesis of that of Peploe and Fergusson or of Park and Gauld. In it one comes upon one of those curious backwaters which, in these days of cosmopolitanism, lie isolated here and there alongside the main stream of Art. Filled by a resurge of Pre-Raphaelitism, temper and method alike are separated from those dominating contemporary effort in Scotland. With Mr. Hunter, no doubt, the quality of decoration which has played so conspicuous a part in some phases of modern painting counts for a good deal, but it is only one strand in the

romantic garb he wears. If touched with old-world charm, ' My Lady's Garden' (1899: Tate Gallery) and other of his earlier works were marked more by delight in quaint beauty and elaborate pattern for their own sakes than by that moral *double entendre* which was an element in Pre-Raphaelitism, but in most of his succeeding pictures one finds allegory combined with or thrust upon comparatively simple incidents, usually however associated with picturesqueness of costume and setting. More recently dramatic situation has attracted him, and his latest exhibited picture, ' David Garrick' (R.A., 1908), was admirable in conception and characterisation and finely expressive in design. Young Hunter is a good colourist, but, trained in London, his technical affinities are with the younger English costume-painters rather than with the school to which his father, Colin Hunter, belonged. In choice of subject and in manner, Messrs. Smith and Turnbull are more closely related to the Pre-Raphaelite tradition. For the most part, drawn from old romance, their subjective motives are treated with an elaboration of detail, and in a manner which recall the early pictures of Millais and Holman Hunt. Interesting as a phase, and because of its unlikeness to other Scottish painting of to-day, their work raises curiosity as to what its future development may be.

CHAPTER X

PAINTER-ETCHERS AND ILLUSTRATORS

THE greatly increased use of etching as a medium of artistic expression, which has been one of the interesting features in British art during the last thirty or forty years, owes much to the energies of Scottish artists. Apart from the wonderful interpretative etchings of Mr. William Hole and the admirable reproductions by men like Messrs. R. W. Macbeth, David Law and C. O. Murray of famous pictures, which lie somewhat outside the scope of this book, Scotsmen have of late years produced much notable original work with the etching needle, and it is to consideration of that, and the pictorial work done by some of these painter-etchers, as they have been called, that this chapter will be devoted. In Scotland, indeed, original etching was of the nature of a revival, for in the first half of last century Wilkie (1785-1841) and Geddes (1783-1844) had produced a series of masterly plates in etching and dry-point. They, however, although one may regard them as harbingers of what was to be, can scarcely be counted an active influence in the recent revival, which is in reality closely related to the movement in England which, after the tentative stirrings indicated by the appearance of the portfolios of the Etching Club, issued during the early sixties, and later in the exquisite, powerful or expressive prints of Whistler, Seymour Haden, and Legros. It is from these three men, united to study of some of the great masters of the past, that most contemporary etchers derive, and in Scotland the first impulse dates from the time when William Strang became a pupil of Legros.

A connection of the Dennys, the famous shipbuilders, William Strang was born at Dumbarton in 1859, and going to London when sixteen received his art education there, principally, if not solely, under M. Legros, who was appointed Professor at the Slade School in 1876. The impression Legros made upon his pupils, and through them on contemporary art, was great, and it is to that, even more than to his own work, admirable and stylish though it be, that he owes a good part of his reputation. And on none of his pupils has his mantle fallen more obviously than on Strang. This is perhaps the clearer because Mr. Strang's chief work has been done in etching and in various drawing media which his master had used previously ; but there is a kinship in spirit also, and many of Strang's motives,

and the way in which they are conceived, are not unlike those one finds in the prints, drawings, and pictures of the other. But while docile and influenced up to a certain point, he has turned the technique he was taught to his own uses. He has enriched it also by study of other and greater masters, specially, perhaps, Rembrandt and Holbein and Millet, and has modified it to suit the demands of personal expression. For in spite of superficial resemblances to this man or that, his art is the outcome of his own personality, and 'as with most Scots,' says Mr. Binyon, 'a persistent racial flavour tinges all Mr. Strang's work.' This is evident to some extent in his choice of subject, and even more clearly in the way in which subject is conceived. The sense of the unseen and the spiritual, which has meant so much to Scottish people as a race, is very real to him, and in his treatment of the drama of humble life, of man face to face with Nature, destiny, and death, as in the etchings to his own ballads—'The Earth Fiend' (1892), and 'Death and the Ploughman's Wife' (1894), and in the series with which he illustrated *The Pilgrim's Progress* (pub. 1895), it is the elemental fact round which all else revolves. With him life is not complex and refined but passionate and elemental. And in his grim, rugged and tragic yet romantic interpretations thereof, one comes into close touch with elemental passion, primal superstition, or unswerving faith. Questions of dogma and creed apart, he is of the breed of Calvinistic Scots.

The Kipling series (1901) is more fanciful, and partakes somewhat of the nature of brilliant improvisation upon themes suggested by that writer. But even there Strang's temperament tells, and the vivid realisations of actual fact one finds in the 'Short Stories' he transmutes into allegories which suggest the higher issues involved in the meeting of West and East, and the conflict of two widely differing civilisations. He is more frankly the illustrator perhaps, and sticks much more closely to the text in the thirty plates to *Don Quixote* (1903).

While these series, to which that inspired by *The Ancient Mariner* should be added, must have involved an enormous amount of labour and much thought and research, they form but a fraction of Strang's etched work which, according to Mr. Binyon's Catalogue (1906), runs to 471 items, and includes besides motives similar in nature to those indicated, many dramatically conceived Scriptural subjects, numerous landscapes, some of them, like 'The Back of Beyond,' and 'Dunglass,' marked by imagination, and a series of portraits of distinguished contemporaries of great interest. It is obvious, however, that these cannot here be dealt with in detail, for something must be said of his technique, and other phases of his art have to be considered also.

Although Mr. Strang has been heard to say that there are no beauties in art but technical ones, he is almost the only man among living etchers, in this country at least, who possesses profound and moving ideas regard-

ing life. But they are of the essence of the man, and so unconscious perhaps that he himself may be unaware of their existence in his plates. While most of his work is coloured by a certain grim realism, and much of it shows a somewhat wilful disregard of plastic beauty of form and a slightly morbid delight in ugliness for its own sake, the thoughts to which it gives expression are often imaginative. His gift is essentially northern. He seems more at home in shadow and storm than in sunshine, and delights in the tragic and intense or in the grotesque and horrible rather than in brilliant comedy or classic grace. So he works in broad masses of light and shade, full of rich suggestion as all fine Gothic work is, but in the first instance impressive in simplicity of disposition and proportion. Possessing exceptional technical knowledge and resource also, his combinations of etching in open or massed line with modifications of aquatint and other processes are exceedingly well fitted to express the great variety of mood and subject which appears in his work. And, if sometimes mannered, his drawing is usually learned and expressive. His peasants are strong and rude in build and angular in form and action, because the artist feels in these qualities fitness for the work they have to do, and sees in them the expression of the toil and weariness they have undergone. On the other hand, he is given to exaggerating these points and is apt to treat the exceptional as the typical. His design, however, is both dramatically significant and decoratively satisfying. His groupings, while primarily expressive of the idea to be conveyed, are balanced and rhythmical, and his light and shade and treatment of accessories at once emotional, explanatory, and decorative. The story is told and the purely pictorial result achieved at the same moment and by the use of the one means. In this sense there are none but technical beauties in his art.

Carrying his learned draughtsmanship and power of coherent and scholarly design into painting, and dealing in his austere manner with themes either simple but significant, as in 'Maternity' and 'Supper Time,' or of grave import, as in 'Pieta' or 'Emmaus,' Strang's pictures possess dignity and considerable distinction. Here, as in his etching, one finds personality expressing itself through study of and respect for tradition. His work is reminiscent now of the early Flemings, now of Giorgione, now of Millet or Watts. But as yet, at all events, the aim and tendencies of his painting are higher than its accomplishment, which is uncertain and not always pleasing, while one misses that element of spontaneity and that rapture in the fresh beauty of the world which are the crowning glory of modern painting. A certain bricky tendency in his flesh, a hot rather than a glowing quality in the passages of local colour, and a rather rotten and crumbly and over-dry quality of texture and surface militate against its sensuous appeal and its atmospheric envelopment. Curiously enough, also, the livingness of the actors in his dramas, which is so conspicuous in

his etchings and drawings, is wanting in many of his pictures, though most of them are convincing in sentiment and some clearly marked by temperament. Their finest quality, however, is the ability with which they are built up as designs and brought into pictorial unity.

The latest phase of Mr. Strang's manifold activities has been one in which he has attained much success. Always drawing with a livelier perception of beauty of form when using pencil or chalk or gold or silver-paint than when etching—in which the drama of light and shade seems to dominate and express his emotion, and the medium being chosen for the purpose of such expression it cannot, of course, be otherwise—some of his most masterly and satisfying work as regards draughtsmanship had been studies of the nude in these mediums. So when, some years ago, he turned his attention to portrait-drawings in chalk, he struck a vein in which he was fitted to excel naturally. Without approaching the work of Holbein, whose incomparably beautiful studies of this kind have evidently influenced him, his portraits have been marked by admirable draughts-manship and a skilful use of a restricted and exacting convention, by fine grasp of character and a dignified and severe sense of style.

When in 1905, after a lapse of many years, the class of Associate-Engraver was revived by the Royal Academy, Mr. Strang was one of two elected, and the choice so amply justified by the work he had done gave universal satisfaction. Previously he had received various honours abroad, including silver and gold medals for etching in Paris (1889 and 1900) and a first gold medal for painting at Dresden in 1897.

Like Strang, D. Y. Cameron (born Glasgow 1865) is both etcher and painter, and as each he has attained distinction. His talent, however, is less humane in interest and more measured in expression. The drama of life and the strivings of the spirit of man, the stress of toil and poverty and the baffling questions of mortality, which are never far off in Strang's most characteristic work, rarely trouble the traditionally romantic atmo-sphere and the glamour of grandiose light and shade in which Cameron steeps his renderings of ancient city and frowning citadel, of long-aisled cathedral and deserted palace, of shadowy workshop and storied water-side. And while Strang's complete mastery of technical resources seems placed at the service of his imaginative promptings, Cameron's accom-plished technique and style and his wonderful knowledge of what is well within the frontiers, not only of his art but of his personal gift, appear to determine what he will do and how it will be done. Thus each in his respective sphere uses his talent to the utmost and produces works of art notable in different ways. Strang is a romantic thinker with something of 'the Shorter Catechist' plus technique : Cameron a stylist plus romantic sentiment.

Etching being one of the most abstract of the arts and strictly limited in its means of expression, it is only by rigorous selection of the essential

qualities in Nature which call for it as the appropriate medium and by heightening their effect, not only by isolating them from the other qualities of impression, colour, aerial tone, and the rest, but, if need be, by insisting upon and even exaggerating the relationship of light to dark, of detail to suggestion, of blankness to elaboration, that one can achieve the finest results possible to the convention. It is because Mr. Cameron is a complete master of all its devices that his etching is so interesting, so perfectly balanced, and of such uniformly high quality. To acquire them he put himself to school to the masters, to Seymour Haden, Rembrandt, Meryon, and Whistler, to name them in something like the order in which the influences appeared in his work ; but excepting in the very earliest of his plates, perhaps up to the 'Clyde Set' (1890), which was considered too tentative to be included in the catalogue of his etchings,[1] it is evident that he has assimilated what he thus acquired. Beginning with the 'North Holland' set (1892), the 'North Italian' (1895-6), the 'London' (1899), the 'Later Venetian' (1900-1), the 'Paris' (1904), the 'French,' and 'Belgian' series, and the separate plates issued from time to time, have shown increasing assertion of individuality and command of a technique of exceptional completeness.

The subject-matter he deals with is very varied. It embraces figure and landscape, city-scenes and interiors, but while some of the figure studies are admirable examples of etching and excellent in pattern, and the landscapes include such poetic pieces as 'A Rembrandt Farm' (1892), 'Ledaig' (1898), and 'The Meuse,' the artist has attained his finest and most characteristic results when treating themes in which architecture forms the dominant feature. In these, early training as an architect, giving grasp of the essential significance of structure, probably counts for something, but the formal and rigid character of the subject-matter counts for more. It lends itself in a very special way to the personal and expressive, if somewhat arbitrary, arrangements of light and shadow and of space and mass in which he delights. The 'North Porch, Harfleur,' and 'St. Laumer, Blois' ('the finest of them all,' says Mr. Wedmore) ; and 'Saint Gervais' and 'Saint Germains l'Auxerrois' are typical of his most developed style, and, in all, the effect is achieved by very similar means. In the first two dark is framed in light, and into the 'eye of the picture' thus formed secondary, more subdued and much smaller, lights are deftly wrought, while a few carefully placed lines suggesting the structure give character to the framing mass without distracting the attention. In the others the process is reversed, and dark frames light. To put the matter thus bluntly is, perhaps, to over-accentuate a device which is so cleverly and artistically used that it is not at all obvious when these plates are seen separately, while more frequently perhaps, as in 'Broad Street, Stirling,' or 'Robert Lee's Workshop,' 'Stirling Palace' or 'The Five

[1] *Cameron's Etchings: a Study and a Catalogue,* by Frederick Wedmore, 1903.

Sisters, York,' the effect is so subtle or so distributed that analysis is much more difficult. Moreover his keen appreciation of style ensures distinction of ensemble. But studied, sometimes delicate and sometimes sharp but always studied, balance and contrast of masses of light and dark are of the essence of his art, whether in etching or painting, and it is in virtue of the tact with which he uses them that his plates and pictures are so effective. In part this tact is due to cultured taste and scholarship, but it is also the expression of that romantic sentiment which enables him to enter into the spirit of the past and to interpret the associations and the sense of the continuity of life which haunt the old capitals and castles and the ancient shrines of the race.

With the qualification that he inclines to over-heaviness and blackness of effect, nearly everything that has been said of D. Y. Cameron's etching is applicable to his illustrative work in black and white, of which the photogravures in Sir Herbert Maxwell's 'The Tweed' (1905) are the most important example, and much of it is true of his painting also. In his earlier days he was more a figure-painter, and in such fanciful studies as 'The White Butterfly' and 'Fairy Lilian' one could trace very clearly the influence of Matthew Maris, and in portraits like 'Daisy' (1897) and 'Robert Meldrum, Esq.' (1898), that of Velasquez, combined with something of the decorative quality of the younger Glasgow group with which he was contemporary though holding himself somewhat aloof. Since finding his feet, however, he has chosen very similar themes to those he etches, while technically his method, if fuller in impasto and heavier in touch, is founded on study of Whistler's suave fused handling. And he has carried his design and his management of chiaroscuro bag and baggage on to his canvases where, the scale being so much greater, the results, distinguished though they often are, incline to be grandiose rather than nobly impressive. Frequently also his tone lacks true aerial quality, and colour is not an integral part of his conception. Conceived as arrangements in black and white, such as would be suitable for etching, the transitions in the atmospheric envelope are not always accounted for, and the colour being arbitrary and no more than an approximation to Nature, without modulation, vibration, and sensuous quality, adds little or nothing to the emotional significance. And he never lets himself go : there is little spontaneity in his pictures, and no reaching after something beyond his immediate grasp. Yet occasionally, as 'Early Spring in Italy,' he paints a charming landscape, and some of his city-scenes, amongst which 'Dark Angers' (Manchester Gallery) and 'St. Andrews' (Liverpool Gallery) are notable, have been really impressive. Moreover, the assured accomplishment of his achievement and its scholarly distinction of style are very definite merits. If his painting lacks that passion for the wonder and bloom of Nature's self, which the higher impressionism has brought into art, it possesses a designed pictorial unity, which

much contemporary painting would be the better of; and that it is greatly appreciated is evident from the medals it has been awarded and the number of examples that have passed into important public collections at home and abroad. A masterly etcher and an interesting painter, Cameron's claims to distinction have been recognised in many quarters. An Associate of the Royal Scottish Academy (1904), he is also a member of the 'Old' and the Scottish Water-Colour Societies, and for a good many years belonged to the Painter-Etchers. His name is on the roll of the 'International Society'; he is one of the 'Society of Twelve' formed by the most original and artistic workers in black and white a few years ago, and he has been elected to several important Continental societies, including the 'Secessions' of Berlin and Munich. As is evident from his work, he has been much abroad; but he never studied in a foreign studio, and, while he was for a time a student in Edinburgh, his academic training was of short duration, and he has disciplined his talent chiefly by severe self-culture.

Born in 1876, Mr. Muirhead Bone is Mr. Cameron's junior by eleven and Mr. Strang's by seventeen years, but, since he settled in London in 1901, his reputation has grown so rapidly that it is now little behind that of the others. Like them a member of the 'Society of Twelve,' his work is amongst the most vital and personal to be seen in the shows of that select and scholarly society, and is notable, indeed, wherever it appears.

The son of a journalist, he studied in the Glasgow Art School, and first attracted attention about 1897 by black-and-white drawings done for *The Scots Pictorial*. For the most part drawings of topographical or topical import, representing places of permanent or events of ephemeral interest—the life of the streets, the play of street urchins, or the Hogmanay jollifications of the populace, the ruins of a great fire, or the launch of the latest leviathan—they revealed a strongly individual and imaginative view of things, and, despite the tentative quality of the handling, seemed to promise a sensitive and significant style which came near realisation in such drawings as that of the nave of Glasgow Cathedral, and 'Homeward Bound — Irish Harvesters Leaving Glasgow Harbour.' And the appearance of *Glasgow 1901*, a book which he illustrated, and in the writing of which he is said to have taken part, was clear evidence of the advent of an artist eminently capable of expressing many aspects of the life and spirit of modern cities. The pictures in that little volume are pregnant with imaginative comprehension : they interpret as well as mirror the complexity of city life—its manifold activities and restless energy, its griminess and squalor, its splendid strenuousness and solid achievement all find a place. With instinctive preference he dealt with the rush and rattle of life and commerce through the streets, with the crowded shipping in the docks, with clanging shipyard and humming

factory, with old buildings disappearing to be replaced by new ; but the University perched on its hill and the place of graves beside the ancient Cathedral were not forgotten ; and the escape to the rest and silence of seaside and country was indicated.

That they were so expressive of the moods and emotions evoked by a great hive of industry was due in large measure of course to pictorial treatment and significant technique. Admirable in line or design and disposition of mass, the impressive and characteristic elements in each scene had been abstracted with fine discrimination and brought together again under an effect of light and shade which increased their pictorial affinity and emotional relationship, while the execution, if somewhat scrappy and scratchy in line, was suggestive in a fine way and indicated a preference for vitality rather than mere accomplishment.

Some time before this Muirhead Bone had taken to etching, but it was not until a series of his plates was seen at the Glasgow Exhibition of 1901 that it was realised what a fine etcher he really was. Marked by the emotional and expressive qualities possessed by his illustrative work, they had a vigour, a depth, and a richness that reproductions must always lack. To write of the subjective elements in the 'Old Jail, Glasgow,' 'Tontine Gates,' 'Denny's Old Workshop,' and the rest, would be to repeat much that has been said of his Glasgow illustrations : their distinguishing qualities were due to technique. The choice of dry-point as a *métier* was felicitous, for it was at once suited to what he had to say, and calculated to stimulate the technical side of his talent. While its rich, soft quality of line and the velvety atmospheric bloom of its massed tones added greatly to the charm and romantic character of his work and gave it fullness, the nature of the method, calling for all his resource as a draughts-man, helped to clarify his ideas and resulted in increasing the constructive element in his drawing and design. And advancing on these lines he has of recent years produced quite a number of remarkable plates, amongst which 'Clare Market' and 'The Shot Tower,' the finely conceived 'Somerset House,' and the superbly designed 'Ayr Prison,' which, for all its small size, has been described as 'one of the most perfectly satisfy-ing of modern works in black and white,' may be mentioned specially. Town views, such as these, he varies with more landscape-like motives, such as the charming and sympathetically touched 'Southampton from Eling,' 'The Fosse, Lincoln,' and 'Distant Ely,' treated with much delicacy and very suggestive in atmosphere. This aspect of his art is admirably illustrated in the series of drawings reproduced in his wife's book, *Children's Children*. In these he reveals exceptionally subtle appre-hension of the silent and solemn beauty of the country, and unusually poignant feeling for the significance of rural life and toil. Yet it is the city that inspires his finest efforts ; and, when his wonderfully wrought and romantically conceived drawings of tall buildings swathed in the

delicate tracery of masons' scaffoldings[1] and of the gaunt and gaping ruins of demolition are added to his etchings, his claim to rank as a highly gifted and original artist, at once romantic and of to-day, is not uncertain. Without comparing his technical power and imaginative gift with those of Meryon, and lacking the airy touch and incomparable grace of Whistler, both of whom have influenced him, Muirhead Bone possesses qualities which make his achievement unique as an artistic interpretation of certain phases of modernity.

In Strang, Cameron, and Bone, Scotland possesses three etchers of distinction and individuality, who deal with a great variety of subject-matter in widely different moods and express themselves with power, style, or subtlety; but, while the interest of this phase of graphic art centres very largely in their plates, there are a few other Scottish painter-etchers of whom something should be said. Of these probably the most interesting is a young artist whose work has only recently commenced to attract notice. A native of Ayr, Mr. Andrew F. Affleck began life in a half-artistic business, but in 1900, after some preliminary work in London, went to Paris to study painting. Before long he was exhibiting figure pictures of some merit in the Salon, but having taken up etching also, obtained in it results at once more distinctive and more personal. From the first his plates were marked by sympathetic use of the medium and instinct for the pictorial treatment of architecture, and his subsequent work has shown consistent advance. He rapidly developed an admirable manner in the use of line, varying its thickness and intensity with the character and distance of the object represented, and attained definite command of the technique of the art. These qualities are obvious in most of his French pieces, and in the more recent Italian series they are quite marked. Combining free and forcible drawing and expressive chiaroscuro with regard for the essential character of the material dealt with and picturesque ensemble, his work possesses qualities which seem to promise finer and more significant results. As it is, prints like 'Notre Dame, Paris: the Rose Window,' 'Perugia,' and 'Cathedral Door, Siena,' are amongst the most successful architectural etchings recently produced.

Delighting in the rapid recording of impressions and in a suggestiveness which owes little to tone and nearly everything to the easy sweep of the bitten line, the method used by Frank Laing in many of his etchings was that invented by Sir Seymour Haden in which the graving is done with the plate immersed in the acid bath, and drawing and biting proceed simultaneously. A Taymouth man, he abandoned Dundee and business for art in the late eighties, and, after two years' study in Edinburgh, went to Paris, where, whether as student or artist, much of his time was subsequently

[1] One of the most remarkable of these, 'The Great Gantry, Charing Cross Station, 1906,' was purchased by the National Art Collections Fund and presented to the British Museum print-room. It was the basis of an almost equally wonderful dry-point.

spent. He had begun to experiment with etching while in Edinburgh, and in Paris he felt more and more drawn to it as the medium best fitted for the expression of his observation and feelings. Gradually his prints, exhibited at the New Salon and elsewhere, began to interest his fellow craftsmen, including Whistler who thought highly of them, and in 1898 a one-man show of some eighty examples attracted the attention of experts and collectors and led to a special volume being set aside for his work in the Bibliothèque Nationale. It included scenes in St. Andrews and Dundee, Antwerp and Venice, but the majority were views of Paris and its environs. His next important set, that of Edinburgh, and his subsequent plates showed increasing technical grasp and a ripening selective faculty. Neither distinguished nor romantic, as Cameron's and Bone's city views are, his, and specially perhaps the Edinburgh series, are noticeable for the admirable way in which the ready-made picturesque is used.

The work of Mr. Robert Bryden, R.E., also possesses interest and is marked by greater variety in subject and process than that of any other Scottish etcher except Mr. Strang, with whom he has likewise a certain intellectual kinship. After a few years in an architect's office, Bryden studied in London, and later worked in Italy and in Spain, which supplied material for his earlier sets of etchings. He then returned to his Ayrshire home, where, as was but natural perhaps, he felt impelled to a series illustrating the poems of Burns, which he interpreted with vigour and intimacy of comprehension and a truth of circumstance and setting which have been rare with illustrators of the national bard. In the types of old Scottish character still to be met with in the villages, and in the landscape of Kyle and Carrick, and in the streets and harbour of the 'Auld Toon' itself he found congenial subjects for many other etchings and a number of dry-points, and the variety involved in these was further increased by scenes from the sacred narrative, some of them, like the dark impressive 'Betrayal,' in mezzotint, or, like a fine Madonna and Saints, essays in line in the Mantegna manner. The Italian set and his early etchings, as a whole, are small in size and deft and dainty in execution and style, but in some of the Spanish series he commenced to show greater power and incisiveness of statement, and, developing in these directions, his later work is on a larger scale and is marked by somewhat rude but expressive vigour of conception, light and shade and handling. More interesting, however, than his etchings are the woodcuts of which he has produced a number of recent years. They include some interesting experiments in chiaroscuro, printed from two blocks, of scriptural subjects ; but the more accessible portraits of ' Poets of the Younger Generation,' reproduced in Mr. William Archer's book, are quite as characteristic of the simplicity, boldness, and effectiveness of the results he achieves.

Of Miss Susan F. Crawford and Mr. James T. Murray, both of whom are Associates of the Royal Society of Painter-Etchers, there is less

to say, for their work, although competent in a way, is less interesting both technically and subjectively. Chiefly architectural or topographical in interest, it partakes more of the character of pen drawing than of etching as a thing *per se*, and, while well drawn and carefully bitten, shows little personal apprehension of Nature or of the inherent beauty of the etched line. Nor need we linger over the etchings of Mr. D. Murray Smith. Charming though his little landscape-plates are, his etching has been mostly illustrative in kind, while he is developing into a painter as the finely felt and coloured pictures shown of late years at the R.B.A. indicate. The landscape mezzotints of Mr. David Waterston, however, if one may hazard an opinion on the few one has seen, show a special talent for expression in black and white. Far more renderings of moods than of facts, his plates reveal a fine appreciation of landscape, and a real instinct for suggesting colour by contrast of texture and tone. Rich and resonant in effect and marked by unusual dramatic power 'A Moorland' and 'The Strath' were admirable original essays in an art in which Lucas's mezzotints after Constable are the technical touch-stone.

Reference has already been made to the powerful and expressive etchings of Colin Hunter, either original or so freely interpretative of his own pictures as to rank as such, and to the wonderful reproductive work, after themselves or others, of Mr. Hole and Mr. R. W. Macbeth ; and amongst other painters who have done original etching, Pettie and Tom Graham and Mr. MacWhirter, and of younger men, Messrs. Roche and Cadenhead may be mentioned.

Scotsmen have been less prominent in journalistic black and white. In love with colour and in these latter days at least caring little for prescribed subject and the story-telling element in art, they have preferred the more congenial paths of painting or the greater freedom of original etching. Yet a number have attained considerable distinction as illustrators, and since the introduction of colour-reproduction a few have been busy in that field. Of Messrs. William Small, A. S. Boyd, and a few more of the older illustrators an account was given in an earlier chapter ; and reference has been made to the illustrative work of certain of Lauder's pupils, and of Sir George Reid and Mr. William Hole, and to the decorated pages by Messrs. Roche and Henry in *The Scottish Art Review* and by Messrs. Burns, Cadenhead, Duncan, and others in *The New Evergreen* as forming part of these artists' activities. Here, therefore, our attention will be concentrated on those younger artists, whose chief work has been done either for the periodic press or for books. And amongst those who have won what Mrs. Meynell wittily called 'The Honours of Mortality' by their connection with pictorial journalism *Punch's* sporting artist, Mr. G. Denholm Armour, may be given the leading place.

Studying in Edinburgh, Denholm Armour commenced as a painter, and for some years in the later eighties his oil-pictures of animal life were

amongst the most promising things of their kind seen in the Scottish exhibitions. Some of them, such as 'Sympathy' (1885), in which a terrier with a bandaged leg is watched by a smaller dog ; 'Antipathy' (1886), a pair of Prince Charlie lap-dogs regarding a cat with disfavour ; and 'A Rehearsal' (1889), a showman putting black-and-white poodles and a monkey through their performance, showed the vein of humorous observation he has since cultivated ; while others, of which the 'Fantasia or Feast of Powder, Morocco' (1890) and 'The Lion's Den' (1891) may be named, were more serious and ambitious in aim. In colour they inclined to blackness and lacked quality, but they were admirably drawn, cleverly designed, and told their stories well. It was not until after he went to England, however, and came under Mr. Crawhall's influence, that he developed the clear and expressive drawing which is perhaps the outstanding quality of his mature work as one sees it in *Punch* and other illustrated papers. Without being distinguished in the true sense, his drawing is stylish and convincing, and attains fine results in a simple way but with no forced or affected economy of line. Marked by keen relish for field-sports and the open air, and dashed with a quiet vein of humour, his drawings of hunting, racing, shooting and fishing incidents of an amusing nature are very English in character and appeal directly to a large class. But their merit as art is greater than their humorous or sporting appeal. Compared with the pictured sporting-jokes of Leech, Doyle, and their contemporaries, they are less rollicking and funny and much less inventive, but as draughtsmanship and design they are incomparably finer. Learning much from Crawhall as to the artistic representation of animals, specially horses and dogs, and profiting by the example of Phil May (1864-1903) in the economical and expressive use of line, he has evolved a very charming manner of his own, instinct with subtly suggested or realised form of character, full of action, and very pleasing in the delicate sweep and finish of the pen-line which is his favourite form of expression. Much the same ideal informs the water-colours of hunts and bull-fights which he paints occasionally, and in which he attains a more charming kind of colour than he had at command when he worked in oil.

 If the terms in which Mr. A. S. Hartrick expresses himself are less exacting, or at least abstract, than those used by Mr. Denholm Armour, they are more complex and involve a more varied combination of qualities for their successful management. While the essence of Armour's art is the setting down of obvious incident and clearly marked character in terse and expressive line with only as much shading as is necessary to help out the relationship of one thing to another in the story or in the broadly decorative arrangement, Hartrick, interested in a greater range of situation and character and frequently dealing with much more elaborate subjective material, often uses a convention into which tone, aerial perspective, and more fully wrought decorative design, sometimes in colour, enter. And

while the results, taken for what they are, are scarcely equal to those obtained by Armour in his more restricted manner, it is only fair to remember the more complicated nature of the problem faced.　The son of a military man, Hartrick (born 1864 at Bangalore) was educated at Fettes College and Edinburgh University, and afterwards studied painting at the Slade School and in Paris.　He then returned to Scotland where he painted for some time and became associated with the Glasgow group, but in 1890 he joined the staff of the *Daily Graphic* and, three years later, when he became a member of the New English Art Club, that of the *Pall Mall Budget*, for which and the *Pall Mall Magazine* some of his most important black-and-white work has been done.　An admirable draughtsman, drawing with facility, character, and style, telling a story well, and arranging his material with decorative feeling, he has executed many excellent illustrations of a historical and decorative kind, such as those to Mr. Maurice Hewlett's *Queen's Quhair* in its magazine form, where he had Mr. D. Y. Cameron as colleague for the landscape and architectural plates ; but his interests and outlook are more engaged with modern things, and his most characteristic work deals with the people and the towns and landscapes of to-day.　In drawings of this nature, whether in pen, chalk, or wash, for he is varied in his methods and varies them with the kind of motive or effect he is treating, he shows a real and sometimes a subtle appreciation of character, and renders the essential qualities of his subject and its setting with insight, power, and considerable distinction.　He is not a consistent executant, however, and the quality of his art is not to be gauged from everything he does.

Like Armour and Hartrick, Mr. Allan Stewart was trained as a painter.　A student of the Royal Scottish Academy, he had attracted some attention before he left Edinburgh in the mid-nineties to give the greater part of his energies to illustration.　If somewhat cold in tone and too heavy and black in colour, his pictures showed distinct promise, and capably and effectively drawn and designed, and painted with facility and power, if rather coarsely, indicated possession of talent for the management of complex figure-subject on a considerable scale.　They included a number of fisher-life subjects, but for the most part dealt with incidents in Scottish history, such as ' 1746 ' (1893)—Prince Charlie's last look at Scotland, which, if a little too reminiscent of Sir W. Q. Orchardson's ' Napoleon on Board the Bellerophon,' was very effective when reproduced—and ' A Fragment of the Armada ' (1894), Don Pexeia landing in Mull.　Since then, however, although he has produced ' To the Honour of Brave Men,' an excellent and moving rendering of Major Wilson's last stand, and probably the best of his pictures, and ' The Gordons at Dargai,' both of which made popular plates, and other pictures, his chief work has been done for the papers and specially for the *Illustrated London News.*　As with his painting, his illustrative drawing is more capable and effective than

distinguished and searching, but, admirable in its own way, it seldom lacks interest and vitality.

Mr. George R. Halkett's work is quite different in kind. It is more political than pictorial ; and, if he is not an 'asset' of his party in the same sense as Sir F. Carruthers Gould is of the Liberal, his witty caricatures in the *Pall Mall Gazette* reveal political instinct, and often hit off the Conservative estimate of a situation very cleverly. His earlier squibs, *New Gleanings from Gladstone*, *The Gladstone Almanack*, and *The Irish Green Book*, the last written as well as pictured by him, were marked by whimsical and ironical qualities which he has scarcely bettered in his maturity, and one or two of the ideas therein are perhaps the most entertaining he has put on paper. But his *Pall Mall* drawings, which began in 1892, while lacking mastery and artistic quality, are freer and more assured in line and fuller in characterisation, and, as becomes the paper in which they appear, less acid in spirit, while some of his contributions to *Punch*, notably 'The Seats of the Mighty' series, have been very popular.

It is as a pictorial satirist also, though not in politics, that Mr. James Greig, who hails from Arbroath, has done his most entertaining work. A member of the Royal Society of British Artists, he paints in water-colour with considerable sparkle and charm, and he has made many drawings illustrating stories and verses for the magazines, but the best qualities of his talent appear in his pungent and ironic comments on men and matters and social topics of the moment. The mordant quality of his humour is not apparent at first sight perhaps, for it is neither obvious in kind nor attractively clever in expression, but it bites its way in as one looks, and remains in one's memory.

Passing from the illustrators who have done their chief work in black and white, we may consider those who have wrought principally in colour. Here, of course, one recalls at once the charming and imaginative renderings of romance and poetry which we owe to Miss Katharine Cameron, Miss Jessie King, and one or two more, but the very definitely decorative character of their achievement led to its inclusion in the chapter dealing with decorative phases, and we are now concerned less with decoration than with illustration in its relation to fact or narrative. And apart from William Hole, whose carefully studied water-colours illustrating the *Life of Jesus* were reproduced in a volume published by the Fine Art Society, A. S. Forrest is perhaps the most conspicuous of the Scots who have done coloured illustration of this kind. Studying in Edinburgh and at the Westminster School, in Professor Fred Brown's time, and training himself by exacting personal study, Mr. Forrest is primarily a draughtsman ; but, his interest being claimed in the first instance by character, he is less a distinguished draughtsman than a keen student of character, type and situation, expressing himself incisively and with facility through drawing. He began by working in black and white for the press, principally for

To-day, in which his humorous and characterful drawings illustrative of stories or of current plays to the comments of ' Jingle,' were a feature for some years, but more recently much of his work has been done in colour, and has been associated with travel or history. In the latter his chief work is probably the series executed for Miss Marshall's *Island Story*, which depicts the chief events in English history with great spirit and, for the most part, in a vivid, pictorial way, in which distinct narrative power is not infrequently combined with considerable decorative effect. Narrative and characterisation—touched with humour—are however the stronger elements in his gift. Evident in his pictures to *Robin Hood* and *Uncle Tom's Cabin*, these are very conspicuous in the travel sketches he has done for books on Morocco, the West Indies, and Portugal, and in a series of Mexican studies which has not yet appeared. Unlike most painters of foreign lands, he brings an unprejudiced eye to bear upon the people and places he visits, and in consequence he is wonderfully successful in conveying a sense of their racial and characteristic qualities to those who have not seen them for themselves. Executed some in water-colours and some in oils, used flowingly, he understands the limitations of colour reproduction so well that it is frequently difficult to say from the reproductions which medium has been used, but of the originals perhaps the most charming are those in which over freely and incisively drawn pencilling washes of water-colour have been floated.

The talent of the brothers Orr of Glasgow, on the other hand, is confined practically to the vigorous rendering of humorous character. Of the three Mr. Monro S. Orr is probably the most accomplished. He finds his chief field in the delineation of old-world, and specially old Scottish, character of about a hundred years ago. A picturesquely costumed period, for the men wore cut-away coats of colour and knee-breeches, and the women delightful poke-bonnets, gay Paisley shawls, and voluminous skirts, it also offers a fine range of well-marked character, and the combination is exactly suited to his powers on their technical as well as their appreciative side. Drawing vigorously and expressively, if with little refinement or style, and colouring or using black and white decoratively and with decision, if with little charm or subtlety, his pictures and drawings are racy and humorously expressive, and never more so than when illustrative of the life or poetry of Burns, or of themes of a kindred nature. Humour also marks the productions of Martin Anderson, a Tayport artist; but the satire of ' Cynicus' is more broad than subtle, and his comedy is apt to degenerate into somewhat vulgar farce, while his artistry is facile without strength or quality. Compared with such work the studies of 'Scottish Life and Character,' which Mr. H. J. Dobson made for Mr. Sanderson's book, seem reticent and refined ; but they overdo ' the homely and pathetic,' and, as W. E. Henley said of Tom Faed's pictures, ' are tremulous with bleat.' Yet in their own way they possess some modest artistic merit and a certain

sentimental appeal. It was for another of Messrs. Black's books, *The Western Highlands and Islands*, that Mr. William Smith, Jr., executed the drawings which, with his illustrations to Mr. Crockett's *Abbotsford*, represent nearly all that has yet been done by Scottish landscape artists in coloured book illustration.

RÉSUMÉ AND CONCLUSION

THE development of Scottish painting, as exemplified in the work of individuals and groups from Jamesone to the younger men of to-day, having been traced in the preceding chapters, it remains to attempt some broader characterisation of Scottish painting as a whole which will set its special qualities in a clearer light and discriminate between the influences which have affected it from without, and those elements which, having been moulded from within, are typical of its aims and expressive of national idiosyncrasy. This, of course, is an even more difficult undertaking than the other, for the field is very wide and the variety great, while the tendency of the Scot to roam and his native independence of character introduce disturbing factors which make generalisation hazardous. So complex indeed did the problem appear, that at one time I was tempted to abandon trying for a satisfactory solution. But to ignore a difficulty is not to dispose of it, and, as the questions involved would have emerged whether I faced them or no, it was decided to make the venture. That settled, the first thing was to ascertain if the work of most painters of Scottish nationality possesses qualities which, in spite of the presence of other elements, give Scottish painting a character of its own. And as the key to the art of a nation must needs lie, as does that of the individual in a personal way, in racial character and in the environment which has helped to shape it and which, in some degree, it has shapen, the most promising avenue of approach seemed to be on that side.

Compounded of many diverse and seemingly antagonistic qualities— some obvious because on the surface, others baffling and obscure because a Scotsman is naturally exceedingly reserved—as Scottish character is, if asked to name the trait most characteristic of the Scots as a race, one would come pretty near the mark, it seems to me, by answering—the faculty of combining idealism and practical achievement. Conceiving things in the abstract, Scotsmen are also apt in formulating means by which to give their ideals concrete expression ; setting up an objective they concentrate all their efforts on its attainment. This is the spirit which, backed by proverbial fervour and thoroughness, has converted a poor and barren country with a trying climate into one of the most prosperous states in

Europe, and secured conditions of municipal and local government which are, in some respects, models of their kind. It has issued in a religion which, if distrustful of the joy of life, narrow, or rather lop-sided, in outlook, and bald in form, is idealistic in spirit, logical in conception, and very democratic in government, and which, in these later years at least, has accepted ' the larger hope ' and learned a wise tolerance of the things of sense ; a religion, too, which, however it may have seemed to starve certain sides of the national character, has acted as a powerful intellectual discipline for the whole people. It is this spirit also that has produced a deductive philosophy which, seizing upon general principles, whether as regards society or natural phenomena, has applied its conclusions to everyday affairs with conspicuous success ; and has evolved a system of education, open to all, in which education is the principal matter, and which is eminently suited to the requirements of the country. And in the sphere of the arts this spirit has been no less potent. Scottish literature and Scottish painting alike are marked by a realistic yet emotional treatment of life and Nature, and are coloured by that lusty vigour of purpose which has moulded the destinies of the nation and has made it prominent in so many branches of human activity. Love of country and relish for home-life have stamped its historical and domestic genre, keen interest in character its portraiture, and intense love of Nature its landscape ; and to the expression of these sentiments there has been brought that faculty for the adaptation of means to end, that practical ability, which has marked the Scots' dealings with more material things.

I

Man set in his natural environment has been the favourite theme with Scottish writers from Henryson to Barrie, and with the painters ever since their art became naturalised in Scotland ; and, accepting the facts of life as they are, Scottish artists have realised them vividly in terms of their several arts, and, at the same time, informed their realistic expression with sentiment and insight. Moreover, their achievement is racy of the people and the soil in a manner and to a degree only equalled by that of the painters of seventeenth-century Holland. Like the poetry of Henryson and Dunbar, of Burns and Hogg, and, like the best romances of Scott, R. L. Stevenson, and Neil Munro, the portraitures of Raeburn and Watson Gordon, of Reid and Guthrie, the pictures of Wilkie and Harvey, of Chalmers and M'Taggart, and the landscapes of Thomson of Duddingston, Wintour, Fraser, MacWhirter, and Wingate deal with people, incidents, and scenes peculiarly and almost exclusively Scottish. All are expressive of that sense of kinship, pride of race, and love of country for which Scottish people are at once ridiculed and envied. Yet admirable as patriotic feeling is, and much as it means to any nation, in art it accom-

plishes little except it be accompanied by an artist's sense of subject and instinct for the medium of expression. It is the combination of first-hand emotion and wonderful interpretative power with mastery of presentment and charm of manner which makes *The Jolly Beggars*, *The Heart of Midlothian*, and *Weir of Hermiston* works of creative art and a refreshment to the spirit, and it is by the presence or absence of these qualities that pictures must be judged also. Tested by that standard, however, while much of it may lack novel insight or distinction, Scottish painting will be found to be vitalised by unusual sympathy, fine regard for fitness, and admirable craftsmanship. On the other hand, concentration on portraiture, genre, and landscape has resulted in a restricted view of things which excludes forms of pictorial art in which noble work has been achieved by some other peoples. The Scots have produced little that is romantic in the sense that Rossetti's and the earlier pictures of Millais are ; little or nothing save a few things by David Scott, into which allegory or mysticism enters, as it does into the art of Blake or Watts or Burne-Jones, of Gustave Moreau, Fernand Khnopff, Giovanni Segantini, or Arnold Boecklin ; practically nothing, except certain things by Dyce, that is academic and 'scholarly' like the work of Leighton and Poynter, Alma-Tadema and Baron Leys, Laurens and quite a number of Frenchmen ; and nothing at all, at once decorative and didactic, comparable to the mural paintings of Puvis de Chavannes. But it is not because one wishes them to paint mystical or literary, archæological or learned subjects, though that is the usual ground for complaint, that one shares to some extent the opinion that Scottish artists, as a whole, have been and are somewhat deficient in culture. Starting as artists after years of uncongenial toil in prosaic occupations, as not a few of them have done, they have often been content to be painters and little more, and the width of interest, the refinement of taste, and the sense of relationship of one thing to another which a liberal education might have stimulated—the few with a touch of genius are above such generalisations—have been lost to their art. Culture in the direction these things imply, while extending the range of subject, need not have made the painters literary in the sense so dreaded to-day, and probably it would have added charm to the rendering of pictorial motives, and perhaps have purged many pictures of that taint of commonness that is their undoing. Still, it should not be forgotten that a liberal education does not imply any gift of artistic perception, and that too literary a training often results in a mental attitude which measures everything by its own intellectual preferences and in relation to the canons of subject and expression in which it has been disciplined.

Left to themselves, Scottish painters have turned as a rule to the subjects lying ready to their hand—to the people, incidents, and landscape at their own doors. And this has tended to encourage sincerity, which in art, as in life, is incomparably more valuable than learning. Further, one

might argue that this is the result of frank acceptance of the character of the medium in which they work, and of delight in those sensations of sight and the sentiments pertaining to it which are the immediate and most natural inspiration for a painter. The tendency to abstraction so obvious in Scottish philosophy, theology, and argument generally, finds vent less in the character of the subjects chosen than in their treatment.

To those who mistake invention for imagination, and confuse subject with its apprehension, Scottish painters may seem deficient in the qualities they believe they prize. And in truth no modern school, save the Dutch, has a simpler or more literal range of subject-matter, or has shown less disposition towards invention, or less desire to deal with the abstractions of idealistic aspiration or homiletic teaching. Content with the world about them and with the hopes and fears and passions of ordinary men, whether dressed in the clothes of to-day or yesterday, Scotsmen have cut themselves off, as we have seen, from much that has inspired some really fine and much merely ambitious art, but the bare fact of having done so entitles no one to say that they have lacked imagination. For imagination has to do with the apprehension of subject much more than with its character, so that, seen and painted in a truly imaginative way, a bare hillside under a grey sky has more poetic appeal than a range of Alps in the glory of dawn or sunset, and a homely incident more significance than a theme of spiritual import conceived with less emotional insight. And if Scottish Art has been deficient in the faculty which creates a world of beauty or terror or mystery afar off, it has been gifted with dramatic instinct, imaginative insight, pictorial power, and exceptional feeling for colour.

II

A very individualistic people themselves, the Scots possess an inherent curiosity as regards character. The history of Scotland has often been individualised, as it were, in a very striking way, in the persons of the chief actors in its great events. A distinguished foreigner has described it as a fierce romance of piety and passion—'Wherever you look into it, it enthralls you with its strong human love and hate.' Many of the best and most typical Scottish anecdotes also, whether humorous or pathetic, are illustrative of character ; and in everyday life people are almost as interested in the reasons which probably underlie a man's actions as in what he does. Moreover, biography is an art in which Scotsmen have excelled. Boswell's *Johnson*, Lockhart's *Scott*, and Carlyle's *John Sterling* are admitted to be the best biographies in English and models in their kind, and turned to painting the same qualities of insight, shrewdness, wit, and respect for personality have succeeded almost equally well. On the average, sincere and workmanlike, if commonplace and undis-

tinguished, Scottish portrait-painting at its best is an abstraction of the qualities in the sitter, physical, mental, and emotional, which create the impression of his or her individuality, expressed with a simplicity and directness of artistic purpose, and a harmony between the observation and the manner, which make a union of biographical and artistic interest its most notable quality. With the precursors trained abroad or influenced by foreign example, and without an artistic atmosphere at home to stimulate personal adventure, conventionality of treatment and generalisation, the predominance of the type over the individual, tended to prevail. At the same time the portraiture of Jamesone and Michael Wright, of Aikman and Allan Ramsay, is not without qualities—simplicity and freedom from affectation, direct interest in the sitter, and a preference for essentials rather than trappings—which differentiate it from that of their southern contemporaries and indicate its origin. But it was not until the advent of Raeburn, who combined something of the traditional simplification of form with extraordinary grasp of individuality, that the national relish for character asserted itself fully. Less elegant and significant in invention and design and less charming in feeling and colour than the work of Reynolds and Gainsborough, his great English contemporaries, his is less dominated by a preconceived type and gives a more convincing rendering of personality. It is this faculty of individualising his sitters, combined with wonderful power of direct and unfaltering handling, that gives his achievement a highly distinctive place in British art, and in a wider survey justifies the contention of that most subtle of critics, R. A. M. Stevenson, that it is the chief link in the development of direct painting between Velasquez and Hals and the modern schools. And after Raeburn, the keen interest in character, the virile expressiveness and the sober dignity, so evident in his art, became the most characteristic elements in Scottish portraiture as a whole. Yet Watson Gordon, Graham Gilbert and Macnee, who may be said to have carried on the Raeburn tradition, were less understudies than independent workers in a similar spirit ; and, in some degree, they and Geddes, Dyce and Duncan who occasionally painted portraits in veins of their own, showed more intimacy of perception in the rendering of individual character than their greater and more powerful exemplar. These also are the qualities which pervade the very varied and richly coloured portraiture of Lauder's pupils—the harmonious work of Chalmers, the distinguished achievement of Orchardson, and the delightful portrait-pictures of M'Taggart—and the more prosaic but trenchant likenesses of Sir George Reid and Robert Gibb. With the younger generation again, although their art shows the influence of Whistler and the old masters, and of Paris and modernity, one can easily discern the persistence of the national instinct for character beneath the more consciously balanced and decorative effects that are one of their chief concerns, and, as they mature, it seems to be asserting itself more

and more. Guthrie possesses it in marked degree. Yule and Brough, although they died so young, united it to much spontaneous distinction of style, and, while Lavery and Henry, like the late Arthur Melville, seem satisfied with the beauty of balanced and harmonious arrangement, Roche and Walton are cultivating greater intimacy of characterisation.

Approaching portraiture chiefly through character, it is not surprising perhaps that Scottish painters have been more successful in painting men than women. With the exception of Allan Ramsay and Raeburn, who did much admirable female portraiture, and Geddes, whose sense of feminine charm was acute, most of the earlier artists were very distinctly at their best when they had a man for subject. Even the pupils of Lauder with their sensitiveness to beauty, all except M'Taggart whose pictures of women and specially of children possess a wild lyric grace, and Herdman whose work was tainted with prettiness, are more happily inspired in male portraiture. And Sir George Reid is emphatically a painter of men. Indeed it is not until one reaches the work of the younger artists of to-day that one finds anything like equal success in both fields. In some cases, no doubt, this is due more to subtle harmony of tone and colour and elegance of design than to juster or deeper reading of character ; but feminine beauty is illusive and alluring in its quality. To grasp it too tightly, as the older men were apt to do, is to crush its bloom, and charm of arrangement is an appropriate setting for the grace of womanhood.

III

Mr. J. M. Barrie has pointed out how the extreme reticence of the Scots to those outside has resulted in closer and more intimate relations within the family circle and in the intensity of home feeling expressed in Scottish literature. It is through art, indeed, whether written or painted, that Scotsmen most easily express those feelings which they disguise or hide in ordinary life. To carry your heart on your sleeve, that is un-pardonable in Scotland.

'But Art—wherein man nowise speaks to man, only to mankind—Art may tell a truth obliquely, as the thing may breed the thought.' It is because they feel this that Scotsmen with creative instincts have used art for the expression of emotion, and that Scotsmen as a whole are so sensitive to the presence of sentiment in all forms of art. This is perhaps the real reason for the intensity of the national enthusiasm for Burns. A brother Scot, in his poetry they find full and unrestrained expression of their own pent-up emotion, and, quoting his verses, they can talk enthusi-astically about the depth of feeling and the nobility and humanity of the ideas expressed without committing themselves personally. Their enthusiasm is really for feelings and emotions of their own, about which

they would not care to speak to others on their own initiative ; but, the poet's generous expression having given them generalised application, they feel at liberty to do so, and that the more fervently because the personal element does not emerge.

It was in a similar spirit to that which informs the vernacular poetry of Scotland, of which Burns was the culmination, that the earlier Scottish genre-painters worked. Rich in humour, vividly realistic, intimate in touch, and full of insight and of grasp of character, expressed strongly and intensely in language, rich and full in tone and colour, that poetry dealt with the life of the common people, and for the most part with its humorous and grosser aspects. 'But on the appearance of Burns,' says R. L. Stevenson, 'this coarse and laughing literature was touched to finer issues, and learned gravity of thought and natural pathos.' A far greater poet, and a more humorous than his precursors, he was also much more inclusive. His work embraces the whole gamut of Scottish peasant life,—'Scotch morals, Scotch religion, and Scotch drink' are all there. On the other hand, Wilkie, under whose touch Scottish genre-painting awoke to life, was essentially a painter of comedy. Pathos rarely and tragedy never coloured his conceptions. But if he was no moralist, and the graver and more purposeful aspects of the national character seldom figure on his canvases, he was an admirable painter, with a quick perception of character and situation, an active sense of pictorial unity, and a deftness and vivacity of brushwork and draughtsmanship well adapted to express what he had to say. The chords touched by him met a ready response from his countrymen, to whom of course they were only new in the sense that they were pictured not in words, but in tone and colour, and soon a considerable number were painting similar subjects, in a very similar manner, but with distinctly less skill and taste. There were some good enough men in this following, but their humour was that of farce rather than of comedy, and superficial in quality, while their sense of feminine beauty, like Wilkie's, was deficient. And later, when a new vein of humour was broached by Erskine Nicol in his admirably painted scenes of Irish life, it also was broad in its kind.

The kindlier and more intimate aspects of home life, with its quiet joys and pathetic touches, the sentiment summed up once for all in Burns's

> ' To make a happy fireside clime
> To weans and wife,
> That 's the true pathos and sublime
> Of human life,'

which are comparatively rare with the Wilkie group, are not infrequent in the occasional domestic pieces of Duncan, Harvey, and Lauder, whose names are more usually associated with historical incident, while co-incident with the appearance of Tom Faed's sincere and touching, if over

sentimental, pictures this element became more marked. Thereafter, in the work of R. T. Ross, the Burrs, Cameron and others, until the reaction against 'literary' subject which began twenty years ago, and even since, it is to be found in a goodly number of fine pictures and more poor ones.

Whether one dates from David Allan's drawings, which are poor enough stuff as art, or from Wilkie's deftly painted and designed and vividly realised pictures of peasant life, the honour of having introduced homely subject and realism into modern painting remains with the Scottish School. It is possible, of course, that in choosing the themes they did, Allan and Wilkie and his disciples were influenced by the seventeenth-century Dutchman, though the close relationship which existed between the Scottish painters and the traditional poetry of Scotland made that influence less potent than it is apt to appear to strangers; and it is certain that Hogarth (1697-1764), and Morland (1763-1804), had painted, the one his pungent satires of contemporary society, the other his incidents of rural and pot-house life, before Wilkie startled the British public with 'The Village Politicians' in 1806. At that time, however, the Dutch love of everyday things had been dead so long, and Hogarth's and Morland's example had borne so little fruit, that it is not straining the facts to say that the effective beginnings of modern realism appeared in the young Scotsmen's pictures. It is certain, at least, that from then until to-day the life of the common people has been increasingly evident in art. In the earlier part of last century, moreover, this kind of subject was to be found chiefly in British pictures. The Barbizon painters were the earliest Frenchmen to take it up, and it was not until Josef Israels abandoned history for genre that the Dutch rediscovered the beauty and significance of the things about them.

IV

The painting of history, or rather of historical incident such as one sees in Wilkie's later work, was only a little later than domestic genre in emerging, and, with the Waverley Novels in course of publication, it could scarcely have been otherwise. Although Sir Walter wrote of the life and character of his own day, or of so recent a past that it was in nearly all essentials contemporary, with an intimacy and a depth of appreciation that make *The Heart of Midlothian, Guy Mannering, The Antiquary,* and other work in that kind his greatest achievement, it was rather through his dealings with the historical and romantic epochs of Scotland's story that he fired the imaginations of the artists of his own and the succeeding generation. Steeped in the spirit of Scottish history seen through the glamour of his own intense patriotism, and vivid and picturesque in character, incident, and setting, his romances appealed to them almost equally as Scotsmen and as artists. To the history

painters he stands in far closer relationship than did Burns and the vernacular school to the painters of domestic genre, for while the latter carried on the tradition of their poetic forerunners in choice and, in some ways, treatment of subject, the latter derived many of their motives direct from Scott's pages. From this it followed that most of their pictures were of the nature of illustrations, sometimes to Sir Walter, and sometimes to that history to the awakened interest in which his work had contributed so largely. That such was the intention of the painters themselves is obvious from the long extracts from history and literature transcribed for the catalogues of the period—a descriptive fashion which extended to landscape. Their ideal as revealed in the pictures of Sir William Allan, who, after painting the Eastern scenes of which he was the pioneer in modern painting, turned to Scottish history under the direct personal influence of Scott, of Thomas Duncan, Sir George Harvey, Robert Scott Lauder, Drummond, and the rest, was to depict incidents in history or literature as they were likely to have happened. And though a large proportion of their work presents anachronisms, they gave considerable attention to archæological accuracy and the probabilities of actuality. Still, if these painters could not dispense with a text for their pictures, Duncan and Lauder, Fettes Douglas and Herdman used their selected themes to considerable pictorial purpose, and with a true if not particularly acute sense of colour ; and John Phillip, after the Wilkieism of his earlier years, revealed in his Spanish pictures, which were a sort of domestic genre in costume, a true, strong feeling for the possibilities of pictorial expression, a brilliant and masterful use of colour, and a power and breadth of handling of a very high order.

None of the men of that period, save Lauder perhaps, chose motives of a heroic kind, and if by chance a subject had something of that character inherent in it, their treatment remained essentially incidental. Questions of technique apart, it is in this that their work differs most obviously from the far more passionate and stirring achievement of Delacroix, Géricault, and Decamps, the figure-painters of the French romantic movement, which on its historical side owed so much to Walter Scott. On the other hand, Scottish caution prevented them losing their heads and being carried off their feet by the glitter and gush of high art like Northcote, Barry, Haydon, and Hilton in England. Nor did they rival Maclise and Egg and Elmore in clever but forced and theatrical drama. Their work was more in line with the quieter tableaux of Leslie and Newton, who had been influenced by the simpler taste in subject inaugurated by Wilkie.

David Scott and William Dyce, the former in virtue of the epical quality of his imagination, and the curious flare his finest things possess in spite of obvious technical weaknesses and a tendency to heroics, the latter through the refined feeling and scholarship which underlie his somewhat academic but aspiring art, occupy a quite exceptional place, which not

only accentuates the personal element in their work, but shows the essential solidarity of the earlier Scottish School. One cannot associate Sir Noël Paton with them except through his penchant for somewhat similar subjects.

v

Superficially the men born between 1830 and 1840, most of whom were trained in the Trustees' Academy under Scott Lauder during the fifties, carried on the kind of subject, domestic and historical, which had been in favour with their predecessors and elder contemporaries. But the manner in which the younger men approached subject was marked by a subtle difference. Gifted with dramatic instinct, grasp of character, and imaginative insight, as the best of them are, they retained much of the old interest in incident for its own sake, but they found in it not opportunity for narrative or coloured illustration, but pictorial motive and incitement. To a great extent, also, they freed themselves from the restriction imposed by chapter and verse, and even when founding on a described event allowed their picture-making instincts full play. The result is that their pictures delight by their purely pictorial qualities, and usually explain themselves without reference to the catalogue. This is as true of the subtly-ironic social comedy of Orchardson, with its setting of gilded French salon or elegant English drawing-room, and of John Pettie's dramatic or amusing episodes of life in the camps and courts, or amongst the Highland caterans and smugglers of the past, as it is of M'Taggart's impassioned picturing of fisher-life and childhood beside the glory of the infinite sea, or amid the sunlit splendour of lane or meadow, of Chalmers's subtle rendering of country-folk in the dim sweet light of cottage interiors, or of Hugh Cameron's or Tom Graham's tender seaside or village idylls. And to the embodiment of this more pictorial and inventive conception of subject, they brought greater technical dexterity and subtlety and finer feeling for ensemble, and a sense of reality, a sensitiveness to beauty and a passion for rich loveliness of colour that none but one or two of their elders had even approached.

Compared with the Pre-Raphaelites, who were their seniors by some six or seven years, they had no gospel to propagate, and compared with certain of that brotherhood and their younger cousins, the decorative and romantic neo-Pre-Raphaelites, they had no love for mysticism or recondite subject. The earlier movement in London had no doubt some effect on the Edinburgh group, especially in inducing greater respect for Nature, but each possessed its own characteristics, and, although the Scots like the English turned to Nature for inspiration, Lauder's stimulating influence and cultured artistic taste led his pupils from an outworn pictorial convention into one nobler and more significant. And so, while the Pre-Raphaelites brought moral fervour and romantic glamour into British

Art, the Scott Lauder men possessed a more purely pictorial conception of motive, a more synthetic grasp of reality, and a more subtle and more widely diffused dower of colour. In these respects, they stand in much the same relationship to the British painting of their time as the Barbizon men, who were greater designers but less gifted colourists, did to the main currents in French Art.

VI

The outburst of talent which had marked the decade of Scott Lauder's mastership of the Trustees' Academy was not maintained in figure at least, and in the art of many of the subject-painters who emerged between that spring-time and the next, which blossomed in Glasgow, one can trace a resurge of the older traditions of Scottish painting, for which Wilkie stood, mingled with the Lauder influence, exercised less through his own pictures than through the example of some of his pupils. But if domestic and costume painting as a whole inclined rather to the methods and story-telling ideals of the past, W. E. Lockhart did some good Spanish work of the Phillip type ; Robert Gibb, taking the exploits of the Scottish regiments as motives for a series of powerful battle-pictures, struck a patriotic vein of his own, and George Wilson painted a number of imaginative things of considerable charm which stand apart from the general tendencies of his time. It was, however, in the association of figure with landscape, in which direction the example of Harvey and of M'Taggart and Cameron counted for much, that the most distinctive work of this interregnum was done. Moreover, the pastorals of R. W. Macbeth, Robert Macgregor, and John R. Reid are not only admirable in their own way, but serve, through certain qualities in Reid's work, as a link with the earlier developments of the most recent movement in Scottish painting. About the same time, also, another side of country-life came into prominence in the sympathetic and refined animal-pictures of Robert Alexander, and in the vivid and forcibly painted Highland landscapes with cattle and sheep of Denovan Adam. It is in the work of these two men that animal-painting first became of importance in Scottish Art.

VII

Beginning in reaction from story-telling, or what is called 'literary' motive, and from the obviously picturesque in subject, and in devotion to Nature and desire to realise her visible beauty with directness, strength, and simplicity, the movement which originated with a group of young men in Glasgow during the early eighties tended to drive historical incident from the field and to restrict domestic and rural incident to aspects which are observed rather than invented. Yet in doing so they moved

not only in concert with the widespread evolution towards realism which was taking place on the Continent, and had Lepage, Manet, and Monet as standard-bearers, but concentrated in a direction in which certain of their Scottish predecessors had been strong. But if realism was their watchword, and if sentiment was at a discount and conventional beauty was tabooed, these boys, being fine artists, had feelings of their own as regards Nature. Beneath the emphatic and impressionistic statement of the facts and tonal relationships of Nature in Roche's, Walton's, Henry's, and Guthrie's pictures of country-folk and girlhood, mostly out-of-doors, there was a tender and naïve vein of poetry, and through the lowness of tone which prevailed there glowed the traditional love of colour. And Melville in brilliant water-colours of the East, and Lavery in clever pictures of society or sport showed original observation, fine colour, and great dexterity of execution. Gradually also, coming under the sway of the French romanticists and the modern Dutchmen, their methods grew more refined and their design more decorative. But as regards subject, their outlook and sympathies remained much as they had been.[1] Even Henry and Hornel, when they flashed upon us with their potently-coloured, decorative phantasies, drew their subjects for the most part from incidents of child play. In manner, however, they were very clearly influenced by the arts of Japan and the pictures of Monticelli which had been a gentler influence with the whole group, and from then onward decorative quality became more prominent in the work of the new school. Revelling in colour and make-believe, these decorators and their immediate confrères painted with the gaiety and irresponsible abandon of the teller of fairy tales.

Delight in the wonder of human life and joy in the loveliness or the mere colour of Nature, united to an artist's pleasure in his material and in giving pictorial expression to beautiful things, are the life of the art of the Glasgow men as they are of that of Lauder's pupils, who were more inclusive in choice of subject. But this narrowness of view, resulting as it did from a needless fear of incident (pictorial fitness resides not so much in the kind of subject as in the way in which it is conceived and the manner and style in which it is treated), has not only limited the appeal of their work but has unnecessarily restricted its range.

The influences which had moulded this movement and given it something of the character of a school within a school were not confined to Glasgow. Lorimer has learned much of that subtle breadth of translucent lighting, which gives charm to his finely intentioned pictures of domestic and social incident, from study of Lepage ; Austen Brown has sat at the feet of many masters both French and Dutch when painting his pastorals ;

[1] William Strang is the only Scottish artist of the period who has devoted himself chiefly to allegory, but amongst those influenced by the decorative phase, there are several who have mingled allegory or romance with decoration.

and quite a group of painters of homely subjects, such as Nicol and the Faeds loved, have profited in some ways and lost in others from the example of Israels, Neuhuys, and Blommers.

While the younger generation of Scottish painters have thus been subjected to many alien influences, and have indeed cultivated them, their art has remained in many ways Scottish at heart. This is fully recognised abroad, where their work has been the object of a cult. Contrasted with the majority of the younger English artists who share in the cosmopolitan spirit of to-day, they are at once more artistic and more national. The attempts in heroic art and the nude which have occupied the attention of such men as Solomon and Hacker, though without the assured mastery of the greater Frenchmen, possess much the same merits and defects as the French work that has inspired them, the *plein-air* attitude and technique have been adopted in their entirety by the Newlyn men, and the New English Art Club group, although Mr. Wilson Steer, Mr. Rothenstein, and one or two other fine artists have arrived, are for the most part experimenting with the impressionism of Claude Monet, or are harking back to the old masters.

<center>VIII</center>

It was not until a hundred years ago that the feeling for Nature, which had given authentic proofs of its existence in Scottish poetry throughout the centuries between Henryson and Burns, revealed itself in Scottish painting. The eighteenth century had passed its meridian ere it obtained pictorial expression at all, and 'More of Rome,' the only pure landscape-painter of that time, found, as his name indicates, his chief inspiration in Italy. Apart from him and Alexander Nasmyth, who did not take to landscape until its last decade, the Scots who painted landscape in that century—the Runcimans, who showed a true appreciation of its pictorial beauties, David Allan, who introduced it as a somewhat conventional setting in some of his pastorals, and a few more—used it, as the poets had done, as accessory to figure-incident. But from the time Nasmyth abandoned portraiture, and specially after Walter Scott's influence commenced to be felt generally, and Thomson of Duddingston began to paint, landscape was painted for its own sake, and eventually became one of the most characteristic phases in Scottish art.

The artist-minister was the greatest Scottish landscape-painter of his day, and in his work Scottish scenery first assumed its true character of ruggedness and strength. Obviously the convention of Claude and the Poussins, of which he was a noble exponent, imposes itself upon his thought ; but his personality declares itself in interest in the beauty and suggestiveness of unrest and storm and atmosphere, and the nature of the

scenery he painted and its sentiment are essentially Scottish. Thus he struck at once the chords of pictorial and natural beauty and of historical and national association, and laid the foundation of Scottish landscape-painting. But most of his immediate contemporaries were either painters of foreign lands, as 'Grecian' Williams and Andrew Wilson in the Classic, or David Roberts, the architectural artist, in the Dutch tradition, or like Patrick Nasmyth, 'the English Hobbema,' or the sea-painter, Jock Wilson, adapters of the Dutch manner to English landscape or to coast and shipping. In the more modern landscape of William Simson, however, one can trace evidences of Thomson's influence, and in certain directions the Highland scenes of Horatio M'Culloch are its direct progeny, and connect it with later developments. Yet the influence of the writers of that day, and specially of Scott, ought not to be over-looked. Thomson, personal though his dealings with Nature had been, had felt it, and in the work of his successors it is even more marked. And in landscape Scott was the inheritor and continuator of the methods and ideals of Gavin Douglas in the Scots Prologues to his translation of the Æneid and of James Thomson in *The Seasons*. Like theirs, his description combines panoramic sweep with a wealth of detail which, realistic in characterisation and extraordinarily vivid in colour, is yet over-wrought for the general effect. Scott's, however, had what the older poetry had lacked, but what Ramsay's, and specially Burns's, vignettes possessed fully, a sense of the spirit of place, and in some measure this he transmitted to the painters. Still the essential quality of his landscape poetry and of their pictures is breadth of intake and piling up of detail, and that this should have been so, in the earlier stages of pictorial representation at least, is not surprising to those familiar with the far-spreading and richly-varied and wonderfully-coloured vistas so characteristic of Scottish scenery.

To a certain extent M'Culloch and his abler followers retained the power of design which Thomson had displayed, but it was more in line than in mass and more scenic than pictorial in quality. On the other hand, they attained a nearer approach to Nature's colouring, if not to its atmospheric envelope, and before very long, in the work of Milne Donald and Bough and Fraser, and of Lauder's pupils, Scottish land-scape-painting awoke to the charm of local colour, and the realism and love of vivid natural effect, which had marked Scottish poetry, became dominating factors in painting also. The rather flimsy generalisation of form and the conventionality of detail which one notes in the work of the earlier men, who had heired them with their technique, was superseded by loving observation, which by such painters as Fraser, MacWhirter, and Murray is expressed with charm and beauty, and this in turn tended to counteract the scenic element and to direct attention to less diffuse kinds of landscape. And beginning with Harvey, the pitch of illumination,

which had been little affected by Turner's great experiment, went up until in the superb impressionism of M'Taggart it reached extraordinary brilliancy. But much of this landscape is deficient in those qualities of selection, concentration, and arrangement, without which really fine landscape art is impossible, and most of its painters from M'Culloch to Peter Graham and Joseph Farquharson have been more interested in the vivid and spectacular effects of Nature than in her subtler and more poetic moods, and have dealt with the more obvious and easily apprehended interest of landscape rather than with its profound and delicate beauty. But if the sentiment in the pictures of M'Culloch and Milne Donald, of Bough, Fraser, and Docharty, of MacWhirter and Murray and their fellows, is not subtle or poetic, it breathes of the open air and is full of love of Nature. And further, some of these artists paint with a skill and dexterity and possess a gift for graceful design or lovely colour which not only save their work from commonness, but give it distinct artistic value and now and then definite charm.

An exalted and poetic feeling for Nature being an individual possession, it were idle to expect that it should ever be the dominant note in a nation's art. The revelation of this faculty has been invariably in the work of one man or of a small group of men, and Scottish art has been fortunate enough to possess several of these 'poetic moments in paint.' In Thomson of Duddingston's landscape delight in the beauty of wild Nature and the emotional moods of atmosphere vitalises the noble artistic convention to which he was devoted, in that of Wintour the old ideals of abstract beauty and dignified design mingle with romantic sentiment, and if G. P. Chalmers's treatment of shadowy running water, dim moorland, and dusky field tends to be too abstract and keeps too aloof from the vital beauty of the world, passion for colour and lovely tone and great subtlety of handling give it a life of its own.

The most poetic manifestations in Scottish landscape are not, however, to be found in the art of the past. They belong to the last thirty years.

The end of art is the pictorial expression of thought and emotion : the beauty inherent in Nature and its significance await the illuminating vision and skill of the artist to reveal them. In pursuit of this, he will respect Nature and her external form the more, for to convey his novel insight he must use the symbols Nature has made common to us all. But he must also mingle with her material forms the leaven of his thought, and express both in terms of pictorial beauty. It is because these qualities of form and spirit are combined in a remarkable way in the work of several living and a few recently deceased painters that one calls the present the most poetic moment in the history of Scottish painting. If I have succeeded in any degree in giving an impression of the work of these artists, mere mention of their names should recall the

special qualities of each. Cecil Lawson (1851-82) suggests a romantic, yet realistic, conception of Nature expressed with a vigour of handling, a largeness of manner, and a sense of style which make his landscape a great achievement ; Hope M'Lachlan (1845-97), individual and poetic apprehension of the grave and impressive moods of twilight and night and solitude ; and Colin Hunter (1841-1904), sea-lochs haunted by the impassioned yet retired spirit of melancholy typical of the Celtic genius. Turning to the living, M'Taggart, who was an impressionist in the finest sense before the pioneer Frenchman of whom one has heard so much more, has for long been painting the most wonderful pictures of the sea ever painted, and landscapes joyous as sunshine and quick with life like the spring ; and Wingate has given us exquisite glimpses of woodland and lea, seen with a poet's eye and thrilled through and through with the rapture of intimate contact with Nature. Amongst the work of the younger generation again, Walton's bucolics are painted with wonderful gusto and animated by intensity of passion, Roche's idylls transfused with a sense of beauty as exquisite as it is personal, and the best of Paterson's sylvan pastorals suffused in an atmosphere of rural quietude and peace. Through the finely balanced if too consciously dignified design of W. Y. Macgregor and D. Y. Cameron, with its stress on massing in light and shade, and in the romantic drawings of modern cities by Muirhead Bone, one can also trace much of the same poetic spirit, and in minor degree it is present in the simpler landscape of A. K. Brown and J. C. Mitchell, and in the more traditional work in its different ways of the Nobles, David Murray, R. B. Nisbet, and Macaulay Stevenson. Further, the influence of the greater of these men and acquaintance with the art of the French and Dutch romanticists has turned the attention of Scottish painters as a whole to the significance and beauty of atmosphere, and to the great part it plays in the emotions pertaining to landscape. The tendency to choose scenes notable for historical association or special beauty, and to treat them in a somewhat topographical manner, so prominent in the art of the earlier Scottish landscape-painters, has now given place, to a great extent, to a simpler taste in subject, a more intimate kind of sentiment, and a desire to express those qualities which in Nature give unity and harmony to a scene.

It was not until well on in the hundred years during which landscape-painting has been practised by Scotsmen that the bulk of the work done could be compared at all favourably with what was being produced in England or France. During the first thirty or forty years the amateur Thomson of Duddingston was the only one who might have been classed with that great dreamer and romantic-impressionist, Turner, with the best of the Norwich School, and with Constable and the 'natural-painters' Cox, De Wint, and Müller, who followed his inspiring lead ; and throughout the following decades, although Wintour, Harvey, Fraser, Bough,

and some of the youngsters trained by Lauder were painting pictures which invite comparison with England, where landscape had retrograded, the Barbizon men, Corot, Rousseau, Daubigny, Diaz, and the rest, with Millet and Troyon, in whose art landscape was accessory, formed a group which far transcended Englishmen and Scotsmen alike. But for the last five-and-thirty years it has been otherwise. Holland has had two or three landscape-painters of very high rank, but the bulk of modern Dutch painting has been genre; France has seen the rise of plein-airism and impressionism, but the achievement of Lepage and of Monet and of their fellows, notable and memorable as it is, takes little account of emotional qualities or of the charms of decorative effect; and England, except for the splendid work of one or two sea-painters and of a few of the younger men, who are swayed by somewhat similar ideals to the Glasgow group, has for the most part been devoted to uninspired realism flavoured with prettiness and sentimentality. In Scotland, on the other hand, this period has been marked by the activity of quite a number of painters whose landscape is steeped in the magic of poetic-realism. Moreover, the thought of these poet-painters is not more beautiful than the expression, the adjustment of means to end in their pictures is excellent; and their example has given a poetic tone and some degree of style to the greater mass of work which must needs be imitative and inferior. Nor, when all the circumstances are considered, is this to be wondered at. Scotland is a very beautiful country; landscape-painting there has but recently come into full powers of expression, and, a capacity for combining idealism with a grasp of facts being a strong element in the national temperament, commerce between that spirit and art in its relation to Nature has issued in a poetic treatment of the real.

IX

Painting being a universal language, evidences of national character are necessarily less obvious in technique than in those subjective and emotional elements with which we have hitherto been chiefly concerned. Yet it can scarce escape the inflection of nationality, and seldom does so. The outcome of the compromise which results from the conflict between the inherent and material qualities of the medium of expression, and the artist's conception of and interest in subject in its visual and emotional aspects, technique is influenced by national temperament, and responds to the ideals which prevail at any particular moment. It varies also not only with the general tendencies of a school or a period, and with racial capacity for easy and dexterous or laborious and polished craftsmanship, but is modified within these great divisions by the personal gift and preferences of individual workers. To expect more of the actual craftsman-

ship of an art wherein the tools used are uniform everywhere, and especially in modern times, with their facilities for communication and their heritage from the past, to look for more clearly marked national differences in workmanship than these causes and influences supply is not only unnecessary but rather foolish. Moreover, the differences wrought in technique by the stress laid by different nations or groups or individual painters upon certain qualities are vital and far-reaching. Preferences in colour, light and shade, and form, delight in realistic representation or decorative effect, love of detail, or of ensemble, inclination towards brightness or lowness of tone have each and all an effect upon technique, and are inseparable from it. And in Scotland, where, as we have seen, the national tendency is towards concentration, the effect of certain preferences has been very marked. 'As soon as it found its feet,' says Sir Walter Armstrong,[1] 'as soon as in Raeburn, Scotland could boast a born painter, a feature began to declare itself, on which not a little of the individuality of her art yet depends. This feature is rigorous selection, a determination to succeed by carrying some single artistic virtue to the highest conceivable pitch, rather than by a lower degree of excellence in many.'

X

When Raeburn freed himself from the graceful but somewhat formal and artificial manner which his predecessors had acquired through contact with late Italian and eighteenth-century French art, he, partly under the influence of Reynolds, but more through innate feeling for fitness, adopted a broad, bold, and simple manner, which gave most convincing expression to his strong sense of essentials and of character. At once this dignified convention, pictorial yet pregnant with character, answering to an instinct which he shared, though in exceptional measure, with his countrymen, was taken up by them, and became characteristic of Scottish portraiture. Amongst his immediate contemporaries and successors, though with a few colour counted for a good deal, technical interest was centred chiefly in the expression of character and form, and constantly faced by a model, as it were, they attained considerable understanding of structure and a power of draughtsmanship, which, united to simplicity of pictorial design, gave their portraiture a strength and solidity and a certain sober dignity not possessed by that of their English rivals. Yet their drawing was not distinguished, and except Raeburn's and Watson Gordon's, and perhaps Macnee's at his best, their modelling was not really powerful or fully realised.

With the earlier genre and historical painters, and the landscape men, the prevailing technique was derived from study of the minor Dutch and

[1] *The Portfolio*, 1887.

Flemish painters of the seventeenth century, and partook of the detailed and delicate handling, the careful distribution of light and shade, and the warm transparent brown tone characteristic of these schools. Dealing with a very similar class of genre and conceiving it in a very similar spirit, and without a tradition of their own, it was but natural that the figure-painters should have turned in that direction. Teniers and Ostade were the chief influences, for they were Wilkie's favourites, and it was more through his work than directly from theirs that the Scottish painters who followed him were affected. Wilkie himself was their frank disciple; but he made what he borrowed his own, and deftness of drawing, dexterity of handling, and skill in light and shade gave his technique and design definite and clearly marked character. And this technique with its conventions in treatment and scale, which he transmitted to Fraser, Burnet, Allan and the rest, and which was continued by Nicol, the Faeds and the Burrs, though with greater insistence upon local colour and in some cases an unfortunate increase in scale, was eminently suited for the expression of that keen interest in character and situation and in characteristic detail which has been noted as typical of the Scottish temperament.

A somewhat similar technique obtained with most of the painters of historical incident, but coming, as the majority did, after the alteration in Wilkie's subjects and style (1825-8), they worked on a larger scale, and were influenced in some measure by the admiration which his later pictures evince for the art of Rembrandt and the Spanish realists. Sir William Allan, who forestalled Wilkie in history as a subject for pictures, had been his fellow-student, and his work shows the influence of both Wilkie's periods; and being master of the Trustees' Academy from 1826, Allan's influence was added to that of the other's pictures in determining the technique and style of his pupils amongst whom were Thomas Duncan, Sir George Harvey, Drummond and Houston. In this way, but more through Sir David than their master, they learned to handle paint with considerable dexterity, and, catching his passion for deep transparent shadows and rich warm lights, they used recklessly, as he was doing, asphaltum with fatal results to the permanency of much of their work, which, when it has not become a wreck has often lost the lustre for which they risked so much. Without the discipline of a proper training in their youth, for with one or two exceptions, both history and domestic painters came into art after beginning life in some more practical calling, and without the constant stimulus the portrait-painters had in having to satisfy their clients by faithful likenesses, few of them attained facility or constructive power in draughtsmanship, and their absorption in the stories which they set themselves to tell led to concentration on that element, and prevented all but two or three from giving much attention to ensemble and decorative effect.

Landscape, on the other hand, was influenced in its beginnings by a

combination of Italian and Dutch influences. When Nasmyth took to painting landscape, he united something of Italian dignity of design and tranquillity of lighting to a variation of Dutch handling, and Thomson gave expression to his deeper and more romantic, yet more naturalistic, apprehension of the beauty and character of Scottish scenery in a style and method which link him with Claude and the Poussins. Combining some of these qualities in his Highland landscapes and adding greater naturalness, the future lay in the direction M'Culloch indicated; but the technique of the majority of the earlier painters was founded more definitely on Dutch convention, and, following Hobbema and Cuyp and Berchem, or Van de Velde and Bakhuysen, several used it with considerable success if with little personality or distinction. Yet the pictures of Jock Wilson and E. T. Crawford reveal a quickening interest in colour and light and atmosphere, and mark the transition to the more realistic and vital work of Milne Donald, Bough and Fraser, and their present-day successors. In some respects these later artists received an impulse from the naturalistic landscape of Constable, Cox, and Müller, but their conception of landscape was in many ways essentially Scottish and an outcome of previous evolution and of latent powers come to fruition.

Nearly all these men—portrait, figure, and landscape painters alike—had received such training as they had at home, or had not come into contact with foreign art or even English art until their methods and styles had been formed to a great extent. The sojourn in Italy, which up till the close of the eighteenth century, when the art of the decadence was the fashion, had been the ambition, in many cases realised, of every Scottish painter, had been abandoned, or, at least, was not considered indispensable, since the establishment of the Trustees' Academy on something like an adequate footing. Yet Italy, then as now, and indeed ever since Italy was, beckoned to the hardy races of the North, and several Scots could not resist the spell. Geddes and Scott and Dyce were of the number, and caught something of the Venetian splendour; but, as regards the future, Lauder's five years in Italy and Phillip's visits to Spain were of far greater importance. For with landscape stirring to new impulses, and Phillip at work on his Spanish pictures, and Lauder back in Edinburgh as master of the Trustees' Academy, the next striking movement in Scottish painting, which was to be marked chiefly by its achievement in colour, was imminent.

XI

That colour should now become the dominating element in Scottish painting is less surprising than that its dominance should have been so long delayed. For the colour of Scotland is wonderfully beautiful, and unusual sensitiveness to colour had ever been prominent in Scottish literature. Taking as granted the existence of this feeling, of which I have spoken already, we are now more immediately concerned in the special character of this colour and in its connection with Scottish painting.

It is not national preference alone that induces one to say that the colouring of Scottish landscape is quite exceptional in its richness, variety, and beauty. Most strangers are surprised and delighted by its exceptional chromatic qualities, and from the remarks of artist-visitors one may cull that of Sir John Millais that in Scotland colour is brought out by the rain, and P. G. Hamerton's that 'no one who knows the Western Highlands well can ever imagine them without colour.' And Mr. Mortimer Menpes, recording his impressions of much globe-trotting in *World Pictures*, expresses the opinion—'No country in the world is to be compared with Scotland for rich colouring. One can dispense with Norway and Sweden, and even Switzerland, if one has Scotland.' Yet as bearing upon the relationship between Nature and Art, quite as important as the fact that brilliant colour is a very marked feature of Nature in Scotland, is its actual quality. In most other northern countries the prevailing tints are either luminous greys or local colours which tell somewhat violently in a too harsh air ; and in the sunny south, although everything stands clear-cut in lucid atmosphere, intensity of light eats up the finer modulations of colour, and reduces it to tints sharply juxtaposed. But in Scotland, while the weather is often wet, the landscape is always full of colour. And this colour is of a particular quality. It combines softness with intensity. In the heavenly blue weather of June, a marvellous inlay of definite and brilliant local colour and delicate form is suffused in a clear and tender sunny radiance which gives great subtlety to the intensity, and, for all its jewelled splendour, blends the whole into an extraordinarily rich and full yet exquisitely soft harmony. Nor is the colour less beautiful and rare, though less brilliant, in the sweet, still days of late summer, when loch and hillside, haugh and harvest-field become tremulous and dreamlike in the enchantment wrought by sunlight turning haze into a gauzy veil shimmering with tints of opal and pearl. Then there are the days when the south-west wind blows flocks of great white clouds, born in the Atlantic, through the aerial blue of rain-washed atmosphere, and waves, glistening like snow and glittering like diamonds in the sun, and booming or chattering as they go, course, one after the other, across a swaying field of sapphire

shot with emerald and ruby, towards shores of golden sand and bronze tangled rock. Or those when, clothed in the saffron and russet and scarlet pageantry of autumn, the straths of the Highlands, seamed with blue streams, and streaked with wine-coloured shadows, and bounded by purple mountains, made a harmony too rich and splendid in its opulence to be captured by Art. And the glory of the sunsets beyond purple moors and mountains, or over the golden or empurpled sea, and the rich quiet of the long afterglows fading imperceptibly into the sweet-coloured dimness of the dusk, which at midsummer has not deepened into dark before the radiance of a new day begins to quicken the eastern skies, are as soft and subtly graded as they are opulent and splendid.

With such colour about them in Nature and a racial instinct for its appreciation, one may well ask, 'Why did not Scottish painters sooner discover and reveal their special gifts as colourists?' Here, as often, the most obvious answer is probably nearest the truth. It was because they had been brought up for the most part in the conventions of a school which sacrificed colour to other things, and specially to tone and chiaroscuro. And this is the more likely since whenever a Scotsman came into direct contact with the art of real colourists his latent feeling took fire. Wilkie's later pictures reveal a great ambition to excel in colour; Geddes, David Scott, Dyce, and Lauder, all of whom had shown an innate tendency to colour before they went abroad, became colourists whenever they saw Rubens and the Venetians; and Phillip's work kindled into splendid colour under the influence of Velasquez and Murillo. Now, however, that Scottish painting had served its technical apprenticeship to the Dutchmen, and Phillip had arrived, and Scott Lauder had come home to inspire a group of gifted pupils, the time was ripe for the slumbering gift to awake. To this Lauder's system of teaching contributed greatly. A colourist himself and a student of the great Italians, his desire was not to impress his own ideals upon his scholars but to stimulate each to full expression of his individual talent. Yet very varied as the work of Orchardson, Pettie, Chalmers, M'Taggart, MacWhirter, Cameron, the Grahams and the rest has been, it possesses a strong and intimate bond in love of colour. It was to them, and their slightly older or younger contemporaries in landscape, that Sir Walter Armstrong referred specially when he wrote, 'The later school is practically one of colour; by its members colour is honoured with a more exclusive devotion than it has found elsewhere since the days of Titian.' In quality the colour of these painters is in many ways exactly like the colour I have indicated as characteristic of Scottish landscape. A passage in Mr. Maarten Maarten's article 'Scotland: An Impression' has a bearing on this so evident that I must quote it. 'The sun went down slowly in a panorama of colours as wonderful as any I ever beheld. The blues and pinks of Highland atmosphere are very peculiar; so, for the

matter of that, is the red and orange of the hillsides. I doubt whether any one can quite appreciate—or even quite believe in—Highland land-scape-painting—say MacWhirter, or A. K. Brown—until he has beheld the actual thing. I confess to having had my doubts, but that single evening convinced me.' And Josef Israels exclaimed to a friend with whom he was walking across a Highland moorland under a brilliant sunset sky, that now he understood where Scottish painters got their love of colour. Their colour, like that of their country, combines softness with intensity, and is rich, varied, beautiful. To Phillip's boldness in the handling of local colour, and his delight in the play of broken tints, which had hitherto been the finest, as it remains the strongest, use of colour in Scottish Art, they added subtlety of expression and a very delicate and refined perception of light and atmosphere. With these gifts they have successfully achieved the most difficult feat in colouration—harmonising positive colours in a high pitch of illumination, a feature specially notice-able in the sun-radiant pictures of M'Taggart. And this passion for colour, which likewise vitalises the deeper-toned harmonies of Chalmers and Pettie, has issued in a kind of painting, somewhat kindred to that of Rubens, which is materially beautiful and pre-eminently suited for the expression of the loveliest qualities of colour. As might be expected also from their more pictorial and inventive conception of subject, the actual brushwork of the best of them is at once more brilliant and more sensitive, and is marked by a far more vital grasp of the significance of touch and handling than that of their predecessors, though it had been founded on the same Flemish and Dutch tradition. And if, excepting Orchardson, who is one of the most distinguished draughtsmen of his century, none of Lauder's pupils draw with conspicuous style, their drawing is usually effective and descriptive, and often suggestive of attitude and gesture in a fine way. Finally, in design, while not intentionally 'decorative' in the sense that the later school is, they conceive subject in its pictorial aspect, subordinate detail to ensemble, and, while not eliminating chiar-oscuro, compose in masses of balanced and subtly related colour, enriched by a rhythmic use of line and arabesque.

Passing over the next five-and-twenty years (1860-85), since they saw no widespread alterations in technique or feeling, we come to a time when Scottish painting was to undergo a further change. During the interval many fine pictures had been painted by Lauder's pupils and some interesting work done by stragglers from the earlier school. A number of younger artists had also added to the interest of the passing years by the excellence of their achievement; but, apart from these, the new arrivés were of an inferior type both as craftsmen and emotionally. Their technique was either a feeble version of the Lauder tradition or a reversion to the older, and their attitude to life and Nature possessed little personal feeling or novel insight. In addition to this dearth of fresh talent some

of the most gifted of the Lauder group, following the example of Wilkie, Dyce, Phillip and others, had gone south, and Chalmers and several of the abler landscape-painters of the transition period were either dead or past their best. Thus the situation in Scotland was not unlike that which obtained in the fifties just before the appearance of the men whose work has been considered in the preceding paragraphs. But, as then, a new force was about to emerge, and that from a direction which, while it had produced individual artists of merit, had not hitherto exercised much influence on Scottish painting as a whole. For it was from Glasgow that the new impulse came.

<p style="text-align:center">XII</p>

Ever since the Pre-Raphaelite protest had fluttered the dovecots of tradition, naturalism had been in the air. Already in France it had superseded romanticism, and had affected academicism and official art to a greater extent than that memorable movement, of which it was in some ways a product, had ever done. And through its splendidly organised atelier system and its great exhibitions, Paris had become the hub of the artistic universe. So when a group of young men in Glasgow, touched by the spirit of naturalism, found themselves out of sympathy with the technique and pictorial ideals which prevailed in Scotland in the early eighties, it was to France that they turned for inspiration. To them Scottish painters seemed too much given over to anecdote and sentiment, over-elaborate and fussy in manner, too flimsy in handling and shrill in tone, and not careful enough of the actual aspects of Nature. With their eyes turned to Paris, where the theory of values, which gives such power of truthful representation in paint, had recently been formulated definitely, and where a few of them had been trained, they were not very conscious of the existing home influences which made towards the same ends, but unconsciously they were influenced by them. By the subtly expressive and impressionistic tendencies of their style, no less than by the simplicity and character of their pictorial motives, Chalmers, Wingate, and specially M'Taggart, although in some respects belonging to the preceding school, had prepared the way for them, and the powerful pictures with which John R. Reid, who had been a pupil of M'Taggart, was attracting so much attention about 1880, were subjectively and in conception and technique exceedingly like their earlier work.

At first nothing was supposed to count but realism and unity of effect, strong painting, true values, and full tone. In pursuit of these they broke, as French painting, as nearly all recent painting, has done, from the technical traditions of the past. The method of painting transparently in the darker passages and with impasto in the lights, with glazes and

scumblings, sanctified by the practice of the great masters and carried on in Scottish painting by Lauder's pupils to our own day, was abandoned by them for the most part for a system based upon the representation of reality in solid pigment throughout. But while the younger Scots took up this method with characteristic fervour, they handled it with dexterity and attained charming qualities of surface and quality. These were derived, like their subjects, rather from their Scottish connections than from their French friends, and were largely due to instinct for colour, for that can be satisfied fully only by a fine use of the medium.

The tendency to low tone so obvious in their art was probably a reaction from the key in which much Scottish painting had been pitched, but, curiously enough, it set them equally against the clear bright painting of level grey light which had come into such favour abroad through Lepage's example ; and—combined with the love of colour which they shared with the Lauder men, and a desire for decorative effect, which gradually arose amongst them through acquaintance with the work of Whistler and Monticelli and with Japanese art—this gave their pictures a special quality of their own. After the harmonies of M'Taggart, Pettie, Orchardson, and MacWhirter, theirs were as the full deep tones of 'cellos and bassoons compared with the more penetrating, delicate, and varied notes of violins and flutes. Add to this sense of colour and the instinct for decorative spacing in flattened masses, which reached its most extra-vagant development shortly after 1890, the naïvely poetic apprehension of Nature, which I have previously indicated as characteristic of certain of the Glasgow men, and you have the grounds for Professor Muther's opinion that ' in their works personal mood is set in the place of form, and tone-value in that of pencilled outline, far more boldly and sharply than in Corot, Whistler, and Monticelli.' But while this devotion to a few selected qualities, like that of the Lauder group, bears out Sir Walter Armstrong's contention that concentration and selection are out-standing features in Scottish painting and proves it up to the hilt, the tendency to realism in which the new school had originated still persisted, and discovering that their instincts were carrying them away too far from form they strove to attain that also. Simultaneously there came increased regard for the art of Velasquez and the great portrait and landscape painters of the past, and design upon more dignified and constructive lines was cultivated assiduously. It .is to this, combined with the feeling for style, which they had from the first, that the element of classicism which marks the later pictures of the stronger men among them is due. Yet distinguished and beautiful as much of the work of the younger genera-tion is, and profoundly as it has affected Scottish painting, there has been a tendency to subordinate to considerations of conscious artistry that sentiment for life and Nature which, strongly felt and fitly expressed, issues in true style. Even the best of the portrait-painters have been

prone to suppress the claims of characterisation and significance of pictorial expression in favour of stylistic elements, acquired by study of other men's work, and imposed, as it were, from without; and desire to obtain a decoratively pleasing ensemble has militated against the spontaneous expression of the deeper and profounder feelings as regards landscape.

XIII

No one familiar with the history of painting in Scotland since it became a living art in the pictures of Raeburn, Wilkie, and Thomson, will find it difficult to trace a more or less connected development, and to find in its successive phases qualities, subjective, emotional, and technical, eminently characteristic of the Scottish people. That these are not of the kind which make a school of painting in the narrow sense that term properly implies—a group of men gathered round a master or masters, and working in a clearly defined mood and manner, and transmitting that convention to their successors—is obvious, since technical ideals have varied from time to time, and independence and personality in relation to subject have marked the art of those belonging to even the more definitely related movements. Yet that there has been a succession of painters whose works are so strongly marked in subject and feeling and in the use of the medium of expression, though varied in the stress laid on these at different times, as to be clearly recognisable as Scottish is quite apparent. And, that being so, it matters little whether or not one is entitled to describe them as a school. It is sufficient that their art is vital and expresses the emotional and æsthetic sentiments of the people who have made it.

That a small country like Scotland should have produced so much art in little more than a century is notable enough in itself, but that so large a proportion should be of excellent quality is indeed wonderful. Caring more for the significance and beauty of common things than for the far-off or fanciful, it possesses at its best a keen and dramatic perception of character and situation, a profound love of Nature, and a touch of poetic glamour expressed with an instinct for the essentials in impression, whether realism or decoration be in the ascendant, a dexterous and masculine quality of handling combined with a fine use of paint, and a gift of colour which assure it a distinct and honourable place.

At present Scottish painting stands high. It is one of the few original and distinctive manifestations in modern painting. Some of the most gifted of Scott Lauder's pupils are happily still at work, and producing pictures which rank with their finest achievements; amongst their immediate successors, although their ranks are thinning also, there are a number of painters of charm or power; and the Glasgow group and its contem-

poraries, 'boys' no longer, are producing work in portraiture and land-scape which seems destined to remain of interest and value. But the prospects for the immediate future are less encouraging. The most promising of those junior to the Glasgow men have been taken, and during the past decade little new talent of genuine merit has emerged. Yet the history of the school teaches one not to despair. It has been a succession of movements, and considerable intervals have separated one wave from its successor. The last surge which came out of the west is not yet exhausted, and before it spends itself on the sands of Time, another, springing from one knows not where, may come, and in its coming maintain the reputation so worthily won by Scottish painting, past and present.

Young and Watson, P. Earl of Buchan

GEORGE JAMESONE
MAISTER ROBERT ERSKINE

J. MICHAEL WRIGHT

SIR WILLIAM BRUCE

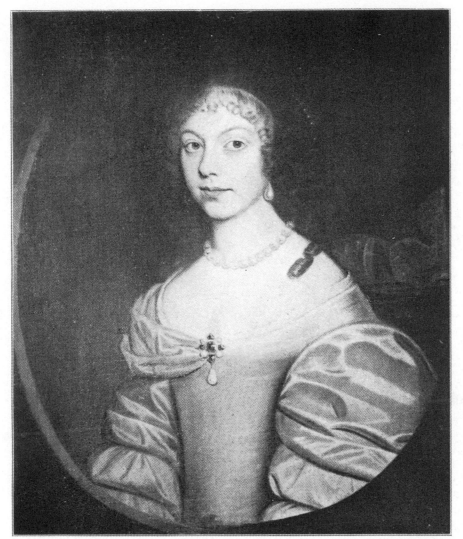

JOHN SCOUGALL

LADY CLERK

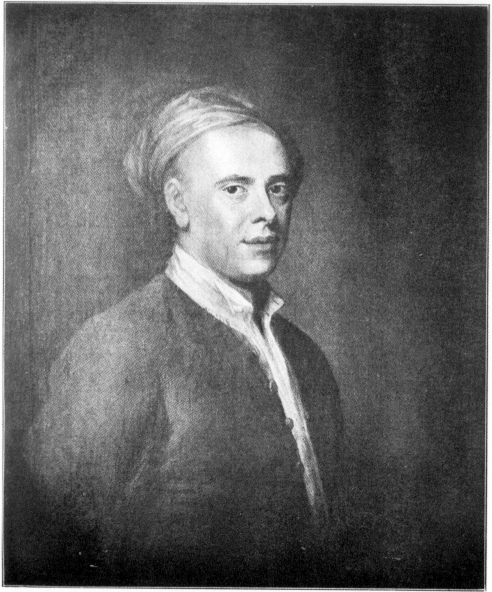

WILLIAM AIKMAN

ALLAN RAMSAY

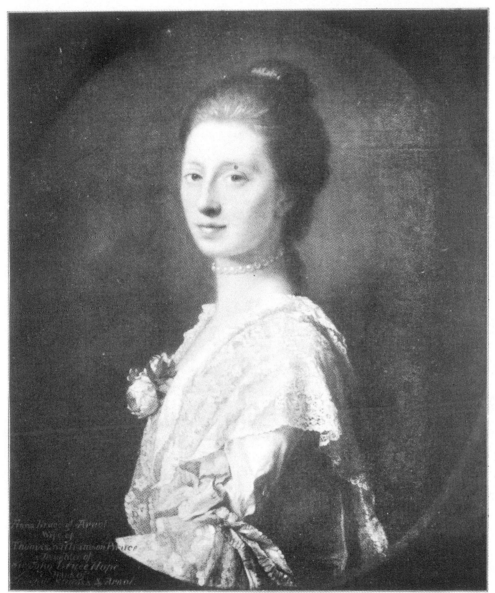

ALLAN RAMSAY

MRS. BRUCE OF ARNOT

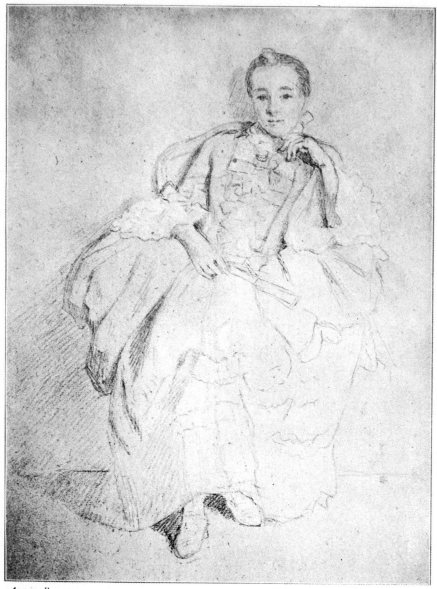

ALLAN RAMSAY

STUDY FOR A PORTRAIT

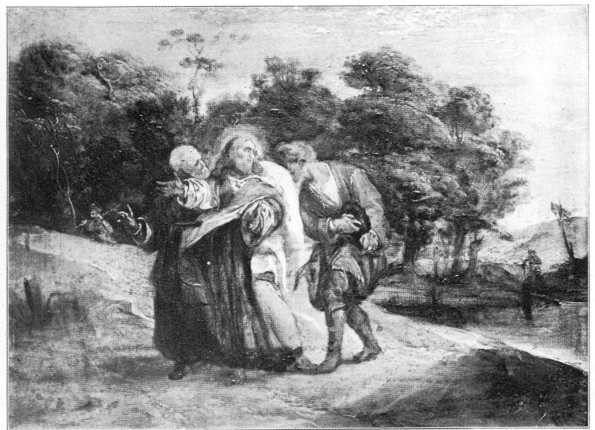

JOHN RUNCIMAN

ON THE ROAD TO EMMAUS

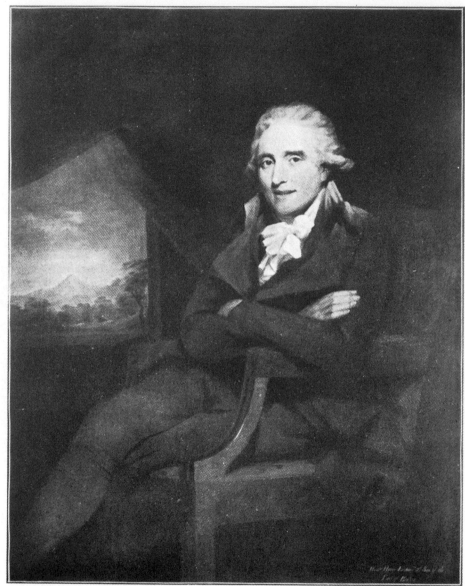

SIR HENRY RAEBURN, R.A.

HON. HENRY ERSKINE

SIR HENRY RAEBURN, R.A.

MRS. JAMES CAMPBELL

Annan, P. J. H. Houldsworth, Esq.

SIR J. WATSON GORDON, P.R.S.A.
HENRY HOULDSWORTH OF COLTNESS

ANDREW GEDDES, A.R.A.

WILLIAM ANDERSON

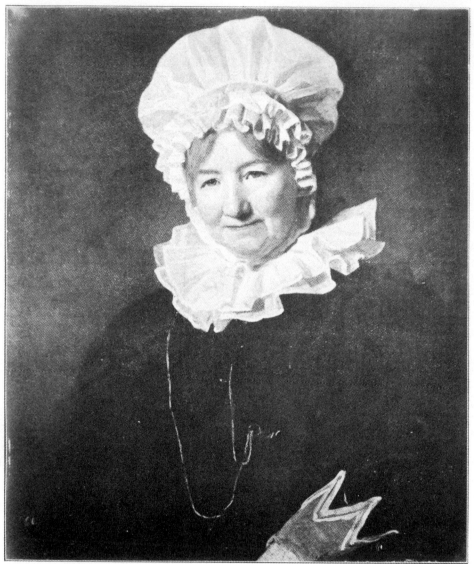

JOHN GRAHAM-GILBERT, R.S.A.

MRS. ARCHIBALD SMITH

SIR DAVID WILKIE, R.A.

THE ERRAND BOY

ALEXANDER FRASER, A.R.S.A.

TAM AND THE SMITH

Annan, P.

W. Strang Steel, Esq.

SIR WILLIAM ALLAN, P.R.S.A.
HEROISM AND HUMANITY

THOMAS DUNCAN, R.S.A.

ANNE PAGE AND SLENDER

R. SCOTT LAUDER, R.S.A.

THE TRIAL OF EFFIE DEANS

DAVID SCOTT, R.S.A.

TIME SURPRISING LOVE

WILLIAM DYCE, R.A.

TITIAN PREPARING FOR HIS FIRST ESSAY IN COLOURING

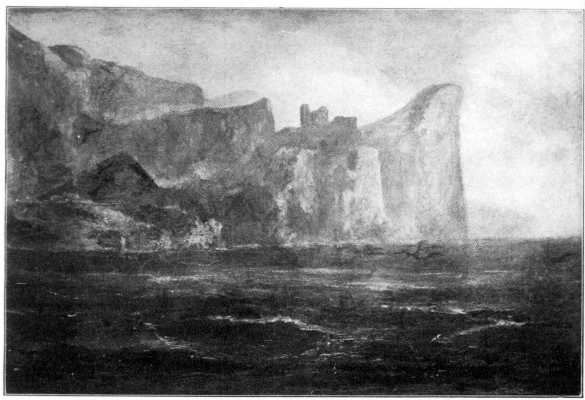

REV. JOHN THOMSON, H.R.S.A.

CASTLE BAAN

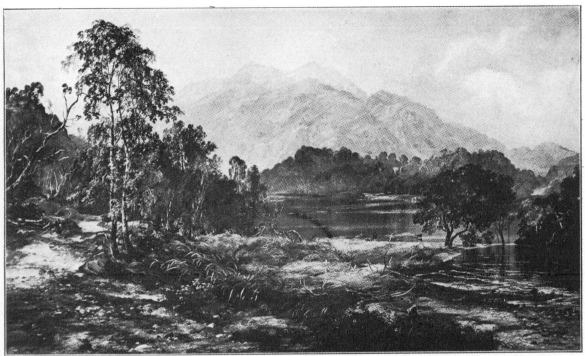

Annan, P.

HORATIO M'CULLOCH, R.S.A.
THE SILVER STRAND

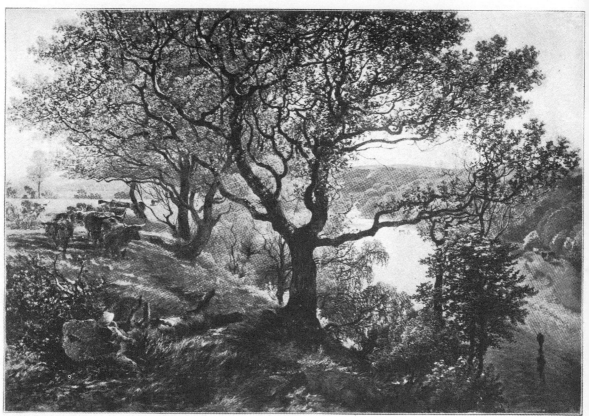

Annan, P.

Stephen Mitchell, Esq.

J. MILNE DONALD
ON THE NITH

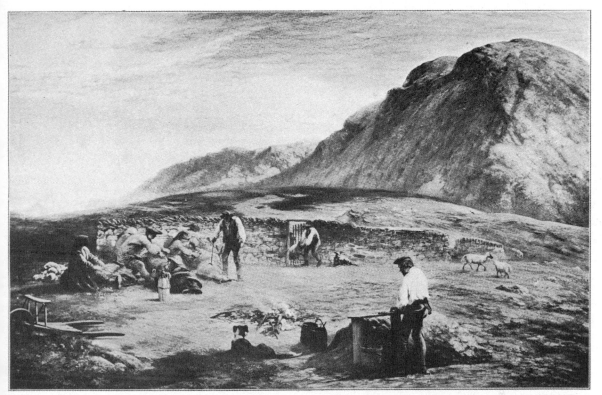

SIR GEORGE HARVEY, P.R.S.A.

SHEEP-SHEARING

DAVID ROBERTS, R.A.

TOMB OF ST. JACQUES, BOURGES

PATRICK NASMYTH
THE THREE TREES

THOMAS FAED, R.A.

THE END OF THE DAY

Annan, P.

R. H. Brechin, Esq.

SIR J. NOËL PATON, R.S.A.
DAWN—LUTHER AT ERFÜRT

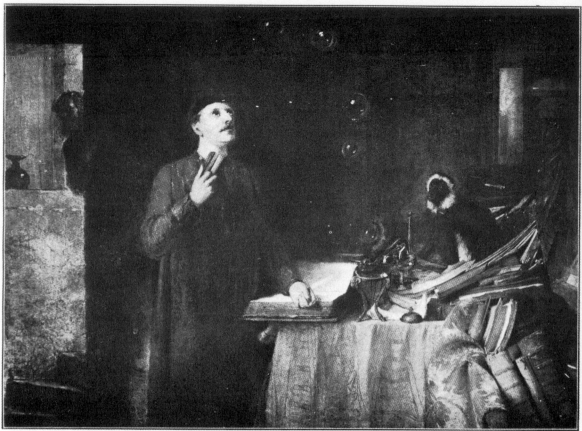

SIR W. FETTES DOUGLAS, P.R.S.A.

THE ROSICRUCIAN

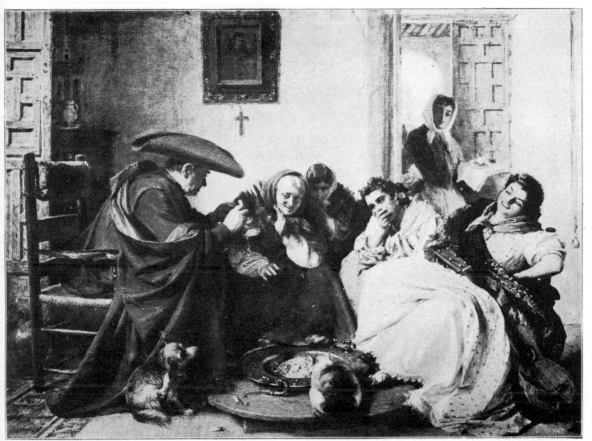

Cassell, P. *Guildhall Art Gallery*

JOHN PHILLIP, R.A.
A CHAT ROUND THE BRASERO

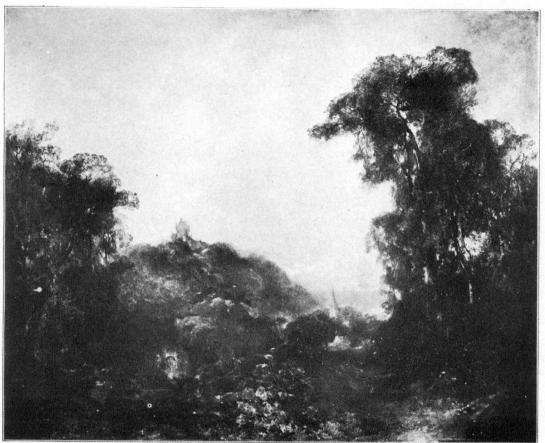

J. C. WINTOUR, A.R.S.A.

A BORDER CASTLE

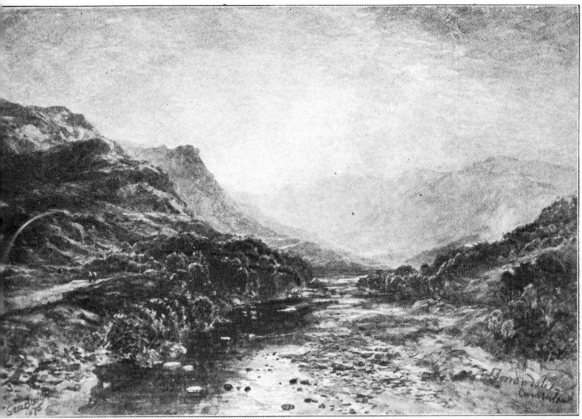

Annan, P. W. Beattie, Esq.

SAM BOUGH, R.S.A.

BORROWDALE

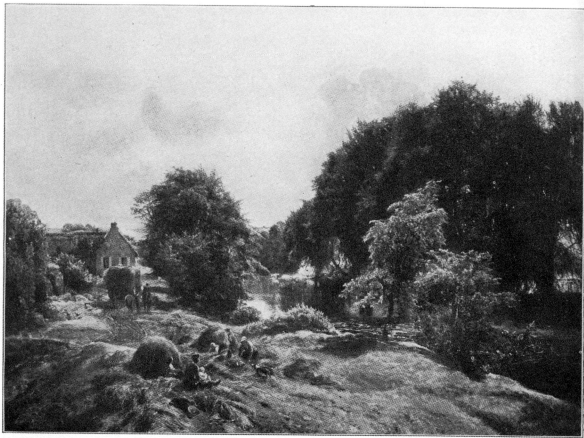

Annan, P.

Colonel Walter Brown

ALEXANDER FRASER, R.S.A.

ON THE AVON—HAYMAKING TIME

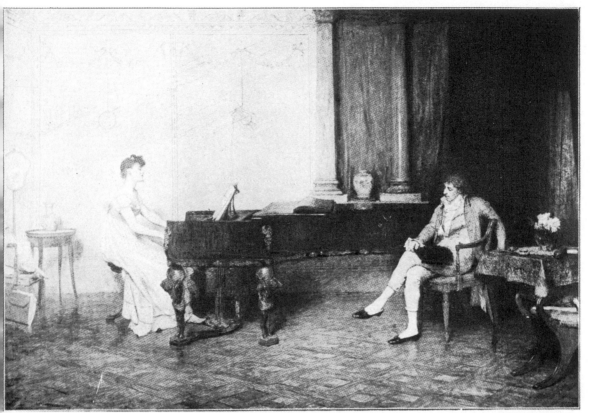

SIR W. Q. ORCHARDSON, R.A.

'IF MUSIC BE THE FOOD OF LOVE, PLAY ON!'

(*Reproduced by permission of The National Art Society*)

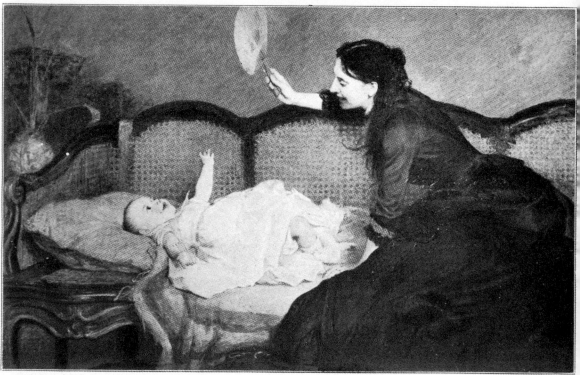

SIR W. Q. ORCHARDSON, R.A.

MASTER BABY

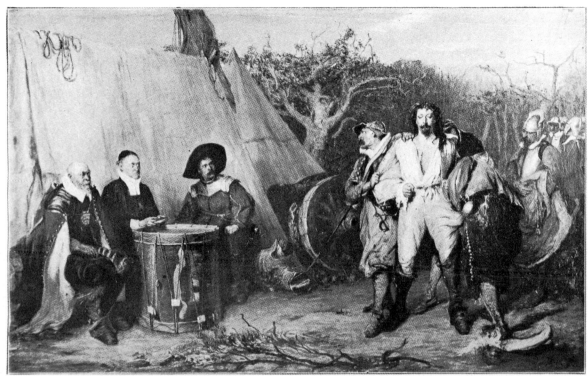

JOHN PETTIE, R.A.
THE DRUMHEAD COURT-MARTIAL

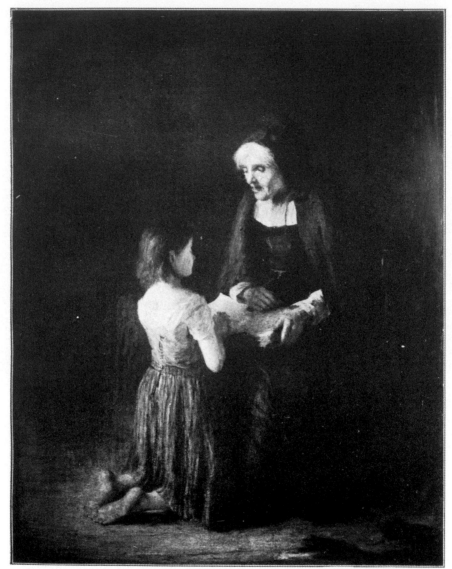

G. P. CHALMERS, R.S.A.

PRAYER

WILLIAM M'TAGGART, R.S.A.

THE VILLAGE, WHITEHOUSE

WILLIAM M'TAGGART, R.S.A.
MIST RISING OFF THE ARRAN HILLS

PETER GRAHAM, R.A.

WANDERING SHADOWS

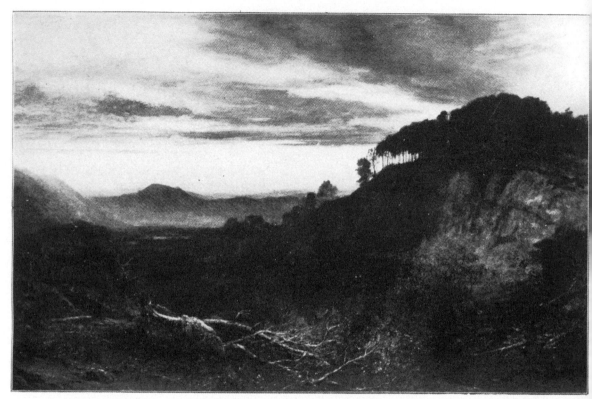

JOHN MACWHIRTER, R.A.

THE SLEEP THAT IS AMONG THE LONELY HILLS

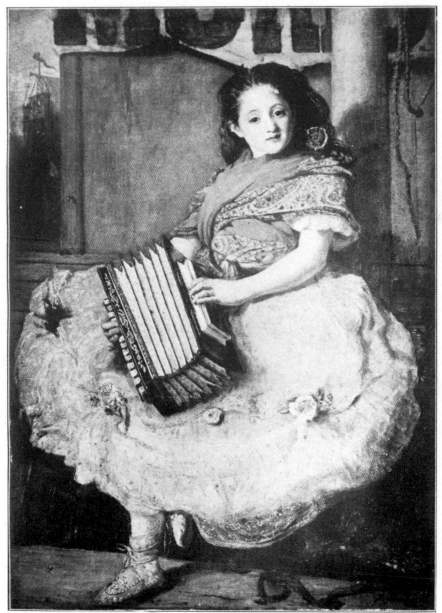

THOMAS GRAHAM, H.R.S.A.

A YOUNG BOHEMIAN

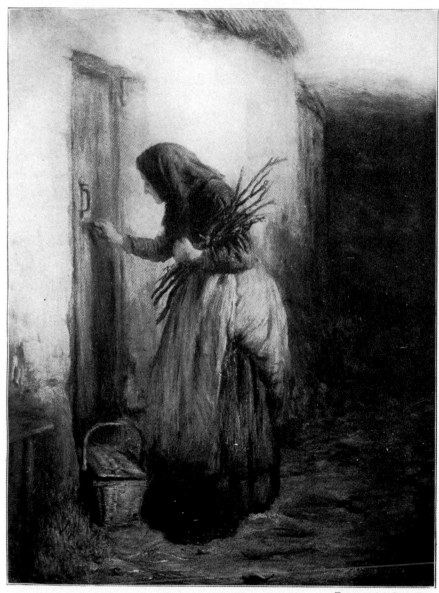

HUGH CAMERON, R.S.A.

A LONELY LIFE

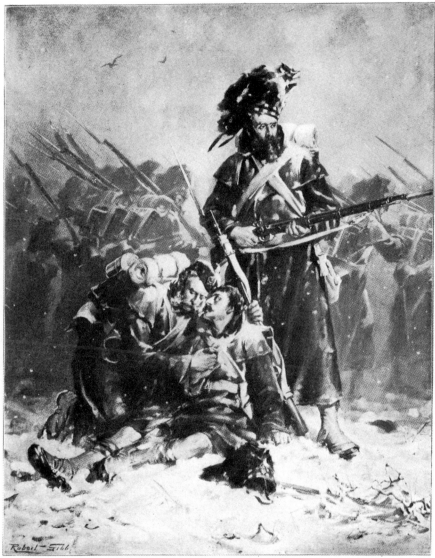

Gray, P. A. Ramsden, Esq.

ROBERT GIBB, R.S.A.

COMRADES

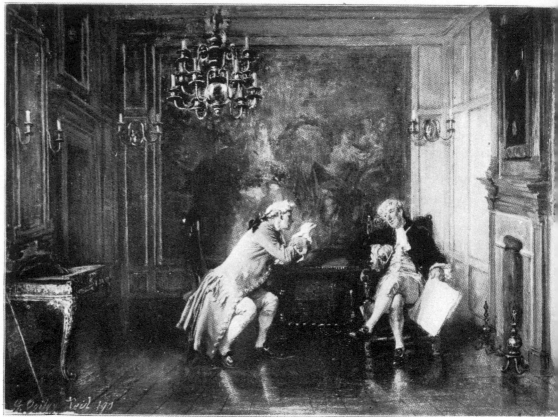

G. OGILVY REID, R.S.A.

DISCUSSING THE NEWS

ROBERT M‘GREGOR, R.S.A.

A SON OF THE SOIL

Gray, P. *Countess of Halsbury*

SIR GEORGE REID, R.S.A.

THE EARL OF HALSBURY

A. K. BROWN, R.S.A.

THE OLD TROSSACHS ROAD

DAVID MURRAY, R.A.

MY LOVE HAS GONE A-SAILING

Annan, P. W. W. Webster, Esq.

J. CAMPBELL NOBLE, R.S.A.

A DUTCH TRADE-WAY

CECIL GORDON LAWSON

THE MINISTER'S GARDEN

Annan, P. Sir R. Usher, Bart.

J. LAWTON WINGATE, R.S.A.

THE HEAD RIGG

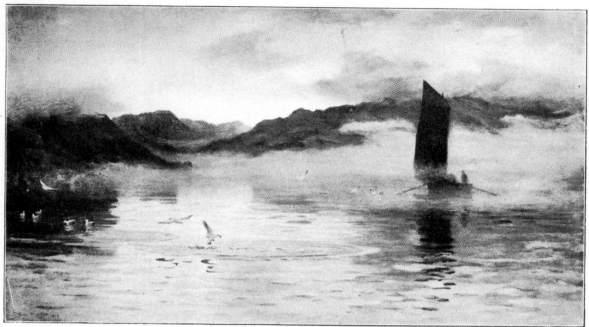

COLIN HUNTER, A.R.A.

SIGNS OF HERRING

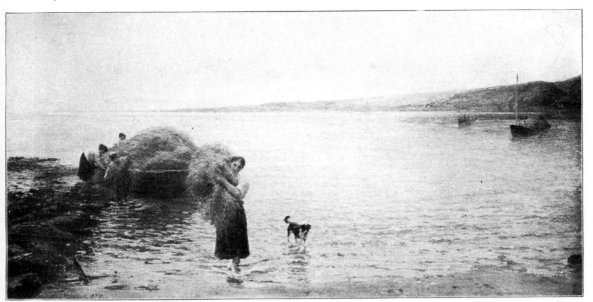

HAMILTON MACALLUM

HAYMAKING IN THE HIGHLANDS

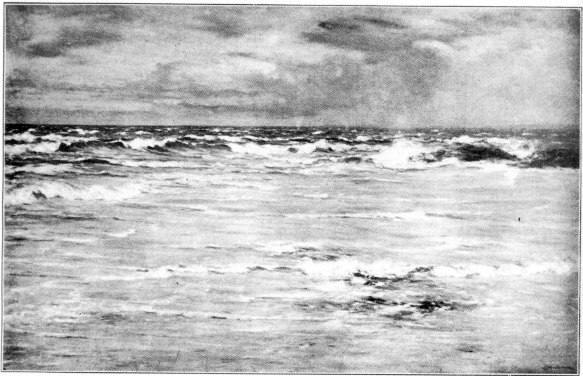

JOSEPH HENDERSON

THE FLOWING TIDE

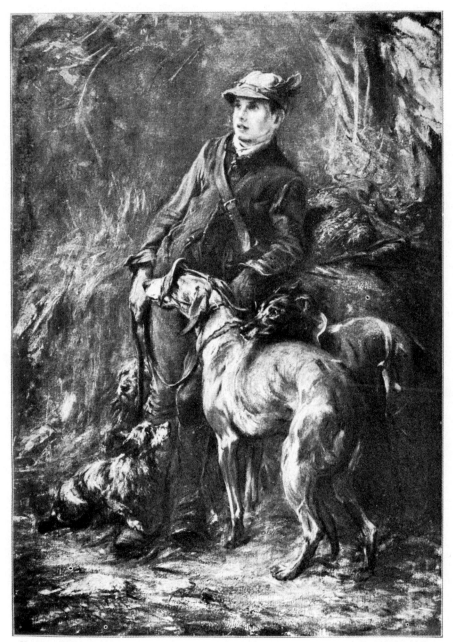

Young and Watson, P. T. J. S. Roberts, Esq.

ROBERT ALEXANDER, R.S.A.

WATCHING AND WAITING

Annan, P. Art Gallery, Ghent

SIR JAMES GUTHRIE, P.R.S.A.

SCHOOLMATES

SIR JAMES GUTHRIE, P.R.S.A.

MRS. JOHN WARRACK, JR.

E. A. WALTON, R.S.A.

GLASGOW FAIR IN THE FIFTEENTH CENTURY

ALEXANDER ROCHE, R.S.A.

IDYLL

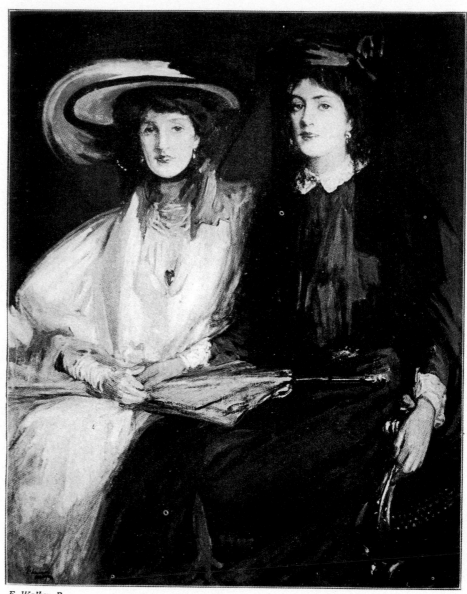

E. Walker, P.

JOHN LAVERY, R.S.A.
THE LADIES EVELYN AND NORAH HELY-HUTCHINSON

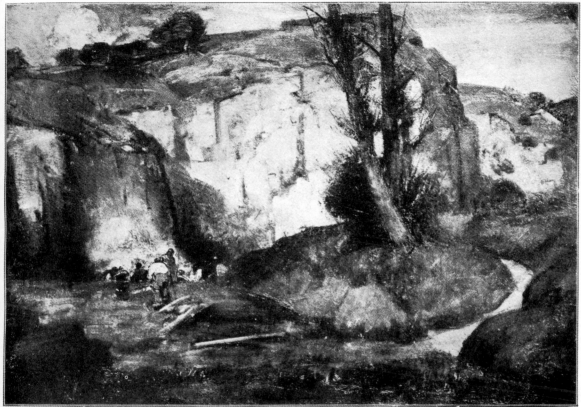

W. Y. MACGREGOR, A.R.S.A.

THE QUARRY

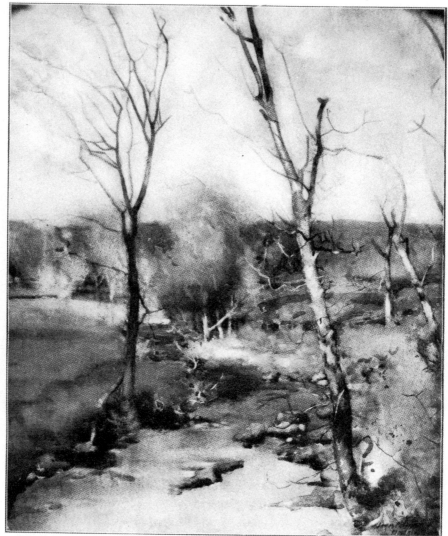

JAMES PATERSON, A.R.S.A.

CRAIGDARROCH WATER, MONIAIVE

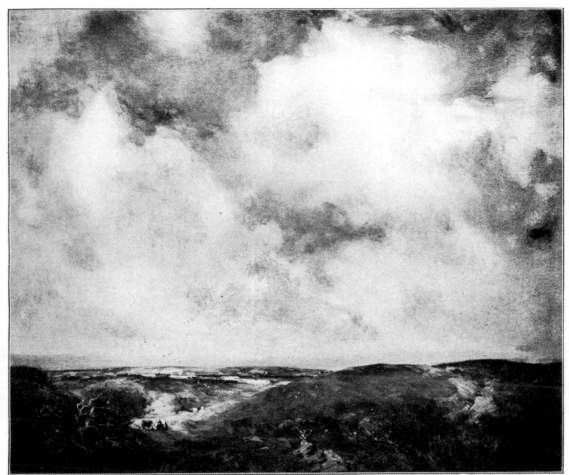

Balmain, P. Mrs. George M'Culloch

J. CAMPBELL MITCHELL, A.R.S.A.

KNOCKBRECK MOOR

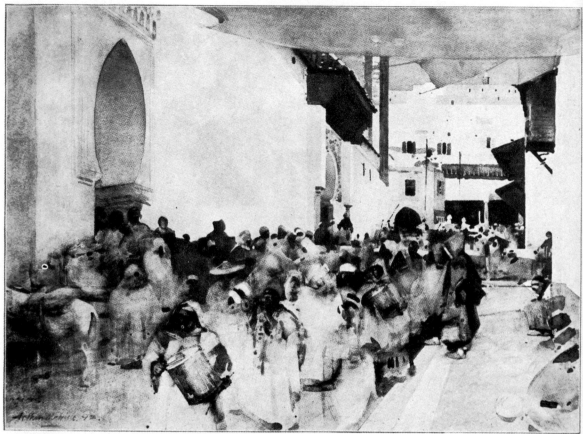

ARTHUR MELVILLE, A.R.S.A.

MOORISH PROCESSION

E. A. HORNEL
THE MUSIC OF THE WOODS

GEORGE HENRY, R.S.A.

THE BLUE GOWN

ROBERT BURNS, A.R.S.A.

ADIEU

J. H. LORIMER, R.S.A.

THE FLIGHT OF THE SWALLOWS

Annan, P.

C. H. MACKIE, A.R.S.A.
AT THE CLOSE OF THE DAY

Annan, P. *Sir Charles Darling*

W. J. YULE

JACK, SON OF MR. JUSTICE DARLING

ROBERT BROUGH, A.R.S.A.

SWEET VIOLETS

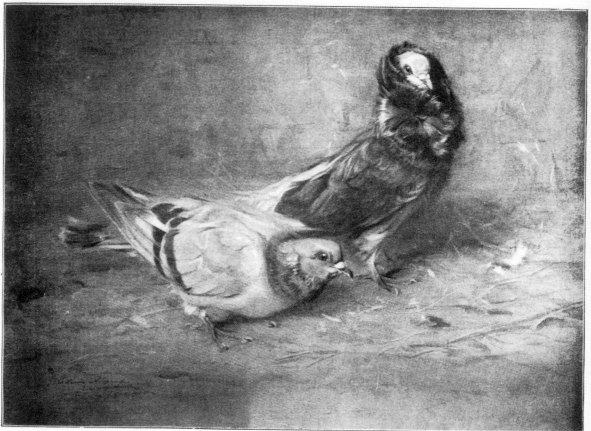

Young and Watson, P.

James Mylne, Esq.

EDWIN ALEXANDER, A.R.S.A.

PIGEONS

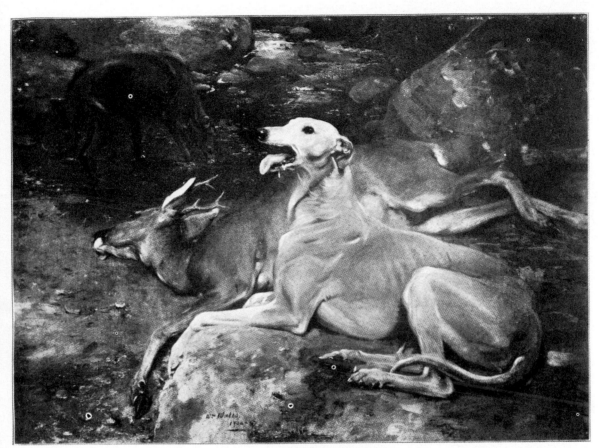

WILLIAM WALLS, A.R.S.A.

THE END OF THE CHASE

D. Y. CAMERON, A.R.S.A.

THE FIVE SISTERS OF YORK

MUIRHEAD BONE

AYR PRISON

INDEX

*Where more than one reference is made to the work of any Scottish painter,
the principal reference is given in heavy type.*